THE NEW HISTORICISM: STUDIES IN CULTURAL POETICS

Stephen Greenblatt, General Editor

1. *Holy Feast and Holy Fast: The Religious Significance of Food to Medieval Women*, by Caroline Walker Bynum

2. *The Gold Standard and the Logic of Naturalism: American Literature at the Turn of the Century*, by Walter Benn Michaels

3. *Nationalism and Minor Literature: James Clarence Mangan and the Emergence of Irish Cultural Nationalism*, by David Lloyd

4. *Shakespearean Negotiations: The Circulation of Social Energy in Renaissance England*, by Stephen Greenblatt

5. *The Mirror of Herodotus: The Representation of the Other in the Writing of History*, by François Hartog, translated by Janet Lloyd

6. *Puzzling Shakespeare: Local Reading and Its Discontents*, by Leah S. Marcus

7. *The Rites of Knighthood: The Literature and Politics of Elizabethan Chivalry*, by Richard C. McCoy

8. *Literary Practice and Social Change in Britain, 1380–1530*, edited by Lee Patterson

9. *Trials of Authorship: Anterior Forms and Poetic Reconstruction from Wyatt to Shakespeare*, by Jonathan Crewe

10. *Rabelais's Carnival: Text, Context, Metatext*, by Samuel Kinser

11. *Behind the Scenes: Yeats, Horniman, and the Struggle for the Abbey Theatre*, by Adrian Frazier

12. *Literature, Politics, and Culture in Postwar Britain*, by Alan Sinfield

13. *Habits of Thought in the English Renaissance: Religion, Politics, and the Dominant Culture*, by Debora Kuller Shuger

14. *Domestic Individualism: Imagining Self in Nineteenth-Century America*, by Gillian Brown

15. *The Widening Gate: Bristol and the Atlantic Economy, 1450–1700*, by David Harris Sacks

16. *An Empire Nowhere: England, America, and Literature from "Utopia" to "The Tempest,"* by Jeffrey Knapp

17. *Mexican Ballads, Chicano Poems: History and Influence in Mexican-American Social Poetics*, by José E. Limón

18. *The Eloquence of Color: Rhetoric and Painting in the French Classical Age*, by Jacqueline Lichtenstein, translated by Emily McVarish

19. *Arts of Power: Three Halls of State in Italy, 1300–1600*, by Randolph Starn and Loren Partridge

ARTS OF POWER

Three Halls of State in Italy, 1300–1600

RANDOLPH STARN AND

LOREN PARTRIDGE

UNIVERSITY OF CALIFORNIA PRESS

BERKELEY LOS ANGELES OXFORD

The publisher gratefully acknowledges the contribution provided by the Art Book Fund of the Associates of the University of California Press, which is supported by a major gift from the Ahmanson Foundation.

University of California Press
Berkeley and Los Angeles, California

University of California Press, Ltd.
Oxford, England

Library of Congress Cataloging-in-Publication Data

Starn, Randolph.
 Arts of power : three halls of state in Italy, 1300–1600 / Randolph Starn and Loren Partridge.
 p. cm. — (The New historicism ; 19)
 Includes bibliographical references and index.
 ISBN 0-520-07383-5 (cloth)
 1. Halls—Italy. 2. Architecture and state—Italy. 3. Symbolism in architecture—Italy. 4. Public art—Italy. 5. Allegories. 6. Italy—Politics and government—1268–1559. I. Partridge, Loren W. II. Title. III. Series.
 NA6815.S787 1992
 725′.17′0945—dc20 91-17678
 CIP

Printed in the United States of America
9 8 7 6 5 4 3 2 1

The paper used in this publication meets the minimum requirements of American National Standard for Information Sciences—Permanence of Paper for Printed Library Materials, ANSI Z39.48-1984. ⊗

For my wife, Frances (of course),
and my mother, Madge, and in memory of my father, Ray Starn

For my wife, Rosemary,
and my parents, Ruth and Don Partridge

With love

CONTENTS

Plates follow page viii

Photograph Credits ix

Acknowledgments xi

Introduction 1

I. The Republican Regime of the Sala dei Nove in Siena, 1338–1340 9

 Siena mi fe' 13

 The Republic Faces Evil 19

 The Republic in Writing 28

 Writing Power / 30

 Reading the Vernacular / 33

 Latin Lessons / 38

 The Republic in Pictures 46

 The Construction of a Republican Panorama / 48

 Patterns of Practical Knowledge / 52

 Mirrors for Magistrates / 55

 The Regime Falls, the Pictures Remain 58

 Figures 1–33 61

II. Room for a Prince: The Camera Picta in Mantua, 1465–1474 81

 From Republics to Princely Regimes 86

 Walls as Mirrors and Windows for the Prince 90

 Bodies Politic / 91

 "Little Things Matter in These Affairs of Princes" / 99

 What's in a Name / 105

 Intermezzo: The Flight of the Peacock 114

Seeing Culture on the Ceiling of the Camera Picta 118

 The Glance / 119

 The Measured View / 123

 The Scan / 126

Mantegna and Momus 131

Figures 34–59 135

III. Triumphalism: The Sala Grande in Florence and the 1565 Entry 149

A Tale of Two Cities Triumphant: 1530 and 1565 152

From Triumphs to Triumphalism 157

 Procession and Passage / 162

 To the Victor Belong the Spoils / 164

 The Program Triumphant / 165

A Triumph of Triumphalism in Florence 168

 The Parade / 168

 The Persona of the Victor / 178

 The Spoils / 185

 Program and Production / 189

 Duke Cosimo I / 189

 The Programmer: Borghini / 192

 The Quartermaster: Caccini / 200

 The Artist as Impresario: Vasari / 203

Figures 60–128 213

Epilogue: Arts of Power 257

Appendix 1. Inscriptions in the Sala dei Nove 261

Appendix 2. Entry Arches and Sala Grande: Diagram Legends 267

Notes 305

Index 367

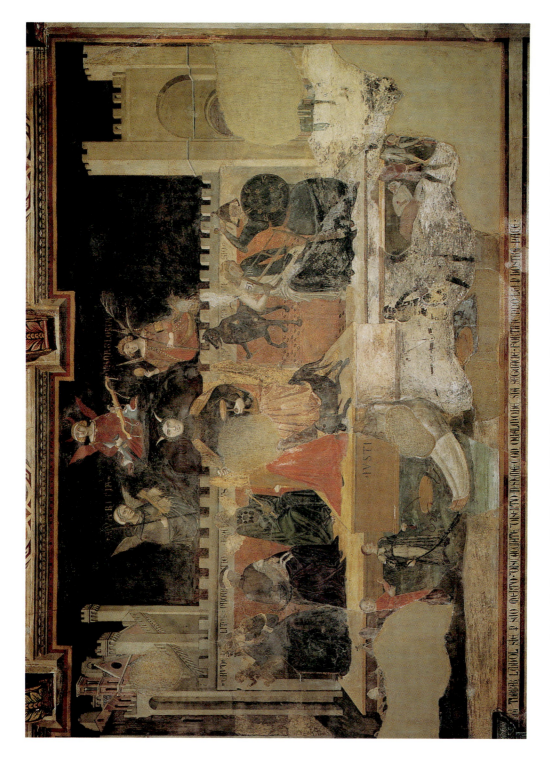

PLATE 1. Ambrogio Lorenzetti, Allegory of Bad Government, Siena, Palazzo Pubblico, Sala dei Nove, west wall.

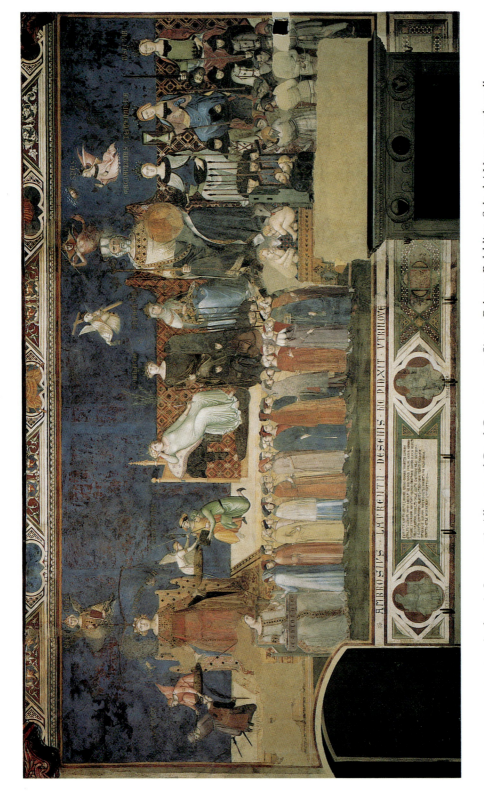

PLATE 2. Ambrogio Lorenzetti, Allegory of Good Government. Siena, Palazzo Pubblico, Sala dei Nove, north wall.

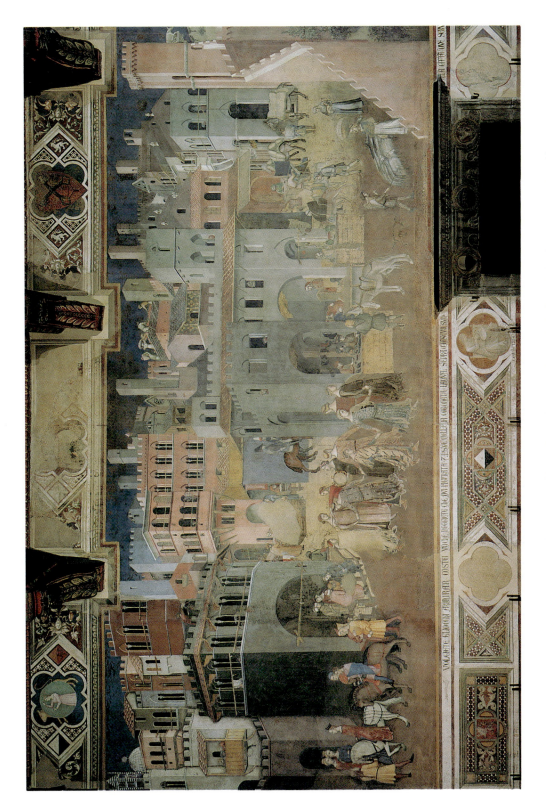

PLATE 3. Ambrogio Lorenzetti, Good City. Siena, Palazzo Pubblico, Sala dei Nove, east wall.

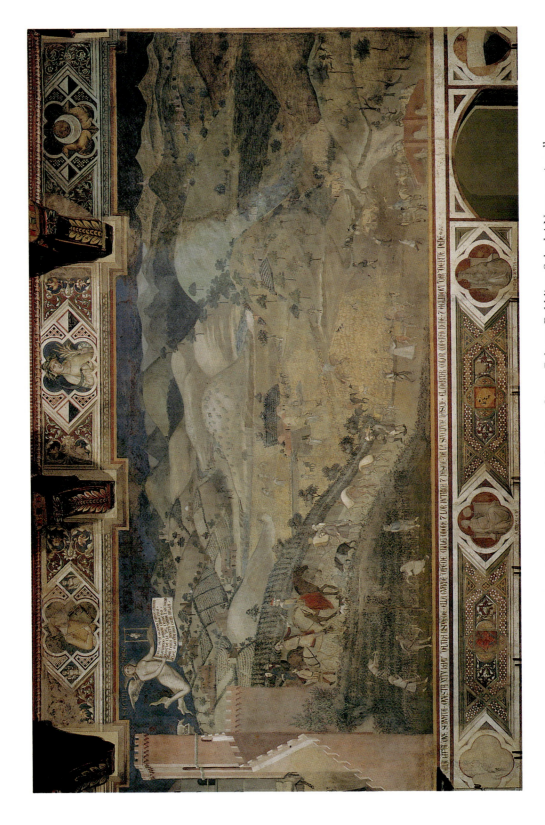

PLATE 4. Ambrogio Lorenzetti, Good Country. Siena, Palazzo Pubblico, Sala dei Nove, east wall.

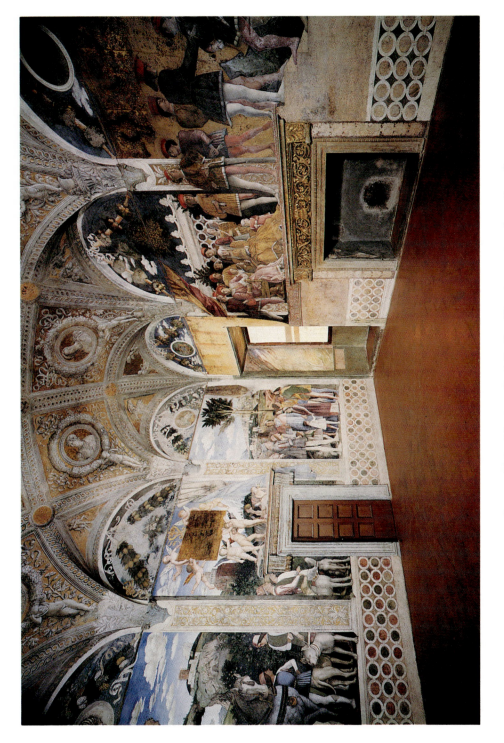

PLATE 5. Camera Picta. Mantua, Castello San Giorgio, west and north walls.

PLATE 6. Andrea Mantegna, Ceiling. Mantua, Castello San Giorgio, Camera Picta.

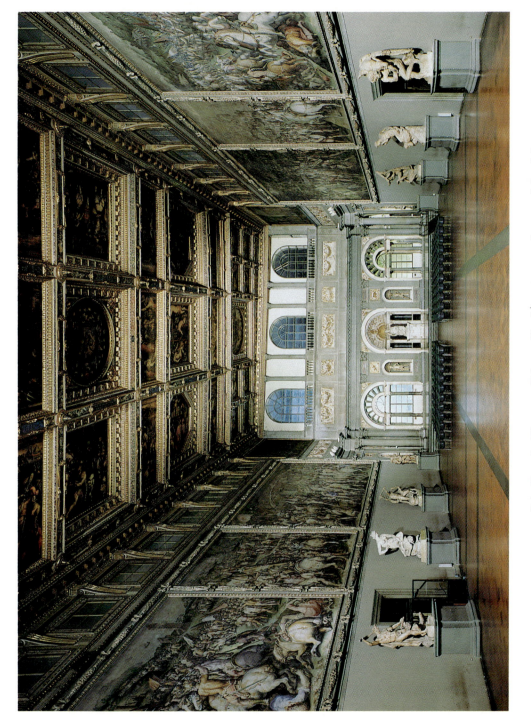

PLATE 7. Sala Grande. Florence, Palazzo Vecchio, view north toward the dais.

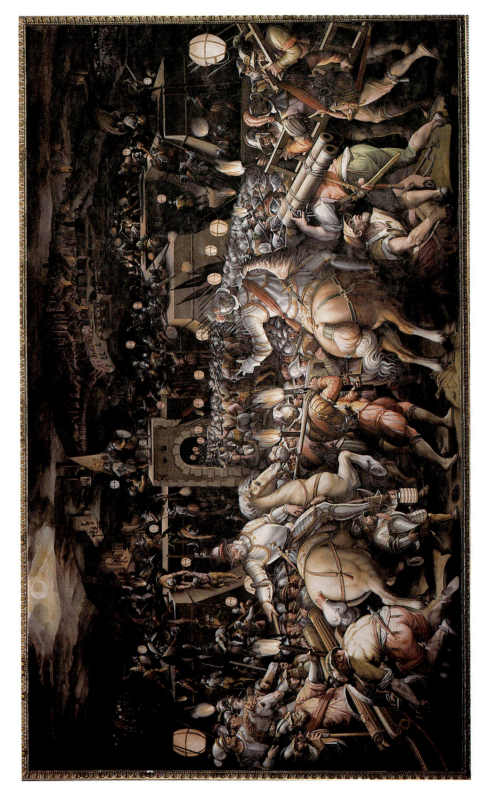

PLATE 8. Giorgio Vasari and workshop, *Conquest of the Fortress near the Porta Camollia in 1554*. Florence, Palazzo Vecchio, Sala Grande.

PHOTOGRAPH CREDITS

ACKNOWLEDGMENTS

We are particularly indebted to the Solomon Guggenheim and J. Paul Getty Foundations, and to the Committee on Research at the University of California at Berkeley for fellowships and grants that greatly facilitated our research and writing. The staffs of the museums, archives, and libraries in Berkeley, Florence, Mantua, Milan, Rome, Siena, and the Vatican were unfailingly helpful and courteous. Special thanks to Ann Gilbert in the Art History-Classics Graduate Service of the University of California at Berkeley for solving many bibliographic problems, and to Ugo Bazzotti in the Soprintendenza of Mantua for providing access to and photographs of Mantegna's Camera Picta. Our colleagues Ruggero Stefanini and William S. Anderson provided respectively the transcriptions and translations of Appendix 1 and the translations of Appendix 2 for which we offer heartfelt thanks. Thanks also to Wendy Partridge for the jacket illustration, Carolyn Van Lang for the diagrams, Evelyn Lincoln for the index, Janice Eklund for computer support, and Keith Thoreen for help with photographs. Students in a fall 1982 graduate seminar on war and peace (Julie Cumming, Nan Hill, Ann Piper, Wendy Ruppel, Regina Stefaniak) and in a fall 1984 graduate seminar on the painted room (Virginia Altman, Linda Graham, Stratton Green) helped to shape our thinking on many issues. For comments on the text at various stages of writing, as well as collegial advice and encouragement we thank the following: Paul Barolsky, Cristelle Baskins, Michael Baxandall, Eve Borsook, William Bowsky, Carroll Brentano, Robert Brentano, Daniel Brownstein, Stephen Greenblatt, Brian Horrigan, Thomas Laqueur, Edmund Pillsbury, Michael Rogin, Rodolfo Signorini, Andrea Starn, Frances Starn, Orin Starn, Regina Stefaniak, the editorial board of *Representations,* and the Berkeley-Stanford Italian Renaissance Reading Group. Thanks finally to our editors Sheila Levine, Rose Vekony, and Edith Gladstone.

INTRODUCTION

The state might be said to begin in marking off centers of power, some chieftain's tent or a room for a throne, an assembly hall or a council chamber. One strand of radical theorizing would end the state by abolishing the center—which revolutionaries have regularly gone on to reconstruct in practice. If we reduce the definition of politics to a minimum of public decision-making, we still need to imagine an arena in which decisions are made. When we extend the definition to include the symbolic dimensions of the political, we anticipate a showplace or stage where the symbols of a given regime are displayed and its rituals acted out. To speak of political decentralization is only another way of saying that power revolves around several centers. The "arts of power" that are the subject of this book gravitate with the logic of politics and the weight of tradition to the centering spaces where the state is in all senses of the word "represented."

A "postmodern" design of a room for state occasions could draw upon a fairly consistent set of historical specifications. It would be located more or less centrally within the capital and the principal building of the regime. It would be regular in shape, perhaps square or nearly square, more likely rectangular in order to create converging lines of sight on the seat of authority as well as a longitudinal axis along which it could be approached. The main entrance would probably be off to one side, with a dais or tribunal placed at a right angle to it—the powers-that-be have seldom wanted to be approached too directly. Besides commanding respect and demanding at least a shiver of awe, the decorations would illustrate the sources and the expansion of the regime's authority, its professed aims, duties, and accomplishments. Symbols of some supernatural, cosmic, or natural order might be interspersed or juxtaposed with mythological or historical narratives figuring real or imagined victories and prefiguring those to come. The ensemble would probably be consecutively arranged around the walls or along the ceiling and thematically paired across the room in a simulated redemption of the world's contingencies.

The residence of Emperor Domitian (A.D. 81–96) on the Palatine hill in Rome has some claim to being an actual prototype for the palaces of the West. The word *palatium*—the name of the site—was first applied there to the residence itself and later to any magnificent official building or "palace." There

1

too the term *aula* seems first to have been used in the sense of a "hall of state." A carefully staged approach to the broad expanse of the *area palatina,* a monumental facade with a colonnade and pediment facing the open square, a vast audience hall (*aula regia*), a hall of justice (*basilica*), and a ceremonial dining hall (*triclinium*)—these forms and functions would reappear in countless variations.[1] So would the rhetoric they inspired or provoked. Martial proclaimed that the emperor's palace was greater than the pyramids of Egypt, that "nothing more magnificent has seen the light of day." Pliny evoked the darker side of this theater of power: "terror, threats, and fear met at the doors in equal portions those who were admitted and those who were shut out. The emperor himself was of terrifying aspect: arrogance sat on his brow, wrath in his eyes, feminine pallor over his body; his face was flushed with scorn. No man dared approach him and address him."[2]

As late as the eighth century the Palatine complex was still in use. Western emperors and Germanic kings had built imposing palaces and villas elsewhere.[3] Like much of the apparatus of statecraft, however, the paradigms for large-scale halls of state seem to have returned to the West by way of Byzantium and, since the Church taught the laity as much about power as about piety, in ecclesiastical form. In what amounted to a *translatio imperii* Pope Leo III (795–816) evidently modeled the two large rooms in his "renewed Palatine" adjacent to San Giovanni in Laterano after the Triconchos and the Hall of Nineteen Divans in the Great Palace at Constantinople.[4] Playing a "new Constantine" to Pope Leo's "new Sylvester," Charlemagne built a three-apsed hall at Aachen that contemporary documents styled the *sacrum palatium* and the "Lateran."[5] The palace Martial imagined at the very center of the cosmos, "its summit . . . level with heaven," had given way to a proliferation of rival centers.

The ancient forms were only dimly remembered in the "palaces" of medieval rulers, nobles, and ecclesiastics, virtually all containing a large multipurpose room for feasts, assemblies, audiences, and receptions.[6] The earliest of these "great halls" were located on the ground floor and made of wood. From the twelfth century on they were mostly constructed in stone, raised to the second floor reached by outside stairs, and covered with timbered ceilings, although by the later fourteenth century the stairs were apt to be internal and the ceilings vaulted in masonry. Occasionally aisled, but almost always rectangular, with a principal entrance near the end of a long wall, they ranged in size up to the immense proportions of William II's hall at Westminster (1099, rebuilt 1394–1401), probably the largest ever built (20 × 72 meters).[7] Few examples of the decorations survive, but we know that in stained glass, mosaic, or more often in paint they included personifications of virtues and vices, allegories, astrological signs, and biblical or secular histories identified by inscriptions.

More rooms and new principles of arrangement were required as the func-

tions and formalities of government multiplied. Antechambers and vestibules were added to the large halls. Rooms were provided for councils and officials, and the *camera regis,* usually relatively small and square or nearly square, became the inner sanctum of the palace where rulers received their families, intimate retainers, and privileged visitors.[8] Here again the papacy, by far the most highly developed European "state" before the sixteenth century, led the way, first with the additions to the Vatican begun late in the thirteenth century and then with the still larger fourteenth-century palace at Avignon. After the definitive move of the popes to the Vatican, the new wing of Nicholas V (1447–1455) set the pattern for later palaces—a central courtyard, the disposition of state rooms *en enfilade* on the second floor, the programmatic fresco cycles on the walls and ceilings.[9] The old rivalry with the Palatine had been won at last.

Jacob Burckhardt claimed that in Italy the state became "a work of art." In the charter text of Renaissance studies he pointed to the invention of diplomacy, the professionalization of warfare, the rise of *Realpolitik,* the writing of political history, the development of political thought—to the "hundred different forms" in which the Italian city-states made statecraft "the object of reflection and calculation."[10] In all this he saw an alliance of power and imagination that both fascinated and repelled him as a manifestation of "the modern political spirit of Europe." For the self-appointed defender of "the culture of old Europe," the union of art and politics was a forced and fitful, if occasionally fruitful, conjunction of distinct and fundamentally incompatible realms.[11] Perhaps it was for this reason that Burckhardt shied away from the corollary of his own insight: that art became in Italy a work of state.

After the Peace of Constance (1183) conceded them a measure of independence, the city-republics of northern and central Italy launched the greatest boom in public building and official art since classical antiquity.[12] Town halls were built of brick or stone, with bell towers, vaulted loggias at the ground level, and large assembly rooms and adjacent council chambers in an upper story. Most of these rooms were decorated with murals as the new republics invested themselves with signs of legitimacy and exploited their lay version of a long-standing clerical rationale for didactic images. Frescoes had special advantages: they were relatively inexpensive, durable, and, since a layer of fresh plaster and paint could always cover outmoded tastes or political opinions, conveniently expendable. The earliest of them featured battle scenes and images borrowed from Christian iconography that together celebrated and sanctified civic victories.[13] Larger palaces with more articulated interiors and civic allegories in paint came later with the expansion of the franchise, the extension of territorial boundaries, and the consolidation of political institutions in the course of the thirteenth century. A new breed of makeshift princes brought in turn new campaigns of building and decoration. These campaigns

grew in scale and shifted in site from the margins of the old communal centers to the later Renaissance and Baroque projects, which recast whole buildings and sometimes whole cities into settings for the triumphs of absolutism.[14]

That the halls of state of these successive regimes were, as Clausewitz would say of war, an extension of politics by other means is a basic premise of this book. It is in a sense an obvious proposition since the halls would presumably not have been commissioned otherwise. Easy distinctions between the trappings and the substance of authority are problematic in any case, and in the last decades of the twentieth century we have seen the real force of the imaginary projected by the media and, more dramatically, the practical consequences of what began as "merely" symbolic challenges to seemingly invulnerable authoritarian states. This experience should remind us—not for the first time of course—that power does not respect distinctions between the real and the ideal, that it operates behind and across political lines, that it is discursive in the etymological sense of "running in various directions." Some of the most telling contemporary analyses have taken the pervasiveness of power relations as a sign of the inadequacy or even the irrelevance of political institutions. The conclusion is understandable, for if power is, as Michel Foucault defined it, "the name for a complex set of strategical relationships in a given society," then it may well be the case that one "impoverishes the question of power if one poses it solely in terms of the state and the state apparatus."[15] But the same line of analysis can yield quite different conclusions: precisely because power is diffuse and invasive, the state must seek to circumscribe and control a sphere of distinctively political interests. By this roundabout route a familiar contemporary critique of the category of the political may actually lead back to politics and so to questions of the state, its claims to legitimacy and its means of making those claims persuasive.

In Italy's painted halls of state political interests converged over the course of three different centuries under three distinctive regimes—the civic republics of the fourteenth, the princely courts of the fifteenth, and the "triumphalist" states of the sixteenth century. Another major premise of this book is that the settings and forms appropriated by each type of regime depended on a particular conception of politics. These differences can be mapped out in the migration of authority from republican town halls to the fortresses of new princes and back again to the old sites newly aggrandized as capitals of regional states. Each site and each regime had in turn a characteristic, if not exclusive, center—the large and small council rooms of the republics, the *camera* of the prince, the great audience halls of the later sixteenth century. The pictorial cycles in these rooms depended on local circumstances, traditions, and tastes as well as prevailing artistic styles, but preferred themes and biases of attention were also embedded in the generic requirements of different political ideologies. The republican regime was obliged somehow to represent both the activities of its citizens and its abstract claims to legitimacy

beyond the interests of a single individual or class. The court of the fifteenth century revolved around the person and persona of the prince. With the magnification of the scale and the pretensions of the Italian states that survived the foreign invasions after 1494, imperial projects of domination were staged in the visual rhetoric of triumphal celebration.

But the argument of the book goes beyond an analysis of the styles of different political cultures. Yet another of its premises is that art, especially painting, far from merely reflecting distinctive political messages, both constructs and contests ideologies. This proposition is in one sense a kind of *ricorso*. It recalls, on the one hand, a venerable science and lore on the conversion of visual representations into realities. So, for example, the notion that the visible world is charged with otherwise invisible meanings, or the role of imagination as the mediator between reason and memory, or the conviction that images are more reliable than words. On the other hand, the dream of perfect signification has sooner or later entailed the counterargument that representations are copies, declensions, or rivals of putative originals, that the *figura* which affords visibility is also a screen or a barrier, that form rivals content. These openings to criticism hover over claims for the authenticity of the image.[16]

As an academic discipline art history has been committed to the Sisyphean task of resolving this old quarrel over representation. Art historical research typically supplies the background, meaning, or message that images are supposed to reflect, express, or communicate. Thus the iconographer refers formal motifs to the sense allegedly prescribed for them by artistic conventions, texts, or, in the ensemble, a "program"; contextual histories of art, invoking "materialist" or "realistic" corrections to the "idealism" of the iconographers, treat art objects as more or less faithful hieroglyphs of their production or reception. Either way, the aim of interpretation is to calibrate the overlap between the art and the world of the artifact. Whatever cannot be assimilated to the presumed unity of the work of art is relegated to art criticism or history respectively.[17]

To empower (or reempower) the image it is not so much the interpretive calculus that needs to be changed as the paradigm itself. For the purposes of this book this means acknowledging that the images of art are fabrications, that they are objects and not visions, that their material presence asserts the absence of the world of their making. It follows that instead of looking through the objects we classify as works of art for the realities allegedly underlying them we might rather look at the signs they encode *as* a kind of reality. Seen in this way, it is, so to speak, the superficiality of painting that invites and at the same time exposes the strategic manipulations of ideology and political interest. A "formalist pragmatics," to give this way of seeing a name, will tack accordingly between two critical guidelines: that insofar as an image is a formal construction, it can neither be reduced to recording a real event

nor deduced from some other extrinsic reference; that insofar as the image is the production and producer of purposeful activity, it will be implicated in the circumstances in which it is made and apprehended. Under the same rubric any formal analysis will necessarily remain pragmatic in the sense of being provisional, while any account of the pragmatic functions of images will always be mediated by considerations of their form. [18]

There is nothing new of course about working on the frontiers between art and history, certainly not in Renaissance studies, where interdisciplinary tres-passing was common from the start. Until recently, however, most inter-disciplinary work of this sort has mostly combined disciplines while respect-ing the established boundaries. We would like to think that this book points beyond secure frontiers to a field of inquiry that sees art as a form of power while charting the operations of power in the forms of art. Art thus figures as an active agent of history rather than its passive reflection, and conventional distinctions that are usually taken for granted—content and form, real and ideal, depth and surface, reality and illusion—become contingent effects of representation, ideology, and artistic intention.

The experiment attempted here is admittedly a highly selective one. It be-gan with the unsettling combination of art, politics, and piety that we ex-plored in a book on the Rome of Pope Julius II. Initially, we wanted to move from the close focus of a case study to a wider panorama, from the image of the *papa terribile* to the conceptions of war and peace that ran through the cul-ture of the Julian court. But as our work proceeded and found its way into print, this theme seemed at once too open-ended and too confining, endlessly elaborated in Renaissance culture, and yet only one of the strands that, as we came to see them, converged in the great public rooms of the Italian city-states. [19] Of these, the meeting room frescoed by Ambrogio Lorenzetti for the principal citizens' council of the republic of Siena (1338–1340) and the so-called Camera degli Sposi painted for Marchese Ludovico Gonzaga of Mantua by Andrea Mantegna (1465–1474) were the most intact and the most cele-brated commissions of a Trecento republican government and a Quattrocento prince. The choices were less obvious after 1500, when Italian states, great and small, broadcast their aggrandizement or mere survival in a triumphal style. But the Sala Grande of the Palazzo Vecchio in Florence, where the wed-ding procession of Giovanna of Austria and Francesco de' Medici culminated in 1565, was deliberately intended to surpass all competitors. Here, if any-where, we could take our bearings on a style that its practitioners themselves regarded as a kind of triumph.

Although there were monographs and specialized studies on all these rooms, no one had considered them together as monuments of public art transformed by fundamental changes in political regimes, artistic practices, and cultural values. This meant that we could work out from a rich fund of

material for our own research in archives, libraries, and museums from Siena and Rome to Milan and Mantua. Each site became the subject of an extended essay in its own right and, as it happened, with the division of responsibility that evolved over time the book was conceived and written in separate sections, the first and second parts and the introduction to "triumphalism" in the third part by R. S. and the analysis of the triumphal entry and the Sala Grande in Florence by L. P. The results reflecting our different interests and approaches are not seamless but we hope that, taken as a whole, they will give new meaning to the old claim that in Italy, as Jacob Burckhardt put it long ago, the state became a work of art.

PART I

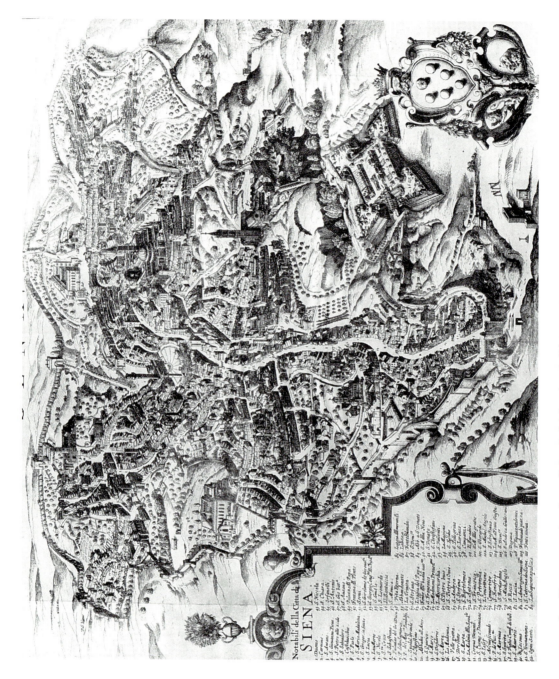

PLATE I. *Siena*, engraving from Orlando Malavolti, *Dell'historia di Siena* (Venice, 1599).

The Republican Regime of the Sala dei Nove in Siena, 1338–1340

In the *Divine Comedy* a woman traditionally identified as Pia dei Tolomei declares, *Siena mi fe'*—"Siena made me" (*Purgatorio* 5.134).[1] It is the city that calls her into being and establishes her identity. But this Siena that preempted God and the family to "make" citizens was also riven by conflict. The other Sienese matron in the *Comedy*, Sapìa dei Provenzani, rejoiced over the defeat of her own countrymen by the Florentines at Colle di Valdelsa in 1269 (*Purgatorio* 13.106–54). In these characters Dante personifies both the celebration of collective values and the assertion of insistently particular interests that came together, if not to rest, in the city-republics of medieval Italy—nowhere more so than in the republic of Siena.

Republican communes had begun to appear in Italy around the turn of the eleventh century. Wresting away the prerogatives of their bishops and the emperor, they established legislative assemblies, advisory councils, and administrative commissions. Economic expansion and the heady feel of independence quickened the pace of political experiment. In the thirteenth century the self-styled *popolo* of the guilds grafted its own statutes, councils, and officials onto the original communes of leading citizens. One faction or another—Guelphs or Ghibellines or some local variation on the conflict between the papal and the imperial parties—demanded recognition for its own institutions. These partisan maneuvers, often accompanied by violence, were more often than not justified by citing the evils of partisanship and violence.

Niccolò Machiavelli was, for once, perfectly conventional when he charged that such justifications were "not for the Common Good but only for the benefit of the victor."[2] Medieval chroniclers had already shown how one regime after another excluded whole classes, parties, professions, or families. Losers and victims had raised a chorus of complaints, from the "murmuring sorrow" of the exiles of Milan in the 1270s to the towering rage of Dante against his enemies in Florence.[3] Modern historians have gone on to demonstrate that the Italian city-republics were consistently dominated by a mixed

11

elite of money and property, that the political franchise was limited, that professions of political virtue were negotiable. Historians exposing the oligarchical domination of a nascent capitalism and students of the close-grained textures of communal society have arrived at a kind of consensus: republican ideals, we are told, served only to mystify and obscure the harsh realities of communal politics. On this account those who dream of a brave new republican world in Italy are dupes of a successful propaganda campaign.[4]

But these charges miss the point of the profoundly unsettling challenges that the communes presented to prevailing conceptions of political authority.[5] Sapìa dei Provenzani, belatedly repentant in Purgatory, recited the common wisdom that heaven was the only true "city" for Christians. The legitimate earthly republic of the Middle Ages was the *respublica christiana* headed by the emperor and the pope; the Latin term *commune* designated the private sphere, the inferior counterpart of the public realm, or *publicum*. Townspeople in the hierarchical vision of medieval society were at the bottom in the third estate, beneath the estates of the clergy and the nobility.[6] Yet town money could buy the land that supposedly guaranteed the hierarchical arrangements of feudal society, while civic statutes and business contracts threatened the values of oral tradition and pledged honor and the near monopoly of the clergy over the written word. Otto of Freising marveled in the middle of the twelfth century that "men practicing mechanical trades" could rebel against the emperor, "their rightful sovereign to whom they ought willingly to give obedience."[7]

In the eyes of the traditional authorities, then, the communes were technically private and voluntary organizations, improvised assemblies, unruly associations of upstarts. Official recognition was conceded more or less grudgingly. Even their own citizens often saw the communes as legal fictions or as guilty usurpers of higher jurisdiction with a reckless tendency to meddle with loyalties to family, neighborhood, guild, parish, or confraternity. Dante likened the Florentine republic to a feverish patient thrashing about on a sickbed (*Purgatorio* 6.148–51), and his contemporary Dino Compagni promised the Florentines retribution at the hands of the emperor.[8]

So how were these fledgling republicans to legitimate their political identity? For all their professions of independence they were nominally subjects of the emperor or the pope. They could not fall back on the sanction of long-standing custom. They resisted the personal ties of the feudal order between lord and vassal, but they betrayed the ideal of impersonal, objective standards of law by their constant tampering with the laws. The commune that claimed to minister for the good of the whole was in another guise only a cluster of institutions and interests.

Aristotle analyzed the central dilemmas of republican politics toward the end of another great age of the city-state. In a passage on the origins and the ends of the state he asks us to imagine a political community of interest

groups: "Let us suppose that one man is a carpenter, another a farmer, another a shoemaker, and so on, and that their number is ten thousand." A government formed along these lines would be politically mimetic, a facsimile of its own society, but it would not be a proper state if its members had "nothing in common but alliance, exchange, and the like." A "mere society" is not a state, even if it meets in one place and establishes laws "for the prevention of mutual crime and for the sake of exchange." The state "exists for the sake of a good life, and not for the sake of life only"; otherwise "law is only a convention, a 'surety to one another of justice,' as the sophist Lycophron says, and has no real power to make citizens good and just."[9] Hence the need for a politics based on standards situated outside particular interests, for a politics defined by the suppression of the political.

Aristotle treated this requirement as a matter of fictive representations of things not actually present. When many individuals band together collectively as citizens, they "become in a manner one of many . . . that is, a figure of the mind and disposition." These symbolic "figures" differ as "works of art from realities, because in them the scattered elements are combined." Like a musical key, which remains constant while different notes are played, the generic constitution of the state endures, "whether the inhabitants are the same or entirely different." And any state "which is truly so called" must aim for virtue and the higher goods of political life, above all for justice.[10]

The republic of interests *and* the republic of principles—for the first time since antiquity the city-republics of Italy confronted the double binds of republican ideology. On the one hand, the republican commune was a "mere alliance," a restrictive one at that; on the other hand, far from merely standing for a sum of private differences, it was supposed to stand above them. Civic councils and commissions represented the diversity of the people, at least of those who were enfranchised, but as the repository of lofty principles the commune had to be clothed in the metaphors of abstract truths. To contend with these conflicting demands was the great task of the new republican culture.

SIENA MI FE'

The high tensions of republican politics passed through the meeting room of the Nine Governors and Defenders of the Commune and the People of Siena, the chief citizens' council of the government that ruled the city from 1287 to 1355. The crucial deliberations of the republic took place in this relatively small rectangular space (14.04 × 7.70 meters) on the second floor of the town hall, the Palazzo Pubblico. Ambrogio Lorenzetti (ca. 1295–1348) painted the fresco cycle there (color plates 1–4; figs. 5–6) that is an acknowledged masterpiece of medieval secular painting and one of the consummate political statements in the history of Western art.

Beyond records of regular payments to Lorenzetti between April 1337 and June 1340, we know nothing about the circumstances of the commission.[11] A reference to "figures painted and located in the chambers of the lords Nine" indicates that the painter worked in the Sala dei Nove from 1338 to 1340. The next reference dates from 1350, when a chronicler mentions the frescoes simply as "Peace" and "War," names that turn up again over the next two hundred years. Not only are the written sources scanty, but the frescoes themselves have suffered severe damage over time. Large areas on the west wall were completely ruined by moisture; some details were altered or lost in restorations beginning only a decade or so after Lorenzetti finished his work. The timbered ceiling was evidently reconstructed at some point and new doorways were cut in subsequent remodeling, probably in the fifteenth century.[12] Even so, Lorenzetti's frescoes are still among the most intact of the mural cycles that once adorned the public buildings of the medieval communes.[13]

The pictures in the Sala dei Nove have gone by the name of "allegories" and "effects" of good and bad government only since the beginning of this century.[14] Most modern studies concentrate on the "program," on content rather than form, on what Erwin Panofsky called the "symbolical values" underlying the imagery.[15] This means in practice that the look of the painting, where it matters at all, becomes a more or less passive illustration of a text, or a group of texts, usually with high philosophical, theological, or literary credentials. The alternative is to view the frescoes as a kind of social history in pictures, down to the fifty-six persons and fifty-nine animals that one historian has laboriously counted in the country scene on the east wall.[16] Either way, as iconography or as description, the imagery becomes something to look through in order to look at the exterior reality that it is taken to illustrate. A hermeneutics of diminishing returns is at work here. The concentration on texts raises questions about the practical politics of the pictures; the obsession with their accuracy tends to overlook their art. The greater the emphasis on realities lying outside them, the more their reality *as* pictures recedes from view.

We need to reconsider the republican "regime" of Lorenzetti's frescoes, the republic of the Nine of course, but also a regime in the sense of a set of rules and practices designed to maintain or improve a given state of affairs. The Lorenzetti frescoes belong to the regime of the Nine in both senses, not only because the Nine commissioned them but also because they enjoin a republican discipline in which precepts and application, theory and practice, content and form are practically inseparable. We can think of the pictures in this way as embedded in constellations of behavior, ideas, texts, and images that together constitute a political culture. Absorbed into but also actively mediating and constructing the ideology of a republican regime, Lorenzetti's frescoes, whatever else they may be, are not passively iconographical or documentary.

The "Siena mi fe'" of Dante's Pia gives us a place to begin. Images taken out of their original settings—and this means most works of art—leave us to infer

context from the artifact, from the inside out. But the Sala dei Nove still exists in a setting that took shape under the Nine. The dust of the museum has not quite settled in Siena. Thanks to a near miracle of preservation or, doing without miracles, to the long stagnation that had already set in with the Black Death of 1348, we can approach Lorenzetti's frescoes from the outside in.

Let us begin, then, with the city and the regime that "made" them.

The Nine Governors and Defenders of the Commune and the People of Siena may have been deliberating under the unfinished pictures when, sometime between 1337 and 1339, they fixed their jurisdiction at a thirty-mile radius from the city.[17] This was the maximum extent reached by the republic, but neither small scale nor great ambitions ensured effective control. The landscape in all directions was crossed by chains of rolling hills, crowned to the south by the mass of Monte Amiata. Temperamental streams, likely either to flood or run dry, cut through the countryside; slopes and valleys hospitable to the classic Mediterranean mix of olives, grain, and vines were studded with stretches of woods, marsh, and barren outcroppings. Besides these physical complications, a thirty-mile limit would have brought the frontiers of Siena practically to the gates of their Florentine archrivals to the north; Sienese claims actually went well beyond the limit into the swampy Maremma to the southwest and across territories claimed in turn by lesser towns. Even where Sienese jurisdiction was acknowledged, special rights and privileges were conceded to smaller towns, local magnates, ecclesiastical corporations, and rural communes in keeping with the terms of their relationship to the republic. Like so many of its professions of unity and order, the expansive symmetry decreed by the Nine was a utopian rejoinder to a proliferation of particular interests.[18]

Most medieval travelers would have caught their first glimpse of the city, as visitors still do, from the north or the south (text plate I). Two main roads to Rome passed through Siena, the Via Francigena, already by the tenth century the main route from France between the more exposed coastal and interior routes, and the road coming from Germany and Austria through Bologna and Pistoia by way of the Futa pass over the Apennines.[19] From a distance, the walls made an imposing show of defending and defining the city. Two soaring landmarks, the white-and-black campanile of the cathedral and its counterpart, the Torre del Mangia of the Palazzo Pubblico, carried communal aspirations and expenses literally to the skies. Yet even these monuments of solidarity hinted at limited resources and conflicting demands. The walls were irregular, built in sporadic campaigns on hilly terrain, and the two towers representing shared commitments also stood for the competing cults of the Church and the commune. Anyone who had not already noticed the centrifugal pressures registered in the appearance of the city from the outside could not have entered it without doing so. Although the main entrances

were oriented to the north and south along the three ridges that carried the main roads and gave Siena its inverted Y-shape on a map, there were no fewer than twenty-seven gates to choose from.[20]

Under the Nine, legislation defied geography to call for straight brick thoroughfares that would be "beautiful and well lighted" and, "since such things confer beauty on the city," lined by buildings with brick facades.[21] The still-enchanted ideal of rationality was at odds with the maze of the real cityscape, but especially along the north-south axis of the Via Francigena, streets were straightened and widened to the prescribed width of six *braccia* (eleven and one-half feet). Brick pavements and facades actually came to replace stonework, although limestone remained the material of preference for architectural details and the more imposing buildings. Obstructing stairways, vendors' stalls, and overhanging balconies were removed. Ever mindful of appearances and always inclined to equate unsightliness with political disorder, the commune relocated "less noble trades" away from the routes traveled by foreigners and "the worthy men and women of Siena."[22] Neighborhood petitions survive welcoming these public improvements and, more impressively, offering to share the cost.

Yet just as bricks of "burnt Siena" come in countless shades, to arrive at the Croce del Travaglio, the central crossroads, is to pass through a multitude of differences. Instead of spreading more or less evenly from a center, the town grew irregularly from top to bottom along its three ridges to accommodate a population of around fifty thousand in 1340. With older structures and more established families along the crests and newer building extending down the slopes, the pattern of settlement reflected the structure of the society. Social classes were mixed and economic activities diversified throughout the city, but the richest districts occupied higher ground, while a larger concentration of the poor lived in lower-lying areas. The three main political units of the city institutionalized the divisive topography and patterns of settlement, each corresponding to one branch of its Y-shape and each assigned equal representation in the councils of the republic. These *Terzi*—Città, Camollìa, and San Martino—were subdivided in turn into an official archipelago of thirty-six *popoli* (parishes), sixty *lire* (fiscal and administrative districts), and more than two hundred *contrade* (neighborhoods).[23]

With every step toward the center of town, then, one would have seen reminders of fragmented loyalties—the towers of the great Sienese clans, the image of a parish saint, coats of arms and emblems of neighborhood societies, the special colors or cut of banners, ribbons, armbands, and liveries.[24] The central core of Siena was all the more highly developed as a kind of compensation. Older towns centered on a main square, an important market, or a key public building in the area where the Romans had laid out the forum. Siena made up for lacking authentic Roman foundations with legends such as the borrowed myth of foundling twins suckled by a she-wolf, but geography and

deliberate policy drew the collective energies of the community into the piazza of the Campo, where the hills and the main thoroughfares descended and converged. This low-lying area, once the "field" suggested by its name, was practically situated and symbolically juxtaposed to the cathedral on the hill above it. It was neutral territory in a divided city. By the time that construction began on the new town hall in the last decades of the thirteenth century the most important public events had already gravitated to this natural meeting place, arena, and theater.[25]

The republic decreed that the Palazzo Pubblico (fig. 1) was to be "the very own and perpetual palace of the Commune of Siena in which the powers and dominations that will exist in Siena must dwell."[26] Like other town halls rising all over northern and central Italy in the thirteenth century, but on a larger scale than most, it was a fortress, meeting place, office building, symbol of the commune, and centerpiece of a long campaign of public redevelopment that transformed the urban core. The commune bought up property, reoriented streets, and passed design controls in the piazza, so a law of 1297 declares, "in order to create a harmonious whole to reflect the harmony of civil society."[27] Construction spanned the fifty-year period after 1297, beginning with the center of the palace incorporating preexisting structures and extending to the quarters built for the Nine in the east wing (completed 1310) and the west wing with the residence of the Podestà (completed 1330). The Torre del Mangia (completed ca. 1349) soared to greater heights from the downhill side of the Campo (paved 1297–1348) so as to dominate all the other buildings in town.[28]

The nine central battlements on the palace facade and the nine sections traced in the paving of the Campo were signatures of a regime that inherited the centrifugal pressures of Sienese society and came closest to containing them.[29] Instituted in 1287, the council of Nine was only one of the four "orders" of the so-called Concistoro, an aggregate council of councils representing the sovereign authority of the republic. Labyrinthine election laws combined co-optation, balloting, and sortition to select three individuals from each of the city's three *Terzi* for two-month terms. Candidates were supposed to be Guelph citizens over thirty and "good and lawful merchants" from the middle ranks of the *popolo*. Magnates and knights were specifically excluded but not altogether consistently so—in a merchant republic definitions of nobility were problematic and great families alternately reviled and respected. The statutes also disqualified—more effectively, it seems—physicians, judges, and notaries owing to their professional and social pretensions. Most of the names on the surviving electoral lists come from the upper and middle ranks of businessmen. This was no democratic regime. Yet in any given year as many as fifty-four citizens sat on the Nine, and the constitution created openings for hundreds of offices in other councils and commissions.[30]

But the countervailing tendency to concentrate authority at the center oper-
ated here too. To coordinate otherwise dispersed operations, the Nine con-
ferred with advisory councils and expert witnesses. Sometimes by delegation
from the general council but often on their own authority, they set tax rates,
authorized expenditures, served as an appeals board in legal cases, super-
vised public works, and saw to the maintenance of communal property; they
also sent out diplomatic missions, received foreign emissaries, provided for the
university, and convoked electoral commissions. Their oath of office pledged
them to use "every means possible" for "the conservation, augmentation, and
magnificence of the present regime."[31] The Nine were a republican alternative
to one-man rule, to the *signori* who were coming to power elsewhere in yet
another Italian political experiment.

To enter the Palazzo Pubblico and climb the stairs to the chambers of the
Nine was to trace out the complications of their office (see fig. 2). Just as the
Nine were in one sense a council among councils, so was their meeting place
only one of a series of rooms on the second floor of the palace that they shared
with the room of the Concistoro and the general council hall or the Sala del
Mappamondo. The quarters of the Podestà took up the entire west wing of
the building. The suggestion that this arrangement maps constitutional
checks and balances, the "executive" space of the Nine and the "judicial"
wing of the Podestà flanking the "legislative" center of the general council,
ignores the overlapping functions of communal institutions.[32] Even so, the
space occupied by the Nine tells us something about the privileges as well as
the constraints of their position. Their living quarters took up most of the
west wing where each panel of nine councillors resided for its two-month
term, and the Sala dei Nove itself opened directly into the hall of the general
council.[33]

Official delegations, petitioners, and guests would have entered from this
side, as visitors still do. They might have paused to admire Simone Martini's
fresco of the Virgin enthroned with her entourage of saints. They would have
seen murals of castles surrendered to the republic—whether or not these in-
cluded the large panorama of the war captain Guidoriccio da Fogliano tradi-
tionally attributed to Simone is an open question after a heated debate in re-
cent years over the authenticity of this famous picture.[34] One probably came
into the Sala dei Nove itself through a door in the southeast corner that was
later walled up and survives today as a door-sized niche; the present entrance
closer to the middle of the wall appears to date from the fifteenth century. The
scenes of desolation painted on the west, "bad government," wall would thus
have been a newcomer's first view of Lorenzetti's frescoes. Then, turning to
the right, visitors would have seen—so we may imagine—the Nine them-
selves, seated against the north wall, probably on a slightly raised platform,
so that they looked magisterially down the length of the room with the
painted personifications of virtue behind them.

These first impressions flow together easily with those we have brought from the city on the outside. The view up the long axis of the Sala dei Nove would have given the Nine the central place in the room that they occupied in the republic. The painted borders around the walls frame and coordinate the pictures, and the juxtaposition of figures or cross-wall pairing of scenes have their own unifying effect. But as disruptive variations in scale and proportion come into focus, the sense of unity begins to dissolve before our eyes. Even at first sight, the inner sanctum of the Nine recalls the play of tensions at the heart of the republican regime.

THE REPUBLIC FACES EVIL

A dystopia of violence, sinister personifications, and menacing texts confronts us on entering the Sala dei Nove (see figs. 3, 5). The physical state of the painting is eerily in keeping with the effect. Amidst the ruins of the picture, we can barely make out a swelling landscape, populated here and there with ghostly armies and surmounted by a harpy figure labeled Timor (Fear) with an extended scroll (fig. 7). Farther to the right, a walled city with gaping windows and doors and dilapidated buildings opens onto spaces where such figures as we can see enact little scenes charged with violence—soldiers exiting the gate, a woman being throttled by one garishly costumed figure and robbed by another, a man assaulting a woman, armed figures grasping a female figure dressed in red, a prostrate body bleeding from a chest wound. Men with picks dismantle a balcony, and only the armorer beneath them works at his trade (see figs. 5, 8–9).

On a platform against a crenellated wall of the desolate city presides a court of vices identified by their attributes and labels (fig. 10). Cruelty, Treason, and Fraud (fig. 12) appear to the right of the enthroned figure of Tyranny (fig. 11), with Furor, Division, and War (fig. 13) on its left; Avarice, Pride, and Vainglory hover in an arc around the horned head. Beneath this anti-court the bound and disheveled figure of Justice, its scales fallen, lies at Tyranny's feet amidst other scenes of desolation.

Like the pilgrim's journey in the *Divine Comedy*, then, the itinerary of Lorenzetti's painting begins with *una città dolente*—a suffering city. The inscriptions along the painted frame proceed around the walls from left to right. Less consistently, but still quite distinctly, the flow of light follows the same trajectory. It rakes "naturally" across the west wall from the south-facing window to fall directly on the north wall; the direction of the light is then reversed so that the panorama of the "good city and country" on the east wall appears to be illuminated from the virtues represented on the north wall. Along the west wall, the figures increase in scale and change in type from the scattered vignettes of evil to the large personifications condensing and emblematizing

the moral of those scenes. Seeing is processual and sequential in the ensemble of Lorenzetti's frescoes. We may not end with violence and vice, but we are evidently meant to begin with them.

Why should this be so in pictures made for republican magistrates in a room where virtue was constantly invoked? The usual inventories of motifs and symbols beg the question, for this gallery of horrors is surely more than an iconographical exercise. We need to consider not only what these representations mean but also what they do, to animate them once again with the force of nagging fears and desires and real interests.

Tyranny (fig. 11), the master evil in Lorenzetti's frescoes, presides at the center of a court of vice, and the inscriptions refer in three places to the accompanying scenes as a tyrannical domain. According to her scroll, Fear reigns where self-interest submits justice to tyranny; the caption running along the bottom frame tells how tyranny conspires against justice with suspicion, war, assault, treachery, and deceit. Where justice is bound, reads the plaque beneath the sinister court, tyranny rises in the company of the vices and the enemies of peace (see fig. 3: A1–3; appendix 1: A1–3). The defense and very definition of the republican regime seem to be at stake here; the good republic seems somehow to depend on the image of an evil counterpart.

Certainly there were real candidates for the tyrant's role in early Trecento Italy—the Visconti of Milan, the Scaligieri of Verona, the Carraresi in Padua, and the lesser crowd of upstart *signori* who were coming out on top in a time of intense political struggle. In a rare moment of political realism Dante declared that "all the cities of Italy" had become "full of tyrants" (*Purgatorio* 6.124–25). Italy had fallen under "the harsh yoke of tyranny," complained Marsiglio of Padua. The Paduan scholar-poet Albertino Mussato composed his Latin tragedy *Ecerinus* (1313–1314) "to inveigh with lamentations against tyranny," particularly against the threat of Cangrande della Scala, who finally absorbed Padua into his little empire in 1328.[35] "Many tyrants from outside the city have attempted to occupy it," wrote Bonvesin da la Riva in 1288, meaning to praise the resistance of Milan in one of the first of a new genre of civic panegyrics. As it happened, the real danger came from the Visconti inside Milan itself.[36] According to the great lawyer Bartolus of Sassoferrato, Aristotle himself had never imagined such corrupt forms of government as could be seen every day in Italy.[37]

Modern historians, weaving separate histories into a history of Italy, have called the two hundred years after the early fourteenth century the Age of Despots.[38] But we are in a world of ideological constructions, not of actual history, in the Sala dei Nove. The Sienese had encountered petty tyrants along their borders—from Pisa and Lucca, for example—but they had no experience of living under a real *signore* until the regime of Pandolfo Petrucci late in the fifteenth century.[39] History brings us back full circle to the symbolic face of evil in Lorenzetti's frescoes. Why the fixation on tyranny in a city-republic

that had not really experienced it? To which tyrants do the pictures and inscriptions mean to refer?

We may take our bearings from Jean Delumeau's account of the far-reaching campaign of the late Middle Ages to master terrible anxieties by representing them, "to vanquish anxiety by naming and identifying, indeed by fabricating, particular fears."[40] This is in the first place a large historical claim about otherwise scattered phenomena, from inquisitional procedures in ecclesiastical and lay courts to confessors' manuals, sermons on sin, books on dying—and, we can surely add, images of evil in art. But the historical claim entails, as historical claims always do, a theory of representation, in this case the view that people are driven to combat "a vague uneasiness and trouble of mind"—anxiety, in a dictionary definition—by differentiating and objectifying it. Externalizing, even multiplying "particular fears" in order to control them is a therapeutics of anxiety that is expressive and repressive at the same time. By propagating reasons for fear, the malady administers the cure.

Such a calculus of anxiety and fear applies well enough to the republican communes in Italy. Called into being by charter and statute, potentially renegotiable, fundamentally artificial, communal institutions raised questions about their own legitimacy outside the "natural" hierarchical order of things. At least in principle, aristocrats and monarchs—and their subjects—were born to their roles, but republican citizens had to be made for theirs by education, practice, and participation. Legislation might guarantee the expression of differences among citizens, but the disruption of difference also needed to be restrained by law. Thus the republican experiment called for the articulation and the suppression of doubts over its legitimacy, the demonstration of fearful consequences for inadequate civic discipline, the assertion and the control of particular interests that a republican regime could neither easily accommodate nor do without. Until the eighteenth and nineteenth centuries, when the federalists, utilitarians, and Social Darwinists rallied to the side of self-interest, the contest between "private interest" and "public principle" was an uneven one because the common good was regarded as the highest goal of the community. The citizen was stalked by his other half, by the passions and appetites of interest, alternately tempter and nemesis.[41]

In conjuring up the specter of tyranny, then, republican discourse was not simply responding to real tyrants. The legitimacy of republican government might be questionable, but a republican defense could point to the tyrant as the very model of political corruption. If monarchy was the paradigm of perfect government, as a long line of authorities said it was, then republican writers could argue that tyranny was its worst form. If the tyrant epitomized the sins of fallen man, then the republic looked back to the integral state of human nature when there was no need for kings. The more corrupting the concentration of power in the tyrant, the better the distribution of power among citizens; the more arbitrary the tyrant, the better the charters and constitu-

tions of the republic—or so the republican argument ran.[42] Republicans, Hobbes would bitterly complain, made it lawful to rebel against monarchy and even for a man to kill a king, "provided, before he do it, he call him a tyrant."[43] If the tyrant had not existed, republican ideology would probably have invented him—as, in effect, it does in the Sala dei Nove.

The tyrant thus became the opposite number of republican virtue and at the same time embodied impulses that republicans feared in themselves. Practically by definition, he ruled without regard for the rights and interests of others. His people were subjects, not citizens. As pride and self-will personified, he fomented the two vices for which republican governments were most often blamed—discord and avarice. Republican writers magnified the pride they must have felt in themselves as a glaring political evil of tyrannical regimes, the source of "warfare and hatred" (Brunetto Latini), "lack of quietude" (Bonvesin da la Riva), "fighting and separation . . . and finally the destruction of the state" (Marsiglio of Padua).[44] Though profit was the life-blood of a republic of manufacturers and merchants, civic moralists censured the pursuit of private gain for destroying whole communities by setting selfish and grasping men against one another. Writing in the 1290s, an anonymous Genoese tells how the power and riches amassed by the sons of an allegorical Lady Genoa turned into pride and greed so that, at the devil's urging, they "lay hands on her person . . . tear her dress to pieces" and "strip her of her patrimony."[45] Albertino Mussato echoed his classical models but picked up a contemporary commonplace on the tyranny of "morbid cupidity," "the lust for money," and "the turn to usury" that allowed "sacred justice to be supplanted by the growth of . . . avarice."[46] Bartolus summed up the prevailing view on two "distinguishing characteristics demonstrating the existence of a tyranny: to keep the city divided, and to impoverish subjects and injure their persons and their property."[47]

This relegation of vice to the realm of tyranny "explained" evil while also displacing it onto an array of alien powers. We can see this cautionary and cathartic operation at work in the Sala dei Nove: the imagery of evil is isolated in the domain of the tyrant and associated with the proliferation of "particular fears" in which pride, discord, and greed have a prominent place. Like the larger political discourse of which they can be viewed as a demonstration and a model, the frescoes on the west wall may represent the aberration of good government, but they also incorporate the internal tensions that the logic of civic republicanism uneasily subsumed.

We can follow a further turn of self-definition in Bartolus of Sassoferrato's commentary on a passage from the *Moralia* of Gregory the Great:

> A tyrant, in the strict sense, is one who rules a whole commonwealth unlawfully. But it should be understood that every person practices tyr-

anny in his own manner. For sometimes one practices tyranny in a commonwealth through the power of an office he has accepted; another in a province, another in a city, another in his own house, while another practices tyranny in his own thoughts through his concealed wickedness. The Lord does not consider one's ability to commit evil but one's desire to commit it; and although one lacks the trappings of power to do what one wishes, he remains a tyrant at heart if wickedness rules him from within. For even if he does not outwardly oppress his neighbors, inwardly he yearns for power so that he may oppress.[48]

Commenting on these jarring lines in his little treatise *On the Tyrant,* Bartolus developed two main criteria for defining tyranny—the exercise of an office without proper authorization or title (*ex defectu tituli*) and rule by violence and fear (*ex parte exercitii*). For all his distinctions and refinements, Bartolus did not prune Gregory's list of little tyrants: "just as there are many ways of ruling unlawfully, so are there many kinds of tyranny" (5.197–98). The one limitation Bartolus proposed—that it is not accurate to speak of a "tyrannical" neighborhood strongman because "there is no realm or rule" in a neighborhood (3.123–24)—is oddly academic in an expert so attuned to the realities of the Italian politics. For the rest, tyranny was where you found it: in the household, in the town hall, in the secret designs of men, in good government itself. "For . . . just as one is seldom found who is completely healthy, wholly free from all bodily defect, so it is a rare thing to find a government that is completely devoted to the public good without some of the qualities of a tyranny" (12.745–49).

One imagines the good citizen's unnerving shock of recognition. Bartolus was referring specifically to cities, above all to those of Italy in his own day, caught "in the knotting coils of this horrendous evil" (preface, line 11). Bonvesin da la Riva had already blamed certain leading citizens of Milan "for bending all their power against their own people"; by seeking "to dominate them in the manner of a vile tyrant" and by inciting them to fight among themselves, these false citizens were "imitating the crime of Lucifer."[49] Bindo Bonichi, a stalwart of the regime of the Nine who died in 1338 just as Lorenzetti began working in the Sala dei Nove, painted his own picture of a world of little tyrants:

> The people murmur about bad priests,
> Yet each always connives evil,
> And so their grumbling's not worth a damn,
> For evil moves from them.
> As the sinner springs from sin,
> So is the part related to the whole:
> The finest-seeming man put
> Into power is the worst.[50]

As Bindo put it in another poem, "When the middle class become tyrants, / Pray to God that He protect the city."[51]

To the question of which tyrants Lorenzetti's fresco represents, perhaps the most compelling answer here again is the Sienese themselves. A Florentine mural showed the expulsion of a real tyrant in 1343—or so the ruling oligarchs of Florence came to perceive the French adventurer Walter of Brienne whom they had themselves called in to save a faltering regime.[52] Lorenzetti's obsessive variations on the theme of tyranny are, if anything, a sign of anxieties that could not be so conveniently confined to a historical scenario. The system of organized suspicion so intricately worked into Sienese political institutions reminded everyone that the city was an arena of petty tyrannies and every citizen a potential little tyrant. In a telling double take the chronicler Agnolo di Tura noted with satisfaction the "pacific time and great estate and felicity" of Siena in 1338, when "money was plentiful for most people," only to add that "on account of so much felicity and fat living, people wavered and wandered without fearing God."[53] The year of scarcity and sickness that followed in 1340 came as a reminder of mortality and a kind of punishment in the chronicler's account. At some fundamental level the outwardly confident and respectable businessmen who celebrated their civic virtue in the Sala dei Nove might have recognized there too the projection of their own bad conscience.

Who, then, is the tyrant? The tyrant, a citizen might have admitted, is me. And yet (to play out an interior monologue) the tyrant is not me. Of course, he is the alien, the enemy. The tyrant is what I must not be, surely what I am not, all that must be denied, resisted, undone. I see what I hate—the invader, the subverter, grotesque and forbidding—but a clear target. At any rate, pictures break no bones.

Deflecting self-incrimination still further, the good citizen might have gone on to insist that the real tyrants in the city were the magnates and the little people. The association of the mob and the overmighty with tyranny was an ancient, and a contemporary, commonplace: one group tyrannizes by dominating, the other by leveling, as Ptolemy of Lucca put Aristotle's argument for the rule of a middle class between these extremes.[54] Times of political trouble flash across these poles of the social order in the Sienese chronicles and the surviving archival records. An odd alliance of butchers and notaries was held responsible for the most serious assault on the regime in 1318; in 1346, according to Agnolo di Tura, "a plot and conspiracy was arranged by the *popolo minuto* of Siena" but led by the son of a notary from the magnate clan of the Tolomei. Donato di Neri saw much the same conjunction of high and low forces in the uprising that ultimately toppled the Nine in 1355.[55] The unhesitating attribution of blame is all the more striking because careful analysis of the same events points to the shifting composition of dissident groups and the contingent timing of violence during or immediately after periods of scar-

city. Closely examined, these uprisings look more like quarrels over privileges than class struggles. But despite, and surely too because of, the fact that the ancestors of the solid citizens of the Nine, like the rebels of 1346, might once have rallied to the cry *"Viva il popolo* and the guilds!" such episodes were perceived as attacks from the edges of the social order. In Cruelty, Treason, Furor, and the rest of Tyranny's entourage in the Sala dei Nove the good citizen could recognize those intimate outsiders bent on "disturbing, subverting, and devastating the pacific state of the city"—and could thus spare himself.[56]

Lorenzetti drew on a very full medieval repertoire to represent the alterity of appetite and interest. To begin with, his Tyrant (fig. 11) clearly takes the devil's part.[57] As the cross-eyed monarch or magistrate of an evil inversion, this figure looms over a sinister court in a thronelike chair on an elevated platform; as the Great Deceiver, it wears armor beneath the cloak and holds what has been described as a poisoned chalice in the left hand. The horns and fangs, the elaborate coiffure, the dark attire and pallid face, the instruments of torture and death—all this was standard diabolical equipment by the eleventh century. In medieval art the devil usually appeared with his minions and messengers, sometimes stirring up evil in the world, more often presiding over the torments of the damned in hell. Lorenzetti's city and countryside are all the more unsettling because they seem to be of this world, a world where innocence rather than guilt is ostensibly made to suffer.

The genealogy of the vices in the picture goes back to the inventories of evil Christianized in late antiquity. In the lore of healing magic and the texts of the ancient moralists virtue did triumph in the end, and only then. When Prudentius, in the fourth century, codified the pairing of personified virtues at war with their malign counterparts, the virtues depended on the vices as a condition of being clearly defined and differentiated. Knowing the good, the moralists agreed, entailed understanding the opposition. Consequently, Gregory the Great's canonical list of the seven "cardinal" or "deadly" sins did not put a limit to burgeoning inventories of vices. Medieval writers and artists "lavished the greatest attention" on them.[58]

Lorenzetti's vices have both the "positive" charge and the easy mutability of these traditions. They come first for the viewer who enters the Sala dei Nove, and they appear to inhabit "negative" space only when contrasted with the virtues personified on the adjacent wall. The trio of vices around the head of the Tyrant includes Superbia at the top (first in Gregory the Great's list and the vice that defines the sinful striving for superiority in Dante's *Purgatorio* 17.119), Vainglory on the right (an interchangeable synonym of Superbia for Gregory and later writers, including Dante), and Avarice on the left (the chief competitor of Superbia as the prime evil after the eleventh century). This arrangement is conventional enough. Variation had itself become a kind of convention. There would have been nothing exceptional about the inclusion of

nine vices (ten counting Tyranny)—or any other number of them such as the thirty-five vices that joust with the virtues in an anonymous poem of the late thirteenth century, or the sixteen paired vices and virtues in the *Fiore di virtù* written a generation later.[59] Nor was there any fixed rule that obliged the painter to fill out the list of cardinal sins—say, by adding Anger, Envy, Sloth, Lust, Accedia (a kind of heavy-heartedness or despair), or Gluttony to the picture.

Still mining both the hard and the more permissive veins of medieval traditions, Lorenzetti represented the vices as a monstrous race. The horned and fanged Devil-Tyrant is neither wholly human nor altogether beast; the androgyny of figure, feminized by the coiffure and the accompanying inscription, is part of the unsettling effect. Treason holds a sheep with a scorpion's tail, Fraud has sprouted bat's wings and claws, Furor takes the form of a centaur with a canine head (see figs. 12–13). A recent book on medieval representations of the "monstrous races" claims that "monstrous forms fascinate and terrify because they challenge our understanding, showing the fragility of traditional conceptions of man."[60] But the image of *homo homini lupus* is also a traditional conception of man, and to suppose that Lorenzetti's images convey no more than a blandly generic "fascination and terror" would only diminish their force. The ancient Enemy took on a new political identity as Lorenzetti's Tyrant, with all the implications of that identity for the legitimation and defense of republican values. The canonical sins of Pride, Avarice, and Vainglory around the Tyrant's head were being transformed by the painter's contemporaries into political forces in a distinctly republican analysis of tyranny. Although Cruelty might infect both the soul and the community, the other members of the painted court of Tyranny—Treason, Fraud, Furor, Division, and War—are not so much the vices of a conventional theologian's or preacher's list as political dangers in the arena of public life.

As Walter Benjamin wrote of the imperatives of new values: "In every era an attempt must be made anew to wrest tradition away from a conformism that is about to overpower it. The Messiah comes not only as the redeemer, he comes as the Antichrist."[61] What Lorenzetti's repertoire of evil brings into view is not an easy innovation on received traditions. The guises and disguises of malignity in the picture grapple with the Antichrist of republican politics and, so we have suggested, the transgressions feared by the republican regime itself. In a world that still granted the superiority of monarchical principles the picture's only monarch is the dark prince of tyranny. In the context of republican politics this new epiphany of the ancient Enemy was an excuse for insubordination, a worthy adversary and, confined to paint, one that could be defeated. The painted Tyrant and the sinister court also externalized and therefore displaced real and imagined internal perils—the threat of swaggering magnates and the mass of the little people, and, more deeply,

the ambivalence of the republican citizen himself. Tyranny and the vices belonged to the painted realm of the Other. In the casuistry of affirmation and denial thus prepared for the good citizen prosperity was not Avarice, political commitment was not Superbia or Vainglory, self-interest was not Treason, Division, or War.

The marginal position and the monstrous mixtures of the dark court play out a textbook scenario of such displacements. The vices loom up in the southwest corner of the room, just outside the wall and a gate of the desolate city—precisely where the anthropologists would want to see a symbolic enactment of perceived dangers. "All margins," Mary Douglas writes, "are to be regarded as dangerous; the periphery is the exposed limit of society's defenses, and any breach is a potential route of invasion for the return of internal perils that the social body seeks to expel."[62] This symbolic no-man's-land is the haunt of the alien, the deviant, the grotesque, the diabolical, and, because it defines margins, of forced conjunctions and perverse double identities. Placed at Tyranny's left hand, the centaur of Furor models the contamination of humanity by appetite and passion. The Sienese did not need to look any farther than themselves to understand the message, but the picture projects it onto the tyrant and his servants. Lorenzetti's younger contemporary Giovanni Boccaccio provides an apt translation: the centaur is the very type of "armed, irascible, uncontrolled men, prone to every crime, such as one sees in the clients, hirelings, and evil ministers to whom the tyrant resorts."[63]

The contagion goes beyond the figures to the yoke, mirror, saw, moneybags, chalice, weapons, and other objects associated with them. These would be perfectly ordinary implements in another setting. Here they are either not being used—the open yoke—or they are being put to perverted uses, like the saw that the figure of Division labeled Siena and dressed in Sienese black and white turns on herself. Fraught with hostile purpose, meant to injure, such instruments belong to an economy of useful objects sundered from constructive uses. The Sienese poet Cecco Angiolieri (died 1312) had already confirmed the analysis by scoffing at the moral. In his precocious travesty of the "tyranny" of capital, goods circulated for no better reason than the desire for them. The world was for sale; money, overriding or actually replacing the values of family, social rank, and function, was its procurer:

> Preach what you will,
> Florins are the best of kin
> Blood Brothers and cousins true,
> Father, mother, sons, and daughters too;
> Kinfolk of the sort no one regrets,
> Also horses, mules, and beautiful dress.
> The French and the Italians bow to them,

So do noblemen, knights, and learned men.
Florins clear your eyes and give you fires,
Turn to facts all your desires
And all the world's vast possibilities.[64]

We would like to know that Lorenzetti and the good citizens of the Nine made of Cecco's scandalous taunt. But perhaps we do know already. For surely the Tyrant's court makes black humor out of its own scandal, an outrageous show of villainous mannequins, masks, and props. This is not to say that the spectacle is not serious. If anything, the sheer exaggeration, stage machinery, and fantastic cast of carnival characters testify to the force of anxieties that had to be overcome.[65]

The citizen's smile—so we may imagine—would have come uneasily at first, if at all: who was blameless, where were there *not* tyrants great and small? Perhaps he might have indulged in the kind of nervous laughter that is irrepressible when strong feelings are repressed or sermons are too demanding. Then, as the clever contrivances of the picture became more and more apparent, he could have delighted in his appreciation of Lorenzetti's construction of new images out of old—and his relief that these marvels of craftsmanship too were for the improvement and greater glory of the city.

THE REPUBLIC IN WRITING

Lorenzetti's frescoes are centered—symbolically as well as physically—on the short north wall of the Sala dei Nove (fig. 14). The visitor entering the room from the adjacent council hall would have turned away from the left or "sinister" side toward the central scenes, from the bottom of the room (and the "depths" of bad government) to its head, from epiphanies of evil to representations of remedies for it. Imagine the Nine pausing amidst official business to receive visiting dignitaries, officials, and petitioners. Looking back obliquely against the direction of the inscriptions on the sinister wall, doubling the gaze of the virtues personified above them, they would have confronted, with their eyes at least, the menacing advance of evil.

Jacques Le Goff traces the "invention" of purgatory to an intermediate space between the "brutal oppositions" of good and evil, salvation and damnation, ultimately of life and death.[66] Around the middle of the twelfth century theologians conceived of such a middle zone as a proving ground of free will and so of institutionalized remedies for sin, from the Church militant and the sacrament of penance to the just governance of the human community. The social corollary was the emergence of a class of people standing between extremes of domination and submission; in other words, the growth of a

"middle class" within the hierarchy of feudal society. According to Le Goff, the formal category and the actual class mediating between oppositions called for a new set of disciplines offering human beings liberation in return for the burden of responsibility for their actions. This is, of course, highly schematic as a historical scenario. Even so, it suggests a rationale for a middle zone in Lorenzetti's frescoes where virtue overcomes vice in preparation for the earthly paradise on the east wall of the Sala dei Nove.

Such a redemptive technology is literally written into the pictures, for the inscriptions in the frescoes convert the viewer of images into a reader of texts in curling Italian Gothic majuscules that indicate correct—and corrective—"readings."[67] The diagram in figure 3 maps the realm of writing in the Sala dei Nove. The inscriptions are most densely concentrated on the middle wall. In the painted frame around the frescoes we find long captions of a single line, identifying labels on the base of quatrefoil medallions, painted tablets with texts of several lines, and on the middle wall the artist's "signature." Within the scenes figures are labeled, scrolls or banderoles inscribed, letters and words written on the objects represented; initials form a nimbus, and a biblical text is quoted in an arc—*Diligite iustitiam q[ui] iudicatis terram* (Love justice you who judge on earth: *Wisdom of Solomon* 1.1). So many words strategically patterned as an armature of writing command attention even before they are read.

Iconographical studies refer the pictures to textual sources as if to demonstrate the efficacy of the imagery. It is not at all the same thing to be concerned with writing in the pictures, among other reasons because the inscriptions challenge their adequacy and contest their authority. As semantic indices, the textual tags and labels single out prescribed meanings, at once suspicious of and obsessed with pictorial means. The words identifying the various personifications anchor and limit attributes that are already more or less stylized—scales of justice, olive branches of peace, scepters, shields, swords, and so forth. Inscribed meanings would be clear without any figures to personify them, but without the written labels on the short wall we would not know that the figures flanking the great personification of Justice seated to the left in the central scene represent the "commutative" and "distributive" branches of this virtue; or, again, that Temperance, with the hourglass, was not, say, Prudence taking the measure of time. The lengthier inscriptions issue peremptory commands, supplying stage instructions for the pictures and cues for the reader's response. But none of these lines grant a voice to the figures; they make declarations about them. The seductive indeterminacy of the image is suspect in these frescoes celebrated for their visual appeal. Writing takes the privileged, literally the prescriptive, role.

Why should this be so? And why should such an appeal to writing be made when it was in a council chamber of a republican city-state?

WRITING POWER

One version of its origins embeds writing in relations of power and vouches for the authority of those who possess it over those who do not, a point that can hardly be lost in a medieval room of state studded with inscriptions.[68] Medieval cosmology called the world into being in words and read it as a book. The Word inaugurated the World whose parts were for Adam to name and his descendants to read. In an emblematic vision of a religion of scripture Dante's God is like a book containing all the scattered pages of the universe bound in one volume (*Paradiso* 33.85–87).[69] In the historical version of the theological scenario writing actually was a sign of mastery in the largely illiterate world of the early Middle Ages, and from at least the twelfth century on writing became the medium of a pervasive codification of knowledge, rules, and routines. As a cultural shift on an epoch-making scale, this collective "reading lesson" has come to rival the notion of a Renaissance "print revolution" brought about by the invention of movable type. "When written models make their appearance," Brian Stock observes in his work on the implications of literacy in the Middle Ages, "a new sort of relationship is set up between guidelines and realities of behavior: the presentation of an objectified pattern within articulated norms."[70] In the reading lesson of the Sala dei Nove, then, the magistrates of Siena were embracing a divine right and appropriating the prerogatives of a literate elite of clerics, academics, and officials for interpreting and regulating the world.

They were doing so as privileged readers in a notoriously divided society. It can be argued that the economic miracle of the Italian city-states depended not so much on what Marx called "primitive accumulation" as on the increasingly sophisticated extension and intensification of economic activity by written contracts, account books, letters of credit, and bills of exchange. The ink-stained hands of the merchant were the sign of his calling. For the businessmen who dominated the government of the Nine, writing and money were equally media of exchange and forms of communication. They knew from practice the theoretical proposition that the circulation of money communicates values, while writing provides a special currency that promotes and enforces a hierarchy of worth in which the high status accorded to noble birth, prowess, and tradition gives way to the superiority of the literate.[71] Some of the earliest surviving texts in the Italian vernacular are Sienese letters recording transactions at the fairs of Champagne.[72]

For men of the class to which the Nine belonged, writing was a means of producing real and symbolic capital as well as a practical investment in political privilege and social control. Writing effectively disenfranchised an illiterate mass of laboring dependents; it contested the prestige of chivalric culture. Writing marked social and political boundaries of the circle of the literate; its

dominion, instead of being consumed by use like violence or treasure, expanded with every new reader. And while the written word served those who could read as a common frame of reference and a shared code, it was open to discussion and debate, as the government of a republican city-state was supposed to be.

Republican ideology, after all, envisions responsible citizens arriving at political decisions, or professing to decide, through public discussion and procedures guaranteed in writing.[73] In the classic contrasts monarchs have their secrets, subjects their duties, and republicans their charters and constitutions. The founding texts of a republican order establish ties of a shared discourse of interaction among citizens who may have little else in common as they come and go between private affairs and the arena of public life. In this way writing comes to represent republican politics in the sense of "standing for" an objective criterion of political participation and a realm of public values lying outside the particular and the contingent. When written standards prevail, to quote Brian Stock again, "individual experience still counts, but its role is delimited; instead, loyalty and obedience are given to a more or less standardized set of rules which lie outside the sphere of influence of the person, the family, or the community."[74] This reads like a good republican agenda, all the more so because rules that are written down can be put to critical scrutiny, subjected to interpretation, and revised. As in another version of the origins of writing, so in a republican regime the written word lends itself not only to closure and the imposition of authoritative standards but also to the exposure and articulation of differences.[75]

Had the written word mattered less, the enemies of republican politics would hardly have been so obsessed with it. Conservative critics have seen arbitrary and mechanical decision-making where republicans supposed they were only adhering to the letter of the law; what republicans have defended as productive or unavoidable emendations of political rules the critics have condemned as evasiveness or indecision. Thomas Hobbes gives a characteristically pungent set of variations on these charges. According to Hobbes, the republican mania for words can only lead to "contention and sedition, or contempt." The "flutter of books" in "popular states" results in false principles and subversion:

In these western parts of the world we are made to receive opinions concerning the institutions, and rights of commonwealths, from Aristotle, Cicero, and other men, Greeks and Romans, that living under popular states, derived those rights, not from the principles of nature, but transcribed in their books. . . . And by reading, men from their childhood have gotten a habit, under a false show of liberty, of favoring tumults, and of licentious controlling of the actions of their sovereigns.[76]

In a monarchy political authority could be embodied in rulers, enacted in rituals, and kept safe from scribbling fanatics. Or so it pleased a long line of antirepublicans to proclaim. Arguing from an ancient analogy, critics of the French Revolution maintained that the correct order of society reflected the true order of nature, the "natural" hierarchy that put the head in its proper place over the members of the body politic and differentiated the community of the ruled into distinct corporations, each with its appropriate function. But republicans confused language with reality, then substituted language for reality; and once cut loose from its moorings in nature and tradition by a torrent of words, power raged unchecked in a destructive flood of catchphrases. The self-evident truths and transcendent principles of republican rhetoric were the empty productions of demagogues and phrasemakers intent on manipulating the fickle god of republican politics—public opinion. "The legal consecration of this language was a unique event," one critic exclaimed, "an unheard-of scandal in the universe, and absolutely inexplicable other than by divine vengeance."[77]

Of course neither the republican fixation on language nor the conservative critique was unique. As early as the eleventh century, the Italian city-republics were instituted by oath and acclamation, formalized in written compacts, sanctioned by treaties, and governed by statutes recorded and revised in writing. Meeting halls, piazzas, open-air arcades and platforms designed for speech making were the functional and symbolic centers of civic life. Magistrates were installed, citizen assemblies convoked, and civic pageants performed to the accompaniment of sermons and oratory. There was much fluttering of books of the kind denounced by Hobbes. Form letters and set speeches composed by professionals, the *dictatores,* were collected in manuals for civic officials and treatises on politics. Account books in which businessmen took note of important events and notarial registers, with their formulas of official testimony and public witness, became sources and models for civic chronicling and history writing, and the lawyers, in their glosses, commentaries, and consulting opinions, developed theoretical and practical defenses of civic independence.[78]

Writing has grown cheap since the Italian city-republics came into being in a flurry of written words. It takes an effort of historical imagination, or perhaps only the sense of loss in this age of electronic imagery and digital sound, to appreciate the potency of the written word for the republican magistrates of Siena. The Italian city-republics spelled out revolutionary claims to sovereign independence against their "natural" superiors. Within their own territories, they extended the written rule of legislation, contract, record keeping, and official procedure, inscribing it over competing ties of family, neighborhood, and private association. Anyone who has worked in the archives knows that the Italian city-republics were in a very real sense paper creations.

READING THE VERNACULAR

The archives of the Sienese republic, like the inscriptions in the Sala dei Nove, were bilingual. Latin was authoritative in the sacred, the official, and the learned precincts of the altar, the chancellery, and the university; Italian was the idiom of the household, the workshop, and the piazza.[79] In practice the two languages coexisted and complemented each other. Latin was the language of record, but the notaries of the republic read out legislation in the vernacular and translated the statutes so that "people who do not know Latin (*grammatica*), and others who may so desire, may be able to see it [the text of the statutes] and make copies to keep for their own use."[80] One language advanced impressive credentials, the other addressed its readers in familiar terms. This is the division of labor at work in Lorenzetti's frescoes. Inscribed on the edges of the painted scenes and inserted on painted plaques or scrolls, the Italian texts are marginal to the Latin labels of the personified virtues and vices. Far from marginal in what it says, however, the Italian "speaks" to the reader, coaching the response and dictating a moral.

Scant attention has been paid to the vernacular inscriptions. Lengthy and hard to read, they are usually cropped from photographs, as if the texts, literally left out of the picture, were secondary and incidental. When a text is cited, it is usually as a neutral guide to the imagery rather than as a charged bid for control of the viewer's response. Reading is thus unwittingly pressed into ideological service. Medieval readers must have been more attuned to the central role of these written marginalia. Lessons were taught in the schools by gloss and commentary; medieval readers looked to the margins for the authoritative references, explication, and analysis. Manuscript illuminations were virtually by definition illustrative of the text. Citizen-readers in Siena would have been quick to respond to being addressed on important matters in their own language. The style of address was familiar. The rhymed exhortations to virtue and admonitions against vice would not be out of place in an anthology of Trecento poetry.

Although there is no way of identifying the author (or authors) of the inscriptions, they may have been composed by Lorenzetti himself. Vasari recalled the painter's reputation as a cultivated man, "esteemed in his native city . . . for having devoted himself to studies in his youth . . . , and always frequenting men of letters and scholars."[81] Artists and authors collaborated on illuminated manuscripts for lay readers when Lorenzetti was working in Florence in the late 1320s and early 1330s.[82] One of the few surviving books of deliberations by the Nine reports that "Magister Ambrosius Laurentii" addressed an advisory council on 2 November 1347 *sua sapientia verba* [*sic*]. According to the notary's minutes, Lorenzetti spoke in favor of proposals for expanding the political franchise, for strengthening the office of Captain of the People, and regulating conflicts of interest among officials.[83] Perhaps he had

done his civic duty with "words of wisdom" some ten years earlier in the Sala dei Nove.

He certainly did so in other works. The earliest of his known paintings is a Madonna and Child with an inscription recording the date (1319) and the patron's commission "for the remedy of his soul"; the last work attributed to him is an Allegory of Redemption (ca. 1340) with four scrolls that were evidently meant to be filled with explanatory texts. We know that the lost scenes Lorenzetti painted on the walls of the communal hospital of Siena (1335) included inscriptions. Both his lost "Roman histories" for the chambers of the magistrates in "the palace with the new prison" and the revolving globe showing Siena's territorial possessions that he painted in the large council hall adjacent to the Sala dei Nove must have had accompanying texts. Three of his surviving altarpieces—a *Virgin in Majesty* (ca. 1335) at Massa Marittima, the *Presentation in the Temple* (1342) now in the Uffizi Gallery, and an *Annunciation* (1344) painted for the tax officials—were civic commissions, and all are laced with inscriptions.[84]

The "poet" or, more likely perhaps, collective author of the inscriptions wrote in the "ethical-didactic" verses that were being composed by citizen-amateurs all over Italy.[85] The best known Sienese practitioner was Bindo Bonichi, the member of the Nine whose views on tyranny we have already encountered. Judging from his poems, Bindo was a well meaning but embattled citizen who might have read the inscriptions in the Sala dei Nove as a vindication and a remedy. In one poem he calls powerful individuals tyrants; in another he accuses people of middling rank, like himself.[86] Any *prepotenza*, he declares, is a kind of tyranny. We are all victims if we allow ourselves to become "the slaves of luxury or of avarice or of any other wickedness and in general of fear. . . . And so the wise man keeps himself a free man."[87] Deceit, bad faith, robbery, arrogance, fear—the litany of evils Bindo associated with tyranny were rehearsed again in the Sala dei Nove.

In his more disillusioned moments, Bonichi urges the wise to retreat into a "secret style."[88] At his most vindictive, he calls for divine vengeance, even the scourge of a tyrant, that "he may reward the sinful people, / Not for his own benefit, but for their harm."[89] Real tyrants acted on less open invitations, but Bindo rallied to the defenses of self-control and civic virtue. "Nothing is so great that virtue is not of greater value," he writes, as much perhaps to fend off temptation as to declare a principle.[90] More conventional in this respect than the poet of the inscriptions, he composed talismanic poems on each of the four cardinal virtues. But virtue was nothing without practice: "To be good it's necessary . . . continually to practice (*operare*) the virtues."[91] This meant living by reason and law, the *ragione* that the poet defines as the antidote for willful passion. "To live justly" is the highest obligation of an individual in political office. In accordance with "just and true principle" the good

magistrate "corrects and teaches the ignorant, and to those who are at fault out of vice, renders punishment."[92] In this way, "Justice lets each one among the people feed (*pascer*) on his own field."[93] Justice in the Sala dei Nove inscriptions similarly "nourishes and feeds (*pasce*)" those who honor her, and under the tutelage of Security each man freely "tills and sows" (see fig. 3: *B2, B3;* appendix 1: *B2 line 10, B3 line 2*).

But the inscriptions are even more expansively "literary" than the acknowledged poet. They pay tribute to another tradition of poetry extending through and beyond Siena and the Trecento. Beginning with Cicero and Boethius, literary historians trace the genealogy of the allegorical "vision poem" through the French cathedral schools and its ramifications in the vernacular. The strategic Italian text is *Il tesoretto* (ca. 1263) by Ser Brunetto Latini, the Florentine notary and scholar Dante acknowledged as his master in their encounter in the *Divine Comedy* (*Inferno* 15).[94] The "little treasure" opens with Ser Brunetto's discovery that his own Guelph party had been exiled from Florence. The poet loses his way in a wood, a *selva diversa*, the predecessor of the *selva oscura* where the *Divine Comedy* begins. There he meets Lady Nature who fortifies him with nine hundred lines on the principles of creation before sending him on a pilgrimage to Virtue and the court of Love.

Traversing a visionary landscape, Ser Brunetto comes upon other personages more than willing to impart "rare and precious wisdom." Virtue is an empress ruling over good customs and manners and "good government (*buon reggimenti*)"; her daughters are the four cardinal virtues, who appear as queens with their titles inscribed around them, as Lorenzetti would identify his virtues, "in letters of gold" (lines 1227 ff.). Ser Brunetto wishes "to portray (*ritrar*) what I saw" in a "beautiful and clear vernacular (*bel volgare e puro*)," so that "it not be obscure" (lines 1115–20). Whatever its other treasures, his poem amasses a thesaurus of words defining the act of seeing and the wonders of sight. What he wants his readers to see most clearly are *tutte le gran sentenze / E le dure credenze* ("all the grand precepts and the hard creeds," lines 1141–42).

Early on his journey Ser Brunetto evokes an image and a moral that reappear in the Sala dei Nove. Twenty-four figures (fig. 18) lined up in the lower portion of the north wall hold a rope made of two cords descending from the scales of Justice that are plaited together by the figure of Concord. Passing through the hands of the "councillors," as they are usually called, the rope rises to the wrist of the magisterial figure seated to the right above them in the middle of a line of personified virtues (figs. 15–17). Although this group of citizens is sometimes cited as one of the most original in the frescoes, the figures are bound as much by textual prescription as by the rope that joins them.[95] The inscription in the plaque beneath the Tyrant on the west wall (fig. 3: *A1;* appendix 1: *A1 lines 1–3*) picks up this play on words: "where Justice is bound, / no one is ever in accord (*s'accorda*), / nor

pulls the cord straight (*né tira a dritta corda*)." In the spirit of the pun we might say that this line leads in turn straight to Ser Brunetto's *Tesoretto*. Since men are born not only to their families, Ser Brunetto writes, but also to their commune, no one can rule on his own; nor should there be divisions among citizens,

Ma tutti per comune	But all in common
Tirassero una fune	Should pull a rope
Di Pace e di ben fare	Of Peace and good deeds,
Che già non può scampare	Because there can be no saving
Terra rotta di parte . . .	A land or city broken by faction . . .

(lines 175–80)

This is as close as we are likely to come to a specific textual source for any of Lorenzetti's images. Even in this best of cases, however, the fit is slightly off—the rope of "Peace and good deeds" in Ser Brunetto is the cord of Concord in the frescoes. Furthermore, the play on the meaning of concord fits only too well into a network of commonplaces that hardly began or ended with Ser Brunetto. According to Cicero, the give-and-take of civic life creates double "bonds of concord"; but these can be strained and broken "if people simply follow their own interest." In the *City of God* St. Augustine included a Ciceronian passage defining *concordia* as "the best and most subtly crafted bond or rope of a healthy society." Medieval paraphrases adapted and extended these passages and others like them.[96] In any case the citizens of Siena did not need to find this lesson in books. They saw it acted out in public works projects to beautify the city's streets, as the documents put it, *ad cordam* or *a dritta corda*—that is, along the straight line of a surveyor's rope. Such "beautiful and honorable improvements," in the words of an approving petition from one neighborhood, bring "praise and commendation," while "giving order and measure (*ordine e regola*) to the city as a whole."[97]

A drawing in a manuscript of *Il tesoretto* attributed to Ser Brunetto Latini himself (fig. 4) figures a paradigmatic relationship between author and reader and the text and the image. Turning from a desk raised on a platform and furnished with books and an inkwell, the author places his book with an admonishing or, as it may be, encouraging gesture into the hands of a seemingly respectful reader. Ser Brunetto dedicated his work to a certain "signore," perhaps even the king of France or his brother Charles of Anjou, but here it is handed down from the teacher to a personage whose bearing is, if anything, humble and submissive.[98] In effect, writing establishes authority and occasions the picture. Word before image, reason before imagination, truth before the *figura* representing it: these were standard hierarchical arrangements spelled out in medieval theology, psychological theory, and aesthetics. The

first proposition turned on the biblical account of creation; the second on the faculty-theory of the brain according to which the imagination or fantasy was the source of images derived from the senses and subjected to discrimination and control by the faculty of reason. The truths of reason, finally, were held to be beyond understanding without the figurative representations that, as representations, also partly obscured the rational order.[99]

Such at least were the claims. But we have seen how stock phrases branched out in vernacular poetry, ancient texts, conventional lore, and official documents. Even if the literate citizens likely to be interested in commissioning Lorenzetti's frescoes did know, say, the poems of Bindo Bonichi or *Il tesoretto*—the drawing in the manuscript suggests just such an audience—we lose the traces of a distinct source in these intertextual devolutions. By the same token, however, we gain a clear sense of the logic of the inscriptions. Although we cannot be at all sure of their precise origins, we can say that they tap a network of commonplaces that could be regarded as authoritative because they *were* commonplace. The vernacular inscriptions foreclose subtle exegesis. Instead, they impose a discipline on the reader-viewer, underwriting meaning but restricting its independence, calling upon the imagination and limiting its operation.

In this sense, it is the text that illuminates the image. The inscriptions direct the reader to "turn your eyes to behold" or simply to "look" (fig. 3: *B2*; appendix 1: *B2 lines 1, 5*); they summon attention to "this city" and "this road," to "this holy Virtue [Justice]" and "this lady [Justice or Security]" (fig. 3: *A3, B1, B3*; appendix 1: *A3 lines 1, 3, B1 line 1, B3 line 4*). Invoking their own visual effects, and a medieval metaphysics of light, the inscriptions note the "resplendent faces" of the virtues and the nurturing "light" of Justice, in contrast with the "dark injuries" of Tyranny (fig. 3: *A2, B1, B2*; appendix 1: *A2 line 8, B1 line 7, B2 line 11*). Words say what images are supposed to show, even if this means contradicting what we can actually see. How could the magisterial figure seated amidst the virtues choose "never to turn his eyes / from the resplendent faces / of the Virtues who sit around him" (fig. 3: *B1*; appendix 1: *B1 lines 6–8*) when he looks out at us just as they do?

Thus for all the hopeful tracing of sources and all the learned exegesis of a larger "program," there are no more compelling guides to Lorenzetti's work than the vernacular inscriptions that have been there for reading all along. They make their own claims to authority and immediacy by appearing in vernacular verse. More important, they do not merely register, they actually dictate the terms of a distinct message, reproducing in political translation the hierarchical relationships between text and image expounded by medieval writers. We hardly need any other texts or, for that matter, any more than a few elements from the pictures for the theory of republican politics set forth by the inscriptions.

Tyranny, the texts on bad government proclaim, arises where justice is pre-

vented from restraining self-interest and dissension; and where tyranny pre-
vails, it encourages vice, drives away well-intentioned citizens, and foments
the enemies of good deeds, peace, and prosperity (fig. 3: *A1, A2;* appendix 1:
A1, A2). According to the verses on the middle wall, justice unites citizens
who choose the common good; the good ruler, admiring virtue, will tri-
umphantly but peacefully obtain the benefits of a civil political order (fig. 3:
B1; appendix 1: *B1*). The texts on the east wall reaffirm this moral to conclude
that rulers must look to justice, giving each person his due. Many goods,
peace and repose among them, adorn the city where this most splendid of
virtues is observed: it nourishes and protects the city and the people who
honor it; the merit of those who do good deeds basks in its light, while the
wicked receive the punishment they deserve (fig. 3: *B2, B3;* appendix 1:
B2, B3).

This is an abbreviated version. But the full inscriptions are neither much
more complex nor very original. They serve to declare, indicate, assert, some-
times exhort—in any case, to direct and concentrate attention, not to compli-
cate it. It was evidently the much cited, well worn idea, not the original one,
that conferred the aura of respectable legitimacy that was precisely at issue in
republican politics.

LATIN LESSONS

The most celebrated defense of the Italian language was written early in the
fourteenth century—in Latin. In *De vulgari eloquentia* Dante proposed to rein-
vent a vernacular that would be learned according to rules, widely accepted,
and deeply revered; a language, in other words, with the authority of Latin.[100]
In the Sala dei Nove, Latin is confined to names and labels, a biblical quota-
tion, and two mottoes (one only in initials) proclaiming the Virgin's protection
of Siena (see fig. 3). Yet the figures that the vernacular talks about have Latin
names. Lorenzetti also used the more privileged language to identify and no
doubt to dignify himself and his work—*Ambrosius Laurentii de Senis hic pinxit
utrinque.* Most importantly, the Latin inscriptions signal the programmatic
claims of the frescoes, and so of the Sienese republic, to the most authoritative
traditions of reading and writing on ethics and politics.

In the *lectio* of the medieval schools one read, as Hugh of St. Victor de-
clared, "to become informed in rules and precepts by a study of written
texts."[101] So defined, "reading" was inseparable from, and practically syn-
onymous with, "teaching," and the aim of both was to arrive at "the truths of
reason which have been discovered in writing to be used by posterity."[102]
Such principles made little allowance for the vernacular or for the individual
reader. To know "grammar" meant to know Latin; one simply imbibed the
vernacular "with the nurse's milk," as Dante put the conventional wisdom.[103]
Since reading was an institutionalized privilege and a corporate task, the texts

established by learned consensus as authentic bearers of the "truths of reason" had to be collected and commented upon in steps and stages, from the letter to the spirit. The ideal reader would master the *sententiae, praecepta,* and *rationes scriptae* that testified reassuringly to the essential orderliness of the knowable world.

The Latin inscriptions in the Sala dei Nove extended the privileges and the obligations of medieval reading beyond the books, the institutions, and the credentials of the professionals. They outlined for citizen-readers the standard categories in the medieval organon—the liberal arts, the virtues and the vices, history (only the inscription identifying Nero survives from what was evidently a series of ancient tyrants), physical science (to include here the unlabeled medallions of the seasons and the planets). Read in horizontal order from left to right, the Latin classifies forms of knowledge or species of a genre—nine vices and nine virtues; the *trivium* of grammar, dialectic, and rhetoric and the *quadrivium* of arithmetic, geometry, music, and astronomy, with the addition of philosophy. The vertical arrangement maps more or less explicit hierarchies: the theological virtues of Faith, Charity, and Hope above the moral virtues; the trio of Avarice, Superbia, and Vainglory over and above the subordinate vices; the liberal arts along the lower border of the north and east walls that subtend the virtues exemplified above them. Finally, the Latin inscriptions also diagram what amount to relations of cause and effect: for example, the passage from Wisdom to Justice to Concord on the left side of the north wall.

This encyclopedic curriculum calls for dutiful readers—and, as the scholarship on the frescoes demonstrates, continues to produce them. The critical literature has itself become an encyclopedia of medieval *sententiae.* The most widely accepted interpretation cites the "Thomistic-Aristotelian tradition"— that is, the political ideas of Aristotle as elaborated by St. Thomas Aquinas and his scholastic followers. Other references have been culled from the biblical book of the Wisdom of Solomon (for the middle wall) and medieval texts on the Mechanical Arts (for the east wall).[104] Quentin Skinner argues that Lorenzetti's project "is best interpreted as an expression of the pre-humanist rhetorical culture that first began to flourish in the Italian city-republics in the early years of the thirteenth century."[105] In this view the program derived from medieval editions, compilations, and paraphrases of Roman moralists (Sallust, Seneca, and especially the Cicero of *De officiis* and *De inventione*) and from the speeches, letters, and treatises on city government composed for medieval magistrates by professional rhetoricians.

Perhaps the clearest lesson to be drawn from these readings is that the frescoes lend themselves to a variety of learned interpretations—indeed, that they positively invite them. In this sense the accumulation of learned references *is* the program of the Latin inscriptions. They list and classify topics as does an index to a medieval book of knowledge; they prompt searches for

texts under the appropriate headings, and the texts supply the references and crossreferences, the arguments and counterarguments, that define the parameters of discourse on a given topic. Quite apart from anything the inscriptions actually say, their formal message is strong and clear: Latin, high culture, and encyclopedic knowledge are at home in the republic of Siena.

How would a circle of interested citizens in Lorenzetti's Siena have devised such an encyclopedic scheme? It is hard to believe that they combed whole libraries as modern scholars have done. Nor would discriminating histories of ideas have seemed so compelling, or perhaps even comprehensible, to medieval readers. "Pre-humanism," Thomism, and Aristotelianism were not their terms, let alone exclusive categories in their thinking. As we have already begun to see, the frescoes are even more eclectic than the equivocal label "pre-humanist" suggests; and as we shall see later on, there is only one inscription in the ensemble that may depend explicitly on St. Thomas or Aristotle. In any case, republican readers in Siena could have found all the commonplaces and most of the texts they needed in the one book that was the acknowledged and, so the author tells us, the indispensable guide to politics, especially in a republican city-state. This was the *Book of Treasure* (*Li livres dou tresor*) by none other than Ser Brunetto Latini.[106]

Ser Brunetto apparently began compiling his great *Treasure* in French before he composed his little one in Italian verse during his exile in France (1260–1266). Before his death in 1294 this earliest of medieval encyclopedias for a lay public had already been translated into Italian as well as a series of complete or partial versions in Castilian, Latin, Catalan, and English. Never at a loss for "the words and teachings of the wise," Ser Brunetto announced that "rulers who wish to amass in small compass things of great value, not merely for their own delight, but to increase their power" would be sure to find in his book "the most precious jewels," an authentic treasure (bk. 1 chap. 1.1). Rulers of cities in particular needed "the highest knowledge" for "the noblest duty there is on earth," according to a passage from Aristotle that Ser Brunetto cited with approval (bk. 3 chap. 73.1). Of the three types of government distinguished by Aristotle—monarchical, aristocratic, and democratic (*le comune*)—"the third is far better than the others" (bk. 2 chap. 44.1). There is no doubt that Ser Brunetto had the Italian city-republics in mind. The last thirty-odd chapters of the *Treasure* were largely based on advice books written in Italy for civic magistrates, and here Ser Brunetto drew invidious comparisons between monarchies and republics. "The rule of kings and other princes," he writes, exacts submission from free and unfree men; therefore, monarchy is greatly inferior to "the type of government found in Italy, where citizens choose their own officials," so that "the people of the city and all its dependents gain the greatest possible benefit" (bk. 2 chap. 73.6).

"I commend to you my *Treasure*, where I still live on," Dante's old mentor

says at the end of their encounter in the *Divine Comedy* (*Inferno* 15.120). Another of Lorenzetti's contemporaries, the Florentine chronicler Giovanni Villani, vouched for Ser Brunetto's reputation as "a great philosopher," "the first to teach how a republic was to be governed according to the proper political rules," or "by the science of politics (*secondo la politica*)."[107] Sienese readers would have been gratified to know that Ser Brunetto had visited their city on official business in 1257 and to see that the *Treasure* included a model letter written by the republic to a newly elected captain that year (bk. 3 chap. 72). But Sienese debts to Ser Brunetto surely went much deeper than this show of old connections. The *Treasure* demonstrated how secular politics, especially civic politics, could be treated within the medieval organon, as a subject that could be "read" by lay readers. Whether and in what sense Lorenzetti's frescoes actually drew upon the *Treasure* is difficult to determine because it is hard to find anything substantial in Ser Brunetto's work that could not be found somewhere in this dense network of compilation, paraphrase, translation, imitation, duplication, and outright theft. But this was of course the point of the encyclopedic enterprise and a large part of its appeal.

Similar principles are written into the Latin inscriptions and the *Treasure*, beginning with the encyclopedic format itself.[108] By way of introduction, and following a distinct strand in the encyclopedic tradition, Ser Brunetto divided "theoretical philosophy" into theology, physics, and the mathematical *quadrivium* of arithmetic, music, geometry, and astronomy. Under "practical philosophy" he included ethics, "economics," that is, knowledge needed for managing a household, and, under the heading of politics, the *trivium* of grammar, dialectic, and rhetoric. Book 1, diverging from this plan, actually proceeded instead to cover theology, universal history, physical science, geography, architecture, and natural history. These subjects went far beyond the theoretical subdivisions of Ser Brunetto's introductory outline and still farther beyond the topics explicitly marked by the inscriptions in the frescoes. Even so, the general purpose of both the first book of the *Treasure* and the painted labels around the frame of the frescoes—the liberal arts, history (represented by Nero), physical science (the seasons and the planets, admittedly without identifying inscriptions)—is much the same: to situate a more central moral and political exposition as material to be "read" within the categories of a scientific knowledge of the world.

Both the central book of the *Treasure* and the core of the Latin inscriptions go on to the virtues and the vices. Book 2 opened with a thirteenth-century translation of an Arabic paraphrase of Aristotle's *Ethics*, then moved to a survey based on previous compilations of classical, biblical, and patristic texts— most important, the *Moralium dogma philosophorum* of the midtwelfth century, the *Summa aurea de virtutibus* compiled by Guillaume Peyraut a century later, and, for the vices, Isidore of Seville's *Sententiae*.[109] The essential navigational guides to this sea of texts were what the school manuals called *distinctiones*. In

the schools and in sermons preached by the rules of a highly schematic *ars praedicandi* these were the divide-and-conquer means of mastering a subject or constructing an argument.[110] Virtue and vice are themselves a kind of master distinction. On the north and west walls, respectively, of the Sala dei Nove the trio Faith-Charity-Hope has its counterpart in the group of Avarice-Pride-Vainglory; the five virtues, together with Peace, are played off against the six vices; the central figure presiding amidst the virtues is the opposite number of Tyranny. To take an example from the long east and west walls, Security confronts Fear (figs. 25, 7), replaying a dialogue of contrasts that Ser Brunetto included in a chapter of the *Treasure* evidently copied from the *Moralium dogma philosophorum,* whose compiler had taken it from some transcription of the *Formula vitae honestae* attributed to Seneca—which is now regarded as a pseudo-Senecan pastiche composed by Martin of Braga in the sixth century.[111]

 The structural principle of paired oppositions underwrites many such intertextual lines of descent, for distinctions and divisions produce nothing so well as further distinctions and divisions. Once inaugurated this speculative venture is capable of amassing, in Ser Brunetto's term, a "treasure" of symbolic capital. Such wealth came cheap enough to fulfill the fondest dreams of the citizens of the Italian city-state anxious about their moral credit. And so the distinctions go on.

 Both the *Treasure* and the frescoes assign the highest place to the contemplative or theological virtues of Faith, Charity, and Hope, and then distinguish these from the subordinate moral virtues. Like the *Treasure* again (bk. 2 chap. 56.1), the north wall ranks the cardinal virtue of Justice beneath the intellectual virtue of Wisdom—hence the place of Sapientia at the top of the left side of the picture and the prominence that Ser Brunetto gives to the Ciceronian analysis of wisdom as "the mother of all good things" and "the leader of all the virtues."[112] Furthermore, both the *Treasure* and the frescoes separate and balance the virtues into active and passive forms. For example, Prudence and Fortitude appear next to each other on the left side of the bench of virtues in the frescoes, while Magnanimity and Temperance are placed together on the right—precisely the relationship that is expounded in the *Treasure* (bk. 2 chap. 58.3, 71–72, 82.2; figs. 16–17).

 Distinctions proliferate among the vices too, so that the less familiar evils in the frescoes turn out to be more or less routine subdivisions of the more canonical ones. Some texts mentioned Furor and War (*Guerra*) as variant forms of the sin of Anger; Division was sometimes associated with Envy and, like Treason, with Pride; Treason and Fraud could be classified as branches of Avarice.[113] Although the vices are not so clearly or subtly balanced as the virtues, the frescoes distinguish vices of violence from vices of deceit on the right and left sides, respectively, of the court of Tyranny (figs. 12–13). This is another arrangement with a precedent in the *Treasure,* whether because of actual bor-

rowing or simply because such schematic arrangements structured virtually all medieval discourse on virtue and vice.[114]

But if distinctions organized the discourse, they also led to a kind of surplus production. In a scholastic version of the dissolution of feudalism, categories are subdivided and the subdivisions redivided so that conceptual territory comes apart and clear lines of authority dissolve. Medieval classifications of the cardinal virtues, which derived from Cicero (in many cases via an influential commentary of Macrobius) and from Seneca, did not agree about a proper order. It was generally conceded that Prudence had the greatest importance, but the same claim was made, sometimes simultaneously, for other virtues. There were various lists of subdivisions—"parts," "species," or simply "virtues," depending on the lexicon; within the lists of the most important subdivisions there were still further lists of attributes, such as the two "manners" and two "duties" of Providence or the three "manners" and twelve "offices" of Amity.[115]

Magnanimity and Peace were, so to speak, dividends of this symbolic inflation. In the tradition descending from Macrobius's reading of Cicero, Magnanimity was an attribute of Fortitude; for Seneca it was a central virtue in its own right; for Martin of Braga, in his Senecan or pseudo-Senecan paraphrase, it was a synonym of Fortitude—a view repeated in the *Treasure,* which also tilted, probably through the Senecan inclinations of the author of the *Moralium dogma philosophorum,* toward Seneca's high esteem for the magnanimous man (bk. 2 chap 81.3). Thus the place of Magnanimity (fig. 17) at the left of the central figure on the bench of virtues is neither an arbitrary choice nor a deviation from the four-virtues scheme so much as a variation on it.[116] Although Peace was not ordinarily classified among the virtues, readers of the *Treasure* and the texts it epitomized would have appreciated its central position in the frescoes: "the benefits of a peaceful community" come from the virtues; their function is "to maintain human society in good peace" (bk. 2 chap. 1.3, chap. 131.8; figs. 14, 16, 19). According to the Sienese statutes, the Nine were responsible for ensuring "that this city and all its people, its contado and all its jurisdictions, are conserved in perpetual peace and pure justice."[117]

The inscriptions, Latin and vernacular, name justice in seven places; the frescoes personify it twice on the central wall, once with the sword and severed head on the far right of the bench of virtues, and again between Wisdom and Concord, where the pans of the scales of Justice are labeled *comutativa* and *distributiva* (see figs. 17, 20). This obsessive exercise in self-justification can be interpreted as a kind of guilty tic. Justice is the hallmark of legitimate government, and the conflicting ideals of self-interest and equity have troubled more secure republics than the government of the Nine. But this repetition is also a function of a discourse geared to the production of distinctions. Justice was the first or the last of virtues in the traditions descending, respectively, from Cicero and Seneca.[118] Temperance and fortitude could be considered

branches of justice because, according to the *Treasure*, "these two qualities serve to address the heart of man to works of justice" (bk. 2 chap. 30.10); concord, too, was understood to be a form of justice because it "binds in one law and in one habitation the people of a city or a country" and teaches citizens "to put before all else the common good" (bk. 2 chap. 108.1). As for wisdom, both Ser Brunetto and the frescoes quote the *incipit* from the Wisdom of Solomon—*Diligite iustitiam qui iudicatis terram*. By locating Justice beneath Wisdom (fig. 20) the picture makes the point, as the *Treasure* puts it, that "justice must serve wisdom (*le sens*)."[119]

The words *(dis)tributiva* and *comutativa* are precise technical terms amidst this glut of distinctions. So far as we know, they first appeared in the translation of Aristotle's *Ethics* (ca. 1250) generally attributed to Robert Grosseteste; Thomas Aquinas used them in the *Summa theologica* for his analysis of the equitable distribution and exchange of goods.[120] Since neither Ser Brunetto Latini nor his sources employed this terminology, the conclusion seems inescapable that, at least in this one detail, Lorenzetti's frescoes are "Thomistic-Aristotelian." It is no less certain, though, that the terms do not fit what the pictures show—the crowning and decapitating "distributive" angel and the "commutative" angel giving (or receiving?) some round object (a strongbox containing money or a bale of fabric have been suggested) and two lances or spears (see fig. 20). For both Aristotle and St. Thomas, the fair distribution of goods concerned the community as a whole, whereas commutative justice involved only exchanges between individuals of equal standing—a difference the frescoes hardly make clear. Punishment is part of commutative but not of distributive justice (where the frescoes include it); transactions of money or goods belong as much to the latter as to the former.

The discrepancies are closely analyzed by Quentin Skinner, who goes on to argue that the frescoes illustrate a much more elementary conception of justice.[121] On his account the angel on the left executes the wicked and crowns the good, while the one on the right mediates a just exchange of goods offered by the two kneeling figures. Both scenes can thus be taken to show justice remedying inequalities, a relatively straightforward proposition that Ser Brunetto Latini treated in some detail. Following the pre-Grosseteste paraphrase of Aristotle's *Ethics*, the *Treasure* declared that justice ought to apply in two kinds of circumstances: not only in rewarding and punishing but also "in giving and receiving and exchanging," where the transactions between, say, drapers and metalworkers are bound to raise questions of fair exchange (bk. 2 chap. 38.1). Therefore the just man is an "equalizer," and the just magistrate punishes and rewards "so that his subjects live in a secure position of equality," though this may mean "killing some, wounding others, or driving some into exile" (bk. 2 chap. 28.20). Skinner concludes that the execution and reward on the one side, and the "exchange" (the "metalworker's spears," the "draper's bale") on the other side of Lorenzetti's scales of Justice, show this

simple distinction rather than the complex theory of distributive and commutative justice. In short, Lorenzetti either ignores or misunderstands the theory, and if this is the case where the references are so precise, we may discount the more general view that the program of the Sala dei Nove is "Thomistic-Aristotelian."

The fact remains that "commutative" and "distributive" justice *are* technically correct Thomistic-Aristotelian terms. That these tokens of philosophical sophistication are without real substance only underscores the mania for distinctions that structures and overburdens the Latin lessons of the frescoes. The technical language is in this sense a bid for the serious philosophical credentials that, so it turns out, the citizens of Siena might well have feared they were lacking. Lorenzetti simply adds the latest jargon to the sturdily middlebrow culture that Ser Brunetto Latini's *Treasure* made available to a new audience of lay readers.

It should be clear enough by now that the *Treasure* did not prescribe a consistent political theory. By Lorenzetti's time it was already a rather old-fashioned vernacular reader's guide, part anthology and part digest, to the Latin authorities. So far as Lorenzetti's frescoes were concerned, little more was needed. As we saw earlier, their message was spelled out in the vernacular inscriptions. What the *Treasure* could provide was a general fund of authoritative references and, hardly less important, an apparatus of distinctions with the cachet of high learning and a long tradition. If the *Treasure* did have a theory, it was that "the government of cities" is predicated on words: its bible is the encyclopedic compilation, its wise men are the ancient moralists in medieval guise, its chief science is rhetoric, its sphere of action in the world is properly defined and directed by writing. It follows that the "image" of the city-republic should be studded with texts in the Sala dei Nove. With the inscriptions in place we could practically dispense with the pictures and still "read" the vision of an ideal republic.

This conclusion brings us back to the preoccupation with writing that was a matter both of republican ideology and of particular historical circumstances. The "power of the written word" was not merely formal or formulaic in such a setting. It was an assertion of political will, like fielding armies or promulgating laws. The republic in command of writing challenged what had been a clerical and monarchical prerogative and the privilege of literate elites. Only a literate republic could claim to be founded on the authority of ideas that were authoritative precisely because they had been inscribed and reinscribed in the canonical texts. Written norms and access to a textual domain seemingly outside special interests and everyday affairs allowed the republic to stake its legitimacy not on persons but despite them, not on the emperor, the priest, the king, or the noble but in light of what could be read in the scope of writing. In this guise it was the republic of principles, not the republic of interests, not an

unruly republican assembly or an oligarchical syndicate of masters, that stood against its traditional superiors and over its own dependents.

The utopian quality of such claims is not simply a matter of republican idealism—or of opportunism. It lies in the capacity of writing to produce such claims and also to obscure the questionable means of their production. For we must not read too carefully. If the reader asks where the inscriptions come from, the answer is surely not from the soaring heights of speculation or the solid ground of principle. Virtue and vice are separable only in the convenient scheme of differential oppositions afforded by writing; even there the symmetrical relation between them makes good and evil, its demonic inversion, seem all too close for comfort. And the more the reader tries to get to the bottom of the texts, the more their ultimate reference recedes in an endless proliferation of words.

THE REPUBLIC IN PICTURES

If the inscriptions in the Sala dei Nove presuppose that good republican magistrates were dutiful, though uncritical, readers of texts, what was their duty as viewers of images? The vernacular inscriptions proclaim, ingenuously or not, that the pictures obediently illustrate the text. The first recorded impressions suggest just the opposite, that the pictures generate their own texts. The Florentine sculptor Lorenzo Ghiberti commented early in the fifteenth century that Lorenzetti's frescoes show "how merchant caravans travel safely in utmost safety [*sic*], and how they leave their goods in the woods, and how they return for them. Also the extortions made during war are perfectly indicated."[122] The pictures prompt a narrative here, though Ghiberti's little fiction is garbled and blithely inattentive—assuming that he actually saw them—to what the pictures show. In a sermon preached in the piazza of the Campo in 1427 San Bernardino of Siena takes the part of a Renaissance beholder, ego and eye, for whom the pictures are a "window" opening onto a world of stories with a moral:

> I see merchants buying and selling. I see dancing, the houses being repaired, the workers busy in the vineyards or sowing the fields, while on horseback others ride down to swim in the rivers; maidens I see going to a wedding, and great flocks of sheep and many another peaceful sight. Besides which I see a man hanging from the gallows, suspended there in the cause of justice. And for the sake of all these things men live in peace and harmony with one another.[123]

These little accounts, both of them focused on Lorenzetti's scenes of the good city and countryside (cf. figs. 21, 24), raise large questions about the

status of realism and naturalism in late medieval art. Following one inter-
pretive convention we might say that both accounts point to the new role of
the image as the bearer of morals and meanings "under the cloak of apparent
verisimilitude." On this reading "late medieval realism" allegorizes doctrine
in narratives seemingly derived from tales that pictures can be made to tell,
and meaning is folded into images of "a startling worldliness."[124] The body
hanging from the gallows of Security (fig. 25) would be in this sense the ulti-
mate demonstration of the power of the image to represent the power of the
state. The alternative interpretive convention draws on the Whiggish scenario
of observation freed from the blinders of authority. Boccaccio already cast
Giotto in the role of the liberator "bringing back to light that art which for
many centuries had lain buried under errors"; he painted the phenomena of
nature so that "they seemed not so much likenesses as the things them-
selves." Panofsky is still—or once again—elaborating upon these tropes of
naturalism triumphant when he calls Lorenzetti's "portrait of Siena and his
panorama of the fertile, rolling country near-by the first post-classical vistas
essentially derived from visual experience rather than from tradition, mem-
ory, and imagination."[125] In this critical tradition Lorenzetti's scenes figure a
progressive transformation, a rite of passage, from "medieval" reverence for
the Word to an oncoming "Renaissance" valorization of the visible World.

The interests of the republican magistrates of Siena would have been served
by both interpretations. As much as the Nine wanted to read textual prescrip-
tions and abstract principles into politics, they also had a stake in seeing the
world of the republic as an aggregation of particular social groups, scenes,
and settings. Monarchies could center on the person of the king and the circle
of the court, but the credentials of the republican regime depended on its ca-
pacity to represent diversity, if also on its commitment to virtue, "in the cause
of justice," as San Bernardino chose to explain the hangman's noose. Every-
day activities thus became the constitutive indices of republican life, a testi-
mony to the energies of a republican people. The busy town in Lorenzetti's
fresco, the travelers, and the country folk at their tasks could be seen in this
light as painted vouchers for the productive plenitude fostered by the republi-
can regime. At the same time, these details demonstrated that principles
could be realized in practice, that republican virtues were not confined to tex-
tual prescriptions and symbolic forms. So much the better, then, that the
fresco on the east wall of the Sala dei Nove could be viewed both as a pictorial
survey and as an allegory of the effects of good republican government. If
nothing else, the picture set into place for the magistrates' inspection the
heterogeneous interests that they were charged to hold together.

In what follows we shall trace the semiotic and semantic trajectories that
culminate in Lorenzetti's great "republican panorama." To do so means reac-
tivating the educative work of vision that leads from the menaces of tyranny
and the admonitions of virtue on the west and north walls of the Sala dei

Nove to the imagery of abundance and peace. But where the republicans of
Siena may have regarded this pictorial denouement as a reward and redemp-
tion, our task is to see how the illusion is made. For of course it is an illusion.
Recent critical discussions have fixed on the artifices of landscape painting
while insisting that the formal and symbolic values with which it is invested
are quite real extensions of political interests.[126] That Lorenzetti's scenes of the
city and the countryside count among the masterpieces of "late medieval real-
ism" is a measure of their persuasive pictorial force but also, as we shall see,
of concerted political effects.

THE CONSTRUCTION OF A REPUBLICAN PANORAMA

The panorama of the city and the country in the Sala dei Nove (figs. 21, 24)
comes at the end of a sequence in the itinerary of the frescoes. The scenes of
devastation and the Tyrant's court are now literally behind us. After following
the inscriptions and the real and painted flow of light to take in the central
wall, the viewer turns to the long expanse of the east wall on the right as if to
an arrival and a release from the reign of the vices and the lessons of the vir-
tues. At the same time this turn initiates another fictive journey into the
depths and details of a scene laid invitingly open to inspection. At the head of
the room under the virtues the nine magistrates could either have looked back
to the vices or let their attention be drawn forward into the panoramic view.
The visual "pull" of the open city and country clearly invites the redemptive
and progressive choice.

Many commentators have noted this absorptive effect without agreeing on
a consistent account of it. That the pictures are not proportioned along the
mathematical lines of a "true" perspective system, with its geometrical grid
and systematic diminution of scale toward a vanishing point, is obvious from
the start—these techniques were developed and codified in Florence nearly a
century later. Panofsky praises Ambrogio Lorenzetti and his elder brother
Pietro, together with Duccio and Giotto, for "spectacular progress not only in
the struggle for an exact perspective construction but also in the representa-
tion of space *per se.*"[127] The fact remains that the spatial constructions in the
most experimental Trecento painting, though they no longer look notably dis-
continuous and finite, were still relatively inconsistent and unstable by Re-
naissance standards. In the Sala dei Nove panorama we could expect only a
point (or points) of view delineated more or less empirically and ad hoc. But
how so and to what purpose?

The visual signals are mixed. Uta Feldges-Henning suggests with some
plausibility, and much allowance for artistic license, that what we see is a view
from the tower of the Palazzo Pubblico itself, complete with the cathedral's
campanile and dome in the northeast corner, a piazza below, and the Sienese
countryside stretching beyond (far beyond the limits of actual perception) to-

ward the port of Siena labeled Talamone near the southernmost margins of the landscape.[128] In his analysis of the "reinvention" of pictorial space in Western art John White argues that "the spectator's situation, always looking outward from himself, the center of his world," has its "pictorial equivalent" in Lorenzetti's construction of the view: from the ten dancing figures in the center left of the cityscape, the picture appears to radiate around a piazza, from there to recede outward both in depth and across the picture plane.[129] Whereas these interpretations locate the spectator within the notional space presupposed by the picture, Jack M. Greenstein proposes an alternative vantage point outside the fresco but within the room. The visionary panorama is, he argues, literally the "vision" seen by the reclining figure of Peace (fig. 16) as she gazes at the west wall:

> Seen from an angle consistent with the gaze of Peace, the fresco takes on the characteristics of a true (by fourteenth-century standards) perspectival view. The buildings, which before had seemed askew, align themselves with the picture plane; the size of the figures diminishes in relation to their distance from the viewer (that is, Peace), not from an imaginary point within the picture; and, finally, instead of arbitrarily growing deeper as it approaches the south margin, the landscape ranges across concentric chains of hills until it reaches a horizon located at the farthest corner of the visual field.[130]

On this account, and in keeping with both ordinary language and medieval optical theories, the "vision" is an illumination of a dreamlike or conceptual sort. The light that, as is often observed, seems partly to flow from the central wall against the direction of the natural light from the window would thus be in both senses the "light" of peace.[131]

Lorenzetti clearly did paint an aerial view with recognizably Sienese details such as the striped campanile and the dome of the cathedral or the gently rounded hills with groves of trees, fields of grain, and vineyards. Clearly too, he meant to construct a coherent illusion of depth with a roomy capacity for particulars. Yet accurate observation and consistent perspective were only partly realized and, so we may suppose, intended in early Trecento painting. In Lorenzetti's fresco the trademark Sienese details are mixed with quite generic ones, and the aerial view implied by sloping roofs and the shallow angle of apparent recession in the cityscape is belied by the underside of cornices and roof supports as if they were seen from below. Furthermore, the dancers in the painted piazza are much larger than the figures in the shop close by, and these figures are much smaller than their customer with the donkey. Then too, both the city and the country halves have their own distinct focal points in the dancers and the riders outside the gate.[132] And so forth.

We could continue to list inconsistencies, if consistency were the point. But

the striking fact about the great panorama is that it incorporates very different perspectives just as it integrates distinct social groups and activities. Here, if anywhere, we have a model of, and for, the genial accommodation of diversity envisaged by republican ideology.

As a general rule, the pictorial autonomy of the images in the Sala dei Nove tends to increase in an inverse ratio to their distance from the inscriptions. On a sliding scale, the distance traversed away from indicators of a literal meaning is a measure of movement *toward* meanings seemingly intrinsic to the images themselves.[133] As the diagram of the inscriptions shows (fig. 3), the court of Tyranny and the wall of the virtues are the most heavily inscribed areas, whereas the panorama on the east wall is the least encumbered by writing in the ensemble. We can follow the semiotic engineering calculated to release textual pressure from one area to another.

The labeled personifications, to begin with, are the images least necessary *as* images to the meanings assigned to them. They appear as servants of writing, as conscripts of a drillmaster determined to teach by the book. Their pictorial attributes are strictly coded—the scale and sword of Justice, the olive crown and olive branch of Peace, the cross of Faith, the fire of Charity; or, among the vices, the moneybags of Avarice, the yoke of Pride, the mirror of Vainglory, and so forth. There are inventive touches such as the reclining figure of Peace reminiscent of antique sarcophagi or coins. The great figure on the north wall usually identified as Common Good (fig. 15) looks like a combination of ruler, saint, and seated magistrate in what were no doubt quite deliberate crossreferences to the highest forms of authority.[134] The black humor of the vices is especially ingenious, as we have already seen. Nevertheless, it is the schematic rigidity of the iconographical format that enables these virtuoso tricks, a kind of pictorial acrobatics that depends on a firm grip. The inventive touches are prevented from seeming new or original in any case: a written label "ages" the images instantly once it refers them back to the "prior" inscription. The denotative force of the written word makes a reversal of priorities hard to imagine.

The space occupied by the personifications is itself a textual concession. Diagrammatic in function, the figures are also diagrammatic in their formal arrangement. Divided into tiers of virtues and vices, lined up on flattened planes like rubrics or headings in an outline, they are more or less isolated from one another and from their surroundings. Their size and position are propositional rather than pictorial values. The large scale and central position of the Common Good, the contrapuntal arrangement of the virtues and the vices, the predominance and several ramifications of Justice function as proofs in an argument. As if to suggest that the sensuous presence of the image would be as much a delay or a distraction as a guide to comprehension, the personifications hardly cast a shadow. In medieval metaphysics and poet-

ics, shadow, "something belonging to a separate, gloomy 'realm,'"could only have diminished the "splendor" claimed for the virtues.[135]

Formula also dictates the gender of the personifications. That the virtues are feminine follows from grammatical protocol for abstract nouns and a long iconographical tradition. Their location in the upper register of the picture (fig. 14) corresponds to a conventional set of displacements whereby the exclusion of real women from political life enables them to be represented as icons of higher values. In effect, the bonding of men through their daughters, sisters, and wives is elevated into a communion of virtue, while female fertility is thematized in the proliferation of symbolic forms. The figures on either end of the virtues' bench are emblematic projections of the feminine in their own right. Peace reclines in a white gown, the contours of her body and her alluring pose bidding for desire—this is the same figure-type that Lorenzetti cast as Eve in his San Galgano *Virgin in Majesty* (1340). The upright figure of Justice, stern executioner of desire unbounded, brandishes a sword over the severed head of a black-bearded man. Lacking a real court, the fraternity of republican citizens looks up here to a fictive court of women representing the principles supposedly uniting and superintending it. And yet, lest there be any doubt about male prerogatives, the feminine court is centered on the overbearing patriarchal figure in Sienese white and black.[136]

In the areas of the pictures below the personifications the formulas begin to dissolve in clusters of figures that are more like colonies than satellites of verbal and visual conventions. The line of twenty-four figures on the north wall—they are usually assumed to represent a council of that number preceding the Nine—models a dependency that looks self-willed and freely chosen (see fig. 18). Woven by Concord from the cords on the scales of Justice, a rope passes through the hands of these figures before rising again to the hand of Common Good. The figure in line closest to Concord is turned as if to relay the rope; shown from the back, this figure also conceals the point of transmission and anticipates the viewer's position in front of the picture. Figures are turned here and there to one another in the double-file procession, and the faces at the head of the line are tilted up as if to complete the circuit back into the realm of the personifications above them. It is for the viewer to take these visual cues to a third dimension, to see variations in form as movements in space, and to attribute different psychological dispositions to different spatial ones—a gesture, the turn of a head, the look of a face. Like marionettes on their string, the figures appear to be acting on their own while acting out the message that comes from above.

Farther away from the labeled virtues and vices, the imagery has more autonomy. The figures on the side walls, for example, show vital signs of a "life" of their own, despite the intrusion of the texts on the banderoles of Security and Fear (figs. 25, 7) or textual surrogates such as the ten women dancing in the painted piazza on the west wall. San Bernardino apparently thought these

dancers (fig. 22) were on their way to a wedding; if so, the woman mounted on a white horse followed by her male attendants could be the bride in a ceremonial procession to her new relations, perhaps the two women in the doorway.[137] Still, the relatively large size of the dancers, their frontal position, finery, and the dance itself, set them apart from the scenes around them. Their motivation, so we are led to infer, lies outside the immediate circumstances of the picture—say, in a prescribed iconographical score on Justice, like Giotto's dancing figures in the Scrovegni Chapel at Padua (fig. 23), or perhaps on the themes of Concord, Good Health, or the sign of Venus in the frame above them.[138] For the most part, however, the figures on the side walls are not so overtly programmatic. When Ghiberti sees the coming and going of merchants, or San Bernardino points to a wedding party and people riding down to the rivers to swim, the description and the story telling *are* the program.

Such responses depend on telltale details set in a space expansive and "deep" enough to prompt narratives connecting them. There is no prima facie difference between, say, the carpenter's plane of Concord or the scale of Justice and the shopkeepers' wares and the peasants' implements in the city and country scenes. These objects can all be easily recognized and imagined in use. Yet in one setting they are mere props because their symbolizing function clearly determines their significance; in the other they could easily be supplemented or replaced because the choice of paraphernalia has no set limit. Women at a window, a swallow's nest, a cat perched on a balcony, a bird in a hanging cage; the man who drives a pig toward the gate; the angles of the archers' crossbows, birds feeding in the fields, the spotted dogs—the triviality of such details becomes an index of the reality of the scene. In the familiar paradox of pictorial realism the absence of clear motivation becomes a faithful sign of the world that the picture ostensibly records.

PATTERNS OF PRACTICAL KNOWLEDGE

It would be easy to supply a plausible moral for the east wall in a few words: the virtuous republic secures a harmonious plenitude of productive activity in the city and the country. But the pictures themselves defer obvious conclusions. Although the inscriptions spell out prescribed messages, the panorama extends and disperses meanings and morals in the *visibilia* of an ingeniously painted world. As a republican image, the panorama is a double tour de force. We have already seen how its depth and detail produce what amounts to a simulacrum of the bounteous society of republican ideology. It remains to be seen that the bounty includes the categories of practical knowledge represented in medieval literature and art.

To begin with, the country scene (fig. 24) recalls the pictorial calendar of monthly tasks codified in Italy before being perfected in the brilliant manuscript illuminations made for Jean de Berry by the brothers Limbourg in the

fifteenth century. As Otto Pächt pointed out long ago, Lorenzetti's images of viniculture, sowing, riding, ploughing and stock raising, harvesting and fishing, threshing, and hunting correspond to a repertoire of activities conventionally singled out for the months from March through September.[139] And yet the calendar is obviously incomplete: autumn and winter occupations such as making wine (October), cutting wood or fattening pigs (November), or slaughtering pigs (December) do not appear. The agricultural calendar would not account for the urban scene in any case. Hence the alternative proposal that Lorenzetti painted the Mechanical Arts under the seven headings set forth in medieval schoolbooks. Hugh of St. Victor's *Didascalion* lists *lanificium* (specifically the manufacture of woolen cloth, but also the production of clothing, leather goods, fur, sails, ropes, and nets), *armatura* (metal work of various kinds, but also the building trades), *navigatio* (travel and commerce of all sorts, by sea or by land), *agricultura*, *venatio* (both hunting and fishing), *medicina* (including drugs and spices), and *theatrica* (still very much a "mechanical" art). According to Feldges-Henning, Lorenzetti complemented the seven Liberal Arts in the medallions beneath the good city and country scenes by painting the seven Mechanical Arts in the scenes themselves. If we allow that the teacher shown reading to his students is a doctor and extend *theatrica* to "choral processions and dances" and "playing at dice," as Hugh of St. Victor does, then even some of the most elusive details will fit.[140]

Yet even a scheme encompassing, in Hugh of St. Victor's words, "the making of all things" is not capacious enough. The medallions in the upper frame on the east wall show the planets Venus, Mercury, and the Moon as well as the seasons Spring and Summer, and the papal coat of arms with its two crossed keys. Greenstein maintains that the panorama should be seen accordingly as "the image of a society at peace, a city whose earthly harmony accorded with the temporal and astral forces which govern it."[141] Lorenzetti would thus have depicted the good city and country in the benign seasons of the year under the signs of the planets whose requisite effects or, in an iconography codified in the fifteenth century, "children" can be discerned in the picture. This scheme allegedly explains the inclusion of elements and activities that were thought to be influenced by the moon (water, travel, hunting) or by Mercury (especially the skilled or learned trades). Astrological lore associated marriage, friendship, and sociability with the "chaste Venus," "in the house of Taurus," as she is shown in the fresco, and these happy foundations of social life were sometimes figured iconographically by dancing figures. All this points up the contrast with the winter seasons and sterner astrology of the corresponding medallions in the top frame of the west wall.[142]

There is at least one other possibility that has not been seriously considered so far. The *Tacuinum Sanitatis* was a layman's index to good health probably compiled by the Arabic physician Ibn Botlan and translated into Latin in Sicily or Naples around the middle of the thirteenth century.[143] This widely circu-

lated book of "tables" contained more than three hundred entries ranging from various foods and drinks to the seasons, types of weather and winds, states of mind, kinds of activity, and varieties of cloth used for wearing apparel. In illustrated versions the *Tacuinum* became a picture book of genre scenes, the earliest known of which come from Lombardy during the last two or three decades of the fourteenth century. Scholars have discerned Lorenzetti's influence in these miniatures.[144] But we might just as well suppose that the striking resemblances between the Siena frescoes and the miniatures testify to earlier precedents in nature and calendar illustration and to shared conventions of representing the arts of civic life. We shall return to this, but for the moment the point is that Lorenzetti's city and country scenes might be characterized as a *Tacuinum Sanitatis* painted large, as a pictorial anthology, part description and part prescription, conducive to the health of the individual and the community.

The motto of the *Tacuinum* bears repeating at this point: "Men, in fact, desire from science nothing else but the benefits, not the arguments; accordingly, our intention is to shorten long-winded discussion and synthesize the various ideas."[145] We can reap the benefits and shorten the discussion by supposing that the scenes on the east wall were eclectic from the start, that rather than limiting the pictorial repertoire Lorenzetti expanded it. This would hardly be surprising. Resemblance and redundancy were as valued and as "natural" in the medieval organon as discrimination and originality are esteemed by modern critics. Here again the compendious systems of knowledge and an array of images sanctioned by the high culture of the schools, the courts, and the Church could only have conferred that much more luster on the republic. The more capacious the criteria, the more complete the inventory of productive activity embraced by the image of the ideal city and country.

In any case, the imagery absorbs whatever "long-winded discussion" may lie behind it. We see more and less than texts can say. The colors of painted fields or the look of the harvester and the exact angle of a scythe are not dictated by personifications of the seasons, the idea of *agricultura,* astrological signs, or the salutary properties of grain; the harvest scene does not directly coincide with a proposition about productivity or with a verbal description of harvest so much as prompt texts on its own, this one included. We may vicariously feel the handle of the scythe or of the painter's brush before trying to account for what we see or contemplating the reasons to harvest or to paint. And if we have been looking at genre scenes in medieval art and not just reading classifications of practical knowledge in medieval texts, many motifs on the east wall will seem familiar *as* motifs adapted from a common stock.

Once the genre scenes on the east wall are themselves recognized as generic, images that might otherwise seem unique merge into a network of prec-

edents, parallels, and variations. In this way too, the painter so often praised as a republican chronicler in pictures resumes his rightful place as a citizen of a republic of artists.[146] No doubt Lorenzetti saw hunters on horseback many times, but the mounted falconer he actually painted is a close copy of a figure-type going back at least a century to Emperor Frederick II's manuscript on falconry.[147] (Compare figs. 26–28.) Similar dances had been performed before in art, and Lorenzetti's ploughman and harvesters clearly derive from pictorial formulas that run into, and through, the fresco.[148] These agricultural scenes resemble those painted around the same time in the so-called *Libro del Biadaiolo*, a chronicle of grain prices from 1320 to 1335 compiled by the Florentine grain merchant Domenico Lenzi and interspersed with political commentary, edifying verse, and nine miniatures.[149] (Compare figs. 29–30.) A *Biadaiolo* picture of a shopkeeper tending his wares and serving his customers can easily be imagined painted on a large scale in the Sala dei Nove, or reduced again a generation later in the *Tacuinum Sanitatis*. (Compare figs. 31–33.) If Lorenzetti sought models outside his shop, he might just as well have examined the sculptural reliefs on public buildings and monuments as real farmers in the fields or city people in the piazza.[150]

Without ever looking much beyond his pattern books, then, the artist could paint whole worlds teeming with activity. This is not to say that his choices, assuming they were his to make, hinged on aesthetic preferences. The aggrandizement of the republic in pictures called for a conflation of schemes of practical knowledge and pictorial formulas that neither began nor ended with Lorenzetti. This strategy was practically inextricable from the ideology of the republican regime and ultimately from republican practice.

MIRRORS FOR MAGISTRATES

Detailed inventories of civic resources were indispensable to the politics and the pride of the Italian city-republics. In a sense the early commune *was* the list of those sworn to obey and defend a set of common rules and obligations. Communal censuses and cadastral surveys can be read between the lines, as Peter Burke shows, for perceptions of social standing and civic values.[151] Panegyric and statistics flowed together in the city descriptions that flourished in the thirteenth and fourteenth centuries. In his *De magnalibus urbis mediolani* (1288) Bonvesin da la Riva celebrated the "marvels" of Milan in a carefully observed account of its site, buildings, inhabitants, and "affluence of all goods," spiritual as well as material. Giovanni Villani's famous survey of Florence, complete with figures on population, food supply, cloth production, banks, notaries, schools, and much else besides, was nearly contemporary with Lorenzetti's frescoes, and his survey has a pictorial analogue in a view of the city painted for the charitable society of the Bigallo (ca. 1340).[152]

Pictorial and archival inventories were closely linked in Siena. The scenes of subject towns in the large council hall of the Palazzo Pubblico belonged to this mixed genre. Sienese painters decorated chests for official papers and painted the likenesses of civic officials in illuminated manuscripts. Covers on tax registers were adorned with views of the city, official portraits, coats of arms, patron saints, and political allegories. Lorenzetti's earliest surviving work is an altarpiece for the tax officials, and his great figure of Common Good was the model for a tax register cover of 1344.[153]

Manuals on city government formalized the assessing regard cultivated in the marketplace and the official vigilance motivated in the council hall as much by mutual suspicion as by loyalty to the republic.[154] According to *The Pastoral Eye* (ca. 1220), the earliest of these "mirrors" or "eyes" for magistrates, good magistrates "first paint things in their minds . . . before speaking." The anonymous author followed the ideal official on his rounds, as if on an inspection tour. Casting an attentive eye over the great and small affairs of civic life, the worthy magistrate had walls, streets, and roads to survey, business in the city and the country to look after, soldiers to review, appearances to make in council and in the piazza.[155]

This outlook was written into the one surviving book of deliberations by the Nine during the period when Lorenzetti was working in their meeting room.[156] The notary recorded that they expected regular reports on the condition of the walls and fortifications, the streets and roads, and the castles of the republic. A special commission had to be named to adjust the tax rates on livestock and meat (fol. 6r). Eight horses requisitioned by the commune from its war captain, Ridolfo da Verano, needed to be inspected (fol. 7r). Giovanni Pucci of Sambuco was caught without a license transporting ten rabbits, a pheasant, and a rooster on a wooded stretch of country road (fol. 11r). Figlino Negri was cited for smuggling two mules loaded with grain in the Tressa neighborhood (fol. 14v). A review board investigating the statutes and privileges of the craft guilds was expected to report its findings (fol. 16v). Mino di Giovanni and Martino di Agnolo had been arrested for poaching (fols. 32v, 36r). And so on.

If the notary had painted his entries instead of writing them, they might have looked something like the scenes Lorenzetti was putting up on the east wall of the Sala dei Nove. Like the notary's book, the picture encompasses the city and the country. Symmetrically divided but visually weighted toward the city, it posits a division of labor and authority recalling the busy agenda of the Nine. The city comes first for the viewer following the scenes from left to right (fig. 21); the eye is arrested there by the dense concentration and the vertical forms of the painted buildings enclosed behind the curtain of walls. The central piazza draws us inward, and the scenes along its margins offer enticing glimpses of a marketplace, or theater, of urban business and plea-

sures. Beyond the walls, the traffic along a network of roads guides attention to and from the urban core (see fig. 24). Here and there workers perform their tasks in the fields or transport the fruits of the land and their labor to market. This is a hinterland as the magistrates would have wished to see it, secure, productive but open to penetration, a place for travel (the road), recreation (the hunt), investment and retreat (country houses and castles), and provisioning (grain fields and vineyards, forests and fresh water). The only peasants shown here are industrious ones.

For both notary and painter the city and the country are settings for little incidents and particular cases. Figlino Negri and his mules laden with grain have their painted counterparts; the pictorial survey of the business of the city can be imagined anticipating the commissioners' report to the Nine on the guilds. Traffic on the streets and roads, artisans plying their trades, provisions bound for market, dancers in the town square—virtually all the activities represented in the picture were subject to more or less intricate communal regulations. In this sense the picture, like the notarial register, is the detailed projection of an official point of view. As a kind of illustrated archive it would have given each panel of nine citizens for a two months' term a pictorial index to their responsibilities. As an inventory of resources, an assets-list in pictures, it celebrated the productive energies and particular interests that the Nine were pledged to defend. As a vision of politics, the fresco showed how the peaceful city-state was supposed to look in precise detail.

Seated at the head of their room, doubling the gaze of the personified virtues behind them and admonished by the vices to one side, the Nine looked upon a world that appeared to reward their best efforts. There were no skirmishes in this painted world, no scheming magnates, hostile workers, or restive peasants. Girls might dance in the painted piazza (fig. 22), though communal statutes, fearful of disorderly conduct and immoderate display, prohibited such behavior in the real one.[157] The gallows (fig. 25) was the only reminder, a grimly threatening one to be sure, that this harmonious prospect might depend on force. For the rest the picture celebrated the utopian dreamwork of a merchant republic in which the common good is the sum of diverse activities and interests. The laws of this earthly paradise are the invisible ones of supply and demand drawing material and symbolic goods to and from the marketplace. Medieval towns were conventionally represented in the guise of the City of God or of the heavenly Jerusalem, but Lorenzetti's city and country are the secular fantasies of republican *homo economicus*.[158]

In the actual course of events recorded by their notary, the Nine were obliged to deal with "damage and devastation and cheating contractors" (fol. 16r). Prostitutes were reportedly walking the streets near the entrances to public buildings (fol. 25r). Ser Andrea di ser Fucci complained that he had

been attacked by unnamed assailants after reading his new redaction of the criminal statutes in an assembly of the General Council (fol. 20v). The measures taken against poachers and unauthorized shipments of grain testify to the nagging fear of famine in 1340 when Lorenzetti may have been putting the finishing touches on scenes of plenty.[159]

Good and evil did not come unalloyed in the proceedings of the Nine. The perfection of the good city and country on the walls of their chamber was a function of forced distinctions, didactic purposes, and wishful thinking. As we have seen, even the details the pictures seem merely to record were screened through the formulas of the pattern books and workshops.

THE REGIME FALLS, THE PICTURES REMAIN

The regime of the Nine fell in March 1355 when the arrival of Charles IV with a force of one thousand knights sparked an uprising by disaffected magnates and a vindictive crowd.[160] There were reports of looting and arson. The official records on which the Nine had set such great store were destroyed in the emperor's presence, and the shattered chest containing their electoral lists was dragged through the streets on the tail of an ass. The anxieties of the regime in the face of the traditional hierarchy and its own internal divisions had not been misplaced.

In the eyes of the emperor and the magnates the overthrow of the Nine probably seemed long overdue. The more familiar modern view, winning moral victories without actually having to struggle for them, is that the government was not democratic enough to fulfill the promise of another, much later age. But the striking fact for its own time is surely not that the republic was imperfect but that it survived with its communal constitution intact for seventy years, from the heady expansion of its first half-century through the turmoil of the generation of the Black Death. Many of its institutions lasted until the conquest of Siena by the Medici duke of Tuscany and Florence in the midsixteenth century.[161] The Sala dei Nove is not the least remarkable survival—and legacy.

For Lorenzetti's frescoes bear witness to the republican experiment that, with all its limitations, was the great political project of the city-republics of medieval Italy. The itinerary of the frescoes conjures up real and imagined enemies in the guise of evil, counters vices with virtues, and rewards virtue in turn in a redemptive republican panorama. As in the Aristotelian formulation with which we began, Lorenzetti represented the republican polity both as a transcendent "figure of mind" and as a utilitarian "alliance." Keyed to writing and symbolic forms, his Siena was a republic of principles; displayed in circumstantial images, it was a republic of interests. But we have also seen how his work exposes the utopian constructions of republican ideology, how the

realm of the principles exists as a function of writing, while the "realistic" details are mediated by abstract distinctions and pictorial conventions. It would be difficult to imagine how a work of art could contend more deeply with the problematic and perhaps ultimately irreconcilable demands of republican representation.

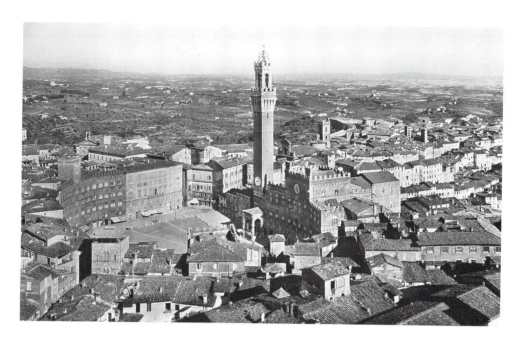

FIGURE 1. The Palazzo Pubblico and the Campo of Siena.

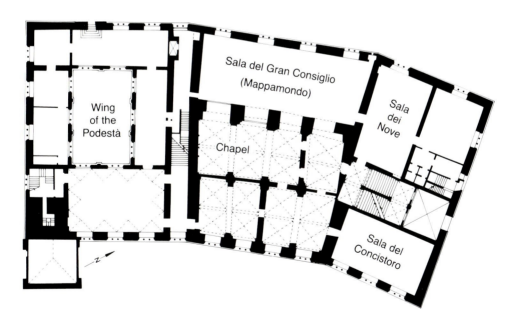

FIGURE 2. Plan of the second floor of the Palazzo Pubblico.

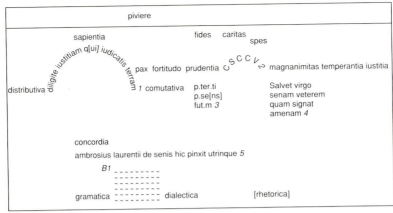

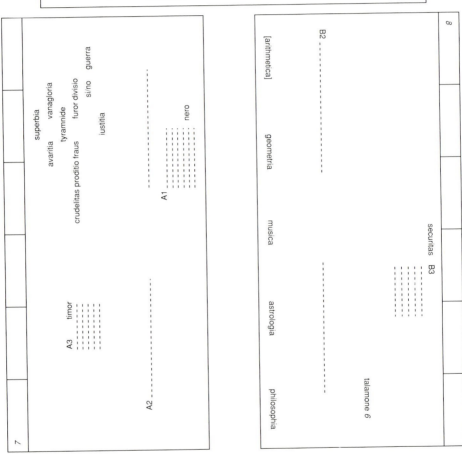

FIGURE 3. Diagram of inscriptions in the Sala dei Nove. *1* "Love justice you who judge the earth" (*Wisdom of Solomon* 1.1), *2* COMMUNE SENARUM CIVITATIS CIVITAS VIRGINIS [Commune of the City of Siena City of the Virgin], *3* PRAETERITI, PRAESENS, FUTURUM: Past, Present, Future, *4* The Virgin protects Siena, which she has long marked for favor, *5* Ambrogio Lorenzetti of Siena painted this on both sides, *6* The name of the port of Siena, *7* frieze with medallions of Mars, Winter, arms of France, Jupiter, Autumn, Saturn, *8* frieze with medallions of Venus, Summer, papal arms, Mercury, Spring, Moon (see appendix 1 for inscriptions *A1–3, B1–3*).

62

FIGURE 4. Ser Brunetto Latini gives his *Tesoretto* to a reader. Florence, Biblioteca Medicea Laurenziana, Florence, Strozzi MS 146, fol. 1.

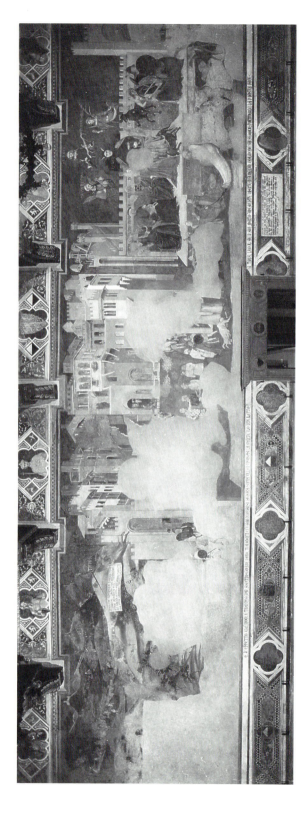

FIGURE 5. Ambrogio Lorenzetti, Bad Government. Siena, Palazzo Pubblico, Sala dei Nove, west wall.

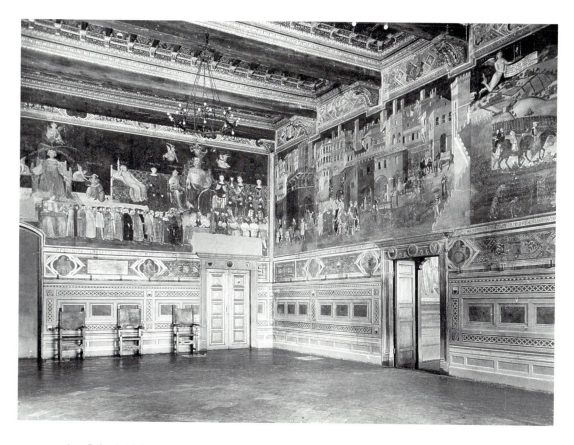

FIGURE 6. Sala dei Nove. Siena, Palazzo Pubblico, north and east walls.

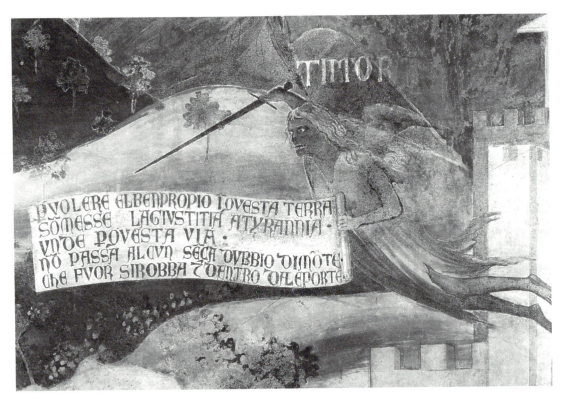

FIGURE 7. Timor, detail of Bad Government.

FIGURE 8. Armorer, detail of Bad Government.

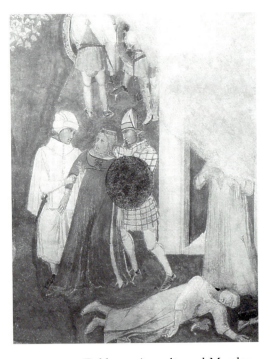

FIGURE 9. Robbery, Assault, and Murder, detail of Bad Government.

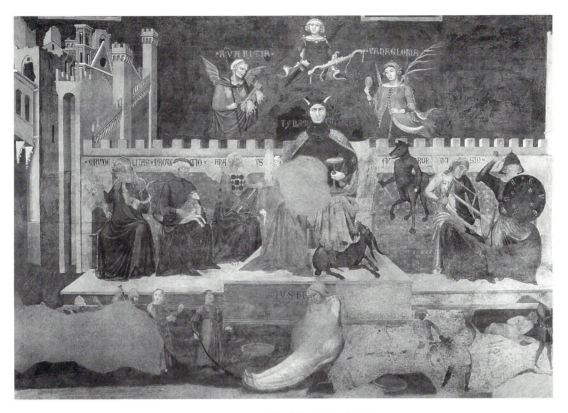

FIGURE 10. Court of Tyranny on the west wall of the Sala dei Nove.

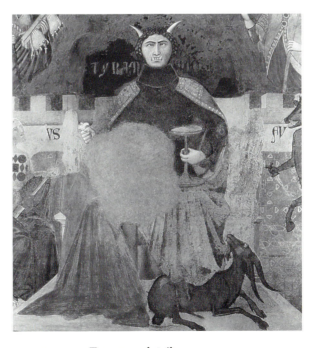

FIGURE 11. Tyranny, detail.

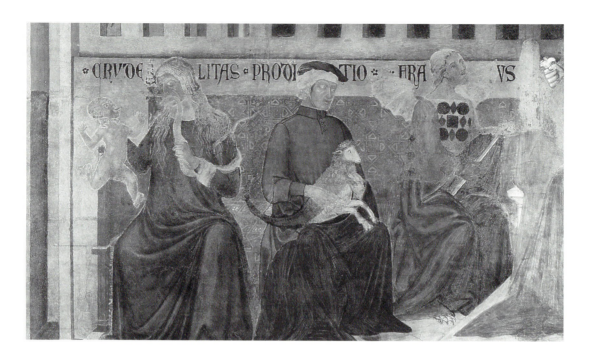

FIGURE 12. Cruelty, Treason, Fraud, detail on Tyranny's right.

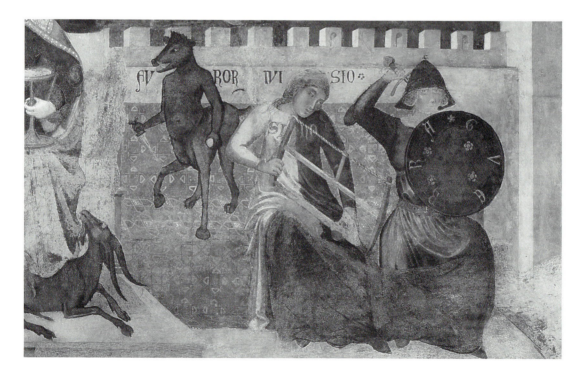

FIGURE 13. Furor, Division, War, detail on Tyranny's left.

68

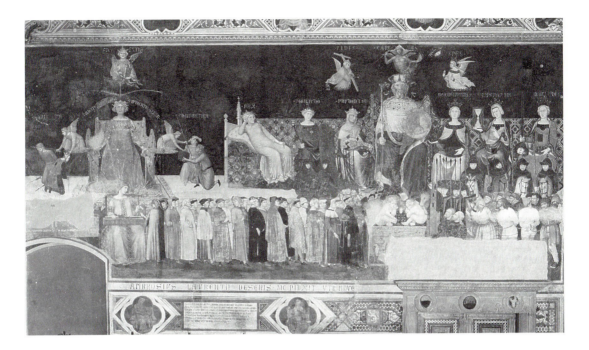

FIGURE 14. Ambrogio Lorenzetti, Allegory of Good Government. Siena, Palazzo Pubblico, Sala dei Nove, north wall.

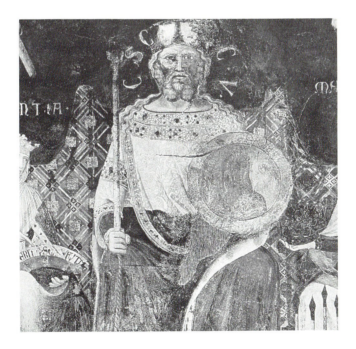

FIGURE 15. Personification of the commune, or Common Good, detail of Allegory of Good Government.

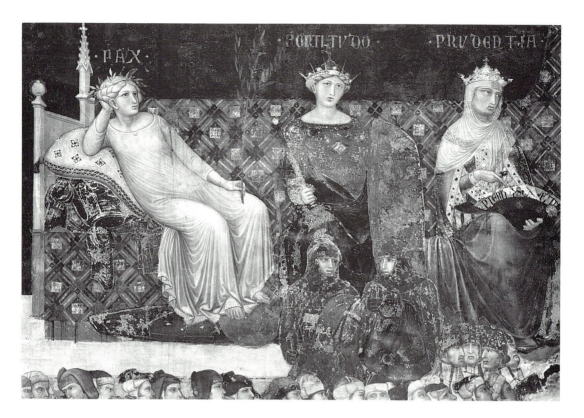

FIGURE 16. Peace, Fortitude, Prudence, detail on the right of Common Good.

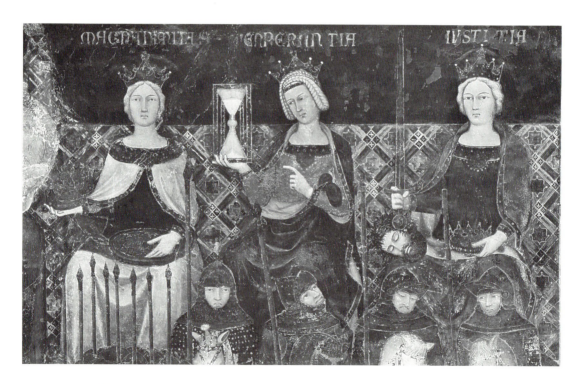

FIGURE 17. Magnanimity, Temperance, Justice, detail on the left of Common Good.

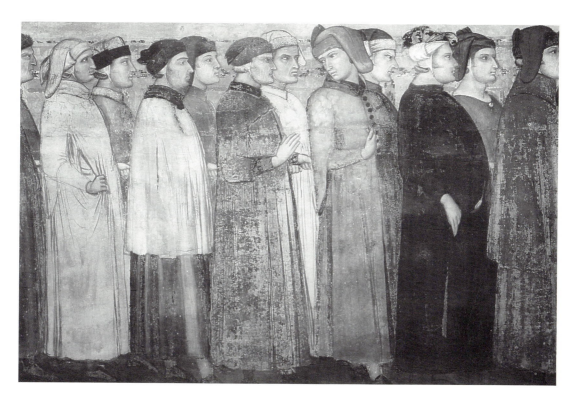

FIGURE 18. Councillors, detail of Allegory of Good Government.

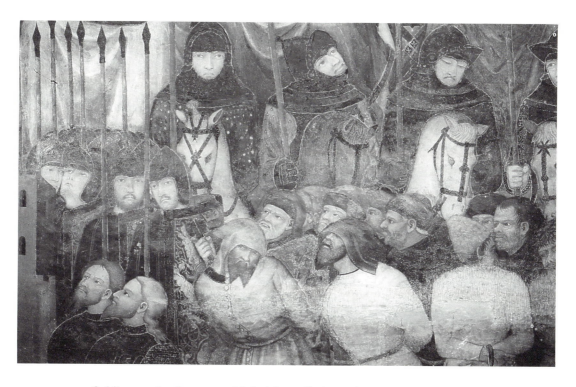

FIGURE 19. Soldiers and prisoners, with knights offering tribute to the commune, detail of Allegory of Good Government.

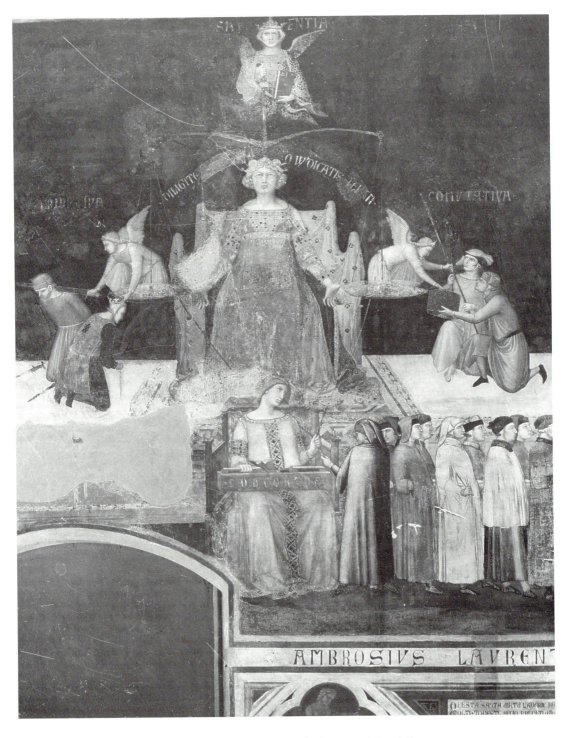

FIGURE 20. Wisdom, Justice, and Concord, detail of Allegory of Good Government.

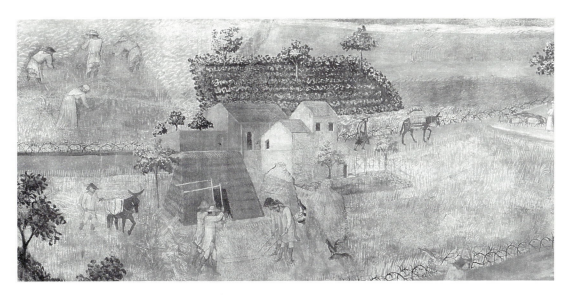

FIGURE 29. Harvest scene, detail of Good Country.

FIGURE 30. The Good Harvest in the *Libro del Biadaiolo.* Florence, Biblioteca Medicea Laurenziana, MS Tempi 3, fol. 6v.

FIGURE 27. Frederick II, from *De arte venandi cum avibus*. Biblioteca Apostolica Vaticana, MS Pal. Lat. 1071, fol. 103r.

FIGURE 28. Nicola and Giovanni Pisano, Falconer as the symbol of December, ca. 1278. Perugia, Fontana Maggiore.

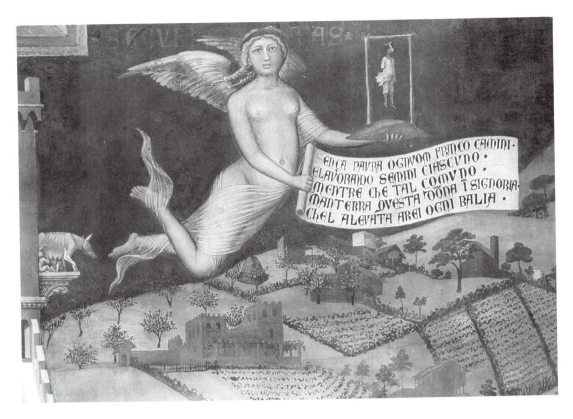

FIGURE 25. Security, detail of Good Country.

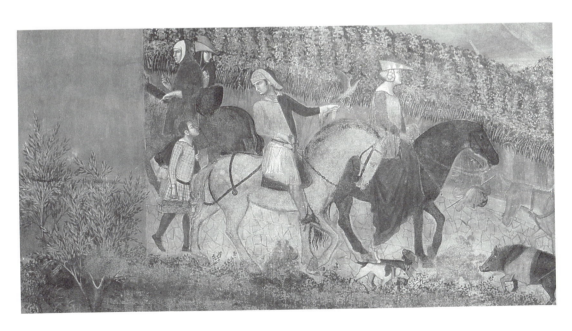

FIGURE 26. Hunters, detail of Good Country.

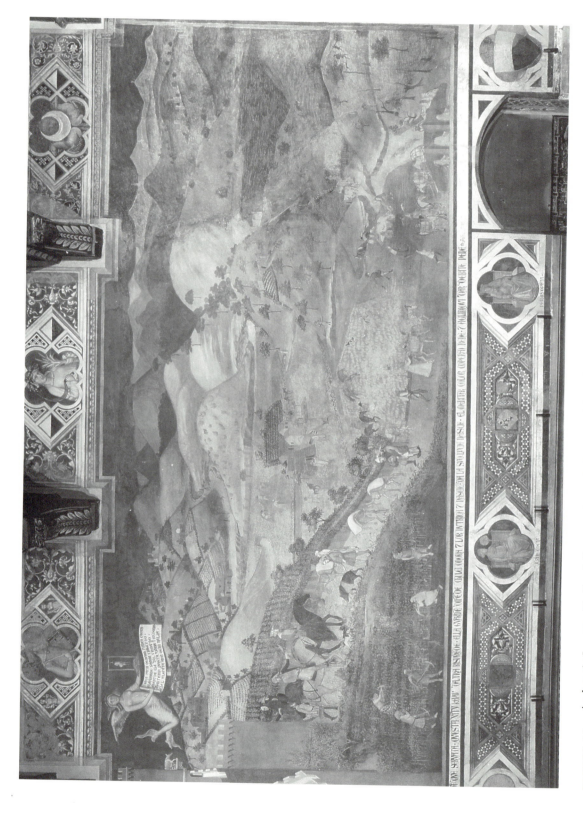

FIGURE 24. Ambrogio Lorenzetti, Good Country. Siena, Palazzo Pubblico, Sala dei Nove, east wall.

FIGURE 31. Shoemaker's or hosier's shop, detail of Good City.

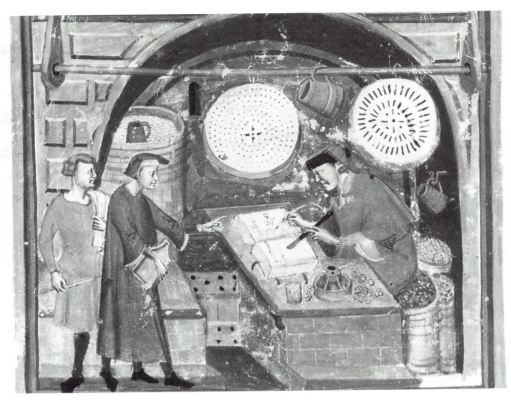

FIGURE 32. Grain merchant in the *Libro del Biadaiolo*, Florence, Biblioteca Medicea Laurenziana, MS Tempi 3, fol. 2r.

FIGURE 33. Shopkeeper, in the *Tacuinum Sanitatis in Medicina*. Vienna, Österreichische Nationalbibliothek, Codex Vindobonensis, series nova, 2644, fol. 92.

PART II

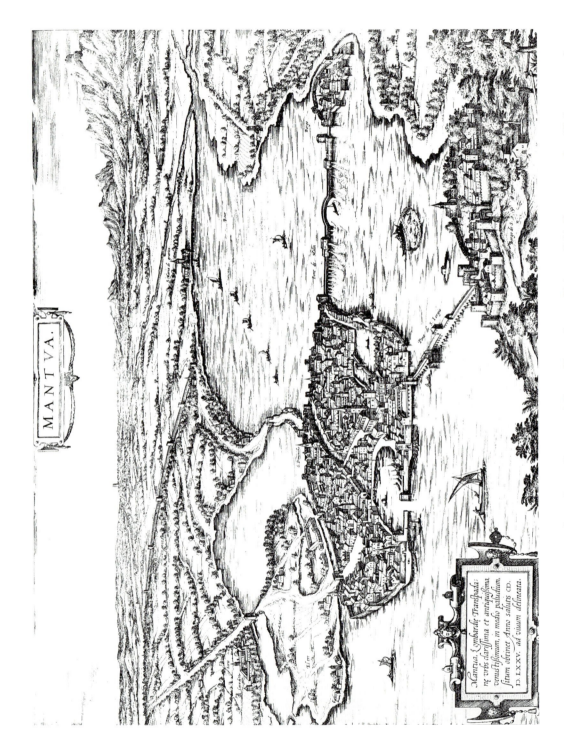

MANTVA.

Mantua, Lombardiæ Transpada-
næ vrbs clarissima et antiquissima,
venustissimum, in medio paludium,
situm obtinet Anno salutis cƆ.
Ɔ LXXV. ad viuam delineata.

PLATE II. *Mantua*, engraving from Georg Braun and Franz Hogenberg, *Civitates Orbis Terrarum*, vol. 2 (Cologne, 1575).

Room for a Prince:
The Camera Picta in Mantua,
1465–1474

In the spring of 1470 Galeazzo Maria Sforza sent two ambassadors to Mantua to renegotiate the contract under which Marchese Ludovico Gonzaga had served for twenty years as lieutenant general of Milan. The Milanese envoys arrived two hours after sunset on 9 April and over the next three weeks sent their master regular reports on the kind of diplomatic maneuvering that led Jacob Burckhardt to call Renaissance statecraft a work of art. Their letter telling how they presented their credentials to the marchese on their first afternoon in Mantua is a closely observed but effortlessly correct dispatch. It is a routine document in the archives of the dukes of Milan, but it plunges us abruptly into the art of Renaissance politics and its corollary, the politics of Renaissance art.[1]

The ambassadors recount that they were first received by Marchese Ludovico's eldest son, Federico, at the gate of the Castello San Giorgio, and then welcomed by the marchese himself "almost at the bottom of the stairs." Escorted up to a room called the Camera d'Oro, they met Marchesa Barbara of Brandenburg and a small group of five courtiers. Formal greetings were exchanged, little speeches made, and preliminary terms delicately broached. Then the marchese called for a recess until the same hour on the following day.

To let the ambassadors relate their own story at this point, their host said

that he never has either one of two thoughts without sweating in the cold or shivering in the heat—one for his soul when he receives the body of Christ [in the mass], the other for the world, when he has to pledge his person and his state. And one is like the other when he has promised something. He would rather lose his state and his own life than go back on a promise because this is his natural instinct; nor has he ever taken more pleasure from anything else than being an observer of his faith and promises, so that he would sooner have little estate with a

good name than have more if it could be said that he had ever been wanting in keeping faith. However, he said that he would give an answer he hoped would satisfy and be welcome to us and that we should be patient until the time his lordship set.

Afterwards he began talking about light matters and, after chatting for a while, showed us a room he is having painted where are portrayed *al naturale* his lordship, Madonna Barbara his consort, Lord Federico, and all his other sons and daughters. While talking about these figures, he had both his daughters come, namely the younger, Madonna Paola, and the elder, Madonna Barbara, who seemed to us a pretty and gentle lady, with a good air and good manners.

About the person of the signor marchese we are of the same opinion as we wrote on another occasion—that he is in prosperous good health, as he was several years ago, though it is true that he seems to have a foot • which is not very strong. Of the response the signor marchese will make tomorrow we will fly to advise you . . .[2]

The painted room (color plates 5–6) Ludovico Gonzaga showed his guests is Andrea Mantegna's masterpiece—arguably *the* masterpiece of Renaissance secular painting.[3] The name by which it is generally known today, the Camera degli Sposi or "Bridal Chamber," first appears in the seventeenth century; to contemporaries it was simply the Camera Picta or the Camera Dipinta, the "Painted Room." We know that Mantegna worked there intermittently from 1465 to 1474, but the documentation is slight and the pictures are congenitally silent, so that we do not know exactly what the Milanese ambassadors saw in 1470. They reported seeing likenesses of the marchese and his wife, Barbara, and of "all" their sons and daughters. This suggests that the portraits in the court scene on the north wall and some of those in the so-called Meeting on the west wall—the eldest son, Federico, appears only there—must have been recognizable, though Mantegna may have finished them later. Technical analyses in the recent restoration campaign (1984–1986) have confirmed that Mantegna painted the ceiling before the walls. That he had not finished his work in 1470 is certain in any event. The dedicatory plaque over the doorway on the west wall declares that he completed *opus hoc tenue* in 1474, and several portraits in the Meeting cannot be dated much earlier.[4]

Whatever the ambassadors actually saw, the striking fact is that they were called upon to look, that practical men on a political mission became connoisseurs in an easy conjunction of politics and painting. Although the conversation had already turned to "light matters," *cose da piacere*, politics obviously did not end where art began in the Camera Picta. From this second floor room of the castle's northwest tower (fig. 34) the ambassadors and their host may have looked north across a fortified moat, the lake formed by the river Mincio, and the sweep of the lower Lombard plain (text plate II); the east window sur-

veyed a stretch of walls encompassing a population of about forty thousand in the 1470s. These were strategic and symbolic vistas. Like the trademark strongholds built adjacent to older city cores by other Italian princes, the Gonzaga castle was a fortress for and against the city, a seigneurial residence, a dynastic seat, an administrative complex, and a theater of power.[5] Occupying a privileged location in this center of privilege, the Camera itself was small in scale and nearly cubical (8.05 × 8.07 × 6.93 m at the center of the vault). (See figs. 35–36.) We know that Marchese Ludovico used it as an audience room and a bedchamber. Some evidence suggests that he may have kept his personal archives there, together with the seals of subject towns and castles and the keys to the holiest site in Mantua, the chapel of the Most Precious Blood in the church of Sant'Andrea.[6]

The court of Mantua was already renowned for its painted rooms.[7] According to a 1407 inventory, the Gonzaga palace contained many *camere* named after motifs that had been standard palace decor in northern Europe since at least the thirteenth century—heraldic beasts (the lion, the leopard); animals associated with the hunt (the falcon, the stag); legendary heroes (Hercules, Lancelot); and historical figures (Roman emperors). In this inventory and others like it, a *camera* usually contained a bed and a *sala* did not; one was relatively small, the other large and centrally located for full-dress events such as public receptions, weddings, and feasts.[8] Such formal and functional arrangements were classified and categorized by writers on architecture later in the fifteenth century: the less accessible was the more distinguished room; the character of the decorations depended on the uses of the space; the rank of the occupant dictated the decorum of the surroundings; and so forth. Francesco Filarete distinguished no fewer than five types of decoration, including a "fourth category" with illustrations of the nature and activities of the inhabitants of a given building or a specific room.[9]

Marchese Ludovico was challenging the competition by showing off his new Camera. Galeazzo Maria Sforza commissioned new decorations for the Sforza castles at Milan and Pavia between 1469 and 1472; the badly damaged frescoes of Borso d'Este and his court in the Sala dei Mesi of the Palazzo Schifanoia at Ferrara are usually dated about the same time, and descriptions of the rooms painted in two Estense villas a decade or so later survive, though the pictures do not.[10] The specifications for the *saletta* just off the great hall of the Castello Sforzesco called for portraits of Galeazzo Maria and his family in the company of courtiers, servants, clients, and allies, many of them identified by name, including none other than Ludovico Gonzaga. The figures were to be represented *da naturale,* "as if [the duke's attendants] were intent on hearing him," or, as a description of a portrait of Borso d'Este and his courtiers at Villa Belriguardo puts it, "breathing and lively as life."[11] Certain prescribed gestures would have been practically interchangeable with those we can still see in Mantua—a pair of hands resting on the shoulders of a favorite,

the hand of a son held by his father, and so on. The similarities may extend down to the dwarf (*la nanneta*) who was supposed to be shown next to the duchess in Milan.[12] Mantegna probably worked from detailed instructions as did his colleagues in Milan. But no written "program" has ever been found—perhaps because Marchese Ludovico, a model Renaissance prince in this respect too, was determined to keep a close rein on all the arts of politics.

FROM REPUBLICS TO PRINCELY REGIMES

The republicans of Siena feared and demonized the *governo d'un solo,* the regime of a prince installed in the Camera Picta. Before returning to the room, we need a longer view of the transformation that Mantegna's frescoes work before our eyes. The main lines of what was actually a long and uneven historical process are clear enough.

In institutional terms the emergence of regimes of princes in northern Italy from the late thirteenth and fourteenth centuries on involves a strategic shift whereby any one of several key executive and military officials in the republican communes—especially the Podestà and the Captain of the People—obtained more or less permanent tenure. The term of a communal office might be extended, then sanctioned by an imperial or papal vicariate, and finally legitimated by a noble title. Economic historians have pointed out that the enduring princely regimes were founded by powerful families in areas where the commercial and manufacturing base was small relative to the surrounding rural economy—so, for example, in Lombardy, Romagna, and the Marches along the Adriatic, but not in Venice or in Florence, where the Medici became real princes only in the sixteenth century. In this view, "the rise of the *signori*" marked the revenge of the land over the town, of territorial over urban interests. What the picture of gradual institutional changes or structural forces tends to miss is the role of social upheaval, political turmoil, and sheer violence. The blunt simplicity of the term *signore,* meaning "lord" or "master," suggests a world of desperate remedies. With the economic crises, social conflicts, incessant wars, and catastrophic epidemics of the later fourteenth century, there was no end of emergencies, and so of would-be *signori* to claim that peace and order were theirs to bestow.[13]

The case of Mantua was fairly typical, complete with a masquerade of distinguished origins.[14] The obligatory myth of origins attributed the founding of the city to Manto, daughter of the prophet Tiresias who escaped from Troy with its treasure and gave birth to a future Etruscan king on the banks of the Mincio. Virgil was born in Mantua, and a medieval bust of the poet was alternately revered as a civic totem and reviled as a pagan idol. Mantuan legends told how the converted centurion Longinus had hidden the sponge that touched Christ's wound on a site sacred to St. Andrew and how the relic re-

appeared to perform convenient miracles for visiting emperors and popes. Between the lines of the myth the union of the fugitive Trojan maiden with a river god can be read to mean that Mantua lay in a backward region of river swamps inhabited in medieval times by herders, fishermen, and poor farmers; the Etruscan connection hints that the town, settled by the Gauls and refounded as a colony of Roman veterans, could not claim a more impressive Roman pedigree. While Virgil says that he was born in Mantua, he admits that the land was impoverished. The miracle of the Most Precious Blood tacitly acknowledges that Mantua was an imperial fief where the early councils of citizens organized in the twelfth century under the administration of the bishop.

Like the legends of the city, flattering court genealogies claiming descent for the Gonzaga from German nobility belied a humble history.[15] The clan of the Corradi took the name Gonzaga from a pocket territory enclosed by two branches of a small tributary of the river Po. Playing the checkerboard politics of the Lombard plain, the family first surfaced in the documents as vassals of the abbey of San Benedetto sul Po, feudatories of the emperor, and clients of the noble factions whose alliances and feuds spilled from their fortified country places into the towns of the lower Po valley. Drawn into Mantua together with other powerful rural families by the end of the twelfth century, the Gonzaga were at one time or another overmighty citizens, officials, and rebels of the republican commune. In 1328 a tortuous realignment of forces ended with an uprising against the regime of the Bonaccolsi family; Luigi Gonzaga became Captain of the People and in the following year was named imperial vicar with the support of the Scaligieri rulers of Verona. Over the next hundred years seven Gonzaga in succession became captains of the commune. The scenario was a familiar one all across Lombardy: the powerful rural family extending its base from the countryside to town; the communal offices and factional ties; the coup against a rival clan that was consolidated by confiscating its property, a mandate from the commune and the emperor, and a system of regional alliances.[16]

The next phase saw the transformation of a loose-knit family condominium into a court centered on the main dynastic line.[17] Although the old practice of dividing family property persisted—Marchese Ludovico took over the last of his brothers' territories only in 1456—Emperor Sigismund, primed by a donation of twelve thousand florins, made Mantua and its territory a marquisate in 1433 and bestowed the title on Gianfrancesco Gonzaga and his descendants. The marriage of the new marchese's eldest son to Barbara of Brandenburg, the emperor's niece and the daughter of an imperial elector, was part of the bargain, and the strategy of the German connection was avidly pursued in the next generation. By 1384 some five hundred people were attached to the Gonzaga court. Nearly two hundred belonged to the household, from the familiars and chamberlains and ladies-in-waiting of the *signore* and his wife to

the bailiffs, stablemaster, gamekeeper, cooks, nurses, and domestic servants; the rest were spread among appointees to administrative posts and soldiers. This large establishment absorbed rents and fees from family property, together with imposts and fines channeled to the court. The chronic deficit from what was not after all a large or particularly wealthy territory the Gonzaga made up from their income as hired soldiers.[18]

Burckhardt saw the cultural finish of the Renaissance court as a cover for the "illegitimacy" of the *signori* in the eyes of the traditional authorities and their own subjects. In Mantua legitimating symbols of princely rule were woven together with the facts of sheer domination into the very fabric of the town. The enclosure in the 1380s of the complex of buildings known collectively as the Court and the construction during the following decade of the adjacent Castello San Giorgio reinforced the defenses and enhanced the image of the regime. In the countryside new Gonzaga palaces and hunting preserves staged the feudal prerogatives and chivalric pursuits of the dynasty while also serving as territorial command posts. Gonzaga patronage provided the expansive court with the showy trappings of magnificence, and the famous school established by the humanist schoolmaster Vittorino da Feltre at the Casa Giocosa in the 1420s met a practical need for a court academy while broadcasting the reputation of the Gonzaga as enlightened patrons.[19]

Marchese Ludovico Gonzaga was the heir to family traditions that he acted out in a self-consciously new Renaissance style. The Milanese ambassadors of 1470 certainly understood the actor and perhaps even the man. Their first letter from Mantua describes the combination of self-staging and crusty directness, the sweat and shivers where his promises were concerned, that other contemporary accounts and the marchese's own correspondence confirm. "His natural instinct," the ambassadors later reminded their master, is "to speak his mind freely" but also—perhaps the lessons of the Casa Giocosa show through here—"with great humanity."[20] We might add, as the ambassadors might have had the point not been obvious to them, that "natural" instincts were bound to be political ones in a Renaissance court centered on the person of the prince.

In the negotiations of 1470 the marchese's word was probably as good a guarantee as any that he would do his duty as lieutenant general of Milan. Even so, war was not really the issue. Renaissance soldiers were often accused of saving their aggression for disputes over wages. On one occasion the marchese politely refused to send a team of knights to a tournament in Milan because jousting was out of style at Mantua. A letter to a trusted Mantuan agent shows that the real reason was his fear of hostility arising between the two courts.[21] A small territory between greater neighbors, Mantua owed its independence to a precarious equilibrium between Milan and Venice; after 1450, when the marchese sided with Francesco Sforza in the conflict over the

Milanese succession, the Mantuan alliance with Milan was the key to the status quo in the lower Po valley, not to mention a crucial source of income for the Gonzaga court. The agreements that had already been renewed three times by 1470, and would be negotiated again before the marchese's death in 1478, were mutual security treaties in the form of military contracts. Under the terms of the Peace of Lodi in 1454, the charter of the first balance of power in European history, Mantua was a mere "adherent" of Milan.

These political constraints would have made peacemakers out of fiercer warriors than Ludovico Gonzaga.[22] Much has been made of his turn from the more conservative, "chivalric" tastes of his father's court.[23] In fact, it was Gianfrancesco Gonzaga who made Vittorino da Feltre court schoolmaster and whose "International Gothic" court painter Pisanello was a humanist favorite; in 1438 Leon Battista Alberti dedicated the Latin version of his canonical treatise on the new Renaissance style, *On Painting*, to the father, not to the son. Ludovico himself had a knightly as well as a humanist education. He was a devotee of hunting, falconry, horses, and hounds. Apart from a few references in his letters and a stilted Latin love poem attributed to him, there is little direct evidence that he knew the classics, though he certainly kept chivalric romances in his library and dictated his correspondence in a homely vernacular.[24] If the story of Marchese Ludovico's "conversion" testifies to a change in taste, it also plays on a rhetoric that cast the patron as the hero of a rite of passage.

Vittorino da Feltre, giving Ludovico the nickname "Hercules" at school, conferred heroic tasks on his pupil and the responsibility for fashioning the hero on himself.[25] In his Latin history of the "illustrious city of Mantua and most serene family of the Gonzaga" (ca. 1460–1464) Bartolomeo Platina represented his patron as the ruler of a new golden age. Turning to "the works of peace" after his early military campaigns, the marchese had "set about adorning the city with buildings public and private and the countryside with agriculture for pleasure and delight."[26] "I too was once pleased by modern [i.e., Gothic] buildings," Marchese Ludovico is made to say in Filarete's *Treatise on Architecture* (ca. 1460–1464), "but as soon as I began to appreciate the ancient ones, I grew to despise the modern." The conversion scenario, and Filarete's self-serving Florentine agenda, are full-blown in passages such as this: "Hearing that they were building in the antique style in Florence, I determined to have one of the men who had been mentioned. Dealing with them, I was so awakened that now I would not build the smallest thing except in the antique style, as you will remember when you were in our rooms."[27]

These claims cannot be dismissed, for all the hyperbole. The court had its Florentine architect-engineer in Luca Fancelli. The transformation of Mantua into a Renaissance showplace began in earnest only in the late 1450s. This was the one success of the church council summoned to Mantua by Pius II in 1459–1460. While the pope's plans to unite Europe for a crusade against the

Turks—Constantinople had fallen at last in 1453—failed miserably, the occasion prompted a flurry of building activity and court commissions. In grandiose Renaissance rhetoric the modest town where the council complained about poor accommodations and muddy streets was slated to become a New Rome and a New Jerusalem. Filarete's dialogue, Platina's history, and Giovanni Pietro Arrivabene's dynastic epic the *Gonzagidos* (ca. 1460–1470) followed closely upon the council. Alberti attended in the papal entourage, and his designs for the major buildings in the new style at Mantua—San Sebastiano (begun in 1460) and Sant'Andrea (begun in 1472)—probably grew out of his contacts with the Gonzaga court at the time. To provide an impressive setting and to make room for the papal retinue Luca Fancelli converted the Castello San Giorgio into the principal residence of the court. Here in about 1465 Mantegna, patiently wooed into Marchese Ludovico's service six years earlier, began work on the decoration of the Camera Picta.[28]

We can speak of the "style" of Renaissance princes and their courts.[29] But since this suggests that art was only an addition or a supplement to politics, we also need to apply the political lexicon to art. Mantegna's work was embedded in a political and aesthetic regime as distinctive as anything we have seen in the Sala dei Nove of Siena. The Milanese ambassadors have given us our entrée. In the company of these expert witnesses we shall look at the walls before turning to the painted ceiling of the Camera Picta. Here again the pictures cannot be reduced to functional "illustrations." As we shall see, their demanding pictorial brilliance, far from merely reflecting, actually constitutes a political culture.

WALLS AS MIRRORS AND WINDOWS
FOR THE PRINCE

The dedicatory plaque (fig. 47) held by a flutter of putti in the Camera Picta addresses Ludovico Gonzaga as the "most illustrious" of princes, *ac fide invictissimo.* "Fidelity" or "faithfulness"—this is the virtue that the marchese claimed for himself in 1470 and, in the sense of a "faithful likeness," that the Milanese ambassadors must have looked for in Mantegna's portraits with the models standing before them. It was also the most problematic of virtues in the Renaissance court. The marchese offered the ambassadors external signs as proof of good faith, but his sweat in the cold and shivers in the heat when he went to mass or gave his word were signs out of season. This little lesson in the semiotics of court culture raises questions that confront us on the walls of the Camera Picta. The stakes were infinitely higher for the ambassadors— their careers depended on reading the marchese's intentions correctly. But the court scenes on the walls still challenge our own understanding of the testimony of appearances.

Reality and appearance, depth and surface, seeming and being—these alternatives go back to Renaissance ways of looking at pictures. In a celebrated passage in his treatise *On Painting* Alberti describes pictures as transparent "windows" opening into spaces coextensive with but other than our own. In other passages, however, he treats the pictures as flat surfaces. Narcissus was the inventor of painting in this sense, for "what is painting but the act of embracing by means of art the surface of the pool?" Alberti says elsewhere that "things that are taken from nature should be emended with the advice of the mirror," so that any unsightly "defect" can be eliminated.[30] Like Alberti's ambivalent artifact, the perfect prince of Renaissance political theory was supposed to model his conduct on the fixed moral principles underlying the changeable surface of events, but the main genre of advice books called "mirrors of princes" hints by its very name that it might be enough for the prince to seem virtuous in order to be regarded as such. Machiavelli's great heresy was not only to expose the differences between actual princes and perfect rulers but, more subversively, to insist that reflections were only appearances.[31]

The scholarship on the Camera Picta tends to divide along these lines. From one perspective the pictures on the walls are seen as more or less open windows into the Gonzaga court; from the other they are a flattering mirror, an artificial construction, a "faithful likeness" only in the sense that the faithful courtier caters to the master's illusions. These disagreements are hardly surprising. The oppositions built into the interpretive tradition practically assure that evidence will be sought in the pictures for one view or the other, and the persistence of scholarly debate becomes in itself the proof that there must be something to argue about.

But pictures do not make the neat categorical distinctions of the critics. The interpenetration of allegedly opposed qualities is the most striking thing about Mantegna's scenes of the court. Their verisimilitude and their utopian artificiality are equally pictorial effects. Any opening we are given into the "world" of the court is a production on a closed surface, any sense of actual people or events an illusion. All these effects appear in the same pictorial space, in the same room, in an ensemble where, as the Milanese ambassadors' report reminds us, politics and art, the practice and the image of princely authority, were virtually indistinguishable. As we shall see, representations of the body, of the seemingly random detail, and even of the artist's identity—or, in the terms of the grand tradition of Renaissance art criticism, the "naturalism," "realism," and "individualism" of Mantegna's work—are implicated in this regime of imagination and power.

BODIES POLITIC

The Milanese ambassadors began their first dispatch from Mantua by noting where the eldest Gonzaga son received them at the castle gate and ended it by

observing that the marchese appeared to be healthy, despite his lame foot. When their host turned to the political business at hand, he described physical sensations, his "natural instinct," and his personal code of keeping faith—and of being seen at doing so. The ambassadors for their part cast an assessing gaze on one of the Gonzaga daughters while they were being shown the family portraits *al naturale* in the Camera Picta. For these practiced observers the intimate reception would have been a measure of the prospects for fruitful negotiations, the appearance of the marchese an index of his reliability, the "good air" of the younger Barbara Gonzaga a sign that she had not inherited the family hunchback and so was fair game in the dynastic marriage market. Whether looking for political advantage or looking at pictures, the ambassadors were connoisseurs of embodied meaning. Both politics and art came into focus in the human form.

The formal side of this equation is obvious from our first sight of the Camera Picta. Representations of the body on the walls (figs. 37, 43) organize our attention by enforcing the division of the scenes into upper and lower registers and providing an index to scale. Through gaps, turns, and intersections of line and color these painted bodies map itineraries for the eye to follow. Variations in the type and position of the figures suggest a cast of characters with distinct roles, and differences in pose and gesture supply the illusion of movement and motivation for the little narratives that the pictures can be made to tell.

Alberti's treatise *On Painting* gives the formal importance of the body a theoretical rationale—the same that it may have offered to Mantegna, who probably knew Alberti's work and, since they were both employed by the same patron, must have known the man himself.[32] The second book of the treatise declares that "all the skill and merit of the painter" lie in "the composition of bodies." Composition consists in turn of planes, members, and the *istoria*, or overall arrangement of figures: the joining of planes in bodies produces "that grace . . . which we call beauty"; the correct rendering of the parts of the body requires careful observation and measurement from nature; the *istoria* binds the parts into a whole so "as to hold the eye of the learned or unlearned spectator . . . with a certain sense of pleasure and emotion." Elaborating on these propositions, Alberti writes that portraits should have surfaces "so joined together that pleasing lights pass gradually into agreeable shadows and there are no very sharp angles." Under the well-proportioned members of bodies that are only drawn or painted we should be able to imagine real bones and muscles; the *istoria* should encompass all ages of man and both sexes in settings that include animals, buildings, landscapes, with "great variety." In the visual equivalent of the rhetoric of the copious style some figures should be standing and others sitting, kneeling, or reclining; heads should be differently turned and bodies variously clothed or nude, in keeping with the subject. While taking care "that the same gesture or attitude does not

appear in any of the figures," the painter must also observe the principles of decorum. The "composition of bodies" depends, in short, on geometrical skills, anatomical studies, and rhetorical categories.[33]

The fit between Alberti's text and Mantegna's pictures is plausibly close, at least as close as many claims for connections of this sort. Even so, the theory only hints at political considerations that the painter could hardly avoid in practice. Alberti likens the model prince in one passage to the ideal *istoria*: just as a few words of command should suffice for princes, "so the presence of only the strictly necessary numbers of bodies confers dignity on a picture." The implications of this analogy are left unexplored, however, and in another passage the fact that the ancient painters "corrected" the portraits of kings "as far as possible while still maintaining the likeness" is adduced as an example of good taste and not as a matter of political prudence.[34] It is as if the body, to be a work of art, had to be disengaged from politics, as if even at the courts of kings, art and politics belonged to separate realms. In Panofsky's famous essay on "the theory of human proportion as a reflection of the history of style" the principle of separation remains intact: for Panofsky the Renaissance combination of "practical studies of proportions" and "the ideal of the human body as a microcosm of a rational, harmonious universe" operates at the level of ideas unsullied by material interests.[35]

Of course no amount of critical alchemy can turn Mantegna's pictures into flesh and blood. The absence of actual bodies is, after all, a condition of their representation as images, and the closest we are likely to come to a real corporeal presence in the Camera Picta are the physical traces of the artist's instruments. Yet it is the very elusiveness of the corporeal as such that enables us to recover the political side of the Renaissance equation of politics and art in the human form. Since Marcel Mauss's pioneering essay on "the techniques of the body," anthropologists and sociologists have shown how conceptions of the body are socially formed (Mary Douglas) or dramatically performed in the encounters of everyday life (Erving Goffman). Patterns of control exercised on the body by different political systems have been closely analyzed (Norbert Elias, Michel Foucault), and we have a magisterial history of the invention of the fictive body of the state to figure the continuity of the political order beyond the transitory body of any particular ruler (Ernst Kantorowicz). It may well be that some physical expressions—for example, of fear, pain, and pleasure—are transcultural. The bodies painted in the Camera Picta are bound to be at least twice removed from nature in any case; once because they are already representations, then again because bodies are sites where social and political ideologies and interests are defined and contested.[36]

It could hardly be otherwise in a room of state painted *sub specie corporis* for a Renaissance *signore*.[37] In the biopolitical schemas inherited from the Middle Ages authority descended through the *corpus christianorum*, the body politic temporarily resident in the ruler, the blood and lineage of the nobility, and

the urban corporations of communes, guilds, neighborhood societies, and family associations. Disembodied authority would have been inconceivable for the Renaissance soldier, paterfamilias, ruler, and personification of the state who, in April 1470, showed his Milanese guests the work of another expert in representations of the body politic.

Let us look more closely at the figures on the walls of the Camera Picta, beginning with the court scene on the north wall (fig. 37). When we stand back to survey the picture, it divides into distinct left and right compartments separated by the central pilaster in the feigned architecture of an open loggia. On the left a drawn curtain reveals the court densely clustered in an open space enclosed by a garden wall of interlocking ovals inlaid with what appears to be colored marble. On the right a line of courtiers extends down the stairs against the closed backdrop of a curtain lifted at the far right corner. This formal division already makes political and social distinctions: the charmed circle of the inner court is set apart from the procession of figures that have more active poses and less differentiated types. (See figs. 38, 41–42.) One thinks here of Mary Douglas's account of the body as a "natural symbol" responding "in direct accordance with the increase and relaxation of social pressures."[38]

The figures on the active side of the picture are links in a chain of poses connecting the inner precinct of the court with the outside, the "world" above the stairs with that beneath them, the servants with the served. Whereas the curtain is drawn behind the seemingly functional activity on the right, it is raised as if to prepare for the performance on the left. We imagine that some message is being delivered or received by the intermediary figure with the arm extended at the top of the stairs. But there is no way of knowing which, if any, chronological sequence or causal order was intended: if we read from left to right, the courtiers "respond"; reverse directions, as most observers seem to do, and they "initiate"—if indeed we are not to read the two sides of the picture as separate tableaux. What we can see clearly enough is the semiotics of courtly dependency and subordination played out in these figures. Legs are parted, tilted, or turned, arms are cocked, all in service and on elegant display. The show of sinuous leg and the tunics of brocaded cloth of gold with white trim exhibit the red, silver-white, and gold-yellow heraldic colors of the Gonzaga. From top to bottom the higher figures upstage those beneath them; the more elaborate costumes and privileged attributes—a dagger worn at the side, gloves carried in the hands—are reserved to the figures at the top of the stairs.

The figures on the left are compactly grouped in a space that has been variously described as a pavilion, tribune, portico, or garden terrace.[39] The only active personages here are Marchese Ludovico in his chair and the messenger to whom he turns (fig. 39). Even though we may imagine that Barbara Gonzaga and one of her sons are responding to an exchange between the

marchese and the messenger, the court is posed with little more apparent function or motivation than the pose itself (figs. 38–40). Yet these passive appearances are obviously hard at work to signal status and authority. The emblematic pose is, so to speak, the prerogative of the inner circle. Here the texture of gold brocade still shimmers, the white trim sparkles, and lines twist and flow with dazzling virtuosity in contrast to the dim line of generic courtiers on the right. Technical analysis has shown that the figures on the court wall were painted in oil or tempera, presumably to give them a more vivid presence than would have been possible in fresco, but the particular effects were consistent with the display of special privilege.[40]

This privileged inner circle (fig. 38) embodies the otherwise distinct forms of community and authority that—so we are led to believe—come together harmoniously at court. On the one hand, the picture is a scene from a family album. The paterfamilias turns to business, the mother is seated amidst her children, the children appear more or less in order of age. The youngest daughter, Paola, is on her mother's right; Ludovichino, the youngest son, is above her. It is probably the third son, Gianfrancesco, who is shown above him, with a hand resting on his brother's shoulder, and it may be Rodolfo, the fourth son, who stands behind his mother, with his unmarried sister Barbara just behind on his left. For all the regalia and rigidity, there are also seemingly intimate details such as Paola's apple (she is a playful little girl in the family correspondence), the otherworldly look of Ludovichino (ordained at the age of nine, he was confirmed as papal protonotary and bishop-elect of Mantua in 1468), the russet-colored dog under the marchese's chair (he had a favorite dog called Rubino), and the court dwarf whose central position and large gaze must have been a standing family joke.[41] On the other hand, this is obviously a state portrait heavily coded with official allusions. The picture seats the marchese at the front in a chair that is surely a faldstool-throne; it also shows the marchesa, as befits her rank, seated and dressed in the most elaborate costume. Thus the family group is a pictorial genealogy and demonstration of fertility framed at each side by the activity of courtiers who transmit official business to and from the outside world. Even the most casual details may well be charged with ulterior meanings. Is Paola's apple the fruit of the Hesperides, or of the judgment of Paris, or of human generation since the Fall? Is the dog Rubino a symbol of fidelity, the marchese's favorite virtue?[42]

We cannot tell which, if any, of these meanings may have been intended, but we can see plainly enough that the inner court is formally and functionally balanced. A diagonal line crossing through the marchese's right hand divides the women from the men. By positioning older members of the court just behind a line of upcoming youth the picture suggests the arrival of one generation and the passing of another. Although the identity of the background figures in black is uncertain—the attributions range from court secretaries to Vittorino da Feltre and Leon Battista Alberti—they are clearly meant

to be sage-looking elders. The head of the older woman on the right may be a portrait of a venerable nurse or a widow in the family, but she also belongs to this rear guard of a departing generation.[43] The youngest children at the center are still within the figurative fold between the reigning middle generation of their parents, and the figurative line from the eldest brother with his hands on the shoulder of the youngest son down to the youngest daughter follows actual ramifications of the family tree.

The picture leaves no doubt who presides over the spectacular intersection of pictorial and political values. The composition is visually tilted to the left; the curtain drawn aside for the spectacle also draws attention to the marchese and improvises a cloth of honor or *baldachino* that was already a convention of state portraiture (fig. 37). Overinterpretation is positively invited here. The painted prince and his consort have no need for real support, but being seated is a mark of distinction, all the more so for the marchese whose chair recalls the throne of Roman imperial reliefs and portraits of contemporary rulers. Even if the pilaster behind the chair or the dog beneath it are not meant to be conventional symbols of fortitude and fidelity, they do give pictorial density to the marchese's side of the picture. Now faded, his gown must once have been a regal red, which together with the white ermine trim and gold undergarment rounded out the display of Gonzaga heraldic colors. There is, finally, nothing discreetly symbolic at all about the forced superposition of the marchese in front of the other figures. The hard-bitten messenger has sacrificed a left arm to his master's preeminence.[44]

The Albertian principle of "variety" applies here, to the point of distraction. Riding up at the sleeve and leg, the marchese's regal robe exposes a bare ankle and slippered foot; his throne is a bed for a dozing dog (fig. 38). Since informality, rather than flouting authority, is its prerogative in highly formal societies, the most authoritative figure is also the most human. Far from compromising the display of princely power, the play on contingent details and the "Renaissance individualism" of the marchese's portrait are integral to it.[45]

Unlike the mixed company of the court scene, the figures in the Meeting on the west wall (fig. 43) are all male so far as we can tell, including the horse, dogs, and putti. The painted piers and curtains frame three groups against a sweeping panorama. But here again the pictures are carefully proportioned between the line of figures and the background; as before, courtiers occupy one side of the wall, while the other side to the right of the winged putti holding the dedicatory plaque over the doorway is the precinct of the marchese and his immediate entourage. The figures of this group (fig. 44) wear costumes of their public roles—the marchese dressed as prince and condottiere, the cardinal with his cap and stole, other personages in heraldic colors. Even without knowing whether the scene represents an actual meeting between the marchese and his son Cardinal Francesco Gonzaga, we can already say,

and see, that the body of the prince and the extended body of the patrilineage are on display as dynastic icons.

The composition is visually weighted again toward the marchese. His profile is fully exposed in front of his companions; his head, a painted analogue of the medallions he commissioned, is higher than any of the other heads in the picture. Raised in a gesture of greeting, his right hand commands attention from the viewer, while communicating to his sons and grandsons something between a paternal blessing, a princely injunction, and a dynastic strategy. This commission, anticipating history rather than passively recording it, is transmitted in turn through the arrangement of the family. The cardinal clasps the hand of his youngest brother, the Apostolic Protonotary and bishop-elect Ludovichino, whose fingers are held by their nephew Sigismondo (1469–1525)—he would become the second Gonzaga cardinal. Representing the secular inheritance, the younger Francesco Gonzaga (1466–1519) stands at his grandfather's left hand. Taken together, the youngest members of the family form the dynastic circle of the future between the patriarch and his son and heir, Federico (1441–1484), who appears on the far right, mirroring his father's profile.[46]

As in the court scene on the north wall, the family is accompanied and set off by its entourage. We know from the marchese's correspondence that Mantegna included portraits of the Emperor Frederick III, the marchese's nominal overlord, and Christian I of Denmark, his brother-in-law and most distinguished relative. According to the same exchange of letters, the room was the talk of the court of Milan—"the most beautiful *camera* in the world," it was said—and Galeazzo Maria Sforza was annoyed that he was *not* portrayed there. This complaint prompted another artful diplomatic exercise. Fifteenth-century writers distinguished "grace" in painting from the sharp "relief" and "purity" of a more severe and, in portraiture, presumably less flattering style. Although the marchese—so he wrote—could not in good conscience omit his suzerain and his own brother-in-law, he had not included Galeazzo Maria's portrait out of respect for the duke's taste. Sforza had evidently gone so far as to burn a "pure" likeness Mantegna had drawn of him, and whether from conviction or only from the desire to humor his employer, Marchese Ludovico conceded that "Andrea is a good master in everything else, but in making portraits he could have more grace and he does not do so well."[47]

None of the secondary figures on the west wall have been conclusively identified. Although Mantegna could have drawn both the emperor and the king from life, less "grace" evidently did not mean more accuracy. The written descriptions and surviving likenesses do not correspond very convincingly to the portraits in the Meeting—or for that matter to one another.[48] On the other hand, if Mantegna had identified the great personages in the picture by their proper insignia, they would have looked less intimate in their relations with the Gonzaga and would have outranked them besides. The court

knew well enough who they were, and this knowledge gave it a certain supe-
riority over less privileged observers and indeed over the subjects of the por-
traits themselves.

Since the Gonzaga court was presumably adept at reading the body lan-
guage that we must painstakingly decipher, what was the point of represent-
ing what it already knew? No doubt the pictures served to communicate, con-
firm, and commemorate shared experiences that set the court apart from the
ordinary world. Together with the illusion of intention and movement com-
monly attributed to them, they actively constructed a court in their own im-
age. The painted court, in other words, could also be seen as a model for a
real one.

To begin with, the pictures directed the prince and his consort to appropri-
ate places in the room.[49] In order to see his portraits simultaneously Marchese
Ludovico would have sat to the side of the fireplace with his back to the east
wall. From that position the painted court would have been illuminated by the
window behind and the Meeting by the window in front of him; mirroring his
own image in the court scene, the marchese would thus have been able to
read the dedicatory plaque and, seated perhaps on just such a chair as he oc-
cupies in the picture, to receive anyone entering the room. The marchesa
would have had the best view of her portrait from a chair in front of the fire-
place corresponding to her place to her husband's left in the picture. In this
seating arrangement, the east and south walls with their simulated hangings
as well as the courtiers on the north and west walls appeared behind or to the
side of the two principal occupants of the room.

Besides literally putting real bodies in their places, the painted simulacra
superseded the originals. We know from contemporary descriptions, but can
hardly tell from the pictures, that the marchese was short in stature and a
hunchback. According to one source, he was "awkward and lethargic . . .
thick and heavy in all his movements" as a boy and prone to corpulence in
later life.[50] The plainspoken chronicler Andrea da Schivenoglia describes the
eldest Gonzaga son, Federico, as a hunchback, though "courteous and pleas-
ant," but belies his description of the future cardinal Francesco as "handsome
and courteous" by noting his "gross lips."[51] Schivenoglia is particularly mer-
ciless on the favorites and officials of the court, some of whom presumably
appear in stately guises in the Camera Picta. Messer Carlo degli Uberti, he
reports, was a rich man who greedily accepted presents; Messer Ludovico Ar-
rivabeni "was considered neither good nor wicked since he was incapable of
much"; Messer Raimondo de' Lupi, the vicar of the court, was "a large fat and
dark man" renowned for his severity and for taking only small bribes; Rolan-
dino della Volta, general steward, "wasn't . . . a real man" because he never
sired children. Giovanni Strigi, the court treasurer, was "a dark fat man who
was thought worthless as a youth but then became extremely rich"; Giacomo

da Crema was the son of a tailor and much loved by the marchese, who gave him, practically overnight, "like Moses," property, a wife, and a host of offices.[52] To the irreverent insider Mantegna's portrait of the Gonzaga court would have seemed a polite fiction or, if he dared to laugh, a joke.

The task of naturalism here was to keep nature at bay by reinventing it. Mantegna's pictorial mirror-of-princes showed his patrons how they would look playing their parts outside the limits of perception and the imperfections of mortality. His portraits gave them the self-image they could not otherwise have seen for themselves. And that image in turn was bound to be mediated by the ideological investments and evasions of the princely regime. Perhaps even in their own eyes Ludovico and Barbara Gonzaga existed most completely as marchese and marchesa of Mantua, as they still exist for us, on the walls of the Camera Picta.

"LITTLE THINGS MATTER IN THESE AFFAIRS OF PRINCES"

The letters the Milanese ambassadors wrote from Mantua in 1470 are studded here and there with arresting details. "Little things" clearly did matter "in these affairs of princes."[53] The ambassadors' reception "almost at the bottom of the stairs," the marchese's lame foot, the look of his daughter, the exact drift of his conversation—these were all clues to the temper and the intentions of the court. A closed gate at night seemed a bad omen until the ambassadors learned that the marchese had kept it shut for other visiting dignitaries too; they had caught a glimpse of newly arrived letters—if these were from Bartolomeo Bonatto, the marchese's agent in Naples, they would determine whether he would be willing to deal with Mantua alone.[54] The ambassadors advised duke Galeazzo Maria that their dispatches would have been as big as a bible if they had reported everything of significance.[55]

In a tightly structured environment the smallest details are subject to a kind of double scrutiny. They may be examined to test protocol but also to detect a chink in the formal facade; they may confirm intended impressions and at the same time betray confidences, indicate the rules of the game and show how to circumvent them. On their way to Mantua, the ambassadors were coached by no less an expert than Baldassare Castiglione, the grandfather of the author of the *Book of the Courtier*. Sent by the marchese to meet them from the border at Bozzolo, Castiglione said that once in Mantua the ambassadors would see for themselves many tokens of good intentions—and many signs of conflicting views, "as is usual at court."[56] In this charged situation the ambassadors kept their eyes open for the specifics that would either corroborate or go beyond the advance report. Because so much depended on divining the marchese's wishes, the slightest object could be a possible clue in the little universe revolving around the prince. Amidst the intricate maneuvers of Renaissance di-

plomacy, the ambassadors picked out little objects of attention as castaways pulled along by a strong current look for a handhold.

The status of contingent details is as fraught with ambivalence in the traditions of viewing Renaissance pictures as it was for the discerning eyes of the Milanese ambassadors. There could be no "rise of realism" in Renaissance art without more or less convincing evidence of close observation of the world or, to put it another way, without some loosening of schemas binding descriptive particularity to some rigidly prescriptive message. In the grand narrative of Renaissance achievements careful attention to observed particulars signals the turn (or return) of art to life. And yet the main critical tradition also celebrates coherence and closure, and in calling for "balance" tends to censure "excessive" concentration on details as distractingly material, mindlessly empirical, or scandalously "feminine." In fact, all these distinctions can be regarded as "effects" of the degree to which details serve the structuring formulas that confer meaning upon them. Roland Barthes treats oppositions between the "real" and the "ideal" accordingly as "mythical." Whether we consider such oppositions semiotic or substantive, or both, they do reappear like the variations on a mythical theme in Renaissance literature on the arts.[57]

The humanist literati redrew the lines of a familiar controversy. The Ciceronian position recovered by Petrarch stood for a neoclassical hierarchy of distinctions: form over matter, the rational over the sensuous response, the cultivated over the naive style—hence order over detail. On the other side, the Greek scholar Manuel Chrysolorus reintroduced the late antique practice of vivid literary description, or ekphrasis, that valued "detailed lifelikeness," variety, expressive immediacy—detail in opposition to order. The typical ekphrastic exercise was a description of a work of art and, as Michael Baxandall shows in a startling reversal of canonical expectations, the ekphrastic mode predominated in humanist writing on art until at least the midfifteenth century. On this account, Pisanello rather than, say, Masaccio was the preferred artist of the literati and northern Italy rather than Florence was the most important center of humanist art criticism.[58]

Alberti's new campaign for rigor in painting can be seen in this light as an old reaction against the subversion of order by detail. Even so, Alberti himself acknowledged the attractions of "copiousness" and "diversity." The painter could produce *copia* through the use of many different figures and settings; *varietas* called for variations in pose and color; both qualities together were "the first thing to give pleasure" in narrative pictures. This may have been a strategic concession to taste on Alberti's part; his appreciation for detail was certainly consistent with one strain of classical rhetorical theory and with one aspect of the Albertian program for the renewal of painting. However, the rest of the passage we are following here hedged in the opening to detail with the call for "moderation," "gravity," "dignity," and "truth." The passage ended by blaming "those painters who, in their desire to appear rich or to

leave no space empty, follow no system of composition but scatter everything about in random confusion."[59]

The court of Mantua was a main arena of debate over these issues.[60] Pisanello had painted the other great set of fifteenth-century frescoes commissioned by the Gonzaga court in a paradigmatic show of *copia* and *varietas*. Vittorino da Feltre had been a pupil of Guarino da Verona, the most authoritative Italian literary practitioner of the copious style, and had himself written an ekphrastic description of a lost painting of St. Jerome by Pisanello. On the other side of the debate, George of Trebizond, who tutored Greek at the Casa Giocosa (1430–1432), launched an early sally against the "dissolute" style of the ekphrastic mode in the mid-1430s. Alberti, it will be recalled, dedicated the Latin version of his treatise on painting to Gianfrancesco Gonzaga in 1438 and by the end of the 1450s was working (together with Mantegna) for his son and heir in Mantua. Large issues had come into focus on the little details of painting long before Mantegna set to work in the Camera Picta. In such a context, his commission must have been regarded as a supreme test of narrative painting.

For both the ambassadors and the connoisseurs, then, "little things" did matter immensely. The little world of the court might yield its secrets to the discerning eye; painted details were a source, albeit a compromised source, of pleasure and an index to the "detailed lifelikeness" that was ambivalently sanctioned by the authoritative pronouncements on painting. Here again political and aesthetic forms of attention converged—on particulars, as we have seen, but also on the question of what, if anything, lay beyond them. Political observation at court turned details into clues; informed aesthetic judgment, more or less mindful of their controversial attractions, took them as cues to elaborate narratives. Either way, the fascinations of detail soon led (as this account has already begun to lead) to the circumstantial world that they appear to represent.

In keeping with our theme, let us consider particular cases. Although we have drawn on detailed testimony elsewhere in the pictures, the letters held by the protagonists on both walls of the Camera Picta invite especially close inspection. In the court scene one letter is shown open (but closed to our reading) in the marchese's hand; another appears folded partly shut in the cardinal's hand in the Meeting (figs. 39, 44). The figure just to the left of the door apparently holds a letter too; yet another letter seems to be tucked into the fold of his companion's hat (fig. 43). Here, if anywhere, we should be able to see how the significant pictorial detail both rivets attention and, like the letters themselves, deflects it toward an absent world.

To be sure, there is no self-evident reason why the letters needed to be shown. The marchese and the cardinal could just as well be holding something else (a glove, a book, some insignia of office)—or nothing at all. But the

seeming arbitrariness of the interpolation is part of its charm. The unexplained detail initiates the search for explanation; the lack of a clear motivation leads to the investigation of motives. The very fact that the letters cannot be read arouses the suspicion that they contain some secret key to the pictures. Challenging the observer to account for them, they become pieces in a puzzle, clues in a mystery to be solved, signs of some external order of events.

We are already predisposed to imagine that they bear messages from another world. Letters "make the absent present," "transport us to faraway places," "bring knowledge of those from whom we would otherwise be separated and perhaps altogether lost," to cite some characteristic Renaissance claims for their power to communicate across distances in space and, for humanists anxious to recover the lost culture of the ancients, in time.[61] The multicentered, intensely developed political world of the Italian states depended on the flow of diplomatic dispatches, official *missive* and *responsive*, letters of appeal or pardon, bureaucratic memos, formal epistles for state occasions. The core archive of the state consisted of the extended correspondence of the prince in the fifteenth-century courts, where political, patrimonial, and domestic affairs closely intertwined. The letters in the Gonzaga archives are by far the best preserved of their kind for the period.[62] The pose Mantegna gave to the marchese, letter in hand, must have been a familiar one.

It is hardly suprising, then, that the painted letters in the Camera Picta have turned the attention of scholars to the archives. Whether or not they are meant to refer to actual letters and specific historical situations is beside the point. We would still want to read them. Some students of the pictures have argued that both letters concern Francesco Gonzaga's elevation as cardinal by Pius II in December 1461. Others have pointed to the cardinal's journey to Mantua on a state visit in August 1472; still others have suggested that the two letters refer to separate occasions. Rodolfo Signorini bases by far the most exacting and comprehensive account on his years of research in the Gonzaga archives. According to Signorini, the letters appearing in both scenes are one and the same, a summons from the duchess of Milan urging Marchese Ludovico to come to the defense of the city during a near-fatal illness of Francesco Sforza. The original, still preserved in the archives, was signed and dated in Milan on 30 December 1461; it is known to have arrived in Mantua on 1 January 1462, just as the new Gonzaga cardinal was making his triumphal progress home to Mantua by way of Milan.[63]

Signorini's reading of the painted letters is virtuoso detective work and a guide to the logic of what he calls the "historical reading" of the pictures. His reconstruction begins at the end of the story, "reasoning backwards" so as to "observe" clues to a sequence of events selectively where others merely "see" discrete particulars. This is of course elementary Holmes and basic history. When news of Francesco Gonzaga's elevation reached Mantua late on 27 December 1461, Marchese Ludovico, according to the chronicler Schivenoglia,

sent his eldest son, Federico, to accompany his brother home from Pavia, where he had been studying at the university. The two brothers returned by way of Milan so as to pay their respects to Francesco Sforza, the marchese's chief patron and ally and a crucial supporter of the cardinal's nomination. Although the duke was gravely ill, the two brothers performed their mission and continued on their way to Mantua. Meanwhile their father had been summoned to Milan himself. The marchese and his sons met on the border at Bozzolo and, as Schivenoglia tells the story,

> at the distance of a bow shot, the marchese . . . dismounted from his horse and went toward [Cardinal Francesco] on foot, and likewise the cardinal toward his father. And when they met, they bowed ceremoniously the one to the other and made great signs of celebration, and the marchese spoke these words; that is, "Since in the world I want to be your father, but with respect to God I want to be your son, I pray you to thank Almighty God that he has made you a beautiful gift, and take it for a beautiful gift and a great joy." And so, weeping for joy, they parted from each other, the cardinal for Mantua, the marchese for Milan.[64]

After quoting this passage, Signorini writes: "If at this point, one observes the fresco of the Meeting again [fig. 44], one will not be able not to acknowledge that this event [the encounter at Bozzolo] is indeed represented there."[65] Playing the detective in turn, we might suspect that the double negative protests too much. But having established to his satisfaction that he has the solution in hand, Signorini goes on to produce his exhibit from the Gonzaga archives on the events of 1 January 1462.[66]

The first two letters from the marchese and his wife to the Mantuan envoy in Rome recount the story of the summons to Milan. A third letter from the marchese to two Mantuan agents at the Sforza court explains that the Milanese courier arrived with the duchess's appeal while the marchese was preparing to go to New Year's mass in the cathedral. Finally, Signorini gives us with a flourish "the message that for five centuries Ludovico has not permitted us to read." After a reassuringly formal salutation in her missive dated 30 December 1461, at the third hour of night, Bianca Maria Sforza urges the marchese "to make ready whatever will be necessary for the conservation of this state." His sons will have heard better news, she writes, but since their departure the day before the duke's illness had taken a turn for the worse; the doctors were saying that only a miracle would save him. With a final appeal that the marchese set out for Milan without delay, the letter ends—only to reappear not once but twice, so Signorini insists, in the Camera Picta. On the north wall (figs. 38–39) the court waits in holiday finery for the marchese, still in his robe and slippers, to command a response to that same letter in his hand; on the west wall (fig. 44) the same letter has just been read and folded

up again by the cardinal, who now understands the reason for the im-
promptu meeting at Bozzolo.

And so the mystery is solved. The detective work goes from conclusion to
clues, then constructs an explanatory narrative that runs in reverse from clues
to conclusion. In a perfect historical reading of a picture this cross traffic
would presumably need to dissolve the picture plane altogether. What it does
instead is expose the fact of painting's two dimensions, the practically count-
less dimensions of any historical event, and the differences between words
and images. In other words, Signorini's interpretation introduces anomalies
that either come into focus as clues to a different tale or must be interpreted as
symbolic. The background panorama (figs. 43, 45–46), for example, may well
include idealized views of Rome, the temple at nearby Tivoli, buildings under
construction in the papal states, and the ghostly traces of the journey of the
Magi to Bethlehem that Signorini detects there, but it is not the landscape at
Bozzolo in the flat Lombard plain.[67] Some of the figures in the pictures do not
fit the story either. If the older man to the left at the rear of the court scene
(fig. 38) is Vittorino da Feltre, as is sometimes supposed, he had been dead for
fifteen years by 1462; Francesco and Sigismondo Gonzaga, the two small chil-
dren in the Meeting (fig. 44), were born four and seven years later, respec-
tively. Emperor Frederick III and King Christian of Denmark may have been
friends of the Gonzaga court, but they were certainly not at Bozzolo in Janu-
ary 1462.[68]

Of course the story can be stretched or turned to accommodate such awk-
ward facts.[69] The painter's landscape, however fanciful its "holy city" and its
"Rome," may commemorate Francesco Gonzaga's elevation as cardinal. Man-
tegna and his patron may have kept to an overarching historical program
while adding or subtracting figures for one reason or another over the long
period of nine years that elapsed from the beginning to the end of the project.
Yet such arguments are self-defeating in the end: in explaining apparent dis-
crepancies they also explain away the solid grounding in events introduced to
guarantee the historical accuracy of the pictures in the first place.

To conclude that the pictures are not historically accurate does not mean,
however, that they are "essentially uneventful and inconsequential."[70] The
strict choices in a long-standing debate over their realism are highly unre-
alistic, and anachronistic besides. We might rather say that like Renaissance
tales posing as true histories, or like Renaissance histories laced with un-
critical tales, the pictures mix facts and fiction to open up "the whole rich vein
of verisimilitudinous fantasy characteristic of so much Renaissance art."[71] Yet
the pictures will not let us settle so easily for this account: both facts and fic-
tions come to us as pictorial effects mediated by contemporary notions of
painting and the kind of attention to "little things" that the Milanese envoys
exercised at court. Pseudohistorical at best, the pictures strain nevertheless to

produce eventful and consequential historical effects, not least by the insertion of details that they seem contingently and passively to record.

Whether or not these details registered historical events, they certainly give the illusion of doing so. They were the elements of a kind of aesthetic and political transubstantiation whereby the formulas of art and ideology could be invested in plausibly particular forms. They extended the claims of the court and its art to mastery, in pictures at least, over the phenomenal world and over outsiders such as ourselves who are left to search for the significance of those "little things" that the inner circle of the court would have understood all along.

WHAT'S IN A NAME

While close observation was part of the Milanese ambassadors' assignment in 1470, so were the courtly rituals of deference and evasion. When Marchese Ludovico asked them on 11 April to report his reservations about a new contract to Milan, they deferred to his good judgment and chose delaying tactics instead. Otherwise, they said in a calculated remark to a member of the Gonzaga household, it would have been better for them to depart, since writing such a report would have offended the duke in Milan and not writing it would have meant disobeying the marchese in Mantua. This little bluff succeeded. The marchese thought better of his objections once he had vented "his natural instinct by saying what he has in mind." Galeazzo Maria Sforza was spared the offense; the ambassadors got the credit by attributing their accomplishment to their master, "who will be most prudent and understand better sleeping than we do awake and will take the prudent provision and deliberation in this matter." With one more profession of "devotion and faith" these perceptive, resourceful, and otherwise independent men signed their dispatch as the duke's humble servants—*Dominationis vestrae servitores*.[72]

Mantegna's signatures in the Camera Picta are no less deeply implicated in the courtly calculus of dependency and self-promotion.[73] The full inscription on the dedicatory plaque (fig. 47) held by the putti on the west walls reads: "For the illustrious Ludovico II, Marquis of Mantua, most excellent of princes and of indomitable faith, and for the illustrious Barbara, his consort, incomparable glory of women, their Andrea Mantegna of Padua completed this slight (*tenue*) work for their honor in the year 1474." The author of these lines had nothing to learn about playing the courtier. Across the gap this language opens between the high estate of the patrons and the "slight work" of the client, Mantegna is "theirs" as a devoted servant or a personal possession might be. Honor is his only acknowledged motive, and "this work" is at once an impersonal object and a personal tribute, either way beyond any suggestion of commission, contract, or compensation. On closer reading, however, the deferential language subtly bids for recognition in return. The adjective

tenue can just as well mean "acute," "fine," and "exacting" as "trifling" or "slight." The show of humility also insinuates a privileged intimacy. Moreover, a gift is never freely given without placing the recipient under some obligation, and in an exchange between unequal parties the superior party must give one better because he who gives last gives best by keeping the upper hand. A prince who could not or would not top a subject's gift risked dishonor for himself by conceding the greater generosity of the subject. Mantegna's dedicatory plaque challenges his patrons to the hilt: resplendent in gold and held aloft by cherubs, it hints that his gift could be matched by another only if it were as good as gold and as sublime as a heavenly apparition.[74]

The formal inscription ostensibly gives the work away, but, stealthily, more intimate signatures reclaim it. On the letter in the cardinal's hand in the Meeting (fig. 44) Rodolfo Signorini has discovered an inscription in a tiny cursive that would have been hard enough to detect when the pictures were new—*A[nd]rea[s] me pi[nxit]*.[75] This furtive label may refer to the inscription, the letter, the figure of the cardinal, or to the whole ensemble of Mantegna's work. It can be read as a personal joke, a special treat for the cognoscenti, or a secret message for posterity; either way, the concealed inscription proclaims the painter's identity more directly than the public declaration on the plaque. If Signorini is right, Mantegna also left a kind of hieroglyph of his identity just below and to one side of his official dedication.[76] A mask worked into the decoration on the feigned pilaster to the right of the west door bears a close resemblance to the bronze portrait-bust in the funerary chapel the artist commissioned for the church of his namesake Sant'Andrea (figs. 49–50). The mask is not simply a generic motif. Apart from the individualized features, it is the only head in the decorative pattern. If this is, as it seems to be, Mantegna's likeness, it can be viewed as a portrait-signature in which the painter, like a new Narcissus, reflects his absorption in his own work and at the same time materializes his alienation from it.[77]

Signatures are usually read as "signing off" or "signing for" a piece of work. In one sense they attest to intentions achieved; in the other they certify possession. A history of art conceived along these lines would be a series of proper names assigned to sequences of works and "hands"; it would be, in other words, the kind of art history that has been canonical since the Renaissance, from Vasari's *Lives* to the monographs arranged by artist on our library shelves. By putting a name to a piece of work the artist (or the forger, for that matter) seems to validate this paradigm, as if the signature not only signed a particular artifact but also endorsed the general proposition that art is an individual enterprise. Whatever the signatory's thoughts before or after signing, the signature itself seems to vouch for self-consciously intended effects.

Granting that signatories have intentions, they would not need to sign for them if intentions were self-evident. Signatures are formulaic, indicative of the absence of the signatory, unreliable guarantees of any particular aim.

They are also practically inseparable from their context. The names inscribed on a Renaissance artifact made for a patron or affixed to a nineteenth-century picture made to be sold have different functions and may reveal more about the conditions of the art market than about the intentions of individuals. Some philosophers have argued that a proper name always refers to the same individual and does not represent, as more conventional definitions would have it, an "abbreviation of conjunctions or a cluster of descriptions." But even this strict construction risks losing the determinacy of names to historical contingency insofar as it posits relating every use of every name to a series of hypothetical causal chains that reach back to some original formulation.[78]

That Mantegna's signatures in the Camera Picta take different forms is not to say that they give us no real testimony. It does mean, however, that we must not be too quick to read them as transparent signifiers of a self-evident identity. Our reading has already pointed to the strains in Mantegna's position and very identity as a court artist. If his signatures lead in this sense outside or beyond the pictures, it is not, at least not very directly, to the anchoring intention of the artist or to an individualistic conception of art.[79] As much as signing off or for the work, we might say that the signatures sign Mantegna into a system of institutional arrangements defining the terms of his position as an artist, courtier, and indeed individual in a Renaissance court.

When Mantegna entered the service of the court of Mantua, Marchese Ludovico granted him the Gonzaga coat of arms together with the marchese's own device, a radiant sun, with or without the motto *par un désir* (fig. 48). The document conferring this privilege on 30 January 1459 begins with Mantegna's credentials: in the first place, "outstanding virtue and mores," then his profession as a painter, and finally his new position as "our most dear familiar (*carissimum familiarem nostrum*) . . . whom we have recently brought into (*conduximus*) our service." Mantegna himself had asked for the favor and the marchese had bestowed it both as a token of affection and as an incentive to further virtue and praise. Henceforth the painter was to have the "free authority" to use his patron's arms "at will, privately and in public."[80]

This document foreshadowed the complexity of Mantegna's position at court. Its opening phrase inserted the painter's name into the blanks of a humanist formula—the man of virtue; the next lines referred to him as a craftsman and a servant of the Gonzaga household. In one capacity he was worthy of "ornaments"; in the other we know that he was hired with the promise of moving expenses, fifteen ducats per month, a house, a yearly provision of grain, and a regular supply of firewood.[81] In yet another role he was adopted into the marchese's *famiglia*. Mantegna belonged to three worlds at once: a realm of transcendent values whose unit of reckoning was virtue; the workaday sphere of production and exchange; the privileged court circle of favors given and received. He did not belong to them equally, however. The patron

received the virtuous client; the client was rebaptized into the family of the patron, ennobled by this rite of passage but also obliged by it to serve his adoptive lineage. The concession of Gonzaga arms eliminated any open suggestion of market relations or contract. A concluding reference to future "virtue and praise . . . and still greater pleasure toward us" was as close as the document would come to hinting at more than virtue rewarded and paternal affection bestowed. This is already enough to underline the irony of the client's having "free" and "private" use of the patron's insignia.

Mantegna did not cease to be the artisan with his paper nobility or the marchese's gift of damask brocade for a courtier's doublet in Gonzaga red and silver.[82] His real family came from the village of Isola di Cartura near Padua. He was the younger son of a carpenter and, as the rags-to-riches topos goes, tended goats as a boy.[83] Around the age of twelve, he was apprenticed to the Paduan painter Francesco Squarcione, who adopted him and whose name he took for himself in a humbler version of acquiring a new identity. This fairly common practice had practical advantages such as exemption from guild fees and the cachet of a family trademark. Squarcione must have trained his new apprentice in the shared work, mixed media, and unassuming practice of the guild system. In any case, he was clearly more enterprising, far more successful, and certainly more pretentious than other contemporary masters in advertising his shop, with its plaster casts and drawing collection, as a *studium*, not a craftsman's *bottega*. Probably too he was less scrupulous in collecting commissions and making special arrangements with his apprentices. There were quarrels and lawsuits, including a case won by Mantegna. The one surviving work from Squarcione's own hand is notoriously at odds with his reputation, but twenty years after breaking with his master in 1447, Mantegna could still call himself Andrea Squarcione.[84]

Especially where family and property were concerned, Mantegna remained something of the old-style artisan. He married within the trade in 1452—his wife was Nicolosia, the daughter of Jacopo Bellini, the patriarch of the Venetian dynasty of painters. At least two of his apprentices took his name, just as he had taken his own master's, and two of his sons were raised to be painters like their father and maternal grandfather. Shrewd in his business dealings, including sales of fodder and cloth, and preoccupied with family interests, Mantegna was repeatedly embroiled in disputes with his allegedly ungrateful relations and his neighbors—just what one might expect of an upwardly mobile and aggressively self-important craftsman.[85] Even after he had been nearly forty years at court, the painter drew up a will in 1504 witnessed with one exception (a humanist doctor) by artisans—two painters, a goldsmith, a weaver, and a hatter. Apart from the property given or promised to Mantegna by the Gonzaga, the provisions of the will could pass for those of a prosperous artisan—two hundred ducats for his daughter's dowry and another fifty for his granddaughter's, a trust of 300 *lire piccole* for his natural son

Giovanni Andrea, and a careful division of the estate between his two surviving legitimate sons. The endowment for the monumental funerary chapel in Sant'Andrea reads as the overreaching gesture of a parvenu.[86]

We should not be surprised at this old-fashioned artisanal core of identity. Recent scholarship reminds us that in true Renaissance fashion the rhetoric of "the rising artist" was largely borrowed from classical authors. We know that most painters and sculptors came from the artisan and shopkeeper class. Few of them could have considered their practice a field for theory or a liberal art rather than a mechanical one, and so far as we can tell, no artist could meet the new humanist standards of learning. Claims to the contrary usually tell us more about strategies of professional legitimation than the artist's actual situation. Mantegna's work on the walls of the Camera Picta can just as well be taken to confirm the persistent features of an older framework of artistic production as to announce a new one. Marchese Ludovico must have given him elaborate instructions on the subject matter; perhaps he specified, as patrons had traditionally done, the showy display of color and expensive materials. In keeping with the convention that the work was the patron's rather than the artist's the Milanese ambassadors did not bother to mention the artist's name, if indeed they knew it.[87]

Mantegna's move to Mantua, then, was not a complete break with the past. What we can say is that it placed him in a different system of work and rewards. His first known commission had come from a baker; by the time that he entered the service of the Gonzaga he was working for the elite in Padua and the Veneto. These individual projects, even the more prestigious ones, were still piecework in the craft tradition and close to the market, to "keeping shop," as Michelangelo later exclaimed with defensive contempt.[88] As court artist, Mantegna had a regular stipend in money and maintenance. The servant was incorporated into the household economy of the masters, complete with the division of revenues into cash and kind. Like the masters too, he entered into the courtly gift economy of titles, privileges, large donations and little favors such as the quail that Mantegna requested from the marchese and gave in turn to Cardinal Francesco. Signing himself "most devoted servant" after nineteen years of service, Mantegna reminded Marchese Ludovico of promises that a regular stipend would be his "least reward." The benefactions eventually included loans and the real estate—a suburban villa, the site for a signorial house in town, rural leases and freeholds—that made the artist a man of property.[89] To crown profit with honor, in the polite formula glossing humble origins and hard work, he petitioned the Emperor Frederick III for the nominal title of court palatine and received what amounted to the right to pay for the privilege. Reputation evidently mattered more than possession. Biographers from Vasari on have given Mantegna the promotion that he seems never to have formally obtained. Eventually, in 1484, he was knighted by Marchese Ludovico's son.[90]

These were the rewards of a system that took a heavy toll in the rituals and anxieties of dependency. The regular position of court painter meant irregular assignments—a sudden change in plans or priorities, a summons to wait on the itinerant marchese or his family, advice on manuscript painting or building projects, a command to draw peacocks for a tapestry or to produce a quick portrait. To leave Mantua or to accept commissions outside the court required permission, though when it came to obliging high-ranking personages who appealed to the marchese, Mantegna probably had little choice and only token rewards above and beyond his due as court painter. Already in 1463 he complained that his salary was four months overdue, and this was only the first of a long litany of laments. A promise of partial payment on some 110 acres of country property at Boscoldo was never made good. Most of nearly thirty surviving letters exchanged by Mantegna and the marchese alternate between the patron's demands and excuses and the client's appeals—and excuses.[91]

The strains endemic to this relationship are all the more striking because the marchese was exceptionally forbearing. It took him nearly three years to lure the undecided and hard-bargaining painter with a combination of great promises, negotiable terms, special favors, and movable deadlines, which the painter always missed. Once in Mantua—even at the very last moment the would-be client leased a house in Padua[92]—Mantegna must have come close to the limits of his patron's willingness or need to accommodate him, even in a system that practically institutionalized the tensions between social dependents and their superiors. His letters to the marchese angled between duty and disaffection, awe and presumption, calculation and innocence. Disclaiming any wish to importune, Mantegna made importunate requests. He recommended himself "humbly" as the "faithful," "most devoted" servant or even "disciple" of his "illustrious," "potent," "most clement" lord; while evading a commitment he professed obedience, and while auguring his patron's prosperity he tended to his own. In his shabby quarrels with his neighbors over a property line, some stolen apples and quinces, and a rankling exchange of insults he challenged the marchese to do *his* duty and intervene on his behalf.[93]

In a last exchange of letters shortly before the marchese's death in 1478 Mantegna bluntly questioned his patron's promises and broadly hinted that Ludovico's reputation all over Italy would suffer if they went unmet. The marchese's reply marks one of those startlingly clear conjunctions of a revelation of character and the disguised truth of a social institution: "Andrea, we have received your letter which in truth does not seem necessary for you to have written, for we have much in mind what we once promised to you when you came here in our service, nor does it seem to us that we have wholly failed in our promises; and we have done as much as we have been able."[94] Harassed by creditors, with his jewels in pawn, the marchese went on to

promise "whatever it will be possible to do." Even though the princely "we" and the patronizing apologies gave the marchese the rhetorical upper hand, the good patron had become the servant of the system, the client of his own client.

Mantegna clearly strained for independence in a dependent role. The lintels above the four doorways in the courtyard of his house in Mantua display the motto *Ab Olympo;* the same inscription appears again in paint beneath the eagle of Jove in his burial chapel in Sant'Andrea. Since the emblem was originally a Gonzaga device, it served to emblazon the artist's attachment to the family in death as in life while putting a mutually flattering classical turn on the source of so much prosperity. But the apparent tribute also reads as a claim to Olympian descent for the artist and his art. A humanist in the next generation wrote that Mantegna's house had been "founded" in the manner of "a little amphitheater" by "that true imitator of antiquity, that second Apelles, the honor of our times." [95] In his own time his literary friends saluted him as a living classic in whom the greatest artists of antiquity, or at least the ancient tropes of praise for them, had been born again.

A Latin elegy written around 1458 by the humanist poet and cleric Janus Pannonius rehearsed most of the repertoire. How could the poet's muse, he asks, sing praise enough for Mantegna's likeness of him and of his friend Galeotto Marzio? The answer of course was with any number of classicizing clichés: painting outlives the mortal flesh of men; it makes the absent present; it is the perfect image of nature, needing only a voice to come to life; it actually surpasses in its studied proportions, light, and color the fleeting likenesses in nature of a glittering pond or polished glass. As the sum of borrowed personae, the painter was greater than any one of them—a new Apelles; Mercury and Minerva's child; Nature's rival as artificer, as glorious among painters as his fellow Paduan Livy was among historians. "When you have filled all lands with the adornment of your works and have spread your name all over the world," the poet intones, "you shall be summoned hence and pass upwards to the towers of heaven. . . . When you have ornamented heaven, heaven shall become your reward, and you shall be the god of painters, under great Jove." [96]

Still earthbound in September 1464, Mantegna took the "consul's" part in an expedition to Lake Garda organized by his humanist friend Felice Feliciano. In this archeological romance, the party crosses a green and perfumed landscape fit for the muses, their leader wreathed with myrtle, pervinca, and ivy. They come upon a "temple" of St. Dominic. There they discover inscriptions from the time of the Roman emperors and record them in their notebooks. For their journey on the lake, they drape their boat with garlands, then set out across the "liquid mirror of Neptune" to the sound of the lute and

sweet singing. At Garda they give thanks to the Christian god for "offering to our longing eyes the spectacle of so many varied and memorable monuments and pleasing vestiges of antiquity." [97]

Mantegna's Olympian motto, the poet's hyperbole, and the humanist's archaeological romance are details of the sort that fill well-worn channels in Renaissance studies. Taken for granted as standard variations on "the revival of antiquity," the bizarre and fantastic seem only familiar and routine, and Renaissance culture only predictable and pedantic in spite of the sheer bombast of the scenario. Mantegna and his friends were identifying with the ancients, personifying them, insisting over and against their own modest social standing that they outranked the non-cognoscenti. The invented descent from the gods fictively reversed the story of Mantegna's own social ascent; the title of "consul" and the seal with the bust of Julius Caesar that the artist used as a personal device for at least twenty years between 1472 and 1492 were talismans against the sense of subjection that his soaring ability must have exposed and magnified. [98] Lying in all senses of the word beyond time, these gestures toward the ancients reached for a creative autonomy that the artisan and the courtier might well have longed for.

The figurative triumphs were nonetheless a kind of flight, even a self-cancellation. They defined a self in relation to forces outside and far removed from self-possession. The more extravagant the masquerade, the more it betrayed that Mantegna was not a god or a caesar; the greater the claim to independence, the more the missing terms of dependency announced their shadowy presence. *Ab Olympo* was, after all, a Gonzaga device, and Olympus was a court. Like Prometheus departing "ab Olympo" and made to suffer for it, the client could escape the court only by leaving it; to elevate oneself by a divine genealogy was also to deify the court. The image of caesar signifying power was emblematic of political subjection, not of art.

It is hard to believe that Mantegna or his literary friends were under any illusions, even in the deepest groves of the muses. Janus Pannonius's rhapsodic elegy calculated the value of Mantegna's portrait—"a heap of Arabian incense is not of so great price." [99] Felice Feliciano's enthusiasm for the classics was probably genuine enough, but the Garda expedition was clearly a would-be client's ploy. Feliciano had addressed a sonnet to Mantegna a year or two earlier, begging for a place in Cardinal Gonzaga's household; a few months before the expedition he dedicated a compilation of antique inscriptions to his "incomparable friend." The sonnet saluted the artist as a new Polygnotus and Apelles, then appealed to him as the author's "lord" who could rescue the poet from the stinging nettle of poverty. Like Mantegna in client's guise, Feliciano tempered praise with the insinuation that praise was his to bestow. The "incomparable friend" was "the prince of painters, and their only light and comet and man of great genius"; but then, painters were only painters: "You should become as learned as may be, and be a man of consummate knowl-

edge in all worthy subjects . . . if you will only study to unite to the goods of body and fortune those of the mind and by these prepare for yourself beyond doubt an illustrious name that will be immortal."[100]

Learning and patronage came together in these exchanges under the seal of an "illustrious" and "immortal" name. The master-pupil relationship was absorbed into an economy of favors supposedly unconstrained by mundane calculations amidst an incessant calculus of interests. Mantegna could serve as Feliciano's broker because he was the client of powerful patrons, who were themselves clients of the Sforza and the pope.

What the epithets of the literati immortalized was not the man but a type. Late in his life, and against considerable evidence, Mantegna was celebrated as a paragon of the cultivated painter—*tutto gentile*, "excellent in every kind of virtue," a man of "courtesy and civility." Vasari picked up these refrains: "His honorable way of life is still held in very present recollection, as is the praiseworthy civility that he had and the lovingness with which he taught art to other painters."[101] It is as if the epithets play the man; as if too a social process has infiltrated them, for these are terms of address for a patron or a favorite in the chain of exchanges organizing the culture of courtly society.

Even countervailing testimony could be absorbed into the conventions of an alternative ideal type. Marchese Ludovico hinted at this when he observed of artists in general, while evidently meaning Mantegna in particular, that "they have something of the fantastic about them (*hanno del fantasticho*)."[102] The truculent behavior, the irascibility, the erratic pace and the perfectionism of Mantegna's work—these were traits of the Saturnine character, of the ancient image of the artist born under the sign of the dark planet, which a modern metamorphosis recast in the figure of the romantic genius.[103]

No wonder, then, that there is no one signature in the Camera Picta. What single identity could it possibly record? The formal dedication inscribed the courtier-client in the fundamental transactions of courtly society, in the ritualized economy of gift-giving. *Andrea me pinxit* can be read as an artisan's mark designating the maker and his craft, the artist and the artifact. Mantegna's features merge into the design of the portrait-mask, and we would be as hard pressed to distinguish the likeness from the mask as we would be to separate the true Mantegna from his classicized persona. Rather than signing for himself, Mantegna signed into the roles that complicated and dispersed the very notion of a self.

This is not to deny him his role as a Renaissance "individual" or a "rising artist." His multiple identities were just as plausibly vectors of self-consciousness and self-promotion as the enclosures of a Cartesian self or the artist's garret. In the recognition of options and alternatives lay the possibility that the self could be fashioned—and refashioned. Besides, the court rewarded the self-conscious artifice and winked at the more or less disguised gesture of am-

bition. As we have seen, the courtier's dedicatory inscription advanced a cunning bid for recognition. The pseudograffito *Andrea me pinxit* asserted possession as a jest that would have allowed Mantegna's patrons to smile at their own displacement. The classicizing mask both concealed his identity and let it be seen.

INTERMEZZO: THE FLIGHT OF THE PEACOCK

With the physical act of looking up to the painted vault (fig. 51) we pass figuratively from one world to another in the Camera Picta, from courtly scenes to a realm that in all respects rises above the space beneath. Formal differences between high and low, vertical and horizontal, the geometrical regularity of the painted ceiling and the variations in setting of the walls articulate a wider play of seeming oppositions. Whereas the court appears between drawn curtains in carefully staged moments of revelation, the vault lies open to inspection and, at the central opening, draws the eye vertiginously upward. The scenes of the court look specific, identifiable, contemporary; the ceiling is schematic, enigmatic, and antique. The area below is a zone of public, purposeful, and mostly male activity, but the vault is set apart as a higher region, by turns classical, feminine, angelic, antic, and exotic.

Yet the room is, after all, one and the same. The painting positively insists on connecting the spaces above and below. (See fig. 36.) Painted pilasters rise up as if to support the vaulting; the grillwork in the drum of the oculus at the center of the vault repeats the pattern of the socle area around the walls beneath, the same pattern of interlocking circles that reappears on the north wall behind the inner circle of the court. Twelve lunettes, three for each wall, form a transitional zone—the illusionistic sky of the background is extended there behind a symbolic register with Gonzaga devices that have been interpreted as emblems of fortitude, justice, and fidelity.[104] From the balustrade around the central opening above, three girls seem to look down into the room in a bid for contact with viewers below that is practically unique in the pictures. What are we to make of the contrasts and connections, of what seem to be at once antitypes and interrelated worlds?

Take the peacock perched on the rim of the central opening, for instance (figs. 52, 54). Are we to imagine it arriving on the ceiling through some flight of fantasy, as a symbol or as a little demonstration of nature at its most artful? Does the peacock stand for the beauty of the room or the self-conscious splendor of the court? Is it an emblem, a textual reference, a mascot, or something else again? Such questions, the iconographers' concern today, would once have been a good courtiers' game, an occasion for knowing play rather than sober iconographical exercises. For the courtiers there would have been no need for easy answers, or perhaps for unequivocal answers at all; it was the

game itself that mattered, unless of course the prince declared a solution and put an end to the hermeneutical pleasures of indeterminacy.[105] Iconography would rather play the prince; the object of the game is to win it with a pre-emptive meaning that will close debate. If we are to come to terms with the significance of the vault, the peacock—wherever it may lead—is a quarry worth pursuing.

One trail leads along a well-traveled path in Renaissance studies to classical literary texts. According to one such interpretation, the Camera's peacock, the symbol of Juno and (as on Roman coins) of concord, conjointly figures harmony in marriage and in the social order. Pliny's *Panegyric to Trajan* is the master text for this reading, which would in any case be plausible enough in the bedroom of a prince. Yet Trajan is not one of the eight caesars shown in the ring of medallions painted on the vault, a glaring omission if the panegyric to him is a source, and though Pliny mentions Trajan's honorable marriage as a model of domestic concord, there is nothing in the text about Juno and peacocks.[106]

Far more convincing is the closely argued hypothesis of Rodolfo Signorini that Lucian's rhetorical showpiece, *The Hall,* is the literary source for the ceiling, and much else besides.[107] Lucian sets his text in a painted room where a speaker stages a mock debate. Is a hall full of beautiful pictures a suitable place to give speeches? Will the paintings—there are ekphrastic descriptions of nine of them in the text—inspire or distract the orator and his audience? What are the relative powers of speech and sight? A peacock makes two appearances on both sides of the argument. In the first instance the speaker relishes how "he twists and turns and puts on airs with his beauty," invoking the spectacle to show how beautiful sights, such as a blossoming spring, inspire a display of beauty in return; in the same way, "the beauty of this hall has power to rouse a man to speech, to spur him on in speaking and to make him succeed in every way" (*The Hall* 11–12). The spokesman for the other side of the argument makes the witty rejoinder that the peacock's cry will win no arguments for the compatibility of looks and voice; yet one would still be drawn to look at it and forget that nightingales were singing, "so invincible, it seems, is the delight of the eyes" (ibid., 19). Despite the trick ending—the images and the debate were a production in words all along, Lucian reminds us—even the rhetorician admits the difficulty of representing "so many pictures without color, form, or space" (ibid., 21).

A text on the power of visual beauty in the perfect room, one that was almost certainly available in the Gonzaga library: iconographers have made do with much less than Lucian's peacock in assigning humanist programs to Renaissance pictures.[108] And there are other apparent correlations between Lucian's hall and the Camera Picta. The text cites the harmonious proportions of the hall, oriented to the morning light, and evokes a gilded ceiling and vivid frescoes on the walls. We know from documents that the ceiling of the Cam-

era was raised by more than a meter, apparently to approximate cubical dimensions, and that an east window was cut before Mantegna set to work.[109] "Reserved modeling," "flawless decoration," "refined symmetry," "gilding . . . [which] is not purposeless and not mingled with the rest of the decorations for its own charm alone"—Mantegna might have been painting Lucian's ceiling, or the walls that Lucian praises for "the beauty of their colors, and the vividness, exactitude, and truth of each detail which unlike the beauties of spring will not fade" (*The Hall* 7, 9).

We can refer even the more enigmatic images to the text—the peacock of course, but also the mysterious women around the rim of the oculus (fig. 54). Speaking of the gilded vaulting of the hall, Lucian's orator opposes its harmonious beauty to garish extravagance; one is the beauty of the modest woman who sets off her looks with simple adornment, such as "a band (or ribbon) that confines the luxuriance of her hair," the other is the false allure of the courtesan who layers on "extraneous charms." The text continues, contrasting "oriental" excess with the cultured refinement of the perfect room that "has nothing to do with barbarian eyes" and, as the translation puts it in an eerie conjunction of ancient and modern prejudices, "Persian flattery or Sultanic vainglory." Such a place "wants a cultured man for a spectator, who, instead of judging with his eyes, applies thought to what he sees" (*The Hall* 6). It would be easy, and ingratiating, for the reader of Lucian to take the part of that cultured spectator in Mantegna's painted room, to look up and rehearse the text for those three "simple beauties," played off with a comb and ribbons against the lavishly coiffed grande dame and her dark, "barbarian" or "oriental," companion in wanton luxury (ibid., 7).

All this seems so plausible, so close, and yet so problematic and so far from closing interpretive accounts. Returning again to the peacock, we find that it escapes the snare of the text because there are so many texts and traditions to which it can be linked. The royal bird associated with the pagan queen of the gods was also the watchbird bearing the eyes of Argos; the emblem of visual beauty, as in Lucian, was also the sign of vanity in Prudentius and other writers. In early Christian art it symbolized Christ, presumably because the "eyes" on its tail never close and its flesh, according to bestiary lore, never decays. With the appropriation of Juno's attributes by the Christian queen of heaven, the peacock or its feathers figured in the iconography of the Annunciation and the Nativity.[110] In a context closer to the culture of the court, it was used in secular decorative schemes, both in tapestries and murals, often in connection with heraldry.[111] Whereas all these variations were not necessarily known, or needed, at the court of Mantua, we can be reasonably certain that the one iconographical reading that has not been proposed was perfectly familiar, for in one of its many guises the peacock was the symbol of St. Barbara, and so of her namesakes the marchesa Barbara Gonzaga and one of her

daughters. Not only that, Barbara was the saint of Heliopolis, "city of the sun" in Egypt, and a protectress of soldiers; her other chief attribute was a tower.[112] The eastern light, the dark (Egyptian?) lady in the oculus, the room in the tower of a soldier's castle—did Mantegna represent St. Barbara's peacock rather than Lucian's?

Of course he may have represented both, and others besides. For if it is true that iconographical texts and traditions ordinarily tell us too much, visual symbols usually tell us too little to foreclose the unfolding of alternative meanings. We cannot recognize Lucian's resplendent creature in Mantegna's rather plain bird. Perhaps it is a peahen rather than a peacock, but even if its display were showier, the painted version could hardly convey anything like the nuances of the text. Lucian's peacock is a stimulus to voice and a stop to speech, against the superiority of seeing over hearing and vice versa; in the end, as a creature of the text, it clinches the argument for the power of words that it seems at first to belie. Moreover, the other alleged correspondences between text and image, as we shall see later, do not hold up under close scrutiny. Yet if this is the peacock of St. Barbara, we have no certain way of saying so. The fit of hagiographical and pictorial details is suggestive but not decisive, among other reasons because the evidence is lacking to show that the saint was actually represented with a peacock in Italian art.[113]

What we can say is that Barbara Gonzaga was no stranger to the multiple uses of this motif. Although they have not been noticed in connection with the Camera, there are three peacocks in the gold and floral borders of a page for Pentecost in a missal evidently illuminated for her by Girolamo da Cremona (fig. 55).[114] Surrounded by a glittering fan of tail feathers, one of these birds appears in the center of the upper border, a perfect location for a symbol of resurrection and immortality. A blank shield that must have been intended for a coat of arms is centered above the two peacocks in the lower border whose crossed tails sweep toward the bottom corners of the page. Taken together, these images combine the strands of long-standing pictorial traditions. They are Christian symbols, heraldic devices, and decorative motifs; if we admit the allusion to St. Barbara, they may be an emblem for Barbara Gonzaga herself.

The fact remains that Mantegna's peacock is mutely indifferent to the search for symbolic meaning that it calls forth, indifferent even to the possibility that we have been hunting the wrong bird all along. The Gonzaga archives refer in several places to peacocks at court. In a letter of 1469 the marchese ordered Mantegna to draw them for a tapestry design.[115] Does the peacock in the Camera Picta preen on the balustrade, as the models for it must have done, without any symbolic complications whatsoever?

If so, our intermezzo ends with the courtiers' laughter. The meaning of the peacock, they might have said, lies in the chase. Or it would lie there, except

for one more observation by way of a finale—that the elusive quarry in the Camera Picta has never moved, never been out of sight. Perhaps the spectacle itself is the best source of whatever meaning we may find in it.

SEEING CULTURE ON THE CEILING
OF THE CAMERA PICTA

The peacock, eluding the hunt for a definitive interpretation, cannot be confined to one pictorial tradition, text, or symbolic meaning. And if this is true of what seemed at first an easy quest, we may wonder about the ceiling as a whole and so about the overarching interpretive conventions it might otherwise be taken to confirm.

One function of a symbolic realm is to articulate and mediate differences between the particular detail and the general type, the contingent and the essential, surface and depth, the "real" and the "ideal." Along the lines of such distinctions, and of Renaissance commonplaces, we might say that the "world" of the walls and the "vision" of the ceiling in the Camera Picta thematize fundamental tensions in Renaissance culture. Viewed in this way, the pictures convert contrast into complementarity and propose a utopian solution—the "ideal," projected onto the ceiling, comes out literally on top. It would be easy to supply the appropriate Renaissance commentaries—that the *vita contemplativa* thus transcends and perfects the *vita activa* that sustains it; that the invitation above to leisure and learning rewards and redeems the worldly chronicle beneath; that the historical actors on the walls are also patrons of the high culture that inspires them from above. One world is time-bound, the other reaches across and beyond time to the realm of the ancients and of myth. These interpretations are plausible. They have the support of Renaissance traditions and of traditional views of the Renaissance, and the court of Mantua would surely have relished the claim that the tensions of Renaissance culture had been resolved in the inner sanctum of the prince.[116]

But this is the liability of such accounts. They take brilliantly assertive and demanding pictures as more or less passive illustrations of prescribed themes, and they put us in the position of rehearsing a self-serving ideology as our own interpretation. The peacock has already led us to an alternative—to the riveting presence of the image, and hence to questions of means rather than of meaning. With its full repertoire of Renaissance pictorial effects, the ceiling is clearly an exercise for the eye, whatever else it may be. Since this exercise is mostly visual, it does not necessarily call for much of the culling of textual references that usually passes for cultural history or, for that matter, art history. The pictures, we might say, constitute their own text.

Rather than set our sights on what the painted ceiling allegedly represents, then, we focus on the implications of how it represents. This means starting

from the responses that the pictures appear to solicit from the viewer, from three distinct modes of visual address that we can define as the glance, the measured view, and the scan. If at this point we take leave of the Milanese ambassadors who have been our guides so far, this is not to say that the ceiling transcends politics for a realm of high culture and ideal form. Seeing and being seen, we argue, institute and define relations of authority and power there, and in this sense the seemingly formal and "ideal" vision is inescapably political and "real."

THE GLANCE

Looking up, the viewer's eyes are soon drawn to the "eyes" of the ceiling: the oculus of course, but also the look of what appear to be three girls peering over the rim (figs. 52, 54). Thus, practically from first sight, the ceiling is an invitation to visual play and punning whereby permanent and calculated effects appear to be casual and transitory details. Some figures dare us to doubt the reality of the illusion. Only a slender pole seems to keep a barrel propped out in space from plummeting into the room, and the hand resting on this frail support can just as well be imagined pushing it away as securing it; the putto across the way looks as though at any moment it might be about to drop the fruit, too large for the pudgy hand. These little dramas occur in an architecture that never existed, under a morning sky where the sun never rose.

There is no way of knowing just how to take the three girls whose eyes prompt these impressions—whether they are taunting, flirtatious, amused, or something else again. They appear a little to one side, in the opening that is itself set apart as a playfully celestial realm. Off center, seemingly intent but without clear motivation, their look comes to us as a glance.

Alberti advised painters to include in their pictures figures that seem to look at the viewer, as if drawing attention to the scene, offering a knowing commentary, and inviting a response.[117] Mantegna's trio could be cited as an illustration, but we can follow their glances beyond the text along a familiar trajectory of Renaissance courtly culture that leads art to aestheticize epistemology and both art and epistemology to practice politics. What Alberti does not say, among other things, is that the beckoning function requires the responses it pretends only to solicit, for by positing a contingent look in return, the painting acknowledges the need for a beholder. Unlike the trees in Bishop Berkeley's forest that cannot be said to exist until noticed, the three figures watch for the answering response that confirms their existence. By admitting a necessary dependence, their seemingly playful look is a serious bid for recognition.

Through this appeal to visual contact where considerations of seeing and knowing are practically inseparable we may enter into courtly calculations of status and power. In the first place, there is what we may think of—and

surely see in operation on the ceiling—as the fundamental rule of visual exchange at court: "We are seen, therefore we are." As Castiglione put it, the good courtier performs his part, "remembering the place where he is, and in the presence of whom, with proper devices, apt poses, and witty inventions that may draw on him the eyes of the onlookers as the magnet attracts iron."[118] In this exclusive little theater, to adopt one of the court's own metaphors, what we know of the world exists in the beholder's eyes. Audiences spring up everywhere, including an internalized one anticipating an external show appropriate to the occasion, or (in Renaissance terms) in keeping with decorum. Anything like a private self becomes the impresario directing the performance or a residual consciousness remaining after it is over. Because an audience is the sum of spectators, no single or secure referent can be relied upon.[119] In this shifting state of affairs, heaven might truly lie in the look of Mantegna's painted maidens.

Yet the fixed look is designed to seem freely responsive to our own. The impression of being "followed" by a painting is a familiar one, especially where our attention is caught by some riveting detail—a pointing gesture, a radically foreshortened object, a human eye.[120] But the combination of contrivance and indeterminacy in the glances from the oculus can also be seen as a variation on the *sprezzatura* or "nonchalance" of Castiglione's model courtier, or the *grazia* of the perfect courtly artifact—that is, as successive escalations of the fundamental connection between seeing and being in the culture of the court. While a hierarchical disposition of authority suggests correspondingly schematic forms of ritual, etiquette, and art, such schema and system will not produce the illusion of naturalness, of arbitrary arrangements freely chosen, that ideologies strive to create; nor are they well suited to the utopian dream of carefree tranquillity that was the ultimate justification for the rule of the Renaissance prince over the unruly alternatives of the nobility or the people. In Castiglione's picture of the ideal court of Urbino just as "the most decorous customs were . . . joined with the greatest liberty," so were artifice and spontaneity the complementary modalities of "true art which does not seem to be art."[121]

Hence the appeal at court of the game, the puzzle, and the joke. The norms of play are closely regulated while the moves are up to any player and are in that sense freely performed. These courtly entertainments both model and mask the privileged separation of court from the workaday world, the seemingly voluntary submission to arbitrary authority, and the scramble for place, for the winning maneuver and the last laugh against one's rivals. One of Ludovico Gonzaga's most intimate courtiers was jesting with utter seriousness when he drew analogies between playing chess at court and questions of "property, the state, and life itself."[122]

Of course if we knew for certain that the painted glances on Mantegna's ceiling were playing courtly games, they would not be playing to perfection.

The courtier's finesse sweeps clear meanings beneath the threshold of easy recognition; the absence of transparent intelligibility arouses the desire to be let in on some inside knowledge that we imagine is being withheld from us as outsiders. Whether or not there is actually a secret to fathom hardly matters. The glance will check our credentials to share an invitation to intimacy in any case, and those who do not know or cannot guess how to pass the test will be excluded from the privileges they have been incited to desire.

That the looks (in all senses) of what seem to be female figures produce such effects genders these courtly arts of seeing and being seen. The women in the oculus are sometimes interpreted as a rarefied, perhaps celestial, trans-figuration of Barbara Gonzaga and the women of the court. It has been sug-gested, for example, that the oculus functions as a Renaissance version of a chivalric *cour des femmes*.[123] The feminine court-within-a-court of illuminated miniatures and literary descriptions—the Gonzaga library, well stocked with medieval romances, would have contained both—was typically set in a *locus amoenus* centered on some motif such as a fountain or a well. Women ruled this alternative world in the name of beauty and love; it was the antitype of the masculine court and, so we might say, of the pictures on the walls of the Camera Dipinta. Such a scheme would go far to explain the counterpoint of predominantly male and seemingly female realms, of soberly official routines and playful ones, of more or less unified narratives set in the public world and the desultory poses in the mise-en-scène under a disk of sky. The festive inver-sions of a painted court of women could offer respite and release from the demands of courtly life.

The offer was safe enough—a painted invitation, teasingly enigmatic, "merely" feminine, and like other courtly games, a play on the creative li-cense that the court wished to see in itself. Besides, the topsy turvy turns of myth and ritual serve notoriously to reflect and reinforce the established order: a court turned upside down is still a court, with the hierarchical con-ception of authority intact. In the Camera Picta the feminine realm of the oculus is still sustained by the walls beneath, and the figures we see above seem to have no more obvious function than preening to invite their own obliging submission to whatever the viewer wishes to make of them. One ver-sion of submission would have the women acting out an allegory of marriage, beginning with the glancing maiden combing her loose hair and ending with the matron with the veiled coiffure and averted eyes. On this reading *Camera degli sposi* would not be such an anachronistic name for the room after all.[124]

Even the less obviously gendered argument that Lucian's *Hall* is the key to the program of the ceiling is, in fact, doubly gendered—first by the crucial reference to women, then again by the imposition of a master text and explic-itly masculine meaning upon them. Lucian's orator, it will be recalled, con-trasts the harmonious beauty of the ceiling in a perfectly decorated room with the false allure of "Persian" or "Sultanic" extravagance: one is like the modest

beauty with "a ribbon that confines the luxuriance of her hair," the other like the courtesan made up with "extraneous charms." Such a room "wants a cultured man for a spectator . . . who applies thought to what he sees." Taking these cues from Lucian, Rodolfo Signorini supposes that the viewer of Mantegna's ceiling is meant to step into the place of that "cultured man" and contrast the true beauty of the three girls with the false allure of the woman and her exotic "oriental" attendant next to them.[125] The feminine apparitions in the oculus are thus compelled to obey the dictates of two texts, Lucian's and Signorini's.

Lucian himself gives a telling rejoinder. Quite apart from the discrepancies between textual and pictorial details or the similarities between the trope of the modest beauty in Lucian and in other authors, the punch line of *The Hall* countermands the authority of the text. After rehearsing arguments for the power of what can be seen in the painted room over anything that can be said about it, Lucian's orator asks once again, "Is not then a hall so beautiful and admirable a dangerous adversary to a speaker?" The answer comes in the very last line: compared with real painting, "word-painting is but a bald thing."[126] On this principle the best way to illustrate Lucian would be the self-canceling one of challenging the subordination of the image to the text. The painter would make Lucian's point by a virtuoso display of the superior autonomy of painting.

In this way the text leads us back to the image. It is there, so to speak, on the surface of the glance, that the role of gender is most deeply implicated in courtly arts of seeing and being seen. Not the least of the little ironies here is that gender matters because we have no incontrovertible proof that women are represented in the oculus. We see only heads, at most a glimpse of neck and shoulder, and the hand with the comb. The girl with the comb could easily be a boy; the Moorish maidservant with the checkered headdress might just as well be, say, a Berber prince. The point is not that these figures actually represent males, but rather that there is nothing exclusively female about them—in other words, that they are made "feminine" by the roles they perform before our eyes.

According to a Renaissance (male) commonplace, "it is the eyes of a woman that do more to attract and allure a man to love . . . than any other beautiful and remarkable part." The standard responses call for the feminine glance to be returned and mastered. Francesco Sansovino's version brings out the implications of this strategy by putting it in such a lurid light: "Fix your gaze lasciviously on her eyes because your thoughts . . . will descend to the woman's heart, penetrating through the entryway of her eyes . . . to the most secret parts, almost as if they were poison, corrupting the blood, imprinting your name and your desire firmly in her heart."[127] In this erotic vision the male gaze is the phallic displacement of an imagined assault that appropriates its desired object; the eyes of a feminized counterpart invite sexual penetra-

tion, Sansovino comes close to admitting, because they are the instruments of the male agent's own projected desire. Sansovino offers a more explicit version of conventions of the feminine that recent theorizing about gender hardly needed to invent. The conventions are familiar enough in the "analysis" of women in courtly literature and, so it has been argued, are reinscribed in the rules of courtly behavior that feminize the persona of the courtier. In the combination of seductive appeal and compliant submission the roles of the Eternal Feminine and the Perfect Courtier are practically interchangeable.[128]

Insofar as the enigmatic glances in the oculus are neither natural nor iconographically secure (let alone innocent), the attempt to see through them is likely to miss how much they actually give away. Made coyly to project a look that desires to be seen, the feminized glance is an epistemological prerequisite or inauguration of viewing; it also brings an "end"—both a purpose and a point of completion—into sight. Looking from the oculus into the room, the three girls invite the viewer to come forward, offering "him" at a glance the tribute of privileged recognition and the simulated promise of intimacy. In responding, the viewer becomes in turn patron, impresario, producer, *and* production of a command performance. Originally, the preeminent viewer would have been the prince; in this sense the play in paint would have acknowledged, confirmed, and indeed constructed his presence in the eyes of the court.

THE MEASURED VIEW

Once the glancing look draws our attention toward the center of the ceiling a different visual logic takes effect. A circle, a center, a hub of painted architecture that seems to open through the vault to an illusionary circle of sky, the oculus consolidates both a surface pattern and a perspectival scheme. The conspiratorial looks and artful poses seem by contrast incidental, distracting, and dispensable. We are released by this contrast from the charm of the glance; more precisely, we are delivered by it to the disciplines of a more demanding way of seeing.[129]

In two-dimensional outline, the oculus is a set of concentric circles inscribed in the square of the architectural ribbing that frames them (fig. 36). This arrangement enforces the centeredness and symmetry of the design and harmonizes them both in a single geometrical pattern. Encompassing space but having no beginning or end, the circle symbolizes the cosmic, the celestial, and the eternal in many cultures whereas the square, "earth" to the circle's "heaven," stands for stability, solidity, and measure. A famous Renaissance icon of perfection, Leonardo's drawing after the classical text of Vitruvius, actually inscribes a male nude within a square and a circle. Although human anatomy is not equal to Leonardo's geometry, Rudolf Arnheim argues that our perceptions of the world do combine the two spatial systems represented by

the circle and the square. One gives the essential orientation of a centric point and a horizon, the other the "dimensions of up and down and of left and right, indispensable for any description of human experience under the dominion of gravity."[130] Mantegna's square-and-circle pattern foists a double order on the viewer as pure geometry and as an archetype of perfect proportion.

The oculus is also one of the showpieces of Renaissance perspectival painting, in its illusionistic third dimension a hub or tube that conducts the eye through the imaginary architecture. Perspectival technique, however routine in practice, is still controversial in theory.[131] The theory of linear perspective tends to conflate optics and geometry, as if how we actually see were identical with the geometrical procedures for representing a three-dimensional world in two dimensions; at stake here is the large issue of whether perspective is in some sense "natural." In any case, workshop practices in the Renaissance were seldom theoretically consistent, nor did they need to be to produce perspectival effects. For our purposes a few basic principles will suffice. In the perspectival theory codified by Alberti, one line, a "principal ray," runs from the eye of a hypothetical beholder to a central vanishing point. Fanning out from the base of this line, a "visual cone" designates the viewer's field of vision and extends up to the picture plane. Starting in reverse from the vanishing point, the theory treats the pictorial space as another cone or pyramid extending out to the picture plane and lays out the characteristic geometrical grid, plotting recession in space in converging lines and reductions of scale. Thus, while the vanishing point, a focal stop or "plug" to infinite recession, corresponds to the retina of the viewer, the cone or pyramid "outside" the picture corresponds as a subliminal or supplementary effect of perspectival construction to the one "inside" it.[132]

Without too much exaggeration, the oculus in the Camera Picta can be diagrammed as such a construction of pictorial space. Seen in this way (fig. 53), the perimeter of the opening becomes the outer boundary of a visual field at the point where its base intersects the picture plane. The parapet is represented as slightly but uniformly tilted inward, so that if we imagine it projected upward it forms a cone with the vanishing point at the apex. A line projected from the viewer's eye to the focal point inside the opening accordingly defines the limits of the distance the eye is supposed to see. And since the vanishing point anchors a pyramidal or conical inversion of "our" side of the picture, we become in effect the object of an alien gaze meeting and then passing our own at the circle of the opening: in the act of seeing we imagine that we are ourselves being seen.

This schema imposes a strict visual discipline in return for the image of a finite world mastered by the beholder and proportioned to the beholder's eye. On the one hand, it posits—just how rigidly is open to question—a "correct" point of view that is fixed, monocular, and focused from an arbitrary distance; it pegs what we see to a centric point in a circular model of vision, converts

the visual field into a geometry problem, and discounts the role of color, shadow, and atmosphere. On the other hand, these visual power plays are also empowering. The position assumed by the beholder scales the figures and objects represented inside the picture both to one another and to their imagined distance from the picture plane. Through the correspondences on either "side" of the picture plane in a perspectival construction—the vanishing point and the point of projection from the eye, for example—the spectator becomes the creature and creator, the subject and object of attention of what appears in the picture.

The interplay between such abstract relations and what is actually represented in the oculus enhances this sense of being treated to a show of illusions performed for our edification and amusement. (See figs. 36, 54.) The oculus looks in outline unnervingly like the iris and pupil of a gigantic eye. The cherubs standing inside the opening appear as if seen from directly beneath; tortuously foreshortened, practically dismembered at these extremes of perspective, their antic gestures are understandable. Above the parapet the figures are not drastically foreshortened; depicted at sharp angles to the central viewpoint, they appear to lean out in space, as if to defy the steep geometry of the central projection—a strategy for exempting human figures from the distortions of a theoretically rigid application of perspective that, as it happens, would be developed in sixteenth- and seventeenth-century painting.[133] Even the routine detail of the large cloud hovers in an air of visual ambiguity. It is off center, ragged and gray, its traces of sublunary light at odds with the structural geometry of a composition that seems to transcend the accidents of ordinary space and time. Moreover, the cloud intrudes upon and masks the central area where the vanishing point belongs. In what amounts to a philosophical joke the vanishing point cannot be seen, as if to confirm that vanishing is invisible and that points are geometrical notions, not real places. Yet the cloud is an opaque site from which light seems to be refracted, and in this sense it acknowledges that perspectival technique does make virtual fetishes of notional points.[134] These visual teasers hint at the controlling presence of a bemused intelligence and prompt the conspiratorial wink that comes with being initiated into a powerful secret.

It is hard to know how much of this was intentional on Mantegna's part. Pictorial jests have been discerned elsewhere in his work. We have already alluded to some more or less obvious instances in the Camera, and there are others, including no doubt some that we have missed.[135] Indeed, with its multiple illusions and trompe l'oeil effects the Camera is itself a kind of spectacular joke. The Renaissance repertoire of geometrical techniques enabled the artist to take the measure of the world while preserving an ironizing detachment from it. The double register of an organizing geometry and discrete pictorial details, of "the ideal" and "the real," to use the categories of Renaissance art criticism, was also a technical opening for the innuendo, the pic-

torial aside, or the visual wisecrack. In this way, like a god or a prince, Mantegna could make a world and have his sport with it.

Where power and control are so clearly on display politics cannot be far behind, least of all in a Renaissance room of state. Let us bring the chief patron of the picture back into the preeminent viewer's role that was his by right. Looking up and turning, a little reluctantly perhaps, from the enticements of those feminine glances, Ludovico Gonzaga finds his attention fixed by the measured view at the center of the room above him. He is master of all he surveys, in part of course because the room is small and because he has commissioned it. But the view of the oculus is made to order in the further sense that it is proportioned to his perspective and subject to his gaze. The harmonious symmetry of the circle-and-square pattern is an ideal expression of an order of things lying beyond contingency and change, while the perspectival construction makes an otherwise utopian vision plausible and brings it under visual control.

From the central vanishing point a steady gaze, a subliminal god's eye manufactured by the machinery of the perspectival construction, seems to be fixed on the prince. He may remember the analogies between divine order and the perfect political regime that he had read and heard discussed by the humanists at court. The first chapter of the treatise *De principe* that Bartolomeo Platina dedicated to his son Federico in 1470 rehearsed the classical texts and tropes—Plato on the divine institution of princes, Aristotle on their laws as a corrective to the errors of the people, the fable of Phaeton on the nod of princes "by which all things are ruled." "The eyes of princes," Platina concluded, "are not private but public, and by their light show the erring the true way." [136] But the texts needed many words to say what the painting shows.

THE SCAN

While the oculus captures and concentrates attention, the rest of the ceiling diffuses it. Supporting the more overtly spectacular performances, the vaulting supplies an ingenious simulated architecture, an overarching design, and a showcase of classicizing details. A tour de force in its own right, the functional, decorative, and didactic look rivals the enticing glances and the geometrical control of the oculus to invite another way of seeing. In this section we examine the scanning operations elicited by the painted vault that have aesthetic and functional charges as distinctive as anything we have seen at the center of the room, among them the antique aura essential to the Renaissance look of Mantegna's art.

To scan suggests a sweeping way of seeing that traces out the logic of a design. Taking visual bearings on the vault, the viewer looks for patterns along the painted ribs and around the visual runways that the ribbing defines (color

plate 6; fig. 36). Following the long curves of the pattern, one may trace the span from one corbel embedded in the wall to another diagonally across, then in a second pass pause at the junctions where one band of painted ribbing crosses another. When the ceiling comes into focus, it is as an assemblage of modules: circles, squares, and triangles. The concentric circles of the oculus ripple out to the circle of medallions that seem to revolve around the central opening; the square of painted ribs framing the center seems itself to be set in another square, turned a few degrees, which can be drawn around the tops of the lunettes. Eight diamond or lozenge shapes are grouped around the perimeter of the inner square, the triangular corners of which connect as halves of a visual hourglass with the vaulting over the central of the three lunettes on each wall. Once the viewer is caught in the labyrinth or mandala of this visual circuitry, to break the spell takes an act of will, a kind of counterattention.

All the more so because the patterning of the vault cannot all be seen at once. To see everything, we must follow the design around or across the room. It has been plausibly suggested that we should begin at the northwest corner with the medallion of Julius Caesar, but even so we still have no particularly privileged point of view, only a succession of possible viewpoints that together afford a full picture of the vault.[137] Although the viewer may pause to examine the details, the connectedness and regularity of the whole are greater than the attraction of the parts and, sooner or later, set the eye in motion again through the routines that the design lays out for it.

This schematic order is at least as important to the classicizing effect of the vault as its antique details. The details are generically classical of course, from the dome-cum-oculus to the sham medallions, swags, mosaics, and sculpted reliefs (color plate 6; fig. 51). However, Mantegna was not copying an original, the Pantheon or Nero's *Domus aurea*. Notwithstanding the obsession with classical precedents in Renaissance studies, the critics have been forced to conclude that he freely adapted scattered sources to his purposes.[138] Renaissance writers distinguished between literary imitation, where ancient texts however corrupted had been transmitted over time, and imitation in the visual arts, where the models were mostly fragmentary or altogether lost. In the preface to his treatise on painting Alberti extolled the "new ancients" of Florence because so little of real antiquity was available to them.[139] The dutiful scholar in a story by Jorge Luis Borges, realizing after a lifetime studying *Don Quixote* that he will never master Cervantes's classic, decides that he will reproduce it word for word and even then leaves "his" work unfinished at his death. The reception of a classic is always a matter of reappropriation and adaptation in light of changed circumstances. The classicizer draws on a repertoire of received forms and reconstitutes them anew in a form that may rank as a fall, a recovery, or a rival but is never *the* original.[140]

Mantegna's vault, seen in this light, is not an imitation of a "source" so

much as a model of (and for) the logic of a "new classic." In the first place, it is a simulation in paint: the garlands, stonework, stucco, metal, and mosaic are a calculated fiction from the start. The elaborate details, rich surfaces, and learned references testify to long study and hard work by the painter and prescribe more of the same for the viewer; the sheer workmanship is an index of fabrication, of an artifact made and made up by the artist. All this hinges, finally, on a methodical pictorial arrangement or syntax. Depending on the count, only five or six motifs are recycled throughout—the medallion, the swag, the ribbon, the figures in relief, the wave pattern on the architectural ribs. Critics like to praise Mantegna's inventiveness, but they do not have to endure the stupefying tedium of actually painting the vault. There is more slogging than *sprezzatura* here. Even the little variations—such as the turn of one emperor's head to another or the shifting postures of the putti supporting the medallions—play off a schematic rigidity that anchors the pattern firmly enough for the pictorial fillip without loosening the hold of the scheme.

A limited repertoire of forms distributed in regular patterns—the organizing principles of the self-conscious classicism on the vault are analogous, in short, to the principles that propel the scanning eye through the design. Here again the "content" of the pictures is practically inseparable from their "form." Furthermore, the formal pictorial structure of the vault sustains the discipline that is still in force whenever we read it in iconographical terms. The vault functions in this way as a classical index or mnemonic device to classify references by kind and summon up lists of particular citations. Ideal users would have memorized texts that they could recall upon seeing the appropriate imagery. Novices or the absent-minded could turn to the library for texts or concordances, like modern viewers without classical educations. Let us try such an exercise, beginning with the medallions of the caesars.

The medallions have a generic antique look of coins, medals, and portrait busts recast into a single form. Scanning the vault, we are likely to take their patterned regularity as a thematic one even before the inscriptions confirm that they represent the first eight Roman emperors. Having established that the medallions are in the ensemble a Suetonius's *Lives of the Caesars* in pictures, we may scan the series again until, in a kind of visual roulette, our eyes come to rest on some particular medallion. At this point an image such as figure 56 might open mental files or lead to references something like the following:

TIBERIUS

Looks
Reportedly handsome, with large eyes
Broad chest and shoulders
Hair long, covering the nape of his neck

Quotes

"Let them hate me, provided they obey my will."

Inspecting the prisons, Tiberius replied to a man who begged for a
speedy death, "I have not yet become your friend."

Lessons, moral and political (mostly cautionary)

There's no changing a corrupt nature

Tyrants are dissimulators (early Tiberius as defender of the constitu-
tion, plain speaker, reformer, and disciplinarian)

Tyrannical appetites will manifest themselves despite efforts to con-
ceal them (later Tiberius as tyrant)

The tyrant is enemy to everybody, including himself (the emperor's
bouts of melancholy)

Et cetera—a large category where Tiberius's vices are concerned

Sources

In principle: Suetonius, Velleius Paterculus, Tacitus, Philo, and
Josephus

In practice: encyclopedias and compilations [141]

What distinguishes the mythological scenes in the twelve spandrels of the
vault from the caesars is not the difference between fiction and fact, or myth
and history. The most conspicuous differences are that the myths are worked
into the structure of the vaulting in feigned mosaic and relief and that, singly
and in three series, they relate pictorial narratives (fig. 36: *A–L*). Scanning
the triangular spandrels on the east wall, we see the least familiar of these
stories—three tableaux from the myth of Arion. The scenes from the tales
of Orpheus and Hercules (north, and south and west walls, respectively)
are more immediately recognizable. The northeast triangle (fig. 57) shows,
all'antica, a bearded lute player on the waves of a golden sea, a boat with three
passengers, and a dolphin surfacing in the foreground—cues to the tale
of Arion as told by Herodotus, Pliny the Elder, and Aulus Gellius, among
others. [142] A rich and famous singer of Corinth, Arion was robbed at sea and
forced to throw himself overboard after singing a song evidently more pleas-
ing to a passing dolphin than to the thieves. The figure on the central east
spandrel (fig. 58) would be Arion traveling on the back of the dolphin to arrive
in port before the robbers. In the third scene (fig. 59) an enthroned ruler or
judge presides over three kneeling figures—this would be Periander of Cor-
inth condemning the malefactors.

Once the imagery calls up the story, both together prompt a search for

meanings and morals. We can easily imagine the results as a set of topics generated by the role of music or by music as a synecdoche of art in the Arion legend.

MUSIC (OR ART MORE GENERALLY)

Its power—for example, to charm Nature and to triumph over ill fortune, and even over death

Its precariousness in a hostile world

Its incompatibility with riches: an artist rich only in his art would have been spared Arion's troubles

Its need for enlightened protectors (such as Periander of Corinth—or Ludovico Gonzaga)

The adjacent scenes (fig. 36: *A–C*) from the myth of another musician, Orpheus, would amplify such a list; the Hercules scenes (fig. 36: *D–I*) would provide the fitting complement of fortitude and wisdom. We have material enough here for a humanist excursus on the virtuous man, and especially the prince, who tempers liberality with justice, civility with strength, contemplation with activity. In this balanced ruler, the humanist teacher might conclude, lies the best hope for immortal fame.[143]

Mechanical or positively trivial as they may be, a classicizing culture needs operations of this sort. Whether or not Renaissance humanism advanced a coherent view of the world is one of the ritual debates of Renaissance studies; either way, the Renaissance humanists were technicians of the classical effect. There were (and are) higher claims for a humanistic education—that it cultivated the humanity, fashioned the virtues, and deepened the wisdom of its charges. In practice, however, humanist pedagogues were drillmasters whose task was to teach their pupils a stock of classical references reproduceable on demand for any occasion, topic, or role. Recent studies have called attention to the lists in their primers, notebooks, and manuals on literary composition.[144] We know too that the traditional "art" of remembering the appropriate lines on a given theme associated texts with images. In scanning Mantegna's ceiling we are ourselves reminded that the *artes memoriae* enjoined the orator to remember his lines by imagining a series of mnemonic images built into the architecture of a room.[145]

The painted vault meets the requirement that a classic must somehow be timeless and timely.[146] It is a model of fixity in time not only because its details are antique but also because they *are* fixed on the surface of the vault. The myths and the caesars illustrate principles of continuity and succession—for example, from myth to history, from the age of gods and heroes to the founding of the Roman empire, and so (by implication) from the Roman emperors to the dynasty of the Gonzaga. We could trace the need to distance or to ap-

propriate classical models across the wide range of humanist culture, but range is not a reliable index of depth. Like the scan that initiates it, the classicizing effect in the Camera Picta calls not so much for deep interpretation as for schematization, variation on assigned themes, and dutiful recitation.

Imagine once again Ludovico Gonzaga in the room painted for his eyes. Scanning the expanse of vaulting, he orients himself to the pattern, following the design, pausing here and there to survey a simulated antique detail, letting his attention be drawn from one *topos* ("place" and "topic" alike) to another. Seated near the fireplace with the east window behind him, his eyes are caught by the medallion of Julius Caesar above him, but to take in the ceiling as a whole he moves to another vantage point. The prince becomes an active agent and instrument of the design, and what he sees there—those emblematic figures calling to mind any amount of lore and learning from ancient myth and history—invites further participation. Some learned member of the court stands by to prompt; a party of guests looks and listens attentively as someone points to a detail, elaborating on some theme prompted by the pictures.

The images and the conversation about them are classical not simply because of their antiquity or their authority as a class but also because they are tokens of the shared culture that defines a class of cognoscenti. The marchese takes great satisfaction in seeing the culture he has cultivated for years confirmed in pictures. The privileges of power and wealth are conveniently assimilated as the rewards of study and learning in the classicism of the vault. Here the prince finds both a distraction from the cares of rule and a highminded justification for them. His old teacher Vittorino da Feltre called him Hercules at school, and as an emblem of fortitude and the active virtues that name will still do nicely for a prince; Orpheus and Arion stand for music and for the powers of human creativity, the marchese's court being renowned for its musicians and its creative brilliance. The ring of emperors crowns the ensemble. The prince basks in the aura of authority and legitimacy that runs, in art, from the age of heroes through the Roman emperors to his own time. One obliging guest exclaims, "*O Mantua felix,* this new Rome!"

MANTEGNA AND MOMUS

The Mantuan humanist and doctor Battista Fiera who witnessed Mantegna's will in 1504 had already testified for his friend in a little dialogue *On Painting Justice.* In this conversation set in Rome in 1488 or 1489 the painter meets in Momus a character modeled after the irreverent demigod of classical literature and, so the author would have us believe, sharper tongued than Mantegna himself:

MANTEGNA: You're pretty blunt, aren't you?

MOMUS: I always am. Unless, that is, I have to deal with the great. Then I take a different line.

MANTEGNA: You're all compliments then, I suppose.

MOMUS: Of course. If I weren't, I'd get nowhere.[147]

Mantegna had gone from Mantua to Rome on the favor of his patrons. The point was on target. So was the ensuing exchange over a commission for an image of Justice. "Nobody bothers about Justice these days. Leave her in peace," Momus exclaims. All the same, replies the painter, Justice has to be represented somehow: "Orders are orders."[148] Mantegna had just come from soliciting learned advice. One philosopher wanted him to depict Justice with one eye, another with one hand holding a scale; another recommended showing her with many eyes, like Argos, and brandishing a sword; yet another with a leaden ruler, since justice must sometimes be measured to the occasion. So one philosopher's Justice, needles Momus, would see nothing behind her back, another's would be like a grocer; for the rest Justice could be either an executioner or twisted to any shape. The denouement comes with the views of another Mantuan, the "Christian Virgil," the Carmelite theologian Battista Guarino, who had told Mantegna that Justice could not be represented at all. Only God was just; the only "inescapable decree of his divine justice" was death. Momus, for once, agreed: this was high philosophy and consummate theology, except that Mantegna would now be obliged to paint Death instead of Justice.[149]

Another Momus, this one in a dialogue by Leon Battista Alberti, had already provided an unsettling commentary on a similar dilemma. Exiled among mortals and capable of a "hundred disguises," Alberti's Momus had lived "in theaters, loggias, and public buildings of all types," even in "the very fortress of the tyrant."[150] Jove, at first fascinated by this demonstration of creativity, had recalled Momus to court as a confidant; his advice would cure the ills of the world. Then, sensing that a world of masking would also disguise his sovereignty, the king of the gods had decided to purge the old world and create a new one where image and being would coincide and all contingencies would be redundant. Momus was exiled again. His revenge came when the new theater in whose statues the gods came to reside collapsed in a tempestuous high-fusion reaction that heralded the dissolution of boundaries between being and seeming. The quest for perfect signification had wrought devastation and death; the gods were now permanently alienated from mortals. Momus, the master of "simulation and dissimulation," was left to teach his lesson: "Feign and yet do not [appear to be feigning]." It was, after all, "a splendid thing to know how to hide the more secret thoughts with the wise artifice of colorful and deceptive fiction."[151]

Presumably such artifices were "wise" because complete congruence be-

tween transcendent principles and their material embodiment had unleashed a reign of terror. Besides, the crafting of artifices defined the human condition. Justice could not be shown as it really is. "Orders are orders," but the patron commanding images of Justice or any other transcendent principle would have to settle for some "colorful and deceptive fiction." The representation would never equal the virtue itself. Hence the uneasy bond of mutual dependence between the artificer and the patron negotiated in the Camera Picta. The Gonzaga court needed the deceptive images; the painter was the complicitous servant of the court but in his simulations, feigning without appearing to do so, its lord. The alternative to the strains in this relationship, as Battista Fiera's Momus reminded Mantegna, was death.

The Milanese ambassadors sealed their agreement with Ludovico Gonzaga on 29 April 1470 with artifices of their own, "with sweet words, trifles (*brusche*), and many demonstrations." "Certainly," they wrote to Galeazzo Maria Sforza, "the court and leading citizens [of Mantua] take great comfort and consolation from this." If the outcome pleases the duke, the pleasure will be theirs; if not, their unhappiness will go "to their very souls."[152] On 3 May 1470 the Milanese chancellery drafted a Latin letter in the name of the duke confirming Marchese Ludovico's new commission as lieutenant general of Milan. "Glory," "splendor," and "strength" accompany the alliances of princes with men of great virtue, the document declared; the marchese has served his allies "with the highest fidelity and affection."[153] From this formulaic flourish one could hardly guess that the marchese was, as the ambassadors put it, a "wily *signore*" or that, six years later, Galeazzo Maria Sforza would be assassinated as a tyrant.

FIGURE 34. Castello San Giorgio, Mantua.

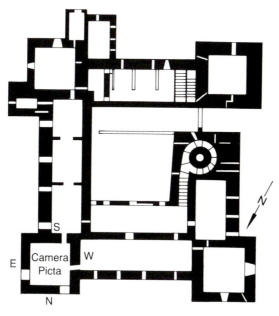

FIGURE 35. Plan of the second floor of the Castello San Giorgio, Mantua.

FIGURE 36. Diagram of the Camera Picta. (Reads properly when imagined held overhead with walls folded inward.) *Medallions*, *I* Julius Caesar, *II* Octavius Augustus, *III* Tiberius, *IV* Caligula, *V* Claudius, *VI* Nero, *VII* Galba, *VIII* Otho; *mythological scenes*, *A* Orpheus killed by the maenads of Thrace, *B* Orpheus at the entrance to the underworld, *C* Orpheus enchants with his music, *D* Hercules and Cerberus; *E* Hercules and Antaeus, *F* Hercules and the Lernaean hydra, *G* Hercules and the Nemean lion, *H–I* Hercules kills Nesseus who abducts Deianeira, *J* Judgment of Periander, *K* Arion rides a dolphin, *L* Arion and the thieves; *devices*, *1* sun, *2* festoon, *3* turtledove and stump, *4* salamander, *5* festoon, *6* winged ring, *7* great dane, *8* festoon, *9* unidentified, *10* tower, *11* festoon, *12* deer.

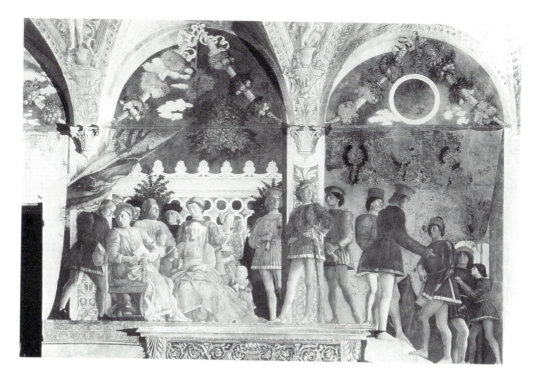

FIGURE 37. Andrea Mantegna, Court of Ludovico Gonzaga. Mantua, Castello San Giorgio, Camera Picta, north wall.

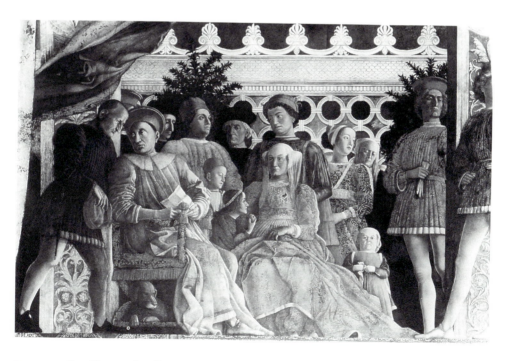

FIGURE 38. Court, detail.

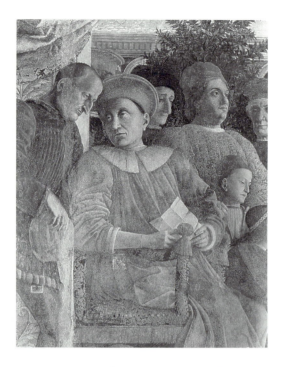

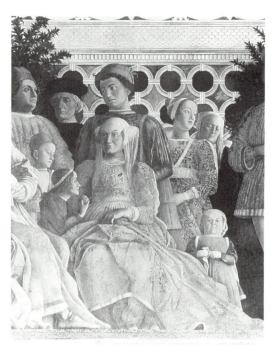

FIGURE 39. Ludovico Gonzaga and a secretary (?), detail of the Court.

FIGURE 40. Marchesa Barbara Gonzaga and her entourage, detail of the Court.

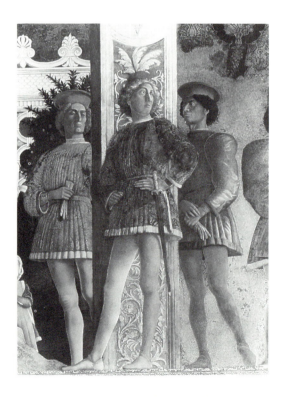

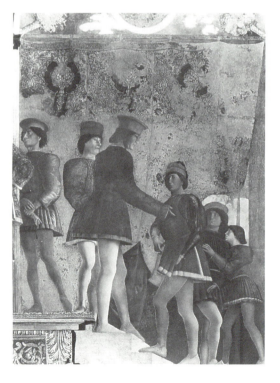

FIGURE 41. Courtiers, detail of the Court.

FIGURE 42. Courtiers, detail of the Court.

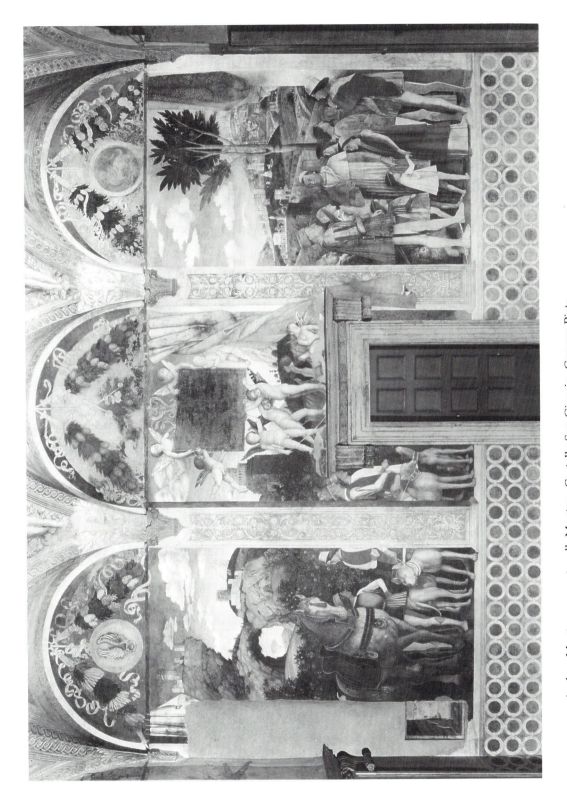

FIGURE 43. Andrea Mantegna, west wall. Mantua, Castello San Giorgio, Camera Picta.

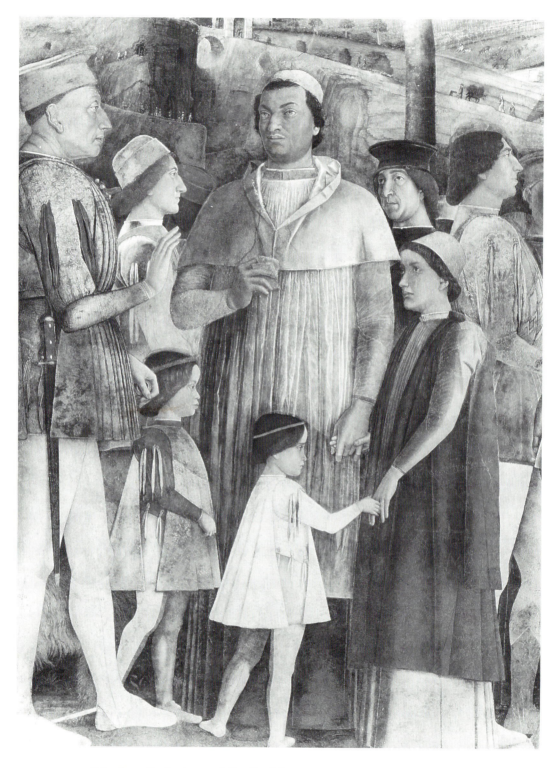

FIGURE 44. Marchese Ludovico and Cardinal Francesco Gonzaga and entourage, detail of the Meeting.

140

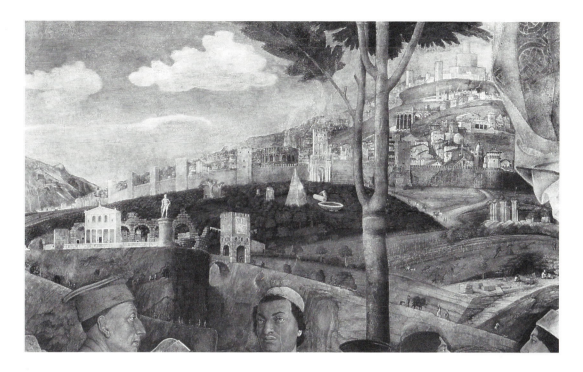

FIGURE 45. Panorama of "Rome," detail, west wall.

FIGURE 46. "The Magi" en route to "Bethlehem," detail, west wall.

141

FIGURE 48. Andrea Mantegna's coat of arms.

FIGURE 47. Dedicatory plaque, detail, west wall. Inscribed ILL(USTRI) LODOVICO II M(ARCHIONI) M(ANTUAE) PRINCIPI OPTIMO AC FIDE INVICTISSIMO ET ILL(USTRI) BARBARAE EIUS CONIUGI MULIERUM GLOR(IAE) INCOMPARABILI SUUS ANDREAS MANTINIA PATAVUS OPUS HOC TENUE AD EORU(M) DECUS ABSOLVIT AN(N)O MCCCCLXXIIII [For the illustrious Ludovico II, Marquis of Mantua, most excellent of princes and of indomitable faith, and for the illustrious Barbara, his consort, incomparable glory of women, their Andrea Mantegna of Padua completed this slight work for their honor in the year 1474].

FIGURE 49. Portrait of Andrea Mantegna, detail, west wall.

FIGURE 50. *Andrea Mantegna*, bronze bust. Mantua, Sant'Andrea, Funerary Chapel of Mantegna.

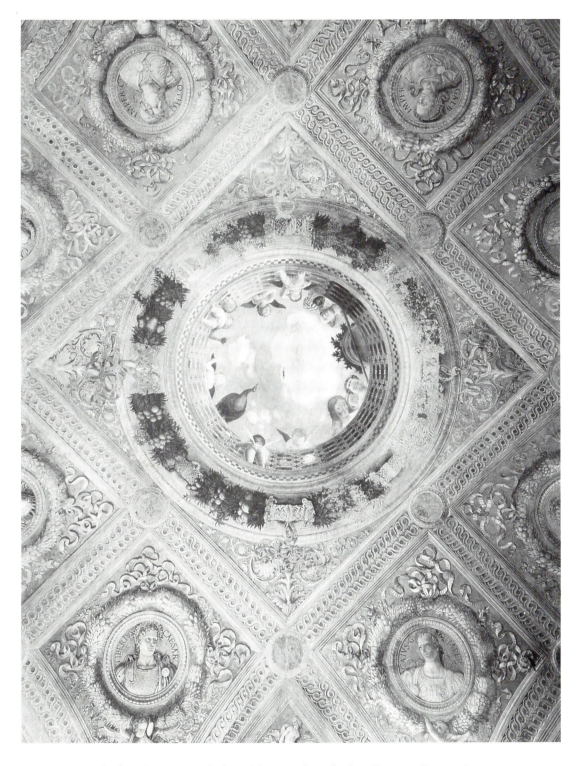

FIGURE 51. Andrea Mantegna, Ceiling. Mantua, Castello San Giorgio, Camera Picta.

143

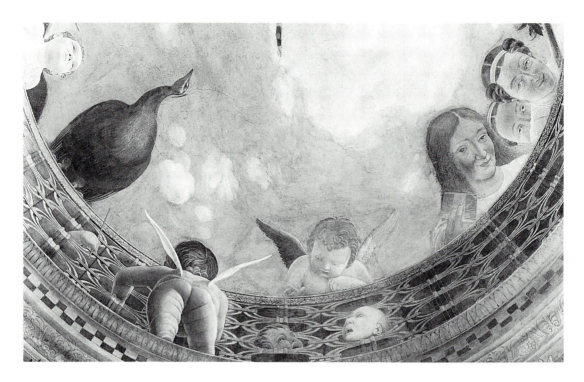

FIGURE 52. Peacock, detail of the oculus.

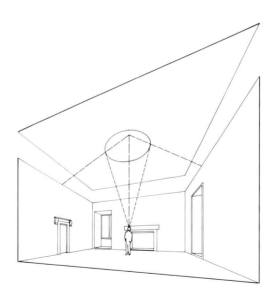

FIGURE 53. Diagram of the oculus and a viewer.

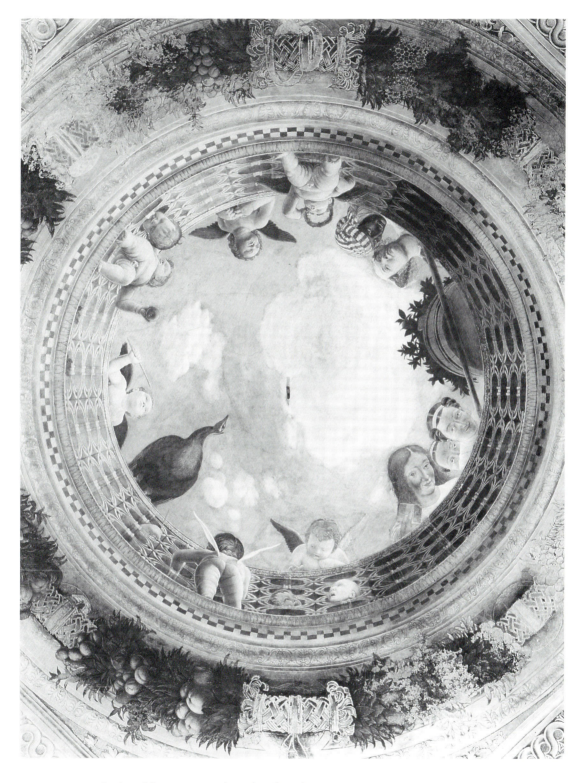

FIGURE 54. Andrea Mantegna, oculus, detail, ceiling.

145

FIGURE 55. Girolamo da Cremona, Missal of Barbara Gonzaga. Mantua, Biblioteca Arcivescovile.

FIGURE 56. Tiberius, ceiling, detail.

FIGURE 57. Arion and the thieves, ceiling, northeast spandrel.

FIGURE 58. Arion riding a dolphin, ceiling, east central spandrel.

FIGURE 59. Judgment of Periander, ceiling, southeast spandrel.

148

PART III

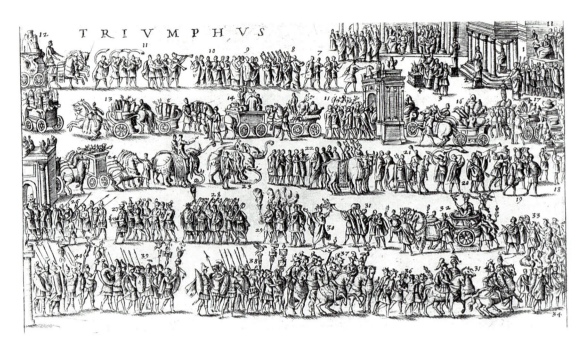

PLATE III(a). Giacomo Lauro, *Roman Triumph*, engraving from *Antiquae urbis splendor* (Rome, 1612). Vatican, Biblioteca Apostolica, R. G. Capp. IV. 648, pl. 11.

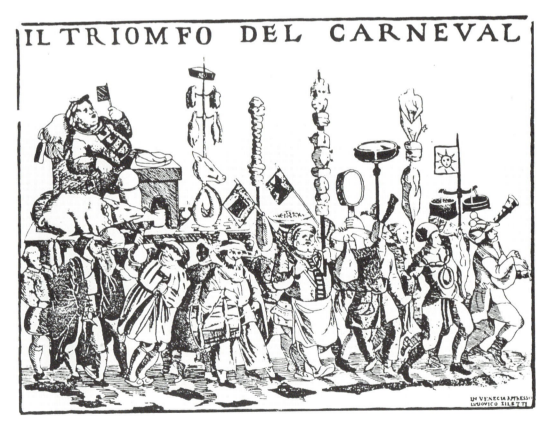

PLATE III(b). *Triumph of the Carnival*, woodcut (Ludovico Siletti pub.; Venice, sixteenth century).

Triumphalism: The Sala Grande in Florence and the 1565 Entry

The Camera Picta was already obsolete when the court of Mantua received the emperor Charles V in March 1530.[1] The room was too small for the emperor's great canopied bed with its grillwork barrier and too intimate for the display of imperial majesty. The documents give us only one glimpse of the emperor there, taking his meal after Easter mass in splendid isolation, surrounded by tapestries and cloths of silver and gold that dazzled those who saw them by their glitter and their cost. No one seems to have noticed Mantegna's pictures—it may be that they were actually hidden by the hangings reportedly draped over the walls of the emperor's nine-room apartment in the castle of San Giorgio. What interested observers was the instant art of processions, platitudes, and props in wood and cloth, paint and gilt, plaster and papier-mâché. The spectacle lasted nearly a month, but the showpiece of the imperial visit was the ceremonial entry with which it began. Nothing was spared from a repertoire of effects that would be endlessly reproduced in the sixteenth century.

The entry of Charles V gives us our own entrée into a world very different from that of Ludovico Gonzaga and Andrea Mantegna. The contrast is all the more striking because so much in the same places seems changed. The Camera Picta was old-fashioned and out of scale in the new political and aesthetic order. The disguises of the occasion had made Mantua a parade ground, a new Rome, a model cosmopolis, and a conqueror's dream. Roles—a generic *triumphator,* an admiring crowd, an obsequious host—seemed to animate actors and props to stage the city. It is as if the careful limits and concentration of the princely court of the fifteenth century had dissolved, as if the walls where Mantegna had worked for months and years had come down to open vast spaces that the new artist-impresario and his teams of collaborators could transform in a matter of days or weeks.

Charles V's progress through Italy—in 1530, and again in 1536—was still a model in 1565 when Giorgio Vasari and his collaborators orchestrated the

Florentine entry of Giovanna of Austria, the betrothed of Duke Cosimo de' Medici's son and heir, Francesco. Since Cosimo's predecessor, Alessandro de' Medici (1511–1537), had been married to the illegitimate daughter of Charles V, Francesco's marriage to Charles V's cousin linked the Medici once again to the Hapsburgs. But connection prompts comparison, underscoring the dependency and marginal position of the Medici. All the more reason for this little Florentine caesar to have turned to triumphal display and to have rushed to completion a monumental audience room to receive the bride. With a volume forty times that of the Camera Picta the refurbished Sala Grande in Florence was said to surpass those made by "all the kings and emperors and popes that ever were."[2]

A TALE OF TWO CITIES TRIUMPHANT
1530 AND 1565

Mounted on a white horse and dressed in gold brocade, Charles V crossed the river Po on a floating bridge with arches adorned at each end by imperial arms and banners. A train of heavy artillery went before him and his entourage of princes and cardinals; an army of six thousand men on foot and horseback came after. As the procession approached the Porta Perdella, the castellan of Mantua came forward and offered the emperor the keys to the city amidst the acclamation of the crowd. After returning the keys, Charles V entered the gate under a canopy preceded by forty youths dressed in white velvet. There he was joined by Marchese Federico Gonzaga and a welcoming party of grandees. At the gates to the two inner circuits of fortifications, arches had been erected, one dedicated to the emperors of the house of Hapsburg, the other to Charles V, "Restorer of Peace." In the piazza in front of the cathedral a column modeled after Trajan's victory monument in Rome stood "towering and beautiful . . . with the most beautiful verses and inscriptions and a winged Victory on top with a laurel wreath in her hand."[3] The emperor proceeded to a special altar draped with gold and silk and after the celebration of the mass remounted for the short ride to the castle of San Giorgio. Marchese Federico issued the command for a barrage of eighty cannons that "seemed to ruin the heavens." As Charles V climbed the spiral staircase, the fastness of the castle closed around him like the walls that had been sealed after the passage of an ancient *triumphator*.

When it was all over the interpretations were just beginning. Summoning Federico Gonzaga to his apartments toward sunset, the emperor gave this version: "truly," he said of this city of simulations, no town in Italy had received him "more joyously and with greater honor" or made him feel "more at home."[4] This half-Burgundian prince must have been reminded of a *joyeuse entrée*. The entry rituals of France and Burgundy in the fourteenth and fif-

teenth centuries were one more sign of feverishly brittle extravagance for the historian of the waning of the Middle Ages.[5] But in a world of peripatetic rulers the impressive dignity and the determination of status in such ceremonies represented the state at least as meaningfully as its weak institutions. The characteristic details are well known from descriptions of costume, marching order, festival machinery, and *tableaux vivants* staging messages of good will, flattery, and exhortation. The tapestries and hangings along Charles V's Mantuan route may have reminded him of the rich cloths and draperies that, according to one French chronicler, changed the secular world of the streets into a temple for the *joyeuse entrée.*[6]

While Charles V spoke like a chivalric monarch of the "joyous" reception and "honor" accorded to him, he was nonetheless an emperor on the triumphant passage that had brought him to Italy to be crowned by the pope only a month before at Bologna. The acclamations of the crowd and the garlands greeting him at the Porta Perdella had been closely associated with advent rituals at least since the first dimly historical rites of entry in the Mediterranean world. The reception of a Roman emperor, the *adventus Augusti,* accompanied by cries of "Benefactor and savior!" along festooned streets became the soteriological episode that the entry of the Christian messiah into Jerusalem converted to the new religion. In hybrid form, with the symbols christianized and the religion given imperial trappings, the ceremony came back to the medieval West by way of Byzantium. The main features of medieval entry rituals have been traced fairly directly to the protocol for the advent of the Byzantine exarch of Ravenna into Rome in the sixth century.[7] The grand finale of a mass and an artillery barrage for Charles V was a sign of the unsettling adaptability of a long tradition.

There were, so far as we know, no trophies, captives, or triumphal carts. Yet the emperor surely recognized in the arches, the victory column, the Latin inscriptions, and the military parade itself the attributes of a triumph *all'antica.* Charles V had actually been victorious not once but twice in the preceding five years over the armies of his great enemy, the king of France. After years of conflict, he had dictated peace at Barcelona and Cambrai in the summer of 1529. In Italy the pope and even the Venetians were subdued. Naples was securely occupied in the south, and satellite states from Urbino and Ferrara to Milan and Genoa revolved in the imperial orbit. If Mantua was a "new Rome," Charles V was Italy's "new caesar."[8]

When his turn came, Marchese Federico Gonzaga replied to the emperor's expression of satisfaction over the reception that "all he had was his sovereign's to dispose of as it pleased him." In such exchanges the ruler accepts less than the subject has to offer and gives less than he might in return. The offer of the keys to the city at the Porta Perdella combined a gesture of good will on the part of a gracious host, the duty of a nominal subject, and a shortage of strategic alternatives. By accepting and then returning the keys, the emperor

confirmed his authority both in the right to receive and in the power to give at his pleasure. These symbolic contests were played out further in the decorative programs of the triumphal arches. The imperial dynasty triumphed on the arch at San Giacomo, but Mantua insinuated participation in the victory: five niches contained statues of Charles V and his Hapsburg ancestors; the sixth held the figure of Manto with verses predicting universal dominion—as if the emperor's destiny were linked with Mantua's mythical prophetess-founder. Another arch located at the entrance to the historical core of the city proclaimed the triumph of peace.[9] Since a renegade imperial army had sacked Rome less than three years earlier, the inscriptions were as much a nervous appeal as a commemoration of his treaties with the French and their Italian allies in 1529. In the end the appeal produced the desired results: Charles V was satisfied by symbolic victories; Federico Gonzaga received the new title of duke of Mantua, though he was not appointed imperial governor of Milan as he had hoped to be.

For Giorgio Vasari, writing twenty years later, the important victories were not political at all. Promoting as usual his own profession and his favorite themes, he portrayed Giulio Romano's arrival in Mantua in 1526 as a triumphal entry in its own right. Enriched and ennobled by the Mantuan court as its "second Apelles," Giulio became in Vasari's account the complete virtuoso—painter, architect, designer, and impresario. As Raphael's favorite, Giulio was a plausible heir to Leonardo, Raphael, and Michelangelo in the grand design of what Vasari was the first to call the *Rinascita*. Like a Roman conqueror, he extended the dominion of the new Roman style over the provinces. The *apparati* he made for the emperor's visit in 1530 had inspired "stupor and wonder—in these inventions Giulio had no equal." Where Mantegna had frescoed rooms and painted scenes of triumph on canvas, Giulio decorated great halls with teams of artists, constructed whole buildings, and transformed an entire city into a triumph of art, "as if for gods rather than men."[10]

About the time of Giovanna of Austria's Florentine entry in 1565 Vasari cast his patron Cosimo I in a triumphal role:

> The glorious deeds of the magnanimous duke I have considered often in my own mind to be so similar to those of the first Octavianus Augustus, that it would be difficult to find any greater resemblance. Both were born under the same ascendant of Capricorn, raised almost unexpectedly to sovereignty at the same immature age, gained their most important victories in the first days of August, and had similar constitutions and natures in their private lives, including singular affection for their wives. In his children, in the election to the principality, and perhaps in many other things, I believe that our fortunate duke might be esteemed more blessed than Augustus, but in both there is a most ardent and most ex-

traordinary desire to build and embellish, and to contrive that others should build and embellish. [11]

Cosimo de' Medici had seemed anything but Augustan when he was elected *capo* or head of the Florentine government at the age of eighteen on 9 January 1537. Penniless, totally inexperienced in government, hemmed in by a 1532 constitution designed to keep power in the hands of the oligarchs, lacking even the title of duke, Cosimo was little more than a puppet with a useful surname. To make matters much worse the economy was weak, Florence was controlled by imperial troops garrisoned in the Fortezza da Basso, Florentine exiles were preparing an invasion, and direct intervention by either imperial or papal forces was a major threat.

By 1565 Cosimo I was master of Florence and Tuscany. He had annexed Siena ten years earlier after a long siege. Except for acquiring the title of grand duke in 1570, his work seemed to be finished. The union between his son Francesco I and Giovanna of Austria not only confirmed the arrival of a dynasty of Medici princes but allowed Cosimo—following the model of Charles V—to abdicate and pass on the reins of power. Now are the "affairs of the city regulated, and boundaries of the realm extended, military goals achieved, peace everywhere prevailing, and the glory of the city and its empire increased," trumpeted the dedicatory inscription on the entry arch dedicated to Cosimo I (fig. 76: 15).[12] The entry of 1565 was Cosimo's triumphant apotheosis after a twenty-eight-year reign. Or so one was expected to believe.

Current scholarship has emphasized the limitations of Cosimo's power and the efficiency of his bureaucracy.[13] While he undoubtedly exercised tighter control over Tuscany than ever before, Cosimo accomplished this feat by simultaneously conceding greater autonomy to local institutions and privileged social groups. He achieved authority over the ecclesiastical establishment within the state only by allowing the papacy a stronger hand in church affairs and a larger share of the revenues. It was the tension between Cosimo's absolute claims and strategic concessions, between the centralization and the dispersion of power, that made the triumphal entry of Giovanna of Austria essential.

Giovanna made her way through Florence by a circuitous itinerary to the civic center (fig. 64). Cleared of obstructions and partially repaved, the processional route passed twelve temporary and two permanent monuments—largely triumphal arches *all'antica*. Simulated marble and bronze statues, reliefs, and medallions decorated these elaborate showpieces that were intended to "help ornament" areas that were "ugly and ill proportioned," to articulate bends and turns, and to establish focal points directing attention and movement in streets and squares.[14]

The procession came to a climactic end in the newly decorated Sala Grande that had been added between 1495 and 1498 to the old communal palace, the

Palazzo dei Priori or della Signoria (figs. 88, 92; color plate 7). Since the republican constitution of 1494 established a general council on the model of Venice, the new council's assembly room was patterned after the Venetian Sala del Maggior Consiglio, except for the oblique angles of the end walls because of the irregularity of the site.[15] Cosimo had begun to transform this old republican hall to serve as his principal audience chamber shortly after moving into the Palazzo della Signoria from the Palazzo Medici on Via Larga in 1540. In the early 1540s Baccio Bandinelli began at the north end a wide and deep dais for Cosimo's throne, reached by four steps and set against the background of a triumphal arch with statue niches on the walls (fig. 92). For the opposite end of the hall the duke commissioned in 1555, the year of his conquest of Siena, the elaborate Rain Fountain from Bartolomeo Ammannati. Empire was as "natural" as the cyclical process by which rain brought fertility to Florence (figs. 93: *60–62; 120–25*).[16]

About four years later Cosimo decided to have Giorgio Vasari commemorate his Sienese victory with a cycle of paintings on the ceiling and walls of this vast space. But, according to Vasari, the old republican hall was "low, dark, melancholy and out of alignment" and its ceiling was "ordinary and simple and not fully worthy of that hall."[17] It was decided on the recommendation of Michelangelo that the ceiling had to be rebuilt and raised by about twelve *braccia* (or twenty-three feet); the higher ceiling was designed to help soften the oblique angles of the ends, bring the room more nearly into square, and introduce more light for the paintings through a series of new clerestory windows on the side and end walls (fig. 92).

Vasari began the design and execution of the ceiling panels in 1563. After the betrothal of Francesco and Giovanna in 1564, the ceiling was rushed to completion—together with the dais and the fountain sculpture (ultimately never installed)—in time for Giovanna's triumphal entry on 16 December of the next year. Michelangelo's *Victory*, carved in the 1530s for the tomb of Pope Julius II but now converted into an emblem of Cosimo's victory over Siena, was placed in the center of the east wall opposite the new entrance (figs. 93: *63; 126*). In 1564 Giambologna designed a pendant *Florence Victorious over Pisa* for the position directly opposite on the west wall, although only the full-scale clay model was ready in time for Giovanna's entry (figs. 93: *64; 127*). Above these sculptures fourteen huge paintings on canvas covered the walls as temporary substitutes for the six frescoes and four paintings on slate completed in 1571 and circa 1600 respectively (fig. 93: *32–34, 42–44, 49–52*).

Since the marriage procession had to pass through the courtyard of the palace, it too was embellished with frescoes and stucco decoration (fig. 89). To reach the Sala Grande from the courtyard Vasari designed a monumental triple-ramp stairway (figs. 90–91), although only the north ramp was ready in time for the wedding.[18] Vasari also built in 1565 a covered corridor linking the palace (henceforth called the Palazzo Vecchio or old palace) with Cosimo's

newly remodeled and enlarged quarters in the Palazzo Pitti. Although it had a different function and derived from a different tradition, this *corridoio* was as much a triumphal passageway as that followed by Giovanna of Austria to the Sala Grande.[19]

FROM TRIUMPHS TO TRIUMPHALISM

The chronicler of Charles V's Italian expedition settled upon a phrase that encompasses practically all the dimensions of his reception in Mantua and points beyond it to the network of themes and variations that reemerged a generation later in Florence: the imperial entry, he wrote, was "un bellissimo triumpho."[20] In the well-stocked lexicon of Renaissance superlatives any impressive ceremony could be called a "triumph"; jousts and balls counted as *trionfose feste*, and weddings and funerals were staged with *pompa et triumpho.* As a distinctive type of public spectacle, however, a triumph was practically synonymous with a procession. The triumphal processions of antiquity had been closely studied, depicted in art, loosely imitated in the streets. Carts or floats pulled through the streets on festive occasions—the great battlewagon or *carroccio* bearing communal banners and trophies, oversized reliquaries and effigies paraded for saints' days, and moving stages for carnival plays—had been known as *trionfi* since the thirteenth century. In a Venetian variation *trionfi* were the regalia carried in official processions of the doge. When, in 1559, Antonfrancesco Grazzini published a collection of what he claimed were *tutti i trionfi* of Florence since the time of Lorenzo the Magnificent, he meant the songs and verses traditionally accompanying the festive cortege in Florence, especially at carnival time. This culture of processions and parades was saturated with the theme of triumph.[21]

For Jacob Burckhardt the "idea" of triumph was a perfect illustration of the transformation of life by art in the distinctively Renaissance form of an antique revival. In terms that their producers would have approved, or smiled at, he wrote that triumphal festivities in Renaissance Italy represented "a higher phase in the life of the people," in which "religious, moral, and political ideas took visible shape."[22] Scholars have traced motifs of triumph across the wide range of Renaissance art and literature.[23] The results do not go far beyond particular cases to explain their structural forms and functions, but they do give us the materials for an analysis of "triumphalism" before returning to the triumph of a triumphalist scenario in Duke Cosimo I's Florence.

The ancient triumph celebrated the conjunction of good fortune, charismatic power, divine favor, and leadership, the *auspicium, imperium, felicitas,* and *ductus* of a victorious commander.[24] The word *triumphus* itself probably derived from the cry "Io triumphe!"—the Latin version, it has been argued,

of an Etrusco-Greek invocation to a god to "go forth," to manifest his presence and grant his blessing. The *triumphator*'s face was daubed with red lead; he wore a tunic embroidered with palm leaves, a multicolored toga, and a laurel-wreath crown; in one hand he held a laurel branch and in the other a scepter. These attributes were modeled after (or actually borrowed from) the image of the Capitoline Jove at whose temple triumphal processions ended. With Roman pieties, however, came the shrewd Roman political controls. Only the senate could confer the honor of a triumphal reception; the ceremony could take place only in Rome and only if certain conditions were met—for example, at least five thousand enemy deaths in battle and a safe return for the army. It could be a matter of weeks of formal negotiations before the entry took place. Thus over the long term an Etruscan new year's festival was grafted into the Roman victory celebration, the entry of the hierophantic king into the arrival of the *triumphator,* and a repertoire of ritual forms into the highly codified sequence of a state procession.

The processional order was already more or less fixed by the second century B.C.[25] The parade entered the city by a gate actually cut through the walls or designated for the occasion. On its way to the Capitoline hill it passed under one or more arches serving to mark the route, commemorate the victory, and display the spoils. Magistrates and senators came first, then horn blowers and trumpeters preceding the booty and the offerings for the Capitoline god—carts and litters loaded with spoils and interspersed with signs, pictures, and statues; crowns given in tribute by provincial cities; sacrificial animals; prisoners dressed according to rank but bound in chains. Accompanied by officials carrying the fasces, the *triumphator* rode in a triumphal cart at the middle of the procession, his powers both cunningly disclaimed and protected by amulets and the patter of a buffoon uttering the reminder, as much perhaps to pacify the gods as to warn the man, that even a *triumphator* was only mortal. The troops responsible for it all were put in last place, marching by unit but given (or taking) the liberty to exult in chants and songs and to joke about their masters. Once the march reached the Capitoline, a round of votive offerings, feasting, and ceremonial leave-taking formalized the transition from war to peace. From the legendary age of Romulus to 19 B.C. the official tables list triumphs as well as lesser victory celebrations. After the time of Augustus the highest honor was reserved to the emperor, with *ornamenta triumphalis* for his generals.

The first documented revival of a triumphal procession was Emperor Frederick II's entry into Rome after defeating the Milanese at Cortenuova in 1237. A slightly later miniature in a compilation of Roman history was evidently modeled after classical reliefs.[26] Archeological fantasies and scenes that could have occurred in the streets came together in medieval allegories on the triumphs of virtue—so, for example, Beatrice's arrival in a triumphal cart in Dante's *Divine Comedy* (*Purgatorio* 29.115–54); or Petrarch's *Trionfi* in verse,

where Chastity triumphs over Love, Fame over Death, and Divinity over Time. Making an appearance in a cart drawn by four white horses, Love in Petrarch's poem is "un vittorioso e sommo duce / pur com'un color che 'n Campidoglio / triunfo carro a gran gloria conduce." By the middle of the fifteenth century a definable Petrarchan iconography had spread from painting to engraving and sculpted relief.[27] In crossing the boundaries between media the iconography of triumph also cut across social and cultural distinctions. The allegorical format was employed to celebrate historical figures and ultimately to exalt living princes, and the image of the public event was grafted into domestic art from private manuscripts to wedding chests.[28]

Although three full accounts of the Roman triumph appeared around 1460, this expansive eclecticism was not altogether reined in by humanist scholarship or that new Renaissance fad—archeology. The tenth and last book of Flavio Biondo's compilation of antiquarian lore, *Roma Triumphans* (1457–1459), ended with what he called a "picture in words," but the description offered as a model for a revival of the ancient ritual actually suggests a carnival procession complete with floats, dwarfs, mimes, masqueraders, and marchers from guilds and confraternities.[29] The documents on Alfonso of Aragon's entry into Naples (1443) and the relief on the gate into the Castel Nuovo supposedly patterned after the event suggest more than a touch of carnival in the procession usually cited as the first reenactment of a triumph *all'antica* in the Renaissance.[30] Even the most classicizing pictorial representation of the fifteenth century, Mantegna's great canvases of the *Triumph of Caesar* (1478–1492), freely adapted archeological details or invented them. "Antiquity, for all its attractions, was only a starting point," concludes the most careful student of these pictures.[31]

Yet antiquity was in an important sense an end rather than a beginning of Renaissance versions of the triumph. A standard view of the ancient triumph emerged only after the discovery in 1546 of the Capitoline tablets listing the triumphs decreed by the Romans—and even then debates and differences of opinion continued. Onofrio Panvinio's complete edition and commentary on the inscriptions appeared in Venice in 1558, and the section *De triumpho* was widely diffused after 1571, when it appeared in Latin and in an Italian translation illustrated by a four-part engraving of a triumphal procession.[32] Two years after the appearance of Panvinio's work Bartolomeo Marliani published a commentary criticizing historians from Livy to his own time for conflating quite different ceremonies. Marliani declared, "One model cannot encompass the variety of triumphs that were celebrated in different times and different manners."[33] The nearest target of this line of criticism was Panvinio, who had stressed continuities from Romulus to Charles V. Whereas "antiquity" for Marliani was a closed record of discrete events and distinct motifs, Panvinio, as he said, not only "expounded" but also "emended" the record and (as he did not say) fabricated inscriptions where inscriptions were lacking.[34] This

was the kind of domestic quarrel between strict construction and liberal interpretation played out in any culture that invokes the authority of its ancients.

Marliani was more accurate, but Panvinio became more authoritative for reasons that the strict constructionist found most objectionable. Panvinio's encyclopedic references and schematic generalizations offered a complete guide to a classical triumph, more complete than any real event had ever been. The engravings accompanying the text were instantly intelligible and deceptively objective (figs. 60–63). Here the viewer could see the ideal Roman triumph—one Roman army winding in numbered and labeled units through three separate triumphal arches dedicated to the victorious generals of three different epochs. Inscriptions testified to the authority of the illustrations, from the dedication to Emperor Maximilian II at the top to the copyright granted by the pope and the Venetian republic in the title plate, which also claimed that the engraving was based on "ancient inscriptions, coins, and monuments of literature." Not only did nearly all later images of the Roman triumph depend on Panvinio (text plate IIIa), but in prints showing contemporary triumphal entries that began to appear regularly in the 1570s the ancient model and the Renaissance copy became practically indistinguishable.[35]

In other prints from the later sixteenth century the antic side of the triumph vied with the forced solemnities of the official version. In a Venetian "Triomfo [*sic*] del Carneval" (text plate IIIb) a motley crowd carries the glutton in triumph. His troops are an army of topers and victors at table. Their only captive in chains is a feral pig; their trophies are edible, some of them skewered for a gargantuan feast. The erudition called for by "symbols" such as a necklace of sausages or the sun face on a banner is a kind of iconographical folly. High culture took a low turn here, probably for all the usual reasons—entertainment, escape from surveillance, and the thin line between solemnity and laughter in the great rituals of public life.[36]

The Florentine *trionfi* published by Antonfrancesco Grazzini in 1559 contained chants, songs, and verses for festive occasions, especially at carnival.[37] The chief protagonists of the anthology belonged to the troublesome fringe of the established order, the "youths," the cohort of restive young men from the genuinely poor to the otherwise respectable sons of the elite. As this group emerges from the peripheries of the official record and traditional scholarship, it has come to seem much closer to the political and psychological centers of "serious" life.[38] Although Grazzini claimed that the *trionfi* were "plebeian" and "vulgar" and that "the worse they seem, the better they are and the more pleasing," he wrote with an easy dismissiveness that neither he nor the critics, who complained about errors, loose language, and inadequate censorship, could really have felt.[39] The authorities were surely not as confident about the conservative implications of such performances—for example, as a social safety valve or as social mimicry where the lower orders

imitate their betters—as some of the more anthropologically minded historians have been. One could never quite tell how, or whether, to draw clear lines between broad jokes, serious protest, and grudging deference.

Grazzini's collection of verse underscores the ambiguous relations between the ceremonial order of a new authoritarianism and the margins of society. By far the largest number of poems are cocky songs of wooing mostly willing maidens, daughters, and wives. The bawdy taunt shades into the double entendre and the propositioning innuendo; seemingly sober lines or serious situations are suddenly a pretext or a ruse for prodigious fantasies of food, drink, and sex. And yet these productions channeled libido and liberality into verse and institutionalized them. Occupational groups and neighborhood organizations competing with one another in rhyme diverted what might otherwise have been social criticism or political protest into professional rivalry or the defense of turf. Prizes were offered for the best chants and songs. In the end the established order probably emerged stronger than ever from these carnivalesque transgressions.

By the end of the sixteenth century, then, a whole repertoire of triumphal effects had been codified. Giovanpaolo Lomazzo observed in his *Trattato della pittura* (1585) that triumphs had long been a favorite subject of "painters rich and copious in invention, their hands at the ready, as well as the connoisseurs, well informed about art."[40] The reader had only to consider Lomazzo's inventory. After a lengthy historical survey his earliest Renaissance example is Mantegna's *Triumph of Caesar* in a list including the triumph of Bacchus by Giovanni Bellini in Venice, of Bacchus and Silenus by Titian in Ferrara, of Bacchus again by Daniele da Volterra in Rome, and of Camillus by Francesco Salviati in Florence, not to forget in Rome "the many facades painted with diverse pomp and triumph." Another list cited artists famed for designing triumphal decorations such as trophies—Giulio Romano, Rosso Fiorentino, Perino del Vaga, Giambologna, Luca Cambiaso, Carlo Urbini, and Lazzaro Calvi. Grazzini also cited allegorical triumphs such as Piero di Cosimo's carnival procession of the triumph of death or Titian's engraving of the *Triumph of Religion;* he mentioned too the great triumphal programs honoring illustrious men—Albrecht Dürer's engravings of a triumph for Emperor Maximilian I, for example, and the apparatus for the various entries of Charles V, Francis I, or Duke Cosimo de' Medici. We even glimpse the underside of the official mode in Lomazzo's disapproval of "gross and heavy" gestures indulged in by some artists.[41] The form was so capacious, the theme so all embracing, Lomazzo concluded, that triumphs could be devised "of any sort that one may desire."[42]

Most triumphant in this march over time and media is the theme of triumph itself—hence the need to characterize a whole complex of "triumphal-

ist" forms and functions. Renaissance writers would have understood such a complex readily enough as a *concetto,* as both an inspiring and a controlling concept or conceit. In the jargon of our own time we can think of triumphalism on the model of linguistics as a "paradigm" governing the inflections applicable to specific sets of conditions or as a "discourse" combining the topics and tropes of a distinctive field of meaning. In the language of cultural anthropology it would be a master "myth" that a given society or regime replays and reworks dynamically through any number of variations. The common factor here is the emphasis on scheme and system or, in another charged contemporary term, "structure."[43]

However we choose to describe it, triumphalism in the grand manner of the sixteenth century presupposed a set of organizing principles and a fixed repertoire of motifs. As we shall see, it involved simple formulas amidst complex forms, limited meanings in an endless proliferation of means, impersonal routine in a show designed to rivet personal attention. To define the logic of this system, to decipher the triumphalist code, is to enter something akin to a structuralist's paradise. Yet, as we shall also see and might expect from recent lines of poststructuralist criticism, the code was shot through with instabilities and contradictions. With the expansive order of the high triumphalist mode came the proliferation of supernumerary effects that strained the order of the system and exposed its limitations. Moreover, the purely formal patterns of the system can hardly be divorced from ideological implications and political intentions, least of all in the formal patterns operating in ceremonies for rulers and halls of state in the later sixteenth century.

Triumphalism, then, was not only a template for an empire of signs; it was also an imperial simulacrum of the world and a political program for its domination. The triumphalist scenario was one way of making sense of the more than half a century of upheaval that new technologies of war and diplomacy had vastly enlarged. During the early sixteenth century there had been many victory celebrations, and few convincing victors, but from around midcentury real winners did emerge, including Charles V and the puppet princes of Italy. And in the wake of foreign conquest Italian rulers proclaimed—none more insistently than the duke of Florence—triumphs in all things and settled into the work of believing the images mirrored back to them in a high triumphalist mode.

PROCESSION AND PASSAGE

As it moves across actual space and time a procession may also negotiate a symbolic passage in individual or collective life. An inaugural procession, a wedding march, a pilgrimage to a shrine, a funeral cortege, or for our purposes a triumph are all rites of passage of this sort. We have seen that triumphal celebrations have been paradigmatically, if not exclusively, processional

in character. Why should this be so? What is anticipated or effected by the processional itinerary through streets, squares, and triumphal arches?

Anthropologists tell us that, like the pre-Socratic philosopher's river, processions are always different and in some sense always the same.[44] The differences between the victory parades, carnivals, and entries of the Renaissance triumph are clear enough. Even so, the processions staged on such occasions were all what the anthropologists would call "liminal" events. They marked discontinuities, the thresholds or *limina* between the end of war and the beginning of peace, winter and spring, the approach and the arrival of some preeminent authority. At the same time, by spanning discrete phases or conditions, these processions literally and symbolically linked space and time between one state of affairs and another. The victorious leader brought home the troops and the booty, the old season ended and the new one began, the distinguished visitor was feted en route to new undertakings.

There would probably have been fewer processions if these transitions had been predictably smooth and easy. In the classic case of the victory parade, to demonstrate that might indeed makes right can just as well threaten the peace as win the war. With some quick turn of events the surging army, the cheering crowd, the victorious hero may become an insurgent force, a mob in the streets, or a seditious general. It is surely not true that "everybody loves a parade," but the powers-that-be have often had good reason to worry over the alternatives. The triumphal procession draws a thin line between exultation and fear. The controlled release and stylization of disorder are the order of the day for a triumphal parade.

As public testimony, a procession solicits witnesses, implicates them in its effects, and seeks, more or less explicitly, to secure their approbation—or, if necessary, to overwhelm signs of resistance. It draws people from private into public spaces; it forms ceremonial links among otherwise distinct individuals, groups, districts, and territories. And yet a celebration of unity occurring at moments when unity may be in question exposes differences between the special event and ordinary experience; it opens the gaps between the utopian and the quotidian. The crowd assembled for the performance may decline to play the part assigned to it. The authorities can never quite tell whether their efforts will be met by cheers, silence, or defiance, least of all when spectacular demonstrations of official successes are most urgently needed.

The most reliable of processions, then, are the oxymoronically permanent ones we find in literature and in art. The ephemeral triumph lasts only in its representations, and only in words and images is the procession sure to proceed according to plan. In the representation at least the triumph never ceases, never fails to master the opposition and celebrate real or imagined victories. By the later sixteenth century representational techniques had been codified for triumphal scenarios "of any sort that one may desire," as Giovanpaolo Lomazzo put it. As we shall see in some detail, there were triumphal

processions of two sorts in Florence in 1565. One conducted Giovanna of Austria through the streets; the other, no less processional in structure and function, is still under way in the decorations of the Sala Grande in the Palazzo Vecchio.

TO THE VICTOR BELONG THE SPOILS

Although it is quite possible to imagine a triumphal procession staged without a real victory, there must be a semblance of victory and a show of spoils. Triumphs, even if they are faked or fabricated, must represent agents or actors as victors in a struggle against some losing counterpart. Gods or demigods, soldiers or civilians, collectivities and their causes may end up in this role. But it will be played and, where proof is called for, verified by some display of goods given up by another side.

These devices work to simplify the complicated proposition of winning. Since there are always indecisive beginnings and subsequent histories to any victorious end, the maxim To the Victor Belong the Spoils is a necessary, if also a necessarily misleading, proposition. The Greeks determined the victory after the fact by erecting trophies stripped from fallen enemies at the "turning point" (*tropaios*) of a battle. Exposing their arms to the elements was intended as much to obtain the assent of gods and men as to destroy their capacity for harm. A Roman triumph remained incomplete until the *triumphator* had passed along the prescribed route to the sacred precincts where offerings were made at the loser's expense.[45]

These examples point to a ceremonial inversion of cause and effect, to the victor and the tokens of victory as outcome rather than origin of a triumphal ritual. The victory celebration makes the representation of victory possible by condensing countless little histories in the persona of a victor. The abstraction of a "cause" (in all senses of the term) is embodied in him; he incorporates the exertion and, so one might want to believe, redeems the sacrifice of bodies that otherwise go unredeemed. Enemy arms, treasure, and insignia are proofs of victory when they are amassed and displayed as such. In effect the means justify the ends, and the triumph produces the victory.

However, it does not end the conflict between warring elements of signification. For while the persona of the victor centers and concentrates attention, a profuse display of the spoils decenters and disperses it. The ritual obligation of the victor is to surrender what he has won to the altar, to his followers, and to the community. In this sense the figure incorporating victory is disembodied and divested by his conquest.

Noting the proliferation of trophies in art, first among the ancients and then, practically "without distinction" in his own day, Giovanpaolo Lomazzo thought that trophies were originally nothing more than "victorious plunder carried away from the enemy" and "borne along in triumph as a sign of the

quality of the victory and afterwards offered to the gods for the grace peti-
tioned from them."[46] With many kinds of victory and many gods to commem-
orate the ancients had already constructed trophies out of many different em-
blems and instruments. So, for example, the triumphs of the gods with their
appropriate attributes, from the nets, ropes, arrows, bows, and spears of Di-
ana to Pomona's baskets loaded with fruit. Eventually the ancients extended
the practice to all the arts and crafts so that cymbals, trumpets, and drums
were heaped up together as trophies of musical triumphs, while triangles,
pentagons, squares, hectagons, and circles became symbols of triumph in
mathematics, architecture, or engineering. Lomazzo complained that contem-
poraries had carried this abuse beyond all restraint. "There is practically no
place that is not smeared with such trophies"; they are used "not only as
ornaments for masks, for history paintings, for arches, and for loggias, but
also in temples around sacred figures, in the ornaments of chapels . . . and
on the pilasters, in which places they are made to swirl around children and
angels."[47]

THE PROGRAM TRIUMPHANT

Taken together, the parade, victor, and spoils constitute a stock of motifs, a
series of specifications, or a plan of operations for a triumphalist program.
But triumphs are programmatic in other senses as well. Occasional produc-
tions or command performances keyed to some particular situation or setting,
they "program" special interests and agendas. As a *programma*, a public text,
notice, or manifesto (from *prographein*, "to write in front of, in public"), a tri-
umph of any sort calls for public witness, if not necessarily for any particular
number of witnesses; it gives notice and makes manifest. And these features
presuppose a text, whether spelled out in writing or not, as their script and
message.

Written programs for triumphal celebrations survive from the sixteenth
century, for reasons that we shall have to consider, but their existence be-
fore that can be inferred from the record. One of the most vivid descriptions
of an ancient triumph, Plutarch's account of the triumph of Paulus Aemilius
(167 B.C.), was written nearly two hundred years after the event; if Plutarch is
accurate, as scholars have supposed, he must have had something like a de-
tailed outline to follow for his schematic version of the occasion.[48] Renaissance
triumphs were clearly textual productions. Piero di Cosimo's great *succès de
scandale* was a float for the carnival of 1511 evoking Petrarch's poetry on the
triumph of death. At first dismayed by the macabre effects, the Florentines,
according to Vasari, came to admire the ingenuity of the spectacle, especially
the programmatic meaning that many took to lie in the words chanted by the
masked figures of death: "We are dead as you see; and dead so shall you
be . . ." Some spectators thought that these lines predicted the return of the

Medici from exile to settle accounts with their enemies. Whether this particular interpretation was correct or not, interpretation itself, the reading of a program, was obviously expected from the audience. Vasari specifically identified the programmers of the carnival triumphs celebrating the election of Giovanni de' Medici as Leo X in 1513, and his descriptions, it has been suggested, unfold as if he were following a written text word for word.[49]

By the second half of the sixteenth century the formal *ragguaglio*, prospectus, or guide was practically an established genre. We have programs for festivals of all sorts, many of them officially printed, often with engravings or diagrams.[50] As we have seen, antiquarian reconstructions of classical triumphs were schematically described and represented in the same formal terms as modern *trionfi* (text plate IIIa). Over time the program "beneath" the representation came to be ever more explicitly imposed "on top" of it. This compensated for iconographical complexity; it was one way of assuring that something intended would not be missed. Conversely, and even more important perhaps, the written program meant that nothing unintended could be added. Addressed to, and created for, a circle of dutiful readers, it transformed participants into spectators at the same time that open-air festivities were being drawn indoors into theaters with an enclosed audience and a fixed bill.[51]

All this implies institutional arrangements and an institutionalized aesthetic administered by teams of cultural bureaucrats, designers, and artisans. Roman triumphs were highly institutionalized. We know that they were governed by the rules and regulations of boards of magistrates such as the *Epulones*, or feast organizers. These commissioners were the distant ancestors of the *festaiuoli* who appear with responsibilities for supervising communal processions and celebrations in the records of the Italian city-states from the fourteenth century on.[52] Their descendants appear in turn as the impresarios of the great triumphalist extravaganzas of the later sixteenth century.

Despite, or because of, its structured agenda, the triumphalist program prescribes an art of inflation. The "epideictic" rhetoric of praise and blame is its characteristic mode, and its appropriate technology is what ancient writers and their Renaissance epigoni called the "abundant" style, or *copia*.[53] Erasmus's working manual *De copia*, first published in 1512, expanded through several editions until 1534, and many times reprinted thereafter, cites a genealogy of ancient practitioners (Virgil, Cicero, and Apuleius) and teachers (the Greek sophists and Quintilian) who had shown how "the speech of man is a magnificent and impressive thing when it surges along like a golden river, with thoughts and words pouring out in rich abundance."[54] "Being able to express one's meaning in a variety of ways" is the ideal generating this initial demonstration of copiousness in a book that runs to nearly three hundred large pages in its modern edition. In other words—and nothing is left concise in the copious style—the aim of Erasmus's book is to show the reader how "to

turn one idea into more shapes than Proteus himself is supposed to have turned into."[55] The body of a discourse becomes its immaterial core and its variations or Protean "shapes" its manifest substance.[56]

The two books of Erasmus's treatise divide *copia* between two chief requirements: "variety of expression" and "abundance of subject matter." In phrases underwritten by the notion that language is something pictured, variety begins with having all the resources of the lexicon "not only at the ready but in full view, so that they present themselves to the eyes even if you are not looking for them."[57] Twenty chapters of the first book explain how different tropes and tactics of composition can be used to diversify one's style. More than two-thirds of the second book consist of practical demonstrations, including a virtuoso exercise of nearly two hundred variations on "Your letter pleased me mightily,"[58] and nearly three hundred versions of "Always, as long as I live, I shall remember you."[59] The exercises stretch the surface, without probing beneath it; dilation and amplification are the requisite techniques—and effects. Erasmus's work envisages a culture where vast treasures of detail have been sorted out, heaped up, and tagged by category and class. This is in its own way a high-technology culture dependent on the mechanical aids of indexes, concordances, anthologies, dictionaries, and encyclopedias.

Let us take the theme of triumph as an exercise in the copious style. First we scan the treasury of the mind's eye. The word "triumph" itself turns up at the head of a column of available usages. Moving down the column, we come upon various synonyms (victory, mastery, domination, etc.), personifications (Alexander or Caesar—or Jesus Christ), and allegories (for example, triumphs riding the tide of good fortune or divine favor, bringing the ship of state into port, charted by courageous captains). Under the heading for "Famous Triumphs" we have at our disposal the classic historical descriptions and texts of the poets, such as Petrarch's *Trionfi*. We could also draw on a stock of maxims—To the Victor Belong the Spoils might be one—and old debating points, such as whether fortune favors prudence or passion. Finally, ranging over this rhetorical booty, we piece together and enlarge upon our authorities at will. We can divide a triumph into parts, enumerate the circumstances leading up to it, and produce a detailed description "so that we seem to have painted the scene rather than described it, and the reader seems to have seen rather than read."[60] At any point we may add "stories, fables, proverbs, opinions, parallels or comparisons, similitudes, analogies, anything else of the same sort . . . not only to make our case look convincing but also to dress it up, brighten, expand, and enrich it."[61]

These methods will fashion as much *copia* on triumphs as one could possibly desire, and then some. Indeed, there is no sure way of knowing where to stop. Thus, while the virtues of *copia* are copiously elaborated by the theorists, so are their warnings against its "excess," "overabundant and extravagant expression," "confusion and disorder."[62] We should expect tensions,

then, whenever triumphs are claimed for a complete program or for a fully programmed triumph. In the perfect system the fundamental sameness of some order, a pattern but also a command, should extend and resonate through the furthest corners of a galaxy of detail. Yet the capacity for expansion and a totalizing drive for inclusion also promote a boundless semiosis of tokens of new conquests.

A TRIUMPH OF TRIUMPHALISM IN FLORENCE

Among the Italian audience halls of the later sixteenth century, the Sala Grande of Florence is an ideal test case of triumphalism (color plates 7–8). It was completed to receive the triumphal entry of Giovanna of Austria. Further, essentially the same planners and artists employed a shared idiom and common techniques for both the entry and the decorations of the Sala Grande. By interweaving an analysis first of the entry, reconstructed on the basis of drawings and descriptions, then of the Sala Grande we shall see how their structural principles generate both the ephemeral and the permanent production of triumphalist effects.

THE PARADE

The Triumphal Entry of 1565 When Giovanna of Austria reached the gates of Florence on 16 December 1565 she and her retinue had already made a triumphal progress from Innsbruck to Tuscany by way of Trent, Mantua, and Bologna. In Tuscany she had been received first at Cafaggiolo, the Medici villa north of Florence on the main road from Bologna, and then had detoured to wait for a week at Poggio a Caiano, the Medici villa west of Florence. It had rained throughout this week, but on the day of the entry it cleared and the sun shone on a beautiful day.[63]

Many hundreds of people gathered at the staging ground for the parade some two miles outside the city. The procession that set out with Duke Cosimo and Giovanna in the center included representatives from almost every conceivable Florentine and Tuscan class and institution, together with a host of luminaries from other courts of Italy and Europe, all grouped according to ceremonial protocol: dukes, marchesi, counts, barons, *signori*, cardinals, archbishops, bishops, clergy, ambassadors, auditors, councillors, senators, magistrates, doctors, lawyers, knights, commanders, lieutenants, sergeants, foot soldiers, trumpeters, drummers, pages, servants, and shield bearers. At the Porta al Prato fifty light cavalry and four thousand infantry staged a mock battle. As arquebuses cracked to the accompaniment of trumpet blasts, drum rolls, shouts of the populace, and cannonades from the Fortezza da Basso and

San Miniato, "it seemed," according to the official script, "as if the base and foundation of the universe were shaken and the ears of all were deafened."[64] A calm, all the more stately by contrast, descended while Giovanna was crowned before the city gate with the ducal crown or *mazzochio* by the archbishop of Siena and the bishop of Arezzo.

After the coronation, the main body of dignitaries formed under a huge canopy carried by fifty youths and the procession continued through the decorated streets of Florence to the Palazzo Vecchio with a brief stop at the cathedral. But the procession was far more than a physical passage from villa to palace. Both the parade and the decoration structured a passage across times, spaces, social classes, family genealogies, political regimes, economic orders, and aesthetic styles.

Initially Vincenzo Borghini, the chief planner of the occasion, wanted the procession to go directly from the Porta al Prato to the Palazzo Vecchio by way of the newly built Mercato Nuovo. This itinerary would have capitalized on the dramatic oblique view across the Piazza della Signoria to the massive Palazzo Vecchio with its soaring bell tower.[65] But even though the more traditional route meant entering less impressively into the Piazza della Signoria from behind the Palazza Vecchio, Cosimo—the self-styled "new Augustus"—insisted that a ceremonial reenactment of the city's founding should trace the location of the walls of the original Roman *castrum*[66] and pass the city's two major Roman monuments: the newly erected Column of Victory, Pius IV's gift to Cosimo I from the Baths of Caracalla in Rome,[67] and the Temple of Mars, as the baptistery was believed to have been.[68] (See the route of the procession in fig. 64.) The erection of classicizing arches to focus and unite the various axial corridors (not to mention the Roman architectural vocabulary, Greek and Latin inscriptions, and classical deities and motifs used for their decoration also evoked the "rebirth" of Roman Florence under the ducal regime. Nevertheless, the parade route passed the city's major medieval monuments—the cathedral, Palazzo del Podestà, and Palazzo Vecchio—and the decoration included personages and narratives from both the republican and ducal eras. In effect, the procession encompassed the postclassical history of Florence as if it were seamlessly unified within a common classical core.

Even so, the very notion of rebirth implied disjunction and discontinuity. The embellishments calculated to hide blemishes and to unify the cityscape were shams of paint, stucco, clay, and canvas over "ugly scaffolding and woodwork";[69] the parade route itself accentuated the essential medieval character of the city and the republican provenance of its major civic monuments. Even if the baptistery had been built by the Romans, Cosimo's new Rome would still have boasted of a pathetically small number of ancient artifacts. Nor could the strategically placed Arch of Maritime Empire (figs. 64: 4; 68) fully disguise the fact that in eight years the regime had been unable to repair the washed-out Trinita bridge.

Seemingly unified and harmonious as it moved across the city, the parade nevertheless defined and exposed social differences. From duke to shield bearer sharp distinctions in power and status were delineated by the color, cut, and cost of the costumes, by the order of march, by the inclusion or exclusion of the participants under the baldachin, by whether they rode on horseback or walked on foot, and so forth. Not so evident, but certainly felt by participants, was the presence of the duke's "new men," the creatures of a more open civil service recruitment for the state bureaucracy and tax and legal reforms, who undercut and challenged the privileges and exemptions of the old patrician families. Tensions would have been further heightened by the network of informers and the foreign police force who patrolled this show of apparent unity and harmony.[70]

"To satisfy the fancy and taste" of the lower orders Borghini proposed two wine-spouting fountains (figs. 64: 4, 11; 68: 3; 75: 4).[71] He also noted that "whereas good princes should not make it a fundamental policy to entertain the people with such pastimes, still they should not scorn them altogether, because for the entire well-being of a city it is not enough that its citizens be occupied with trades, rich in goods, harmonious among themselves, and at peace with their neighbors, since it is necessary at times to make them happy and to gladden them; therefore, the Romans with great gravity and the Athenians with great wisdom did not disparage these delightful and popular celebrations and entertainments."[72] Borghini's idyllic picture of the *popolo* and recourse to scholarly pedantry flattered Cosimo with the wisdom and gravity of the ancients in attending to the peace and prosperity of all his subjects. Unstated, of course, was Cosimo's dependence on the good will of the populace for the success of the entry procession, his need to negotiate a safe passage through an underclass whose resentment could break out into dangerous hostility.

The triumphal arches and monuments articulating the processional route were themselves designed to negotiate a passage through the claims, conflicts, and anxieties of the regime. The Arch of Florence decorating the Porta al Prato (fig. 65) was the largest and most elaborate of the temporary arches, since it not only represented the city but also had to create, according to Borghini, a vitally important first impression.[73] For Vasari, the arch "built with dimensions truly heroic" and "visible not only to those entering the city, but even at a distance of several miles," "well showed ancient Rome risen again in her beloved daughter Florence."[74] Ancient roots and imperial destiny were also represented by two devices simulating Roman medals: a *deductio*, or founding of the Roman colony, and the Marzocco, the Florentine lion of Mars, holding a shield inscribed TRIBU SCAPTIA, "the tribe that was of Augustus, the founder of Florence" (figs. 65: 16, 25; 86).[75]

Between these devices stood statues of Mars and a muse, personifications

of Arms and Letters (fig. 65: *4, 6*), the two supreme attributes of imperial rule, according to a standard topos in mirror-of-princes treatises.[76] Because Arms "concerned external affairs," while Letters "concerned the internal affairs of civic government,"[77] these allegories also betokened the arch's function—to effect a transition from outside to inside the city. Beneath Arms and Letters large chiaroscuro paintings depicted noted military heroes and men of letters from classical antiquity to the Renaissance (fig. 65: *5, 7*). In the ranks of the former the presence of Francesco Ferrucci, who lost his life defending the Florentine republic against the Medici in the siege of 1530, only hinted at the conflicts embraced by this show of historical continuity. Similarly, the visual unification of Augustan legionnaires, Florentine knights, and foreign mercenaries masked the troubled Florentine debate from the early fifteenth century up to Cosimo's day over the relative worth of knights, infantry, civic militia, and mercenaries.[78]

The Arch of Austria and Tuscany at the entrance to Borgo Ognissanti featured two colossal female statues personifying Austria and Tuscany, dressed respectively as a Roman warrior and an ancient priestess (fig. 66: *1–2*). The paintings flanking the statues (fig. 66: *3–4*) depicted major imperial and Tuscan cities. "Passage through" was also intended to invoke "unification between" Austria and Tuscany because, as Vasari wrote, the allegory of Austria "wished to signify that she was come parentally to take part in the rejoicings and festivities in honor of the illustrious bridal pair, and to meet and embrace her beloved Tuscany, thus in a certain way uniting the two most mighty powers, the spiritual [Tuscany] and the temporal [Austria]."[79]

Union across space and time: this was also the principal theme of the next two arches along the processional route. The triumphal arch at the Ponte alla Carraia (fig. 67) commemorated the marriage of Francesco and Giovanna on the model of the nuptials of Peleus and Thetis attended by the Olympian gods under the auspices of Hymen. On the base of the arch a pair of classical river gods embraced to represent the rivers that traversed Tuscany and Austria— the Arno and the Sieve, and the Danube and the Drava (fig. 67: *4–5*). At the next arch at Ponte Santa Trinita, the procession made yet another figurative passage across the Tyrrhenian Sea to Elba, and across the oceans to Peru and the New World—spheres of Medici and Hapsburg maritime influence represented by two classical giants and related paintings (fig. 68: *1–2, 8, 10*).

At this point the procession had traveled almost halfway to the Palazzo Vecchio yet had passed only four of the fourteen monuments articulating the route (fig. 64: *1–4*). The disproportionate length of the itinerary to these four arches suited the theme of territorial expansion, although the repeated juxtaposition of Tuscany and Austria also exposed the pretense of Florentine grandeur in a larger world over which the Medici court had little control except by art and artifice.

In any case, the nature of the decoration changed when the procession

turned the corner at the Ponte alla Carraia and entered into the Piazza Santa Trinita. The Column of Victory (figs. 69, 79) newly arrived from Rome recalled the alleged Roman founders of the city—Augustus, Mark Antony, and Lepidus—and anchored the southwest corner of the old *castrum* (fig. 64: 5). It also set the stage for the next triumphal arch at the Canto de' Tornaquinci representing the imperial genealogy of the Hapsburgs (figs. 64: 6; 70). This arch in turn opened to a theater at the Canto de' Carnesecchi dedicated to Medicean genealogy (figs. 64: 7; 71). According to Vasari, "the intention was, after bringing Austria [on the previous triumphal arches] to the most splendid nuptials with her cities, rivers, and oceans, and after having caused her to be received by Tuscany with her cities, the Arno, and the Tyrrhenian Sea, to introduce then her great and glorious caesars, as if they, having conducted thither with them the illustrious bride, were come before to meet as kinsmen with the house of Medici, and to prove of what stock, and how glorious, was the noble virgin whom they sought to present to the Medici; . . . then, having introduced the triumphant caesars, to bring the magnanimous Medici to do honor to the new-come bride."[80]

Set within classicizing architecture and dressed mostly in Roman armor, these Hapsburg and Medicean effigies mediated between past generations, their living progeny, and generations yet to come. Their bloodlines and titles appeared to be rooted in, or at least heir to, Roman antiquity; together they controlled, or had controlled, an area close in size to the old Roman empire. Dominating the back of the Arch of Austria with its pillars of Hercules and motto *Plus Ultra*, the device of Charles V alluded to a dominion actually extending well beyond the mythical boundaries of the ancient world (fig. 70: 17).

In his letter to Cosimo of 5 April 1565 Borghini made much of the visual and verbal linkage between the decoration of the Arch of Austria and the Theater of the Medici.[81] Both represented the chain of Hapsburg and Medici command over Austria and Florence from the past to the present. Maximilian II, father of the bride, and Cosimo I, father of the groom, appeared in analogous positions over the principal arch of each construction; the imperial arms of the one and the ducal arms of the other centered the two major facades, which had similar inscriptions. There were other ties between the personages shown on the two monuments: Charles V had conferred the ducal title upon Cosimo I; he was the father-in-law of Cosimo's predecessor, Alessandro, and had been crowned emperor in Bologna in 1530 by the Medici pope Clement VII; the daughter of Catherine de' Medici, the queen of France, was the wife of the Hapsburg king of Spain, Philip II; Garzia de Toledo, the brother of Cosimo I's wife, Eleonora, as a prominent member of Philip II's court. And so forth. The procession between one corner and the other thus symbolically united the houses of Medici and Hapsburg on the occasion of yet another marriage between the two families—all the more so because these dynastic bonds were fragile and served to make the Medici more subservient than equal. Except in

effigy, not a single member of the imperial family was present at the wedding aside from the bride. Besides, nothing was more problematic in any dynastic state than continuity, as Cosimo I knew only too well from the extinction of Cosimo il Vecchio's line with the death of Duke Alessandro in 1537, and from the recent unexpected death of his wife and two sons in 1562.

The Theater of the Medici negotiated an awkward turn in the parade route (fig. 64: 7). The shift in direction again signaled a change in the nature of the decoration, since the four-faced Arch of Religion at the Canto alla Paglia figuratively converted the procession through it into a spiritual passage (figs. 64: *8; 72*). A personification of "the most holy Christian religion" surmounted the principal west facade (fig. 72: *1*). In the attic (story above main entablature), three paintings depicted Melchizedek offering bread and wine, Moses and Aaron sacrificing the paschal lamb, and the chalice and host of the eucharist (fig. 72: *8–10*). Together they represented "the three kinds of true religion [before law, of law, and of grace] that have been from the creation of the world down to the present day."[82] At the summit of the east facade was "a most beautiful altar all composed and adorned after the ancient use, upon which, even as one reads of [the altar of] Vesta, was seen burning a very bright flame" (fig. 72: *22*).[83] In the attic below a tableau depicting the Romans learning religion from the Etruscans was flanked by scenes of Roman augury and sacrifice (fig. 72: *25–27*). On the lower portions of the arch, paintings represented the founders of the Roman church and the five founders of the principal Tuscan religious orders, from St. Romualdo to Cosimo I (fig. 72: *12, 16, 29, 32, 35–39*).[84] Inasmuch as these events occurred in the Holy Land, Rome, and various locations in Tuscany, the arch projected the metaphorical reach of the procession still further across time and holy space.

"The principal device" of the arch (figs. 72: *6; 84*), "the ancient labarum with a cross and the motto IN HOC VINCES [By this you will conquer],"[85] was a sign of the triumph of Christianity under Emperor Constantine. Yet the aggressive romanizing of the arch, and indeed of nearly all the entry decoration, as well as the evocation of Etruscan piety (fig. 72: *25*), appropriated divine sanction for the regime over and above the traditional ecclesiastical authority. On the Arch of Austria and Tuscany, the personification of Tuscany as an ancient priestess held her own against the military might of Austria (a Roman warrior) by virtue of "the excellence that the Tuscan nation has always displayed from the most ancient times in the divine cult" (fig. 66: *1–2*).[86] The Arch of Florence had already alluded to the city's divine favor under the zodiacal sign of its Roman founder, Augustus. According to Vasari, the "principal device [on the Arch of Florence; figs. 65: *26; 79*], composed of two halcyons making their nest in the sea at the beginning of winter with the sun entering into the sign of Capricorn which renders the sea smooth and tranquil," signified that "Florence, with Capricorn in the ascendant, is able to flourish in the greatest felicity and peace."[87] To at least one observer it was

clear that this classical numen had endured: after a week of rain, he wrote, the day of Giovanna's entry was "very beautiful and calm," "one of those days called halcyon days, confirming what the device of the halcyon birds prophesied."[88] In any event, the court of classical deities silhouetted against the sky on the Arch of Florence, like the classical altar on top of the Arch of Religion, were channels of a particularly pagan divinity. Just so, writes Vasari, "the principal device [on the Arch of Hymen; fig. 67: *11*] was a gilded chain composed of marriage rings with their stones, which, hanging down from heaven, appeared to be sustaining this terrestrial world, alluding to the Homeric chain of Jove, and signifying that by virtue of nuptials—where heavenly causes are wedded with terrestrial matter—nature and the world are preserved and rendered eternal."[89]

But, of course, the "wedding of heavenly causes with terrestrial matter" could hardly be allowed to offend the Church in the age of the Counter-Reformation. Orthodoxy was a must, even if cooperation with the Church had offered no political advantages to Cosimo, who suppressed dissent in the name of religion and demanded the title of grand duke from the pope as a reward. Thus, statues of Grace and Good Works, the twin foundations of salvation according to post-Tridentine theology, were prominent on the temporary arch framing the central doors of the cathedral with the life of the Virgin in ten stucco reliefs (fig. 73). High clergy from the major Tuscan cities played key roles in the actual procession, not only crowning Giovanna before the walls but also conducting religious ceremonies in the newly whitewashed cathedral where the nuptials took place two days later on 18 December. (Giovanna stopped and dismounted only for these two rituals in her progress to the Palazzo Vecchio.) Finally, the procession was staged on the third Sunday of Advent, the liturgy for which recalled the precursor's role of John the Baptist, the patron saint and protector of Florence. As the party would have been reminded by the stucco reliefs on the Arch of the Virgin Mary, the patron of the cathedral was the Christian Flora, Saint Mary of the Flowers, whose feast of the Annunciation (25 March) marked the supposed springtime founding of the city under most favorable auspices. And to reemphasize this connection the marriage festivities ended officially in March of the following year with the staging of the traditional drama of the Annunciation in the church of Santo Spirito.[90]

Sala Grande Giovanna was met by her bridegroom on stepping through the Arch of Security (figs. 64: *14; 78*) into the courtyard of the Palazzo Vecchio (fig. 89) en route to the Sala Grande. The moment of conjunction between the houses of the Medici and the Hapsburgs may have been staged at this particular location because by tradition courtyards in the palaces of rulers could represent microcosms of city or state.[91] The decoration included views of fifteen Hapsburg towns[92] interwoven with fourteen simulated medal reverses com-

memorating signal events of recent occurrence in Tuscany.[93] Giovanna's procession through the courtyard—measured by the regular succession of the columns—was, therefore, simultaneously an actual passage to the very center of Florentine power, and a symbolic parade of (and through) the major achievements of ducal Tuscany and the principal geographical centers of the Hapsburg empire. The simulated Roman medal reverses and Roman-style grotesques on the portico vaults, as well as the gilt classical capitals, fluting, and grotesque work on the octagonal piers, ornamented an aesthetic trajectory back across time to antiquity, the supposed model and root of ducal and imperial power. This power was called into question here again, however, by the ad hoc character of these signs—thin veneers of fresco and stucco *all'antica*—superposed on a Gothic (and republican) fabric.

Probably because a courtyard is geometrically regular, partially covered and partially open to the sky, it has been seen as an *axis mundi* where heaven and earth conjoin. Verrocchio's bronze fountain figure of *Cupid with a Dolphin*, moved from the Medici villa at Careggi and installed in the courtyard eight years before, figured such associations here.[94] Apparently driven by a water jet, the slowly rotating and spiraling *figura serpentinata* with its fleeting stance and widespread wings suggested that the smiling and joyful Cupid had just flown down from heaven to the land and oceans of the earth evoked by the globe under his foot and the fish in his arms. As the agent of Venus, and so of love and fecundity, Cupid was an especially appropriate emblem for the wedding festivities.

From the courtyard Giovanna and her retinue—at this point consisting of only the highest ranking dignitaries—proceeded up Vasari's new stairway (figs. 90–91). Like the entry decoration, this passageway channeled movement and encouraged free flow as the triple-ramp stairs turned back on themselves in order to keep the gradient, in Vasari's words, "gentle and pleasant, so that going up is almost like walking on the level."[95] But this monumental stairway had an uplifting psychological effect as well, subtly preparing the participants for the spectacular finale awaiting them in the Sala Grande.[96]

As in most audience halls, the entrance to the Sala Grande was not at the end, where visitors could instantly perceive the full impact of the scale and the organization of the space, but on the side (fig. 93: *b*). This introduction in medias res was rather like that of spectators at a parade where the full extent of the procession only gradually unfolded. Once inside the hall their experience was more like that of being *within* a procession. The rectangular shape of the space, and the running bands of architectural elements and painted decoration placed symmetrically on the floor, walls, and ceiling compelled movement down the center (fig. 92). The head of the hall was articulated by a triumphal arch motif, the foot by the (planned) Fountain of the Rain, both providing focal points at either end of the processional axis similar to those Giovanna had passed along the entry route (fig. 93). The pictures in the ceil-

ing along the central longitudinal and transverse axes included coats of arms, standards, allegories, and emblems of Florence and its guilds, quarters, and *rioni* (wards); there were also six views of the city, each with processions, one passing through a triumphal arch (figs. 93: *1–5, 8–9, 35, 45*; *94–99*; *102*; *108*; *113*). These elements recast the experience of parading through Florence itself.

While simulating a review of the physical city and its institutions, the hall's processional route passed beneath pictorial narratives of six key moments in Florentine history: the founding of the city by the Romans, its first military victory, its earliest territorial conquests, the expansion of the city to the third circuit of walls, the foundation of the Guelph party, and the reception of Pope Eugenius IV under the first Medicean regime of the early fifteenth century (figs. 93: *2–7*; *96–101*). Along cross-axes from this central band of pictures, additional scenes extended the decoration across space and time to the major cities and regions of Tuscany, and the wars of Pisa and Siena that resulted in the two most important additions to Florentine territory. The two roundels at either end of the central band displayed the insignia of the four quarters of Florence in their correct positions vis-à-vis the Sala Grande: Santa Maria Novella and San Giovanni to the north, Santa Croce and Santo Spirito to the south (fig. 93: *8–9*). Views of the cities and regions of Tuscany appeared in clusters of four panels near the side of the quarter to which they were administratively subject[97] and in positions corresponding to their compass directions from Florence (figs. 93: *10–13, 14–17, 18–21, 22–25*; *103*).[98] The scenes of the republican conquest of Pisa (1496–1509) were located appropriately to the west (fig. 93: *26–31, 35*), while those of the ducal conquest of Siena (1553–1555) appeared on the east wall (fig. 93: *36–41, 45*).[99] This expansion from the central axis of the ceiling was intensified by the temporary paintings on the side walls showing the civic centers of the ten largest towns in Tuscany, probably also arranged on the walls according to their approximate directions from Florence.[100] The planned fountain representing or alluding to major rivers of Tuscany (the Arno of Florence and Pisa, and the Arbia south of Siena) as well as the temporary paintings high on the four corners of the walls embracing the entire decorative ensemble referred to the Florentine empire on land and on sea (fig. 93: *49–51, 60*).[101]

At the head of the hall the statues of Giovanni delle Bande Nere and Alessandro de' Medici, flanking Cosimo I's throne, represented the two collateral lines of the Medici that had been more fully portrayed by the effigies on the Theater of the Medici (figs. 93: *54, 56*; *116*; *118*). Five crystal chandeliers shaped like ducal crowns honored the line of Medici dukes and lighted the center of the hall in front of the temporary stage for a play performed the day after Christmas.[102] Above the stage at the south end three chandeliers in the form of imperial crowns alluded to Giovanna's lineage: her grandfather (Charles V), father (Ferdinand I), and brother (Maximilian II).

Above all the decoration, like the entry, emphasized linkage through time from the present across the republican era to classical antiquity. The dimensions of the hall were truly Roman in scale,[103] and the structural changes made to regularize it drew upon the planning principles and architectural vocabulary of ancient Rome. Many of the scenes were designed according to Roman compositional formulas; a number of actors within the scenes wear Roman costumes; triumphal arches and chariots, classicizing grotesques, putti, festoons, devices, and mythological figures appear throughout, along with Latin inscriptions in Roman lettering with classical turns of phrase.

Like the entry, too, the decoration of the Sala Grande imaged a spiritual realm that had favored Florence from its foundation to the present, offering immortal victory and peace to its citizens. Personifications *all'antica* included no fewer than twenty-seven water deities, twenty-three goddesses, thirteen gods, ten zodiacal signs, four mountain ranges, and one hundred and twenty-five putti.[104] Probably no pagan temple had conjured up a stronger numen.[105] These signs of divine favor presided over the fertility of Tuscan land and the abundance of its crops,[106] the poetic inspiration of its citizens,[107] the courage and strength of its soldiers and sailors,[108] the wisdom of its public policies and the righteousness of its councils of war,[109] the fame and glory of its victories on land and sea.[110] But again, as in the entry, only a few elements related the divine protection of the city to the Church: the depiction on the ceiling of Florentines establishing the Guelph party and protecting Pope Eugenius IV (figs. 93: 6–7; 100–101); the effigies on the dais of Pope Leo X and Pope Clement VII (figs. 93: 55, 57; 117; 119); and above the dais three chandeliers in the form of papal tiaras.[111] Even so, the roles that these three popes took in reestablishing Medici domination after the exile of the family in 1433, 1494, and 1527 reminded the knowing viewer that Medici power—political, financial, and military—had been as significant as spiritual intervention in Florentine destiny.

Triumphalist history sought to override disjunctions and conflicts—especially the historical discontinuity between the republican and the ducal regimes.[112] But within the structure and content of the decoration in the Sala Grande more than a few traces of tension and insecurity persisted. The date of 70 B.C. given by the inscription for the *Foundation of Florence* in the ceiling of the Sala Grande (figs. 93: 2; 96), for example, was at best a compromise in an old debate about whether the city was founded between 80 and 70 B.C. as a *municipium* (as supporters of a republic argued) or between 60 and 43 B.C. as a *colonia* (as advocates of a ducal regime wanted to believe).[113] And there was the much-debated question of the razing of Florence in the early Middle Ages. The fourteenth-century chronicler Villani, like most humanists of the fifteenth century, and even Cosimo I's own official historian, Benedetto Varchi, believed that Florence had been completely destroyed by the Huns and refounded by Charlemagne. Borghini evidently agreed, because a scene show-

ing this refounding was planned as the pendant for the *Foundation of Florence*. His master was prepared to admit that Florence had been subjugated (*soggiogata*); but Cosimo, following the minority opinion of the fifteenth-century humanist historian Leonardo Bruni, would not allow that it had ever been destroyed (*desolata*).[114] Thus, the rebuilding of Florence by Charlemagne was dropped from the program and *Building the Third Circuit of Walls* was added as a pendant for the *Foundation of Florence* (figs. 93: *2–3*; *96–97*). The "new Augustus" imposed continuity on the city's medieval history to save for himself the role of refounder. Needless to say, this gesture implied a gap after all in the allegedly unbroken line of descent from the past to the present.

The entry procession was staged to move from the country to the capital, from the periphery to the hub, first in a direct line, then at the end circling with ever sharper focus on the center of power—the Palazzo Vecchio. Repeating the cycle, the procession moved across the courtyard and circled up the stairs to the Sala Grande, then down the hall's main axis to the dais. But countering this two-staged and ever more centered and narrowed movement, the decoration in the Sala Grande figured centrifugal movement outward across the territorial state of Tuscany to its boundaries and beyond.

THE PERSONA OF THE VICTOR

Entry A mock battle greeted Giovanna of Austria in front of the Arch of Florence at the Porta al Prato. Her procession in the streets was accompanied by a multitude of soldiers marching through triumphal arches that by origin and tradition celebrated military conquest. The iconography of the event returned repeatedly to images of conflict—so, for example, the contest between the joys and afflictions of marriage on the Arch of Hymen (fig. 67: *8*); the struggle of virtue with vice on the equestrian monument in the Piazza di Sant'Apollinare (fig. 74); the conquest of Siena on the Arch of Prudence (fig. 76: *7–8*); and the statues of Fury and Discord on the Arch of Security flanking the entrance to the Palazzo Vecchio (fig. 78: *10–11*). And the entry was only the beginning of three months of celebrations that would include in the Piazze of Santa Maria Novella and Santa Croce a mock siege of a fortress, hunts, jousts, athletic contests, and an ox race.[115]

In the triumphalist mode real and imagined battles are the pretext for victory and its representation in the persona of the victor. Although the parade was to honor, crown, and, in scarcely veiled allusions, "conquer" the Hapsburg bride, there was no doubt about the victor's identity. Riding at the center ahead of Giovanna, preceded and followed by a sizable show of military force, Cosimo de' Medici was the focal point of the parade. The bridegroom did not ride in the procession at all.[116] Even if few spectators perceived Cosimo's central position within such a throng, and still fewer participants could have seen

him in person, the victorious persona of the duke was the cynosure of the spectacle.

Cosimo's coat of arms above the entrance to the first triumphal arch rose eighteen feet high dominating the arms of Florence and of Francesco and Giovanna (fig. 65: *27–29*). The sign of the ascendant Capricorn on the principal device was, we recall, the birth sign of Augustus, the city's founder, and of Cosimo I, the New Augustus and refounder of the city (figs. 65: *26*; *79*).[117] "Hercules with a club and the skin of the Nemean lion" was paired with another device representing the founding of Florence (a *deductio*) because this emblem was "very ancient in the city, and the one wherewith public papers are generally sealed" (figs. 65: *16–17*; *86–87*).[118] Cosimo had taken over this emblem of the Florentine republic for his personal seal, co-opting both republican authority and the legendary role of Hercules as yet another founder of Florence.[119] The paintings alluded none too subtly to the twinned benefits supposedly secured and reconciled by the ducal regime—Arms and Letters; Industry and Agriculture; Poetry and Disegno (fig. 65: *5, 7, 9, 11, 13, 15*).[120] The effigies of Fidelity and Affection flanking the personification of Florence referred as much to the supposed devotion of the citizenry to Cosimo as to their city (fig. 65: *1–3*).[121]

Other allusions to Cosimo came to light en route to the Theater of the Medici.[122] But just as he rode in the middle of the procession so here, at the midpoint of the fourteen monuments along the parade route, he sat enthroned in effigy above the triumphal arch leading into the theater. Dressed no doubt in military garb, with the lion of Florence and the wolf of Siena at his feet, Cosimo was the *generalissimo* (fig. 71: *2*). Flanked by the last representatives of the two collateral lines that he united in his own person Cosimo was the *pater familias* (fig. 71: *4, 6*). As heir to the prestige and authority of Cosimo il Vecchio and Lorenzo the Magnificent, represented below him in the vaulted passageway of the arch, Cosimo was the *pater patriae* (fig. 71: *9–10, 12–13*). Above the effigy a painting of Samuel anointing David figured Cosimo as *divus*, the divinely sanctified ruler (fig. 73: *3*).

The parade went on to "the most pious" Cosimo on the Arch of Religion dressed "in the habit of a Knight of St. Stephen," the religious military order he founded in 1561 (figs. 64: *8*; 72: *12, 14*).[123] In the Piazza di Sant'Apollinare came the equestrian monument of Virtue (Cosimo's virtue of course) overcoming Vice (figs. 64: *10*; *74*).[124] When the procession turned onto the short and narrow Via dei Gondi to enter the Piazza della Signoria, attention was focused exclusively on Cosimo in the climactic tour de force of the parade— the Arch of Prudence crowned by a quadriga, a four-horse chariot that rotated as the procession passed beneath it (figs. 64: *12*; *76*). After mere allusions to Cosimo on the Arch of Florence at the beginning, or single representations of him on the Theater of the Medici and on the Arch of Religion at the center of the procession, here, near the end, twelve scenes represented him as com-

mander of troops and galleys, victor on land and sea, peacemaker and marriage broker, lawmaker and judge, model husband and father, sanctified and just ruler (fig. 76: *7–13, 24–28*). The nine sculpted virtues of good government were doubtless meant to refer to him as well (fig. 76: *2–6, 20–23*). One device, or medal reverse, illustrated Cosimo's new fortifications within Tuscany, another the "marvelous care and diligence of the duke in achieving the common peace of Italy"; both had the motto *Pax Augusta* (fig. 76: *27–28*). The principal device on the west facade displayed the Augustan sign of Capricorn, and tails of two Capricorns were knotted around the oak crown at the very top of the arch carried in a quadriga "by two lovely little angels" (figs. 76: *1, 19; 80*). This crown was "in the likeness of that of the first Augustus" and inscribed "with the same motto that he once used with it: *Ob Cives Servatos* [For saving the citizens]."[125]

Saved or not, many Florentines resented the harsh treatment of dissenters. Cosimo's enemies propagated a literary counterimage of him that was as grossly inflated as his heroic persona: this Cosimo was a bloody tyrant, a Nero who let Florence burn, a libertine, a monstrous seducer and murderer, even of his own children. In this war of representations a scene for the Arch of Prudence was proposed (but vetoed, of course) showing open rebellion, "plots discovered," in order to illustrate Cosimo's clemency and his leniency toward conspirators' children.[126]

After the procession through the Arch of Prudence spilled out into the broad Piazza della Signoria, the two remaining monuments commemorated peace and prosperity of Tuscany on sea and land (figs. 64: *13–14; 77–78*). The Neptune Fountain, according to Vasari, signified "tranquillity, felicity, and victory in the affairs of the sea"; the arch on the Palazzo Vecchio represented security on land or, more fulsomely, "how in well-ordered cities, abundant in men, copious in riches, adorned by arts, filled with sciences, and illustrious in majesty and reputation, one lives happily and in peace, quietness, and contentment."[127] Did Cosimo personify Neptune too in a bid to dominate the republican colossus of Michelangelo's *David*? The obsessive insistence that he should be victorious in all things may well be consummated in this looming, brutish figure of power.

Sala Grande The struggle to inevitable victory continued within the Sala Grande. The completion of the frescoes on the walls in 1572 brought to twenty the number of monumental paintings illustrating Florentine victories and omitting Florentine losses in the wars of Pisa and Siena (figs. 93: *26–45; 104–13*). Much of the sculpture arranged along the side walls of the room—Michelangelo's *Victory*, Giambologna's *Florence Victorious over Pisa*, and later Vincenzo de' Rossi's six groups of the *Labors of Hercules*—figured heroic conquests (figs. 93: *63–64, 66–68, 70–72; 126–27*). Most of the marble effigies on

the dais were dressed as warriors (figs. 93: *53–54, 56, 59;* 115–16; 118). At the opposite end of the hall Federico Zuccaro's painted curtain for the temporary stage represented the easy triumph of a hunt.[128]

As if to preside over and receive the tribute of so many victories, or to vindicate the display of so much slaughter, Duke Cosimo's throne was located at the end of the visual and processional axis, framed by a triumphal arch, and elevated on a monumental dais set apart by stairs and (originally) a balustrade.[129] Surrounded by effigies of Medici commanders (figs. 93: *53–54, 56;* 115–16; 118), Cosimo was the *generalissimo,* just as he had been on the Theater of the Medici. Flanked by statues of Alessandro and his own father, Giovanni delle Bande Nere, he was once again the reigning heir and, since his own marble image in the guise of Augustus stood in a niche to his right, the *pater patriae,* the New Augustus (figs. 93: *53–54, 56;* 115–16; 118).[130] Here too he was the sanctified ruler, perpetually blessed by the marble Pope Leo X directly behind the throne (figs. 93: *55;* 117).[131] Charles V, who had conferred Cosimo's ducal title, was originally to have appeared in this niche. Represented instead kneeling before Clement VII on the side of the dais (figs. 93: *57–58;* 119) he was shown beholden to a Medici pope for *his* legitimization.[132]

When a drama was performed in the Sala Grande on the Feast of St. Stephen (26 December), a temporary stage opposite the dais was built together with "two banks of seats as in an ancient theater" for several hundred guests along the side walls (fig. 128). From these seats spectators had only an oblique view of the stage, but they looked directly at a *rialto,* or raised platform, built in the center of the room. This was reserved for the duke and his party, who alone had a direct view of the stage. Their privileged position was further enhanced by the painted stairway on the stage apron that seemingly led up to the proscenium arch and by the stage backdrop with a view of the Piazza Santa Trinita: only from the *rialto* would the perspectival illusion emerge without distortion. Only the duke had a full view of the drama where "it seemed as if paradise with all the choirs of angels had opened."[133]

Once the stage was removed, Cosimo's gaze from the throne was intended to center on Ammannati's Rain Fountain (figs. 93: *60–62;* 120–25). The fountain and its sculpture, rather like the Arch of Florence, would display the imperial virtues of Arms (Flora's arrows and military chain) and Letters (Hippocrene spring and Pegasus) as the foundation of Tuscan peace and prosperity (river Arno, cycle of rain). Flora or Florence wearing Cosimo's chain of the Order of the Golden Fleece would form a pair with Cosimo's self-proclaimed chief virtue of Prudence holding an anchor and dolphin, the device with its motto *Festina Lente* (Make haste slowly) that Augustus had adopted. As Detlef Heikamp points out, the oval band (thematically a rainbow) on which Juno sat recalled the ring device of Cosimo il Vecchio, while Prudence and Flora derived from the classical types of Apollo and Diana, the

sun and the moon.[134] Taken together these references figured the courtly pun on Cosimo as "cosmos."

The decoration along the center of the ceiling, like the decoration of the Arch of Florence, focused on the city itself—its history and culture (figs. 93: 2–7; 96–101). But again like the Arch of Florence, it also alluded to the duke since all of the scenes prefigured his deeds: just as the triumvirs first founded the city, so he refounded it and fulfilled its Roman destiny; as the third circuit of walls expanded and fortified the city to its maximum extent under the republic, so he, far more extensively, embellished and strengthened the city, and expanded and fortified the entire Tuscan state; as the Florentines made their first show of independent military strength by defeating the Ostrogoths from the north with the aid of Roman troops, so he made his first military stand at Montemurlo north of Florence and defeated the exiles in alliance with imperial troops; just as the Florentines began their territorial expansion with the annexation of Fiesole, so he completed it by the more impressive annexation of Siena; as Guelph Florence defended the Church during the papacy of Clement IV and subsequently offered hospitality to the exiled Pope Eugenius IV (who in turn helped establish the first Medici rule in Florence under Cosimo il Vecchio), so Cosimo I founded the military Order of St. Stephen dedicated to the defense of the Church and contributed to the election of Pius IV and Pius V (who gave Cosimo the title of grand duke). Finally, to complete the triumphant litany, Eugenius IV found safe haven at Livorno, where Cosimo established a naval base as part of a new Florentine maritime empire.

An octagonal painting at the north end of the ceiling showed Cosimo facing his throne on the dais. Wearing ermine-lined ducal robes and the chain of the Order of the Golden Fleece with a suit of contemporary armor at his feet, he sits alone at a desk in his study with a model of Siena, drawing up plans for the siege of that city (figs. 93: 36; 109–10). The scene is closely related to the east facade of the Arch of Prudence, which also celebrated Cosimo's victory over Siena (fig. 76). The arch was topped by two angels holding an oak crown; in the painting two angels hover above the duke's head, one with a laurel crown of victory, the other with an olive branch of peace and a palm of glory. Constancy and Fortitude stood in niches at the lower level of the arch and standing above on the attic silhouetted against the sky were Patience and Vigilance, with Prudence seated between them in the center below the quadriga. In the painting Fortitude and Silence stand and sit respectively to the right, while Patience and Vigilance float above Cosimo's desk to the left; Prudence is in the center closest to Cosimo. Finally, just as Cosimo's roles as commander in chief and *pater patriae* were supported by an imperial—specifically Augustan—alter ego on the Arch of Prudence, so too in the niche over the door in the background of Cosimo's study—the traditional location in Florence for busts of ancestors[135]—there is a marble bust of a Roman emperor, almost certainly a likeness of Cosimo himself.[136]

The Augustan hero, alone with his personal virtues, planning the war against Siena—Borghini and Vasari knew very well that this was a self-serving manipulation of history. They had first designed a scene showing the duke making his decisions "by way of counsel," a version confirmed by the most recent study of the siege of Siena.[137] But Cosimo insisted that "the assistance from that circle of counselors, which you want to place around [the scene of] my deliberation on the war of Siena, is not necessary, because we were alone."[138] Not even Cosimo demanded to be included in battles in which he had never participated, however; only his field marshal, Giangiacomo de' Medici, the marchese of Marignano, is shown actually commanding the troops (figs. 111–12). Even so, the duke's role in the victory was deliberately contrasted with the corresponding octagonal scene on the opposite side of the ceiling. Here on a high bench before a council in the pre-ducal Sala Grande the republic debates the earlier war against Pisa—presumably with all the controversy and compromise Medicean historians attributed to republican decision-making (figs. 93: *26*; 104–5). Very different from the calm and solitary Cosimo, this group has as its emblem a torch-bearing Nemesis denoting, as Vasari pointed out, revenge—the irrational spirit of the mob.

Vasari also tells us that the speaker in the rostrum haranguing the citizens is Antonio Giacomini.[139] There is surely a reason for this specific identification, especially since the figure does not appear to be a portrait. Vasari states that the scenes of the Pisan war were based directly on Guicciardini's *Storia d'Italia.* In his only reference to Antonio Giacomini, Guicciardini says that he was the Florentine commissary responsible (along with the military commander Ercole Bentivoglio) for the victory against the Pisan mercenary army commanded by Bartolomeo d'Alviano at Torre di San Vincenzo in 1505 (illustrated on the wall below, figs. 93: *34*; 107). After the battle, Giacomini urged the Florentine government immediately to exploit the "reputation of victory" in order to breach the walls of Pisa as had been attempted unsuccessfully in 1499 at the battle of Stampace (also represented on the wall below, figs. 93: *33*; 106). Guicciardini lists many reasons why the officials in charge of the war and other responsible citizens felt that such a campaign should not be attempted, but this "did not cool the ardor of the people, who often govern with more appetite than reason." When the head of the republican government, the *gonfaloniere* Piero Soderini, called for a vote from the Great Council almost all members agreed that Pisa should be taken by force. Thus, "audacity having overcome prudence, it was necessary that the authority of the best part cede to the will of the majority." Giacomini's campaign failed; even after the walls were breached by artillery, "neither the authority nor the pleadings of the captain [Ercole Bentivoglio] or the Florentine commissary [Antonio Giacomini], neither respect for their own honor nor for the honor generally of the Italian militia, was enough to make them attack." The result of "this very great dishonor" was "infamy in all of Europe for the Italian militia, corruption

of the happy victory against Alviano, and annihilation of the reputation of the captain and the commissary."[140] As a man in whom "audacity had overcome prudence," Giacomini was the perfect foil for Cosimo who was represented as subject to no will but his own, suppressing any vindictive appetite by reason, and controlling audacity by prudence. Furthermore, the contrast between the prudent Cosimo and the audacious Giacomini underlined a crucial point in contrasting the Sienese with the Pisan war: the strength, efficiency, and success of Cosimo's militia versus the weakness, inefficiency, and failure of the republican militia.[141]

In *Cosimo I Plans the War of Siena* the detail of the bust of Cosimo in the guise of Augustus was too small to be read easily from the floor of the hall. But Cosimo's Augustan persona was overwhelmingly evident in the central tondo of the ceiling, the *Apotheosis of Cosimo I* (figs. 93: 1; 94–95). Here Cosimo is enthroned on an imperial faldstool, dressed in the ancient Roman military garb of a supreme commander. The inscription records that Cosimo, like Augustus, founded the state, enlarged the empire, and established peace. As *pater patriae* he receives the Augustan civic oak wreath from Flora or Florence. Far more boldly than ever before in Renaissance portraiture, he is the embodiment of the *auspicium, imperium, felicitas,* and *ductus* of the ancient *triumphator*. Seated amidst the clouds of a painted heaven, surrounded by twenty-six cupids and a classical deity, Cosimo, like Augustus, is a mortal god.

The centrality of the image heightened its impact within the overall structure of the room. When the enthroned Cosimo—seated in the center of the dais, blessed from behind by Leo X, and drenched by light from the windows—lifted his eyes upward, he would have seen himself enthroned in the center of the ceiling, silhouetted against the light, and crowned from behind by the goddess Flora. The major historical scenes in the ceiling were also organized in responsive pairs on either side of the apotheosis: on the central axis construction of the first circuit of walls was paired with that of the third, war making with peacemaking, and defense of the Church with that of the pope; on the transverse axis triumphal entries into Florence were paired with those commemorating the defeats of Pisa and Siena (figs. 93: 2–3, 4–5, 6–7, 35, 45; 96–101; 108; 113). Four temporary scenes high in the four corners of the hall that showed Cosimo providing for an empire on land and sea—draining swamps, building fortifications, founding cities, and constructing ports—framed the entire decorative ensemble (fig. 93: 49–52). The *Apotheosis of Cosimo I*, in short, was a fulcrum for the entire decorative scheme, the locus where scenes representing the history and the destiny of Florence and Tuscany found their structural center and chronological culmination. Here the "divine" Cosimo was positioned both at the cutting edge of history and outside space and time.[142] As an *axis mundi*, the junction between heaven and earth, Cosimo's image focused the decoration and presided over the trajectory of its expansion.[143]

THE SPOILS

Entry The temporary arches of the entry parade were themselves figurative spoils covered with trophies, time machines plundered from a treasury of ancient forms to stage the transition from past conflicts to a utopian present of surpassing abundance.[144] The painting of Agriculture on the Arch of Florence and the wine-spouting fountains on the Arch of Maritime Empire and the Arch of Happiness represented Tuscany as "the garden of Europe," more fertile than "all the nations of the world" (figs. 65: *9;* 68: *3;* 75: *4*).[145] The bounty of the land and the booty of Tuscan "felicity" conspicuously showed forth in the costumes of the nobility, often embroidered and trimmed with gold and jewels, the liturgical dress of the clergy, the parade armor and weapons of the knights, and the bright livery of the pages. The huge canopy—itself consuming hundreds of yards of silver, gold, and red cloth—was carried by fifty noble youths, each with a sword at his side and dressed in a tunic of rose and gold with scarlet hose and a blue velvet cape. Cosimo's fourteen pages were dressed in yellow, silver, green, and white. The ducal crown or *mazzochio* with nine fleurs-de-lis worn by Giovanna held thirty-eight pearls, twenty-three diamonds, eighteen rubies, four balases, three spinels, and one sapphire.[146] And this was only the beginning of a potlatch exercise in material prodigality and expendability that lasted for three months.[147]

The history of Tuscan culture was ransacked for trophies. Disegno and Poetry on the Arch of Florence or Religion on the Arch of Religion paid the tribute of an almost endless proliferation of Tuscan worthies: artists from Cimabue to Michelangelo, poets from Dante to Giovanni della Casa, founders of religious orders from San Romualdo to Cosimo (figs. 65: *13, 15;* 72: *12, 16, 29, 32, 36, 37, 39*). Few could have absorbed or comprehended this pantheon of figures, let alone the iconographical crust of obscure devices and learned inscriptions in Greek and Latin that celebrated them. But that was part of the effect: to enrich by plundering, to empower by overwhelming, to exalt by mystifying. If nothing else, the display of Florentine religious, artistic, and literary greatness served to conceal what it also proclaimed—that the golden age of Florentine culture had already passed.

Borghini's parallel account of Greek, Roman, and Florentine marriage customs suggests that the mock battle before the Arch of Florence was meant to enact a symbolic rape of the eighteen-year-old Giovanna by partisans of the bridegroom.[148] Giovanna was thus the prize trophy of the marriage parade. The vast majority of Medici festivals concerned dynastic continuity (marriages, baptisms, and deaths), and the production of the parade anticipated the reproduction of offspring. On the Arch of Florence the principal inscription forecast the bride's fecundity: the deities were in couples of male and female and "a gracious throng of children" gamboled within the decorative en-

framements (fig. 65: *4, 6, 8, 10, 12, 14, 30*).[149] Further along the parade route Venus Genetrix presided over the Arch of Hymen, which was covered with "a quantity of little angels and cupids . . . scattering flowers and garlands or sweetly singing."[150] An inscribed ode beseeched Latona to "grant a son like his father" (fig. 67: *2, 12*). In the Theater of the Medici Catherine de' Medici was celebrated in a painting showing her receiving her children destined for high titles and prosperous reigns (fig. 71: *20*). The principal inscription on the Arch of Security again alluded to the fruitfulness of the bride, and the two paintings flanking the door featured Diana of Ephesus, the many-breasted goddess, and the nymph Amalthea, nursemaid of Jupiter, who signified "the abundance and fertility of the earth" (fig. 78: *12–14*).[151]

The parade took place under the sign of Capricorn, the beginning of the zodiacal calendar and the season of the sun's rebirth. Transpiring in the Christmas season, it marked the beginning of the liturgical year and the birth of a Son. The fifty youths who carried the baldachin over the bride, as Richard Trexler's analysis of Florentine public ritual reminds us, harnessed the vitality and sexual energy of youth for the city's regeneration.[152] The entry ritual itself was sexually coded. First, at the entrance to the city a mock battle with guns and cannons blazing symbolically subjugated and took possession of Giovanna. Then she passed the recently erected Column of Victory in the Piazza Trinita, through the narrow channel of the Arch of Austria laying out the generative line of her own imperial birth, and into the womb-like Theater of the Medici dedicated to dynastic continuity and featuring the bridegroom, Francesco, over the main internal arch (figs. 69; 70; 71: *29*). The prize trophy of the entry was made to perform the symbolic conception and birth of an heir.

Sala Grande The Palazzo Vecchio and Sala Grande, expropriated twice before by the Medici in 1512 and 1530,[153] were Cosimo I's most conspicuous spoils from the earlier republican regime. According to the court historian Giambattista Adriani, Cosimo had transferred from the Palazzo Medici on the Via Larga in 1539 "to show that he was an absolute prince and arbiter of the government . . . and to govern the state with greater dignity and obedience from the citizens and subjects."[154] On a more realistic note Adriani adds that the move provided greater security at less expense, since Cosimo had to have his residence and his person continuously guarded.[155]

The form, size, and function of the original republican Hall of the Great Council had been taken over from the Sala del Maggior Consiglio in Venice. To capture something of the aura of the Venetian government—a model for political stability and financial security—Cosimo I in his turn continued to exploit Venetian precedents. The ceiling of the Sala Grande was based on the modular wood frame of the *soffitto veneziano,* the first ever in Florence; the triumphal arch motif for the dais derived from Jacopo Sansovino's arched Loggetta at the base of the campanile of San Marco in Venice.[156] The scenes show-

ing the Florentines protecting the Church and the pope (figs. 100–101) were surely inspired by the pictorial cycle in the hall of the Maggior Consiglio featuring the doge defending Pope Alexander III (1159–1181), a mainstay of Venetian political hagiography.[157] These borrowings, yet another gesture of conquest and, unwittingly, of dependency, must have been intended to outrival the Venetians at their own game.

Battle pictures had been commissioned for the Sala Grande by the republican regime of the early sixteenth century to promote civic preparedness and a civic militia.[158] Cosimo took over this program—Michelangelo's *Battle of Cascina* and Leonardo's *Battle of Anghiari* had remained unfinished—to glorify his own military preparedness and the creation of a new Tuscan militia, but with a distinctive twist.[159] One element of the republican program, the history of Florentine victories over Pisa, now became the vastly expanded but subordinate term of a binary opposition. It set off the inefficient militia and rash leadership of the republic against the efficient militia and prudent leadership of the duchy.

Cosimo's advisers again ransacked Florentine history to enrich this program (figs. 93: *2–7*; 96–101). The insignia and personifications of Tuscan towns and regions subdued by Cosimo became a kind of allegorical inventory of the duchy's natural resources (figs. 93: *10–25*; 103). Included were eighteen river gods (twelve crowned with wreaths) carrying fifteen cornucopias and seventeen water-spouting urns; eleven nature deities held vegetation or wore wreaths of flowers or grapevines.[160] Trophies were massed in the roundels— four shields, sixteen standards, two *marzocchi,* four Medici *palle,* three coats of arms, twenty-one insignias of the guilds, the chains of the Order of the Golden Fleece and the Order of St. Stephen, and the ducal scepter and crown (fig. 93: *1[a–z], 8[b–l], 9[b–l]*).

Looking from his throne Cosimo would have taken in as well the fictive embodiments of a quite literal *libido dominandi.* He would have seen a multitude of children in the decoration, and no fewer than five representations of Flora or Florence as a sexually charged woman with full firm breasts exposed, in one case completely nude (figs. 93: *1, 8–9, 35, 64*; 95; 102; 108; 127). Drawn to the end of the hall his gaze would have commanded the planned Rain Fountain and the two goddesses representing Florentine and Tuscan fertility: Juno, the goddess of marriage (to whom his duchess, Eleonora of Toledo, was often compared),[161] her breasts caressed by the spread wings of the eagle of Jupiter (to whom Cosimo was often compared),[162] and Ceres, the goddess of fruitfulness who, completely nude, pressed streams of water from her ample breasts (figs. 120–21). These female personifications were to have been flanked on the left by two male nudes (Prudence, a surrogate for Cosimo; the river Arno); on the right the program called for two potent females (the Hippocrene spring; Flora or Florence), one nude with her legs spread apart over an urn, the other with flowers at her bosom but more modestly dressed, pre-

sumably because she was already possessed by Cosimo whose chain of the Order of the Golden Fleece encircled her breasts (figs. 122–25). The formal structure of this overt sexual code—a vertical shaft piercing an oval—virtually diagramed male fantasies of sexual conquest (fig. 93: *60*).

But then, the entire hall was structured like a giant showcase for a conqueror's trophies. The forty-two large panels inserted just behind the framework of the new ceiling were literally *quadri riportati*, independent easel paintings tributary to the overarching decorative strategy. The fourteen temporary paintings on the walls, like their eventual replacements (four paintings on slate, six frescoes with festooned enframements, and a *basamento* of tapestries), mostly had the look of being mounted for the occasion. The old republican hall contained a series of sculptures confiscated from the Medici;[163] new artifacts were brought in from other predominantly Medicean projects, beginning with Michelangelo's *Victory*. Eight other marble groups were added over time, only one of them made specifically for the hall (figs. 93: *63–72*; 126–27). The proliferation of decorative additions and refinements continued until the early seventeenth century.

Making a virtue out of necessity, Cosimo evidently pretended to believe that the renovation of the confiscated hall confirmed his inheritance of the republic's *virtù*. In Vasari's version, "His greatness depends upon the origin of the palace and its old walls; an artist who wanted to paint lavishly the stories of the revered republic could not do so on a new wall, because such stones would not have been witness to the host of distinguished events that these old walls would have seen." But of course the alterations also announced the superiority of the ducal regime: the old building in its "ugliness and lack of harmony or unity reflected the disorder of changeling past governments," whereas the restored and improved palace "has been made stable and appears to offer rest and quiet," demonstrating precisely "[Cosimo's] beautiful method for correcting architecture, just as he has done in the government—which is to subject it no longer to the will of many, but to one alone, his will." The decoration, Vasari trumpeted in a letter to his patron, would "surpass any other ever made by mortals because of its grandeur and magnificence, whether it be the decoration in stone, the bronze statues, the marbles, the fountains, or the inventions and stories of the paintings." Vasari continues in a crescendo of hyperbole: "Since all these inventions were born—all, I say—from your exalted conceits, [the hall,] together with the richness of its material, will surpass all the halls made by the Venetian Senate and all the kings and emperors and popes that ever were because, even if they had had the money, none of them had in their palaces either a masonry fabric so grand and so magnificent or the indomitable spirit to know how to begin an enterprise so awesome and of such importance."[164]

While describing the drama performed in the Sala Grande on St. Stephen's day, Giovanni Battista Cini waxed eloquent over the ceiling—"stupendous

and most extravagant, admirable for its variety and the multitude of striking painted histories, admirable for its ingenious inventions and the very rich compartmentation, for the infinity of gilt, which is resplendent to all who see it." Cini concluded, "I truly do not believe that in our part of the world there could be a report of any other hall greater or more showy than this one; without a doubt I believe that it would be impossible to find among all [such halls] either a more beautiful, a richer, a more decorated, or a more comfortable one than that which was seen the day the comedy was performed."[165]

 This high-flown triumphalist rhetoric should be read in light of its subtexts: that Tuscany actually played a minor part in the theater of contemporary politics, that it was a satellite of the Spanish masters of Italy, that its ruler was a relative upstart among the crowned heads of Europe. For Vasari and Cini the tokens of limitless wealth, abundance, and fertility in the Sala Grande belonged to the victor; in the decoration the victor also belongs to the spoils.

PROGRAM AND PRODUCTION

Duke Cosimo I

Both the entry and the Sala Grande were supervised by nearly the same men, and the process of production was similar for each. Borghini and Vasari alike insisted that the two programs flowed from Cosimo's mind and will. In a letter to the duke of 5 April 1565—the first draft of the program for the entry—Borghini returns obsessively to the patron's role: "I send all to Your Excellency so that with your most prudent and most wise judgment you can work out what you want, and add or subtract, or even change all that does not correspond entirely to your wish and design, because it is necessary that the decisions for these festivals all be born from the judgment of Your Illustrious Excellency, including the conceits, designs, and intentions that cannot come from other than your genius"; "the judgment (as I said) and the selection is completely reserved to Your Illustrious Excellency"; "Your Excellency will have to determine the what, the how, and the where"; "I have ordered that the plan of the entire entry be sent . . . to Your Illustrious Excellency, not as something fixed, but because with this brief sketch you can consider and decide the how much, the more, the less"; "nothing can be put into production that has not first been seen and approved by Your Illustrious Excellency"; "I have proposed all to Your Excellencies [the plural here and below includes Francesco de' Medici] so that you can deliberate about what seems most appropriate"; "the invention, the quality, and the quantity of this entry must be born from the satisfaction of Your Excellency, . . . but all can be freely changed to accommodate the taste of Your Excellencies"; "this, like all other aspects, will be resolved by Your Excellencies"; "you can make this or not as

Your Illustrious Excellencies please"; "Your Excellency will consider all"; "and it would be necessary to accommodate this invention to the desire of Your Excellency, and to that which must follow your taste and fantasy"; "and this is how it would seem to me, but much more would it seem to me that which contented Your Excellency"; "and depending on how Your Excellency decides these or other inventions, the designs will be done"; "and once again it is necessary to observe that with regard to the distribution of sites, if one that is planned for a location seems better in another one, it is possible to vary them according to the desire of Your Illustrious Excellency"; and "I know that all these things are to a certain degree superfluous, because Your Illustrious Excellency has [already] thought of everything."[166] As an exercise in *copia* on the theme of "the duke decides," Erasmus could not have done better.

Borghini expressed similar sentiments to Vasari: "It is much more important to discover the intention, fantasy, and desire of His Excellency, which opens the way to many things, and smooths and facilitates the road, as you know, because when one does not know if a thing accords with the will or not of the patron, one gropes one's way";[167] or "the satisfaction of His Excellency must go before all else."[168] Vasari in turn, when laying out to Cosimo the first draft of the program that he and Borghini had devised, insisted that "all of these inventions, all I say, were born from your supreme conceit."[169]

Like the centering on Cosimo in the entry procession, the Sala Grande, and the regime itself, then, the entire program was to hinge on the duke. The degree to which it did we can gauge by comparing the changes from the initial to the final *concetto*.[170]

The initial scheme consisted of three parts: the "beginnings and development" of Florence along the central axis of the ceiling;[171] the quarters of the city and their vicariates at either end;[172] and the wars of Pisa and Siena on the sides of the ceiling and on the side walls.[173] In the twelve rectangular panels in all three bands of the ceiling the insignias of the twenty-one guilds were to have amplified the first and second parts of the program.[174] Although the basic structure of this first *concetto* informs the final one,[175] many changes were made. It is telling to review them as a whole.

Cosimo's apotheosis supplanted "Florence in a celestial glory" in the central roundel of the ceiling (figs. 93: *1*; 94–95), and the placement of shields around him emphasized his control of the city and its guilds. Eight of the twelve rectangular panels freed up by the removal of the insignias of the guilds (fig. 93: *27–28, 30–31, 37–38, 40–41*) were used for additional battle scenes to amplify the significance of Cosimo's Sienese campaign in contrast to the Pisan campaign under the republic.[176] The suppression of counselors from the scene of planning the conquest of Siena (figs. 93: *36*; 109–10) served to credit Cosimo alone for the military strategy. In the remaining four rectangular panels from which guild symbols were removed (fig. 93: *4–7*), new scenes filled out the early history of the republic but also prefigured Cosimo's deeds

(figs. 98–101).[177] Banners of the Florentine quarters in the sixteen small square fields (fig. 93: *10–25*) were moved to the end roundels (figs. 93: *8–9; 102*) because Cosimo demanded that "all our territory" be represented in their place, thereby stressing the extent of his sovereignty and setting up a comparison between the relatively small cities of the old republican state and his recent conquest of what was now the largest city under ducal control, Siena. The scene of Charlemagne's "restoration or amplification" of a devastated Florence was replaced by the building of the third circuit of walls under the republic (figs. 93: *3; 97*), because Cosimo insisted that Florence had never been destroyed; this change made Cosimo alone the refounder of Florence and implicitly contrasted the republican fortifications of the city itself and Cosimo's fortification of all of Tuscany. In the case of *Cosimo I Plans the War of Siena* (figs. 109–10) the evolution of the preparatory drawings shows that it was not until the last moment—and, therefore, probably at the insistence of Cosimo himself—that the most significant aspect of this scene was settled upon: the representation of the duke as an artist, the *rex artifex*, practicing the art of war with the architect's compass in hand like many medieval representations of the Supreme Architect creating the world.[178] All the evidence suggests that these changes resulted from Cosimo's direct intervention.

Absolute, godlike authority over the program and the production was imputed to Cosimo by Cosimo Bartoli, Cosimo's agent in Venice and himself sometimes a programmer of decorative projects for the Medicean court.[179] In a letter to Vasari while he and his workshop were executing the frescoes on the walls of the Sala Grande, Bartoli wrote: "From the Romans onward there have never been sculptors, painters, architects, or engineers who have had the greatest, the most beautiful, and the most honored occasion to demonstrate their genius as all of you have had at the hand of His Highness. What more perfect occasion could be given to you, tell me by your faith, than that which you have written to me concerning the new hall to serve for spectacles, magistrates, and [the reception of] foreigners? God has given us Duke Cosimo for the conservation, augmentation, and exaltation of Florence, and then He gave all of you who, as his hands and arms, are able to execute the most honorable, the most useful, and the most praiseworthy conceits of His Highness. Enjoy the happiness then of such a patron. Strive most cheerfully to honor both His Highness and yourselves and to make true the saying that Florence is not only the most beautiful city in Italy but is itself each hour outdoing its beauty."[180]

For Bartoli, then, Vasari and his workshop were the "hands and arms" who executed the conceits of the God-given duke. But in an earlier letter of 22 September 1565 while the preparations for the entry of Giovanna were in full swing, he offered another fundamental insight about the relations between Cosimo and his artists and programmers: "Messer Giorgio mio, we are the men of the duke and the prince, and it is necessary to walk that road that their excellencies wish, and above all you, of whom they have more need than

bread."[181] If the programmers and artists were dependent on Cosimo, so was he dependent on them. Yet in his drive for control Cosimo demanded that he be omnipotent and omniscient in all things. His power was real enough but so therefore were the demands on his time. Borghini wrote that Cosimo was "preoccupied with so many and such great affairs" that he, Borghini, was "ashamed" to take more than a minimum of his time for such "lowly matters" as, for example, the "invention for the last scene of the Sala Grande."[182] Bartoli understood, however, that Cosimo's power was to a substantial degree created, manifested, and sustained by show, requiring hours of consultation with his artists and programmers. Since projects with the scale and the tight deadlines of the Sala Grande and the entry were beyond the power of any single individual to plan or to execute, Cosimo had to depend on others. The process of programming and production, in other words, exposes a fundamental paradox of the absolutist regime: in art as in politics authoritarian control was checked, as it was sustained, by an essential dispersion of effort through a division of labor within a bureaucratic structure. To a substantial degree Cosimo de' Medici was an agent of his own regime.

In the case of the Sala Grande and the entry, authority over this bureaucratic structure was vested in a trio answerable directly to Cosimo: Vincenzo Borghini for the program, Giovanni Caccini for the finances and supplies, and Giorgio Vasari for the design and execution.[183] The division of labor into finance, program, and design was by this time such a deeply ingrained part of the system of artistic production that the division was reproduced in the allegorical apparatus on the Arch of Florence where, in effect, Industry and Agriculture corresponded to finance, Poetry to program, and Disegno to design.

The Programmer: Borghini

In order to arrive at the *concetti* for his programs Borghini began with a detailed plan of the area to be decorated. For the Sala Grande he no doubt had a drawing of the compartmentation of the ceiling and the walls similar to the three extant drawings by Vasari that document three progressive stages in the evolution of Borghini's ideas.[184] For the entry he had a ground plan of the city, probably drawn by an artist in Vasari's workshop, which included "the plan of the entire procession as well as detailed plans, with their measurements of those places expected to be decorated."[185]

Since entries and halls of state are simulacra that have meaning within the universe of other entries and halls of state, Borghini next set about researching precedents. We do not know which precedents Borghini considered for the Sala Grande, but Vasari's remark about surpassing the audience halls "made by the Venetian Senate and all the kings and emperors and popes that ever were" leaves no doubt that he considered previous halls, certainly those

in Venice and Rome. Since Vasari had recently visited and taken notes on nearly all the Italian examples for the revised and expanded second (1568) edition of his *Lives,* he would have been a convenient mine of information for Borghini.

There can be little question that Venetian ceilings in the Doge's Palace inspired the Sala Grande ceiling, but it outdid in scale any then extant. We have already observed too that the scenes representing Florence as the defender of the Church and protector of the pope within the central band of the Sala Grande (figs. 93: *6–7;* 100–101) were probably inspired by similar scenes on the walls of the Venetian Sala del Maggior Consiglio. The effort to create an archaeologically correct scene of the Romans founding Florence (fig. 96) had a precedent in the *adlocutio* scene in the Sala di Costantino in the Vatican where the vision of Constantine was set on the site—represented according to the best antiquarian information then available—where Constantine founded the church of St. Peter's.[186] Scenes of battle, union, or triumph signifying territorial expansion and pacification were common in council and audience halls.[187]

In the cross-wall or cross-vault opposition of one campaign against another, however, as well as such detailed elaboration of both campaigns, the scenes in the Sala Grande were new. Also new was the representation of an abbreviated history of a city from its founding to the present (figs. 93: *2–7;* 96–101).[188] There were other novelties besides. Although Charles V and Francis I had been portrayed in the guise of ancient Roman emperors, a duke had not been so represented, at least not so blatantly. Lorenzetti's panoramic view of Good Government or the scenes of Sienese conquests in the Sala del Mappamondo of the Palazzo Pubblico of Siena may have prompted Cosimo's request that "in one of those paintings in the ceiling be seen *tutti li stati Nostri,*" but the end result—six portraits of the city and sixteen scenes of the cities and regions of Tuscany—was unprecedented (figs. 93: *2–5, 10–25, 35, 45;* 96–99; 103; 108; 113); so too was the divinization of a living ruler in the central roundel of the Sala Grande (figs. 94–95). Finally, the culmination of the narrative in scenes of triumph on either side of the central roundel was a structural innovation designed to center the program on Cosimo's image. The program of the Sala Grande was empowered both by drawing upon accepted patterns and by defying the force of tradition.

We are much better informed about Borghini's research into precedents for the entry. Since the occasion was also a coronation, a marriage celebration, and a festival, Borghini gathered information on forty-one recent triumphal events dating (with a fifteenth-century exception) from 1512 to 1561, including twenty-one entries, ten marriages, six coronations, and four festivals, most for popes, emperors, kings, or dukes.[189] Of the forty-one ceremonies Borghini investigated over three-fourths involved the Hapsburgs (22) and the Medici (7); of the twenty-two Hapsburg rituals, those of Emperor Charles V,

Cosimo's chief patron and model, accounted for exactly half (11).[190] Here as in the Sala Grande Borghini clearly understood that the repeat performance was the key to the legitimacy of the ritual.

But in spite of, or perhaps because of, this indebtedness Borghini also wanted to improve upon precedent: "From 1512 onward I have observed some of the many things made for marriages of lords, entries of great princes, and coronations of popes, emperors, and kings, and they are so numerous and of such inventiveness that it is almost impossible not to accept to some extent the things already done. . . . These precedents cannot be completely escaped, but overall I do not wish to imitate them to such an extent that this invention would seem copied."[191] Novelty testified to the power of imagination, so much so that Borghini recommended executing the entry "with the greatest secrecy possible." One artist was not to know what another was doing; in this way Florentine genius would reign supreme and would outdo Venice, Bologna, and the court of Ferrara (itself preparing for a wedding). Secrecy was also important because "the less one knows of something, and by not knowing anticipates it, the more it seems welcome and agreeable as something new and unexpected."[192] Borghini, of course, does not need to add that secrecy was also a product of the defensiveness and suspicion of the political regime.

Once the *concetto* was established, the next step was to "prepare the designs for the program with all the particulars: and reading poets and other excellent writers and also reconsidering everything better and rethinking all the details, one will simultaneously be sharpening, embellishing, and enriching these inventions with stories, inscriptions, and devices making them charming and beautiful."[193] Enrichment and embellishment were viewed as graceful in themselves; Borghini notes, for example, that since the Column of Victory had already been decided upon, it was now necessary "to execute the decoration as soon as possible, because . . . without the ornamentation one would lose all the grace of this column."[194] The process of elaboration was supposed to generate variety "for the satisfaction of the painters and sculptors who desire this variety in order to better show off their art," as well as to "bring grace and pleasure."[195] And yet, Borghini warns, "one must be careful not to multiply excessively,"[196] because these inventions have the potential for growing and multiplying "without ever ending."[197] Nor should one compromise clarity and precision by too great a mixture of elements or by repetition of motifs.[198] In selecting motifs and subjects one had to balance "truth with judgment, the judgment of discretion."[199] One needed to create "a poetry, *una grottesca*, dependent upon and confirmed by the truth, which is the more difficult the more one must create a certain artifice and dissimulation, so that the *concetto* is present but does not seem to be."[200] Finally, following the example of imperial Rome, that "period of good taste in inventions,"[201] one must add a certain *romanitas* in order to create a "grandeur of conception," a "magnifi-

cence," "gravity," and "adroitness" of form, and a "gracefulness" and "elevation" of language.[202]

Thus in creating a *concetto* Borghini strove to find a balance within the dynamic and inherently contradictory principles of tradition and innovation, graceful elaboration and stately restraint, copious variety and decorous moderation, true fact and artful fiction, straightforward clarity and poetic concealment. In a programmer's guise Borghini replayed his patron's role of balancing opposing political and social forces within the framework of an imperial ideology.

Although he does not explicitly say so, Borghini also structured conceits to correspond to the ceremonial functions they were designed to serve. In the Sala Grande, for example, the cross-axial arrangement of the triumphs over Pisa and Siena—the third part of the tripartite program—marked the cross-axial entrance route into the hall (fig. 93: *35, 45*). The first part of the scheme—the history of Florence (fig. 93: *2–7*)—paralleled the processional axis of the hall and expanded the visual focus on the duke across space and time. The topographical expansion at the ends of the ceiling containing the second part—the four quarters of Florence and the Tuscan state (fig. 93: *8–25*)—reinforced the sovereignty and dominion claimed by all state rituals staged on the huge dais.

The conceit had a conflicted structure, however. It claimed that the history of the Florentine republic prefigured Cosimo's deeds. Yet the many changes made in the course of its evolution indicate that it also rejected the claim of the republic in favor of other (Medicean and Roman) traditions. In consequence the structure was expansive, totalizing, and centered on Cosimo, and it was at the same time a virtual theater of polemical comparisons and contrasts. Not surprisingly one of the most characteristic, consistent, and contentious debates in contemporary Florentine historiography revolved around the relative merits of republican and princely forms of government, and their respective means of war making and empire building.[203]

The overall *concetto* for the entry, like that for the Sala Grande, was also tripartite. Borghini described "the aim and intention of the invention" most succinctly at the beginning of the draft program sent to Duke Cosimo on 5 April 1565. First, the city must "declare the contentment, happiness, and satisfaction that it has received from this marriage." Second, the city must "honor as politely as it can both the bride and our lords, in order to express its affection and devotion toward its illustrious lords as well as to pay the debt that it has with Your Excellencies." Finally, the city must "show the hope that it has in looking forward to and anticipating all the benefits, tranquillity, and happiness, that the wisdom and goodness of our lords, and especially the union and conjunction of these two houses of Austria and the Medici, promise their subjects in general and this city in particular."[204] In a letter to Domenico Mellini on 2 September 1565 Borghini expanded upon the benefits of Cosimo's

rule, presumably to be continued under Francesco, in a list closely corresponding to the sequence of decorative monuments in the entry: "rewarding and cherishing genius and the arts, whether liberal or mechanical [Arch of Florence]; defending the people from external and domestic injury [Column of Victory]; fearing God and cultivating holy religion in his people [Arch of Religion]; punishing and extinguishing vice [equestrian monument of Virtue Overcoming Vice]; nurturing and delighting the people [Arch of Happiness]"; but above all providing "good government, both domestically and militarily, with holy laws and traditions [Arch of Prudence]," "the aim and first intention" of which was "the bliss and happiness of his city."[205]

In the same letter, Borghini explained that the Arch of Happiness and its fountain spouting red and white wine—with the two swans that "by means of jets of water at times spurted with force on him who drank too much"[206]—fulfilled the first part of the *concetto*, civic contentment and satisfaction (fig. 75: 4). He might have included the fountain on the Arch of Maritime Empire with red and white wine issuing from the breasts of a siren "seated upon a very large fish, from whose mouth at times, at the turning of a key and not without laughter among the expectant bystanders, a rushing jet of water was seen pouring upon such as were too eager to drink" (fig. 68: 3).[207] As if to satisfy the tastes of the *popolo* while keeping it at a distance, Borghini saw to the placement of these two fountains near the civic center at the midpoint of each group of seven monuments decorating the parade route but where, at the southeast and southwest boundaries of the Roman *castrum*, they were also marginal to the ancient core of the city (fig. 64: *4, 11*).

The monuments to Florence, Austria and Tuscany, Hymen, Maritime Empire, Austria, and the Medici (fig. 64: *1–4, 6–7*) fulfilled the second part of the conceit—receiving, honoring, and celebrating the bride and groom and their houses—and related ceremonially to the coronation of Giovanna uniting the Hapsburgs and the Medici. The arches and monuments of the remaining half of the decoration (fig. 64: *8–14*) answered to the third part of the invention—the benefits of Cosimo's regime for Florence and Tuscany. The complementary spiritual and temporal claims of Cosimo's persona and regime were underscored by Giovanna's prayers in the cathedral and her reception at the Palazzo Vecchio by Francesco. All three aspects of the program—public happiness and festivity, welcome and union, Cosimo and his regime—were interwoven in the movement of the procession across the city, just as the thematic juxtapositions of the conceit (Tuscany and Austria, Elba and New World, Augustus and Cosimo, Austria and Medici, Religion and Prudence, etc.) were bound together by the processional itinerary. Even so, the complications and conflicting exigencies of the entry taxed Borghini's meticulous and fastidious mind. The program came close to collapsing of its own weight.[208]

Borghini worked closely with the designing artists (primarily Vasari) on de-

tailed drawings, although Borghini made some of the sketches himself (figs. 79–87).[209] A flexible policy of give-and-take was required at this point. Not only did the project, as Borghini pointed out, "have to correspond to the necessity of the invention, but the invention had to accommodate itself to the spaces available."[210] It was difficult to stabilize the invention "until the form of the arch or other element to be made is resolved, because depending on the space available for the histories and the placement of the statues it is sometimes necessary to change the invention; and, contrariwise, sometimes one must accommodate the form of the arch to the invention, since in a small space one cannot put something that has many items, and a single subject placed in a large space will get lost; and it sometimes happens that to fill up every space one puts in rubbish, or contrariwise, for the lack of space the invention is mutilated and imperfect."[211] But once a "form with its measurements" was fixed, Borghini could turn to "the thousand details of devices, coats of arms, inscriptions, portraits,"[212] as well as trophies, grotesque work, festoons, attributes, postures, costumes, and so forth.[213]

As the *concetto* took shape "through the tedium and effort of research," Borghini began to refer to it as a "machine," a "tapestry," something "interwoven." It required a global view, a detailed written program, a long "list of all the things to do," and constant small adjustments right up to the very end. In this way "confusion" and "disorder" could be avoided and the whole brought to a high "finish and ultimate perfection."[214] Control of a multiplicity of integrated details also required extreme mental concentration, "a lively, clear, and purified intellect and imagination."[215] According to contemporary theories of creativity, including Borghini's own writings on art theory, "purified intellect and imagination" were manifestations of divinity in human beings. In order to achieve this state of concentration Borghini had to escape to his retreat in Poppiano (this is a principal reason why so many letters remain to document this project) where he had the "opportunity, out of the spotlight," to be "fixed, attentive, and completely occupied with this project alone," "without having to have a thousand [other] thoughts in mind or being interrupted every hour and called to other tasks."[216] Here Borghini "became" the duke, playing a role like that of Cosimo alone planning his campaign against Siena.

Although Borghini alone had the responsibility for generating and perfecting the *concetti* of the entry and the Sala Grande and for overseeing their completion through the various stages of revision, he depended on assistance from others. Lelio Torelli, Cosimo's first secretary and chief jurist, helped Borghini do research for a scene in the ceiling of the Sala Grande intended to show that Florence had never been subjugated; Torelli also supplied appropriate titles of books identifying various writers on legal matters represented on the Arch of Florence.[217] For contemporary and historical scenes on the Arch of Florence and the Arch of Prudence, Borghini consulted the poet and play-

wright Giovanni Battista Cini.[218] For both the Sala Grande and the entry inscriptions Borghini turned to antiquarian and philologist Piero Vettori, poet and classical authority Fabio Segni, and court historian Giambattista Adriani,[219] although he reviewed and revised all their submissions with a particular eye to gravity, magnificence, brevity, and good latinity before submitting them for final approval to the duke.[220] The demands of the program, like those of a military campaign, went beyond the powers of a single individual.

Besides acting as the coordinator between Cosimo and the programming team, Borghini also had to mediate between the patron and the artists. By allowing the artists a certain freedom of expression and sowing enough rivalry among them to call forth their best efforts, Borghini was a master of management psychology *avant la lettre.* Since "the work would have to be assigned to various artists," Borghini wrote, "each will have the desire to exercise his genius and to make some demonstration and proof of his worth." As long as "they did not go beyond the conceit given to them," he continued, this "was to be permitted and even desired, because each would exert himself to make beautiful things."[221] In the case of his friend Vasari, an experienced impresario, Borghini catered to his sense of intellectual and creative independence by calling on him to play an active part in designing the program for the entry and the Sala Grande.[222] Although Vasari claimed the invention of the program for the Sala Grande entirely for himself,[223] the evidence suggests that his contribution to the program was minimal. If necessary, Borghini could also be masterfully self-deprecating to flatter a temperamental but highly respected artist such as Bronzino. In his instructions to the artist for the Arch of Hymen he wrote: "I know that I take ever and a day in wanting to give form to this design; but do not look at what I say as much as what seems to you will turn out well, since I know only how to express my conceit and not how to realize it; however, if you are not satisfied with what I say, do what you judge best, and all will be approved by me, and I am certain that it will be better than what I say."[224]

In a further effort to promote a sense of independent creative effort Borghini even proposed to his patron that, if "some association of youths, or some city of your most happy state, or some national group of merchants might spontaneously have an idea to make something by their own will and action, it would not be bad, if Your Excellencies liked the idea, to leave some space vacant to satisfy their fantasy."[225] The proposal remained just that, surely because of what was left unsaid—that these "happy" institutions would have to pay their own bills and subordinate their "spontaneous" ideas to the controlling themes of the program.

Borghini fully recognized that the nature of his projects precluded complete coordination and total control. As he phrased it in letters to his collaborators, "these things are by their nature difficult, and much more so by accidents, since one must contend with bungled work resulting from the material, the

men, the weather, the money, and the ministers; these things have a thou-
sand difficulties, with the painters, the carpenters, the sculptors, and so on,
and most often one has to fight with the sites, the spaces, and the measure-
ments; therefore, do not be surprised if something has to be corrected, be-
cause very often I have said one thing, and another was done." But Borghini
was prepared to accept some rough edges or personal "fantasy," because "es-
sential things" ultimately would be controlled by the *concetto* and "will in
every way adjust themselves and harmonize all together."[226]

The process was completed only after the event, when Borghini had the
program written out and published. Borghini claimed that the major purpose
of such a description was to give the *concetto* a polished structure and to
clothe it with literary refinement,[227] although directing attention, fixing mean-
ing, making the ephemeral permanent, and packaging a project for export
must have been equally important considerations. Like the advance prepara-
tions, the written descriptions after the fact were a product of collaboration.
For the entry Borghini supplied notes, explanations, and inscriptions piece by
piece as fast as he could prepare them,[228] and Domenico Mellini shaped them
into full-dress rhetorical form. Only two days after the event Mellini had a
manuscript at the Giunti press where Borghini saw it a few days later, calling
several errors to his attention.[229] The small book was ready to distribute to the
participants and the imperial court about three weeks later in early January.[230]
As if the entry were beyond the scope of a single text, Giovanni Battista Cini
wrote another version that Vasari published with revisions and without credit
at the very end of the 1568 edition of his *Lives*.[231] Vasari's description of the
Sala Grande, surely also worked up in part from Borghini's notes, was pub-
lished posthumously in 1588 as the last dialogue of the *Ragionamenti,* begun in
1558, describing all his work in the Palazzo Vecchio.[232]

Since, in Borghini's words, "the material was large," the great challenge of
these descriptions was "to cut away the superfluous with great efficiency and
skill without leaving out whatever is necessary or the nerve of the thing, and
to tighten up with reason the essentials, in order to give satisfaction and plea-
sure to readers, naturally enemies of length."[233]

The Vasari-Cini description confronts this challenge in the opening sen-
tence where the stated purpose is to "describe with the greatest clearness and
brevity . . . an abundance of material." But the task was an impossible one, as
the constant apologies to the reader for either needing to omit material or
having gone on too long indicate.[234] Still apologetic but obviously unrepen-
tant, toward the end of his account Vasari writes: "I thought, when I first re-
solved to write, that it would take much less work to bring me to the end of
the description given above, but the abundance of the inventions, the mag-
nificence of the things done, and the desire to satisfy the curiosity of crafts-
men, for whose particular benefit, as has been told, this description is writ-
ten, have in some way, I know not how, carried me to a certain extent against

my will to a length that might perchance appear to some to be excessive but that is nevertheless necessary for one who proposes to render everything distinct and clear."[235]

The apologies cannot be taken entirely at face value. In themselves, they were empowering tropes. The sheer volume of material that defies even the fullest account was part of the desired effect. "The rich and gracious effects," "the abundance of inventions," and "the magnificence of things done" were equivalent to the victor's spoils, spoils that figured the conquered empires of classical and republican culture. Borghini was like the victor of the triumphalist mode giving clarity, structure, and purpose to a victorious programming campaign by his "divine" intellect, concentration, and learning. But just as the spoils of victory tended to overwhelm the victor, so too the vast resources of Florence's cultural heritage and the huge scale of the triumphal enterprises were not only beyond Borghini's complete control but laden with contradictions resistant to easy resolution. One might paraphrase Vasari to say that Borghini was often "in some way, he knew not how, carried to a certain extent against his will to lengths that might perchance appear to some to be excessive, tedious, or repetitive."

The Quartermaster: Caccini

In his 5 April 1565 letter to Cosimo, Borghini outlined the tasks he had in mind for Giovanni Caccini: "I believe it will facilitate everything, to have a congenial person, sharp and quick of judgment who, as *provveditore* (superintendent) or with whatever other title, would solicit, oversee, and check work, putting it into order and taking delivery, as well as keep order in the records and payments by type of work and have them at hand every day, even every hour."[236] Acting on the advice of Borghini and Vasari, he was probably also in charge of acquiring well in advance the necessary supplies for the temporary arches listed by Borghini: large quantities of wood (including poles and beams for the internal framework, planks and boards for the framing), ironware (including a large number of spikes), and canvas for the paintings.[237] Other necessities included a large supply of bricks for bases three or four feet high to elevate the arches for unobstructed viewing; lumber and canvas for temporary awnings to protect the arches from the weather; and carts, sledges, rope, hoisting tackle, scaffolds, and cranes for erecting the statues to go on top of the arches.[238] Caccini was also responsible for acquiring the stone and overseeing the repaving of part of the parade route.[239] Above all he was to keep the expenditures in line and, along with Borghini, protect the financial interests of the duke.

Borghini had estimated that the total cost would be around eleven to twelve thousand *fiorini*.[240] When Alessandro Allori was rumored to have said that his Arch of Florence alone would cost 4,000 *scudi*,[241] Borghini and Caccini were

thrown into a panic: this remark suggested that total costs would be closer to fifty thousand *scudi*, a fear that Vasari shared.[242] A letter of reprimand by Borghini produced a denial from Allori that he had ever quoted such a high sum.[243] But in the end the cost of the entire entry was about double Borghini's original estimate.[244]

What clearly emerges from this episode and the composite documentary record is that, while commanding rather inexact and ad hoc methods of financial planning and control, Borghini and Caccini were under strong pressure from two sides to keep the records accurate and the expenses low: from their patron whose resources were clearly limited, and from his more affluent subjects who in the long run bore much of the burden, as confirmed by a special tax levied on 30 July 1566 to cover the shortfall for the marriage festivities.[245] Yet neither stringent budget constraints nor Borghini's nagging concern that his *concetto* had not fully captured the intention of Cosimo or achieved the "brilliance and beauty" commensurate with "so great a subject" could extinguish the great hope to realize the potential "majesty" of the entry. For in Borghini's words, "there perhaps has never been a greater, more exalted occasion than this one, because of both the grandeur of him who stages it, and the concourse of lords and great men who will participate."[246]

This conflict between majesty and parsimony was at the core of Caccini's financial relations with the artists. Already in his letter of 5 April 1565 Borghini had advised Cosimo that it would be wise to allocate the work "as soon as possible with fixed prices and firm deadlines."[247] And on 16 June Caccini wrote to Borghini that when he and Vasari had met with the duke the morning before, they had been commanded "to see to fixing the prices this week with the sculptors and also with the painters . . . in order that they know what they are to receive and I [Caccini] what to give them."[248]

This task was easier said than done. Since Caccini knew nothing about art and had no idea how to evaluate it, he had to depend on appraisers and artists, especially Vasari and Bronzino.[249] But artists were not to be trusted, Borghini felt, since they were often completely self-interested and out to gouge Cosimo for as much money as possible. Constant vigilance and payments only large enough to keep them working would be prudent policy. "Beware of the greed and the lack of discretion of certain ugly animals," Borghini warned Caccini.[250]

In another note to Caccini, Borghini also made it clear that he was even less pleased with the appraisers: "They are either the greatest ignoramuses of this art or the greatest laggards who want to vindicate some particular interest of theirs or allow themselves to be corrupted. . . . So many and so large are their evident extravagances that they cannot excuse themselves in any way; and I say that in this work concerning the paintings and the painted decoration I remain very poorly satisfied with them; and it does not seem possible to me to excuse these appraisers either for their great ignorance or for their consider-

able ill will and partiality because, considering the time spent on a painting, its quality, and the quality of the painters, it is evident that they went astray in everything. And to give you an example, they have valued the history above the portal of the cathedral, which is good and beautiful, at twenty-four *scudi*, and those on the arch of the Porto al Prato, which are equally beautiful, filled with more figures, and two-thirds larger, at twenty-three *scudi*, which is something very strange and unreasonable. They have valued the two uppermost paintings of the Arch of Hymen, which are extremely beautiful, at ten *scudi* each, and though they are not from Bronzino's own hand, they are of his design, with his help, and, it seems to us, as if from his hand; but the histories on the Theater of the Medici, which are from lesser and worse artists, they have valued at either fourteen or twenty *scudi*, all extravagant and arbitrary estimates, which all need to be reconsidered and where necessary corrected. But above all the estimate for the work of Michele di Ridolfo [on the Arch of Maritime Empire] seems to me irrational; these are canvases sixteen by eighteen *braccia* and the discomfort alone of working on extremely high scaffolds and going up and down them is worth some money, to say nothing of the time spent."[251]

To counterbalance the artists' greed, the appraisers' ignorance, and Caccini's evident lack of aesthetic judgment Borghini formulated a series of criteria in order to help Caccini arrive at just payments. The work of a master was worth more than that of a laborer; major established masters such as Bronzino, Ammannati, and Vincenzo de' Rossi were to get more than younger, less experienced ones; and a foreign artist should get something additional because of greater expenses and less comfort in his living arrangements. Difficult and time-consuming work on site should be paid more than work done in the studio. The greater the mental effort, the time expended, and the physical discomfort in making a work of art, the higher the compensation. Large figures were worth more than small; nudes more than draped figures; original figures, faces, trophies, and angels more than accessories worked up from cartoons designed by others; and work with small brushes more than work with broad brushes.[252]

These guidelines clearly indicate the degree to which art for such projects as the entry and the Sala Grande was mass-produced by assigning specialized tasks to individuals within a large work force. Paradoxically, aesthetic quality—implicitly defined as original conception, virtuoso execution, and strict discipline born of hard thought, long experience, and willing service to a single master—was the most valued and deserving of the highest compensation. Judgments about originality and virtuosity, however, were notoriously subjective; they were also conditioned by the knowledge of visual traditions, art theory, and cultural needs, which Borghini possessed to a high degree. But bureaucrats like Caccini needed straightforward criteria in order to bring these projects under tight financial control. And the more art financing be-

came bureaucratized and standards of value objectified, the less relevant subjective judgments of aesthetic quality became. Borghini himself, who never completely separated manual labor from originality, believed certain kinds of art should be paid for by the yard and reported at one point that "all [of the artists] had proposed among themselves to be paid by the square *braccia*."[253]

Caccini, rather like the victor of the triumphalist mode, was caught in a bind. He was expected to produce a triumph of quartermastering by delivering the most matériel for the least cost in support of a campaign whose strategy he neither understood nor controlled, while the heat of the battle depleted his stockpiles, strained his record keeping, taxed his delivery systems, and drove up his costs.

The Artist as Impresario: Vasari

Working in coordination with Borghini and Caccini, Vasari was responsible for overseeing the execution of all the decoration for the entry and the Palazzo Vecchio. In addition, he personally designed the architecture for all the temporary entry monuments except the Arch of Florence and the Theater of the Medici;[254] he oversaw the design of all details of the Arch of Security, the courtyard of the Palazzo Vecchio, and the Sala Grande, including the stage, sets, and seats for the St. Stephen's day play.[255] Each project was produced by a team of masons, carpenters, sculptors, and painters with a major painter or sculptor acting as foreman and charged with the overall design responsibility for visualizing Borghini's ideas.

Before completing his draft program for the entry, Borghini made a list of the artists and artisans who would be available. The list reflects not only Borghini's knowledge and thoroughness but especially the extraordinary resources of Florence: eighty painters, forty sculptors, and twenty-four carpentry shops.[256] Of these, perhaps after further consultation with Vasari, Borghini mentioned by name in his letter to Cosimo of 5 April 1565 fifty-one painters, twenty-five sculptors, and fifteen carpentry shops.[257] Not all were actually used for the entry and Sala Grande, yet the number involved was still truly monumental in comparison with more routine commissions for the period and indicate the degree to which projects such as these were major public works. The entry alone employed at least twenty-six painters, twenty-six sculptors, ten carpentry workshops, and eight chief masons;[258] the work in the cortile and the Sala Grande up until 1565 occupied at least two masons, two carpenters, three architects, twenty-one painters, thirty-five sculptors (including stucco workers and stonecutters), one glassmaker, and one gold beater.[259] To oversee and make arrangements for this vast army Vasari often made his rounds on horseback for much of the day, encountering so many difficulties that he often complained of severe headaches, and said that he felt half dead with fatigue.[260] The following letter of 21 September 1565 from Va-

sari in Florence to Borghini at his retreat in Poppiano is worth quoting at length for a more telling portrait than that of the impresario who calmly surveys his work on the ceiling of the Sala Grande (fig. 113).

> I have not responded to your letter, first, because I did not have the measurements [of the spaces on the entry arches] for the inscriptions; and now I tell you, make them with as many letters as you wish, because the inscriptions have to be made as large as you wish them, and because they are separate from everything that has been made, the measurements for all of them will be awaited from you.
>
> The other things are coming to an end; and the duke has said to begin putting the poles everywhere in place [to shelter the arches from the weather?], finishing by the middle of November at the latest. And as you have heard, the Prince [Francesco] departs within eight days; it is necessary that you return because he wants to see and to speak with you before leaving; and the duke has asked many times for you, and I have told him that you were away writing the inscriptions. In short, it is necessary that you come here next week to finish and to tie up everything.
>
> Francesco Moschini has finished everything [for the Arch of Security], and he is doing his narrative [relief for the cathedral doors], as is Maso Boscoli. Alessandro Allori lacks three narrative paintings [for the Arch of Florence]. It will be a while before I have seen it all together; and we wish to finish this decoration, which has had twenty-two painters at work at one time. Francesco della Camilla is finishing up [the Arch of Tuscany and Austria], and Bronzino goes slowly as usual [on the Arch of Hymen]. Michele di Ridolfo has finished the Arch of Maritime Empire; Giovanni dell'Opera is making the sculpture of [Armed] Religion and its narrative painting [for the Arch of Religion]; Battista Lorenzi is well along [on the sculpture for the Arch of Hymen]. Maestro Giovanni Stradano has finished four narrative paintings and is working on the rest [for the Arch of Austria], and he will do those things on the arch you wrote about concerning the portraits that you want to paint in color. The arch is still being painted. The Theater of the Medici will take a long time, and there is always something being added; here there is still much to do.
>
> The things on the Arch of Religion are well along; and I believe that if one of its narrative paintings is done, it will be finished soon. The doors of the cathedral are finished; only the papal coat of arms remains. The horse [representing Virtue Overcoming Vice] by Vincenzo Danti is very far along, as are the Arch of Prudence and the Arch of Security. Battista Naldini and Jacopo Zucchi are doing the paintings for the latter. The cortile is about finished and there is enough to do for precisely four days. The [fresco decoration by Lorenzo Sabbatini in the] vestibule before the

Sala del Dugento [in the Palazzo Vecchio] is finished and the [stucco decoration of the] dais of Bandinelli [in the Sala Grande] already has gone around the cornices and enclosed the column, and this week they are hurrying below to work on the niches. Federico Zuccaro has ten days' work left on his curtain for the stage, and I lack two large panels to complete the Sala Grande; then I can unveil the ceiling all the way to Venice. In short everything [is going well], the stage and the like can then be brought in [to the Sala Grande]. I have still not been feeling well and have no rest, God help me. Everything has been said to Caccini, and you will have an answer.

I have nothing more to say except that I am very depressed. The Giant [Neptune by Ammannati] is near the fountain. The corridor [from the Palazzo Vecchio to the Pitti Palace designed by Vasari] is finished, the duke was there, and he is satisfied with it.

Yesterday afternoon I was with His Excellency at the Pitti until about 10 in the evening discussing things including the departure of the Prince [Francesco]. And with this I will make an end by telling you that here there are rumors that the Turks have fled from Malta, have left the artillery of Malta, and have taken a galley and thus their departure, never to return again.[261]

Besides acting as an impresario for the whole artistic enterprise, Vasari had to focus on the design and execution of his own painting in the Sala Grande. This, as we know from a letter he wrote to Caccini, was also demanding and draining work: "And in truth in attending to the work I am doing in the Sala Grande I have become, and I know it, another person. Therefore, when the duke saw that I was no longer coming to the palace, he resolved to come on Wednesday to see me at my house; and he yelled at me saying that he wanted me to do this work for my enjoyment, not to kill myself." But in spite of his Herculean tasks, Vasari's desire for the honor of the victor's triumph kept him going. "In truth," he wrote, "if it comes off, this will be the most honorable enterprise that was ever executed."[262] Borghini had reminded Vasari that aside from their obligation to serve Cosimo effectively, they had to do their jobs well for the entry not only to silence the tongues of the "chattering Indians," or rival artists, but for the sake of "our honor."[263]

Since it was virtually impossible for Vasari alone to decorate the Sala Grande and the cortile, to say nothing of the entry, his honor, like his patron's in the war of Siena, depended more on design than execution. Vasari, in fact, invented a theory of *disegno* almost precisely at this time. In the 1568 edition of his *Lives* he wrote that *disegno* (in the sense of conception or invention) has "its origin in the intellect, draws out from many things a general judgment, is like a form or idea of all the objects in nature . . . and is cognizant of the proportion of the whole to the parts and of the parts to one another and to the

whole. . . . *Disegno* is nothing more than a visible expression and declaration of the concept that one has in the mind, which is imagined and created in the intellect by the idea."[264] So defined, *disegno* made the artist divine and brought him honor and eternal glory; it was a godlike facility of the mind to create visual images derived from the abundance of nature or fantasy but unified by the same rules of proportion that ordered the cosmos.[265] Borghini was referring to this kind of intense mental effort when he told Vasari that for the Sala Grande he needed "time," "diligence," and "study, study, and more long and considered study."[266] Vasari claimed that the only thing that kept him from breaking under the heavy burden of the entry and the Sala Grande was his "great practice and judgment and resolve."[267]

But of course *disegno* was also the physical act of drawing, the process by which the hand "through the study and practice of many years" translated the "intellect's refined and judicious *concetto*" into a drawing with speed and facility, a sketch "hastily thrown off out of the artist's impetuous mood."[268] This aspect of *disegno* depended on two new developments that were quintessential aspects of Mannerism or *bella maniera:* the employment of a loose, varied, and flowing graphic line, and of a repertoire of motifs and compositions developed by the constant and long-term practice of copying from nature, antique art, and contemporary or near contemporary masters. Ideally, the hand and mind worked in concert, but it was perfectly possible to separate the two aspects of *disegno.* Thus Borghini, while not accomplished technically as a draftsman, nevertheless made drawings that "amazed" and "stunned" Vasari because they conveyed so precisely Borghini's "intention and meaning" (figs. 79–87).[269]

In any case, the theoretical distinction between design and drawing and between design and execution coincided with their increasingly common separation in practice because of the large scale and short deadlines of state projects. Edmund Pillsbury shows that in the Sala Grande Vasari was responsible for the overall layout as well as most of the initial designs of individual scenes that he then turned over to assistants (Stradano, Zucchi, and Naldini being the most important in that order) for elaboration into finished *modelli* and cartoons. "Where Vasari re-imposed his control over the final form of the compositions was in the detail studies done after the cartoons had been made and the panels were ready to paint."[270] As Paola Barocchi observes on the basis of style, and Borghini's criteria for payment confirm, the actual painting of the scenes usually was a workshop production with several artists doing different parts, often with no direct participation by Vasari himself.[271] The results were often uneven, mechanical, and formulaic. "I sometimes had to redo everything in my hand," Vasari notes, "to completely repaint the panel, in order that it be in a single style."[272] Borghini also complained that a portion of the entry decoration was of relatively low quality when expressing his outrage at some of the high appraisals for the Theater of the Medici. "We know,"

he wrote to Caccini, "that much was done there by assistants (*garzoni*) and in a hurry."[273]

Besides encompassing conception and execution *disegno* also had an historical dimension. For the second edition of his *Lives* Vasari vastly expanded the material to include sixteenth-century artists and added to nearly all the biographies a discussion of each artist's drawing style based in large part on his own collection of drawings.[274] *Disegno* thus became a major new unifying thread of the whole work. The development toward an ever greater refinement of *disegno* gave unity and purpose to a history of the arts culminating in the *bella maniera* of Vasari's own age. Since the progressive refinement of rhetorical eloquence beyond the ancient authors was to have been a unifying theme of Borghini's project for a history of Florentine culture, it has been convincingly suggested that Borghini helped Vasari devise his theory of *disegno*.[275] What is certain is that projects like the entry or the Sala Grande ranked among the highest cultural expressions of the age, combining as they did classical tradition with modern invention, verbal conceits with visual forms, and eloquence with *disegno*.

As an example of *disegno* in practice, consider the scene of the battle of the Florentines against the Pisan bastion of Stampace (fig. 106). Like all the scenes from the war of Pisa, this episode had a textual foundation—Guicciardini's *History of Italy*[276]—and was produced by the bureaucratic procedure that the theory of *disegno* justified. Naldini was dispatched to Pisa to make a drawing of the city, walls, and battlefield. By talking to some "old artist" or by copying "some old picture" he was to reconstruct "every detail" of "the breach that had been made by the artillery from the Florentine camp," "the defensive moat and counterbastion inside the walls thrown up by the Pisans" to defend the breach, "any defensive trenches or moats outside the walls for the defense of the [Florentine] army," "the Florentine camp with its sentinels, artillery, guards," and so forth. Then he was to go up in the tower of Stampace and add to his drawing a panorama of the city of Pisa as seen from there.[277] Using Naldini's drawing as the setting for the scene, Vasari and his workshop would have then worked up the cartoon; the finished scene would have been a collaborative enterprise with Vasari probably reserving the most important foreground figures for himself.

Of particular interest for the theory and practice of *disegno* is the nature of the composition—its sources and rhetorical structure. The scene consists of three parts. On the left, dressed in contemporary armor with his coat of arms blazoned on his tunic, is the commander, Paolo Vitelli. Seemingly spurred on by the messenger at his feet, Vitelli gives the soldiers grouped to the left and right of the composition the command to move forward diagonally toward the breach in the walls to the accompaniment of the trumpeters. The diagonal that begins with Vitelli's baton continues deep into space following along the breached city wall, giving the composition a dominant left-to-right movement

toward the dais in concert with the dominant movement of the other two scenes on this west wall. On the extreme right two soldiers, one mounted and one on foot, are in an animated discussion or argument. The figures in the center of the scene, bracketed by the two diagonal lines of troops, are shown in postures of extreme torsion as a hero is armed for battle with sword, shield, and spurs by three companions, his rearing horse steadied by a fourth.

Most of the figures in the foreground are in classical dress, a subtle allusion to the ancient destiny of Florence, which was a fundamental part of the *concetto* of the whole program, as we have seen. Their attire becomes even more suggestive when we realize that the horse tamer in the central group is a virtuoso rearview paraphrase of one figure from a well known sculptural group (now at the entrance to the Capitoline) discovered in Rome in 1560 of the Dioscuri, the protectors of Rome.[278] Furthermore, the hero being armed is a masterful *figura serpentinata* that recalls Salviati's powerful image in the nearby Sala delle Udienze: Mars, the ancient protector of Florence, the New Rome, here about to mount a rearing horse, a common attribute in many Florentine depictions of the god of war, including that in Vasari's own *Foundation of Florence* (fig. 96).[279] The implication is that Mars will ultimately lead Florence to victory in spite of the republican government's mismanagement of the Pisan war. If these allusions are correct, then it may well be that the arguing soldiers to the right, either walking or turning away from the battle, were intended to suggest the indecisiveness of Vitelli that resulted in his failure to clinch the victory and that led instead to his arrest, imprisonment, and decapitation for treason by the Florentine government. Perhaps for this reason Vasari based the messenger to the left on Roman reliefs of prisoners pleading for mercy from a victor,[280] as if prefiguring the position Vitelli would soon have vis-à-vis the Florentine government.[281]

The foreground frieze of about a dozen figures is ordered into three groups. Based on the formulas of Roman battle reliefs these forms are strongly three-dimensional, in exaggerated poses, and rhythmically interconnected by the repetition and variation of a limited repertoire of postures and gestures. The background vouches for the authenticity and truth of the scene by a variety of accurately observed details. This combination of intellectual abstraction, studied observation, and poetic imagination to recapture the past in the present is the essence of *disegno*.

Like nearly all the scenes of the Pisan war, however, the painting lacks much *bella maniera* or eloquence. The *Battle of Stampace* is structured to encourage the viewer's eye to wander from group to group taking in details from left to right, from foreground to background, delighting in references to the classical past, the verisimilitude of details, and individual passages of technical virtuosity. But in general the composition images a Florentine republic that was fragmented, unfocused, and chaotic so as to demand of the viewer a critical, if not condemning response.

When one looks directly across the room to the scene of Cosimo's victory at Siena's Porta Camollia (fig. 111; color plate 8), to which the battle at Stampace was the deliberate counterpart, the full sense of *disegno* as *bella maniera*, as a creative process ultimately surpassing tradition, becomes evident. Here is no dissension within the ranks, no hesitation, no time lost arming while the enemy takes countermeasures. We see a bold, decisive stroke coordinated by two mounted commanders. Their troops are pouring over the bastions and flooding through an arched gate in a massed column that crosses the foreground from left to right and curves back to the left toward the dais along a route lighted by lanterns. Since the figures are not dispersed into various groups, and the background details are obscured by distance and darkness, the viewer's eye is overwhelmed by the all-encompassing pyramidal structure that is stable and focused, yet charged with dramatic action and virtuoso effects of nocturnal illumination from more than sixty sources of light. Here too, classical allusions have been dropped, and the viewer's sense of witnessing an actual contemporary event is infinitely greater: in effect, Florentine forces no longer depend on a Roman pedigree but have become themselves the agents of Florence's destiny. The visual structure figures a duchy that was united, coordinated, and focused; it was calculated to overwhelm, awe, and control the viewer.

Vasari's physical and intellectual command over the coordinated production of such a scene, which in scale and virtuosity surpassed anything in the Florentine tradition, paralleled the real or imagined tour de force of Cosimo's victory over Siena. In other words *disegno* itself, in the fullest sense of the term, was the fitting expression and product of the political and cultural imperialism of the ducal regime.

Disegno pertained not only to the bureaucratic production of paintings but, using the metaphor of the patriarchal family, also provided the theoretical basis for the unification of all the arts. "Design [is] the father of our three arts of architecture, sculpture and painting," said Vasari.[282] The Accademia del Disegno—its foundation in 1563 was celebrated in one of the paintings on the Arch of Florence—unified the arts within a single institution, liberated from the control of separate guilds.[283] It was no accident that the scholarly Borghini, a member of the literary Accademia Fiorentina that served as a model for the Accademia del Disegno, was its first head, since its primary purpose was to teach the intellectual bases of art making such as mathematics, geometry, and anatomy. But the very act of teaching *disegno* implied rules, and rules suggested exclusions. Indeed, in privileging line and draftsmanship, *disegno* suppressed color and painterliness. In championing contour, it often forced and flattened human anatomy for rhythmic, artificial effects. And so on. But knowledge also empowered, elevating art from a craft to a liberal art, transforming the artist from an artisan to an intellectual worthy of honor and glory.

And artists were honored. For the first time in such an extended description

of a work of art, Domenico Mellini listed nearly all the artists who participated in making the entry decoration and credited their individual contributions. In the ceiling of the Sala Grande ten artisans, artists, and programmers—all dressed alike as gentlemen—were portrayed in two panels that together comprised the most conspicuous and complete visual signature ever to appear on a work of art until then (figs. 93: *45, 47;* 113–14). Included were the chief mason, chief carpenter, chief gilder, chief grotesque painter, chief designers and painters, and chief programmers.[284] At exactly the same time that Vasari was overseeing the entry and the Sala Grande, he was vastly expanding his *Lives* to include living artists in the second edition. Here, significantly, he presented his own life, as well as the description of the decoration for the 1565 marriage festivities carried out by the members of the new Accademia del Disegno, as the triumphant climax of the previous two and a half centuries of the history of art.

The structural hierarchy in all this is revealing. The panel with the chief mason, carpenter, gilder, and grotesque maker was placed at the very end of the ceiling, marginalized surely because their work was largely manual. In contrast, the programmers and designers were represented as close as possible to the very center of the ceiling. In addition, the designers and programmers together in a scene of triumph (fig. 113) implied that the union of eloquence and *disegno* in the hall was a victory as worthy of commemoration as Cosimo's triumph in the art of war. While the placement of the programmers in the immediate foreground recognized their importance, Vasari still gave himself as artist in chief the pride of place in the very center of the group in front of his three design assistants, just as he gave his own life the privileged position at the very end of the *Lives,* immediately following the description of the marriage festivities.

Within his own "Life" Vasari describes the Sala Grande as an encyclopedia of his entire achievement, or indeed of all that was possible for art to achieve. In its "greatness and variety" the Sala Grande represented "wars on land and sea, stormings of cities, batteries, assaults, skirmishes, building of cities, public councils, ceremonies ancient and modern, triumphs, and so many other things, for which, not to mention anything else, the sketches, designs, and cartoons of so great a work required a very long time. I will not speak of the nude bodies, in which the perfection of our arts consists, or of the landscapes wherein all those things were painted, all which I had to copy from nature on the actual site and spot, even as I did with the many captains, generals and other chiefs, and soldiers, who were in the enterprises that I painted. In short, I will venture to say that I had occasion to depict on that ceiling almost everything that human thought and imagination can conceive; all the varieties of bodies, faces, vestments, habiliments, armor, helmets, cuirasses, various headdresses, horses, harnesses, caparisons, artillery of every kind, naviga-

tions, tempests, storms of rain and snow, and so many other things that I am not able to remember them." [285]

Even these grandiose claims were subsumed within a larger hierarchy, however. Just as the official *capo* or head of the Accademia del Disegno was Cosimo, so the artists' portraits in the Sala Grande were subsidiary to the deeds of the patron; their deeds were featured only in an appendix to Mellini's description, the primary intent of which was to glorify the duke. The *Lives* and the Accademia del Disegno were products and organs of an authoritarian regime. And the individual artist, for all his new claims to status as a scholar, gentleman, "prince," and even demigod was, nevertheless, yet another courtier-bureaucrat whose "mind" and "hand" were bound to the rules of *disegno* used to perpetuate and glorify the regime. As the great dedicatory inscription in the Sala Grande (fig. 93: *46*) states, Vasari was the "pupil of the duke (ALUMNI SUI)."

Thus, while the state was figured by triumphalist art, art making was the production of the triumphalist state. It involved a large bureaucracy, an extensive division of labor, a careful allocation of resources, all controlled from the top to mobilize the display of intellectual, artistic, and material resources. With the blurring of boundaries between art and politics the Medicean state was represented as an all-embracing political and aesthetic structure, which both governed the ideology of the regime and allowed for negotiations and exchanges in the arena of "mere" appearances. But what was negotiated and exchanged? First of all, money. We have already seen that these productions were public works employing huge numbers of workers from the building and artistic trades. The cloth industry also must have been heavily involved from weaving and dyeing to tailoring in order to provide sufficient quantities of canvases, canopies, and costumes. The fountains of wine and the series of banquets throughout the festivities would have significantly affected the market economy. In fact, it is hard to imagine any economic sector that would not have found financial benefit in the production of the entry and the Sala Grande. And financial gain (and free flowing wine) demanded participation. Thus while the upper classes showed themselves to themselves, the lower classes constituted the bulk of the viewing audience for the entry.

But through symbolic appropriation, as we have seen, much else was negotiated and exchanged besides: fear of death for apotheosis; anxiety about male impotence and dynastic discontinuity for female fecundity and phallocentric virility; the violence and domination of rape for the desire and eroticism of possession; the risk and disruption of war for the thrill and pride of triumph; the loss of an immediate past for the gain of a perpetually present golden age of an ancient past; the danger of repression and want for the promise of peace and prosperity; the turmoil and upheaval of social mobility and factionalism for the security and privilege of social hierarchy and rank; the drudgery

and concerns of everyday experience, in short, for the wonder and awe of theater—the theater of absolutism.

The theater of triumphalism transformed open, spontaneous festivity into a fixed bill with a captive audience, especially in its movement from entry to audience hall. By its capaciousness and flexibility it suggested, if only momentarily, whole worlds claimed by the regime, and brought these worlds, if only illusionistically, under the control of the duke. In this theater the plenitude of the past however conflicted could be suspended in the present to claim however uncertainly an abundant and secure future.

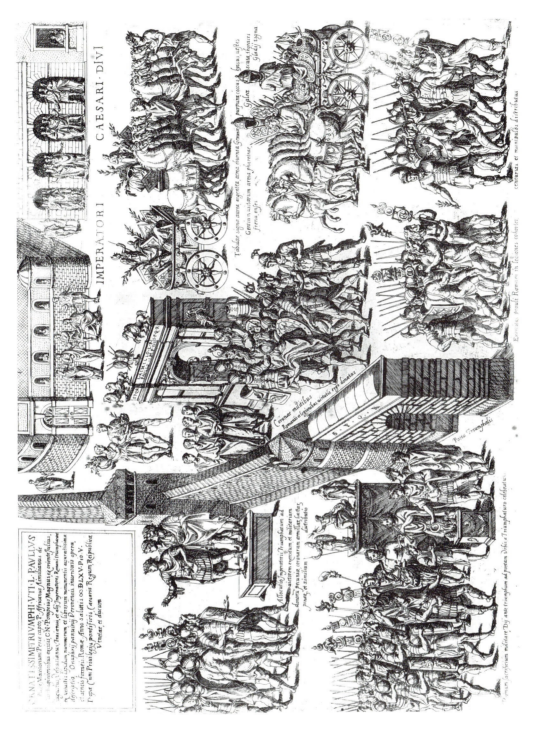

FIGURE 60. *Roman Triumph*, first of four-part engraved frieze from Onofrio Panvinio, *De triumpho*, pub. Michele Tramezzino (Venice, 1571), Vatican, Biblioteca Apostolica.

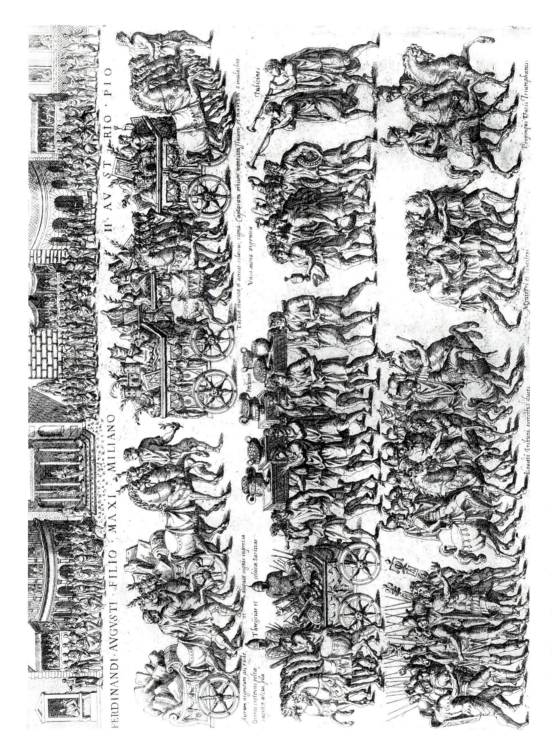

FIGURE 61. *Roman Triumph,* second of four-part engraved frieze, ibid.

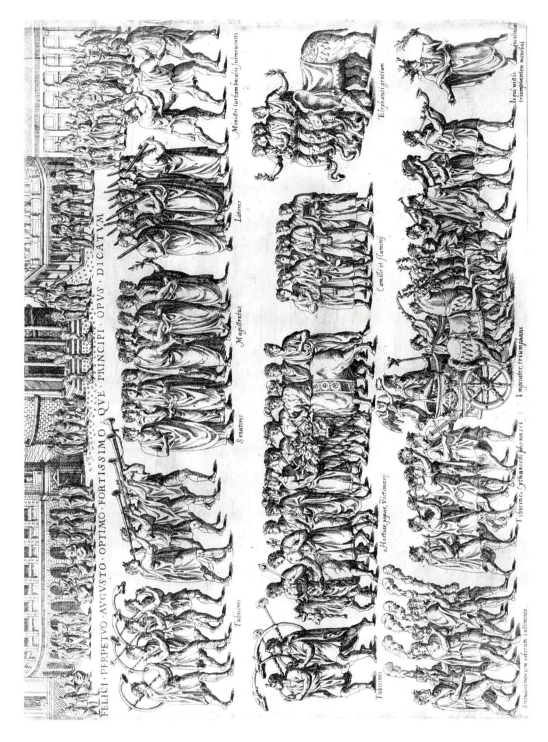

FELICI · PERPETVO · AVGVSTO · OPTIMO · FORTISSIMO · QVE · PRINCIPI · OPVS · DICATVM

Tubicines

Senatores

Magistratus

Lictores

Ministri turfam baculis submouentes

Tubicines

Hostiae, papae, Victimarij

Tibicines, cytharoedi phonasci

Camilli et flaminij

Elephanti genium

Tubicines

Spectatorum odoribus suffimenta

Imperator, triumphans

Iepti uidis triumphantem moneleti

FIGURE 62. *Roman Triumph*, third of four-part engraved frieze, ibid.

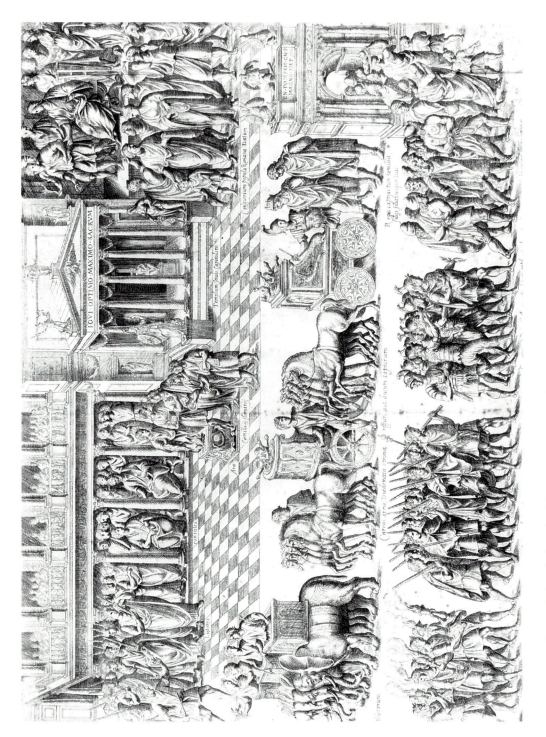

FIGURE 63. *Roman Triumph*, fourth of four-part engraved frieze, ibid.

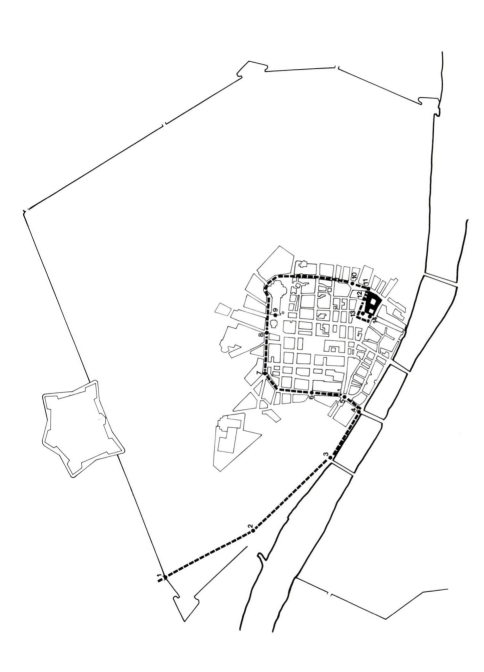

FIGURE 64. Route of 1565 marriage procession. *1* Arch of Florence—Porta al Prato, *2* Arch of Austria and Tuscany—Borgo Ognis-santi, *3* Arch of Hymen—Ponte alla Carraia, *4* Arch of Maritime Empire—Ponte Santa Trinita, *5* Column of Victory—Piazza Santa Trinita, *6* Arch of Austria—Canto de' Tornaquinci, *7* Theater of the Medici—Canto de' Carnesecchi, *8* Arch of Religion—Canto alla Paglia, *9* Arch of the Virgin Mary—cathedral portal, *10* equestrian monument of Virtue Overcoming Vice—Piazza di Sant'Apollinare, *11* Arch of Happiness—Borgo de' Greci, *12* Arch of Prudence—Via dei Gondi, *13* Neptune fountain—Piazza della Signoria, *14* Arch of Security—Palazzo Vecchio portal.

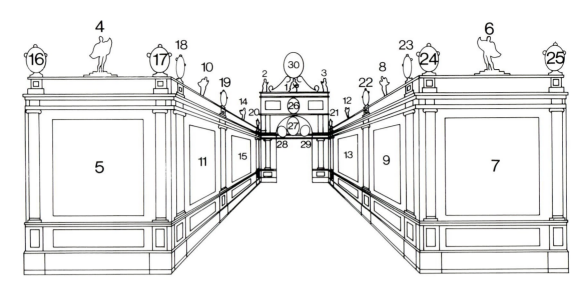

FIGURE 65. Arch of Florence. *1* Florence, *2* Fidelity, *3* Affection, *4–5* Mars or Arms, *6–7* Muse or Letters, *8–9* Ceres or Agriculture, *10–11* Industry, *12–13* Disegno, *14–15* Apollo or Poetry, *16–26* symbolic devices of Florence's founding, Arms, Poetry, Industry, Military Glory, Military Fidelity, Agriculture, Disegno, Letters, and Peace, *27–29* coat of arms of Cosimo I, Florence, and Francesco and Giovanna, *30* inscription (appendix 2: 1).

FIGURE 66. Arch of Austria and Tuscany. *1 and 3* Austria, *2 and 4* Tuscany (appendix 2: 2).

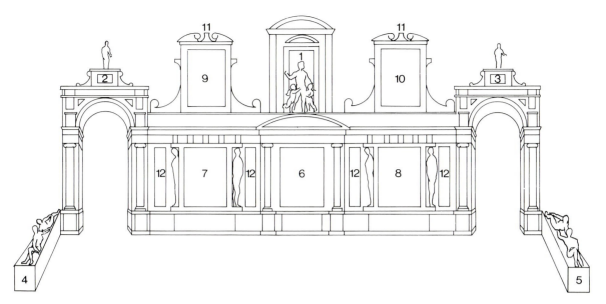

FIGURE 67. Arch of Hymen. *1* Hymen, *2* Venus Genetrix, *3* Latona, *4* Danube and Drava rivers, *5* Arno and Sieve rivers, *6* Three Graces with the Joys of Marriage, *7* Three Graces and Classical Deities Prepare the Nuptial Bed, *8* Joys of Marriage Banish the Afflictions of Marriage, *9* Giovanna, *10* Francesco, *11* chain of marriage rings hanging from heaven, *12* Marriage ode (appendix 2: 3).

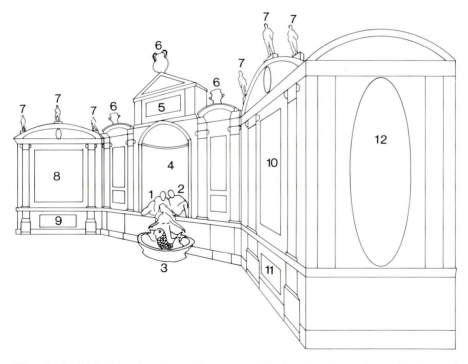

FIGURE 68. Arch of Maritime Empire. *1* Oceanus, *2* Tyrrhenian Sea, *3* siren wine fountain, *4* Proteus, *5* Tethys or Amphitrite, *6* gold vases, *7* male youths, *8* Peru and the New World, *9* Perseus and Andromeda, *10* Elba, *11* Argonauts Sacrifice on Elba, *12* Neptune (appendix 2: 4).

219

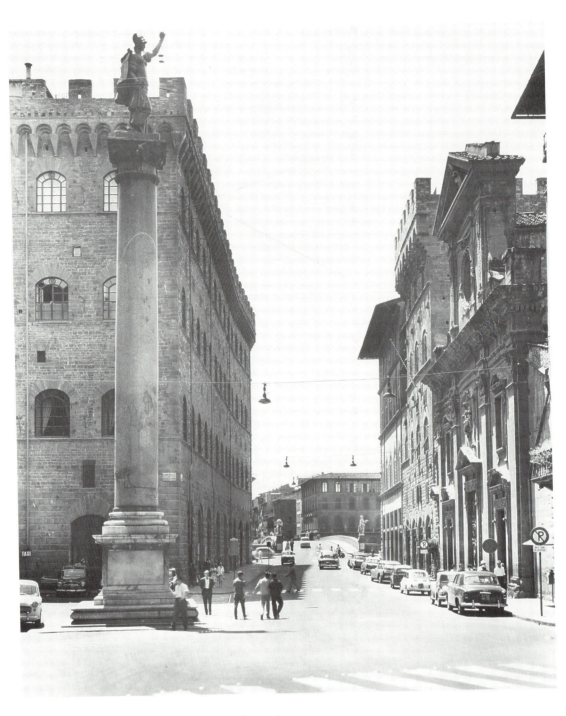

FIGURE 69. Column of Victory (appendix 2: 5).

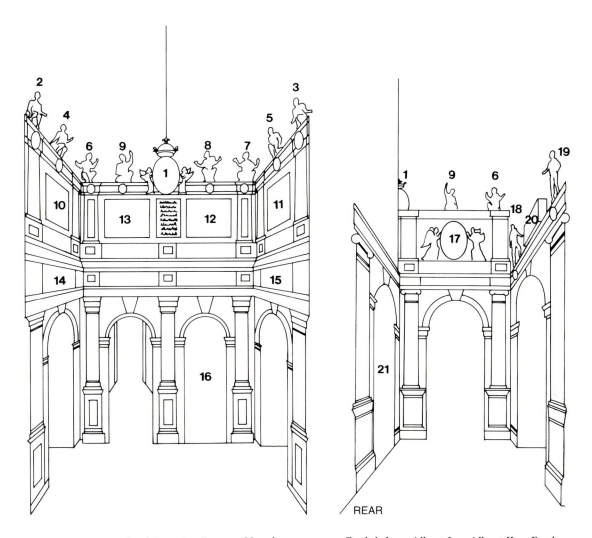

FIGURE 70. Arch of Austria. *Front*, *1* Hapsburg arms, *2* Rudolph, *3* Albert I, *4* Albert II, *5* Freder-ick, *6* Charles V, *7* Maximilian I, *8* Ferdinand I, *9* Maximilian II, *10* Rudolph Makes Albert I Archduke of Austria, *11* Albert I Defeats Adolf, *12* Ferdinand I Defends Vienna, *13* Maximilian II Elected Em-peror, *14–15* inscriptions, *16* false arch; *rear*, *17* Pillars of Hercules device, *18* Philip I, *19* Philip II, *20* Garzia de Toledo Presents Malta to Philip II, *21* false arch (appendix 2: *6*).

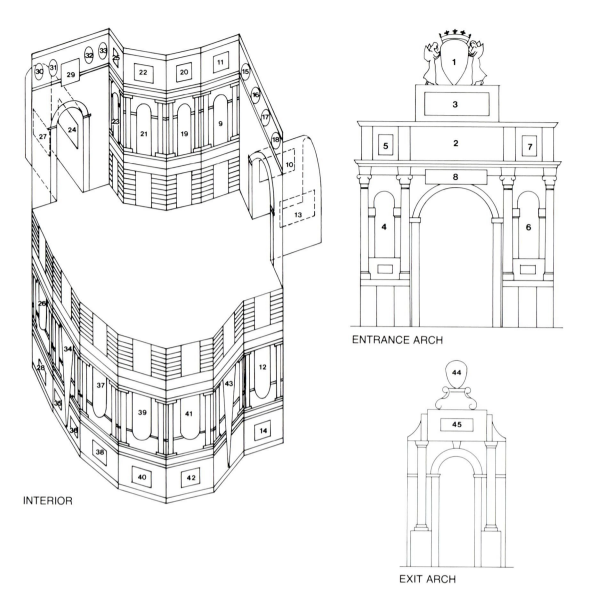

ENTRANCE ARCH

INTERIOR

EXIT ARCH

FIGURE 71. Theater of the Medici. *Entrance arch,* 1 Medici arms, 2 Cosimo I, 3 David Anointed by Samuel, 4 Giovanni delle Bande Nere, 5 thunderbolt device, 6 Alessandro, 7 rhinoceros device, 8 inscription; *interior,* 9 Cosimo il Vecchio, 10 Cosimo il Vecchio Acclaimed *pater patriae,* 11 Piero il Gottoso, 12 Lorenzo the Magnificent, 13 Lorenzo the Magnificent Unifies Italy, 14 Giuliano, 15 Giovanni di Bicci, 16 Lorenzo, 17 Pierfrancesco, 18 Giovanni il Popolano, 19 Queen Catherine, 20 Queen Catherine with her Children, 21 Prudence and Liberality, 22 Piety, 23 Duke Giuliano, 24 Duke Giuliano Made a Roman Citizen, 25 Cardinal Ippolito, 26 Duke Lorenzo, 27 Duke Lorenzo Made the Florentine Captain General, 28 Piero, 29 Francesco, 30 Cardinal Giovanni, 31 Cardinal Ferdinando, 32 Garzia, 33 Pietro, 34 inscription, 35 Capricorn device, 36 weasel device, 37 Pope Pius IV, 38 Pius IV Receives the Decrees of the Council of Trent, 39 Pope Leo X, 40 Leo X Confers with Francis I, 41 Pope Clement VII, 42 Cement VII Crowns Charles V, 43 inscription; *exit arch,* 44 Medici arms, 45 inscription (appendix 2: 7).

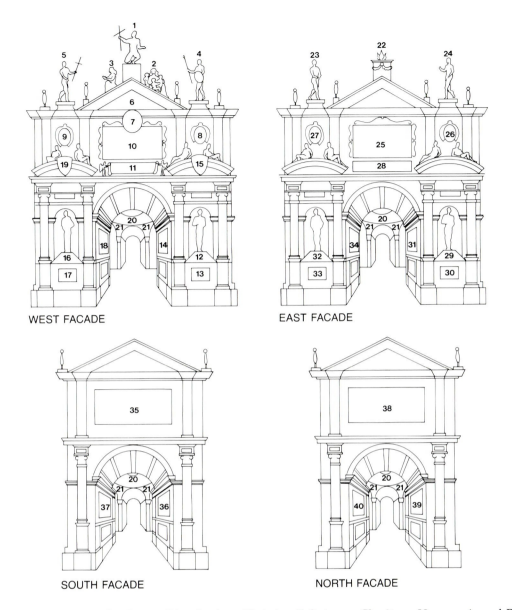

WEST FACADE

EAST FACADE

SOUTH FACADE

NORTH FACADE

FIGURE 72. Arch of Religion. *West facade*, *1* Christian Religion, *2* Charity, *3* Hope, *4* Armed Religion, *5* Peaceful Religion, *6* Cross of Constantine, *7* Medici arms, *8* Religion before Law, *9* Religion under Law, *10* Religion under Grace, *11* inscription, *12* Cosimo I, *13* Defeat of Damiata, *14* Cosimo I Creates Knights of St. Stephen, *15* arms of Cosimo I, *16* San Giovanni Gualberto, *17* Miracle of Blessed Peter Igneus, *18* San Giovanni Gualberto Founds Vallombrosa, *19* Medici arms, *20* angels, *21* symbols of the Evangelists; *east facade*, *22* Classical Religion, *23* Contemplative Life, *24* Active Life, *25* Etruscans Teach Religion to the Romans, *26–27* Classical Augury and Sacrifice, *28* inscription, *29* San Romualdo, *30* Vision of San Romualdo, *31* San Romualdo Founds the Camaldolese hermitage, *32* Blessed Filippo Benizi, *33* Annunciation, *34* Filippo Benizi Founds Santissima Annunziata; *south facade*, *35* SS. Peter and Paul Dispute Pagan Philosophers, *36* Blessed Giovanni Colombini Founds the Gesuati, *37* San Giovanni Tolomei Founds the Olivetan order; *north facade*, *38* SS. Peter and Paul Preach to Nero, *39* St. Francis Founds the Franciscans, *40* Council of Florence (appendix 2: *8*).

223

FIGURE 73. Arch of the Virgin Mary. *1* Medici arms, *2* Grace, *3* Good Works, *4* Virgin and Child with Florentine patron saints, *5* Ship and Safe Haven device, *6* Birth of the Virgin, *7* Presentation, *8* Marriage, *9* Annunciation, *10* Visitation, *11* Birth of Christ, *12* Adoration of the Magi, *13* Circumcision, *14* Pentecost, *15* Assumption (appendix 2: *9*).

FIGURE 74. Equestrian monument of Virtue Overcoming Vice. *1* Virtue Overcoming Vice, *2* Egyptian Ibis (appendix 2: *10*).

FIGURE 75. Arch of Happiness. *1* Happiness, *2* arms of Francesco and Giovanna, *3* Bacchus and Bacchants, *4* wine fountain (appendix 2: *11*).

EAST FACADE WEST FACADE

FIGURE 76. Arch of Prudence. *East facade,* 1 quadriga, 2 Prudence, 3 Patience, 4 Vigilance, 5 Constancy, 6 Fortitude, 7–8 Sienese War, 9 Cosimo I Abdicates, 10–11 Cosimo I's Land and Sea Power, 12 Cosimo I Makes Laws, 13 Cosimo I Addresses Troops, 14 devices, 15 inscription, 16 arms of Cosimo I, 17 arms of Francesco and Giovanna, 18 arms of Florence; *west facade,* 19 Capricorn device, 20 Temperance, 21 Facility, 22 Punishment, 23 Reward, 24 Cosimo I Receives Petitions, 25 Cosimo I and Eleonora, 26 Cosimo I Concludes the Marriage Contract between Francesco and Giovanna, 27–28 Cosimo I Fortifies and Pacifies (appendix 2: 12).

FIGURE 77. Neptune Fountain (appendix 2: 13).

225

FIGURE 78. Arch of Security. *1* Security, *2* Roman standard, *3* Virtue and Fortune, *4* Diligence and Victory, *5* Eternity, *6* Fame, *7* arms of Florence, *8* arms of Francesco and Giovanna, *9* arms of Cosimo I, *10* Fury, *11* Discord, *12* Prosperity, Concord, and Civilization, *13* Abundance, Peace, and Majesty, *14* inscription (appendix 2: *14*).

NVLLVM NVMEN
ABEST.

VIGILAN DE
HOC PRAESIDIO E[X]
FA
TORVM NVMINE

HOC FIDIT

FIGURE 79. Vincenzo Borghini, Device. Florence, Biblioteca Nazionale Centrale, Fondo Magliabeciano MS 2.10.100, 57v (appendix 2: 1.26; 5).

FIGURE 80. Borghini, Device. Ibid., 58r (appendix 2: 12.19).

FIGURE 81. Vincenzo Borghini, Device. Florence, Biblioteca Nazionale Centrale, Fondo Magliabe-
ciano MS 2.10.100, 58v (appendix 2: *4.12*).

FIGURE 82. Borghini, Device. Ibid., 59v (appendix 2: *14.2*).

FIGURE 83. Borghini, Device. Ibid., 60r (appendix 2: *10.2*).

FIGURE 84. Borghini, Device. Ibid., 60v (appendix 2: *8.6*).

FIGURE 85. Borghini, Device. Ibid., 61r (appendix 2: *9.5*).

FIGURE 87. Borghini, Devices. Ibid., 82r (appendix 2: 1.10, 17–24).

FIGURE 86. Borghini, Devices. Ibid., 81v (appendix 2: 1.16, 25).

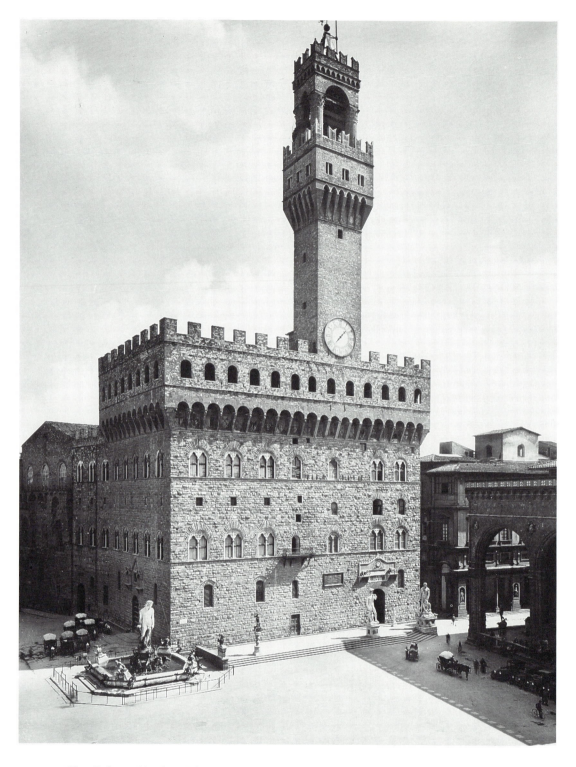

FIGURE 88. Palazzo Vecchio, Florence.

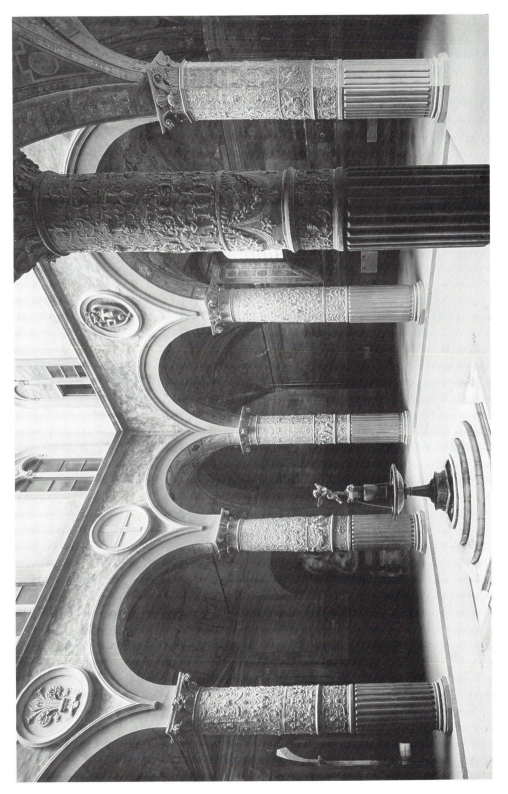

FIGURE 89. Courtyard, Palazzo Vecchio, Florence. Cupid with a Dolphin fountain by Verrocchio installed in 1557; frescoes on portico vaults and walls, and stucco decoration on columns all by Vasari and workshop for the 1565 marriage.

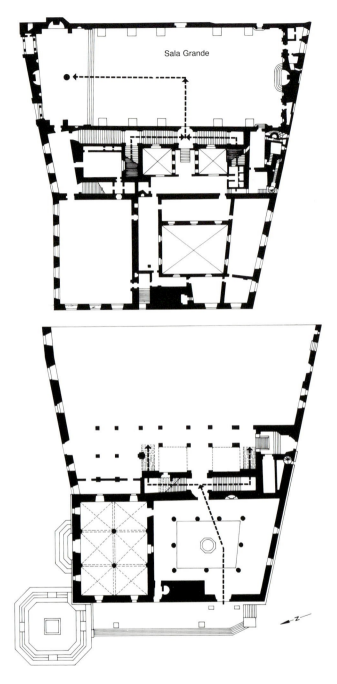

Sala Grande

FIGURE 90 (*bottom*).　Ground Floor plan, Florence, Palazzo Vecchio. Dotted line indicates route to the Sala Grande.

FIGURE 91 (*top*).　Piano Nobile plan, Florence, Palazzo Vecchio. Dotted line indicates route to the throne on the dais of the Sala Grande.

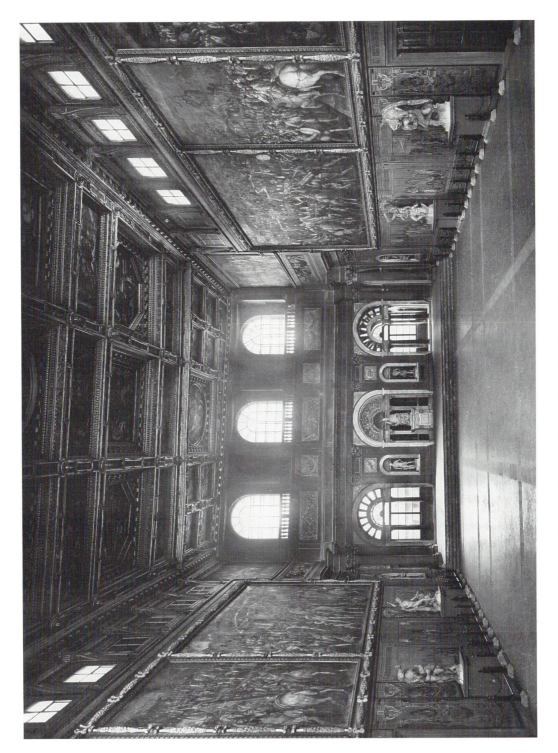

FIGURE 92. Sala Grande, Florence, Palazzo Vecchio. General view looking north toward the dais.

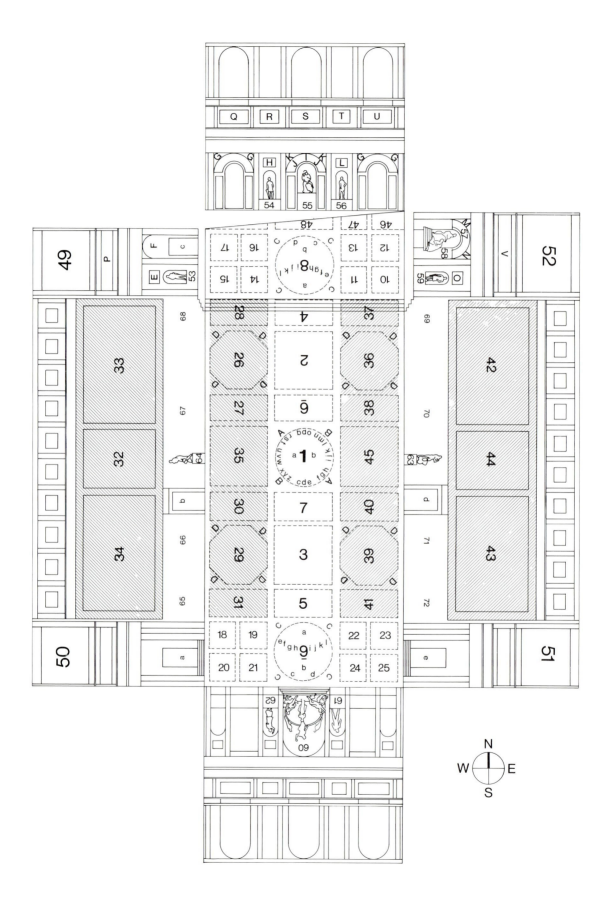

FIGURE 93. Diagram of the Sala Grande. *1* Apotheosis of Cosimo I, *2* Foundation of Florence, *3* Building the Third Circuit of Walls, *4* Florentines Defeat the Ostrogoths, *5* Union between Florence and Fiesole, *6* Florentines Named Defenders of the Church by Clement IV, *7* Eugenius IV Seeks Refuge in Florence, *8* quarters of Santa Maria Novella and San Giovanni, *9* quarters of Santa Croce and Santo Spirito, *10* Casentino, *11* Mugello, *12* Romagna, *13* Fiesole, *14* San Miniato, *15* Pescia, *16* Pistoia, *17* Prato, *18* Chianti, *19* Certaldo, *20* Colle Val d'Elsa and San Gimignano, *21* Volterra, *22* San Giovanni Valdarno, *23* Borgo Sansepolcro and Anghiari, *24* Arezzo, *25* Cortona and Montepulciano, *26* Florence Declares War against Pisa, *27* Conquest of Vicopisano, *28* Conquest of Cascina, *29* Defeat of Venetians in the Casentino, *30* Battle of Barbagiani, *31* Naval Battle between the Florentines and Pisans, *32* Siege of Livorno Lifted, *33* Battle of Stampace, *34* Defeat of the Pisans at Torre di San Vincenzo, *35* Triumphal Entry into Florence after the Conquest of Pisa, *36* Cosimo I Plans the War of Siena, *37* Conquest of Monastero, *38* Conquest of Casole, *39* Battle at Marciano in the Val di Chiana, *40* Conquest of Monteriggioni, *41* Turks Routed at Piombino, *42* Conquest of the Fortress near Porta Camollia, *43* Battle at Scannagallo in the Val di Chiana, *44* Conquest of Porto Ercole, *45* Triumphal Entry into Florence after the Conquest of Siena, *46* inscription, *47* Portraits of the Chief Mason, Carpenter, Gilder, and Grotesque Painter, *48* putti, *49* Cosimo I Drains the Pisan Swamps [*replaced with* Boniface VIII with Twelve Florentine Ambassadors], *50* French Return the Keys to Livorno [*replaced with* Cosimo I Created Duke], *51* Cosimo I Builds Cosmopoli on Elba [*replaced with* Cosimo I Created Grand Master of the Order of St. Stephen], *52* Cosimo I Fortifies Tuscany [*replaced with* Cosimo I Crowned Grand Duke of Tuscany], *53* Cosimo I, *54* Giovanni delle Bande Nere, *55* Leo X, *56* Alessandro, *57* Clement VII, *58* Charles V, *59* Francesco I, *60* Rain Fountain, *61* Prudence, *62* Flora or Florence, *63* Victory, *64* Flora or Florence Victorious over Pisa, *65* Cosimo I as Augustus, *66* Hercules and Cacus, *67* Hercules and the Centaur, *68* Hercules and Antaeus, *69* Giovanni delle Bande Nere, *70* Hercules and Queen Hippolyta, *71* Hercules and the Erymanthian boar, *72* Hercules and King Diomedes (appendix 2: *15*).

FIGURE 94. Vasari and workshop, *Apotheosis of Cosimo I*, Sala Grande, ceiling (appendix 2: *15.1*).

236

FIGURE 95. Vasari and workshop, *Apotheosis of Cosimo I*, detail, Sala Grande, ceiling (appendix 2: 15.1).

FIGURE 96. Vasari and workshop, *Foundation of Florence,* Sala Grande, ceiling (appendix 2: 15.2).

FIGURE 97. Vasari and workshop, *Building the Third Circuit of Walls*, Sala Grande, ceiling (appendix 2: 15.3).

FIGURE 98. Vasari and workshop, *Florentines and Romans Commanded by Stilicho Defeat the Ostrogoths Commanded by Radagasius*, Sala Grande, ceiling (appendix 2: 15.4).

FIGURE 99. Vasari and workshop, *Union between Florence and Fiesole*, Sala Grande, ceiling (appendix 2: 15.5).

FIGURE 100. Vasari and workshop, *Florentines Named Defenders of the Church by Pope Clement IV*, Sala Grande, ceiling (appendix 2: 15.6).

FIGURE 101. Vasari and workshop, *Pope Eugenius IV Seeks Refuge in Florence*, Sala Grande, ceiling (appendix 2: 15.7).

FIGURE 102. Vasari and workshop, *Quarters of Santa Maria Novella and San Giovanni*, Sala Grande, ceiling (appendix 2: *15.8*).

FIGURE 103. Vasari and workshop, *Certaldo, Chianti, Volterra, Colle Val d'Elsa and San Gimignano*, Sala Grande, ceiling (appendix 2: *15.18–21*).

FIGURE 104. Vasari and workshop, *Florence Declares War against Pisa*, Sala Grande, ceiling (appendix 2: *15.26*).

FIGURE 105. Vasari and workshop, *Florence Declares War against Pisa*, detail, Sala Grande, ceiling (appendix 2: *15.26*).

FIGURE 106. Vasari and workshop, *Battle of Stampace in 1499*, Sala Grande, west wall (appendix 2: 15.33).

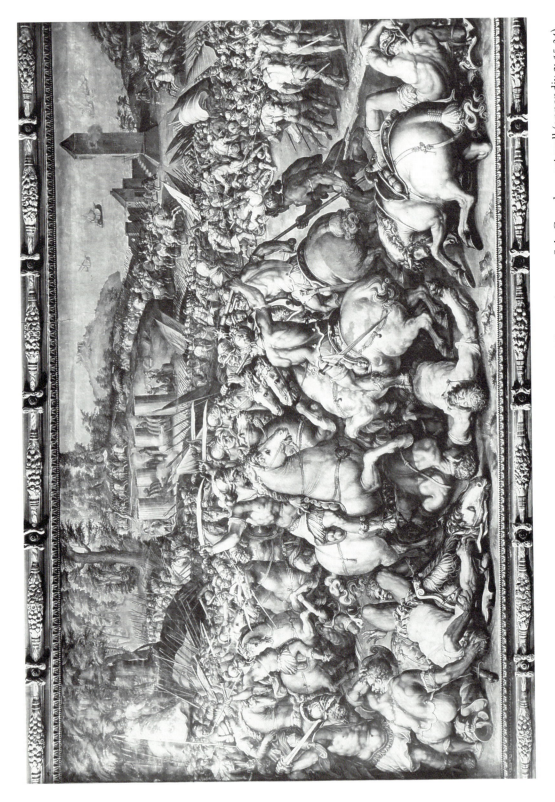

FIGURE 107. Vasari and workshop. *Florentine Defeat of the Pisans at Torre di San Vincenzo in 1505*, Sala Grande, west wall (appendix 2: 15.34).

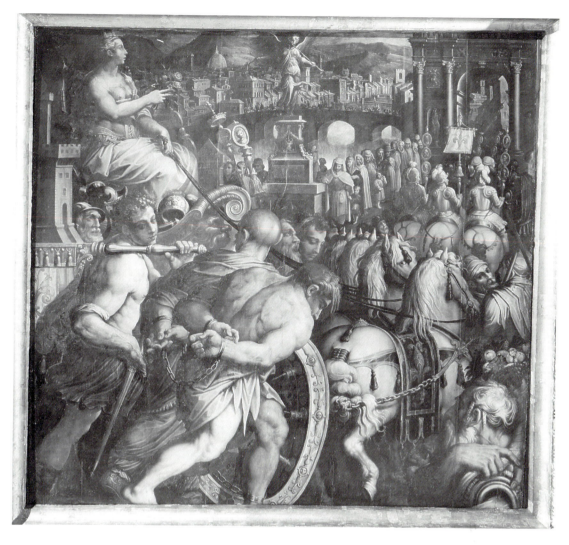

FIGURE 108. Vasari and workshop, *Triumphal Entry into Florence after the Conquest of Pisa*, Sala Grande, ceiling (appendix 2: 15.35).

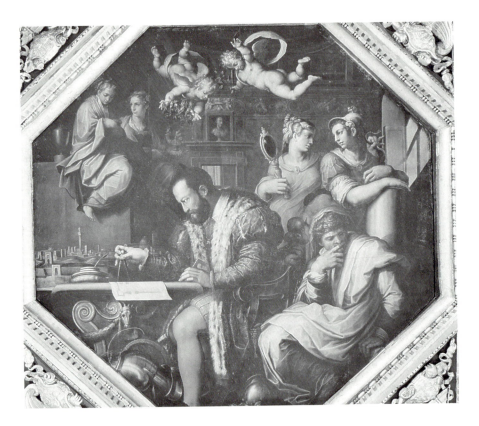

FIGURE 109. Vasari and workshop, *Cosimo I Plans the War of Siena*, Sala Grande, ceiling (appendix 2: 15.36).

FIGURE 110. Vasari and workshop, *Cosimo I Plans the War of Siena*, detail, Sala Grande, ceiling (appendix 2: 15.36).

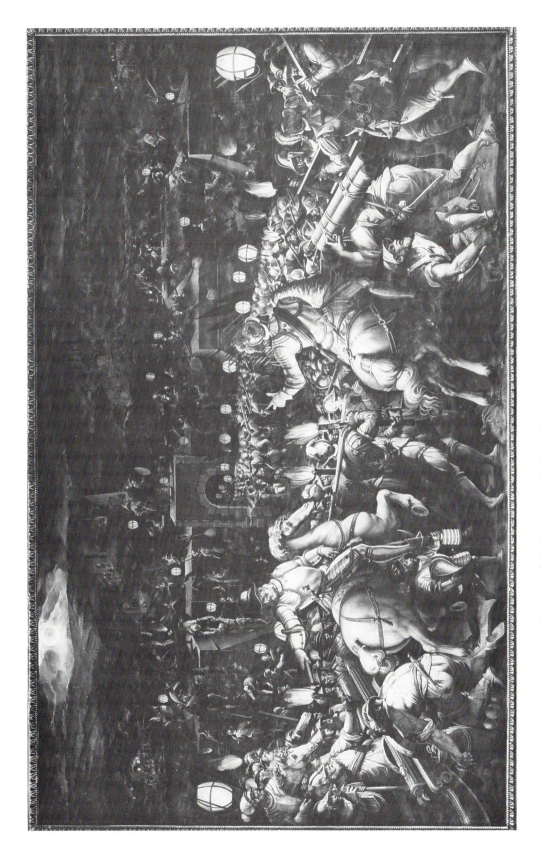

FIGURE 111. Vasari and workshop, *Conquest of the Fortress near the Porta Camollia in 1554*, Sala Grande, east wall (appendix 2: 15.42).

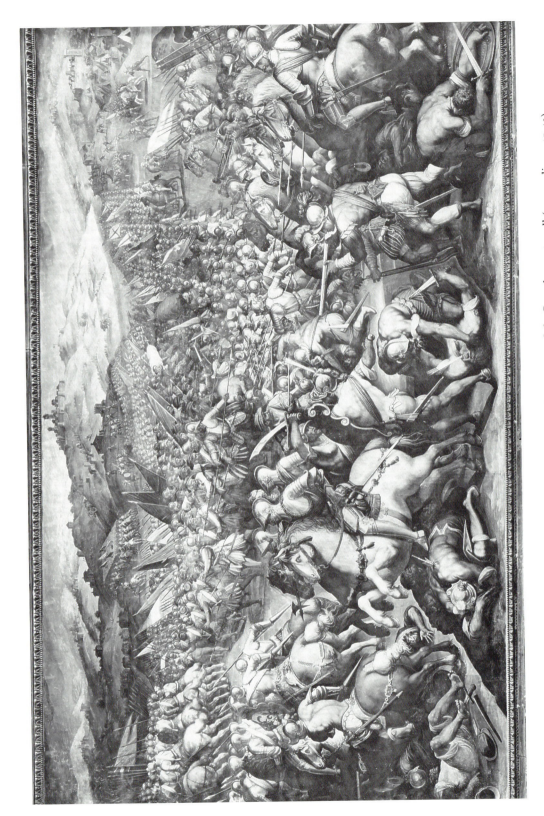

FIGURE 112. Vasari and workshop, *Battle at Scannagallo in the Val di Chiana in 1554*. Sala Grande, east wall (appendix 2: 15.43).

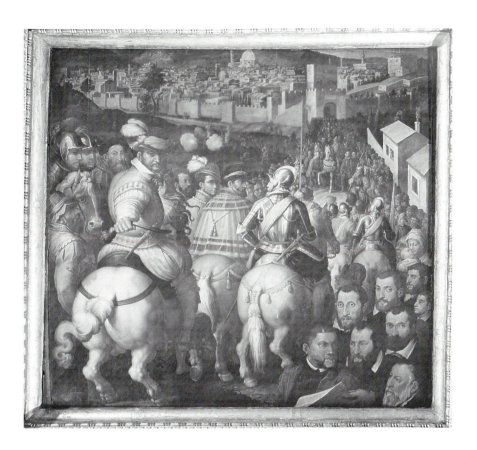

FIGURE 113. Vasari and workshop, *Triumphal Entry into Florence after the Conquest of Siena*, Sala Grande, ceiling (appendix 2: 15.45).

FIGURE 114. Vasari and workshop, Portraits of the Chief Mason, Carpenter, Gilder, and Grotesque Painter, Sala Grande, ceiling (appendix 2: 15.47).

FIGURE 115. Bandinelli, *Cosimo I, Second Duke of Florence,* Sala Grande, dais (appendix 2: 15.53).

FIGURE 116. Bandinelli, *Giovanni delle Bande Nere,* Sala Grande, dais (appendix 2: 15.54).

FIGURE 117. Bandinelli and de' Rossi, *Pope Leo X,* Sala Grande, dais (appendix 2: 15.55).

FIGURE 118. Bandinelli, *Alessandro de' Medici, First Duke of Florence,* Sala Grande, dais (appendix 2: 15.56).

FIGURE 119. Bandinelli and Caccini, *Pope Clement VII Crowns Emperor Charles V*, Sala Grande, dais (appendix 2: 15.57–58).

FIGURE 120. Ammannati, *Juno* (for the Sala Grande Rain Fountain), Florence, Bargello (appendix 2: *15.60*).

FIGURE 121. Ammannati, *Ceres* (for the Sala Grande Rain Fountain), Florence, Bargello (appendix 2: *15.60*).

FIGURE 122. Ammannati, *River Arno with the Marzocco* (for the Sala Grande Rain Fountain), Florence, Bargello (appendix 2: *15.60*).

FIGURE 123. Ammannati, *Hippocrene Spring of Mt. Parnassus with Pegasus* (for the Sala Grande Rain Fountain), Florence, Bargello (appendix 2: *15.60*).

FIGURE 124. Ammannati, *Prudence* (for the Sala Grande Rain Fountain), Florence, Bargello (appendix 2: *15.61*).

FIGURE 125. Ammannati, *Flora or Florence* (for the Sala Grande Rain Fountain), Florence, Bargello (appendix 2: *15.62*).

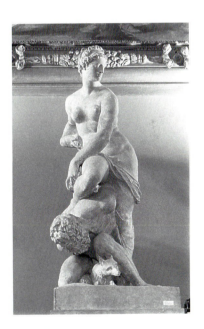

FIGURE 126. Michelangelo, *Victory,* Sala Grande (appendix 2: *15.63*).

FIGURE 127. Giambologna, *Flora or Florence Victorious over Pisa,* Sala Grande (appendix 2: *15.64*).

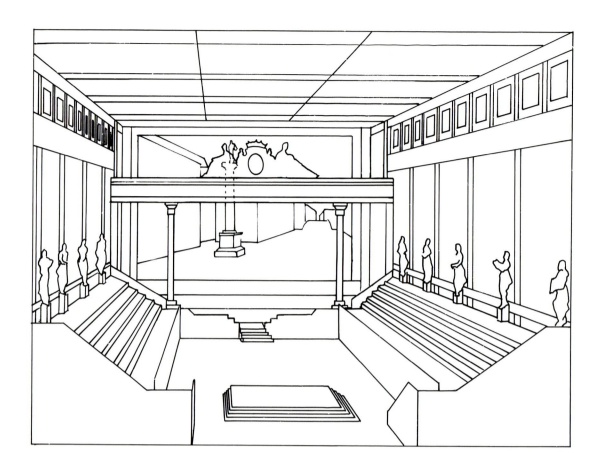

FIGURE 128. Reconstruction of the Theater in the Sala Grande for the 1565 St. Stephen's Day Play.

Epilogue: Arts of Power

The three halls of state examined in this book correspond to the three ages into which Giorgio Vasari first divided the *Rinascita* of the arts. In this scheme Lorenzetti was a prophet, Mantegna a founder, and Vasari himself an heir to the masters of the Third Age running from Leonardo to Michelangelo. Each generation, according to Vasari, drew on and superseded the last within a "rebirth" or "revival" of classical art that ultimately surpassed the ancients. Art had imitated nature, then improved upon it with grace and imagination, the skills of hand and mind that came together in perfect design.

In one version or another this remains a master narrative in histories of Renaissance art. Dominant figures in a procession of generations, the rhetoric of renewal, the plot culminating in a High Renaissance, the climactic fusion of "the real" and "the ideal" are still the leitmotifs in a tale of rising artists freed from tradition for the mission of mastering nature within the formal discipline of art. These conventions are bound up in turn with the main themes of Western culture's accounts of itself since the Renaissance—ideals of individualism and ideas of secular progress, the quest to differentiate yet somehow to synthesize matter and mind or will and reason, the desire both to accommodate contingency and to transcend it. We might conclude along these lines with the triumphant progress of representation and invention to the finale of Vasari's Sala Grande.

The large scenario passes the test of small, seemingly neutral details. The mounted falconer in Lorenzetti's Good Country (fig. 26), while drawing on medieval conventions (figs. 27–28), could be a prophetic image of Vasari's First Age: though still highly formulaic, the turn of the figure to his companion in the sweeping panorama reads as a turn away from received formulas toward a new verisimilitude. In Mantegna's dapple-grey horse and courtiers on the west wall of the Camera Picta (fig. 43) we could choose to see the characteristics of Vasari's Second Age: "a new manner of coloring, of foreshortening, and of natural attitudes"; "richer ornament"; "more depth and more life-

257

like reality in design"; "much better expressions . . . and gestures"; "more reality [in] landscapes, trees, greenery, flowers, skies, clouds, and other objects of nature"; in sum, "the truth of nature" with "rule, order, proportion." The artists of the Third Age supposedly overcame a residual "dryness, hardness, and sharpness of manner." Their works, it might have pleased Vasari to observe of the commander in a Palazzo Vecchio battle scene (fig. 112), exhibited "a certain freedom" and "an invention abundant in every respect" together with the "rule" and "order" learned from precedents in classical art or within the Florentine tradition, such as an ancient statue of a mounted Mars or the rearing horses in paintings by Paolo Uccello and Leonardo. To proportion Vasari then added, so he might have claimed, "a certain correctness of judgment, a grace exceeding measurement," and to draftsmanship "a resolute boldness," "a minuteness and perfection of finish," "abundance," "bizarre fantasies," and "wide knowledge of buildings, and distance and variety in landscapes." Together these developments constituted for Vasari the *bella maniera*, a "modern" style of "delicacy, refinement, and supreme grace."[1]

This account leaves out, among other things, the questions addressed in this book. Vasari's knowledge of the courts of his own day was intimate and profound, however clouded by his obligations to them. No one knew better that the artist was beholden to patrons, to the character of the regimes he served, and to the circumstances of his commissions. As we have seen, Vasari invested his own role with the attributes of the prince by treating a triumphalist scenario produced for the Medici as a triumph of the painter's art. Despite (or because of) this close alliance, however, Vasari needed to elevate stylistic over functional requirements in order to affirm the superiority of his profession. He consigned politics and painting to separate realms that overlapped without coinciding. The history of art led along a self-sufficient trajectory from one artist to the next, from one phase of development to another. Form and function—or, for that matter, dysfunction—were distinguishable levels in the making and meaning of art.

Instead of merely turning tables in an old contest over priorities, we have shown the intertwining in our halls of state of form and content, ideal and real, structure and meaning, perception and communication. We have been more concerned with transferences, exchanges, and interrelations than with differences between politics and art. Rather than the narrative teleology of a Renaissance style, we have stressed the pictorial and political specificity of three comparable sites under three distinct regimes. Those sites were, in all senses, centers of representation into which aesthetic and political ideologies and interests flowed. Each regime, we have argued, exhibited its distinctive configuration of power and authority within the constraints of the material and cultural resources at its disposal. This is not to say that such representations, precisely because they have never been more (or less) than representations, were altogether consistent or transparent, that art merely reflected

fixed intentions or illustrated set agendas. If anything, we have seen how totalizing impulses cancel themselves in the need to incorporate contradictions, attempts at communication disclose the media of communication, static programs provoke alternative responses.

Our horses are of a different color from those of the high narratives of the Renaissance. Rather than riding the road toward naturalism, Lorenzetti's falconer looks from our perspective like an artifact from chivalric illustrations and imperial iconography, a detail traced out from workshop pattern books, a personification of the season or the art of hunting in a pictorial allegory, and an emblem of the appropriation of competing sources of authority, representations of nature, and respectable schemes of learning by the (allegedly) felicitous republic of merchants. If Mantegna's dapple-grey stallion was probably drawn from life after steeds in the Gonzaga stables, we would see it too as a princely icon, reined into a masculine scheme of courtly relations, bearing a heraldic star, but also standing for the dependence of the court on the virtuosity of the artist as the producer of credible illusions. The empty saddle and waiting pose invite stories of some plausible order of events that, so we are led to imagine, actually happened once upon a time. Whether or not Vasari's horse is a triumph of the *bella maniera*, it is certainly a triumphalist trophy in which ancient prototypes, Florentine traditions, and contemporary techniques paid tribute to the victory scenario of a would-be absolute prince.

We hope that the title "arts of power" will already convey on the outside some sense of the manifold relations we have explored in this book. As works of art commissioned by the powerful, our three painted rooms were strategic instruments, tactical weapons, technical machines of government no less than armies, laws, institutions, and taxes. Reading "power" in the genitive case, we have seen how the results were generated and, for that matter, gendered by political authorities. Halls of state belonged in this sense to the commissioning regimes; they changed as much with the configuration of power as with the style of art. But the title should suggest as well that art has the power not just to execute orders but to subvert them, not simply to reflect the objectives assigned to it but also to construct its own objects and audiences. If in this sense painted rooms may have created good citizens or dutiful subjects, they have also inspired skeptics, critics, iconoclasts, and historians.

In the last decade of the twentieth century "the state as a work of art" has ceased to be the new phenomenon that fascinated and troubled Jacob Burckhardt in Renaissance Italy. Having traced part of its genealogy, we sense both the profound continuity and the radical transformation in a present where the hall of state enters our living rooms on an electronic screen.

Appendix I

INSCRIPTIONS IN THE
SALA DEI NOVE

Notes, transcriptions, and translations by
RUGGERO STEFANINI

The inscriptions in the Sala dei Nove may be divided into two sets of three
that correspond with one other metrically and topographically. Three com-
ment on the scenes of bad government (A1, A2, A3) and three on the scenes
of good government (B1, B2, B3). A1 and B1 are two stanzas of canzone with
broken-up frons and one-block sirma: *ABbC, ABbC: CDdEE*. A2 and B2 are
also two stanzas sharing the same metric pattern, which is slightly different
from that of A1-B1: *ABBC, ABBC: cDdEE*. A3 and B3 are instead two single
sirmas (or envois) whose pattern repeats the sirma of A1-B1: *XYyZZ*. A1 and
B1 are inscribed in two cartellos placed in the frieze running beneath the
frescos: A1 is to be found under the so-called Allegory of Bad Government
(i.e., the tribune on which Tyranny and the vices are seated); B1 is situated
under the Allegory of Good Government, more precisely under the throne of
Concord (see fig. 3). A2 and B2 are inscribed opposite each other, on a single
line apiece, in the narrow strip of painted framing at the bottom of the
frescoes. The scenes of bad government unfold above A2, and those of good
government above B2. A3 and B3 are written on two cartellos held respec-
tively by Timor, on one wall, and by Securitas, on the wall facing it, in the
scenes that contrast the effects of bad and good government.

In the following edition, we start by reproducing the inscriptions, placing
in brackets those groups of words that have by now disappeared from the
wall because of repainting and alterations but have been preserved in descrip-
tive literature. In A1-B1 and in A3-B3 we keep the paragraphs of the originals
but must divide the very long line of A2-B2. We then give the text of every
inscription in the standard metric arrangement and in a more readable form
(i.e., with graphic, though not linguistic, updating); the English translations
and a few notes follow.

We give precedence to the bad government inscriptions (A) in order to
keep, here too, the sequence *Inferno* → *Paradiso*—i.e., a progress from chaos
and sin to order and salvation. Undoubtedly, this arrangement was also

261

meant for the hall of the Nine, as the position and succession of the frescoes in relation to the entrance door clearly show.

A. BAD GOVERNMENT

WEST WALL

A1

LADOVE STA LEGATA LA IUSTITIA · NESSUNO ALBE(N) COMUNE GIAMAY
SACORDA · NE TIRA ADRITTA CORDA · P(ER)O CONVIE(N) CHE TIRANNIA
SORMONTI · LA QUAL P(ER) ADEMPIR LA SUA NEQUITIA · NULLO VOLER
NE OP(ER)AR DISCORDA · DALLA NATURA LORDA · DE VITII CHE CO(N) LEI
SON QUI CO(N)GIONTI · QUESTA CACCIA COLOR CALBEN SON PRONTI · E
CHIAMA ASE CIASCUN CAMALE I(N) TENDE · QUESTA SEMPRE DIFENDE ·
CHI SFORÇA O ROBBA O CHI ODIASSE PACE · UNDE OGNITERRA SUA
I(N) CULTA GIACE ·

Là dove sta legata la giustizia, 1
nessuno al ben comun giammai s'accorda
né tira a dritta corda,*
però convien che tirannia sormonti.
La qual, per adempir la sua nequizia, 5
nullo voler né operar discorda
dalla natura lorda
de' vizii che con lei son qui congiónti.
 Questa caccia color ch'al ben son pronti
e chiama a sé ciascun ch'a male intende; 10
questa sempre difende
chi sforza o róbba o chi odiasse pace:
unde ogni terra sua inculta giace.

There, where Justice is bound, 1
no one is ever in accord for the Common Good,
nor pulls the cord [i.e., of civic concord] straight [i.e., with force and full
 commitment];
therefore, it is fitting that Tyranny prevails.
She,† in order to carry out her iniquity, 5
neither wills nor acts in disaccord
with the filthy nature
of the Vices, who are shown here conjoined with her.

*For the *figura* (pseudo-)*etymologica* referring *Concordia* to *chorda* (cord or rope, musical chord), cf. Cicero, *De republica* 2.69; Isidore of Seville, *Etymologiae* 3.22.6; and Dante, *Paradiso* 26.45–51.
†Stefanini translates the feminine pronouns literally; the androgynous ambiguity of this traditionally male figure contributes, of course, to its sinister effect. [Authors' note.]

She banishes those who are ready to do good
and calls around herself every evil schemer. 10
She always protects
the assailant, the robber, and those who hate peace,
so that her every land lies waste.

A2

[. .
.] E P(ER) EFFETTO · CHE DOVE E TIRANNIA E GRAN
SOSPETTO · GUERRE RAPINE TRADIMENTI EN GANNI · PRENDANSI SIGNORIA
SOPRA DI LEI · EPONGASI LA MENTE ELO INTELLETTO · [IN TENER SEMPRE A
IUSTICIA SUGGIETTO · CIASCUN P(ER) ISCHIFAR SI SCURI DANNI ·
ABBATTENDO E TIRANI · E C]HI TURBAR LAVUOL SIE P(ER) SUO MERTO ·
DISCACCIATE DISERTO · IN SIEME CON QUALUNQUE SIA SEGUACIE ·
FORTIFICANDO LEI P(ER) VOSTRA PACE ·

[. -anni* 1
.] e per effetto
che dove è tirannia è gran sospetto,
guerre, rapine, tradimenti e 'nganni,
prendansi [prendasi?] signoria sopra di lei[,?]† 5
e pongasi la mente e lo 'ntelletto
in tener sempr'a giustizia suggetto
ciascun, per ischifar sì scuri danni,
 abbattendo e' tiranni;
e chi turbar la vuol sie per suo merto 10
discacciat'e diserto
insieme con qualunque sia seguace,
fortificando lei per vostra pace.

[. 1
.] and for the reason
that, where there is Tyranny, there are great fear,
wars, robberies, treacheries and frauds,
she must be brought down.† 5
And let the mind and understanding be intent
on keeping each [citizen] always subject to Justice,
in order to escape such dark injuries,
 by overthrowing all tyrants.
And whoever wishes to disturb her [Justice], let him be for his unworthiness 10
banished and shunned

*The rhyme word at the end of the first line may have been *malanni* (mishaps, calami-
ties), belonging to the sematic range of *danni, inganni, tiranni.*
†I consider *prendansi* (3d pers. pl.) a mistake and would substitute the required third
person singular, which is also paralleled and supported by the following *pongasi.* [Au-
thors' note: Alternatively, reading *prendansi,* the passage might be translated "where
there is Tyranny, there is great fear; / wars, robberies, treacheries, and frauds / take
authority over the city."]

together with all his followers, whoever they may be:
thus Justice will be fortified to the advantage of your peace.

A3

P(ER) VOLERE ELBENPROPIO I(N)QUESTA TERRA ·
SOM(M)ESSE LA GIUSTITIA ATYRANNIA ·
UNDE P(ER) QUESTA VIA ·
NO(N) PASSA ALCUN SE(N)ÇA DUBBIO DIMO(R)TE ·
CHE FUOR SIROBBA E DENTRO DALEPORTE ·

Per voler el ben propio, in questa terra 1
sommess'è la giustizia a tirannia,
unde per questa via
non passa alcun senza dubbio di morte,
ché fuor si róbba e dentro dalle porte. 5

Because each seeks only his own good, in this city 1
Justice is subjected to Tyranny;
Wherefore, along this road
nobody passes without fearing for his life,
since there are robberies outside and inside the city gates. 5

B. GOOD GOVERNMENT

NORTH WALL

B1

QUESTA SANTA VIRTU LADOVE REGGE · INDUCE ADUNITA LIANIMI
MOLTI · EQUESTI ACCIO RICOLTI · UN BEN COMUN PERLOR SIGNOR SIFANNO
LOQUAL P(ER) GOVERNAR SUO STATO ELEGGE · DINO(N)TENER GIAM(M)A GLIOCHI
 RIVOLTI ·
DALO SPLENDOR DEVOLTI · DELE VIRTU CHETORNO ALLUI SISTANNO ·
P(ER) QUESTO CONTRIUNFO ALLUI SIDANNO · CENSI TRIBUTI ESIGNORIE
DITERRE · PER QUESTO SENÇA GUERRE · SEGUITA POI OGNI CIVILE
EFFETTO · UTILE NECESSARIO EDIDILETTO ·

Questa santa virtù, là dove regge, 1
induce ad unità gli animi molti,
e questi, a ciò ricolti,
un ben comun per lo signor si fanno.
Lo qual, per governar suo stato, elegge 5
di non tener giammà' gli occhi rivolti
dallo splendor de' vólti
delle virtù che torno a lui si stanno.
 Per questo con triunfo a lui si dànno
censi, tributi e signorie di terre; 10

per questo senza guerre
seguita poi ogni civile effetto—
utile, necessario e di diletto.

This holy Virtue [Justice], wherever she rules, 1
induces to unity the many souls [of citizens],
and they, gathered together for such a purpose,
make the Common Good their Lord;
and he, in order to govern his state, chooses 5
never to turn his eyes
from the resplendent faces
of the Virtues who sit around him.
 Therefore to him in triumph are offered
taxes, tributes and lordship of towns; 10
therefore, without war,
every civic result duly follows—
useful, necessary, and pleasurable.

B2

VOLGIETE GLIOCCHI ARIMIRAR COSTEI · VOCHE REGGIETE CHE QUI
FIGURATA · E P(ER)SUE CIELLE(N)ÇIA CORONATA · LAQUAL SE(M)PRA
CIASCUN SUO [DRITTO RENDE · GUARDATE QUANTI BEN VENGAN DA LEI ·
ECOME E DOLCE VITA ERIPOSATA · QUELLA] DELA CITTA DUE SERVATA ·
QUESTA VI(R)TU KEPIU DALTRA RISPRE(N)DE · ELLA GUARD(A)E DIFENDE ·
CHILEI ONORA E LOR NUTRICA E PASCIE · DA LA SUO LUCIE NASCIE · EL
MERITAR COLOR COPERAN BENE · E AGLINIQUI DAR DEBITE PENE ·

Volgete gli occhi a rimirar costei, 1
vo' che reggete, ch'è qui figurata
e per su' eccellenzia coronata,
la qual sempr'a ciascun suo dritto rende.
Guardate quanti ben vengan da lei 5
e come è dolce vita e riposata
quella della città du' è servata
questa virtù che più d'altra risprende.
 Ella guard'e difende
chi lei onora e lor nutrica e pasce. 10
Dalla suo luce nasce
el meritar color ch'operan bene
e agli iniqui dar debite pene.

Turn your eyes to behold her, 1
you who are governing, who is portrayed here [Justice],
crowned on account of her excellence,
who always renders to everyone his due.
Look how many goods derive from her 5
and how sweet and peaceful is that life
of the city where is preserved
this virtue who outshines any other.

> She guards and defends
> those who honor her, and nourishes and feeds them. 10
> From her light is born [both]
> Requiting those who do good
> and giving due punishment to the wicked.

B3

SENÇA PAURA OGNUOM FRANCO CAMINI ·
ELAVORANDO SEMINI CIASCUNO ·
MENTRE CHE TAL COMUNO ·
MANTERRA QUESTA DON(N)A I(N) SIGNORIA ·
CHEL ALEVATA AREI OGNI BALIA. ·

Senza paura ogn'uom franco cammini 1
e lavorando semini ciascuno,
mentre che tal comuno
manterrà questa donna in signoria,
ch' ell'ha levata a' rei ogni balia. 5

Without fear every man may travel freely 1
and each may till and sow,
so long as this commune
shall maintain this lady [Justice]* sovereign,
for she has stripped the wicked of all power. 5

*Stefanini prefers Justice, although "this lady" may also be Security. [Authors' note.]

Appendix 2

ENTRY ARCHES AND SALA GRANDE: DIAGRAM LEGENDS

Translations by WILLIAM S. ANDERSON

1. ARCH OF FLORENCE

PORTA AL PRATO

1. Florence, adorned with flowers holding a ducal crown (sculpture).

2. Fidelity (sculpture).

3. Affection (sculpture).

4. Mars or Arms, holding a broken lance [symbol of Giovanni delle Bande Nere; Vasari says a sword] and a shield with a wolf [symbol of the conquest of Siena] (sculpture).

5. Arms (painting), *background* with the Temple of Mars (baptistery) showing men of bodily valor, including soldiers of Julius Caesar's and Augustus's legion of Mars; *middle ground* with men of mental valor, such as *provveditori* (quartermaster generals), including Gino Capponi, Neri Capponi, Piero Capponi, Bernardetto de' Medici, Luca di Maso degli Albizzi, Tommaso di Guido del Palagio, Pietro Vettori, Antonio Giacomini, Antonio Ridolfi; *foreground* with men of bodily and mental valor, including Giovanni delle Bande Nere, Filippo Spano, Farinata degli Uberti, Buonaguisa della Pressa, Federico Folchi, Nanni Strozzi, Manno Donati, Meo Altoviti, Bernardo Ubaldini della Carda, Niccolò Acciaiuoli, Giovanni de' Medici, Giovanni Visdomini, Francesco Ferrucci, Forese Adimari, Corso Donati, Vieri de' Cerchi, Bindaccio da Ricasoli, Luca da Panzano; *above* architrave inscribed in hexameters:

 Hanc peperere suo patriam qui sanguine nobis
 Aspice magnanimos heroas; nunc et ovantes
 Et laeti incedant, felicem terque quaterque
 Certatimque vocent tali sub Principe Floram.

 Those who have created this fatherland for us by their blood,
 Behold them the great-hearted heroes; now both triumphant
 And happy let them enter, and thrice and four times fortunate
 Eagerly let them hail Flora (Florence) under such a ruler.

6. Muse or Letters, holding a book and flutes (sculpture).

7. Letters (painting), *background* with a temple of Minerva; *middle* and *foreground* showing theologians—archbishop Antonino, Cardinal Giovanni Domenici, general of the Camaldolese Don Ambrogio, Roberto de' Bardi, Luigi Marsili, Leonardo Dati; philosophers—Marsilio Ficino, Francesco Cattani da Diacceto, Francesco Verini the Elder, Donato Acciaiuoli; lawyers—Accursio and his son Francesco, Lorenzo Ridolfi, Dino Rossoni di Mugello, Forese da Rabatta; physicians—Taddeo Dino, Tommaso del Garbo, Torrigiano Valori, Niccolò Falcucci; mathematicians—Guido Bonatto, Paolo del Pozzo, Leon Battista Alberti, Antonio Manetti, Lorenzo della Volpaia; navigator, Amerigo Vespucci; writers and scholars—Agnolo Poliziano, Pietro Crinito, Giannozzo Manetti, Francesco Pucci, Bartolomeo Fonzio, Alessandro de' Pazzi, Marcello Vergilio Adriani, Cristofano Landini[i], Coluccio Salutati, Brunetto Latini, Dante; Latin poets—Claudian, Carlo Marsuppini, Zanobi Strada; and historians—Francesco Guicciardini, Niccolò Machiavelli, Leonardo Bruni, Poggio Bracciolini, Matteo Palmieri, Giovanni Villani, Matteo Villani, and Ricordano Malespini; *above* architrave inscribed in hexameters:

 Artibus egregiis Latiae Graiaeque Minervae
 Florentes semper quis non miretur Etruscos?
 Sed magis hoc illos aevo florere necesse est
 Et Cosmo genitore et Cosmi prole faventi.

 In the exceptional arts of Latin and Greek wisdom
 Who would not admire the always flourishing Etruscans?
 But it is even more necessary for them to flourish in this age
 Under the favor of Cosimo the father and his children.

8. Ceres or Agriculture, crowned with wheat holding a sickle and ears of wheat (sculpture).

9. Agriculture (painting), *background* forested and with sacrifices being offered before the Temple of Ceres; *middle* and *foreground* with nymphs of the hunt around a fountain, men with wild and domestic animals, girls weaving garlands and carrying fruit; architrave *above* inscribed in Virgilian hexameters (based on Virgil, *Georgics* 2.532–34 and *Aeneid* 1.531):

 Hanc olim veteres vitam coluere Sabini,
 Hanc Remus et frater, sic fortis Etruria crevit,
 Scilicet et rerum facta est pulcherrima Flora,
 Urbs antiqua, potens armis atque ubere glebae.

 This life once the ancient Sabines cultivated,
 And Remus and his brother, this was how mighty Etruria grew,
 And no doubt this way Florence became beautiful,
 An ancient city, powerful in war and in the fertility of its soil.

10. Industry, holding a scepter like the caduceus of Mercury topped with an eye within the palm of a winged hand (fig. 87, *center row center*) (sculpture).

11. Industry (painting), a forum resembling the Mercato Nuovo with statues of For-
tune (on a wheel) and Mercury (holding a caduceus and purse) filled with mer-
chants selling gold and silk cloth, draperies, embroidery, wood carvings, intarsia,
and toys; *above* architrave inscribed in hexameters:

> Quas artes pariat solertia, nutriat usus,
> Aurea monstravit quondam Florentia cunctis.
> Pandere namque acri ingenio atque enixa labore est
> Praestanti, unde paret vitam sibi quisque beatam.

> The arts that ingenuity might invent and experience foster,
> Golden Florence once showed to all people.
> For it labored with keen talent and extraordinary toil
> To open the door by which everyone might make his life happy.

12. Disegno, a nude with three heads (for painting, sculpture, and architecture)
holding the instruments of the arts (sculpture).

13. Disegno (painting), ancient and modern statues and paintings (many in the Me-
dici collections) displayed within a large courtyard being copied or designed
by various artists including Michelangelo (with his device of three interlocked
rings), Andrea del Sarto, Leonardo da Vinci, Pontormo, Rosso, Perino del Vaga,
Francesco Salviati, Antonio da Sangallo, Rustici, Cimabue, Giotto, Gaddi, Buf-
falmacco, Benozzo Gozzoli, Donatello, Brunelleschi, Lorenzo Ghiberti, Fra Fi-
lippo Lippi, Masaccio, Desiderio da Settignano, and Verrocchio; *above* architrave
inscribed in hexameters:

> Non pictura satis, non possunt marmora et aera
> Tuscaque non arcus testari ingentia facta,
> Atque ea praecipue quae mox ventura trahuntur;
> Quis nunc Praxiteles caelet, quis pingat Apelles?

> Painting is not enough, marble and bronze cannot
> Nor Tuscan arch bear witness to mighty deeds,
> Especially those which are to come.
> What Praxiteles now would sculpt, what Apelles would paint?

14. Apollo or Poetry, a nude holding a crown of laurel and lyre (sculpture).

15. Poetry (painting), *background* with Pegasus on the summit of Mt. Helicon covered
with laurels; *middle* and *foreground* with a meadow of laurels in which cupids play
shooting arrows and throwing down crowns of laurel, the spring of Aganippe
surrounded by the nine muses, poets reciting or singing include Dante, Petrarch,
Boccaccio, Cino da Pistoia, Montemagno, Guido Cavalcanti, Guittone d'Arezzo,
Dante da Maiano, Giovanni della Casa, Luigi Alamanni, Lodovico Martelli, Vin-
cenzo Martelli, Giovanni Rucellai, Girolamo Benivieni, Franco Sacchetti, Luigi
Pulci, Bernardo Pulci, Luca Pulci, Ceo, Altissimo, Francesco Berni, Burchiello,
Antonio Alamanni, Bernardo Accolti, all flanked by the river gods Arno (with a
lion and crowned with laurel by two cupids) and Mugnone (with Fiesole, a
nymph [Diana] with a crown of stars and a moon on her brow); for a preparatory

drawing by Butteri see Scorza, "A New Drawing," fig. 79; *above* architrave inscribed in hexameters.

Musarum hic regnat chorus, atque Helicone virente
Posthabito, venere tibi Florentia vates
Eximii, quoniam celebrare haec regia digno
Non potuere suo et connubia carmine sacro.

Here reigns the chorus of the Muses. Verdant Helicon
Left behind, poets have come to you, Florence,
Special poets, since they could not celebrate worthily
This royal marriage or by sacred song.

16. Founding of Florence, a *deductio* inscribed COL[ONIA] JUL[IANA] FLORENTIA [Florence, a Julian colony] (fig. 86, *lower left*).

17. Florentine Arms, Hercules holding a club and lion's skin (fig. 87, *upper left*).

18. Florentine Poetry, Pegasus smiting an urn held by the river god Arno (fig. 87, *lower right*).

19. Florentine Industry, Mercury holding a caduceus, purse, and cock (fig. 87, *center row left*).

20. Florentine Military Glory, kneeling Flora crowned with laurel by two crowned emperors in military dress; inscribed GLORIA POP[ULI] FLOREN[TINI] [Glory of the Florentine people] (fig. 87, *bottom row center*).

21. Florentine Military Fidelity, Flora seated before an ancient altar swearing an oath with one hand outstretched and the other upraised; inscribed FIDES POP[ULI] FLOR[ENTINI] [Fidelity of the Florentine people] (fig. 87, *top row center*).

22. Florentine Agriculture, two intertwined cornucopias filled with corn (fig. 87, *center row right*).

23. Florentine Disegno, three graces with hands linked (to denote the interdependence of painting, sculpture, and architecture) holding instruments of the arts and standing on a pedestal with a sign of Capricorn (fig. 87, *lower left*).

24. Florentine Letters, enthroned Flora with a lion receiving boughs of laurel from citizens (fig. 87, *upper right*).

25. Founding of Florence, Marzocco holding shield; inscribed TRIBU SCAPTIA [Of the Scaptian tribe (i.e., the tribe of Emperor Augustus)] (fig. 86, *lower right*).

26. Florentine Peace, principal device with two halcyons nesting at sea in winter with a sign of Capricorn above; inscribed HOC FIDUNT [In this they trust] (fig. 79, *top*).

27. Coat of arms of Cosimo I, with the chain of the Order of the Golden Fleece.

28. Coat of arms of Florence (red lily on white field).

29. Coat of arms of Francesco I and Giovanna of Austria.

30. Inscription, INGREDERE URBEM FELICISSIMO CONJUGIO FACTAM TUAM, AUGUSTISSIMA VIRGO, FIDE, INGENIIS, ET OMNI LAUDE PRAESTANTEM; OPTATAQUE PRAESENTIA TUA, ET EXIMIA VIRTUTE, SPERATAQUE FECUNDITATE, OPTIMORUM PRINCIPUM PATERNAM ET AVITAM CLARITATEM, FIDELISSIMORUM CIVIUM LAETITIAM,

FLORENTIS URBIS GLORIAM ET FELICITATEM AUGE. [Enter the city by most happy marriage made yours, most noble lady, (the city) in loyalty, talent, and every virtue outstanding: And by your longed-for presence, surpassing virtue, and hoped-for fertility, exalt the grandeur of the greatest princes of your father's and grandfather's family, the joy of your most loyal citizens, and the glory and felicity of the city of Florence.]

NOTE: There are a number of discrepancies between Mellini (*Descrizione dell'entrata*) and Vasari-Cini (*Descrizione dell'apparato* in *Le vite*, ed. Milanesi, 8:521–50) and the sketched plan of Borghini (Ginori Conti, *L'apparato per le nozze*, fig. 1) with regard to the location of elements on this arch. We have followed Borghini's plan in locating Arms (4–5) to the left and Letters (6–7) to the right, although they are reversed by Vasari-Cini. For the locations of Agriculture and Industry (8–11) we have followed both Mellini and Vasari-Cini but have followed Mellini in placing Poetry to the left (14–15) and Disegno to the right (12–13), although they are reversed by Vasari-Cini, and on the plan Poetry or Disegno and Industry or Agriculture are transposed. Since the two descriptions and the plan all agree concerning the placement of devices in the ovals (16–25), we have followed their order but suggest the transposition of three pairs (18–19, 20–21, and 22–23) to place them nearest the allegories to which they refer. Since no drawings exist for the entrance arch proper, this part of the drawing is hypothetical (1–3, 27–30).

Artists: Alessandro Allori, chief architect and designer; Alessandro Allori (four works) and Giovanni Maria Butteri (two works, including 15), painters; Zanobi Lastricati (1, 4, 6, 8, 10, 14, 12) assisted by Cresci Butteri (2–3), Fra Giovanni Vincenzo Casali, and Camillo d'Ottaviano, sculptors; Giovanni Susini, carpenter; Baccio Lottini and Francesco di Bartolomeo, chief masons. Borghini's preparatory drawings are in the Biblioteca Nazionale Centrale, Florence, Fondo Magliabeciano MS (hereafter BNCFlor) 2.10.100: 41v, 52v, 53r, 57v, 81v, 82r; see Ginori Conti, *L'apparato per le nozze*, figs. 1, 19; Testaverde Matteini, "Una fonte iconografica," tav. 1–3; Scorza, "Vincenzo Borghini and *invenzione*," figs. 3a, 4, 7, 8a; and Scorza, "A New Drawing," text fig. A, fig. 81.

2. ARCH OF AUSTRIA AND TUSCANY

BORGO OGNISSANTI

1. Austria, a young woman in Roman armor holding a scepter with an angel at her feet holding an imperial crown (sculpture); *above* probably Hapsburg coat of arms.

2. Tuscany, a young woman in ancient religious vestments holding a sacerdotal lituus with an angel at her feet holding a papal tiara (sculpture); *above* probably Medici coat of arms.

3. Austria (painting), allegories of cities (including Vienna, Neustadt, Linz, Klosterneuburg) and rivers of Austria; inscribed in elegiac couplets:

Augustae en adsum sponsae comes Austria; magni
Caesaris haec nata est, Caesaris atque soror.
Carolus est patruus, gens et faecunda triumphis,

Imperio fulget, regibus et proavis.
Laetitiam et pacem adferimus dulcesque Hymeneos
Et placidam requiem, Tuscia clara, tibi.

Here I am, Austria, companion of the august bride; of great
Caesar (Ferdinand I) she is daughter, and of Caesar (Maximilian II) sister.
Charles (V) is her uncle, her family is full of triumphs.
With power she shines, with kings and ancestors.
Happiness and peace we bring and sweet weddings
And quiet rest, great Tuscany, to you.

4. Tuscany (painting), allegories of cities (including Fiesole, Pisa, Siena, Arezzo,
 Volterra, Pistoia, Cortona, Borgo Sansepolcro) and rivers (including Ombrone,
 Arbia, Serchio, Chiana, Cecina); inscribed in elegiac verse:

Ominibus faustis et laetor imagine rerum,
Virginis aspectu Caesareaeque fruor.
Hae nostrae insignes urbes, haec oppida et agri,
Haec tua sunt; illis tu dare jura potes.
Audis ut resonet laetis clamoribus aether,
Et plausu et ludis Austria cuncta fremat?

In fair omens I am pleased and in the view of things,
And I enjoy the sight of the royal (Caesarean) lady.
These our noble cities, these towns and fields
Are yours; to them you can give laws.
Do you hear how the skies resound with happy sounds
And with applause and games all Austria roars?

Artists: Francesco della Cammilla (1–2), sculptures; Santi di Tito and Carlo Portelli,
painters; Lorenzo del Berna, carpenter. For Borghini's preparatory sketches see
BNCFlor 2.10.100: 80v; Ginori Conti, *L'apparato per le nozze*, fig. 3; Pillsbury,
"Drawings by Vasari and Vincenzo Borghini," pl. 24–25a; Pillsbury, "The Tempo-
rary Façade on the Palazzo Ricasoli," fig. 7; and Fagiolo, *La città effimera*, fig. 109.

3. ARCH OF HYMEN

PONTE ALLA CARRAIA (PALAZZO DEI RICASOLI)

1. Hymen, holding a garland of flowering marjoram, a torch, and a veil; flanked by
 Love and Conjugal Fidelity (sculpture); inscribed (from Catullus, *Carmen*
 61.43–5) BONI CONJUGATOR AMORIS [Joiner of good love].

2. Venus Genetrix (sculpture); inscribed (from Epithalamium of Theocritus, *Idyll*
 18.51–52) Κύπρις δὲ, Θεὰ Κύπρις, ἶσον ἔρασθαι ἀλλάλων [May Cypris (Aphro-
 dite) grant that you love each other equally]. *Below*, arch to Via della Vigna.

3. Latona (sculpture); inscribed (from Theocritus, *Idyll* 18.50–51) Λατὼ μὲν δοίη, Λατὼ κουροτρόφος ὔμμιν εὐτεκνίαν [May Leto who fosters boys grant you many children]. *Below* arch to the Lungarno.

4. Danube River with an Eagle Embracing the Drava River, crowned with roses and flowers (sculpture); inscribed in elegiac verse:

 Quamvis Flora tuis celeberrima finibus errem,
 Sum septemgeminus Danubiusque ferox;
 Virginis Augustae comes, et vestigia lustro,
 Ut reor, et si quod flumina numen habent,
 Conjugium faustum et foecundum et Nestoris annos,
 Tuscorum et late nuntio regna tibi.

 Although, famous Florence, I roam your land,
 I am the seven-mouthed mighty Danube.
 Companion of the august lady, I follow her tracks
 And, I think, if rivers have any divinity,
 A marriage both happy and fruitful, years as long as Nestor's,
 And rule far and wide by the Tuscans I proclaim to you.

5. Arno River with a Lion Embracing the Sieve River, the Arno crowned with lilies, the Sieve with leaves and apples [Medici *palle*] (sculpture); inscribed in elegiac verse:

 In mare nunc auro flaventes Arnus arenas
 Volvam, atque argento purior unda fluet.
 Etruscos nunc invictis comitantibus armis
 Caesareis, tollam sidera ad alta caput.
 Nunc mihi fama etiam Tibrim fulgoreque rerum
 Tantarum longe vincere fata dabunt.

 To the sea now sands gleaming with gold I, the Arno,
 Shall roll, and the water more pure than silver will flow.
 As the Etruscans now are attended by the invincible weapons
 Of Caesar, I shall raise to the high stars my head.
 Now by my glory and the glitter of all this even the Tiber
 Will be far surpassed as the gift of destiny.

6. Three Graces with Youth and Delight, Beauty and Contentment, Gladness and Play, and Fecundity and Repose (painting); inscribed in elegiac verse:

 Quae tam praeclara nascetur stirpe parentum
 Inclita progenies, digna atavisque suis?
 Etrusca attollet se quantis gloria rebus
 Conjugio Austriacae Mediceaeque Domus?
 Vivite felices; non est spes irrita, namque
 Divina Charites talia voce canunt.

What will be born from such glorious parentage,
(What) noble offspring worthy of its ancestors?
How greatly will Etruscan glory be exalted
By the joining of the Austrian and Medici houses.
Live happy. It is not a vain hope, because
With divine voice the graces sing such things.

7. Three Graces, Juno, Venus, Concord, Love, Fecundity, Sleep, Pasithea, Thalassius, and Cupids with Torches, Incense, and Flowers Prepare the Nuptial Bed (painting); for Bronzino's preparatory drawing in the Louvre see Pillsbury, "The Temporary Façade on the Palazzo Ricasoli," fig. 5; and Scorza, "Vincenzo Borghini and *invenzione*," fig. 9b.

8. Love, Fidelity, Delight, Contentment, Gladness, and Repose Banish with Torches Jealousy, Contention, Affliction, Sorrow, Lamentation, Deceit, Sterility (painting); for Bronzino's preparatory drawing in Oxford see Scorza, "Vincenzo Borghini and *invenzione*," fig. 9a.

9. Giovanna of Austria in the Company of Maidens Crowned with Flowers, Holding Torches, and Pointing to the Evening Star (painting); inscribed O DIGNA CONJUNCTA VIRO [O worthy to marry a man].

10. Francesco I de' Medici in the Company of Young Men Crowned with Flowers, Holding Torches, and Pointing to the Evening Star (painting); inscribed O TAEDIS FELICIBUS AUCTE [O by happy (marital) torches exalted].

11. Principal device (arranged *over* 9 and 10), a gilded chain of marriage rings set with stones appearing to hang from heaven and to support the earth; inscribed NATURA SEQUITUR CUPIDE [Nature follows eagerly].

12. Ode in Asclepiadean meter:

Augusti soboles regia Caesaris,
Summo nupta viro Principi Etruriae,
Faustis auspiciis deseruit vagum
Istrum regnaque patria.

Cui frater, genitor, patruus, atque avi
Fulgent innumeri stemmate nobiles
Praeclaro Imperii, prisca ab origine
Digno nomine Caesares.

Ergo magnanimae virgini et inclytae
Jam nunc Arne pater suppliciter manus
Libes, et violis versicoloribus
Pulchram Flora premas comam.

Assurgant proceres, ac velut aureum
Et caeleste jubar rite colant eam.
Omnes accumulent templa Deum, et piis
Aras muneribus sacras.

Tali conjugio Pax hilaris redit,
Fruges alma Ceres porrigit uberes,
Saturni remeant aurea saecula,
Orbis laetitia fremit.

Quin dirae Eumenides monstraque Tartari
His longe duce te finibus exulant.
Bellorum rabies hinc abit effera,
Mavors sanguineus fugit.

Sed jam nox ruit et sidera concidunt;
Et nymphae adveniunt, Junoque pronuba
Arridet pariter, blandaque Gratia
Nudis juncta sororibus.

Haec cingit niveis tempora liliis,
Haec e purpureis serta gerit rosis,
Huic molles violae et suavis amaracus
Nectunt virgineum caput.

Lusus, laeta Quies cernitur et Decor;
Quos circum volitat turba Cupidinum,
Et plaudens recinit haec Hymeneus ad
Regalis thalami fores.

Quid statis juvenes tam genialibus
Indulgere toris immemores? Joci
Cessent et Choreae; ludere vos simul
Poscunt tempora mollius.

Non vincant hederae bracchia flexiles,
Conchae non superent oscula dulcia,
Emanet pariter sudor et ossibus
Grato murmure ab intimis.

Det summum imperium regnaque Juppiter,
Det Latona parem progeniem patri;
Ardorem unanimem det Venus, atque Amor
Aspirans face mutua.

Royal offspring of Augustus Caesar,
Married to the supreme prince of Etruria,
With fair auspices has left the wandering
Danube and her father's kingdom.

Whose brother, father, uncle, and grandparents
Gleam, numberless nobles, with the pedigree
Glorious of empire, of ancient origin,
Caesars of worthy name.

Therefore, for the high-spirited and noble lady
Sprinkle now, father Arno, her hands dutifully
and with varicolored violets
Wreathe, O Florence, her fair hair.

Let the nobles rise and like the golden
Heavenly sun duly adore her.
Let all heap up the temples and sacred
Altars with pious gifts.

With such a marriage happy peace returns,
Motherly Ceres extends rich fruits,
The golden age of Saturn returns,
The world roars with joy.

And even the cruel Eumenides and monsters of Tartarus
Far from these boundaries are banished while you rule.
The insane madness of war goes from here,
Bloody Mars flees.

But now night rushes up and stars fall;
The nymphs arrive, and Juno attending the bride
Smiles on everything, and the kindly Grace
Along with her nude sisters.

One wreathes with snow-white lilies her temples,
A second carries garlands of purple roses,
And the third has soft violets and sweet marjoram
That bind her virginal head.

Play, happy Quiet are seen, and Beauty;
Around which flutters a throng of cupids
And clapping the marriage god echoes this at
The royal bedroom's doors.

Why do you stand by, young people, forgetting
To enjoy such festive couches? Let laughter
And song quiet down; you should play
More softly the time demands.

Let not the winding ivy bind arms,
Let not mussels replace sweet kisses,
Let sweat come forth from the bones
With a pleasant murmur from their depths.

May Jupiter grant supreme power and rule,
May Latona grant a son like his father;
May Venus grant single-minded passion, and Love also
Favoring with mutual fire.

Artists: Agnolo Bronzino, chief designer and painter (6–8) assisted by Alessandro Al-
lori (two paintings [probably two that Bronzino also worked on], all ornamenta-
tion) and Lorenzo Sciorini (9–10); Battista Lorenzi (1–5), sculptor; Lorenzo del
Berna, carpenter; Giovanni di Piero di Valdimarina, chief mason. For the pre-
paratory drawings of Borghini and Vasari see BNCFlor 2.10.100: 48v–49r; Ginori
Conti, *L'apparato per le nozze*, fig. 4; Pillsbury, "Drawings by Vasari and Vincenzo
Borghini," pl. 25b; Pillsbury, "The Temporary Façade on the Palazzo Ricasoli,"
figs. 1, 3, 4, 8; and Pillsbury, "Vincenzo Borghini as a Draftsman," fig. 2.

4. ARCH OF MARITIME EMPIRE

PONTE SANTA TRINITA

1. Oceanus, holding branches of coral, shells of mother-of-pearl, etc. (sculpture).

2. Tyrrhenian Sea, holding branches of coral, shells of mother-of-pearl, etc.
 (sculpture).

3. Siren seated on a fish, from the siren's breasts red and white wine flowed into the
 basin and from her mouth, at the turning of a valve, a jet of water drenched the
 unwary drinker (sculpture).

4. Proteus (painting); inscribed in hexameters:

 Germana adveniet felici cum alite virgo,
 Flora, tibi, adveniet soboles Augusta, Hymenei
 Cui pulcher Juvenis jungatur foedere certo
 Regius, Italiae columen. Bona quanta sequentur
 Conjugium? Pater Arne tibi, et tibi Florida Mater,
 Gloria quanta aderit? Protheum nil postera fallunt.

 The German maiden will arrive with good omen,
 Florence, to you the Augustan offspring will arrive,
 To whom the handsome youth will be joined in the secure bond of marriage,
 Royal youth, pillar of Italy. What blessings will attend
 The marriage? Father Arno and mother Florence, to you
 How much glory will come? The future does not at all deceive Proteus.

5. Tethys or Amphitrite, Goddess and Queen of the Sea, holding a rostral crown
 (painting); inscribed VINCE MARI, JAM TERRA TUA EST [Conquer at sea; already the
 land is yours].

6. Gold vases, filled to overflowing with riches of the sea (sculpture).

7. Male youths, holding gold festoons of conches, shells, coral, sword grass, sea-
 weed, etc. (sculpture).

8. Allegory of Peru and the New World, a nymph surrounded by New World ani-
 mals looking at a vision in the sky of Christianity—Christ (on a cross formed by
 the constellation of the Southern Cross) shining sunlike through dark clouds

(painting); inscribed (with reference to Virgil, *Aeneid* 1.603 and 605, and Lucretius 3.1) in hexameters:

Di tibi pro meritis tantis, Augusta propago,
Praemia digna ferant, quae vinctam mille catenis
Heu duris solvis, quae clarum cernere solem
E tenebris tantis et Christum noscere donas.

May the gods for all your merits, child of Augustus,
Bring you due rewards, you who release the prisoner
Bound by a thousand harsh chains, and enable her to see the bright sun
After such darkness and to know Christ.

Above, probably the Hapsburg coat of arms with the imperial crown.

9. Perseus Saves Andromeda from the Sea Monster (painting).

10. Allegory of Elba, female warrior in armor holding a trident seated on a rock in the port of Elba surrounded by galleys, a boy on a dolphin, and a boy with an anchor (painting); inscribed in hexameters:

Evenere olim Heroes qui littore in isto
Magnanimi votis petiere. En Ilva potentis
Auspiciis Cosmi multa munita opera ac vi;
Pacatum pelagus securi currite nautae.

There once came forth heroes who on this shore
Sought with high spirit gods in prayers. Behold Elba
Under the auspices of mighty Cosimo fortified with great works.
Race over the secured sea in confidence, sailors.

Above, probably the coat of arms of Cosimo I with the ducal crown.

11. Argonauts Returning with Medea and the Golden Fleece Offer Sacrifices to Jupiter on Elba (painting).

12. Neptune, holding a trident standing in his chariot chasing away troublesome winds (fig. 81) (painting); inscribed (from Virgil, *Aeneid* 1.137) MATURATE FUGAM [Speed your flight].

NOTE: There is a drawing only for the central section with the fountain; the rest is hypothetical.

Artists: Michele di Ridolfo (4–5, 8–12, and all ornamentation), chief designer and painter; Giovanni dell'Opera (1–3), sculptor; Antonio Particini, carpenter. For Borghini's preparatory drawings see BNCFlor 2.10.100: 50r; Ginori Conti, *L'apparato per le nozze,* fig. 5; Scorza, "Vincenzo Borghini and *invenzione,*" fig. 3b.

5. COLUMN OF VICTORY

PIAZZA SANTA TRINITA

Column of Victory commemorating the victory of Cosimo I's Florentine army over the Sienese and French army at Marciano on 2 August 1554; the granite shaft from the Baths of Caracalla in Rome—a gift of Pope Pius IV to Cosimo I—was raised in 1565.

Justice in armor holding a sword and scales by Francesco del Tadda, 1581 (porphyry and bronze); a similar figure (in porphyry-colored terracotta) by Bartolomeo Ammannati was in place for the 1565 marriage. For Borghini's preparatory sketch see BNCFlor 2.10.100: 57v (fig. 79, *bottom*).

6. ARCH OF AUSTRIA

CANTO DE' TORNAQUINCI

Front

1. Hapsburg coat of arms, supported by two winged victories with imperial crown above (sculpture); *below,* panel inscribed VIRTUTI FELICITATIQUE INVICTISSIMAE DOMUS AUSTRIAE, MAJESTATIQUE TOT ET TANTORUM IMPERATORUM AC REGUM, QUI IN IPSA FLORUERUNT ET NUNC MAXIME FLORENT, FLORENTIA AUGUSTO CONJUGIO PARTICEPS ILLIUS FELICITATIS, GRATO PIOQUE ANIMO DICAT [To the virtue and prosperity of the invincible house of Austria, to the majesty of so many great emperors and kings, who in it flourished and now especially flourish, Florence for this august marriage, sharing in its happiness, with grateful and pious spirit dedicates (this)].

2. Rudolph (1218–1291), first Hapsburg ruler of Austria (sculpture); *below,* coat of arms.

3. Albert I (1248–1308), son of Rudolph (sculpture); *below,* coat of arms.

4. Albert II (1298–1358), son of Albert I (sculpture); *below,* coat of arms.

5. Frederick III (1415–1493), emperor from 1452–1493, grandson of Albert II, father of Maximilian I, leaning against an olive trunk (sculpture); *below,* coat of arms.

6. Charles V (1500–1558), emperor from 1519–1556 (sculpture); *below,* coat of arms.

7. Maximilian I (1459–1519), emperor from 1493–1519 (sculpture); *below,* coat of arms.

8. Ferdinand I (1503–1564), emperor from 1558–1564, father of Giovanna (1547–1578) (sculpture); *below,* coat of arms.

9. Maximilian II (1527–1576), emperor from 1564–1576, brother of Giovanna (sculpture); *below,* coat of arms.

10. Rudolph Invests His Son Albert I with the Archduchy of Austria (painting); inscribed RODULPHUS PRIMUS EX HAC FAMILIA IMP[ERATOR] ALBERTUM PRIMUM AUSTRIAE PRINCIPATU DONAT [Rudolph first ruler of this family endows Albert I with the principate of Austria]. *Below,* arch to Via della Vigna.

11. Albert I Defeats Adolf in 1298 (painting); inscribed ALBERTUS I IMP[ERATOR] ADOL-
PHUM, CUI LEGIBUS IMPERIUM ABROGATUM FUERAT, MAGNO PROELIO VINCIT ET
SPOLIA OPIMA REFERT [Ruler Albert I defeats Adolf, whose rule had been legally
annulled, in a great battle and brings home the key spoils]. *Below*, arch to the
Mercato Vecchio, now Via degli Strozzi.

12. Ferdinand I Defends Vienna against the Turks in 1529 (painting); inscribed FERDI-
NANDUS PRIMUS IMP[ERATOR], INGENTIBUS COPIIS TURCORUM CUM REGE IPSORUM
PULSIS, VIENNAM NOBILEM URBEM FORTISSIME FELICISSIMEQUE DEFENDIT [Emperor
Ferdinand I, when a huge force of Turks with their king had been routed, de-
fends the noble city of Vienna bravely and successfully].

13. Maximilian II Invested with the Empire by the German Electors, the spiritual
electors accompanied by an allegory of Faith at their feet, the temporal electors by
Hope; around the head of Maximilian II angels drive away malign spirits sym-
bolizing the hoped-for triumph of the Catholic church within the empire and the
establishment of religious peace (painting); inscribed MAXIMILLIANUS II SA-
LUTATUR IMP[ERATOR] MAGNO CONSENSU GERMANORUM, ATQUE INGENTI LAETITIA
BONORUM OMNIUM, ET CHRISTIANAE PIETATIS FELICITATE [Maximilian II is hailed
emperor by general agreement of the Germans, and with great joy of all good
people and with the pleasure of pious Christians]. *Below*, arch to Via de'
Tornabuoni.

14. Inscription in elegiac verse:

IMPERIO LATE FULGENTES ASPICE REGES;
AUSTRIACA HOS OMNES EDIDIT ALTA DOMUS.
HIS INVICTA FUIT VIRTUS, HIS CUNCTA SUBACTA,
HIS DOMITA EST TELLUS, SERVIT ET OCEANUS.

Far flung with power gleaming behold the kings;
The lofty house of Austria has sired them all.
Their courage was invincible; they conquered everything;
The earth has been mastered by them, and the ocean serves them.

15. Inscription in elegiac verse:

IMPERIIS GENS NATA BONIS ET NATA TRIUMPHIS,
QUAM GENUS E COELO DUCERE NEMO NEGET;
TUQUE NITENS GERMEN DIVINAE STIRPIS ETRUSCIS
TRADITUM AGRIS NITIDIS, UT SOLA CULTA BEES;
SI MIHI CONTINGAT VESTRO DE SEMINE FRUCTUM
CARPERE ET IN NATIS CERNERE DETUR AVOS,
O FORTUNATAM! VERO TUNC NOMINE FLORENS
URBS FERAR, IN QUAM FORS CONGERAT OMNE BONUM.

Family born for good rule and triumphs,
Which no one would deny derives its origin from heaven;
And you, shining sprig of divine stock given
To gleaming Etruscan fields, to bless cultivated soil;
If I happen from your seed fruit

To pluck and in your children may see their grandparents,
O Lucky me! Then indeed flourishing
City I would be called, on whom chance would heap every good thing.

16. False Arch against the south flank of the Tournaquinci tower painted with an illusionistic street scene in which a woman on a white horse accompanied by grooms is riding toward the viewer.

Rear

17. Pillars of Hercules, principal device of Charles V with motto PLUS ULTRA [More beyond] supported by winged victories.

18. Philip I (1478–1506), father of Charles V (sculpture); *below,* coat of arms.

19. Philip II (1527–1598), son of Charles V (sculpture); *below,* coat of arms.

20. Garzia de Toledo Presents to Philip II an Allegory of Malta, a woman in armor with a white Maltese cross, symbolizing the victory over the Turkish forces in the siege of Malta in 1565 (painting; location approximate, shape hypothetical); inscribed MELITA, EREPTA E FAUCIBUS IMMANISSIMORUM HOSTIUM STUDIO ET AUXILIIS PIISSIMI REGIS PHILIPPI, CONSERVATOREM SUUM CORONA GRAMINEA DONAT [Malta, snatched from the jaws of savage enemies by the zeal and help of most pious King Philip, awards her savior a crown of grass].

21. False Arch against the west flank of the Tornaquinci tower painted with an illusionistic street scene in which a woman and a child are drawing water from a fountain.

Artists: Giovanni Stradano, chief designer and painter (10–13, 16, 20–21); Domenico Poggini (4–5), Antonio di Gino Lorenzi (1, and two emperors or rulers), Stoldo di Gino Lorenzi (two emperors or rulers), Francesco di Giovanni Battista Particini (18), Nanni di Stocco (two emperors or rulers), and Pompilio Lancia (19), sculptors; Antonio Particini, carpenter; and Francesco di Gratia Dio, chief mason. For Borghini's preparatory drawings see BNCFlor 2.10.100: 96v, 97r; Ginori Conti, *L'apparato per le nozze,* figs. 6–7; Fagiolo, *La città effimera,* fig. 106.

7. THEATER OF THE MEDICI
CANTO DE' CARNESECCHI

Entrance Arch

1. Medici coat of arms, with the ducal crown supported by two winged victories (sculpture).

2. Duke Cosimo I (1519–1574) seated, flanked by a she-wolf and a lion symbolizing Siena and Florence (sculpture); inscribed (from Virgil, *Aeneid* 6.403) PIETATE INSIGNIS ET ARMIS [In piety distinguished and war].

3. David Anointed by Samuel (painting), alluding to the election of Cosimo I as duke; inscribed A DOMINO FACTUM EST ISTUD [By the Lord this has been done].

4. Giovanni delle Bande Nere (1498–1526), standing in armor holding a broken lance (sculpture); *below,* inscribed (from Virgil, *Aeneid* 8.513) ITALUM FORTISS[IMUS] DUCTOR [Of the Italians the bravest leader].

5. Flaming Thunderbolt device of Giovanni delle Bande Nere (painting).

6. Duke Alessandro de' Medici (1511–1537), standing in armor holding a sword and baton (sculpture); *below,* inscribed SI FATA ASPERA RUMPAS, ALEXANDER ERIS [If you shatter cruel fate, you will be Alexander; cf. Virgil, *Aeneid* 6.882–83].

7. Rhinoceros device of Duke Alessandro (painting); inscribed NON BUELVO SIN VENCER [No beast without conquering].

8. Inscription (location hypothetical): VIRTUTI FELICITATIQUE ILLUSTRISSIMAE MEDICEAE FAMILIAE, QUAE FLOS ITALIAE, LUMEN ETRURIAE, DECUS PATRIAE SEMPER FUIT, NUNC ASCITA SIBI CAESAREA SOBOLE CIVIBUS SECURITATEM ET OMNI SUO IMPERIO DIGNITATEM AUXIT, GRATA PATRIA DICAT [To the virtue and happiness of the most noble Medici family, which has always been the flower of Italy, light of Etruria, glory of its country, and now by taking to itself the child of caesar has increased its citizens' security and all its power's distinction, a grateful country dedicates this].

Interior

9. Cosimo il Vecchio (1389–1464), standing (sculpture).

10. Cosimo il Vecchio Acclaimed *pater patriae* (painting); inscribed COSMUS MEDICES, VETERE HONESTISSIMO OMNIUM SENATUS CONSULTO RENOVATO, PARENS PATRIAE APPELLATUR [Cosimo Medici, when the old and noblest of all senatorial decrees were revived, is hailed father of his country].

11. Piero de' Medici il Gottoso (1416–1469), son of Cosimo il Vecchio (painting).

12. Lorenzo the Magnificent (1449–1492), son of Piero il Gottoso (sculpture).

13. Lorenzo the Magnificent Unifies Italy (painting); inscribed LAURENTIUS MEDICES, BELLI ET PACIS ARTIBUS EXCELLENS, DIVINO SUO CONSILIO CONJUNCTIS ANIMIS ET OPIBUS PRINCIPUM ITALORUM ET INGENTI ITALIAE TRANQUILLITATE PARTA, PARENS OPTIMI SAECULI APPELLATUR [Lorenzo de' Medici, superior in the arts of war and peace, when by his divine advice had been united the wills and resources of Italian leaders and the prevailing peace of Italy had been gained, is hailed father of the best age].

14. Giuliano de' Medici (1453–1478), son of Piero il Gottoso (painting).

15. Giovanni di Bicci de' Medici (1360–1429), father of Cosimo il Vecchio (painting).

16. Lorenzo de' Medici (1395–1440), son of Giovanni di Bicci (painting).

17. Pierfrancesco de' Medici (1430–1475), son of Lorenzo (painting).

18. Giovanni de' Medici il Popolano (1467–1498), son of Giovanni and father of Giovanni delle Bande Nere (painting).

19. Catherine de' Medici (1519–1589), daughter of Duke Lorenzo, Queen of France (sculpture).

20. Queen Catherine Presented with her Children—including the future King Charles IX of France and Queen Elisabeth of Spain—by Allegories of France and Spain (painting).

21. Allegories of Prudence and Liberality Embracing (painting).

22. Allegory of Piety with a stork and surrounded by angels holding models of ecclesiastical buildings commissioned by the Medici (painting).

23. Giuliano de' Medici, Duke of Nemours (1479–1516), son of Lorenzo the Magnificent (sculpture).

24. Duke Giuliano Made a Roman Citizen on the Capitoline Hill in Rome in 1513 (painting); inscribed JULIANUS MEDICES EXIMIAE VIRTUTIS ET PROBITATIS ERGO SUMMIS A POP[ULO] ROM[ANO] HONORIBUS DECORATUR, RENOVATA SPECIE ANTIQUAE DIGNITATIS AC LAETITIAE [Giuliano de' Medici, because of his outstanding virtue and honor, is honored with the highest award by the Roman people, as a spectacle of ancient distinction and joy is revived].

25. Cardinal Ippolito de' Medici (1511–1535), illegitimate son of Duke Giuliano (painting).

26. Lorenzo de' Medici, Duke of Urbino (1492–1519), son of Piero de' Medici (1471–1503), holding a sword (sculpture).

27. Duke Lorenzo de' Medici Given the Baton of Captain General of the Florentine Army (painting); inscribed LAURENTIUS MED[ICES] JUNIOR MAXIMA INVICTAE VIRTUTIS INDOLE, SUMMUM IN RE MILITARI IMPERIUM MAXIMO SUORUM CIVIUM AMORE ET SPE ADIPISCITUR [Lorenzo de' Medici, the younger, because of his great quality of invincible courage, gains the highest military command through the tremendous love and hope of his citizens].

28. Piero de' Medici (1472–1503), son of Lorenzo the Magnificent, father of Duke Lorenzo (painting).

29. Francesco de' Medici (1541–1587), son of Cosimo I and groom (sculpture); inscribed SPES ALTERA FLORAE [Second hope of Florence].

30. Cardinal [in 1560] Giovanni de' Medici (1543–1562), son of Cosimo (painting).

31. Cardinal [in 1563] Ferdinando de' Medici (1549–1609), son of Cosimo (painting).

32. Garzia de' Medici (1547–1562), son of Cosimo (painting).

33. Pietro de' Medici (1554–1604), son of Cosimo (painting).

34. Inscription in hexameters:

> HI, QUOS SACRA VIDES REDIMITOS TEMPORA MITRA
> PONTIFICES TRIPLICI, ROMAM TOTUMQUE PIORUM
> CONCILIUM REXERE PII; SED QUI PROPE FULGENT
> ILLUSTRI E GENTE INSIGNES SAGULISUE TOGISUE
> HEROES, CLARAM PATRIAM POPULUMQUE POTENTEM
> IMPERIIS AUXERE SUIS CERTAQUE SALUTE.

NAM SEMEL ITALIAM DONARUNT AUREA SAECLA,
CONJUGIO AUGUSTO DECORANT NUNC ET MAGE FIRMANT.

These, whose sacred temples you see bound by the papal
triple mitre, Rome and all the pious
councils ruled with piety; but those who nearby gleam,
distinguished members of a distinguished family, in war or peace
heroes, exalted their noble country and powerful people
by their rule and by the definite security (they gave).
For once to Italy they gave the golden age,
and now they honor it and increase its security by this august marriage.

35. Capricorn device of Cosimo I (painting); inscribed FIDUCIA FATI [Confidence in destiny].

36. Weasel device of Francesco I (painting); inscribed AMAT VICTORIA CURAM [Victory loves diligence].

37. Pope Pius IV (1559–1565) (sculpture).

38. Pope Pius IV Receives the Decrees of the Council of Trent from two Cardinal Legates (painting).

39. Pope Leo X (1513–1521) (sculpture).

40. Pope Leo X Confers with Francis I (painting).

41. Pope Clement VII (1523–1534) (sculpture).

42. Pope Clement VII Crowns Charles V Emperor in Bologna (painting).

43. Inscription in elegiac verse:

PONTIFICES SUMMOS MEDICUM DOMUS ALTA LEONEM,
CLEMENTEM DEINCEPS, EDIDIT INDE PIUM.
QUID TOT NUNC REFERAM INSIGNES PIETATE VEL ARMIS
MAGNANIMOSQUE DUCES EGREGIOSQUE VIROS?
GALLORUM INTER QUOS LATE REGINA REFULGET,
HAEC REGIS CONJUNX, HAEC EADEM GENITRIX.

Supreme pontiffs have sprung from the lofty house of the Medici:
Leo, then Clement, then Pius.
Why mention now so many men distinguished in piety or war,
Noble-spirited generals and extraordinary people?
Among them the Queen of France shines far and wide,
She who is both wife and mother of a king.

Exit Arch

44. Medici coat of arms

45. Inscription in elegiac verse:

VIRTUS RARA TIBI, STIRPS ILLUSTRISSIMA, QUONDAM
CLARUM TUSCORUM DETULIT IMPERIUM;
QUOD COSMUS FORTI PRAEFUNCTUS MUNERE MARTIS
PROTULIT ET JUSTA CUM DITIONE REGIT;
NUNC EADEM MAJOR DIVINA E GENTE JOANNAM
ALLICIT IN REGNUM CONCILIATQUE TORO.
QUAE SI CRESCET ITEM VENTURA IN PROLE NEPOTES,
AUREA GENS TUSCIS EXORIETUR AGRIS.

Rare ability brought you once, most distinguished family,
The brilliant rule of the Tuscans;
Which Cosimo, performing the brave role of warrior,
Extended and with just power ruled;
Now, still greater, it attracts Giovanna
Of divine family to this kingdom and unites her by marriage.
If it grows likewise in future offspring
A golden race will arise in Tuscan fields.

Unspecified locations: Coat of arms commemorating Medici marriages with the Hapsburgs of Austria (Duke Alessandro to Margaret of Austria [1522–1586], and Duke Francesco I to Giovanna of Austria [1547–1578]); the Toledo of Spain (Cosimo I to Eleonora da Toledo [1519–1562]); the La Tour d'Auvergne (Duke Lorenzo to Madeleine de La Tour d'Auvergne [1501–1591]); the Savoy (Duke Giuliano to Philiberte of Savoy [1498–1524]); the Orsini of Bracciano and Rome (Lorenzo the Magnificent to Clarice Orsini [1451–1488], his son Piero to Alfonsina Orsini [1472–1520], and Isabella [1542–1576, daughter of Cosimo I] to Paolo Giordano Orsini); the Sforza of Milan (Giovanni [father of Giovanni delle Bande Nere] to Caterina Sforza [1462–1509]); the Salviati of Florence (Giovanni delle Bande Nere to Maria Salviati [1499–1543]); the Valois of France (Catherine de' Medici to King Henry II of France); and the d'Este of Ferrara (Lucrezia [1545–1561, daughter of Cosimo I] to Alfonso II d'Este [1533–1597]).

Artists: Vincenzo de' Rossi (2, 4, 6, 9, 12, 19, 23, 26, 29, 37, 39, 41), chief architect and sculptor, assisted by Larione Ruspoli and Raffaello Peri, sculptors; Lambert Sustris (3, 10–11, 13–18, 20–22, 24–25, 27–28, 30–33, 38, 40, 42, and all ornamentation), painter; Daccio Descherini, carpenter; and Domenico di Zanobi, chief mason. For Borghini's preparatory drawings see BNCFlor 2.10.100: 51v, 52r, 60r, 68r, 68v; and Ginori Conti, *L'apparato per le nozze,* figs. 8–9; Fagiolo, *La città effimera,* fig. 10.

8. ARCH OF RELIGION

CANTO ALLA PAGLIA

West Facade

1. Christian Religion (sculpture).

2. Charity with three children (sculpture).

3. Hope (sculpture).

4. Armed Religion [Church Militant], or Minerva in armor holding a spear and shield with the red cross of the Order of St. Stephen on her breast (sculpture).

5. Peaceful Religion [Church Triumphant], dressed in ecclesiastical and civil robes and holding a cross (sculpture).

6. Labarum of Constantine with Cross [fig. 84], the principal device; inscribed IN HOC VINCES [By this you will conquer].

7. Medici coat of arms with three papal tiaras, commemorating popes Leo X, Clement VII, and Pius IV.

8. Religion before Law, or Melchizedek Offers a Natural Sacrifice of Bread, Wine, and Other Fruits of the Earth (painting).

9. Religion under Law, or Moses and Aaron Sacrifice the Paschal Lamb as Ordained by God (painting).

10. Religion under Grace, or the Eucharistic Sacrifice offered by figures kneeling before an altar with a chalice and host with the Holy Spirit above; angels above the altar hold a scroll inscribed IN SPIRITU ET VERITATE [In spirit and truth] (painting).

11. Inscription supported by two angels. VERAE RELIGIONI, QUAE VIRTUTUM OMNIUM FUNDAMENTUM, PUBLICARUM RERUM FIRMAMENTUM, PRIVATARUM ORNAMENTUM, ET HUMANAE TOTIUS VITAE LUMEN CONTINET, ETRURIA SEMPER DUX ET MAGISTRA ILLIUS HABITA, ET EADEM NUNC ANTIQUA ET SUA PROPRIA LAUDE MAXIME FLORENS, LIBENTISSIME CONSECRAVIT [To true religion, which is the basis of all virtues, the support of public affairs and the distinction of private, and the light of all human life, Etruria, which has always been considered its leader and teacher and flourishing now especially in its ancient and present fame, most freely has dedicated (this)].

12. Cosimo I, dressed as a knight of the Order of St. Stephen and holding its red cross (painting); *above,* inscribed COSMUS MEDIC[ES] FLOREN. ET SENAR. DUX II, SACRAM D. STEPHANI MILITIAM CHRISTIANAE PIETATIS ET BELLICAE VIRTUTIS DOMICILIUM FUNDAVIT, ANNO MDLXI [Cosimo de' Medici, second duke of Florence and Siena, founded in 1561 the home of the sacred order of St. Stephen of Christian piety and warlike courage].

13. Defeat of Damiata by Florentine Knights of St. Stephen (painting).

14. Cosimo I Creates Knights of the Order of St. Stephen in Pisa with the palace, church, and hospital of the order in the background (painting); inscribed COSMUS MED[ICES] FLOR. ET SENAR. DUX II, EQUITIBUS SUIS DIVINO CONSILIO CREATIS MAGNIFICE PIEQUE INSIGNIA ET SEDEM PRAEBET LARGEQUE REBUS OMNIBUS INSTRUIT [Cosimo de' Medici, second duke of Florence and Siena, having created his knights by divine inspiration, lavishly and reverently offers them insignia and a residence and generously equips them with everything].

15. Coat of arms of Cosimo I, as Grand Master of the Order of St. Stephen.

16. San Giovanni Gualberto, dressed as a knight (painting); inscribed above JOANNES GUALBERTUS, EQUES NOBILISS[IMUS] FLOREN[TINUS], VALLIS UMBROSAE FAMILIAE AUCTOR FUIT, ANNO MLXI [Giovanni Gualberto, most noble knight of Florence, was founder of the Vallombrosan order in 1061 (*sic*)].

17. Miracle of the Blessed Peter Igneus, who, on the order and with the benediction of San Giovanni Gualberto, carries a cross through a fire to the confusion of heretics and Simonists (painting).

18. San Giovanni Gualberto Founds the Monastery of Vallombrosa (painting); inscribed S. JO[ANNES] GUALBERTUS IN VALLOMBROSIANO MONTE, AB INTERVENTORIBUS ET ILLECEBRIS OMNIBUS REMOTO LOCO, DOMICILIUM PONIT SACRIS SUIS SODALIBUS [San Giovanni Gualberto on Mt. Vallombrosa, a place far removed from intruders and all temptations, founds a home for his holy companions].

19. Medici coat of arms, with three cardinals' hats commemorating cardinals Ippolito, Giovanni, and Ferdinando (cardinals ordained respectively in 1531, 1560, and 1563).

20. Angels dance and sing above a balustrade (painting) below an oculus open to the sky.

21. Symbols of the Four Evangelists in the pendentives (painting).

East Facade

22. Classical Religion, an ancient altar with flame of Vesta (sculpture).

23. Contemplative Life, looking toward heaven (sculpture).

24. Active Life, crowned with flowers (sculpture).

25. Etruscans Teach Religion to the Romans, three Romans present twelve children to old Etruscan priests for religious instruction (painting); inscribed ETRURIA PRINCIPES DISCIPLINAM DOCETO [Let Etruria to princes give instruction].

26. Classical Augury and Sacrifice, a priest augurs from entrails of sacrificial animal (painting).

27. Classical Augury and Sacrifice, a priest with crooked lituus takes auguries from flying birds (painting).

28. Inscription in elegiac verse:

FRUGIBUS INVENTIS DOCTAE CELEBRANTUR ATHENAE,
ROMA FEROX ARMIS IMPERIOQUE POTENS.
AT NOSTRA HAEC MITIS PROVINCIA ETRURIA RITU
DIVINO ET CULTU NOBILIORE DEI,
UNAM QUAM PERHIBENT ARTES TENUISSE PIANDI
NUMINIS, ET RITUS EDOCUISSE SACROS;
NUNC EADEM SEDES VERAE EST PIETATIS, ET ILLI
HOS NUMQUAM TITULOS AUFERET ULLA DIES.

For inventing grain learned Athens is famed,
Rome for being fierce at war and powerful in empire.
But this our mild province of Etruria is known
For its divine practice and superior worship of God,
Which they say uniquely possessed the skills for honoring
The deity and teaching sacred practices;

> Now it is the site of true piety and from it
> This reputation never will be taken any time.

29. San Romualdo (painting); inscribed above ROMUALDUS IN HAC NOSTRA PLENA SANCTITATIS TERRA, CAMALDULENSIUM ORDINEM COLLOCAVIT ANNO MXII [Romualdo in this our land full of holiness founded the Camaldolese order in 1012].

30. Vision of San Romualdo, who dreams of a stairway to heaven as a sign to build his hermitage on that spot (painting).

31. San Romualdo Founds the Camaldolese Hermitage (painting).

32. Blessed Filippo Benizi (painting); inscribed above PHILIPPUS BENITIUS CIVIS NOSTER INSTITUIT ET REBUS OMNIBUS ORNAVIT SERVORUM FAMILIAM, ANNO MCCLXXXV [Filippo Benizi, our citizen, instituted and in every way promoted the Servite order in the year 1285].

33. Annunciation, with a multitude in supplication before the Virgin over which an angel scatters a vase of flowers symbolizing grace (painting).

34. Filippo Benizi and Seven Companions Take the Servite Habit and Build the Monastery and Church of SS. Annunziata (painting); inscribed SEPTEM NOBILES CIVES NOSTRI IN SACELLO NOSTRAE URBIS, TOTO NUNC ORBE RELIGIONIS ET SANCTITATIS FAMA CLARISSIMO, SE TOTOS RELIGIONI DEDUNT ET SEMINA JACIUNT ORDINIS SERVORUM D. MARIAE VIRG. [Seven of our noble citizens in a shrine of our city, now most famous in the whole world for religion and holiness, give themselves totally to religion and sow the seeds of the Servite order of the Virgin Mary].

South Facade

35. SS. Peter and Paul and Other Apostles Dispute with Pagan Philosophers, some of whom throw away or tear up books, and others of whom—such as Dionysius the Areopagite, Justinus, Pantaenus, etc.—humbly and devoutly accept the evangelical wisdom (painting); inscribed NON EST SAPIENTIA, NON EST PRUDENTIA [NON EST CONSILIUM CONTRA DOMINUM] [There is no wisdom, there is no prudence (there is no counsel against the Lord); Proverbs 21:30].

36. Blessed Giovanni Colombini Founds the Gesuati Order in 1351 in the Campo of Siena and takes the habit of a beggar (painting); inscribed ORIGO COLLEGII PAUPERUM, QUI AB JESU COGNOMEN ACCEPERUNT; CUIUS ORDINIS PRINCEPS FUIT JOANNES COLOMBINUS, DOMO SENENIS, ANNO MCCCLI [The origin of the begging order, which took its name from Jesus, of which order the founder was Giovanni Colombini of Siena in 1351].

37. San Giovanni Tolomei with a Model of the Monastery of Monte Oliveto Given Permission in 1319 to Found the Olivetan Order (painting); inscribed INSTITUITUR SACER ORDO MONACORUM QUI AB OLIVETO MONTE NOMINATUR, AUCTORIBUS NOBILIBUS CIVIBUS SENENSIBUS, ANNO MCCCXIX [The holy order of monks that is named from Mt. Oliveto is founded by authority of the noble citizens of Siena in 1319].

North Facade

38. SS. Peter and Paul Preach to Emperor Nero (painting); inscribed NON EST FOR-TITUDO, NON EST POTENTIA [CONTRA DOMINUM] [There is no strength, no power (against the Lord); composite of Proverbs 21:30 and 2 Paralipomenon 20:6].

39. St. Francis Founds the Franciscan Order on La Verna (painting); inscribed ASPER-RIMUM AGRI NOSTRI MONTEM DIVUS FRANCISCUS ELEGIT, IN QUO SUMMO ARDORE DOMINI NOSTRI SALUTAREM NECEM CONTEMPLARETUR, ISQUE NOTIS PLAGARUM IN CORPORE IPSIUS EXPRESSIS DIVINITUS CONSERVATUR [The very rough mountain of our terrain is chosen by St. Francis where with supreme devotion he might medi-tate on the beneficial death of our Lord, and with the stigmata marked on his own body he is miraculously saved].

40. Western and Eastern Churches Unified at the Council of Florence under Pope Eu-genius IV in 1439 (painting); inscribed NUMINE DEI OPTIMI MAX[IMI] ET SINGULARI CIVIUM NOSTRORUM RELIGIONIS STUDIO, ELIGITUR URBS NOSTRA IN QUA GRAECIA, AMPLISSIMUM MEMBRUM A CHRISTIANA PIETATE DISJUNCTUM, RELIQUO ECCLESIAE CORPORI CONJUNGERETUR [By will of God almighty and by the unique religious zeal of our people our city is chosen where Greece, that stout limb that had been separated from Christian piety, might be joined to the rest of the body of the Church].

Artists: Nanni di Stocco (1), Pompilio Lancia (2–3), Giovanni dell'Opera (4), Maso Boscoli (5), and Domenico Poggini (23–24), sculptors; Tommaso Manzuoli di San Friano (8–10), Michele di Ridolfo (12–14), Pier Francia (16–18), Battista Naldini (25–27), Domenico Beceri (29–31), Carlo Portelli (32–34), Francesco Morandini da Poppi (35, 38), Andrea del Minga (36), Girolamo Macchietti del Crocifisso [prob-ably identical with Giomo dall'Ungharo] (37), Mirabello (39), Vittorio Gobbo (40), and Marco da Faenza (ornamental details), painters; Antonio Particini, carpenter; Giovanni di Matteo Pali, chief mason. For the preparatory drawings of Borghini see BNCFlor 2.10.100: 60v, 95v, 96r; Ginori Conti, *L'apparato per le nozze*, figs. 10–11; Fagiolo, *La città effimera*, fig. 108.

9. ARCH OF THE VIRGIN MARY

CATHEDRAL PORTAL

1. Medici coat of arms, with the papal tiara and keys above (sculpture).

2. Allegory of Grace, holding an allegory of the wind (a blowing head) symbolizing divine grace (sculpture).

3. Allegory of Good Works, holding a sail symbolizing the action of the Holy Spirit in good works (sculpture).

4. Virgin and Child Adored by the Patron Saints of Florence [probably including SS. John the Baptist, Bernard, Zenobius, Cosmus, Damian, Anne, Vittorio, etc.] (painting).

5. Ship Sailing to a Safe Haven, the principal device symbolizing the actions of Grace and Good Works (fig. 85) (painting); inscribed Σὺν Θεῷ [With God], and

CONFIRMA HOC DEUS QUOD OPERATUS ES IN NOBIS [Strengthen, O God, the work which you have performed through us].

6. Birth of the Virgin (relief).

7. Presentation of the Virgin (relief).

8. Marriage of the Virgin (relief).

9. Annunciation (relief).

10. Visitation (relief).

11. Birth of Christ (relief).

12. Adoration of the Magi (relief).

13. Circumcision (relief).

14. Pentecost (relief).

15. Assumption (relief).

Artists: Maso Boscoli (1–3), Domenico Poggini (6), Giovanni dell'Opera (7), Vincenzo de' Rossi (8), Francesco della Cammilla (9), Vincenzo Danti (10), Giambologna (11), Stoldo di Gino Lorenzi [or Jacopo Centi da Pistoia, on one list] (12–13), Francesco Moschini [or Jacopo Centi da Pistoia, on one list] (14), and Jacopo Centi da Pistoia (15), sculptors; Tommaso Manzuoli di San Friano (4–5), painter; Roberto di Filippino (1), painter and gilder; Antonio Crocini, carpenter. For the preparatory drawings of Borghini see BNCFlor 2.10.100: 56v, 61r; Ginori Conti, *L'apparato per le nozze*, fig. 12.

10. EQUESTRIAN MONUMENT OF VIRTUE OVERCOMING VICE

PIAZZA DI SANT'APOLLINARE

1. Virtue Overcoming Vice, a Herculean hero in armor mounted on a rearing horse raising a sword to dispatch at his feet a monster, already wounded by a broken lance, in the form of a woman with a scorpion's tail symbolizing the Medicean defeat of civic discord and rebellion and the restoration of peace and harmony (sculpture).

2. Egyptian Ibis, killing with its beak and claws serpents wound around its legs (cf. fig. 83), the principal device; inscribed PRAEMIA DIGNA [Rewards that are worthy].

Artists: Vincenzo Danti (1) assisted by Giambologna and by Simone Colombini (for armature), sculptors; Lorenzo del Berna (base), carpenter. For the preparatory drawing of Borghini see BNCFlor 2.10.100: 60r; and Scorza, "Vincenzo Borghini and *invenzione*," fig. 3d.

11. ARCH OF HAPPINESS

BORGO DE' GRECI

1. Happiness, joyous and smiling crowned with flowers (sculpture); inscribed HI-LARITAS P. P. FLORENT[INA] [Happiness of the people of Florence]. (Seated flanking figures probably satyrs.)

2. Coat of arms of Francesco I and Giovanna of Austria.

3. Bacchus and Bacchants, drinking, dancing, singing, and playing (paintings); inscribed (from Horace, *Carmen* 1.37.1–2) NUNC EST BIBENDUM, NUNC PEDE LIBERO PULSANDA TELLUS [Now is the time to drink and with free foot to beat the earth].

4. Fountain, with two satyrs holding on their shoulders wine skins—from which poured red and white wine—and two putti holding two swans—from whose beaks spurted water from time to time to drench the unwary wine drinker (sculpture); inscribed ABITE LYMPHAE VINI PERNICIES [Away water, the bane of wine]. *Right*, paired doors to Via dei Leoni; *left*, door to Borgo de' Greci.

Artists: Ignazio Vannola da Scesi [or Assisi] (1) and Nanni di Stocco (4), sculptors; Santi di Tito (3), painter; Filippo di Giuliano di Baccio d'Agnolo, carpenter; Bernardo di Monna Mattea, chief mason. For the preparatory drawing of Borghini see BNCFlor 2.10.100: 97v; and Ginori Conti, *L'apparato per le nozze*, fig. 13.

12. ARCH OF PRUDENCE

VIA DEI GONDI

East Facade

1. Quadriga, with two angels in the triumphal chariot supporting the Augustan civic crown of oak ringed by two Capricorn tails (sculpture); inscribed OB CIVES SERVATOS [For saving the citizens]. (As the marriage procession passed through the arch, the quadriga rotated to face the Piazza della Signoria.)

2. Prudence or Civic Virtue, a seated and crowned woman holding a scepter in her right hand with her left foot on a globe (sculpture).

3. Patience (sculpture).

4. Vigilance (sculpture).

5. Constancy (sculpture).

6. Fortitude (sculpture).

7. Cosimo I Sends His Army against Siena (painting).

8. Cosimo I's Triumphal Entry into Siena (painting).

9. Cosimo I Abdicates in Favor of Francesco I, handing Francesco a scepter with a stork, symbolic of the Tuscan state (painting); inscribed REGET PATRIIS VIRTUTIBUS [He will rule with his father's virtues].

10. Cosimo I's Naval Fleet, symbolizing his maritime power (painting).

11. Cosimo I Visits His Tuscan State on Horseback, symbolizing his power on land (painting).

12. Cosimo I, Surrounded by Counselors, Emends and Issues Laws (painting); inscribed LEGIBUS EMENDES [By laws you will correct].

13. Cosimo I Addresses His Troops [*adlocutio*] (painting); inscribed ARMIS TUTERIS [By weapons you will protect].

14. Devices or medal reverses: *A* and *B*, curule chairs with fasces and a woman with a balance signifying the unity of supreme power and equity; *C* and *D*, a woman in ancient armor and soldiers with one hand on an altar presenting their other hand to their captain signifying military virtue and loyalty; *E* and *F*, a woman in a chariot and a woman on a ship, both holding a palm and a laurel crown, signifying victory on land and sea (paintings); inscribed MORIBUS ORNES [By customs you will adorn].

15. Inscription. REBUS URBANIS CONSTITUTIS, FINIB[US] IMPERII PROPAGATIS, RE MILITARI ORNATA, PACE UBIQUE PARTA, CIVITATIS IMPERIIQUE DIGNITATE AUCTA, MEMOR TANTORUM BENEFICIORUM PATRIA PRUDENTIAE DUCIS OPT[IMI] DEDICAVIT [With affairs of the city regulated, boundaries of the realm extended, military goals achieved, peace everywhere prevailing, and glory of the city and empire increased, the country, mindful of such benefits, dedicated this to the prudence of our supreme ruler].

16. Coat of arms of Cosimo I (location hypothetical).

17. Coat of arms of Francesco I and Giovanna of Austria (location hypothetical).

18. Coat of arms of Florence (location hypothetical).

West Facade

19. Capricorn, with its stars and holding in its paws a scepter of Osiris with an eye on top (fig. 80), the principal device; inscribed (from Juvenal, *Satires* 10.365) NULLUM NUMEN ABEST; SI SIT PRUDENTIA [No god is absent, if prudence may be present].

20. Temperance (sculpture).

21. Facility (sculpture).

22. Punishment, a Nemesis with sword, the first pillar of justice (sculpture).

23. Reward (or Remuneration or Grace), the second pillar of justice (sculpture).

24. Cosimo I Receives Petitions (painting).

25. Cosimo I Holds Duchess Eleonora da Toledo by the Hand (painting).

26. Cosimo I Concludes the Marriage Contract between Francesco I and Giovanna of Austria (painting); inscribed FAUSTO CUM SIDERE [With happy omen].

27. Cosimo I's Fortifications of Tuscany (painting); inscribed PAX AUGUSTA [Peace of Augustus].

28. Cosimo I Pacifies Italy (painting); inscribed PAX AUGUSTA.

Artists: Giambologna (quadriga of 1, 2, 22–23), Alessandro Scherano (angels, Capricorn tails, and oak crown of 1, 3–4), Francesco Moschini (5–6), Valerio Cioli (20–21), sculptors; Federico Zuccaro (7–9, 13, 25–28?), Lorenzo Sabbatini (12), Santi di Tito (three works, 10–11?, 24?), Bernardo di San Giorgio (six works, 14 A–F?), Vittorio Gobbo (two works, including 25?), Bartolomeo Gobbo (19, and another device), painters; Giovanni di Giovanni Francesco da Settignano [Giovannino detto il Rossino], carpenter; Bernardo di Monna Mattea, chief mason. For the preparatory drawings of Borghini see BNCFlor 2.10.100: 53v, 54r, 58r, 132v; Ginori Conti, *L'apparato per le nozze*, figs. 14–16; Fagiolo, *La città effimera*, fig. 107; Testaverde Matteini, "Una fonte iconografica," tav. 7; and Scorza, "Vincenzo Borghini and *invenzione*," figs. 3e, 8b.

13. NEPTUNE FOUNTAIN

PIAZZA DELLA SIGNORIA

Neptune Fountain (marble and bronze), by Bartolomeo Ammannati and workshop, 1560–65; Neptune holding a baton [according to Vasari-Cini, *Descrizionze dell'apparato*, p. 565, a trident] and crowned with pinecones surrounded by three tritons blowing water-spouting conch shells, all standing in a shell on a chariot drawn by four sea horses within an octagonal basin; signs of the zodiac on the lion-hubbed wheels of the chariot (*north wheel:* Virgo, Aries [sign of Francesco I, ascendent], Taurus, Gemini; *south wheel:* Pisces, Libra [Justice of Cosimo I, ascendent], Scorpio, Sagittarius).

Completed by 1575 on the rim of the basin Doris (holding a conch shell and a dolphin), Nereus (holding a dolphin and a fish), Thetis (holding a shield and a dolphin), and Peleus (holding a cornucopia and a dolphin), each flanked by fauns or satyrs (eight total); similar figures in stucco—some with baskets of fruit and chestnuts, some with children, shells, and dolphins—combined with scenes in relief interspersed with festoons, sea shells, crabs, etc., were in place for the 1565 marriage. See John Pope-Hennessy, *Italian High Renaissance and Baroque Sculpture* (London and New York, 1970), pp. 74–76, 374–76.

14. ARCH OF SECURITY

PALAZZO VECCHIO PORTAL

1. Security, a seated woman crowned with laurel and olive leaning against a column (sculpture).

2. Roman standard with Eagle and Laurel, planted in the ground (fig. 82), principal device over a window of the Palazzo Vecchio; inscribed (from Livy 5.55,1) HIC MANEBIMUS OPTUME [Here we will do best to stay].

3. Virtue and Fortune, embracing (sculpture); inscribed VIRTUTEM FORTUNA SEQUETUR [Fortune will follow virtue].

4. Diligence and Victory, embracing (sculpture); inscribed AMAT VICTORIA CURAM [Victory loves diligence].

5. Eternity, holding a Janus head (sculpture); inscribed (from Virgil, *Aeneid* 1.278) NEC FINES NEC TEMPORA [Neither limits nor times].

6. Fame, blowing a trumpet (sculpture); inscribed (from Virgil, *Aeneid* 1.287) TERMI-NAT ASTRIS [Its limit is the stars].

7. Coat of arms of Florence.

8. Coat of arms of Francesco I and Giovanna of Austria.

9. Coat of arms of Cosimo I, with the chain of the Order of the Golden Fleece and the ducal crown supported by two boys.

10. Fury, a chained male with an expression of anger and rage (sculpture).

11. Discord, a chained female with snakes for hair with an expression of venom, violence, and fraud (sculpture).

12. Prosperity, Concord, and Civilization, symbolized by three women: Nature or Diana of Ephesus with a mural crown, Concord holding a caduceus, and Minerva as the patroness of crafts, the liberal arts, etc. (painting).

13. Abundance or Fertility, Peace, and Majesty or Reputation, symbolized by three women: Amalthea holding a cornucopia filled with fruit and flowers with a corn-measure at her feet filled with ears of corn, Peace crowned with olive holding an olive branch, and Majesty or Reputation with a grave and venerable expression (painting).

14. Inscription. INGREDERE OPTIMIS AUSPICIIS FORTUNATAS AEDES TUAS AUGUSTA VIRGO, ET PRAESTANTISSIMI SPONSI AMORE, CLARISS[IMI] DUCIS SAPIENTIA, CUM BONIS OMNIBUS DELICIISQUE SUMMA ANIMI SECURITATE DIU FELIX ET LAETA PERFRUERE, ET DIVINAE TUAE VIRTUTIS, SUAVITATIS, FECUNDITATIS FRUCTIBUS PUBLICAM HILARITATEM CONFIRMA [Enter with the finest auspices your favored home, august lady, and take delight in your distinguished bridegroom's love and in the famous duke's wisdom, along with all good things and pleasures, in utmost peace of mind long happy and prosperous, and by the fruits of your divine virtue, sweetness, and fertility strengthen public happiness].

Artists: Vasari, chief designer; Francesco Moschini (1, 10–11), Valerio Cioli (3), Stoldo di Gino Lorenzi (4), Lorenzo di Antonio Pinacci da Carrara (5–6), sculptors; Jacopo Zucchi (12) and Battista Naldini (13), painters; Luigi di Matteo (Nigi [or Dionigi] di Matteo Nigretti [or dalla Nighittosa]) and Giovanni Monti, carpenters; Fruosino Mecholi, chief mason. For the preparatory drawing by Borghini see BNCFlor 2.10.100: 50v; Ginori Conti, *L'apparato per le nozze*, fig. 17; Pillsbury, "Vincenzo Borghini as a Draftsman," fig. 3.

15. SALA GRANDE

1. *Apotheosis of Cosimo I* (Cosimo surrounded by 26 putti crowned with an oak wreath by Flora or Florence). Attributes of Cosimo: *a* cross of the Order of St. Stephen and chain of the Order of the Golden Fleece, *b* ducal crown and scepter. Florentine coats of arms: *c* city (after 1251), *d* people, *e* commune (before 1251). Insignia of twenty-one guilds, one of the major seven in the center of each group

of three: *f* bakers (*fornai;* white star on red field), *g* wool merchants (*calimala*), *h* carpenters (*legnaiuoli*); *i* vintners (*vinattieri*), *j* money changers or bankers (*cambio*), *k* armorers and sword makers (*spadai e corazzai*); *l* stone and wood workers or builders (*maestri di pietre e di legname*), *m* doctors and pharmacists (*medici e speziali*), *n* locksmiths (*chiavaioli*); *o* blacksmiths (*fabbri*), *p* judges and notaries (*giudici e notai;* white star on gold field), *q* flax or linen workers and secondhand dealers (*linaioli e rigattieri;* white and red); *r* shoemakers (*calzolai*), *s* furriers (*vaiai e pellicciai*), *t* leather workers and tanners (*cuoiai e galigai;* white and black); *u* harness makers (*correggiai*), *v* retailers and silk merchants (*Por Santa Maria e seta*), *w* butchers (*beccai*); *x* oil makers and cheese sellers (*oliandoli*), *y* wool manufacturers (*lana*), and *z* innkeepers (*albergatori;* red star on white field). Inscriptions: *1 top,* S.P.Q.F. [SENATOS POPULUSQUE FLORENTINUS] OPTIMO PRINCIPE. *left,* CONSTITUTA CIVITATE. *bottom,* AUCTO IMPERIO. *right,* PACATA ETRURIA. (The Senate and people of Florence under the supreme prince. The state founded. The empire enlarged. Etruria pacified.) *2 above,* OPUS IUSSU COSMI DUCIS COEPTU[M] ANNO A CHRISTI ORTU MDLXIII. *below,* PERFECTUM A MATERIA A PICTURA A RELIQUO ORNATU ANN[IS] DUOB[US] MENS[IBUS] III. (This work begun by the command of Duke Cosimo in the year 1563 from the birth of Christ. Completed by its materials, pictures, and remaining embellishments in two years three months.) *3 right,* BELLUM PISAN[UM] SUMMA P[OPULI] F[LORENTINI] CONSTANTIA ANNO [*sic:* ANNIS] XIIII PERFICITUR. *left,* BELLUM SEN[ESE] SUMMA [COSMI] D[UCIS] PROVIDENTIA MEN[SIBUS] XIIII FINITUR. (The Pisan war was completed by the supreme endurance of the Florentine people in fourteen years. The Sienese war was brought to an end by the supreme providence of Duke Cosimo in fourteen months.)

2. *Foundation of Florence. Foreground,* triumvirs with laurel wreaths, i.e., Octavian [Augustus] (helmet at feet with rudder and Capricorn holding a *palla;* soldier behind with fasces and axe), Mark Antony (consigning Florentine standard to Roman soldiers, helmet with Hercules), and Lepidus (helmet with equestrian Mars); Aries in sky. *Background,* Roman legions, aqueduct, walls under construction, Temple of Mars, bridge, *deductio,* forum, amphitheater. *In distance,* Fiesole. Inscribed *bottom,* FLORENTIA ROM[ANORUM] COLONIA LEGE IULIA A III VIRIS DEDUCITUR. *left,* AB URBE CONDITA *right,* ANNO ANTE CHRISTUM NATUM LXX. (The Roman colony of Florence is founded under Julian law by the triumvirs. From the founding of the city 70 years before Christ.)

3. *Building the Third Circuit of Walls. Foreground,* the *signoria* receives the plan of the walls from Arnolfo di Cambio; drum, cymbal, and trumpet fanfare. *Middle ground,* mass by bishop for foundation of Porta San Friano with divine radiance above. *Background,* Florence with cathedral dome incomplete. Inscribed *bottom,* CIVIB[US] OPIB[US] IMPERIO FLORENT[IA] LATIORI POMOERIO CINGITUR. *left,* POST ORTUM CHRISTUM *right,* ANNO MCCLXXXIII. (For its citizens, its wealth, and its power Florence is surrounded by larger city boundaries. The year 1283 after the birth of Christ.)

4. *Florentines and Romans Commanded by Stilicho Defeat the Ostrogoths Commanded by Radagasius. Lower left* (indicating the place of battle), allegories of the River Mugnone (with urn) and Fiesole (Diana with quiver, arrows, and crescent moon). Inscribed *bottom,* FLOREN[TIA] GOTHOR[UM] IMPETU FORTISS[IME] RETUSO ROM[ANO] CONS[ULI] VICTORIAM PRAEBET. *left,* POST ORTUM CHRISTUM *right,* ANNO CCCCV. (Having beaten back most bravely the attack of the Goths, Florence provides victory for the Roman consul. The year 405 after the birth of Christ.)

5. *Union between Florence and Fiesole.* Allegories of the Florentines (mounted Roman warrior with Florentine standard and Marzocco on helmet with two pairs of men exchanging the kiss of peace) and Fiesolans (mounted Roman warrior with standard of Fiesole with Diana on helmet) flank the heads of the two governments shaking hands and holding a common standard (also held by an old Roman warrior, "a *patrino*" signifying "the cause of these two peoples" [Vasari, *Le vite*, ed. Milanesi, 8:211]) on a dais under the arch of a Florentine gate as the people of Fiesole file into Florence with their belongings. Inscribed *bottom*, FLORENTIA CRESCIT FAESULARUM RUINIS. *left*, POST PARTUM VIRGINIS *right*, ANNO MX. (Florence grows by the destruction of Fiesole. The year 1010 after the virgin birth.)

6. *Florentines Named Defenders of the Church by Pope Clement IV.* Clement IV on a dais in St. Peter's gives his standard to Count Guido Guerra [Vasari, *Le vite*, ed. Milanesi, 8:210, says incorrectly Count Guido Novello; cf. F. Schevill, *Medieval and Renaissance Florence*, 2 vols. (New York, 1961), 1:133–44] in the company of cardinals, Florentine Guelphs (one a warrior with the standard of Florence), and trumpeters. Inscribed *bottom*, FLOR[ENTINI] CIVES A CLEMENTE IIII ECCLESIAE DEFENSORES APPELLANTUR. *left*, POST PARTUM VIRGINIS *right*, ANNO MCCLXV. (Florentine citizens named defenders of the Church by Clement IV. The year 1265 after the virgin birth.)

7. *Pope Eugenius IV Seeks Refuge in Florence.* Background, Livorno; foreground, Eugenius IV, blessing and disembarking under the papal umbrella with various cardinals, is received by Florentine ambassadors kneeling in obeisance; *right foreground*, Neptune, nereid, triton blowing conch, and the Condulmero arms. Inscribed EUGENIO IIII PON[TIFICI] MAX[IMO] URBE SEDEQUE PULSO PERFUGIUM EST PARATUM. POST ORTUM CHRISTUM ANNO MCCCCXXXIII. (A refuge was prepared for Pope Eugenius IV, driven from the city [of Rome] and his see. The year 1433 after the birth of Christ.)

8. *Quarters of Santa Maria Novella and San Giovanni.* *a* Flora or Florence, *b* Marzocco flanked by putti holding Medici *palle*, *c–d* Caporioni as Roman warriors; standards of the quarters, *e* viper, *f* unicorn, *g* red lion, *h* white lion; *i* golden lion; *j* green dragon, *k* keys, *l* vair.

9. *Quarters of Santa Croce and Santo Spirito.* *a* Flora or Florence; *b* Marzocco flanked by putto holding Medici *palla*; *c–d* Caporioni as Roman warriors; standards of the quarters, *e* wheel, *f* black lion, *g* ox, *h* golden chariot; *i* flail, *j* dragon [for *i* and *j* Vasari, *Le vite*, ed. Milanesi, 8:201, gives *drago* and *sfera*], *k* conch, *l* ladder.

10. *Casentino.* Foreground, allegories of Casentino (armed youth with standard and arms of Poppi), River Arno (with urn, cornucopia, and wreath), River Archiano and Mt. Falterona (woman with tree growing from head); *background*, Poppi, Pratovecchio, Bibbiena. Inscribed *bottom*, PUPIUM CLAUSENTINI AGRI CAPUT. *right*, ANNO SSA[LUTIS] MCCCCXL. (Poppi, the capital of Casentino. Year of salvation 1440.)

11. *Mugello.* Foreground, allegories of tribunal of justice (judge reading book with putto holding fasces and arms of Scarperia), River Sieve (with urn and cornucopia), Mugello (youth with standard); *background*, Scarperia. Inscribed *bottom*, MUGELLANA PRAETURA NOBILIS. *left*, ANNO D. MCCCVI. (Noble Mugello, seat of justice. Year of Our Lord 1306.)

12. *Romagna.* Foreground, allegories of Via Flaminia (woman with standard and arms of Castrocaro), River Savio (with urn, cornucopia, and wreath), warlike spirit of

people (armed Bellona with sword and whip); *background*, Castrocaro. Inscribed *bottom*, FLAMINIA NOSTRAE DITIONIS. *right*, ANNO SALUTIS MCCCCIII. (Flaminia of our state. Year of salvation 1403.)

13. *Fiesole. Foreground*, allegories of Fiesole (Diana with standard and arms of Fiesole), River Mugnone (with urn, cornucopia, and wreath), quarries (Atlante of stone), bishopric (flying putto with crosier [and stonecutting tools]); *background*, Fiesole. Inscribed *bottom*, FAESULAE IN PARTE URBIS ADSCITAE. *left*, A CHRISTO NATO MX. (Fiesole incorporated into part of the city [of Florence]. 1010 from the birth of Christ.)

14. *San Miniato. Foreground*, allegories of tribunal of justice (judge with book, fasces, and arms of San Miniato), River Elsa (with urn and cornucopia [according to Vasari, River Pesa]), military strength? (Roman warrior with standard); *background*, San Miniato al Tedesco. Inscribed *bottom*, PRAETURA ARNENSIS INFERIOR. *right*, ANNO DOMINI MCCCLXIX. (Seat of justice for the lower Arno valley. Year of Our Lord 1369.)

15. *Pescia. Foreground*, allegories of River Nievole and silk industry (river god with urn and spider on head), River Pescia (with urn, cornucopia, and wreath), Pescia (youth in Roman dress with standard and arms of Pescia); *background*, Pescia. Inscribed *bottom*, PISCIA OPPIDUM ADEO FIDELE. *left*, ANNO D. MCCCXXXIIX. (Pescia, a very faithful town. Year of Our Lord 1338.)

16. *Pistoia. Foreground*, allegories of Alps (old man with chestnut growing from head and shield with device), River Ombrone (with urn, rudder, fruit, and wreath), mountains of Pistoia (Pan playing panpipe with standard and arms of Pistoia), bishopric (flying putto with crosier [and chestnuts]); *background*, Pistoia. Inscribed *bottom*, PISTORIUM URBS SOCIA NOBILIS. *right*, ANNO D. MCCCXXXI. (Pistoia, a noble allied city. Year of Our Lord 1331.)

17. *Prato. Foreground*, allegories of abundance (sleeping nymph with cornucopia), River Bisenzo (with urn, wreath, and putto holding cornucopia), Prato (youthful man with standard and arms of Prato); *background*, Prato. Inscribed *bottom*, PRATUM OPPI[DUM] SPECIE INSIGNE. *left*, ANNO SSA MCCCL. (Prato, a town of remarkable beauty. Year of salvation 1350.)

18. *Chianti. Foreground*, allegories of wine making (Bacchus with arms of Chianti, wreathed in grapes, holding wine cup), River Pesa (with urn, cornucopia, goat, and wreath), and River Elsa (with urn, cornucopia, goat, and wreath); *background*, Castellina, Radda, and Brolio. Inscribed *bottom*, AGER CLANTIUS ET EIUS OPPIDA. *right*, ANNO SALUTIS MCXCVII. (Chianti region with its towns. Year of salvation 1197.)

19. *Certaldo. Foreground*, allegories of beauty of countryside (nymph with a lamb and floral wreath), eloquence [as birthplace of Boccaccio] (armed Minerva with olive branch and shield with gorgon head), tribunal of justice (judge with scroll, fasces with two-headed axe, putto with arms and standard, and cornucopia at feet); *background*, Certaldo. Inscribed *bottom*, CERTALDENSIS PRAET[URA] AMOENISS[IMA]. *left*, ANNO DOMINI MCCCLXXVI. (The most lovely seat of justice, Certaldo. Year of Our Lord 1376.)

20. *Colle Val d'Elsa and San Gimignano. Foreground*, allegories of River Elsa (with urn, cornucopia, wreath, and satyr drinking wine from a cup) flanked by the founders of Colle Val d'Elsa and San Gimignano (with arms and standards of the towns, one with a wreath); *background*, Colle Val d'Elsa and San Gimignano. Inscribed

bottom, GEMINIANUM ET COLLE OPPIDA. *right*, ANNO SSA MCCCXXXVIII. (The towns of San Gimignano and Colle. Year of salvation 1338.)

21. *Volterra.* Foreground, allegories of founder of city? (old man as Tirreno, son of king of Lidia, or Tusco, son of Hercules?; see del Vita, *Lo Zibaldone*, pp. 290–91), River Cecina (with urn and cornucopia), Volterra (young man with standard and arms), commerce or eloquence? (Mercury with caduceus), bishopric (flying putto with crosier); *background*, Volterra. Inscribed *bottom*, VOLATERRAE TOSCOR[UM] URBS CELEBER[RIMA]. *left*, ANNO SALUTIS MCCLIIII. (Volterra, the highly celebrated city of Tuscany. Year of salvation 1254.)

22. *San Giovanni Valdarno.* Foreground, allegories of tribunal of justice (judge with fasces and axe), wine (Bacchus with arms of San Giovanni Valdarno, wreathed with grapes and drinking wine from a cup), agricultural produce (Vertumnus with hoe and flask; Pomona with fruit and floral wreath); *background*, San Giovanni Valdarno on the Tiber River. Inscribed *bottom*, PRAETURA ARNENSIS SUPERIOR. *right*, ANNO D. MCCXCVII. (Seat of justice for upper Arno valley. Year of Our Lord 1297.)

23. *Borgo Sansepolcro and Anghiari.* Foreground, allegories of founder of Borgo Sansepolcro (Arcadius wearing pilgrim's hat holding standard and arms of Sansepolcro), River Sovara (with cornucopia), River Tiber (with rudder, wreath, Romulus, Remus, and she-wolf), Apennines (with urn and wreath), bishopric (flying putto with crosier and branch); *background*, Borgo Sansepolcro. Inscribed *bottom*, BURGUM UMBRIAE URBS ET ANGLARI. *left*, ANNO SALUTIS MCCCCXL. (Borgo, a city of Umbria, and Anghiari. Year of salvation 1440.)

24. *Arezzo.* Foreground, allegories of Arezzo (Mars with standard and arms of Arezzo), River Castro (with urn and cornucopia), abundance (Ceres with wheat and sickle), bishopric (flying putto with crosier [and sword, signifying that Bishop Guido di Pietramala ruled the city both spiritually and temporally]); *background*, Arezzo. Inscribed *bottom*, ARRETIU[M] NOBILIS ETRURIAE URBS. *right*, ANNO SA MCCCLXXXI. (Arezzo, noble city of Etruria. Year of salvation 1381.)

25. *Cortona and Montepulciano.* Foreground, allegories of Cortona (male youth holding olive branch, and standard and arms of Cortona), River Chiana (with urn, cornucopia, and wreath), wine (Bacchus with ivy wreath holding grapes and cup), Montepulciano (male youth holding standard and arms of Montepulciano), bishopric (flying putto with crosier); *background*, Cortona. Inscribed *bottom*, CORTONA POLITIANUMQUE OPP[IDA] CLARA. *left*, ANNO SALUTIS MCCCCXII. (Cortona and Montepulciano, renowned towns. Year of salvation 1412.)

26. *Florence Declares War Against Pisa.* Antonio Giacomini addresses the *signoria* from the rostrum in the pre-Vasarian Sala Grande; *above* flies revenge (Nemesis with a flaming sword); *at lower left* mace bearer. Inscribed *bottom*, S.P.Q. [SENATUS POPULUSQUE] FLOR[ENTINUS] PISANIS REBELLIB[US] MAGNO ANIMO BELLUM INDICIT. *right*, A CHRISTO NATO MDV. (The senate and people of Florence declare war against the Pisan rebels with great spirit. 1505 from the birth of Christ.)

27. *Conquest of Vicopisano.* Foreground, River Arno (with urn, Marzocco, cornucopia, reed, and wreath); *middle ground*, siege of Florentine and Swiss troops; *background*, Vicopisano. Inscribed *bottom*, VICUM FLOR[ENTINI] MILITES IRRUMPUNT. *right*, ANNO SALUTIS MCDXCVIII. (Florentine troops storm Vicopisano. Year of salvation 1498.)

28. *Conquest of Cascina. Right foreground,* Paolo Vitelli (mounted with baton of command); *background,* Cascina. Inscribed *bottom,* CASCINA SOLIDA VI EXPUGNATUR. *right,* A PARTU VIRGINIS MCCCCIC. (Cascina is conquered by massive force. 1499 from the virgin birth.)

29. *Defeat of the Venetians in the Casentino. Foreground,* Florentines take prisoners, allegory of the Apennines (with ice and snow), retreat of the Venetians; *middle ground,* Florentines commanded by Abbot Basilio attack the Venetian column; *background,* Vernia and Montalone. Inscribed *bottom,* VENETI PISARUM DEFENSORES VICTI. *left,* ANNO A CHRISTI ORTU MCCCCXCVIII. (The Venetians, allies of Pisa, defeated. The year 1498 from Christ's birth.)

30. *Battle of Barbagiani.* French and Florentine infantry and cavalry attack the Pisan walls at Barbagiani; *background,* Pisa. Inscribed *bottom,* GALLI AUXILIARES REPELLUNTUR. *left,* HUMANAE SALUTIS ANNO MD. (French auxiliaries are repulsed. Year of human salvation 1500.)

31. *Naval Battle Between Florentines and Pisans. Foreground,* Neptune and triton (holding rudder, blowing conch); *middle ground and background,* Florentine galleys attack Pisan brigantines loaded with grain. Inscribed *bottom,* COMMEATU ET SPE EXCLUDUNTUR. *left,* POST PARTUM VIRGINIS MDIX. (They are cut off from supplies and hope. 1509 from the virgin birth.)

32. *Siege of Livorno Lifted in 1496* (fresco). Emperor Maximilian (mounted holding a baton with the chain of the Order of the Golden Fleece around his neck, and double eagle on helmet) leads the forces allied with Pisa away from Livorno; *background,* Livorno and the Genoese fleet with imperial troops being lost in a storm. [Temporary painting of 1565: Pisa?]

33. *Battle of Stampace in 1499* (fresco). *Left foreground,* Paolo Vitelli (mounted, holding baton of command with his coat of arms on chest); *background,* Pisa with breached bastion of Stampace, and dirt counterbastion inside walls. [Temporary paintings of 1565: Prato and Fiesole?]

34. *Florentine Defeat of the Pisans at Torre di San Vincenzo in 1505* (fresco). [Temporary paintings of 1565: Volterra and Pistoia?]

35. *Triumphal Entry into Florence after the Conquest of Pisa. Foreground,* Flora or Florence (with mural crown holding flowers seated on a quadriga filled with trophies and flanked by prisoners) and the River Arno (with urn and cornucopia); *middle ground,* winged Victory (standing on a pedestal blowing two trumpets) and a triumphal arch; *background,* Florence. Inscribed *bottom,* LAETA TANDEM VICTORIA VENIT. *left,* ANNO DOMINI *right,* ANNO MDVIIII. (Joyful victory comes at last. Year of our Lord, the year 1509.)

36. *Cosimo I Plans the War of Siena.* Cosimo I (dressed in ermine-lined coat with armor at his feet, wearing chain of the Order of the Golden Fleece, seated on chair with a putto holding a *palla,* before a desk with model of Siena and inkwell with quill pen, holding architect's compass and square, looking at architectural plan of walls and bastions of Siena, just under which is a Capricorn with festoons; *above door,* a niche with bust of Cosimo in Hadrianic style; *above niche,* two winged putti with ducal crown and *palla*); *surrounding Cosimo,* Patience (female with urn), Vigilance (female holding burning lamp), Prudence (female holding mirror), Fortitude (female with column), Silence (male with finger to lips), and two winged

putti (holding laurel crown of victory, and olive branch and palm of peace and immortality). Inscribed *bottom*, BELLUM COGITANTES PRAEVENIT. *left*, AB HUMANI GENERIS SALUTE MDLIII. (He anticipates those who are planning war. From the renewal of human life 1553.)

37. *Conquest of Monastero.* Inscribed *bottom*, PRAELIUM ACRE AD MONASTERIUM. *left*, AB HUMANI GENERIS SALUTE MDLIII. (The fierce battle at Monastero. From the renewal of human life 1553.)

38. *Conquest of Casole. Foreground*, fully armed soldier, soldier emerging from tent; *middle ground*, Giangiacomo de' Medici, marchese di Marignano, mounted with baton of command, holding a *parlemento* with troops; *background*, siege of Casole. Inscribed *bottom*, CASULI OPPIDI EXPUGNATIO. *left*, POST PARTUM VIRGINIS MDLIIII. (Storming of the town of Casole. 1554 from the virgin birth.)

39. *Battle at Marciano in the Val di Chiana. Foreground*, Chiana River (and marshes, with cornucopia and cattails); *left*, forces of French and Florentine exiles commanded by Piero Strozzi near Marciano; *right*, forces of Cosimo I commanded by Giangiacomo de' Medici, marchese di Marignano. Inscribed *bottom*, GALLI REBEL-LESQUE PROELIO CEDUNT. *right*, POST PARTUM VIRGINIS MDLIIII. (The French and exiles yield in battle. 1554 after the virgin birth.)

40. *Conquest of Monteriggioni.* Inscribed *bottom*, MONS REGIONIS EXPUGNATUR. *right*, POST PARTUM VIRGINIS MDLIIII. (Monteriggioni is conquered. 1554 after the virgin birth.)

41. *Turks Routed at Piombino. Foreground*, Tyrrhenian Sea (holding conch and coral). Inscribed *bottom*, PUBLICI HOSTES TERRA ARCENTUR. *right*, POST PARTUM VIRGINIS MDLV. (The enemies of the state are repelled from the land. 1555 after the virgin birth.)

42. *Conquest of the Fortress near Porta Camollia in 1554* (fresco). *Foreground*, Giangiacomo de' Medici, marchese di Marignano (mounted, holding baton of command). [Temporary paintings of 1565: Borgo Sansepolcro and Arezzo?]

43. *Battle at Scannagallo in the Val di Chiana in 1554* (fresco). *Left*, forces of Sienese, French, and Florentine exiles commanded by Piero Strozzi; *right*, imperial and Florentine forces of Cosimo I commanded by Giangiacomo de' Medici, marchese di Marignano. [Temporary paintings of 1565: Montepulciano and Cortona?]

44. *Conquest of Porto Ercole in 1555* (fresco). *Right*, Giangiacomo de' Medici, marchese di Marignano, with baton of command. [Temporary painting of 1565: Siena?]

45. *Triumphal Entry into Florence after the Conquest of Siena. Foreground*, Giangiacomo de' Medici, marchese di Marignano, with Chiappino Vitelli and Federico da Montaguto; *lower right*, Vincenzo Borghini and Giambattista Adriani flanking Giorgio Vasari with *from left to right* Giovanni Stradano, Jacopo Zucchi, and Battista Naldini. Inscribed *bottom*, EXITUS VICTIS VICTORIBUSQUE FELIX. *left*, POST PARTUM VIRGINIS *right*, ANNO MDLV. (A happy ending for the conquered and for the victorious. 1555 after the virgin birth.)

46. Six Putti with Inscription. Inscribed MDLXV. HAS AEDES ATQUE AULUM HANC TECTO ELATIORI, ADITU, LUMINIBUS, SCALIS, PICTURIS, ORNATUQUE AUGUSTIORI IN AMPLIO-REM FORMAM DECORATAM DEDIT, COSMUS MEDICES ILLUSTRISSIMUS FLORENT[IAE] ET SENEN. DUX, EX DESCRIPTIONE ATQUE ARTIFICIO GEORGII VASARII ARRET[INI] PIC-TORIS ATQUE ARCHITECTI ALUMNI SUI. (In 1565 Cosimo de' Medici, the most il-

lustrious duke of Florence and Siena, dedicated this building and this hall with its higher ceiling, entrance, windows, stairs, paintings, and more majestic ornamentation decorated in a more lavish way according to the program and art of Giorgio Vasari of Arezzo, painter and architect, his [Cosimo's] pupil.)

47. Portraits of Bernardo di Mona Mattea (mason), Battista Botticelli (carpenter), Stefano Veltroni (gilder), and Marco da Faenza (grotesque painter).

48. Seven Putti with a Mask and Two Stick Horses (?) Inflating a *pala.*

49. *Pope Boniface VIII Enthroned and Surrounded by Cardinals Paid Homage in 1295 by Twelve Ambassadors—All Florentines—Representing the Major European and Asian Powers.* (Jacopo and Francesco Ligozzi, 1590–92 [in time for the baptism of Cosimo II], oil on slate.) *Background,* a *quadro riportato* representing allegories of Florence flanked by Asia, Europe, Africa, and America. Inscribed *top,* BONIFACIUS VIII P.M. [PONTIFEX MAXIMUS] CUM XII PRINCIPES XII FLORENTINOS SIBI LEGASSENT FLORENTIAM QUINTUM ELEMENTUM APPELLAVIT. (Pope Boniface VIII, when twelve princes appointed twelve Florentines as ambassadors to himself, called Florence the fifth element.) [Temporary 1565 painting, *Cosimo I Drains the Pisan Swamps.*]

50. *Cosimo I Enthroned under a Baldachin Paid Homage by the Florentine Senators after His Creation as Duke in 1537.* (Domenico Passignano, 1597–ca. 1600 [in time for the marriage of Maria de' Medici to Henry IV of France in 1600?], oil on slate.) *Left foreground,* Flora or Florence? (holding ducal crown and shield) and River Arno (with Marzocco); *background,* Florentine cathedral seen through arch with Medici arms. Inscribed *top,* FLORENTINUS SENATUS CIVITATIS PRINCIPEM POST ALEXANDRUM PARI IURE AC POTESTATE CONFIRMAT. (After [the assassination of Duke] Alessandro, the Senate of Florence confirms the city's duke with equal jurisdiction and power.) [Temporary 1565 painting, *French Return the Keys to Livorno.*]

51. *Cosimo I Created Grand Master of the Order of St. Stephen in Pisa by the Ambassador of Pope Pius IV in 1562.* (Domenico Passignano, 1597–ca. 1600 [in time for the marriage of Maria de' Medici to Henry IV of France in 1600?], oil on slate.) *Right foreground,* Pisa (soldier with Pisan standard), River Arno, and an unidentified water deity (Tyrrhenian Sea?). Inscribed *top,* PIUS IV PONT[IFEX] MAX[IMUS] PER NUNTIUM APOSTOLICUM EQUESTRIS ORDINIS SANCTI STEPHANI MAGISTERIUM DEFERT. (Through his papal ambassador Pope Pius IV confers the grandmastership of the Order of the Knights of St. Stephen.) [Temporary 1565 painting, *Cosimo I Builds Cosmopoli on Elba.*]

52. *Cosimo I Dressed in Ermine Robes Crowned Grand Duke of Tuscany by Pope Pius V in 1570.* (Jacopo and Francesco Ligozzi, dated 1591 [in time for the baptism of Cosimo II], oil on slate.) *Foreground on left,* Prudence (holding mirror), Justice (holding scales and sword), River Tiber (with urn, cornucopia, Romulus, Remus, she-wolf); *on right,* Peace (with olive wreath, holding olive branch), Faith (with scriptures and white dove), River Arno (wreathed with an urn, rudder, cornucopia filled with flowers, and Marzocco); *background* inscribed with Ghislieri arms. Inscribed top, PIUS V PONT[IFEX] MAX[IMUS] OB EXIMIAM DILECTIONEM AC CATH[OLICAE] RELIG[IONIS] ZELUM PRECIPUUMQ[UE] IUSTITIAE STUDIUM DONAVIT. (Pope Pius V gave [the grand ducal title] in consideration of his [Cosimo's] exceptional love and zeal for the Catholic religion and outstanding devotion to justice.) [Temporary 1565 painting, *Cosimo I Fortifies Tuscany.*]

53. *Cosimo I, Second Duke of Florence.* (Baccio Bandinelli, head completed by Vincenzo de' Rossi?, marble.) Standing in ancient Roman military dress holding baton (now broken).

54. *Giovanni delle Bande Nere.* (Baccio Bandinelli, marble.) Standing in ancient Roman military dress holding baton.

55. *Pope Leo X.* (Baccio Bandinelli, completed by Vincenzo de' Rossi, marble.) Seated in full pontificals, crowned with the tiara, holding two keys in left hand and blessing with right. Installed by 1565, but *Pope Clement VII Crowning Charles V* originally intended for this niche.

56. *Alessandro de' Medici, First Duke of Florence.* (Baccio Bandinelli, marble.) Standing in ancient Roman military dress holding scroll or (broken) baton.

57. *Pope Clement VII.* (Baccio Bandinelli, marble.) Seated in full pontificals, crowned with the tiara, holding the imperial crown.

58. *Emperor Charles V.* (Giovanni Caccini, marble.) Kneeling before Pope Clement VII to receive imperial crown. Clay version of 1592 for baptism of Cosimo II replaced by marble version in 1594.

59. *Francesco I, Third Duke of Florence.* (Giovanni Caccini, marble.) Standing in ancient Roman military dress holding baton and *mappa* with dolphin under left foot. Clay version of 1592 for baptism of Cosimo II replaced by marble version in 1594.

60. Rain Fountain. (Bartolomeo Ammannati, marble, 1555–63, now in the Bargello.) *Center,* Juno [signifying Air] (seated on clouds and rainbow holding tambourine [signifying thunder] and unidentified object broken off [thunderbolt or scepter?] flanked by two peacocks) and Ceres [signifying Earth] (nude holding breasts from which water originally spouted); *left,* River Arno (nude male with urn, festoon, two cornucopias, and the Marzocco with *palla* and book); *right,* Hippocrene spring of Mt. Parnassus (nude female with urn and ivy across chest holding cornucopia and laurel wreath with Pegasus).

61. *Prudence.* (Bartolomeo Ammannati, marble, 1555–63, now in the Bargello.) Apollonian nude male holding anchor with dolphin and unidentified object broken off [baton or scroll?].

62. *Flora or Florence.* (Bartolomeo Ammannati, marble, 1555–63, now in the Bargello.) Diana-like draped female with chain of the Order of the Golden Fleece across chest, holding arrows and flowers.

63. *Victory.* (Michelangelo, marble, early 1530s.) Originally for the Julius Tomb, donated to Cosimo I by Leonardo Buonarroti after Michelangelo's death in 1564, moved to the Sala Grande in 1565 to signify victory over Siena.

64. *Flora or Florence Victorious over Pisa.* (Giambologna, clay, 1565.) Nude female oppresses nude male who has wolf between legs; marble version (early 1570s, now in the Bargello) replaced clay version in 1589 for marriage of Ferdinando I to Cristina of Lorraine; clay version reinstalled in 1980.

65. *Cosimo I as Augustus.* (Vincenzo de' Rossi, marble, 1562–72, in the Bargello since 1868.) Holds fasces and shield with Capricorn and corona borealis. Originally for the triumphal arch of the Uffizi; probably moved to the Sala Grande in 1592 for the baptism of Cosimo II.

66. *Hercules and Cacus.* (Vincenzo de' Rosssi, marble, 1562–87.) Originally for a fountain with the twelve labors of Hercules. Placed in the Sala Grande in 1592 for the baptism of Cosimo II.

67. *Hercules and the Centaur.* See no. 66 *above.*

68. *Hercules and Antaeus.* See no. 66 *above.*

69. *Giovanni delle Bande Nere.* (Baccio Bandinelli, marble, 1540–ca. 1555, now in Piazza San Lorenzo.) Seated holding broken lance. Originally for the tomb of Giovanni delle Bande Nere in San Lorenzo; probably transferred to the Sala Grande in 1592 for the baptism of Cosimo II; placed on base in Piazza San Lorenzo in 1850.

70. *Hercules and Queen Hippolyta.* See no. 66 *above.*

71. *Hercules and the Erymanthian Boar.* See no. 66 *above.*

72. *Hercules and King Diomedes.* See no. 66 *above.*

A Medici coat of arms of Cosimo I with ducal crown and chain of the Order of the Golden Fleece (wood); *B* Medici coat of arms of Cosimo I with ducal crown, cross of the Order of St. Stephen, and chain of the Order of the Golden Fleece (wood); *C* Capricorn device of Cosimo I (wood); *D* turtle and sail device of Cosimo I (motto FESTINA LENTE [Make haste slowly] not included; wood); *E* turtle and sail device of Cosimo I (motto FESTINA LENTE not included; stucco); *F* Medici coat of arms of Cosimo I with chain of the Order of the Golden Fleece flanked by two kraters, and surrounded by five festoons; *G* three interlocked rings, device of Cosimo il Vecchio; *H* thunderbolt device of Giovanni delle Bande Nere; *I* Medici coat of arms with papal tiara; *J* yoke device of Leo X inscribed ENIM SUAVE [from *Iugum enim meum suave est*: For my yoke is sweet (Matthew 11:30)]—near the two devices are four putti with *palle*, two winged putti each riding a winged lion, four winged goat-footed satyrs blowing trumpets, four winged sphinxes, and fourteen festoons; *K* winged Victory with laurel crown; *L* rhinoceros device of Alessandro de' Medici (motto NON BUELVO SIN VENCER [No beast without conquering] not included); *M* Peace with olive branch and torch over arms; *N* Victory with laurel crown and laurel branch; *O* weasel device of Francesco de' Medici inscribed AMAT VICTORIA CURAM [Victory loves diligence]; *P* twelve winged putti with two festoons, a monkey, and an ape; *Q* eight winged putti with two festoons, five *palle*, and a crown; *R* four winged putti with a festoon; *S* five winged putti with two festoons and two herms; *T* two winged putti with a festoon; *U* seven winged putti (central one with a sail and turtle of Cosimo I's device) with two festoons; *V* sixteen winged putti (one playing with an eagle) with three festoons. *a* door to Studiolo of Francesco I; *b* main entrance to Sala Grande; *c* door to vestibule and Sala dei Dugento; *d* door to *Depositeria; e* door to Quartiere di Leone X.

NOTE: The ceiling is diagramed as if reflected on the floor, or as if seen from above. The letters within scenes, however, correspond to elements as they would appear when seen from below. Therefore, the relation of the quarters of Florence to the towns under their jurisdiction will appear incorrect unless the roundels are reflected (reversed) in the mind's eye.

The orientation of the numbers corresponds to the orientation of the scenes within the room. The numbers are given different sizes according to the following

code: *1* and *49–52*, those scenes of 1565 on the ceiling and walls representing Cosimo that focused and embraced the whole decorative ensemble; *2–9*, the scenes of the history and quarters of Florence along the central axis of the ceiling; *10–25*, the scenes along the transverse axes at either end of the ceiling representing the expansion of the Florentine empire throughout Tuscany from 1010 to 1490 [included here are *46–48* for convenience but without any coded significance]; *26–45*, the scenes of the Pisan and Sienese wars on the ceiling and walls, the Pisan war (*26–35*) being distinguished from the Sienese (*36–45*) by the different directions of the cross-hatching; *53–64*, the marble [in one case, clay] sculpture planned and mostly executed by 1565; and *65–72* the marble sculpture not planned in 1565 and probably added in 1592.

Unless indicated otherwise, all elements are by Vasari and his workshop (1563–65 for ceiling and temporary paintings, 1566–71 for wall frescoes), and the descriptions of elements within scenes are always from left to right. Unless the medium is given, all paintings are oil on panel, except temporary paintings, which were oil on canvas. Baccio Bandinelli and workshop executed the dais from ca. 1543 to Bandinelli's death in 1560; except for Caccini's two sculptures, it was completed by Vasari and workshop in 1565, including the reliefs, which are all in stucco. For a complete list of known artists and artisans who worked in the Sala Grande see note 259 below.

The inscriptions are all transcribed as they now appear in the room, but comparison with old photographs shows that several changes were made in the course of the recent restoration. When abbreviation marks are present in the inscriptions themselves, words have been silently expanded; otherwise the expansions have been put within brackets.

NOTES

INTRODUCTION

1. For the word *palatium*, see Brigitta Tamm, *Auditorium and Palatium: A Study on Assembly-Rooms in Roman Palaces during the 1st Century B.C. and the 1st Century A.D.* [Acta Universitatis Stockholmiensis, Stockholm Studies in Classical Archaeology, 2] (Stockholm, 1963), pp. 57–59; Brigitta Tamm, "Aula regia, αὐλη and aula," *Stockholm Studies in Classical Archaeology 5, Opuscula* (1968): 135–242, esp. 238; and Christoph Liutpold Frommel, *Der römische Palastbau der Hochrenaissance*, 3 vols. (Tübingen, 1973), 1:1–2. Tamm, "Aula regia," notes that *aula* first referred to a temple of the gods, then to a courtyard surrounded by walls (it is in this sense that Vitruvius calls the backdrop wall of a theater the *aula regia*), and finally to a palace facade or the entire palace. In his poem *Silvae* of A.D. 93–94, where he refers specifically to Domitian's Palatine residence, Statius seems to be the first to use *aula* in the sense of a room inside a palace; see *Silvae* 4.2, ed. J. H. Mozley, Loeb Classical Library (London and New York, 1927), pp. 210–13, and next note. Initially the term seems to have been associated with the dining room or *triclinium* and then applied to any large interior space.

The dimensions of Domitian's *aula regia*, *basilica*, and *triclinium* were respectively 31.44 × 32.10, 29.05 × 31.64, and 20.19 × 30.30 meters. The ceremony of *salutatio* in the *aula regia* was the emperor's formal audience for his subjects, normally only those who were counted as friends. In a *consilium* in the *basilica* the emperor met with his advisers and magistrates to debate domestic and foreign policy, receive and dispatch ambassadors, and conduct trials and render judgments. The *triclinium* was used for the *convivium* or state banquet. See William L. MacDonald, *The Architecture of the Roman Empire* (New Haven and London, 1965; revised edition 1982), 1:47–74; and Tamm, *Auditorium and Palatium*, pp. 91–216.

2. Martial, *Epigrams* 8.36, ed. Walter C. A. Ker (Loeb Classical Library: Cambridge, Mass., and London, 1978–79), 2 vols., 2:26–29: "Nothing more magnificent has seen the light of day. One would think that the seven hills rose up, one on top of the other. Ossa with Thessalian Pelion atop was not so high. It pierces heaven, and hidden amid the lustrous stars its sunlit peak echoes to the thunder in the cloud below. . . . This house, Augustus, which reaches the stars with its summit is level with heaven, and yet is less than its lord." See also *Epigrams* 7.56, ibid., 1:262–63. Pliny's description appears in *Panegyricus* 48.3, ed. Betty Radice, Loeb Classical Library (Cambridge, Mass. and London, 1969), pp. 428–31.

Statius (*Silvae* 4.2), describing a banquet with "a thousand tables," was especially impressed by "the vast expanse of the building, and the reach of the far-flung hall, more unhampered than a plain, embracing beneath its shelter a vast expanse of air." Covering the enormous space, the ceiling was so high that "the tired vision scarcely

reaches the summit," like "the golden ceiling of the sky." The splendid patterned and colored marble revetment he saw as a contest between "Libyan mountain and gleaming Illian stone . . . , and much Syenite and Chian and the marble that vies with the gray-green sea; and Luna also, but only for the columns' weight." The vigorous articulation of the walls made the "august, huge edifice magnificent not with a hundred columns but rather enough to support heaven and the gods were Atlas eased of his burden." Although equal to the neighboring Capitoline temple of Jupiter Optimus Maximus, who "views it with awe" and rejoices that the emperor has a "like abode," the majestic hall was still "lesser than its lord" who "fills the house, and gladdens it with his mighty spirit."

3. For late antique and early medieval rooms of state, see Bryan Ward-Perkins, *From Classical Antiquity to the Middle Ages: Urban Public Building in Northern and Central Italy A.D. 300–850* (Oxford, 1984); Géza de Francovich, *Il Palatium di Teodorico a Ravenna e la cosidetta "architettura di potenza"* [Quaderni di Commentari, 1] (Rome, 1970); Karl M. Swoboda, "The Problem of the Iconography of Late Antique and Early Medieval Palaces," *Journal of the Society of Architectural Historians* 20 (1961): 78–89; Irving Lavin, "The House of the Lord, Aspects of the Role of Palace Triclinia in the Architecture of Late Antiquity and the Early Middle Ages," *Art Bulletin* 44 (1962): 1–27; and Fikret K. Yegül, "A Study in Architectural Iconography: *Kaisersaal* and the Imperial Cult," *Art Bulletin* 64 (1982): 7–31.

4. The Triconchos may have been built by Constantine and then restored by Theophilus (829–842), but examples of three-apsed dining and reception halls survive in the West only until the fifth century (e.g., at Piazza Armerina): Lavin, "The House of the Lord"; Paolo Verzone, "La distruzione dei palazzi imperiali di Roma e di Ravenna e la ristrutturazione del Palazzo Lateranese nel IX secolo nei rapporti con quello di Constantinopoli," *Roma e l'età carolingia* [Atti delle giornate di studio 3–8 maggio 1976, Istituto di Storia dell'Arte dell'Università di Roma, Istituto Nazionale di Archeologia e Storia dell'Arte] (Rome, 1976), pp. 39–54.

The Hall of Nineteen Divans seems to have been built by Emperor Justinian (483–565); in the Byzantine ceremonial book it was said to be "larger than all other *triclinia*." Its dimensions were ca. 12 × 58 meters compared to Leo's eleven-apsed *triclinium* of ca. 15 × 68 m. Leo's smaller hall (ca. 12 × 26 m) was in use by 799, the larger one after 800. Early descriptions of the halls are in Verzone, "La distruzione dei palazzi imperiali," p. 53 nn. 64, 74, and 76; Caecilia Davis-Weyer, *Early Medieval Art 300–1150, Sources and Documents* (Englewood Cliffs, N.J., 1971), pp. 88–92; G. Rohault de Fleury, *Le Latran au Moyen Age,* 2 vols. (Paris 1877); and Philippe Lauer, *Le Palais de Latran,* 2 vols. (Paris, 1911), 2:483–84.

It would seem that the destruction or abandonment between 745 and 774 of Domitian's palace, as well as the imperial scale, form, and function of Leo's halls encouraged the designation of the Lateran by the ninth century as (*sacrum*) *palatium,* or New Palatine, rather than *patriarchium;* similarly, in the Donation of Constantine, probably faked in Leo III's reign, the Lateran was said to "surpass and take precedence over all other palaces in the world": Verzone, "La distruzione dei palazzi imperiali," and Lavin, "The House of the Lord."

For a critical discussion of the decorative programs of the halls of Leo III, see Hans Belting, "I mosaici dell'aula leonina come testimonianza della prima 'renovatio' nell'arte medioevale di Rome," *Roma e l'età carolingia,* pp. 167–82; Hans Belting, "Die beiden Palastaulen Leos III. im Lateran und die Entstehung einer päpstlichen Programmkunst," *Frühmittelalterliche Studien* [Jahrbuch des Instituts für Frühmittelalterforschung der Universität Münster] 12 (1978): 55–83; Christopher Walter, "Papal Political Imagery in the Medieval Lateran Palace," *Cahiers archéologiques fin de l'antiquité et*

moyen-âge 20 and 21 (1970 and 1971): 155–76, 109–36; and G. Ladner, "I mosaici e gli affreschi ecclesiastico-politici nell'antico Palazzo Lateranese," *Rivista di archeologia christiana* 12 (1935): 265–92.

Although elsewhere in the two halls of Leo III the narrative decoration was in fresco, the main apse of each was in mosaic—a revival of a Byzantine and Early Christian medium that seems to have been imitated only by the Normans in Sicily: Otto Demus, *The Mosaics of Norman Sicily* (London, 1949); Eve Borsook, *Messages in Mosaic, The Royal Programmes of Norman Sicily, 1130–1187* (Oxford and New York, 1990).

5. See Lavin, "The House of the Lord," p. 14 n. 103, for the hall at Aachen as the "Lateran." For a description of the hall (ca. 20 × 47 m) see H. M. Smyser, ed., *The Pseudo-Turpin* (Cambridge, Mass., 1937), pp. 46–47, 92–94; and Ernest Duemmler, ed., *Hibernici exulis carmina*, "Epitaphium Karoli Imperatoris," and *Theodulfi carmina*, "De septem liberalibus artibus in quandam pictura depictis," in *Monumenta Germaniae Historica, Poetae Latini Aevi Carolini* (Berlin, 1881), 1:407–11 and 544–49; see also Heinrich Fichtenau, "Byzanz und die Pfalz zu Aachen," *Mitteilungen des Instituts für Österreichische Geschichtsforschung* 59 (1951): 1–54; and Leo Hugot, "Die Pfalz Karls des Grossen in Aachen," *Karl der Grosse*, vol. 3. of *Karolingische Kunst*, ed. Wolfgang Braunfels and H. Schnitzler (Aachen, 1965), 3:534–72.

For Charlemagne's hall at Lorsch (760–777/90) see Mario D'Onofrio, "La Königshalle di Lorsch presso Worms," in *Roma e l'età carolingia*, pp. 129–30. For Ermoldus Nigellus's 825–826 description of the hall at Ingelheim, based in part on the basilica at Trier (begun perhaps in 787, finished around 807; ca. 16 × 35 m), see Davis-Weyer, *Early Medieval Art*, pp. 84–88; see also Walter Sage, "Die Ausgrabungen in der Pfalz zu Ingelheim am Rhein 1960–1970," *Francia* 4 (1976): 141–60; and Walter Lammers, "Ein karolingisches Bildprogram in der Aula Regia von Ingelheim," *Festschrift für Hermann Heimpel* (Göttingen, 1972), 3:226–89. All of Charlemagne's decorative projects were executed in fresco.

6. The literature on medieval halls and their decoration is extensive, but especially useful are H. M. Colvin, *The History of the King's Works*, vols. 1 and 2, *The Middle Ages* (London, 1963); Mark Girouard, *Life in the English Country House, A Social and Architectural History* (New Haven and London, 1978); E. W. Tristram, *English Medieval Wall Painting*, 3 vols. (Oxford, 1944 and 1950); Tancred Borenius, "The Cycle of Images in the Palaces and Castles of Henry III," *Journal of the Warburg and Courtauld Institutes* 6 (1943): 40–50; D. J. A. Ross, "A Lost Painting in Henry III's Palace at Westminster," *Journal of the Warburg and Courtauld Institutes* 6 (1943): 160; E. Clive Rouse and Audrey Baker, "The Wall-Paintings at Longthrope Tower near Peterborough, Northants," *Archaeologia* 96 (1955): 1–57; Urban T. Holmes, Jr., "Houses of the Bayeux Tapestry," *Speculum* 34 (1959): 179–83; Phyllis Abrahams, ed., *Les œuvres poétiques de Baudri de Bourgueil (1046–1130)* (Paris, 1926), esp. pp. 196–253; Paul Deschamps and Marc Thibout, *La peinture murale en France au début de l'époque gothique de Philippe Auguste à la fin du règne de Charles V (1180–1380)* (Paris, 1963); Paul Deschamps, "Les peintures murales de la Tour Ferrande à Pernes," *Congrès Archéologique de France* 121 (1963): 337–47; Nikolaus Gussone, "Zur Problematik zeitgenössischer Darstellungen mittelalterlicher Pfalzen," *Francia* 4 (1976): 107–19; Gottfried Schlag, *Die deutschen Kaiserpfalzen* (Frankfurt am Main, 1940); Walter Hotz, *Kaiserpfalzen und Ritterburgen in Franken und Thüringen* (Berlin, 1940); *Deutsche Königspfalzen, Beiträge zu ihrer historischen und archaeologischen Erforschung* [Veröffentlichungen des Max-Planck-Instituts für Geschichte, 11/1–3], 3 vols. (Göttingen, 1963, 1965, and 1979); Heinrich Mayer, *Bamberger Residenzen* (Munich, 1951); Leopold Auer, "Die baierischen Pfalzen in ottonisch-frühsalischer Zeit," *Francia* 4 (1976): 173–91; Carlrichard Brühl, "Königspfalz und Bischofsstadt in fränkischer Zeit," *Rheinische Vierteljahrsblätter* 23 (1958): 161–274; Pierre Riché, "Les repré-

sentations du palais dans les textes littéraires du haut moyen âge," *Francia* 4 (1976): 161–71; P. A. Faulkner, "Some Medieval Archiepiscopal Palaces," *Archeological Journal* 127 (1970): 130–46; Pierre Héliot, "Nouvelles remarques sur les palais épiscopaux et princiers de l'époque romane en France," *Francia* 4 (1976): 193–212; Roger Sherman and L. H. Loomis, *Arthurian Legends in Medieval Art* (London and New York, 1938); and Oswald Raimund Trapp, *Tiroler Burgenbuch*, vol. 5, *Sarnatal* (Vienna, 1981), 5:109–76.

7. W. R. Lethaby, "The Palace of Westminster in the Eleventh and Twelfth Centuries," *Archaeologia* 60 (1906): 131–48.

8. For the *camera regis* see Paul Binski, *The Painted Chamber at Westminster* [The Society of Antiquaries of London, Occasional Paper (n.s.), IX] (London, 1986); and J. E. A. Jolliffe, "The Camera Regis under Henry II," *English Historical Review* 68 (1953): 1–21 and 337–62.

For an excellent discussion of the fully evolved sequence of state rooms in the sixteenth and seventeenth centuries, including court ritual, see Hugh Murray Baillie, "Etiquette and the Planning of the State Apartments in Baroque Palaces," *Archaeologia* 101 (1967): 169–99.

9. For the papal palace in the Vatican before Avignon, see D. Redig de Campos, "Les constructions d'Innocent III et de Nicolas III sur la colline Vaticane," *Mélanges d'archéologie et d'histoire* 71 (1959): 359–76; and F. Ehrle and H. Egger, *Der vaticanische Palast in seiner Entwicklung bis zur Mitte des XV. Jahrhunderts* [Studi e Documenti per la storia del Palazzo Apostolico Vaticano, 2] (Vatican, 1935). For the papal palace at Viterbo, which anticipated some aspects of the plan of Nicholas III, see Gary M. Radke, *The Papal Palace in Viterbo* (New York, 1980). For the papal palace at Avignon see L. H. Labrande, *Le Palais des Papes et les monuments d'Avignon au XIVe siècle*, 2 vols. (Marseilles, 1925); Sylvain Gagnière, *Der Papastpalast von Avignon* (Nancy, 1975); and Enrico Castelnuovo, *Un pittore italiano alla corte di Avignone, Matteo Giovannetti e la pittura in Provenza nel secolo XIV* (Turin, 1962), pp. 22–46 and 110–20. The following works discuss the papal palace in the Vatican after Avignon: Carroll William Westfall, "Alberti and the Vatican Palace Type," *Journal of the Society of Architectural Historians* 33 (1974): 101–21; John Shearman, "The Vatican Stanze: Function and Decoration," *Proceedings of the British Academy* 57 (1971): 369–89; Ursula Paal, *Studien zum Appartamento Borgia im Vatikan* (Tübingen, 1981); and Christoph Liutpold Frommel, "Il Palazzo Vaticano sotto Giulio II e Leone X. Strutture e funzione," in *Raffaello in Vaticano* (Rome, 1984), pp. 118–35.

The plan of the papal palace built by Paul II (1464–71) in the center of Rome—the Palazzo Venezia—was itself a refined and regularized version of the plan of the Vatican papal palace: Christoph Liutpold Frommel, "Francesco del Borgo: Architekt Pius' II. und Paul II. II. Palazzo Venezia, Palazzetto Venezia und San Marco," *Römisches Jahrbuch für Kunstgeschichte* 21 (1984): 71–164.

10. Jacob Burckhardt, *The Civilization of the Renaissance in Italy*, trans. S. G. C. Middlemore (Vienna and New York, n.d.), p. 2.

11. Jacob Burckhardt, *Force and Freedom: Reflections on History*, ed. James Hastings Nichols (Boston, 1964), p. 7.

12. For communal palaces see Hélène Wieruszowski, "Art and the Commune in the Time of Dante," in her *Politics and Culture in Medieval Spain and Italy* (Rome, 1971), pp. 465–502; C. R. Brühl, "Il 'palazzo' nelle città italiane," in *La coscienza cittadina nei comuni italiani del Duecento* [Centro di Studi sulla Spiritualità Medioevale, Convegni, XI] (Todi, 1972), pp. 265–69; Jürgen Paul, *Die mittelalterlichen Kommunalpaläste in Italien* (Dresden, 1963); Jürgen Paul, *Der Palazzo Vecchio in Florenz, Ursprung und Bedeutung seiner Form* (Florence, 1969); Juergen Schulz, "The Communal Buildings of Parma," *Mitteilungen des Kunsthistorischen Institutes in Florenz* 26 (1982): 279–324; Marvin Trach-

tenberg, "Archaeology, Merriment, and Murder: The First Cortile of the Palazzo Vecchio and Its Transformations in the Late Florentine Republic," *Art Bulletin* 71 (1989): 565–609; and N. Rodolico and G. Marchini, *I palazzi del popolo nei comuni toscani del medioevo* (Milan and Florence, 1962).

13. Fragmentary examples of thirteenth-century decorations remain in Novara, Brescia, and Mantua, for which see Gaetano Panazza, "Affreschi medioevali nel Broletto di Brescia," *Commentari dell'Ateneo di Brescia* 145–46 (1946–47): 79–104; and *Mantova: le arti,* vol. 1, ed. Giovanni Paccagnini (Mantua, 1960), 1:253–57. The best preserved example of this type of decoration (ca. 1291–1317; restored 1467) is in San Gimignano: Giovanni Cecchini and Enzo Carli, *San Gimignano* (Milan, 1962); and Leone Chellini, "Le iscrizioni del territorio Sangimignanese, III. Iscrizioni del Palazzo Comunale," *Miscellanea storica della Valdelsa* 37 (1929): 57–84.

14. See, for example, Wolfgang Braunfels, *Urban Design in Western Europe: Regime and Architecture, 900–1900* (Chicago, 1988); Marcello Fagiolo, ed., *La città effimera e l'universo artificiale del giardino* (Rome, 1980); Maurizio Fagiolo Dell'Arco and Silvia Carandini, *L'effimero barocco: strutture della festa nella Roma del '600,* 2 vols. (Rome, 1978); Richard Krautheimer, *The Rome of Alexander VII, 1655–1667* (Princeton, 1985); Anne-Marie Lecoq, "La 'Città festeggiante': Les fêtes publiques au XVe et XVIe siècles," *Revue de l'art* 33 (1976): 83–100; and Henry A. Millon and Linda Nochlin, eds., *Art and Architecture in the Service of Politics* (Cambridge, Mass., and London, 1980).

15. Michel Foucault, *Power/Knowledge: Selected Interviews and Other Writings, 1972–1977,* ed. Colin Gordon (New York, 1980), p. 158; for the argument that this position impoverishes in turn the question of the state, cf. Sheldon S. Wolin, "On the Theory and Practice of Power," in *After Foucault: Humanistic Knowledge, Postmodern Challenges,* ed. Jonathan Arac (New Brunswick and London, 1988), pp. 179–201.

16. For powerful and influential accounts of the issues and the alternatives, cf. Michel Foucault, *The Order of Things: An Archeology of the Human Sciences* (New York, 1970), pp. 17–25; and Jacques Derrida, "Restitutions of the Truth in Pointing [*pointure*]," in *The Truth in Painting,* trans. Geoff Bennington and Ian McLeod (Chicago and London, 1987), pp. 257–382.

17. On the paradigmatic claims of art history see, e.g., Michael Podro, *Critical Historians of Art* (New Haven and London, 1982); Norman Bryson, *Vision and Painting: The Logic of the Gaze* (New Haven and London, 1983), pp. 13–35; Michael Baxandall, "Art, Society and the Bouguer Principle," *Representations* 12 (1985): 32–43; and W. J. T. Mitchell, *Iconology: Image, Text, Ideology* (Chicago and London, 1986).

18. For similar interpretive agendas in literary studies and cultural history: Lynn Hunt, ed., *The New Cultural History* (Berkeley and Los Angeles, 1989); and H. Aram Veeser, ed., *The New Historicism* (London, 1989). David Freedberg, *The Power of Images: Studies in the History and Theory of Response* (Chicago and London, 1989) has recently argued for the (re)empowerment of images on quite different grounds: images are powerful, he insists, insofar as they appear to have a "life" of their own and elicit active, often passionate, responses from the viewer. Drawing mostly on religious and erotic images, he notes "above all . . . the absence here of an approach to the problem of figurated propaganda and of arousal to political action" (p. xxiv). While this book explores such an "approach," it also suggests that to discount both the contexts and the formal properties of images, as Freedberg tends to do, actually diminishes their power to appropriate, transform, and, for that matter, resist the objects or practices they represent.

19. Loren Partridge and Randolph Starn, *A Renaissance Likeness: Art and Culture in Raphael's 'Julius II'* (Berkeley and Los Angeles, 1980); Randolph Starn and Loren Partridge, "Representing War in the Renaissance: The Shield of Paolo Uccello," *Represen-*

tations 5 (1984): 32–65; Randolph Starn, "Reinventing Heroes in Renaissance Italy," *Journal of Interdisciplinary History* 17 (1986): 67–84; Randolph Starn, "The Republican Regime of 'The Room of Peace' in Siena, 1338–40," *Representations* 18 (1987): 1–32; Randolph Starn, "A Room for a Renaissance Prince," in *The New Cultural History*, ed. Lynn Hunt (Berkeley and Los Angeles, 1989); Loren Partridge and Randolph Starn, "Triumphalism and the Sala Regia in the Vatican," in *"All the world's a stage . . .": Art and Pageantry in the Renaissance and Baroque*, ed. Barbara Wisch and Susan S. Munshower [Papers in Art History from the Pennsylvania State University, 6] (University Park, Pa., 1990), 1:23–81.

The major extant examples of decorated council and audience halls are in the communal palaces in Perugia, Siena, Padua, Florence, Rome, Venice, and Modena; the ducal palaces in Angera, Mantua, and Ferrara; and the papal palaces in the Vatican and Rome. The following works provide the basic bibliography for these projects.

Perugia: Jonathan B. Riess, *Political Ideals in Medieval Italian Art, The Frescoes in the Palazzo dei Priori, Perugia (1297)* (Ann Arbor, 1981).

Siena: Nicolai Rubinstein, "Political Ideas in Sienese Art: The Frescoes by Ambrogio Lorenzetti and Taddeo di Bartolo in the Palazzo Pubblico," *Journal of the Warburg and Courtauld Institutes* 21 (1958): 179–207; Mariana Jenkins, "The Iconography of the Hall of the Consistory in the Palazzo Pubblico, Siena," *Art Bulletin* 54 (1972): 430–51; Edna Carter Southard, *The Frescoes in Siena's Palazzo Pubblico, 1298–1539* (New York, 1979); Cesare Brandi, ed., *Il Palazzo Pubblico di Siena: vicende costruttive e decorazione* (Milan, 1983).

Padua: Carlo Guido Mor et al., *Il Palazzo della Ragione di Padova* (Venice, 1964).

Florence: Wieruszowsky, "Art and the Commune in the Time of Dante"; Johannes Wilde, "The Hall of the Great Council of Florence," *Journal of the Warburg and Courtauld Institutes* 7 (1944): 65–81; Ettore Allegri and Alessandro Cecchi, *Palazzo Vecchio e i Medici* (Florence, 1980).

Rome: Carlo Pietrangeli, "La Sala degli Orazi e Curiazi," "La Sala dei Trionfi," "Nel Palazzo dei Conservatori: La Sala del Trono," *Capitolium* 37 (1962): 195–203, 463–70, 868–76; Roger Aikin, "Christian Soldiers in the Sala dei Capitani," *Sixteenth-Century Journal* 16 (1985): 206–27; Maria Elisa Tittoni Monti, *Gli affreschi del Cavalier d'Arpino in Campidoglio: analisi di un'opera attraverso il restauro* (Rome, 1980); Sybille Ebert-Schifferer, "Ripandas kapitolinischer Freskenzyklus und die Selbstdarstellung der Konservatoren um 1500," *Römisches Jahrbuch für Kunstgeschichte* 23 (1988): 75–281.

Venice: Staale Sinding-Larsen, *Christ in the Council Hall, Studies in the Religious Iconography of the Venetian Republic* [Institutum Romanum Norvegiae, Acta ad Archaeologiam et Artium Historiam Pertinentia, 5] (Rome, 1974); Umberto Franzoi, *Storia e leggenda del Palazzo ducale di Venezia* (Venice, 1982); Wolfgang Wolters, *Der Bilderschmuck des Dogenpalastes. Untersuchungen zur Selbstdarstellung der Republik Venedig im 16. Jahrhundert* (Wiesbaden, 1983); and Patricia Fortini Brown, *Venetian Narrative Painting in the Age of Carpaccio* (New Haven and London, 1988), pp. 39–42, 52–56, 261–65.

Modena: Erika Langmuir, "*The Triumvirate of Brutus and Cassius:* Nicolò dell'Abate's Appian Cycle in the Palazzo Comunale, Modena," *Art Bulletin* 59 (1977): 188–96.

Angera: Luca Beltrami, *Angera e la sua rocca, Arona e le sue memorie d'arte* (Milan, 1904); Mario Salmi, "La pittura e la miniatura gotica in Lombardia," in *Storia di Milano*, 16 vols. (Milan, 1954), 4:548–53; and Dieter Blume, "Planetengötter und ein christlicher Friedensbringer als Legitimation eines Machtwechsels: Die Ausma-

lung der Rocca di Angera," *Akten des XXV. Internationalen Kongresses für Kunstgeschichte, Wien 1983* (Vienna, 1986), pp. 175–85.

Mantua: Giovanni Paccagnini, *Il Palazzo Ducale di Mantova* (Turin, 1969); Joanna Woods-Marsden, *The Gonzaga of Mantua and Pisanello's Arthurian Frescoes* (Princeton, 1988); Rodolfo Signorini, *Opus Hoc Tenue: la Camera Dipinta di Andrea Mantegna; lettura storica, iconografica e iconologica* (Parma, 1985); Peter Eikemeier, "Der Gonzaga-Zyklus des Tintoretto in der Alten Pinakothek," *Münchner Jahrbuch der Bildenden Kunst* 20 (1969): 75–142; Frederick Hartt, *Giulio Romano,* 2 vols. (New Haven, 1958); Paolo Carpeggiani and Chiara Tellini Perina, *Giulio Romano a Mantova* (Mantua, 1987); Ernst H. Gombrich et al., *Giulio Romano* (Milan, 1989).

Ferrara: Paolo D'Ancona, *The Schifanoia Months at Ferrara* (Milan, 1954); Aby Warburg, "Italienische Kunst und internationale Astrologie im Palazzo Schifanoia zu Ferrara," *Gesammelte Schriften,* 2 vols. (Leipzig, 1932), 2:459–81; Werner L. Gundersheimer, *Art and Life at the Court of Ercole I d'Este: The "De triumphis religionis" of Giovanni Sabadino degli Arienti* (Geneva, 1972), pp. 56–72; Charles M. Rosenberg, "The Iconography of the Sala degli Stucchi in the Palazzo Schifanoia in Ferrara," *Art Bulletin* 61 (1979): 377–84; R. Varese, ed., *Atlante di Schifanoia* (Ferrara, 1989).

For papal audience halls, see L. D. Ettlinger, *The Sistine Chapel before Michelangelo* (Oxford, 1965); Paal, *Studien zum Appartamento Borgia;* Shearman, "The Vatican Stanze: Function and Decoration"; John Shearman, *Raphael's Cartoons in the Collection of Her Majesty the Queen and the Tapestries for the Sistine Chapel* (London, 1972); I. L. Zupnick, "The Significance of the Stanza dell'Incendio, Leo X and François I," *Gazette des Beaux-Arts,* s. 6, 80 (1972): 195–204; Rolf Quednau, *Die Sala di Costantino im Vatikanischen Palast: Zur Dekoration der beiden Medici-Päpste Leo X. und Clemens VII* (Hildesheim and New York, 1979); Loren Partridge and Randolph Starn, "Triumphalism and the Sala Regia"; Morton C. Abromson, "Clement VIII's Patronage of the Brothers Alberti," *Art Bulletin* 60 (1978): 531–47; Richard Harprath, *Papst Paul III. als Alexander der Grosse, Das Freskenprogramm der Sala Paolina in der Engelburg* (Berlin and New York, 1978); Filippa M. Aliberti Gaudioso, Eraldo Gaudioso et al., *Gli affreschi di Paolo III a Castel Sant'Angelo 1543–1549,* 2 vols. (Rome, 1981). For recent essays concerned with art and politics in Italy, if not halls of state: Charles M. Rosenberg, ed., *Art and Politics in Late Medieval and Early Renaissance Italy: 1250–1500* (Notre Dame and London, 1990).

I. THE SALA DEI NOVE IN SIENA

1. Dante Alighieri, *Opere,* ed. Manfredi Porena and Mario Pazzaglia (Bologna, 1966); all citations below refer to this edition.

2. *Istorie fiorentine* 1.1, in *Tutte le opere di Machiavelli,* ed. Mario Martelli (Florence, 1971), p. 690.

3. Randolph Starn, *Contrary Commonwealth: The Theme of Exile in Medieval and Renaissance Italy* (Berkeley and Los Angeles, 1982), esp. chaps. 3, 5.

4. See, in general, Nicola Ottakar, "Il problema della formazione comunale," in *Questioni di storia medioevale,* ed. Ettore Rota (Milan, 1946), pp. 355–84; Gina Fasoli, "Le autonomie cittadine nel medioevo," in *Nuove questioni di storia medioevale* (Milan, 1969), pp. 145–76. Especially forceful critical surveys are Sergio Bertelli, *Il potere oligarchico nello stato-città medioevale* (Florence, 1978); and Lauro Martines, *Power and Imagination: City-States in Renaissance Italy* (New York, 1980), pp. 34–72; see too Daniel Waley, *The Italian City-Republics* (New York, 1969), pp. 221–39.

5. While dampening "the brilliant flame of liberty" claimed for the communes (J. C. L. S. Sismondi, *Histoire des républiques italiennes du moyen-âge*, 16 vols. [Paris, 1826], 3:245), modern historians have recognized the importance of the experiment in self-government and the "reinvention" of republican political discourse in the city-states: see, e.g., J. K. Hyde, *Society and Politics in Medieval Italy: The Evolution of the Civil Life, 1000–1350* (New York, 1973), pp. 94–118; Alberto Tenenti, "Archeologia della parola 'stato,'" in his *Stato: un'idea, una logica* (Bologna, 1987), esp. pp. 34–40; Roberto Celli, "Pour l'histoire des origines du pouvoir populaire: l'expérience des villes-états italiennes (XIe–XIIe siècles)," *Publications de l'Institut d'Etudes Médiévales, Louvain* 3 (1980): 1–63; and in general the valuable syntheses, with bibliography, by Quentin Skinner, *The Foundations of Modern Political Thought*, 2 vols. (Cambridge, 1978), 1:3–65; and J. P. Canning, "Law, Sovereignty and Corporation Theory, 1300–1450," in J. H. Burns, ed., *The Cambridge History of Medieval Political Thought, ca. 350–1450* (Cambridge, 1988), pp. 350–64. John Hine Mundy, "In Praise of Italy: The Italian City-Republics," *Speculum* 64 (1989): 815–34, has recently made the case for a full-scale re-evaluation; on the "republican tradition," see William R. Everdell, *The End of Kings: A History of Republics and Republicans* (New York and London, 1983).

6. The classic analysis is by Georges Duby, *The Three Orders: Feudal Society Imagined*, trans. Arthur Goldhammer (Chicago, 1980).

7. *Ottonis et Rahewini gesta Federici I. imperatoris*, ed. Georg Waitz and B. De Stimson (Hannover and Leipzig, 1912), p. 117; cf. R. L. Benson, "*Libertas* in Italy (1152–1226)," in *La notion de liberté au moyen-âge: Islam, Byzance, Occident*, ed. George Matedisi, Dominique Sourdel, and Janine Sourdel-Thomine (Paris, 1985), pp. 192–95, for the scandalized fascination of Otto of Freising and other northern traditionalists with the Italian city-states.

8. *Dino Compagni's Chronicle of Florence* 3.42, trans. Daniel D. Bornstein (Philadelphia, 1986), p. 101. Although the "illegitimacy" of the Italian city-states, a central theme of Jacob Burckhardt's *Civilization of the Renaissance in Italy*, has been contested by later historians, the defensive insistence of the communes on their rights and privileges and their susceptibility to quick political mutations are only among the most striking indications of deep-seated and persistent insecurities. Particularly suggestive on the practical and theoretical variations on this theme: William J. Bouwsma, *Venice and the Defense of Republican Liberty: Republican Values in the Age of the Counter-Reformation* (Berkeley and Los Angeles, 1968), pp. 1–51; Jacques Heers, *Parties and Political Life in the Medieval West*, trans. David Nichols (Amsterdam and New York, 1977), pp. 79–89; and, most controversially, Richard Trexler, *Public Life in Renaissance Florence* (New York, 1980), pp. 13–33.

9. Aristotle, *The Politics* 3.9, ed. Stephen Everson (Cambridge, 1988), pp. 63–64.

10. Ibid., 3.11, ed. Everson, p. 66; for the ideology of the *polis* as a radical departure from the conception of sovereignty embodied in a single ruler, see Jean-Pierre Vernant, *The Origins of Greek Thought* (Ithaca, N.Y., 1982), pp. 49–68.

11. For documents, dating, and early references to the frescoes, see Edna Carter Southard, *The Frescoes in Siena's Palazzo Pubblico, 1289–1539* (New York, 1979), pp. 271–77.

12. Alessandro Angelini, "I restauri di Pietro di Francesco agli affreschi di Ambrogio Lorenzetti nella 'Sala della Pace,'" *Prospettivo* 31 (1982): 78–82; Cesare Brandi, "Chiaramenti sul 'Buon Governo' di Ambrogio Lorenzetti," *Bollettino d'arte*, s. 4, 40 (1955): 119–23, analyzes the condition of the frescoes before the newly completed (1986–89) restorations.

13. The pioneering study on the genre is Hélène Wieruszowski, "Art and the Com-

mune in the Time of Dante," in her *Politics and Culture in Medieval Spain and Italy* (Rome, 1971), pp. 465–502; more recent studies include Jonathan B. Riess, *Political Ideas in Medieval Art: The Frescoes in the Palazzo dei Priori, Perugia, 1297* (Ann Arbor, 1981); Samuel Y. Edgerton, *Pictures and Punishment: Art and Criminal Prosecution during the Florentine Renaissance* (Ithaca, N.Y., 1985); and Hans Belting, "The New Role of Narrative in Public Painting of the Trecento: *Historia* and Allegory," *Studies in the History of Art* 16 (1985): 154–68.

14. Edna Carter Southard, "Ambrogio Lorenzetti's Frescoes in the Sala della Pace: A Change of Names," *Mitteilungen des Kunsthistorischen Institutes in Florenz* 24 (1980): 361–65.

15. George Rowley, *Ambrogio Lorenzetti,* 2 vols. (Princeton, 1958), 1:99–107; Eve Borsook, *Ambrogio Lorenzetti,* trans. Piero Bertolucci (Florence, 1966), pp. 12–14; and Chiara Frugoni, *Pietro and Ambrogio Lorenzetti* (Florence, 1988) discuss the iconography of the frescoes; but the study to which most subsequent accounts have been indebted is Nicolai Rubinstein, "Political Ideas in Sienese Art: The Frescoes by Ambrogio Lorenzetti and Taddeo di Bartolo in the Palazzo Pubblico," *Journal of the Warburg and Courtauld Institutes* 21 (1959): 179–207; see, e.g., Uta Feldges-Henning, "The Pictorial Programme of the Sala della Pace: A New Interpretation," *Journal of the Warburg and Courtauld Institutes* 35 (1972): 145–62; Karl Clausberg, "Formen der politischen Progaganda der Kommune von Siena in der ersten Trecento-hälfte," in *Bauwerk und Bildwerk in Hochmittelalter,* ed. Karl Clausberg (Kunstwissenschaftliche Untersuchungen des Ulmer Vereins, Bd. 11), pp. 86–100; and Chiara Frugoni, "*Immagini troppo belle:* La realtà perfetta," in her work *Una lontana città: Sentimenti e immagini nel medioevo* (Turin, 1983), pp. 136–210. Rubinstein's interpretation has recently been challenged and revised in two important articles by Quentin Skinner, "Ambrogio Lorenzetti: The Artist as Political Philosopher," *Proceedings of the British Academy* 72 (1986): 1–56; and Jack M. Greenstein, "The Vision of Peace: Meaning and Representation in Ambrogio Lorenzetti's Sala della Pace Cityscapes," *Art History* 11 (1988): 492–510. Cf. Randolph Starn, "The Republican Regime of the 'Room of Peace' in Siena, 1338–40," *Representations* 18 (1987): 1–32. Hans Belting and Dieter Blume, eds., *Malerei und Stadtkultur in der Dantezeit: Die Argumentation der Bilder* (Munich, 1989) came to our attention too late to be considered.

16. C. M. de la Roncière et al., *L'Europe au moyen-âge: documents expliqués,* 3 vols. (Paris, 1971), 3:142; for the problems of treating the frescoes as social history, see Michael Baxandall, "Art, Society, and the Bouguer Principle," *Representations* 12 (1985): 32–43.

17. Cited from a rubric in the Sienese constitution of 1337–1339 by William M. Bowsky, *A Medieval Italian Commune: Siena under the Nine, 1287–1355* (Berkeley and Los Angeles, 1981), p. 4; the following pages are indebted both to this fundamental book and the unstinting encouragement of its author.

18. The best study of Sienese *contado* (countryside) under the Nine is Giovanni Cherubini, "Proprietari, contadini e campagne senesi all'inizio del Trecento," in his *Signori, cittadini, borghesi: ricerche sulla società italiana del basso medioevo* (Florence, 1974), pp. 231–311; Mario Ascheri suggests lines for further research in his manuscript, "Siena in the Fourteenth Century: State, Territory, and Culture," pp. 10–27. See too William M. Bowsky, "*Cives Silvestres:* Sylvan Citizenship and the Sienese Commune (1287–1355)," *Bullettino senese di storia patria* 72 (1965): 3–13; Bowsky, *A Medieval Italian Commune,* pp. 1–11; and Odile Redon, *Uomini e comunità del contado Senese nel duecento* (Siena, 1982).

19. Renato Stopani, ed., *La Via Francigena nel senese: storia e territorio* (Florence, 1985);

Thomas Szabó, "La rete stradale del contado di Siena: legislazione statuaria e amministrazione comunale," *Mélanges de l'Ecole Française de Rome: Moyen Age–temps modernes* 85 (1975): 141–86.

20. See Duccio Balestracci and Gabriella Piccinini, *Siena nel trecento: assetto urbano e strutture edilizie* (Florence, 1977), pp. 17–30.

21. Ibid., p. 45, citing legislation of 1334; cf. Roberto Rocchigiani, "Urbanistica ed igiene negli statuti senesi del XIII e XIV secolo," *Studi senesi* 70 (1958): 369–419.

22. Balestracci and Piccinini, *Siena nel trecento*, p. 49, from a petition of 1345 presented to the General Council by a group of *buoni homines* "e' quali si dilectano e vorreboro l'acconcio della città."

23. Ibid., pp. 17–40, 113–30, and maps 1–2, 5–6; Edward D. English, "Urban Castles in Medieval Siena: The Sources and Images of Power," in *The Medieval Castle: Romance and Reality*, ed. Kathryn Reyerson and Faye Power (Dubuque, Iowa, 1984), pp. 175–98, discusses the fortified enclaves of the magnates in the city and the commune's efforts to control them.

24. The famous horserace for the *palio*, the banner of the Virgin, still brings out old divisions, and newer ones: Giovanni Cecchini and Dario Neri, *Il palio di Siena* (Milan, 1958) is the best historical study; see too Alan Dundes and Alessandro Falassi, *La terra in piazza: An Interpretation of the Palio of Siena* (Berkeley and Los Angeles, 1975).

25. See Enrico Guidoni, *Il campo di Siena* (Rome, 1971).

26. From a provision of 1288, quoted by Fortunato Donati, "Il palazzo del comune di Siena," *Bullettino senese di storia patria* 11 (1904): 323.

27. Quoted by Guidoni, *Il campo*, p. 21; for the fountain (1408–19) that completed the development of the piazza, see Ann Coffin Hanson, *Jacopo della Quercia's Fonte Gaia* (Oxford, 1965).

28. For the history of the building, see the contribution by Michele Cordaro in *Il Palazzo Pubblico di Siena: vicende costruttive e decorazione*, ed. Cesare Brandi (Milan, 1983), pp. 33–35; this collaborative volume consolidates and supersedes the earlier literature on the palace. For town halls elsewhere in Tuscany, cf. Wolfgang Braunfels, *Die mittelalterliche Stadtbaukunst in der Toskana*, 2d ed. (Berlin, 1959); and Niccolò Rodolico and Giuseppe Marchini, *I palazzi del popolo nei comuni toscani del medio evo* (Milan, 1962).

29. Ernesto Sestan, "Siena avanti Montaperti," in *Scritti vari*, 2 vols. (Florence, 1988), 2:35–70, corrects the dated accounts of Sienese history before the Nine by Robert Langton Douglas, *A History of Siena* (London and New York, 1902); and Ferdinand Schevill, *Siena: The Story of a Medieval Commune* (New York, 1909; new edition, with an introduction by William M. Bowsky, New York, 1964); but much work remains to be done on the earlier period. The introduction to Ludovico Zdekauer, ed., *Il constituto del comune di Siena dell'anno 1262* (Milan, 1897) is the best account of government institutions; the major chronicles are published in Alessandro Lisini and Francesco Iacometti, eds., *Cronache senesi*, in *Rerum italicarum scriptores*, n.s. 15, pt. 6 (Bologna, 1931–37).

30. Bowsky, *A Medieval Italian Commune*, pp. 63–74.

31. Ibid., pp. 54–59; the oath of office, dating after 20 October 1339, appears on pp. 55–56.

32. Judith Hook, *Siena: A City and its History* (London, 1979), p. 80.

33. See Brandi, ed., *Il Palazzo Pubblico*, p. 528.

34. The most recent treatment of the *Maestà* is by Andrew Martindale, *Simone Martini* (Oxford, 1988), pp. 14–17. Alice Sedgwick Wohl, "In Siena, an Old Masterpiece Challenged, a New One Discovered," *News from RILA* 2 (1984): 1–4, gives a concise summary and bibliography for the controversy over the Guidoriccio fresco; for subsequent views, see Michael Mallory and Gordon Moran, "New Evidence Concerning

'Guidoriccio,'" *Burlington Magazine* 128 (1986): 250–59; Andrew Martindale, "The Problem of 'Guidoriccio,'" *Burlington Magazine* 128 (1986): 259–73; Joseph Polzer, "Simone Martini's *Guidoriccio* Fresco: The Polemic Concerning its Origin Reviewed, and the Fresco Considered as Serving the Military Triumph of a Tuscan Commune," *RACAR* [Canadian Art Review] 14 (1987): 16–69; Piero Torriti, "Letters," *Burlington Magazine* 131 (1989): 485–86; Luciano Bellosi, ed., *Simone Martini: Atti del Convegno* (Florence, 1988); Joseph Polzer, "Simone Martini's Guidoriccio da Fogliano: A New Appraisal in the Light of a Recent Technical Examination," *Jahrbuch der Berliner Museen* (1983): 103–41; Joseph Polzer, "The Technical Evidence and the Origin and Meaning of Simone Martini's *Guidoriccio* Fresco in Siena," *RACAR* 12 (1985): 143–48.

35. Marsiglio of Padua, *The Defender of the Peace*, trans. Alan Gewirth (New York, 1956), p. 4; Albertino Mussato, *Ecerinus*, ed. Luigi Padrin (Bologna, 1900), p. 5, cited by Skinner, *Foundations*, 1:39; cf. Nicolai Rubinstein, "Marsilius of Padua and Italian Political Thought of his Time," in *Europe in the Later Middle Ages*, ed. J. R. Hale, J. R. L. Highfield, and Beryl Smalley (London, 1965), pp. 44–75; J. K. Hyde, *Padua in the Age of Dante* (Manchester, 1966), pp. 298–99.

36. Bonvesin da la Riva, *De magnalibus urbis mediolani/Le meraviglie di Milano* 7.1, ed. Maria Corti, Italian trans. Giuseppe Pontiggia (Milan, 1974), pp. 166–67.

37. *De regimine civitatis* 1.70–71, ed. Diego Quaglione, in Diego Quaglione, *Politica e diritto nel trecento italiano* (Florence, 1983), p. 152. For further references to the fear of tyranny, see Skinner, *Foundations*, 1:53–58; and Nicolai Rubinstein, "Some Municipal Ideas on Progress and Decline in the Italy of the Communes," in *Fritz Saxl, 1890–1948: A Volume of Memorial Essays*, ed. D. J. Gordon (London, 1957), pp. 179–97.

38. D. M. Bueno de Mesquita, "The Place of Despotism in Italian Politics," in *Europe in the Later Middle Ages*, ed. J. R. Hale, J. R. L. Highfield, and Beryl Smalley (London, 1965), pp. 301–31; P. J. Jones, "Communes and Despots: The City-State in Late Medieval Italy," *Transactions of the Royal Historical Society*, 5th s., 5 (1965): 71–96; Martines, *Power and Imagination*, pp. 94–110.

39. Emergency powers given to Bonaguida Lucari on the eve of the Sienese victory over the Florentines at Montaperti (1260) were soon rescinded: Ernesto Sestan, "Ricerche intorno ai primi podestà toscani," and "Le origini del podestà forestiero," in *Scritti vari*, 2:20–22, 59–61. On the Petrucci regime, see Mario Ascheri, *Siena nel Rinascimento: Istituzioni e sistema politico* (Siena, 1985).

40. Jean Delumeau, *La peur en Occident (XIVe–XVIIIe siècles): une cité assiégée* (Paris, 1978), p. 17; see too, William J. Bouwsma, "Anxiety and the Formation of Early Modern Culture," in *After the Reformation: Essays in Honor of J. H. Hexter*, ed. Barbara Malament (Philadelphia, 1980), pp. 216–46.

41. Particularly suggestive on these themes: J. G. A. Pocock, *The Machiavellian Moment* (Princeton, 1975), p. 122; Hannah F. Pitkin, *Fortune Is a Woman: Gender and Politics in the Thought of Niccolò Machiavelli* (Berkeley and Los Angeles, 1984), esp. pp. 90–93; and Milton L. Myers, *The Soul of Modern Economic Man: Ideas of Self-Interest, Thomas Hobbes to Adam Smith* (Chicago, 1983).

42. Skinner, *Foundations*, 1:42–44, 53–59; Mundy, "In Praise of Italy," pp. 821–23.

43. *Leviathan* 2.29, ed. Michael Oakeshott (Oxford, 1957), p. 214.

44. Cited by Skinner, *Foundations*, 1:42, 44, 57.

45. Anononimo genovese, *Poesie*, ed. L. Cocito (Rome, 1970), p. 415, quoted and trans. by Martines, *Power and Imagination*, p. 115; cf. Lester Little, *Religious Poverty and the Profit Economy in Medieval Europe* (Ithaca, N.Y., 1978), pp. 35–39.

46. *De gestis italicarum post mortem Henrici VII. Caesaris Historia* in *Rerum italicarum scriptores*, ed. Ludovico Muratori, 25 vols. (Milan, 1723–51), 10, cols. 586–87, 716, cited by Skinner, *Foundations*, 1:43.

47. *De tyranno* 8.540, ed. Quaglione, in Quaglione, *Politica e diritto nel trecento*, p. 202.

48. *De tyranno* 2.53–62, ed. Quaglione, pp. 177–78, quoting Gregory the Great, *Moralia* 12.38; the references in the following paragraphs are to this same edition.

49. Bonvesin da la Riva, *De magnalibus* 8.15, pp. 198–99.

50. *Rime di Bindo Bonichi*, ed. Pietro Bilancioni (Scelta di curiosità letterarie inedite o rare dal secolo XIII al XVII; Bologna, 1867), p. 181, quoted and trans. in Martines, *Power and Imagination*, p. 113, but corrected here to read "murmur about bad priests" (*mormora, perchè ha mal prelato*).

51. *Rime di Bindo Bonichi*, p. 180: "Quando i mezzani diventano tiranni, / Preghi Iddio la cittade, che la guardi."

52. Edgerton, *Pictures and Punishment*, p. 41.

53. Agnolo di Tura, "Cronaca," in *Cronache senesi*, ed. Lisini and Iacometti, p. 523.

54. *De regimine principum* 4.8, ed. R. Spiazzi, in Thomas Aquinas, *Opuscula philo-sophica* (Turin, 1954), p. 336, cited by Mundy, "In Praise of Italy," p. 824.

55. Mundy, "In Praise of Italy," p. 549; Donato di Neri, "Cronaca," in *Cronache senesi*, ed. Lisini and Iacometti, pp. 576–79.

56. See William M. Bowsky, "The Anatomy of Rebellion in Fourteenth-Century Siena: From Commune to Signory?" in *Violence and Disorder in Italian Cities, 1200–1500*, ed. Lauro Martines (Berkeley and Los Angeles, 1972), pp. 229–72; the quotations from sentences against the rebels of 1346 are on pp. 259–60.

57. See Jeffrey Burton Russell, *Lucifer: The Devil in the Middle Ages* (Ithaca, N.Y., 1984), pp. 210–12; and John Freccero, "The Sign of Satan," in his *Dante: The Poetics of Conversion* (Cambridge, Mass., 1986), pp. 167–79.

58. Morton W. Bloomfield, *The Seven Deadly Sins* (East Lansing, Mich., 1952), p. 67.

59. "La giostra delle virtù e dei vizî," in Gianfranco Contini, ed., *Poeti del Duecento*, 2 vols. (Milan and Naples, 1960), 1:328–29; "Fiore di virtù," in Cesare Segre and Mario Marti, eds., *La prosa del Duecento* (Milan and Naples, 1959), pp. 883–99. The most reliable manuscript of the "Fiore" is in the Biblioteca Comunale of Siena (Codice 1.2.7): see *La prosa del Duecento*, p. 1108.

60. John Block Friedman, *The Monstrous Races in Medieval Art and Thought* (Cambridge, Mass., 1981), p. 3.

61. Walter Benjamin, *Illuminations*, trans. Harry Zohn (New York, 1969), p. 255.

62. Mary Douglas, *Purity and Danger: An Analysis of Conceptions of Pollution and Taboo* (London, 1966), p. 121; for the "politics and poetics" of this theme, see Peter Stallybrass and Allon White, *The Politics and Poetics of Transgression* (Ithaca, N.Y., 1986), pp. 1–26.

63. *Genealogie deorum gentilium*, as cited and discussed by Ezio Raimondi, "Il politico e il centauro," in his *Politica e commedia dal Beroaldo al Machiavelli* (Bologna, 1971), p. 277; see too Frances Pitts, "Nardo di Cione and the Strozzi Chapel Frescoes" (Ph.D. diss., University of California, Berkeley, 1982), p. 98.

64. Quoted and trans. by Martines, *Power and Imagination*, p. 81.

65. Cf. Freccero, "Infernal Irony: The Gates of Hell," in his *Dante*, pp. 93–109.

66. Jacques Le Goff, *The Birth of Purgatory*, trans. Arthur Goldhammer (Chicago, 1984), pp. 4–7, 209–34.

67. Cf. Michel de Certeau, *The Writing of History*, trans. Tom Conley (New York, 1988), p. 217: "Writing designates an operation organized about a center: departures and returns all depend on the impersonal authority which is developed here and to which they return." The types of inscriptions in medieval art—Lorenzetti's include practically the entire repertoire—have received little attention as such; but see the suggestive comments by Miecsylaw Wallis, "Inscriptions in Paintings," *Semiotica* 9 (1973):

3–14; and the papers on "L'art de la signature" in *Revue de l'art* 26 (1974), esp. Jean-Claude Lebensztejn, "Esquisse d'une typologie," pp. 46–56. Cf. the introductory bibliographical essay by Norbert H. Ott in Hella Fruehmorgen-Voss, *Text und Illustration im Mittelalter* (Munich, 1975), pp. ix–xxi.

68. Fundamental here is the "writing lesson" in Claude Lévi-Strauss, *Tristes tropiques,* trans. John Russell (New York, 1961), pp. 290–93.

69. Ernst Robert Curtius, *European Literature in the Latin Middle Ages,* trans. Willard Trask (New York, 1963), pp. 302–47, cites many medieval examples of such metaphors; for the persistence of the "argument of the book" see Jesse M. Gellrich, *The Idea of the Book in the Middle Ages* (Ithaca, N.Y., 1985), esp. pp. 29–50.

70. Brian Stock, *The Implications of Literacy: Written Language and Models of Interpretation in the Eleventh and Twelfth Centuries* (Princeton, 1983), p. 18; see too R. Howard Bloch, *Etymologies and Genealogies: A Literary Anthropology of the French Middle Ages* (Chicago, 1983); and the papers on medieval literacy, oral traditions, and written language in *New Literary History* (Autumn 1984) and *Yale French Studies* 70 (1986).

71. See, e.g., Jack Goody, *The Logic of Writing and the Organization of Society* (Cambridge, 1986), pp. 175–84.

72. These were first edited by C. Paoli, *Lettere volgari del secolo XIII* (Scelta di curiosità letterarie inedite o rare dal secolo XIII al XVII; Bologna, 1871).

73. Republican discourse during the French Revolution is exemplary in this respect. Marie-Hélène Huet notes the special role accorded to writing in the effort to imbue citizens with the authority and legitimacy formerly situated in the person of the king: "By transferring the authority of the law from the person to the group, from the Father [i.e., the monarch] to his children, one went from image to sign, as it were, from icon to abstract representation." The proliferation and public proclamation of written laws attest to the "constant concern of [the republican government] for the legitimacy of its acts." See Marie-Hélène Huet, *Rehearsing the Revolution* (Berkeley and Los Angeles, 1982), pp. 5, 49–50; for the Revolution as "an age of writing, not of image-making," cf. E. H. Gombrich, "The Dream of Reason: Symbolism of the French Revolution," *The British Journal for Eighteenth-Century Studies* 2 (1979): 203.

74. Stock, *Implications of Literacy,* p. 18.

75. For a powerful and influential statement: Jacques Derrida, "The Violence of the Letter: From Lévi-Strauss to Rousseau," in his *Of Grammatology,* trans. Gayatri Spivak (Baltimore, 1976), pp. 101–40.

76. *Leviathan* 2.21, ed. Oakeshott, pp. 140–41.

77. François La Harpe, quoted by Lynn Hunt, *Politics, Culture, and Class in the French Revolution* (Berkeley and Los Angeles, 1984), p. 25; see too François Furet, *Interpreting the French Revolution,* trans. Elborg Forster (Cambridge, 1981), pp. 49–50, 175–76.

78. See Robert Marichal, "La scrittura," in *Storia d'Italia,* ed. Ruggiero Romano and Corrado Vivanti, vol. 5, no. 2, pp. 1267–1313; Armando Petrucci, "Il libro manoscritto," in *Letteratura italiana,* ed. Alberto Asor Rosa, 9 vols. (Turin, 1984–), 2:499–513; Angelo Cicchetti and Raul Mordente, *I libri della famiglia in Italia* (Rome, 1985), vol. 1 (Filologia e storiografia letteraria); Giovanni Arnaldi, *Studi sui cronisti della marca trevigiana nell'età di Ezzelino da Romano* (Rome, 1963).

79. Ivano Paccagnella, "Plurilinguismo letterario: Lingue, dialetti, linguaggi," in *Letteratura italiana,* 2:103–36.

80. Alessandro Lisini, ed., *Il constituto del comune di Siena volgarizzato nel MCCCIX–MCCCX,* 2 vols. (Siena, 1903), 1:137.

81. Giorgio Vasari, *Le vite de' più eccellenti pittori, scultori ed architettori,* ed. Gaetano Milanesi, 9 vols. (Florence, 1878–85), 1:525.

82. See Susanna Partsch, *Profane Buchmalerei der bürgerlichen Gesellschaft in spätmit-*

telalterlicher Florenz: Der Specchio Umano des Getreidehändlers Domenico Lenzi (Worms, 1981), pp. 63–65, 85, 90–91.

83. The proposals were read in the vernacular to a council of 201 citizens, both officeholders and ninety members especially selected by the Nine—as the ponderous civic formulas of the notary declare, "ad fortificationem dictarum sotietatum et hominum et personarum ipsarum [i.e., of the people and pacific state of the city] et circa paces et concordias . . . et ad fortificationem et corroborationem offitii d. novum, et ad conservationem boni et pacifici status comunis senarum et omnium et singularem volentium ben vivere et in pace quiescere" (*Archivio di Stato di Siena, Concistoro*, 2 [1347], fol. 8v). Rowley, *Ambrogio Lorenzetti*, 1:132, cites the document without mentioning its contents or context.

84. See Rowley, *Ambrogio Lorenzetti*, 1:8–17, 18–25, 57–62; and for subsequent scholarship and excellent color illustrations, Frugoni, *Pietro and Ambrogio Lorenzetti*, pp. 37 ff.

85. Federigo Tozzi, *Antologia d'antichi scrittori senesi* (Siena, 1913) is still useful. Aldo Rossi, "Poesia didattica e poesia popolare," in *Storia della letteratura italiana*, ed. Emilio Cecchi and Natalino Sapegno, 8 vols. (Milan, 1965–), 2:431–509; and Salvatore Guglielmino and Hermann Grosser, *Il sistema letterario: Duecento e Trecento* (Milan, 1987), pp. 89–93, are representative surveys of "ethical-didactic" poetry.

86. *Rime di Bindo Bonichi*, pp. 180, 186.

87. The tortured (and tortuous) quality of Bindo's verse comes through strongly in these lines:

> Sovente avven che l'uom, ch'a gran balìa
> Fà servo il liber per obbligamento,
> Et apparne strumento,
> Onde poi chi succede il vuol per dritto;
> Se poi divien piu forte quello afflitto,
> A chi 'l gravo fà simil gravamento;
> Onde io discerno e sento
> Ch'ogni signoreggiar è tirannia.
> De non sia l'ôm servile
> Da natura parlando
> E 'l vero esaminando
> Ciascun servo divien per accidente;
> Alcun per esser vile
> Molti ration fallando,
> O che tiraneggiando
> L'attor per forza preme il pazïente
> Et post ch'uomo per forza a hom non serva
> È servo di lussaria o d'avarizia
> O d'alcuna nequizia
> Et tutti in general della paura.
> E' servo l'uom di qual vizio l'oscura
> Et oscurato, aver non puo letizia,
> Perchè vive in trestitia
> Onde sagge'è chi se liber conserva.
>
> *Rime di Bindo Bonichi*, pp. 129–30

88. Ibid., p. 85.

89. "Iddio permette, che regni il tiranno, / Acciò che prema il popol peccatore, / Non già per ben di lui, ma per suo danno": ibid., p. 181.

90. "Nulla cosa è si grande / Che più virtu non vaglia": ibid., p. 82.

91. "All'esser bon bisogna / Perfetta conoscenza / Et pura coscienza / Et le virtu continovo operare": ibid., p. 35; Bindo treats the cardinal virtues on pp. 46–49.

92. "Et poi come conviene è fero e molle / Corregge ammaestrando l'ignorante, / Et qual per vizio pecca, dando pena / Benchè non sia di vena / Sta per paura hom sovente leale": ibid., p. 79.

93. "Giustizia fa la gente / Ciascun pascer suo campo": ibid., p. 47.

94. Kathryn L. Lynch, *The High Medieval Dream Vision: Poetry, Philosophy, and Literary Form* (Stanford, 1988), is a recent study, with extensive bibliography; the references to *Il tesoretto* in the following paragraphs are to the edition, with an English translation, by Julia Bolton Holloway in the Garland Library of Medieval Literature, s. A, vol. 2 (New York, 1981). On Ser Brunetto see Thor Sundby, *Della vita e delle opere di Brunetto Latini*, trans. Rodolfo Renier (Florence, 1884); and, for subsequent scholarship, the entry by Francesco Mazzoni in *Enciclopedia dantesca*, 6 vols. (1970–84), 3:579–88, s.v. "Latini, Brunetto."

95. See below, p. 51.

96. Skinner, "Ambrogio Lorenzetti," pp. 12–14, quotes Cicero, *De finibus* 2.35.117 and St. Augustine, *De civitate Dei* 2.21, together with other references to the *vinculum concordiae*.

97. Sienese documents regularly mention measurements *ad cordam* or *a dritta corda* according to Balestracci and Piccinini, *Siena nel trecento*, p. 46; petitions welcoming improvements to straighten streets between 1357 and 1359 are quoted in ibid., p. 45.

98. On Ser Brunetto's civic audience, see esp. Charles T. Davis, "Brunetto Latini e Dante," *Studi medievali*, s. 3, 8 (1967): 421–50.

99. Erich Auerbach, "Figura," in *Scenes from the Drama of European Literature* (New York, 1959), pp. 11–76; and Curtius, *European Literature*, pp. 40 ff., are classic discussions of these themes. Marcia L. Colish, *The Mirror of Language: A Study in the Medieval Theory of Knowledge* (New Haven, 1968); Umberto Eco, *Art and Beauty in the Middle Ages*, trans. Hugh Bredin (New Haven, 1986); Gellrich, *Idea of the Book*, pp. 94–138; and Lynch, *High Medieval Dream Vision*, pp. 21–45, are useful guides to some of the more important variations.

100. *De vulgari eloquentia*, in Dante Alighieri, *Opere*, ed. Porena and Pazzaglia; cf. *Convivio* 1, in ibid., pp. 1039–1108.

101. Quoted by M. D. Chenu, *Toward Understanding St. Thomas*, trans. A.-M. Landry and D. Hughes (Chicago, 1964), p. 64.

102. Albertus Magnus quoted in ibid., p. 131 n. 6.

103. *De vulgari eloquentia* 1.1, in *Opere*, ed. Porena and Pazzaglia, p. 1226; for scholastic methods of reading, see Chenu, *Toward Understanding St. Thomas*, pp. 134–36; Gellrich, *Idea of the Book*, pp. 94–138.

104. Rubinstein, "Political Ideas," is the seminal work for the Thomistic-Aristotelian interpretation. Cf. Chiara Frugoni, "The Book of Wisdom and Lorenzetti's Fresco in the Palazzo Pubblico at Siena," *Journal of the Warburg and Courtauld Institutes* 43 (1980): 239–41; and Frugoni, *Una lontana città*, p. 145; and for the Mechanical Arts, Feldges-Henning, "The Pictorial Programme." See Skinner, "Ambrogio Lorenzetti," pp. 2–3 et passim, for the critical reception of these views.

105. Skinner, "Ambrogio Lorenzetti," pp. 3 ff.

106. The edition cited below is *Li livres dou tresor*, ed. Francis O. Carmody [University of California Publications in Modern Philosophy, no. 22] (Berkeley, 1948); Carmody's introduction is fundamental for biographical and philological details, but see

too P. A. Messelaer, *Le vocabulaire des idées dans le 'Tresor' de Brunetto Latini* (Assen, 1963) and the works cited in notes 94 and 98 above.

107. Giovanni Villani, *Cronica*, ed. F. G. Dragomanni, 4 vols. (Florence, 1844–45), 1:174.

108. On "the presence of meaning in a spatial form," from the encyclopedic *summa* to medieval architecture and painting, see Gellrich, *Idea of the Book*, pp. 94 ff.; see too Robert Collison, *Encyclopedias: Their History throughout the Ages* (New York, 1967), p. 62.

109. For Ser Brunetto's sources, see Carmody's introduction to the *Tresor*, pp. xxii–xxxii; Rosemond Tuve, "Notes on the Virtues and Vices," *Journal of the Warburg and Courtauld Institutes* 26 (1963): 290 et passim; and Skinner, "Ambrogio Lorenzetti," pp. 3 ff.

110. Chenu, *Toward Understanding St. Thomas*, p. 173; James J. Murphy, *Rhetoric in the Middle Ages: A History of Rhetorical Theory from Saint Augustine to the Renaissance* (Berkeley and Los Angeles, 1974), pp. 324–25.

111. Ser Brunetto's text (bk. 2 chap. 84.13) takes the form of a dialogue in which the menaces of Fear—"You will die. You will be decapitated . . . enslaved . . . maligned . . . exiled . . . made poor . . . blinded," etc.—are countered by the counsels of Security. This same dialogue draws a contrast between "the malice of citizens," "the face of the fell tyrant," and virtuous men. As Tuve, "Notes," pp. 290–93, points out, the *Moralium* also specifically contrasts Justice and Injustice—Ser Brunetto's "droitfet" and "torfet" (bk. 2 chap. 110). These distinctions obviously come very close to those made in Lorenzetti's frescoes. Ser Brunetto's textual borrowing can be traced in Carmody's notes to bk. 2 chap. 84; Claude Barlow discusses the attribution of Martin of Braga's "Senecan" *Formulae vitae honestae* in the introduction to his edition of *Martini Episcopi Bracarensis Opera Omnia* (New Haven, 1950), pp. 4–6.

112. *De officiis* 1.43.153, cited, with other classical and medieval references, by Skinner, "Ambrogio Lorenzetti," pp. 18–19; cf. *Tresor* (pp. 228, 232–33). On medieval classifications of the virtues generally: Odon Lottin, *Psychologie et morale aux XIIe et XIIIe siècles*, 6 vols. (Louvain, 1942–60), 1:528–33, 3:153–94, 459–535.

113. So, e.g., late thirteenth-century Italian writers drawing on earlier compilations: Guido Faba, *Summa de vitiis et virtutibus* 1.10, 12, 14, ed. Virgilio Pini, in *Quadrivium* 1 (1956): 99; Bono Giamboni, *Il libro de' vizî e delle virtudi* 36–38, ed. Cesare Segre (Turin, 1968), pp. 48–50.

114. Following the *Moralium dogma philosophorum* again, the *Treasure* divides injustice into cruelty and negligence, then subdivides cruelty into its violent and deceptive forms; both forms are assigned bestial aspects, one of the lion, the other, as it appears in the frescoes, of the snake: bk. 2 chap. 110.7–12. Such distinctions follow from the general practice of dividing ethical qualities into "active" and "passive" categories; along these lines vices of "excess" could be distinguished from vices of "defect," sins of "commission" from those of "omission," etc.: see Lottin, *Psychologie et morale*, 3:155–60.

115. See Lottin, *Psychologie et morale*, 3:186–94.

116. As first observed by Tuve, "Notes," p. 92; Skinner, "Ambrogio Lorenzetti," pp. 28–31, adds further references.

117. Lisini, ed., *Il constituto*, 2:488; on the importance assigned to peace in contemporary political writing, see Skinner, "Ambrogio Lorenzetti," p. 8; Skinner, *Foundations*, 1:44–45, 56–61; and Greenstein, "The Vision of Peace," passim. Cf. the Trecento poet Jacopo del Pecora's line "Correte alle virtù, dov'e' la pace" in Natalino Sapegno, *Il trecento*, 2d ed. (Milan, 1955), p. 133.

118. For the details, see Skinner, "Ambrogio Lorenzetti," p. 27.

119. For *le sens* as "wisdom," see Alexander Murray, *Reason and Society in the Middle Ages* (Oxford, 1978), pp. 77, 236.

120. Aristotle, *Ethica Nicomachea* 5.2.12–13, trans. Robert Grosseteste, ed. Robert Gautier (Leiden, 1972), pp. 233, 236; Thomas Aquinas, *Summa theologiae* 2a, 2ae, q. 61, 2–3, Blackfriars' New English *Summa*, ed. Thomas Gilby (London and New York, 1975), 37:89–98.

121. Skinner, "Ambrogio Lorenzetti," pp. 37–41; Starn, "The Republican Regime," p. 29 n. 27, arrives at similar conclusions. Cf. esp. Rubinstein, "Political Ideas," pp. 182–83.

122. Lorenzo Ghiberti, *I commentari*, ed. Julius von Schlosser (Berlin, 1912), p. 28.

123. *Le prediche volgari di San Bernardino da Siena dette nella piazza del Campo, l'anno 1427*, ed. Luciano Banchi, 3 vols. (Siena, 1880–88), 3:373.

124. Erwin Panofsky, *Renaissance and Renascences in Western Art* (New York, 1969), p. 142; Johan Huizinga, *The Waning of the Middle Ages* (New York, 1955), p. 151. For a historian's version of "realistic visual narrative" in fourteenth-century Italian art, see George Holmes, *Florence, Rome, and the Origins of the Renaissance* (Oxford, 1986), p. 232.

125. Panofsky, *Renaissance and Renascences*, p. 142; Boccaccio's description appears in the fifth tale of the sixth day of the *Decameron*, trans. Richard Aldington (New York, 1930), p. 378. Cf. Derek Pearsall and Elizabeth Salter, *Landscape and Seasons of the Medieval World* (London, 1973), p. 181, where Lorenzetti's work represents "a significant shift toward the landscape of fact"; and Uta Feldges-Henning, *Landschaft als topographisches Porträt: Der Wiederbegin der europäischen Landschaftsmalerei in Siena* (Bern, 1980), pp. 32–35.

126. Cf. Kenneth Clark, *Landscape into Art* (London, 1949), pp. 10–12, and John Barrell, *The Dark Side of the Landscape* (Cambridge, 1980); Ronald Paulson, *Literary Landscape: Turner and Constable* (New Haven and London, 1982); and Ann Bermingham, *Landscape and Ideology, 1740–1860* (Berkeley and Los Angeles, 1986).

127. Panofsky, *Renaissance and Renascences*, p. 139.

128. Feldges-Henning, *Landschaft*, p. 64.

129. John White, *The Birth and Rebirth of Pictorial Space* (London, 1957), pp. 92–96.

130. Greenstein, "The Vision of Peace," p. 497.

131. David C. Lindberg, *Theories of Vision from Al-Kindi to Kepler* (Chicago and London, 1976), pp. 101–2; and Joseph Mazzeo, "Light Metaphysics, Dante's 'Convivio,' and the Letter to Can Grande della Scala," *Traditio* 14 (1958): 212, as cited by Greenstein, "The Vision of Peace," pp. 498, 507 nn. 23, 25.

132. Katherine B. Crum, "Space and Convention in Landscapes of Early Tuscan Painting, 1250–1350" (Ph.D. diss., Columbia University, 1984), pp. 205–11, gives an observant analysis of the details.

133. In Norman Bryson's terms the more literal pole would be "discursive" and the more pictorial one "figural"; see his studies: *Word and Image: French Painting of the Ancien Regime* (Cambridge, 1981), pp. 1–28; *Vision and Painting: The Logic of the Gaze* (New Haven, 1983), pp. 52–66.

134. Frugoni, *Una lontana città*, pp. 157–66, gives a comprehensive account of the iconographical details. For antique motifs and influences see Rowley, *Ambrogio Lorenzetti*, 1:95–96; Mary D. Edwards, "Ambrogio Lorenzetti and Classical Painting," *Florilegium* 2 (1980): 146–60, offers the interesting but inconclusive hypothesis that Lorenzetti was inspired by the accounts of painting in Pliny's *Natural History*. Quentin Skinner suggests that the regal figure amidst the virtues, rather than personifying the Common Good or the commune, is "a symbolic representation of the type of *signore* or *signoria* a city needs to elect if the dictates of justice are to be followed and the common

good secured" ("Ambrogio Lorenzetti," p. 44); but there is no compelling reason to read the inscription evidently identifying this figure (fig. 3: *B1*; appendix 1: *B1 line 1*) as a reference to justice secured *by* a *signore* or to reduce a multivalent personification to one literal meaning. In any case, a similar figure appears labeled as the commune on the nearly contemporary tomb of Bishop Guido Tarlati in the cathedral at Arezzo. See too note 153 below for the apparent copy after Lorenzetti in a context suggesting that the image was associated with the commune.

135. Cf. Angus Fletcher, *Allegory: The Theory of a Symbolic Mode* (Ithaca, 1964), pp. 157–61, 222–24; Meyer Schapiro, *Words and Pictures: On the Literal and the Symbolic in the Illustration of a Text* (The Hague, 1973); and, on light, Paul Hills, *The Light of Early Italian Painting* (New Haven and London, 1987), p. 20. Sixten Rigbom analyzes medieval rules and conventions for pictorial representation under what he calls "the tyranny of literature" in "Some Pictorial Conventions for the Recounting of Thoughts and Experiences in Late Medieval Art," in *Medieval Iconography and Narrative: A Symposium,* ed. Flemming G. Andersen (Odense, 1980), pp. 38–69; see too Belting, "The New Role of Narrative," p. 159.

136. There is no discussion of gender in the literature on the frescoes. Marina Warner, *Monuments and Maidens: The Allegory of the Female Form* (New York, 1985) is a general survey; for the lines of interpretation suggested here, see Christine Brooks-Rose, "Women as a Semiotic Object," and Monique Canto, "The Politics of Women's Bodies," in *The Female Body in Western Culture,* ed. Susan Rubin Suleiman (Cambridge, Mass., 1986), pp. 305–16, 339–52; and in general, the forum on "Engendering Art" in *Representations* 25 (1989): 3–70.

137. On such marriage rituals, see Christiane Klapisch-Zuber, *Women, Family, and Ritual in Renaissance Italy* (Chicago and London, 1985), pp. 183–87.

138. Anna Eorsi, "Donne danzanti sull'affresco: Efficacia del buon governo in città di Ambrogio Lorenzetti," *Acta Historiae Artium Academiae Scientiarum Hungaricae* 24 (1978): 85; Greenstein, "The Vision of Peace," pp. 502–3.

139. Otto Pächt, "Early Italian Nature Studies and the Early Calendar Landscape," *Journal of the Warburg and Courtauld Institutes* 12 (1950): 41. Cf. James Carson Webster, *The Labors of the Months in Antique and Medieval Art* (Evanston and Chicago, 1938); Bruno Bresciani, *Figurazioni dei mesi nell'arte medioevale italiana* (Verona, 1968); and Pearsall and Salter, *Landscape and Seasons,* pp. 119 ff.

140. Feldges-Henning, "The Pictorial Programme," pp. 151–57; Christopher A. Knight, "Allegorical Genre in Ambrogio Lorenzetti's 'The Effects of Good Government in the City and the Country,'" *Apocrypha* 2 (1975): 18–23, adds further details. P. Sternagel, *Die artes mechanicae im Mittelalter: Begriffs- und Bedeutungsgeschichte bis zum Ende des 13. Jahrhunderts* (Kallmünz, 1968) is the best study on the Mechanical Arts scheme.

141. Greenstein, "The Vision of Peace," p. 503.

142. These correlations seem at once forced and not closely correlated enough. It is the wedding scene, not the dance, that appears under Venus in the frame above; Spring appears above the dancing figures, so that their motivation need not be considered astrological at all. On the other hand, the papal coat of arms is located over the gate, where it would signal the Guelph allegiance of the city; there is no particularly salient reason why Mercury should appear over the hunters just outside the city gate, but Summer presides appropriately enough over the harvest scenes, and the Moon is the "planet" we might expect to find over the body of water (the so-called *Lacus Selva*) and the port of Talamone labeled at the far edge of the picture.

143. Luisa Cogliati Arano, *The Medieval Health Handbook,* trans. Oscar Ratti and Adele Westbrook (New York, 1970); Brucia Witthoft, "The *Tacuinum Sanitatis:* A Lombard Panorama," *Gesta* 17 (1978): 49–60.

144. Arano, *Handbook*, p. 14.

145. Ibid., p. 6.

146. Sherwood A. Fehm, "Notes on the Statutes of the Sienese Painters' Guild," *Art Bulletin* 44 (1972): 198–200; for guild and workshop practices, see the recent exhibition catalogue *Art in the Making: Italian Painting before 1400*, ed. David Bomford, Jill Dunkerton, Dillian Gordon, and Ashak Roy (London, 1989), pp. 9–11.

147. Cf. Partsch, *Profane Buchmalerei*, fig. 162, for the same figure from the Laurenziana manuscript of Ser Brunetto Latini's *Treasure.*

148. Cf. Partsch, *Profane Buchmalerei*, pp. 27, 35, 42.

149. See ibid.; and Giuliano Pinto, *Il libro del biadaiolo: carestia e annona a Firenze dalla metà del '200 al 1348* (Florence, 1978).

150. K. Hoffmann-Curtius, *Das Programm der Fontana Maggiore in Perugia* (Düsseldorf, 1968); John White, "The Reconstruction of Nicola Pisano's Perugia Fountain," *Journal of the Warburg and Courtauld Institutes* 33 (1970): 70–83; Luisa Becherucci, *Andrea Pisano nel campanile di Giotto* (Florence, 1965).

151. Peter Burke, "Classifying the People: The Census as Collective Representation," in his *The Historical Anthropology of Early Modern Italy* (Cambridge, 1987), pp. 27–39.

152. See Stefanini's comments in Bonvesin da la Riva, *Volgari scelti*, trans. Patrick S. Diehl and Ruggero Stefanini (New York, 1987), pp. 237–38; and Villani, *Cronica* 11:91–94, ed. Dragomanni, 4:173–78. See, in general, J. K. Hyde, "Medieval Descriptions of Cities," *Bulletin of the John Rylands Library* 48 (1965–66): 308–40.

153. The basic surveys are by Bruce Cole, *Sienese Painting from Its Origins to the Fifteenth Century* (New York, 1980); Enzo Carli, *La pittura senese del trecento* (Venice, 1981); and the exhibition catalogue *Il gotico a Siena: Miniature, pitture, oreficerie, oggetti d'arte* (Florence, 1982). See *Le Biccherne: Tavolette dipinte delle magistrature senesi (secoli XIII–XVIII)*, ed. Luigi Borgia, Enzo Carli, Maria Assunta Ceppari, Patrizia Sinibaldi, and Carla Zarilli (Rome, 1984), pp. 21–30, and, for the Common Good cover of 1344, pp. 96–97; for Sienese fiscal records, which are among the most extensive for any medieval city-state, see William M. Bowsky, *The Finance of the Commune of Siena, 1287–1355* (Oxford, 1970).

154. Fritz Hertter, *Die Podestaliteratur Italiens im 12. und 13. Jahrhundert* (Leipzig, 1910); Angelo Sorbelli, "I teorici del reggimento comunale," *Bullettino dell'Istituto Storico Italiano* 59 (1944): 31–136.

155. Lodovico Antonio Muratori, ed., *Oculus pastoralis*, vol. 4 in *Antiquitates italicae* (Milan, 1738–42), cols. 110–52; the quotation is in col. 123; a new edition has been published by D. Franceschi in *Memorie dell'Accademia delle Scienze di Torino* 11 (1966): 3–19; for the disputed date of the work, see Skinner, "Ambrogio Lorenzetti," p. 3 n. 3.

156. Archivio di Stato di Siena, *Concistoro*, 1 (1338); the references below are to this source.

157. Eorsi, "Donne danzanti," p. 502.

158. Cf. Feldges-Henning, "The Pictorial Programme," pp. 159–61.

159. Agnolo di Tura, "Cronaca," in *Cronache senesi*, ed. Lisini and Iacometti, p. 523.

160. The chronicle of Donato di Neri in Lisini and Iacometti, eds., *Cronache senesi*, pp. 576–79, is the main source for these events. There are further details from the archives in Julien Luchaire, *Documenti per la storia dei rivolgimenti politici del commune di Siena dal 1354 al 1369* (Lyons, 1906); Pietro Rossi, "Carlo IV di Lussemburgo e la repubblica di Siena, 1355–69," *Bullettino senese di storia patria* 38 (1930): 5–39, 179–242, examines at pp. 7–15 the diplomatic background. For a brief account and further research, see Bowsky, *A Medieval Italian Commune*, pp. 298–306.

161. Cf. Victor Rutenberg, "La vie et la lutte des Ciompi de Sienne," *Annales: Econo-*

mies, sociétés, civilisations 20 (1965): 95–109; and Bowsky, *A Medieval Italian Commune,* pp. 306–14.

II. THE CAMERA PICTA IN MANTUA

1. From Galeazzo Maria Sforza's instructions on 3 April (fols. 51–52) to the report on 29 April 1470 (fol. 38) that a new contract had been sealed with Ludovico Gonzaga, there are twenty-five letters by or from the ambassadors, Pietro da Pusterla and Messer Tommaso de' Tedaldi da Bologna, or their secretary Marco Trotto in Archivio di Stato di Milano, Archivio Ducale Sforzesco (hereafter ASMil, ADS), Potenze Estere, 395. Copies of the contracts that Francesco Sforza and his son Galeazzo Maria had negotiated with Marchese Ludovico every three or four years since November 1450 are in ASMil, ADS, Registri, 37, pp. 193, 202, 208–16 of the modern pagination; the actual 1470 contract survives in a file of Gonzaga *condotte* in the Archivio di Stato di Mantova, Archivio Gonzaga (hereafter ASMan, AG), 51, no. 2, together with the ratification by Galeazzo Maria and his secretary Cicco Simonetta, dated Pavia, 7 May 1470 (no. 3). ASMan, AG, 386, ad annum, contains a *motu proprio* illuminated with Sforza heraldic devices in which Galeazzo Maria named Ludovico Gonzaga lieutenant general on 30 April 1470. Vincent Illardi reviews the relatively few publications on Milanese diplomacy and diplomatic correspondence, "the most extensive in Europe," in "The Visconti-Sforza Regime of Milan: Recently Published Sources," *Renaissance Quarterly* 31 (1978): 339–42. The classic survey is Garrett Mattingly, *Renaissance Diplomacy* (Boston, 1955). The Sforza court during these years has been studied in detail by Gregory P. Lubkin, "The Court of Galeazzo Maria Sforza, Duke of Milan (1466–1476)" (Ph.D. diss., University of California, Berkeley, 1982).

2. ASMil, ADS, Potenze Estere, 395, doc. 65; this letter has been published by Antonia Tissoni Benvenuti, "Un nuovo documento sulla 'Camera degli Sposi' del Mantegna," *Italia medioevale e umanistica* 24 (1981): 357–60.

3. Rodolfo Signorini incorporates and extends more than a decade of research in *Opus Hoc Tenue: la Camera Dipinta di Andrea Mantegna; lettura storica, iconografica e iconologica* (Parma, 1985); even where they take issue with him, the following pages are indebted to Professor Signorini's work and to his generous encouragement. The standard earlier monograph is Luigi Coletti and Ettore Camesasca, *La Camera degli Sposi del Mantegna a Mantova* (Milan, 1959); there is a brief guide by Giovanni Paccagnini, *Mantegna. La Camera degli Sposi* (Milan, 1968). The scholarly literature on Mantegna is cited, synthesized, and on many points superseded by Ronald Lightbown, *Mantegna* (Berkeley and Los Angeles, 1986), which includes a chapter (pp. 99–117) and an extensive bibliography (pp. 499–503) on the Camera; Paul Kristeller, *Andrea Mantegna* (Engl. trans. London, 1901; German ed. Berlin, 1902), one of the great early art historical monographs, is still invaluable for critical judgments and the appendix of documents. The most recent interpretations, both containing new material and insights, are by Claudia Cieri Via, "Il luogo della corte: la 'Camera Picta' di Andrea Mantegna nel palazzo ducale di Mantova," *Quaderni di Palazzo Te* 6 (1987): 23–44; and Daniel Arasse, "Il programma politico della Camera degli Sposi, ovvero il segreto dell'immortalità," in ibid., pp. 45–64.

4. Documents published by Rodolfo Signorini, "Lettura storica degli affreschi della 'Camera degli Sposi' di Mantegna," *Journal of the Warburg and Courtauld Institutes* 38 (1975): 109–11, indicate that Mantegna must have begun his work around the date of the simulated graffito "1465. d. 16 iunii" painted on the north window embrasure; reviewing the question of dating, Signorini, *Opus Hoc Tenue,* pp. 115–16, and Light-

bown, *Mantegna*, pp. 115–16, suggest that the ambassadors may have seen only drawings on the walls in 1470. Michele Cordaro, "Aspetti dei modi di esecuzione della 'Camera picta' di Andrea Mantegna," *Quaderni di Palazzo Te* 6 (1987): 9, concludes that the ceiling was painted first, followed, respectively, by the north (the court), east, south, and west (the Meeting) walls.

5. Giovanni Paccagnini, *Il Palazzo Ducale di Mantova* (Turin, 1969), is the standard work; for the functions and symbolism of the tower, see Cieri Via, "Il luogo della corte," pp. 23–25.

6. Signorini, *Opus Hoc Tenue*, pp. 248–49, documents the marchese's references to "nostra camera" and concludes that in keeping with princely practice elsewhere he slept and held audiences there; the marchesa, as was also customary, evidently had her own quarters. A curtained bed for the marchese was probably located in the southeast corner, with tooled leather hangings on the walls behind it; oriental carpets and velvet-upholstered chairs are mentioned in the Gonzaga correspondence, and Signorini believes that the Camera contained furnishings similar to the carpets and the marchese's faldstool shown in the court scene: ibid., pp. 150–51. For objects housed in the room, perhaps in the cupboard with a wooden door on the south wall or in the recently discovered niche under the painted curtain on the west wall, see Cieri Via, "Il luogo della corte," p. 25.

7. In 1366 Galeazzo Visconti invited artists from Mantua to paint a number of rooms; in 1380 his son Giangaleazzo sent for another group of Mantuan painters "to paint hunts and various figures in certain halls and rooms of our castle in Pavia": R. Maiocchi, *Codice diplomatico artistico di Pavia dall'anno 1330 all'anno 1530* (Pavia, 1939), 1:2–3, 5, as cited by Evelyn Samuels Welch, "Galeazzo Maria Sforza and the Castello di Pavia, 1469," *Art Bulletin* 71 (1989): 353.

8. Andrew Martindale, "Painting for Pleasure: Some Lost Fifteenth-Century Secular Decorations of Northern Italy," in *The Vanishing Past: Studies in Medieval Art, Liturgy and Metrology Presented to Christopher Hohler*, ed. Alan Borg and Andrew Martindale (London, 1981), p. 124 n. 20, refers to the unpublished inventory of 1407 and a duplicate in ASMan, AG, 329. For painted rooms in the Gonzaga palace before Mantegna, see Joanna Woods-Marsden, *The Gonzaga of Mantua and Pisanello's Arthurian Frescoes* (Princeton, 1988), esp. pp. 3–8.

9. Charles M. Rosenberg, "Courtly Decorations and the Decorum of Interior Space," in *La corte e lo spazio: Ferrara estense*, ed. G. Papagno and A. Quondam (Rome, 1982), pp. 529–44.

10. See Martindale, "Painting for Pleasure," esp. pp. 127–28 n. 55; Samuels Welch, "Galeazzo Maria Sforza," pp. 352–53; and R. Varese, ed., *Atlante di Schifanoia* (Ferrara, 1989).

11. The specifications for the lost Milanese court scenes are in Luigi Beltrami, *Il castello di Milano* (Milan, 1894), p. 280; cf. Martindale, "Painting for Pleasure," p. 128 n. 55. The Ferrarese evidence comes from the descriptions (1497) of the palaces of Belriguardo and Belfiore by Giovanni Sabadino degli Arienti: Werner Gundersheimer, *The "De triumphis religionis" of Giovanni Sabadino degli Arienti: Art and Life at the Court of Ercole I d'Este* (Geneva, 1972), p. 109. For image making at Milan in another medium, see Gary Ianziti, *Humanistic Historiography under the Sforzas: Politics and Propaganda in Fifteenth-Century Milan* (Oxford, 1988).

12. Marchesa Barbara's dwarf has not been identified by name, but see Signorini, *Opus Hoc Tenue*, p. 286 n. 123. The Gonzaga palace included a *camera a nanis* in the fourteenth century, and Pisanello inserted several dwarf knights in his Arthurian cycle of the 1440s: Alessandro Luzio and Rodolfo Renier, "Buffoni, nani e schiavi dei Gonzaga ai tempi d'Isabella d'Este," *Nuova antologia di scienze, lettere ed arti*, s. 3, 34

(1891): 619–50; 35 (1891): 113–46; Woods-Marsden, *The Gonzaga and Pisanello's Arthurian Frescoes*, pp. 132–33.

13. See above, p. 315, note 38, for guides to a vast literature; and for the most recent synthesis, with extensive bibliography, Denys Hay and John Law, *Italy in the Age of the Renaissance, 1300–1530* (London and New York, 1989), pp. 236–44.

14. F. Amadei, *Cronaca universale della città di Mantova* (1745), ed. G. Amadei, E. Marani, and G. Pratico, 5 vols. (Mantua, 1954–57) is fundamental; based on extensive archival research, *Mantova: la storia*, 3 vols. by F. Coniglio, L. Mazzoldi, and R. Giusti (Mantua, 1958–63) is the standard modern survey. The more useful recent studies appear in conference volumes and collaborative histories: Carlo Mozzarelli, "Lo stato gonzaghesco: Mantova dal 1382 al 1707," in *I ducati padani, Trento e Trieste*, vol. 17 of *Storia d'Italia*, ed. Giuseppe Galasso (Turin, 1979); Mario Vaini, "Economia e società a Mantova dal Trecento al Cinquecento," in *La corte e "Il Cortegiano*," ed. Adriano Prosperi (Milan, 1980), pp. 275–319. For the Virgil statue, see Rodolfo Signorini, "Two Notes from Mantua," *Journal of the Warburg and Courtauld Institutes* 41 (1979): 320–21.

15. Alessandro Luzio, "I Corradi di Gonzaga, signori di Mantova," *Archivio storico lombardo* 40 (1913): 247–82; the most useful modern history of the family (with bibliography) is Giuseppe Coniglio, *I Gonzaga* (Varese, 1967).

16. M.Cattini and M. Romani, "Le corti parallele: Per una tipologia delle corti padane dal XIII al XVI secolo," in *La corte e lo spazio*, ed. G. Papagno and A. Quondam (Rome, 1982), pp. 47–82.

17. In the typology of Cattini and Romani, ibid., p. 62, Ludovico Gonzaga's court represents the *corte signorile* that arose between the earlier decentralized "consortial" and the sixteenth-century "bureaucratic-ritual" courts of Lombardy.

18. See the fiscal accounts for 1384 in ibid., p. 56.

19. For Gonzaga patronage generally: *Mantova: le arti*, vol. 2, ed. E. Marani (Mantua, 1961) and vol. 3, ed. C. Perina (Mantua, 1965); *Arte, pensiero e cultura a Mantova nel primo Rinascimento in rapporto con la Toscana e con il Veneto* [Atti del VI Convegno Internazionale di Studi sul Rinascimento, 27 September–1 October 1961] (Florence, 1965); Giuseppe Amadei and E. Marani, *I Gonzaga a Mantova* (Milan, 1975); *Mantova e i Gonzaga nella civiltà del Rinascimento* [Atti del convegno organizzato dall'Accademia Nazionale dei Lincei e dall'Accademia Virgiliana . . . , Mantua, 1974] (Milan, 1978); Mario Dall'Acqua, "Mecenatismo e collezionismo dei Gonzaga da Ludovico a Isabella d'Este," in *La corte e "Il Cortegiano*," ed. Adriano Prosperi (Milan, 1980), pp. 295–315; D. S. Chambers and J. Martineau, eds., *Splendours of the Gonzaga* (exhibition catalogue, Victoria and Albert Museum; London, 1981). A major study of urban planning and artistic production under the Gonzaga has been promised by Kurt W. Forster. For additional bibliography, see Woods-Marsden, *The Gonzaga and Pisanello's Arthurian Frescoes*, pp. 255–58.

20. "Veramente per quello possiamo comprender questo sig.e marchese è benissimo disposto, ma non po fare che non segna, quello è suo naturale instinto, ad dire volenter quello che ha in l'animo": ASMil, ADS, Potenze Estere, 395, fol. 76 (11 April 1470); a few months earlier, preoccupied with the tensions between Naples and Milan, which had both contributed to his *condotta* since 1466, the marchese wrote to his confidant and agent in Milan that "maj trovamo in magior affanno di mente che quando siamo in simile animo; perchè quando habiamo promesso e che siamo obligati, sè ben vedessemo la manifesta ruina del stato nostro e che fossimo per perder la propria vita, voressimo attender le promesse e non manchar de la fede nostra": ibid., no pagination (Ludovico Gonzaga to Zaccaria Saggi, 25 February 1470). The 1475 medal of the marchese by Bartolomeo Melioli is inscribed: FIDO · ET · SAPIENTI · PRINCIPI · FIDES · ET · PALLAS · ASSISTUNT (Faith and Pallas [goddess of wisdom] attend the faithful and

wise prince). The marchese, dressed in armor, crowned with a wreath, is seated over a dog, as in the Camera, and faces the personifications of Faith, with the upraised finger, and Wisdom, with the Medusa shield. For the medal and the iconography of fidelity at Ludovico's court, see Signorini, *Opus Hoc Tenue*, pp. 189–90. Woods-Marsden, *The Gonzaga and Pisanello's Arthurian Frescoes*, pp. 76–77, cites other examples of his self-professed but widely credited integrity.

21. The marchese wrote to Zaccaria Saggi on 12 April 1469 that the "propria veritate" and "cagione vera" for not sending jousters to Milan was "perchè non vorissimo [*sic*] che tra quelli de sua ex. et nostri potessi per modo alchuno nascere nè guerra nè discordia" (ASMil, ADS, Potenze Estere, 395, doc. 13). Two years later he was inquiring about his eldest son's "progresso ala giostra" (Barbara to Ludovico Gonzaga, 13 September 1472; ASMan, AG, 2101, fol. 117).

22. R. Quazza, *La diplomazia gonzaghesca* (Milan, 1941), pp. 40–43; cf. in general Giovanni Soranzo, *La lega italica (1454–1455)* (Milan, n.d.); and Michael Mallett, "Diplomacy and War in Late Fifteenth-Century Italy," *Proceedings of the British Academy* 67 (1981): 273–75. In a characteristic appeal, the marchese asked the ambassadors to remind their master "che vorìa vedere tutta la liga unita bene insieme ad unum, et unum vole per ben de Italia et sicurezza sua": ASMil, ADS, Potenze Estere, 395, fol. 73 (11 April 1470). Some years later, declaring that it was his habit and nature to speak "sinceramente et con la fede nostra usata," he instructed Zaccaria Saggi to assure Galeazzo Maria that he expected from the duke "ogni opera possibile per la conservatione del nostro, come anche noi havemo facto et faressimo per la conservatione et mantenimento del suo, dependendo el nostro da quello"; but Galeazzo Maria was also to understand that the marchese assumed "che quella [sua Excellentia] non debia puncto venire al acto de la guerra et ch'ella saperà pigliarli tale modo et via per la sua prudentia et intelligentia ch'ella non haverà ad venirli": ASMil, ADS, Carteggio, 396, fol. 90 (27 April 1476).

23. So, e.g., Dall'Acqua, "Mecenatismo," p. 295, on "una vera e propria 'rivoluzione' nel principe e nelle sue scelte estetiche, con il passagio dal gotico al umanesimo"; or Paolo Carpeggiani, "I Gonzaga e l'arte," in *Mantova e i Gonzaga*, p. 168, on the rejection of "anachronismi screditati agli occhi di Ludovico, il quale, ben presto, assume il ruolo di promotore di un articolato programma di rinnovamento culturale e artistico."

24. In the considered view of Woods-Marsden, *The Gonzaga and Pisanello's Arthurian Frescoes*, pp. 82–83, "a change in artistic taste undeniably took place at the court of Mantua between the painting of the [Sala del Pisanello in the late 1440s] and Mantegna's arrival in 1460. To connect this shift from chivalric to classical themes, however, to the reigns and personalities of the two successive Marchesi distorts historical reality. No abrupt break in artistic policy took place between Gianfrancesco and Lodovico. . . . The first decade of Lodovico's marquisate should accordingly be regarded as a transitional period both for the region and for its patrons in terms of supply of, and demand for, works *all'antica*. During these years Lodovico at first followed prevailing court taste and then slowly developed his preference for the new style, influenced by artists, such as Fancelli and Donatello, who practiced it, and princes, such as Cosimo de' Medici and Sigismondo Malatesta, who patronized it." Marchese Ludovico's literary leanings, however, did not follow this pattern; like many princely and patrician patrons (and unlike humanist critics and the literary historians who have followed them), the marchese was apparently able to combine classical and chivalric pursuits (ibid., pp. 83–85, for evidence and bibliography). For the details on the marchese's classical education, see Signorini, *Opus Hoc Tenue*, pp. 23–27, 45–47.

25. This story is told by Francesco Prendilacqua, *De vita Victorini Feltrensi dialogus* in

Il pensiero pedagogico dell'umanesimo, ed. Eugenio Garin (Florence, 1958), pp. 600–601.

26. Platina, *Historia* in *Thesaurus Antiquitatum et Historiarum Italiae,* ed. J. G. Graevius, 10 vols. (Amsterdam, 1704–25), vol. 4, pt. 2, col. 201, as quoted by Lightbown, *Mantegna,* p. 83; Signorini notes (*Opus Hoc Tenue,* p. 23) that Platina also saluted Ludovico for his military prowess and political virtue as a new Cato and paid tribute to his learning in *Divi Ludovici marchionis Mantuae somnium,* ed. A. Portioli (Mantua, 1887), p. 22, and in a panegyric published in Amadei, *Cronaca universale,* 2:226–34.

27. *Filarete's Treatise on Architecture,* trans. J. R. Spencer, 2 vols. (New Haven and London, 1965), 1:380.

28. For connections between the council and artistic commissions, see esp. *Mantova: la storia,* 2:13–18; *Mantova: le arti,* 2:260–65; Carpeggiani, "I Gonzaga e l'arte," pp. 167–77. The basic works on the new architecture in Mantua are E. J. Johnson, *S. Andrea in Mantua: The Building History* (College Station, Pa., 1975); D. S. Chambers, "Sant'Andrea at Mantua and Gonzaga Patronage," *Journal of the Warburg and Courtauld Institutes* 40 (1977): 99–127; A. Calzona, *Mantova, città dell'Alberti. Il S. Sebastiano: tomba, tempio, cosmo* (Parma, 1979); C. Vasić Vatoveć, *Luca Fancelli, architetto: epistolario gonzaghesco* (Florence, 1979). On Mantegna's entry into Gonzaga service see Kristeller, *Mantegna* (1902 ed.), p. 89; and for a concise account incorporating more recently discovered documents, Lightbown, *Mantegna,* pp. 76–78.

29. See, e.g., Werner Gundersheimer, *Ferrara: The Style of a Renaissance Despotism* (Princeton, 1973).

30. Leon Battista Alberti, *On Painting* 2.27 and 2.46, trans. Cecil Grayson (London, 1972), pp. 63, 89; see the recent important book by Mark Jarzombek, *On Leon Battista Alberti: His Literary and Aesthetic Theories* (Cambridge, Mass., 1990), esp. pp. 85 ff.

31. The basic work on Renaissance mirrors-of-princes genre is Alan Gilbert, *Machiavelli's Prince and Its Forerunners* (Durham, N.C., 1938); Quentin Skinner, *The Foundations of Modern Political Thought,* 2 vols. (Cambridge, 1978), 1:128–38, cites and extends the literature on Machiavelli's subversion of the genre. For a fresh analysis of the problematic of appearances in Machiavelli, see Sebastian de Grazia, *Machiavelli in Hell* (Princeton, 1989), pp. 293–317.

32. Michelangelo Muraro, "Mantegna e Alberti," in *Arte, pensiero e cultura a Mantova,* pp. 103–32; F. Arcangeli, "Un nodo problematico nei rapporti fra L. B. Alberti e Mantegna" and Lionello Puppi, "Il trasferimento del Mantegna a Mantova: Una data per l'incontro con l'Alberti," in *Andrea Mantegna e Leon Battista Alberti* (Mantua, 1972), pp. 12–14, 15–20. According to Lightbown, *Mantegna,* p. 38, the painter "had not mastered the principle of Alberti's perspective . . . before 1450 . . . [but] it seems plausible to suppose that a copy of Alberti's treatise on painting or some other means of instruction fell in Mantegna's way in 1450." Mantegna could have met Alberti on any number of the latter's visits to Mantua (1461, 1463 for nearly a year, 1465, 1470) and during the court's trip to the baths at Poretta in 1472.

33. Alberti, *On Painting* 2.35–40, pp. 73–81; cf. Jarzombek, *On Leon Battista Alberti,* pp. 103–8.

34. Alberti, *On Painting* 2.40, pp. 79–81.

35. Erwin Panofsky, "The History of the Theory of Human Proportions as a Reflection of the History of Styles," in *Meaning in the Visual Arts* (Garden City, N.Y., 1957), pp. 105–6; cf. Michael Ann Holly, *Panofsky and the Foundations of Art History* (Ithaca, N.Y., 1984), pp. 136–42. Kenneth Clark, *The Nude: A Study in Ideal Form* (Garden City, N.Y., 1959) is a canonical text on the foreclosure of politics by the "ideal" representation of the body; for the persistence of the canon, despite a burgeoning critical literature, see Patricia Simons's review essay of *Bodylines: The Human Figure in Art,* ed. Felic-

ity Woolf and Michael Cassin (exhibition catalogue; London, The National Gallery, 1987), in *Art History* 10 (1987): 541–49.

36. Marcel Mauss, "Les techniques du corps," *Journal de la psychologie* 31 (1936): 177–93; for subsequent studies see Jonathan Benthall and Ted Polhemus, eds., *The Body as a Medium of Expression* (New York, 1975); and the two remarkable collections of essays, Catherine Gallagher and Thomas Laqueur, eds., *The Making of the Modern Body* (Berkeley and Los Angeles, 1987), and Michel Feher, ed., *Fragments for a History of the Human Body*, 3 vols. (*Zone*, nos. 3–5; New York, 1989). The most recent work, with extensive bibliography, on the symbolism of the royal body is Sergio Bertelli, *Il corpo del re: Sacralità del potere nell'Europa medievale e moderna* (Florence, 1990).

37. Randolph Starn, "Reinventing Heroes in Renaissance Italy," in *Art and History: Images and Their Meaning*, ed. Robert I. Rotberg and Theodore K. Rabb (Cambridge, 1988), pp. 67–84.

38. Mary Douglas, *Natural Symbols: Explorations in Cosmology*, 2d ed. (London, 1973), p. 101.

39. Kristeller, *Mantegna* (1901 ed.), p. 237, suggested a pavilion; Elizabeth Welles proposes a platform erected for festivals in "A New Source for the Architecture of Mantegna's Camera degli Sposi," *Source* 2 (1983): 10–15. Other scholars have argued that the model for the architecture was classical or Byzantine: cf. Cieri Via, "Il luogo della corte," p. 28, on Renaissance conceptions of the Roman atrium, complete with curtained portico, hearth, painted walls, and symbolic centrality in the household; and Bertelli, *Il corpo del re*, p. 133, who suggests that the format derived from the wooden tribune (*prokypsis*) draped with gold curtains (*katapètasmata*) for the ritual appearances of Byzantine emperors. In the opinion of Lightbown (*Mantegna*, pp. 101–2), "if there was a guiding principle of overall simulation in the conception, it was the transformation of a square chamber in a frowning tower into one that was in part a rich tapestried chamber, in part a bright garden room."

40. Cordaro, "Aspetti dei modi di esecuzione," p. 17.

41. Despite the notorious unreliability of Renaissance portraits and much controversy over the identities of the figures in the court scene, Lightbown (*Mantegna*, pp. 105–6) and Signorini (*Opus Hoc Tenue*, pp. 133–34) agree on these identifications; cf., however, Cieri Via, "Il luogo della corte," pp. 28–29. For Rubino and the marchese's fondness for white mastiffs (*alani*) such as those on the Meeting wall, see Rodolfo Signorini, "A Dog Named Rubino," *Journal of the Warburg and Courtauld Institutes* 41 (1978): 317–20, and Signorini, *Opus Hoc Tenue*, pp. 186–94. For court dwarfs, see note 12 above; as David Kuchta has shown, court dwarfs took the parts of alter ego, jester, and abject victim ("The Patronage of Dwarfs in Early Modern Europe"; seminar paper, University of California, Berkeley, 1986).

42. Cieri Via, "Il luogo della corte," p. 36 et passim is especially insistent on such "symbolic" readings.

43. Signorini, *Opus Hoc Tenue*, p. 246, reviews the preceding identifications of the male figure in three-quarter profile and prefers Alberti; Cieri Via, "Il luogo della corte," p. 31, identifies him as Vittorino. Lightbown, *Mantegna*, p. 106, suggests the marchese's intimates Zaccaria Saggi and Marsilio Andreasi for the two elderly men and "an old nurse or a widow serving as duenna" for the older woman behind the younger Barbara Gonzaga.

44. Signorini tentatively identified this figure as Marchese Ludovico's eldest brother, Alessandro, in "Lettura storica," p. 123, but leaves him anonymous in *Opus Hoc Tenue*, pp. 131, 133.

45. For similar effects in Borso d'Este's Salone dei Mesi at Ferrara, see Luciano Cheles,

"L'immagine del principe tra informalità e ostentazione," in *Atlante di Schifanoia*, pp. 57–63.

46. Arasse, "Il programma politico," pp. 55–56, gives a particularly telling account of the political implications of the composition.

47. On this incident Rodolfo Signorini, "Federico III e Cristiano I nella Camera degli Sposi di Mantegna," *Mitteilungen des Kunsthistorischen Institutes in Florenz* 18 (1974): 230–32, quotes the correspondence between the marchese and Zaccaria Saggi in November and early December 1475; see now Signorini, *Opus Hoc Tenue*, pp. 170–81. For contemporary critical terms see Michael Baxandall, *Painting and Experience in Fifteenth-Century Italy* (Oxford, 1972), pp. 128–35.

48. Reviewing the evidence, Lightbown, *Mantegna*, pp. 109–11, questions Signorini's identification of Frederick III as the figure in profile dressed in a yellow and blue tunic to the left of Federico Gonzaga and proposes "on grounds of age, dignity, and costume" that the emperor is the personage wearing a red *berretta capitanesca* between these two figures. However, the reddish hair and black attire of the figure behind Cardinal Francesco's left shoulder correspond, Lightbown points out, to some (but not all) descriptions of the Danish king on his Italian pilgrimage of 1474. Mantegna must have seen the king on his visits to Mantua in March and May 1474; he evidently accompanied the Gonzaga party that received titles from the emperor at Ferrara in 1468: Signorini, "Federico III e Cristiano I," pp. 227–30, 233. To suggest just how problematic such identifications are, the figure in the red *berretta* bears a striking resemblance to the Bonsignori portrait of Francesco Sforza in the National Gallery, Washington, D.C. This portrait has been attributed to Mantegna himself and is inscribed *An. Mantinia;* it has been proposed that the National Gallery image was copied after Mantegna by Bonsignori: Fern Rusk Shapley, *Catalogue of the Italian Paintings, National Gallery of Art, Washington,* 2 vols. (Washington, D.C., 1979), 1:75–76; 2:plate 49. Moreover, the figure in profile, third from the right, looks rather like Pollaiuolo's *Galeazzo Maria Sforza* in the Uffizi: L. D. Ettlinger, *Antonio and Piero Pollaiuolo* (Oxford and New York, 1978), cat. no. 13, plate 69. It may be that Marchese Ludovico inserted his Sforza patrons after all.

49. This interpretation follows from Lightbown's reconstruction (*Mantegna,* p. 104) of the ideal viewpoints for the marchese and his consort implied by the pictures.

50. Prendilacqua, *De vita Victorini,* p. 596. This remarkable case of Renaissance self-fashioning is worth quoting at length: "Con accorto artificio [Vittorino] dominò la lascivia della carne diminuendo via la varietà dei cibi, che è il più efficace coefficiente della golosità; e così lo ridusse ad un regime di vita semplice. Soddisfatto di averlo tratto alla mensa comune, lasciò dapprima che il ragazzo ne godesse a volontà, usando una via di mezzo tra la severità e l'indulgenza, per non offenderne l'animo delicato e suscettibile con l'uso intempestivo di sproni e di freno. A volte, convocati durante il pasto dei cantori, o col suon della lira o con altra attrazione, a tal segno incantava il tenero animo, che, preso da nuovo diletto, accadeva che il giovinetto si levasse di tavola quasi digiuno. Avvenne così che in pochi mesi, senza nessun rigore, riacquistò una bellissima linea e diventò quanto mai parco di cibi e bevande. Regola che in seguito, giunto al governo della nostra città, come possiamo ancora vedere, continuò ad osservare con assoluta costanza: padrone di sè a tal punto da potere, con la maggior facilità, ingrassare in pochi giorni e poi di nuovo dimagrare, sottoponendosi ad una dieta rigorosa." See Rodolfo Signorini, "Manzare poco, bevere acqua assai e dormire poco," in *Vittorino da Feltre e la sua scuola: umanesimo, pedagogia, arte,* ed. N. Giannetto (Atti del Convegno di Studi promosso dalla Fondazione Cini; Florence, 1981), pp. 115–48.

51. Andrea da Schivenoglia, *Cronaca,* Biblioteca Comunale of Mantua, MS 1019, fol.

40r, describing Federico at twenty-one and Francesco at nineteen in an entry of 5 February 1462; a faulty edition was published by Carlo d'Arco, in G. Müller, ed., *Raccolta di cronisti e documenti storici lombardi* (Milan, 1857), vol. 2. See E. Marani, "Il codice 1019 della Biblioteca Comunale di Mantova ossia il manoscritto autografo del memoriale di Andrea da Schivenoglia," *Civiltà Mantovana*, n.s., 5 (1984): 1–9. A new edition has been promised by Rodolfo Signorini.

52. These descriptions are from Schivenoglia's list (*Cronaca*, fols. 53v, 54v) of members of the marchese's council and "alchunj oficiallj principallj."

53. "Importono le picchole coxe in queste faccende di signori": Marco Trotto to Galeazzo Maria Sforza, Mantua, 10 April 1470, ASMil, ADS, 395, fol. 68.

54. Ibid., fol. 65 (10 April 1470); fol. 73 (11 April 1470).

55. Ibid., fol. 43 (14 April 1470).

56. Ibid., fol. 66 (9 April 1470); G. Rodella, "Tradizione diplomatica e cortegianesca nella famiglia Castiglione," in *Baldassare Castiglione, 1478–1978* (Viadana, 1978), pp. 16–17, discusses the career of this founder of the family's fortunes at court.

57. Roland Barthes, "The Reality Effect," in *The Rustle of Language*, trans. Richard Howard (New York, 1966), pp. 141–48. Cf. Michael Podro, *Critical Historians of Art* (New Haven and London, 1982), esp. pp. 6–12, for the idealizing strains in the founders of modern art history; and for "a pervasive valorization of the minute, the partial, and the marginal" in poststructuralist criticism, Naomi Schor, *Reading in Detail: Aesthetics and the Feminine* (New York, 1987), p. 3 et passim.

58. See Michael Baxandall, *Giotto and the Orators: Humanist Observers of Painting in Italy and the Discovery of Pictorial Composition, 1350–1450* (Oxford, 1971; corrected ed. 1986), esp. pp. 51–66, 78–96.

59. Alberti, *On Painting*, 2.40, p. 79.

60. Baxandall, *Giotto and the Orators*, pp. 127–39.

61. Cecil H. Clough, "The Cult of Antiquity: Letters and Letter Collections," in *Cultural Aspects of the Italian Renaissance: Essays in Honour of Paul Oskar Kristeller*, ed. Cecil H. Clough (Manchester, 1976), pp. 33–67; A. Quondam, ed., *Le carte messaggiere: Rhetorica e modelli di communicazione; per un indice di libri di lettere del Cinquecento* (Rome, 1981), pp. 12–20.

62. P. Torelli, ed., *L'archivio Gonzaga di Mantova*, vol. 1 (Ostiglia, 1922), is the basic introduction and guide.

63. Signorini reviews preceding interpretations, rehearses the case he has developed in a series of articles, and responds to criticism in *Opus Hoc Tenue*, pp. 119–43; the most recent accounts by Cieri Via, "Il luogo della corte," and Arasse, "Il programma politico," accept the identification of both the court and meeting scenes with these events, but see note 70 below.

64. Schivenoglia, *Cronaca*, fols. 38r–38v, quoted by Signorini, *Opus Hoc Tenue*, p. 127.

65. Ibid. p. 127.

66. Ibid., pp. 130–35.

67. Ibid., pp. 146–70.

68. See note 48 above.

69. See Signorini's response to objections in *Opus Hoc Tenue*, pp. 151, 168–69.

70. Martindale, "Painting for Pleasure," p. 120. Lightbown, *Mantegna*, p. 111, argues along similar lines that the difficulties of interpreting the Meeting "disappear if the scene is treated as an ideal composition, which figures the Marchese with the heirs to his secular dignities, Federico and Gianfrancesco [*sic*], and with the son to whose exalted dignity in the church he hoped his son Lodovico and his grandson Sigismondo would in turn succeed."

71. David Summers, *The Judgment of Sense: Renaissance Naturalism and the Rise of Aesthetics* (Cambridge, 1987), p. 37; see too William Nelson, *Fact or Fiction: The Dilemma of the Renaissance Storyteller* (Cambridge, Mass., 1973), esp. pp. 38–55.

72. ASMil, ADS, 395, fols. 72–76.

73. For the various types of signatures in Renaissance art, see the essays on "L'art de la signature" by André Chastel, Anne-Marie Lecoq, and esp. Jean-Claude Lebensztejn, in *Revue de l'art*, no. 26 (1974); and Dario A. Covi, "Lettering in Fifteenth-Century Florentine Painting," *Art Bulletin* 45 (1963): 1–17.

74. The fundamental analyses of the logic of gift giving are: Marcel Mauss, *The Gift* (New York, 1967); Marshall Sahlins, "The Spirit of the Gift," in *Stone Age Economics* (Chicago, 1972), pp. 149–83; and Pierre Bourdieu, *Outline of a Theory of Practice*, trans. Richard Nice (Cambridge, 1977), pp. 4–15. For the practice and rhetoric of gift giving in Renaissance courts, see M. Fantoni, "Feticci di Prestigio: Il dono alla corte medicea," in *Rituale, ceremoniale, etichetta*, ed. Sergio Bertelli and Giuliano Crifò (Milan, 1985), pp. 141–61; Frank Whigham, Jr., *Ambition and Privilege: The Social Tropes of Elizabethan Courtesy Theory* (Berkeley and Los Angeles, 1986), pp. 112–16. In the most recent studies of patronage as a complex social institution with wide and deep ramifications the gift has come to be understood as a privileged unit of cultural production and exchange in early modern Europe: see, e.g., the suggestive remarks in Ronald Weissman, "Taking Patronage Seriously," in *Patronage, Art and Society in Renaissance Italy*, ed. F. W. Kent, Patricia Simons, and J. C. Eade (Oxford, 1987), pp. 27–30; and the exemplary analyses of the cultural economy of gift giving by Mario Biagioli, "Galileo's Strategies for the Social and Cognitive Legitimation of Science" (Ph.D. diss., University of California, Berkeley, 1989); and Paula Findlen, "Museums, Collecting, and Scientific Culture in Early Modern Italy" (Ph.D. diss., University of California, Berkeley, 1989).

75. Rodolfo Signorini, "Il Mantegna firmò la sua camera," *Gazzetta di Mantova*, 3 September 1972, p. 3; this reading is accepted by Lightbown, *Mantegna*, p. 415.

76. Rodolfo Signorini, "L'autoritratto del Mantegna nella Camera degli Sposi," *Mitteilungen des Kunsthistorischen Institutes in Florenz* 20 (1976): 205–12; Lightbown, *Mantegna*, p. 416, also accepts this identification.

77. Arasse, "Il programma politico," p. 60, claims to have detected the "secret signature" of a "Mantegnesque profile" in the large cloud of the oculus; if so, it is so secret as to be practically invisible to other eyes.

78. There is a critical survey of these issues by Stephen P. Schwartz in *Naming, Necessity, and Natural Kinds*, ed. Stephen P. Schwartz (Ithaca, 1977), pp. 13–41.

79. In his analysis of signatures as part of "a typology of forms of iteration," Jacques Derrida, "Signature Event Context," in his *Margins of Philosophy*, trans. Alan Bass (Chicago, 1982), pp. 307–30, argues that "the category of intention will not disappear; it will have its place, but from that place it will no longer be able to govern the entire scene and system of utterance. Above all, we will then be dealing with different kinds of marks or chains of iterable marks and not with an opposition between citational utterances on the one hand and singular and original event-utterances on the other. The first consequence of this will be the following: given that structure of iteration, the intention animating the utterance will never be through and through present to itself and to its content."

80. The document was published by Stefano Davari, "Lo stemma di Andrea Mantegna," *Archivio storico dell'arte* 1 (1888): 81–82.

81. Letter of Ludovico Gonzaga to Mantegna, 16 April 1458, in Kristeller, *Mantegna* (1902 ed.), doc. 11, pp. 516–17.

82. C. M. Brown, "Gleanings from the Gonzaga Documents in Mantua—Gian

Cristoforo Romano and Andrea Mantegna," *Mitteilungen des Kunsthistorischen Institutes in Florenz* 17 (1973): 158.

83. Giorgio Vasari, *Le vite de' più eccellenti pittori, scultori ed architettori,* ed. Gaetano Milanesi, 9 vols. (Florence, 1878–85), 3:384; Ernst Kris and Otto Kurz, *Legend, Myth, and Magic in the Image of the Artist* (New Haven and London, 1979).

84. In documents of 1454, 1459, and 1466; he was known as Andrea Squarcione to the Florentine architect and writer Filarete in the early 1460s and so named in the inventory of the Medici palace in 1492: see Lightbown, *Mantegna,* pp. 254 n. 29, and 15–29 for an excellent account, with bibliography, of Mantegna as a "Squarcionesque."

85. No sooner had the painter arrived in Mantua than the marchese intervened lest Mantegna be drawn into an imbroglio between Giovanfilippo da Coreggio and his workmen at a country dinner to which the painter and his wife had been invited: Dall'Acqua, "Mecenatismo," p. 310 (Marchese Ludovico to Niccolo Cattabeni, Cavriana, 21 June 1460). In his letters to his patron Mantegna complained over boundary disputes with his neighbors (17 June or July 1468), envious associates (30 June 1474), and thefts of apples and pears (22 September 1475): Kristeller, *Mantegna* (1902 ed.), docs. 40, 52, 59, pp. 525–26, 529, 531–32.

86. The will of 1 March 1504 and a codicil of 24 January 1506 are in Kristeller, *Mantegna* (1902 ed.), docs. 163, 175, pp. 570–72, 578–79; additional funds for the chapel are mentioned in doc. 190, p. 583 (a letter from Mantegna's son Ludovico to Marchese Francesco Gonzaga, 2 October 1506).

87. Baxandall, *Painting and Experience,* pp. 3–27, and Peter Burke, *The Italian Renaissance: Culture and Society in Italy,* rev. ed. (Princeton, 1987), pp. 74–82, provide the best general analyses of the status of Renaissance artists.

88. Quoted by Burke, *The Italian Renaissance,* p. 80.

89. For the quail and the "least reward": Kristeller, *Mantegna* (1902 ed.), docs. 48 and 70, pp. 528 and 535. Lightbown, *Mantegna,* pp. 119–27, gives a detailed account of Mantegna's financial affairs and real estate transactions, which are particularly well documented for the 1470s.

90. The title, among the many that Frederick III freely dispensed only to require chancellery fees for the privilege, is mentioned in a letter to Marchesa Barbara Gonzaga from Ferrara, 2 February 1469: Signorini, *Opus Hoc Tenue,* p. 171. Although Mantegna's title of count is sometimes cited (with the titles conferred on his brother-in-law Gentile Bellini and, later, Titian) as a sign of "the rise of the artist" (e.g., by Burke, *The Italian Renaissance,* p. 76), there is no evidence that it was officially registered or that he actually used it. In any case, the traffic in honors was so inflated that Emperor Sigismund himself told Gianfrancesco Gonzaga in 1432 that the title of count palatine was more appropriate for "ordinary citizens than for princes": Lightbown, *Mantegna,* p. 120.

91. See Lightbown's survey of the evidence: *Mantegna,* pp. 119 ff.

92. G. Fabris, "Le case di Pietro d'Abano, di Andrea Mantegna e dei Savonarola in Padova," *Atti e memorie della R. Accademia di Scienze, Lettere ed Arti di Padova,* n.s., 45 (1929): 63.

93. See note 85 above.

94. Kristeller, *Mantegna* (1902 ed.), doc. 71, p. 535 (15 May 1478).

95. Ibid., Schriftsquellen 23, pp. 497–98 (Giovanni Bonavoglia, *Monumentum Gonzagium,* a poem completed in 1526); the motto was discussed cursorily by Alphons Dorez, in *Comptes-rendus de l'Académie des Inscriptions et Belles-Lettres* (Paris, 1918), pp. 370–72. For Mantegna's house: E. Rosenthal, "The House of Andrea Mantegna," *Gazette des Beaux-Arts,* s. 6, 60 (1962): 327–48.

96. Janus Pannonius, *Poemata* (Utrecht, 1784), 1:276–79, trans. by Lightbown, *Mantegna*, pp. 459–60, with bibliography on the (lost) double portrait of 1458 and the career of this Hungarian humanist who studied and taught in Ferrara and Padua, became bishop of Pecs, and died in 1472 after a failed conspiracy against King Matthias Corvinus.

97. Kristeller, *Mantegna* (1902 ed.), doc. 23, pp. 523–24.

98. According to Caroline Elam, "Mantegna and Mantua," in *Splendours of the Gonzaga*, ed. D. S. Chambers and J. Martineau (exhibition catalogue, Victoria and Albert Museum; London, 1981), p. 25 n. 9, Mantegna used his Gonzaga device as his seal until at least 1468 and the seal of Julius Caesar's head from 1472 to 1498; in 1505–6 he signed himself with the initial M.

99. Lightbown, *Mantegna*, p. 460.

100. Kristeller, *Mantegna* (1902 ed.), doc. 22, p. 523; on Feliciano, see Lightbown, *Mantegna*, pp. 94–95, and Signorini, *Opus Hoc Tenue*, pp. 101–4.

101. Vasari, *Le vite*, ed. Milanesi, 3:408–9; the flattering references (from Filippo Nuvoloni, Battista Guarino, Ambrogio Calepino, and Pietro Bembo) are cited by Lightbown, *Mantegna*, pp. 127–28.

102. Ludovico Gonzaga to Zaccaria Saggi, 30 November 1474, in a letter first published by Signorini, "Federico III e Cristiano I," pp. 231–32.

103. Rudolf and Margot Wittkower, *Born Under Saturn* (London, 1963).

104. Signorini, *Opus Hoc Tenue*, pp. 194–213; Cieri Via, "Il luogo della corte," pp. 34–36.

105. Salvatore Settis, *La "Tempesta" interpretata* (Turin, 1978), p. 118, cites a nice example from the Riminese humanist Giovanni Aurelio Augurelli, who wrote (ca. 1500) of a courtly discussion of an emblematic painting: "Molti esprimono molte opinioni, nessuno si trova d'accordo con l'altro; ebbene, tutto ciò è ancor più bello delle immagini dipinte."

106. Germano Mulazzani, "La fonte letteraria della 'Camera degli Sposi' di Mantegna," *Arte Lombarda*, n.s., 50 (1978): 35–46.

107. As Rodolfo Signorini first proposed in "Un nastro fra i capelli: *Il Perì toû òikou* di Luciano archetipo letterario della 'Camera dipinta' di Andrea Mantegna," *Gazzetta di Mantova*, 1 December 1978, and fully argued in *Opus Hoc Tenue*, pp. 236–46. This interpretation has curiously been ignored in subsequent studies: Lightbown, *Mantegna*, pp. 102–3, 419; Cieri Via, "Il luogo della corte," pp. 41–44; and Arasse, "Il programma politico," p. 45; though they find Mulazzani's reading (see note 106) too generic, these scholars do not take Signorini's more specific and far more convincing analysis into account. There are analyses of Lucian's ekphrases by J. Bompiani, *Lucien écrivain: imitation et création* (Paris, 1958), pp. 718–20; and Valeria Ando, *Luciano critico d'arte* (Palermo, 1975), pp. 19–31. The references that follow in parentheses are to the edition and translation by A. M. Harmon, in *Lucian*, 8 vols., Loeb Classical Library (Cambridge, Mass., 1953), vol. 1.

108. Debates over the relative powers of speech and sight were commonplace among humanist literati and their classical authorities; for references and illustrations in Renaissance art, see Erwin Panofsky, "Reflections on Love and Beauty," *Problems in Titian Mostly Iconographical* (New York, 1969), pp. 119–38. The Gonzaga library contained a Greek codex of Lucian's works that had belonged to Guarino da Verona and is now Codex Guelf 2907 in the Herzog August Bibliothek, Wolfenbüttel: Signorini, *Opus Hoc Tenue*, pp. 243, 299 n. 485.

109. Signorini, *Opus Hoc Tenue*, pp. 239–40, argues that the remodeling was based on the text.

110. *Paulys Realencyclopädie der classischen Altertumswissenschaft*, ed. Georg Wissowa

and Wilhelm Kroll, 19.2 (Munich, 1938), cols. 1414–21, s.v. "Pfau"; *Dictionnaire d'archéologie chrétienne et de liturgie,* 15 vols., ed. Fernand Chabrol and Henri Leclercq (Paris, 1903–53), vol. 13.1, cols. 1075–98, s.v. "paon." For peacocks in annunciations: the feathers of the angel in Simone Martini's Uffizi *Annunciation,* and the bird itself in annunciations by Crivelli, Gozzoli, Ghirlandaio; in adorations: Botticelli's Uffizi *Adoration;* in representations of Juno: Giulio Romano, Sala of Cupid and Psyche in the Palazzo Te in Mantua. For the overlapping iconography of the mythical phoenix: Ernst H. Kantorowicz, *The King's Two Bodies: A Study in Medieval Political Theology* (Princeton, 1957), pp. 388–95.

111. So, e.g., the fourteenth-century murals in the Sala del Pavone in the Palazzo Davanzati in Florence: Maria Fossi Todorow, ed., *Il palazzo Davanzati* (Florence, 1955), p. 21; and the peacocks in the borders of the Visconti book of hours. In 1448 a Florentine merchant gave his bride a garland of peacock tails embellished with silver and pearls and noted payments for five hundred eyes of peacock feathers: Mark Phillips, *The Memoir of Marco Parenti: A Life in Medici Florence* (Princeton, 1987), pp. 42–43. See in general Guy de Tervarent, *Attributs et symboles dans l'art profane, 1450–1600* (Geneva, 1958–59), vol. 2, cols. 297–99, s.v. "paon."

112. *Bibliotheca Sanctorum,* 10 vols. (Rome, 1961–69), vol. 2, cols. 750–67.

113. Louis Réau, *Iconographie de l'art chrétien,* 3 vols. (Paris, 1955–59), vol. 3.1, pp. 174–76, cites only two Italian St. Barbaras; the one painted by Mantegna's Venetian near contemporary Vivarini stands alone with only a tower as her attribute. Among the many examples in George Kaftal, *Saints in Italian Art,* 4 vols. (Florence, 1952–85), the only St. Barbara with a peacock appears in an eighth-century fresco in Santa Maria Antiqua in Rome (Kaftal, *Iconography of the Saints in Central and South Italian Painting,* no. 43a).

114. For this manuscript, see U. Meroni, ed., *Mostra dei codici gonzagheschi* (Mantua, 1966), p. 13; for similar motifs in Milan in the late fourteenth century, cf. Millard Meiss and Edith W. Kirsch, *The Visconti Hours in the National Library, Florence* (New York, 1972), BR 35v (Anna and Joachim Give Thanks).

115. Marchese Lodovico directed Mantegna to make drawings for a tapestry of the "*galine de India* which are in the garden here at Mantua" in a letter of 11 July 1469: Kristeller, *Mantegna* (1902 ed.), doc. 42, p. 526; Lightbown, *Mantegna,* p. 103, argues that these must have been peacocks. Marchesa Barbara wrote to her husband on 9 February 1471 that she had two *pavoni* brought from Luzara and was sending one to Ludovico, "el quale haverò caro che piacqua"; the marchese replied the next day from Governolo, thanking her for the *pavone,* "el quale c'è stato gratissimo et per amor vostro lo goderemo de la bona voglia": ASMan, AG, 2100, ad datum.

116. For the topos of *concordia discors:* Manfredo Tafuri, "Discordant Harmony: Alberti to Zuccari," *Architectural Digest* 49 (1979): 36–44; Cristelle Baskins, "*Concordia discors:* The Portrayal of Battle on Tuscan Wedding Chests" (M.A. thesis, University of California, Berkeley, 1981). Signorini, *Opus Hoc Tenue,* pp. 23–25, cites many variations on Ludovico Gonzaga as a model for the integration of arms and letters, faith and fortitude, justice and wisdom, etc.

117. Alberti, *On Painting* 2.42, p. 86: "I like to see someone in the 'istoria' who tells the spectators what is going on, and either beckons them with his hand to look, or with ferocious expression and forbidding glance challenges them not to come near, as if he wished their business to be secret, or points to some danger or remarkable thing in the picture, or by his gestures invites you to laugh or weep with them."

118. Baldassare Castiglione, *Book of the Courtier,* trans. Charles Singleton (Garden City, N.Y., 1957), p. 72.

119. For especially revealing analyses in what has become an extensive literature on

courtly role-playing: Wayne Rebhorn, *Courtly Performances: Masking and Festivity in Castiglione's "Book of the Courtier"* (Detroit, 1978); Stephen Greenblatt, *Renaissance Self-Fashioning from More to Shakespeare* (Chicago, 1980); Whigham, *Ambition and Privilege.*

120. As Michael Kubovy, *The Psychology of Perspective and Renaissance Art* (Cambridge, 1986), pp. 85–86, explains this phenomenon: "If you are looking down the barrel of a gun, you need to take only a very small step sideways in order not to be looking down the barrel of a gun. We say here that objects are represented in a visually unstable situation. . . . It is quite natural, therefore, that we perform the unconscious inference: the object is shown in a visually unstable orientation; I am moving enough to destabilize the view; the view is not destabilized; therefore, the object must be turning to follow me."

121. Castiglione, *Book of the Courtier,* p. 12; see Eduardo Saccone, "*Grazia, Sprezzatura, Affettazione* in the Courtier," in *Castiglione: The Real and the Ideal in Renaissance Culture,* ed. Robert W. Hanning and David Rosand (New Haven, 1983), pp. 36–59; and for a kind of visual *sprezzatura,* H. W. Janson, "The 'Image Made by Chance' in Renaissance Thought," in *De Artibus Opuscula XL: Essays in Honor of Erwin Panofsky,* ed. Millard Meiss (New York, 1961), pp. 254–66.

122. "Mi sonno ricordato esser debitore di Vostra Excellentia d'una tazza di pome rostiole, perse al giuocho de' schachi con essa, e non senza mia grandissima vergogna, caricho, difetto, manchamento, oprobrio e vilipendio, non mi riputando in minor disgratia, sciagura e veramente infortunio il perdere un giuocho de' schachi che il perdere le facultà, lo stato e la vita propria": Zaccaria Saggi to Marchese Ludovico, 5 March 1473, ASMan, AG, 1624, fol. 741, quoted by Signorini, *Opus Hoc Tenue,* p. 80 n. 145. A few days later Saggi wrote coyly about having seen the "signor al mondo ben savio e grave [i.e., Ludovico] corrutiarsi giuocando a schachi . . . , il maledetto bellicoso giuoco": ibid., p. 81, quoting the same exchange of letters, 11 March 1473, fol. 744. This exchange is obviously itself a game or joke in which self-mockery is bound up with self-ingratiation, and ritual gift giving with antagonism.

123. Cristelle Baskins, "The *Locus Amoenus* and the Princely Court: Mantegna's Camera degli Sposi" (paper read at the Berkeley-Stanford graduate colloquium in art history, 1983); for the *locus amoenus* motif, see Paul F. Watson, *The Garden of Love in Tuscan Art of the Early Renaissance* (Princeton, 1979).

124. Arasse, "Il programma politico," pp. 52–53.

125. See pp. 115–16, and notes 107–8 above.

126. *The Hall* 21, in *Lucian,* ed. and trans. Harmon, 1:199.

127. A. Christine Junkerman, "*Bellissima Donna:* An Interdisciplinary Study of Venetian Sensuous Half-Length Images" (Ph.D. diss., University of California, Berkeley, 1988), quoting Federico Luigini da Udine, *Il libro della bella donna* (Venice, 1553), in *Trattati d'amore del Cinquecento sulla donna,* ed. Giuseppe Zonta (Bari, 1913), p. 135; and Francesco Sansovino, *Ragionamenti d'amore del Cinquecento,* ed. Giuseppe Zonta (Bari, 1912), p. 167. For such tropes, and the epistemology and sexual politics informing them, see now the brilliant book by Thomas Laqueur, *Making Sex: Body and Gender from the Greeks to Freud* (Cambridge, Mass., 1990), pp. 115–22 et passim.

128. Cf. the tentative remarks in Joan Kelly's 1977 essay, "Did Women Have a Renaissance?" reprinted in *Women, History and Theory* (Chicago, 1986), pp. 43–45; and the papers in Margaret W. Ferguson, Maureen Quilligan, and Nancy Vickers, eds., *Rewriting the Renaissance: The Discourse of Sexual Difference in Early Modern Europe* (Chicago, 1986), where connections between gender and courtly politics are a recurrent theme.

129. This distinction owes much to Norman Bryson, *Vision and Painting: The Logic of the Gaze* (New Haven, 1983), esp. chap. 5, "The Gaze and the Glance"; the weak term

"measured view" avoids the technical meaning of "Gaze" in Lacanian theory and indicates a rather more limited range of effects that Lacan himself confines, in the seminars on "The Look as the *objet petit a*," to the "geometral dimension—a partial dimension in the field of the gaze, a dimension that has nothing to do with vision itself": Jacques Lacan, *The Four Fundamental Concepts of Psychoanalysis*, trans. Alan Sheridan (New York, 1977), p. 88. For lucid exegesis in a large literature: Kaja Silverman, *The Subject of Semiotics* (New York and Oxford, 1983), pp. 149 ff.; and Jacqueline Rose, *Sexuality in the Field of Vision* (London, 1986), pp. 167–97.

130. Rudolf Arnheim, *The Power of the Center: A Study of Composition in the Visual Arts* (Berkeley and Los Angeles, 1982), p. x.

131. See the recent critical survey of the literature in Kubovy, *Psychology of Perspective*, esp. chaps. 1, 4, and 10; and now Martin Kemp, *The Science of Art: Optical Themes in Western Art from Brunelleschi to Seurat* (New Haven and London, 1990).

132. Cf. Bryson, *Vision and Painting*, pp. 103–10; and the diagrams in Lacan, *Four Fundamental Concepts*, pp. 91, 106.

133. Arnheim, *Power of the Center*, pp. 16–18; see also Kubovy, *Psychology of Perspective*, pp. 116–21. Kemp, *The Science of Art*, p. 43, analyzes Mantegna's discovery here of "what every illusionistic decorator should know; namely, that a certain amount of sly ambiguity helps enormously in achieving the impression of precision."

134. See Hubert Damisch, *Théorie du nuage: pour une histoire de peinture* (Paris, 1972), pp. 143–46, 187.

135. Kubovy, *Psychology of Perspective*, pp. 1–16, devotes a whole chapter to visual punning in Mantegna's work; Lightbown, *Mantegna*, p. 104, and esp. Martindale, "Painting for Pleasure," cite details such as the precariously perched barrel as examples of a courtly taste for jesting but do not carry the point further.

136. *Bartholomaei Platinae de principe* 1.1, ed. Giacomo Ferraù (Palermo, 1979), pp. 53–56; the quotation ("Principum enim oculi non privati, sed publici sunt et tanquam lumina quaedam errantibus viam ostendentia") is on p. 56.

137. Cieri Via, "Il luogo della corte," p. 36, suggests that the viewer was intended to follow the order of the emperors around the room, which she describes as a "solar temple."

138. Cf. ibid., pp. 36–37, of the supposed influence of the (subsequently discovered) *Domus aurea;* and on Mantegna's classical sources, Signorini, *Opus Hoc Tenue,* pp. 101–10, 152–70, 214–18; Lightbown, *Mantegna,* pp. 100–101; and, in another context, Andrew Martindale, *The Triumphs of Caesar by Andrea Mantegna* (London, 1979), pp. 56–74.

139. Alberti, *On Painting*, p. 33.

140. Thomas M. Greene, *The Light in Troy: Imitation and Discovery in Renaissance Poetry* (New Haven, 1982); and David Quint, *Origin and Originality in Renaissance Literature: Versions of the Source* (New Haven, 1983) are especially stimulating on these themes. The Borges story, "Pierre Menard, author of *Don Quixote*," is in *Ficciones* (New York, 1962), pp. 45–56. Panofsky, *Renaissance and Renascences*, Roberto Weiss, *The Renaissance Discovery of Classical Antiquity* (Oxford, 1969), and P. P. Bober and R. O. Rubinstein, *Renaissance Artists and Antique Sculpture* (London, 1986) are indispensable on the uses of antiquity in Italian Renaissance art; Patricia Fortini Brown has promised a major reconsideration of this issue.

141. Besides Suetonius, the texts for this exercise include Velleius Paterculus (*Historiae* 2.94–131), Tacitus (*Annales* 1–6), and Flavius Josephus (*Jewish Histories* 18). Signorini, *Opus Hoc Tenue*, pp. 214 ff., gives the classical references for the caesars and the mythological scenes.

142. Signorini, *Opus Hoc Tenue*, cites Herodotus's *History* 1.24, Pliny the Elder's

Natural History 9.9, and Aulus Gellius's *Noctae Atticae* 16.19; see too *Paulys Realencyclopädie*, vol. 2.1, cols. 836–41, s.v. "Arion." Arasse, "Il programma politico," pp. 56–60, cites a (mis)reading by Aeneas Sylvius Piccolimini, the future Pope Pius II, to argue that Mantegna's Arion stood for immortality, in particular the immortality of the "mystical body" of the state. This proves once again that the iconography invites many interpretations.

143. Edward E. Lowinsky, "Music in the Culture of the Renaissance," *Journal of the History of Ideas* 15 (1954): 509–53; Edward E. Lowinsky, "Humanism in the Music of the Renaissance," in *Medieval and Renaissance Studies*, ed. Frank Tirro (Durham, N.C., 1982), pp. 87–220; Claude V. Palisca, *Humanism in Italian Renaissance Musical Thought* (New Haven and London, 1985), pp. 100–106, 333–38.

144. See, e.g., the important essay by Anthony T. Grafton and Lisa Jardine, "Humanism and the School of Guarino: A Problem of Evaluation," *Past and Present* 96 (1982): 51–80; reprinted in Grafton and Jardine, *From Humanism to the Humanities* (Cambridge, Mass., 1986), pp. 1–28. There are useful surveys on the full range of humanist theory and practice in Albert Rabil, Jr., ed., *Renaissance Humanism: Foundations, Forms, and Legacy*, 3 vols. (Philadelphia, 1988), esp. vol. 3 (*Humanism and the Disciplines*).

145. Frances Yates, *The Art of Memory* (Chicago, 1966).

146. Particularly suggestive on these issues: Frank Kermode, *The Classic: Literary Images of Permanence and Change* (Cambridge, Mass., 1983); W. J. T. Mitchell, *Iconology: Image, Text, Ideology* (Chicago, 1986), pp. 95–115; and Anthony Grafton, "Renaissance Readers and Ancient Texts: Some Comments on Some Commentaries," *Renaissance Quarterly* 38 (1985): 615–49.

147. Battista Fiera, *De iusticia pingenda*, ed. and trans. James Wardrop (London, 1957), p. 27. In the postface to his *Pictures and Punishment* (Ithaca, N.Y., 1985), pp. 222–26, Samuel Y. Edgerton, Jr., imagines a "happy ending" in which Mantegna extols the wonders of "objective realism" and the "morally uplifting" powers of linear perspective. Needless to say, such is neither the actual conclusion nor the moral of the dialogue.

148. Fiera, *De iusticia pingenda*, p. 28.

149. Ibid., pp. 29–41; the quotation is on p. 39.

150. *Leon Battista Alberti: Momus o del principe*, ed. Giuseppe Martini (Bologna, 1942), p. 75, as quoted in the searching analysis by Jarzombek, *On Leon Battista Alberti*, p. 161.

151. Ibid., p. 58, quoted by Jarzombek, *On Leon Battista Alberti*, p. 165.

152. ASMil, ADS, Potenze Estere, 395, fol. 57. The agreement (ASMan, 51, no. 2) lists fourteen provisions, among them that the marchese was to be "reconducto . . . alli soldi, servicij et stipendij" of Milan for three years and one year "ad ben placito" during which time he was to serve and obey "drictamente [*sic*], diligentemente, et lealmente"; that he was to treat Milanese allies and enemies as his own in return for a similar pledge from the duke; that he was to provide the duke with safe conduct, provisions, and lodging "per honesto precio"; that he was to receive 30,000 ducats in time of peace and 70,000 ducats in time of war; that he would have the right to confiscate enemy movables, leaving to the duke any conquered territory, fortifications, munitions, and half the ransom of captured soldiers; that he was to attend the duke three or four times a year unless he had reason to "dubitare del stato suo"; that in case of his death his eldest son would assume his office.

153. Ibid., fol. 46: "Non ignorates quantum glorie ac splendoris afferat principibus quantumne firmamentum ac roboris accedat statui ac rebus publicis apud se habere alios dominos ac proceres virosque integerrimos, ac omni virtutum genere prestantes easque honoribus attollere et beneficiis prosequi, qui belli pacisque temporibus in

omni rerum fortuna optime consulere et salubiter providere possint. Ex hoc numero potissimum eligendum semper duximus ill. et magnanimum dominum Lodovicum Gonzagam marchionem Mantue, qui ut est statui et rebus nostris finitimus, ita omni quidem tempore summa fide et caritate affectus fuit."

III. THE SALA GRANDE IN FLORENCE

1. The major source, attributed to Luigi Gonzaga da Borgoforte, is the *Cronaca del soggiorno di Carlo V in Italia dal 25 luglio 1529 al 25 aprile 1530,* ed. G. Romano (Milan, 1892), pp. 239–53; there are also observations by the Venetian ambassadors with Charles V in *I diarii di Marino Sanuto,* 58 vols. (Venice, 1879–1903), 52, cols. 79–80, 244–45. Cf. André Chastel, "Les entrées de Charles Quint en Italie," in *Les fêtes de la Renaissance* (Paris, 1975), 2:197–206; and Amedeo Belluzzi, "Carlo V a Mantova e Milano," in *La città effimera e l'universo artificiale del giardino. La Firenze dei Medici e l'Italia del '500,* ed. Marcello Fagiolo (Rome, 1980), pp. 47–62.

2. Karl Frey, *Der literarische Nachlass Giorgio Vasari,* 3 vols. (Munich, 1923, 1930; Burg b. M., 1940, ed. Herman-Walther Frey), doc. cccxcvii, 1:722.

3. Gonzaga da Borgoforte, *Cronaca,* p. 243.

4. Ibid., p. 252.

5. Johan Huizinga, *The Waning of the Middle Ages* (New York, 1955).

6. Bernard Guenée, "Les entrées françaises à la fin du Moyen-Age," *Comptes-rendus de l'Académie des Inscriptions et Belles-Lettres* (1967): 210–12; Josèphe Chartrou-Charbonnel, *Les entrées solennelles et triomphales à la Renaissance (1440–1551)* (Paris, 1920). The term *triomphe* was first used instead of the traditional *entrée* for the entries of Charles VIII and Louis XII in Italy: see Cynthia J. Brown, *The Shaping of History and Poetry in Late Medieval France: Propaganda and Artistic Expression in the Works of the Rhétoriqueurs* (Birmingham, Ala., 1985), pp. 9–90. Samuel Kinser has promised a book on French entries through the mid sixteenth century.

7. See Ernst Kantorowicz, *Laudes Regiae: A Study in Liturgical Acclamations and Medieval Ruler Worship* (Berkeley and Los Angeles, 1946).

8. For Charles V's triumphal progresses in Italy outside of Mantua, see the papers by Vincenzo Cazzato, Giordano Conti, and Maria Luisa Madonna in *La città effimera,* ed. Fagiolo, pp. 22–46, 63–68; Richard Ingersoll analyzes sixteenth-century entries into Rome, including the 1536 entry of Charles V, in "The Ritual Use of Public Space in Renaissance Rome" (Ph.D. diss., University of California, Berkeley, 1985), pp. 356–406.

9. Gonzaga da Borgoforte, *Cronaca,* pp. 241–42.

10. Giorgio Vasari, *Le vite de' più eccellenti pittori, scultori ed architettori,* ed. Gaetano Milanesi, 9 vols. (Florence, 1878–85), 5:547. Translations used in the text (often with modifications) are based on: Gaston du C. de Vere, trans., *Lives of the Most Eminent Painters, Sculptors, and Architects by Giorgio Vasari,* 10 vols. (London, 1912–15); Louisa S. Maclehose, trans., *Vasari on Technique* (New York, 1960); and Jerry Lee Draper, "Vasari's Decoration in the Palazzo Vecchio: The *Ragionamenti* Translated with an Introduction and Notes," (Ph.D. diss., University of North Carolina, Chapel Hill, 1973).

11. Vasari, *Le vite,* ed. Milanesi, 8:569. See also Frey, *Der literarische Nachlass,* doc. xdvii, 2:170–71, and doc. dii, 2:188, where Vincenzo Borghini and Vasari compare the deeds of Cosimo to those of emperors, in the latter case specifically Augustus.

At the death of Julius Caesar, Augustus was adopted and made his chief heir at age eighteen, the same age at which Cosimo was elected *capo* of Florence. Suetonius notes that Augustus "won his first consulship and his most brilliant victories" in August.

The victory of Cosimo I's forces over the exiles at Montemurlo occurred on 1 August 1537. The victory over Piero Strozzi in the Val di Chiana was on 2 August 1554, a victory that marked the beginning of the end of the Sienese war.

12. The diagrams constituting figs. 64–78 should be consulted in conjunction with appendix 2.1–14, which gives in full the titles, descriptions, inscriptions, artists, and so forth.

Eric Cochrane, *Florence in the Forgotten Centuries, 1527–1800* (Chicago and London, 1973), p. 91, makes a similar point about the triumphant Cosimo in the 1560s: "He now had 'no other obligations of dependency' abroad except those he chose to assume on his own initiative. He was 'without debts . . . and with enough ordinary revenue' to satisfy all his needs. He had 200 pieces of artillery and he could gather together 24,000 infantrymen and 20 galleys in less than eight days. His subjects were protected from the designs of evildoers by an efficient system of justice. His neighbors were all obligated to him without his being in the least obligated to any of them. And he was content to manage his own affairs without 'molesting, disturbing, or disquieting' those of others. Or at least so he boasted in a letter to Emperor Ferdinand in 1563."

Luigi Carcereri, *Cosimo primo granduca*, 3 vols. (Verona, 1926–29), the only modern biography of Duke Cosimo, is outdated; the major works dealing with his life and political career include Rudolf von Albertini, *Das florentinische Staatsbewusstsein im Übergang von der Republik zum Prinzipat* (Bern, 1955), pp. 274–344; Antonio Anzilotti, *La costituzione interna dello stato fiorentino sotto il duca Cosimo I de' Medici* (Florence, 1910); Cochrane, *Florence in the Forgotten Centuries*, pp. 13–92; Furio Diaz, *Il Granducato di Toscana: I Medici* (Turin, 1987), pp. 1–229; Elena Fasano Guarini, *Lo stato mediceo di Cosimo I* (Florence, 1973); J. R. Hale, *Florence and The Medici, The Pattern of Control* (New York, 1978), pp. 127–43; Giorgio Spini, *Cosimo I de' Medici e l'independenza del principato mediceo* (Florence, 1945); and Giorgio Spini, ed., *Architettura e politica da Cosimo I a Ferdinando I* (Florence, 1976).

13. For an excellent survey: Anthony Molho, "Recent Works on the History of Tuscany: Fifteenth to Eighteenth Centuries," *The Journal of Modern History* 62 (1990): 57–77. See also R. Burr Litchfield, *Emergence of a Bureaucracy: The Florentine Patricians, 1530–1790* (Princeton, 1986), with a good bibliography.

14. For Vincenzo Borghini's sensitivity to the urban fabric of Florence and the need to correct flaws, exploit vistas, and articulate turns see Giovanni Bottari and Stefano Ticozzi, *Raccolta di lettere sulla pittura, scultura ed architettura scritte da' più celebri personaggi dei secoli XV, XVI e XVII*, vol. 1 (Milan, 1822), doc. LVI (Borghini to Cosimo, 5 April 1565): "prima bisogna risolvere i luoghi che hanno bisogno di esser aiutati da qualche ornamento" (pp. 133–34); with regard to the Arch of Hymen (fig. 64: 3), Borghini was concerned about the "veduta di lontano" (p. 135); the Arch of Maritime Empire (fig. 64: 4) was necessary because "sulla coscia del Ponte a S. Trinita rovinato, ha bisogno di qualche cosa per coprir quel difetto della rovina" (p. 135); the Arch of Austria (fig. 64: 6) "rassettasse que' torcimenti, le sproporzioni delle strade, massimamente che quivi termina la veduta di tutta quella strada di Santa Trinita" (p. 136); the Theater of the Medici (fig. 64: 7) was necessary because "il luogo è brutto e sproporzionato, e quella testa ha bisogno d'esser aiutata, massime volgendosi come fa, il viaggio, e mutando veduta" (p. 136); the Arch of Happiness (fig. 64: 11) was proposed to articulate the turn from S. Firenze onto the Via dei Gondi because "la veduta del palazzo, e l'entrata non ha grazia" (p. 137). With regard to the Via del Garbo, Borghini notes "una difficoltà della strettezza . . . alla quale si potrebbe rimediare in parte, come anche si fece nell' entrata di Papa Leone in molti luoghi più larghi, di levar i tetti bassi, e certi muricciuoli pur pochi, che danno impedimento" (p. 138); from the Arch of Religion (fig. 64: 8) Borghini notes that "la veduta . . . , bat-

tendo in S. Maria del Fiore e nella cupola, si può poco megliorare" (p. 139); see also p. 159.

15. Johannes Wilde, "The Hall of the Great Council of Florence," *Journal of the Warburg and Courtauld Institutes* 7 (1944): 65–81.

16. The iconography of this fountain is described by the ducal secretary, Tanai de' Medici, in a letter to Francesco I de' Medici dated 1 May 1579: "L'Amannato si truova in casa che si medica e per quanto ho ritratto da lui delle quatro statue di marmo che si truovono di suo in Palazzo ve n'è dua che havevono andare i' nichie e mettevono in mezo una porta che era la Flora ch'à i fiori in grenbo e 'l braccio armato e dinota Fiorenza, l'altra è un giovane che significha il prudente che ha l'impresa di Cesare Agusto in mano, la fenmina che si preme le poppe è fatta per la terra [i.e., Ceres] e quel'altra è Giunone per l'aria e questo sedeva sopra un gran cerchio, che circhonda la "Terra" al qual cerchio va di dentro le due figure che sono nella loggia de' Bardi che l'una è fatta pel fiume d'Arno e l'altra pel fonte di Parnaso, che però ha sotto il cavallo allato [i.e., Pegasus] e tutto questo gruppo significa come nasce l'acqua, perchè la terra succia l'aria, e poi getta fuori l'acqua e ne nascono le fonti e i fiumi, e però à fatto la fonte di Parnaso, sendo che Fiorenza habbia molto proprio la poesia, et Arno che fa fertile la città." See Detlef Heikamp, "Ammannati's Fountain for the *Sala Grande* of the Palazzo Vecchio in Florence," in *Fons Sapientiae, Renaissance Garden Fountains* (Washington, D.C., 1978), doc. xxi, pp. 158–59; or Giovanni Gaye, *Carteggio inedito di artisti dei secoli XIV, XV, XVI*, 3 vols. (Florence, 1839–40), 3:423–24.

17. Vasari, *Le vite*, ed. Milanesi, 4:451 (Life of Cronaca).

18. Vasari's stairs replaced those of Cronaca of 1510. The south ramp was finished in 1572. For the history of cortile, stairs, and all aspects of the Sala Grande, see Ettore Allegri and Alessandro Cecchi, *Palazzo Vecchio e i Medici, Guida storica* (Florence, 1980), pp. 32–39 (dais), 215–17 (stairs), 223–26 (Rain Fountain), 227–29 (cortile fountain), 231–33 (Great Council Hall), 235–55 (Sala Grande ceiling), 256–67 (Sala Grande walls), 268–70 (Michelangelo's *Victory*), 271–73 (Giambologna's *Florence Victorious over Pisa*), 277–83 (cortile decoration), 369–71 (south end wall), 372–76 (four paintings on slate), and 381–85 (Vincenzo de' Rossi's *Labors of Hercules*). For Vasari's renovation of the roof and ceiling see Ugo Muccini, *The Salone dei Cinquecento of Palazzo Vecchio* (Florence, 1990).

19. There were many elevated walkways in Rome ranging in date from the empire through the Renaissance: see Fagiolo, ed., *La città effimera*, pp. 17–19.

20. Gonzaga da Borgoforte, *Cronaca*, p. 252.

21. Georg Weise, *L'ideale eroico del Rinascimento* (Naples, 1961), 1:133–35, lists many examples of contemporary usage.

22. Jacob Burckhardt, *The Civilization of the Renaissance in Italy*, trans. S. G. C. Middlemore (Vienna and New York, n.d.), p. 216.

23. Beginning with Werner Weisbach, *Trionfi* (Berlin, 1919); for good surveys and more recent research, see Giovanni Carandente, *I trionfi del primo Rinascimento* (Turin, 1963); Andrew Martindale, *The Triumph of Caesar by Andrea Mantegna in the Collection of Her Majesty the Queen at Hampton Court* (London, 1979); Bonner Mitchell, *Italian Civic Pageantry in the High Renaissance, A Descriptive Bibliography of Triumphal Entries and Selected Other Festivals for State Occasions* (Florence, 1979); Bonner Mitchell, *The Majesty of the State, Triumphal Progresses of Foreign Sovereigns in Renaissance Italy (1494–1600)* (Florence, 1986); Charles L. Stinger, "Roma Triumphans: Triumphs in the Thought and Ceremonies of Renaissance Rome," *Medievalia et Humanistica*, n.s., 10 (1981): 189–201; Antonio Pinelli, "Feste e trionfi: continuità e metamorfosi di un tema," in *Memoria dell'antico nell'arte italiano* [Biblioteca di storia dell'arte, n.s., 1–3], ed. Salvatore Settis, 3 vols. (Turin, 1985), *I generi e i temi ritrovati*, 2:279–350; Hans Martin von Erffa,

"Ehrenpforte," in *Reallexikon zur deutschen Kunstgeschichte,* ed. Otto Schmitt, Ernst Gall, and L. H. Heydenreich, 8 vols. (Stuttgart and Munich, 1937–), vol. 4, cols. 1443–1504; and Robert Baldwin, "Triumph and the Rhetoric of Power in Italian Renaissance Art," *Source* 9 (1990): 7–13. For a full bibliography, see Robert Baldwin, "A Bibliography of the Literature on Triumph," in *"All the world's a stage . . . ": Art and Pageantry in the Renaissance and Baroque,* ed. Barbara Wisch and Susan S. Munshower [Papers in Art History from the Pennsylvania State University, 6] (University Park, Pa., 1990), 1:359–85.

24. H. S. Versnel, *Triumphus. An Inquiry into the Origin, Development and Meaning of the Roman Triumph* (Leiden, 1970), esp. pp. 356–97; for useful syntheses of a large, often controversial, literature see Concetta Barini, *Triumphalia: Imprese ed onori militari durante l'impero romano* (Turin, 1952); Robert Payne, *The Roman Triumph* (London, 1962); H. H. Scullard, *Festivals and Ceremonials of the Roman Republic* (Ithaca, N.Y., 1981), pp. 213–18; and Ernst Kunzl, *Der römische Triumph: Siegesfeiern in antiken Rom* (Munich, 1988).

25. See Scullard, *Festival and Ceremonials,* pp. 215–16; and Kunzl, *Der römische Triumph,* pp. 31–35; cf. E. Rice, *The Grand Procession of Ptolemy Philadelphus* (Oxford, 1983); and Michael McCormick, *Eternal Victory: Triumphal Rulership in Late Antiquity, Byzantium, and the Early Medieval West* (Cambridge, 1986).

26. For Frederick II see Carl A. Wellemsem, *Kaiser Friedrichs II. Triumphator zu Capua. Ein Denkmal hohenstaufischer Kunst in Süditalien* (Wiesbaden, 1953); and Pinelli, "Feste e trionfi," p. 322. For the miniature produced in Rome in the second half of the thirteenth century, now in the Stadtbibliothek, Hamburg, see Weisbach, *Trionfi,* p. 8 fig. 1.

27. The fundamental inventory is still in the "Catalogue des illustrations exécutées d'après Pétrarque," in Prince d'Essling and Eugène Müntz, *Pétrarque: ses études d'art, son influence sur les artistes, ses portraits et ceux de Laure, l'illustration de ses écrits* (Paris, 1902).

28. Carandente, *I trionfi,* pp. 18 ff, cites and illustrates many Quattrocento examples in various media. Cristelle Baskins, *"Lunga pittura:* Narrative Conventions in Tuscan Cassone Painting circa 1450–1500" (Ph.D. diss., University of California, Berkeley, 1988) offers a searching reconsideration of *cassoni* painting; the standard reference work is Paul Schubring, *Cassoni: Truhen und Truhenbilder der italienische Renaissance* (Leipzig, 1915 and 1923); see also Ellen Callmann, *Apollonio di Giovanni* (Oxford, 1974); and Brucia Witthoft, "Marriage Rituals and Marriage Chests in Quattrocento Florence," *Artibus et Historiae* 5 (1982): 43–59.

29. There are numerous editions with variant titles; we consulted Flavio Biondo, *De Roma triumphante libri decem* (Venice, 1511), pp. cxxiiii–cxxxii. Roberto Valturio included a study of ancient triumphs at the end of his treatise *De re militari* (ca. 1460), published at Verona in 1472 and, in Italian translation, in 1483: Martindale, *The Triumph of Caesar,* pp. 50–51, 58. Valturio's work and the miniatures of the triumphal entry of Sigismondo Malatesta into Florence (1448) in an Oxford manuscript of Basinius of Parma's epic poem *Hesperis* are discussed as an exercise in princely progaganda by Helen S. Ettlinger, "The Image of a Renaissance Prince: Sigismondo Malatesta and the Arts of Power (Ph.D. diss., University of California, Berkeley, 1988), pp. 153–70; see also Helen S. Ettlinger, "The Sepulchre on the Facade: A Re-evaluation of Sigismondo Malatesta's Rebuilding of San Francesco in Rimini," *Journal of the Warburg and Courtauld Institutes* 53 (1990): 133–43.

30. George L. Hersey, *The Aragonese Arch at Naples, 1443–1475* (New Haven and London, 1973). See also Cornelius von Fabriczy, "Der Triumphbogen Alfonsos I. am Castel Nuovo zu Neapel," *Jahrbuch der königlich preussischen Kunstsammlungen* 20 (1899):

3–30, 125–58; and Hanno-Walter Kruft and Magne Malmanger, "Der Triumphbogen Alfonsos in Neapel. Das Monument und seine politische Bedeutung," *Acta ad Archaeologiam et Artium Historiam Pertinentia* 6 (1975): 213–305.

31. Martindale, *The Triumph of Caesar*, p. 68.

32. *Onophrii Panvini Veronensis Fastorum libri V a Romulo rege usque ad Imp. Caesarem Carolum V . . . ; eiusdem in Fastorum libros Commentarii . . .* (Venice, 1558) was preceded by a defective edition of the *Fasti* alone (Venice, 1557) and followed by a Heidelberg printing of 1588. The 1571 Latin and Italian editions of the commentary *De triumpho* were printed together with the four-part engraving by Michele Tramezzino in Venice; cf. P. S. Leicht, "L'editore veneziano Michele Tramezzino ed i suoi privilegi," in *Miscellanea di scritti di bibliografia ed erudizione in memoria di Luigi Ferrari* (Florence, 1952), pp. 357–67. Subsequent editions of *De triumpho* appeared in Antwerp (1560?, 1596?), Venice (1600), Paris (1601), Helmstadt (1674), and Padua (1642, 1681); a twelve-part set of engravings of "amplissimi ornatissimique triumphi" based on the 1571 edition was published in Rome by Giovanni Jacopo Rossi ca. 1650. Davide Aurelio Perini, *Onofrio Panvinio e le sue opere* (Rome, 1894), though outdated and inaccurate, is the only full study; but see Eric Cochrane, *Historians and Historiography in the Italian Renaissance* (Chicago and London, 1981), pp. 437–39 et passim.

33. Bartolomeo Marliani, *Romanorum virorum Triumphi cum Commentario* (Rome, 1560), p. 117.

34. Panvinio's lists of triumphs and near triumphs appear in the *Fasti* at pp. 199 and 217, respectively, of the Heidelberg ed.; he gives his own account of his procedures in the prefatory letter (pp. vii–viii) to Cardinal Alessandro Farnese, but cf. Cochrane, *History and Historians*, p. 428.

35. See, e.g., Maurizio Fagiolo Dell'Arco and Silvia Carandini, *L'effimero barocco: strutture della festa nella Roma del '600*, 2 vols. (Rome, 1978), 1:17–24, 62–63, 131–33 et passim; 2:22–24, where engravings of entries, especially the papal *possesso* resemble the format of the Panvinio engraving. The frescoed frieze (1569) by Michele Alberti and Giacomo Rocchetti in the Palazzo dei Conservatori on the Capitoline hill in Rome representing the triumph of Paulus Aemilius was influenced by Panvinio's reconstruction; the tablets of the Roman *fasti* were installed in the next room (Sala della Lupa): Carlo Pietrangeli, "La Sala dei Trionfi," *Capitolium* 37 (1962): 463–70.

36. For Italian cases see Giuseppe Cocchiara, *Il mondo alla rovescia* (Turin, 1981); and Piero Camporesi, *Bread of Dreams*, trans. David Gentilcore (Chicago, 1989), pp. 78–85 et passim. The classic work is Mikhail Bakhtin, *Rabelais and his World*, trans. Hélène Iswolsky (Cambridge, Mass., 1968); for more recent studies and a fresh synthesis, see Peter Stallybrass and Allon White, *The Politics and Poetics of Transgression* (Ithaca, N.Y., 1986), esp. pp. 1–26.

37. The original was entitled *Tutti i Trionfi, Carri, Mascheraate* [sic], *ò canti Carnascialeschi andati per Firenze dal tempo del Magnifico Lorenzo de Medici . . .* (Florence, 1559). The best modern editions of the carnival *trionfi* are Charles Singleton, ed., *Canti carnascialeschi del Rinascimento* (Bari, 1936); Charles Singleton, ed., *Nuovi canti carnascialeschi del Rinascimento* (Bari, 1940); and now Riccardo Bruscagli, ed., *Trionfi e canti carnascialeschi toscani del Rinascimento*, 2 vols. (Rome, 1986).

38. Richard C. Trexler, *Public Life in Renaissance Florence* (New York, 1980), pp. 387–418.

39. Singleton, ed., *Canti carnascialeschi*, p. 472.

40. Giovanpaolo Lomazzo, *Trattato dell'arte della pittura, scultura ed architettura*, 3 vols. (Rome, 1855; reprint of first 1585 Milan edition), 2:299.

41. Ibid., p. 308.

42. Ibid., p. 309.

43. Particularly useful guides to a vast literature: Jonathan Culler, *Structuralist Poetics: Structuralism, Linguistics, and the Study of Literature* (Ithaca, N.Y., 1975); Philip Pettit, *The Concept of Structuralism: A Critical Analysis* (Berkeley and Los Angeles, 1977). Cf. John Fekete, *The Critical Twilight* (London, 1977), p. 197: "[In structuralism] attention is shifted away from the ways in which human beings have altered and do alter and may yet alter their objectifications: in consequence structuralism finds nothing to investigate but order, the codes of order, reflections upon order, and the experience of order."

44. Fundamental here are Arnold van Gennep, *The Rites of Passage*, trans. Monika Vizedom and Gabrielle L. Caffee (London, 1909); and Victor Turner, *The Ritual Process: Structure and Anti-Structure* (Ithaca, N.Y., 1969).

45. *Paulys Realencyclopädie der classischen Altertumswissenschaft*, ed. Georg Wissowa and Wilhelm Kroll, 8.1 (Munich, 1939), cols. 662–74, s.v. "Tropaia."

46. Lomazzo, *Trattato*, 2:312.

47. Ibid., p. 314.

48. *Aemilius Paulus* 33–34 in *Plutarch's Lives*, trans. Bernadotte Perrin, Loeb Classical Library (London and New York, 1918), pp. 443–47.

49. Vasari, *Le vite*, ed. Milanesi, 4:137; cf. John Shearman, "Pontormo and Andrea del Sarto, 1513," *Burlington Magazine* 104 (1962): 478–83; see John Shearman, "The Florentine Entrata of Leo X, 1515," *Journal of the Warburg and Courtauld Institutes* 38 (1975): 136–54.

50. Marcello Fagiolo, "L'effimero di stato: strutture e archetipi di una città d'illusione," in *La città effimera*, ed. Fagiolo, pp. 9–10; Fagiolo Dell'Arco and Carandini, *L'effimero barocco*, 1:379–82.

51. See Fabrizio Cruciani, *Il teatro del Campidoglio e le feste romane del 1513* (Milan, 1968); Ludovico Zorzi, *Il teatro e la città: saggi sulla scena italiana* (Turin, 1978), esp. pp. 63–234; and in general George R. Kernodle, *From Art to Theater, Form and Convention in the Renaissance* (Chicago, 1944).

52. Cf. Scullard, *Festivals and Ceremonials*, pp. 10–21; and Richard C. Trexler, ed., *The Libro Ceremoniale of the Florentine Republic by Francesco Filarete and Angelo Manfidi* (Geneva, 1978), pp. 4–7.

53. Bryan Vickers, "Epideictic and Epic in the Renaissance," *New Literary History* 14 (1983): 497–537; John O'Malley, *Praise and Blame: Rhetoric, Doctrine, and Reform in the Sacred Orders, 1450–1521* (Durham, N.C., 1979); C. Kallendorf, "The Rhetorical Criticism of Literature in Italian Humanism from Boccaccio to Landino," *Rhetorica* 1 (1983): 33–59.

54. *Copia: Foundations of the Abundant Style*, trans. Betty I. Knott in *Collected Works of Erasmus*, ed. Craig R. Thompson (Toronto, 1970), 24:295.

55. Ibid., p. 302.

56. See Robert Klein, "The Theory of Figurative Expression in Italian Treatises on the Impresa," in his *Form and Meaning* (Princeton, 1981), pp. 3–24.

57. Erasmus, *Copia*, p. 307.

58. Ibid., pp. 348–54.

59. Ibid., pp. 354–65.

60. Ibid., p. 577.

61. Ibid., p. 607.

62. Ibid., pp. 299, 658.

63. The principal sources are Domenico Mellini, *Descrizione dell'entrata della sereniss. Reina Giovanna d'Austria et dell'apparato, fatto in Firenze nelle venuta, & per le felicissime nozze di S. Altezza et del illustrissimo, & eccellentiss. S. Don Francesco de Medici, Prencipe di Fiorenza, & di Siena* (Florence, 1566); Giorgio Vasari [using without credit the manu-

script of Giovanni Battista Cini], *Descrizione dell'apparato fatto in Firenze per le nozze dell'illustrissimo ed eccellentissimo Don Francesco de' Medici principe di Firenze e di Siena e della serenissima regina Giovanna d'Austria* in *Le vite,* ed. Milanesi, 8:517–617; Vincenzo Borghini's letter to Cosimo I dated 5 April 1565 in Bottari and Ticozzi, *Raccolta di lettere,* doc. LVI, 1:125–204; and Vincenzo Borghini's unpublished working papers in Florence, Biblioteca Nazionale Centrale, Fondo Magliabechiano MS 2.10.100 (hereafter BNCFlor 2.10.100).

See also Jean Seznec, "La mascarade des dieux à Florence en 1565," *Mélanges d'archéologie et d'histoire* 52 (1935): 224–43; Piero Ginori Conti, *L'apparato per le nozze di Francesco de' Medici e di Giovanna d'Austria* (Florence, 1936); A. M. Nagler, *Theatre Festivals of the Medici 1539–1637* (New Haven, 1964), pp. 13–48; Giovanna Gaeta Bertelà and Annamaria Petrioli Tofani, *Feste e apparati medicei da Cosimo I a Cosimo II, Mostra di disegni e incisioni* [Gabinetto Disegni e Stampe degli Uffizi, 31] (Florence, 1969), pp. 15–24; Edmund P. Pillsbury, "Drawings by Vasari and Vincenzo Borghini for the *Apparato* in Florence in 1565," *Master Drawings* 5 (1967): 281–83; Edmund P. Pillsbury, "An Unknown Project for the Palazzo Vecchio Courtyard," *Mitteilungen des Kunsthistorischen Institutes in Florenz* 14 (1969): 57–66; Edmund P. Pillsbury, "The Temporary Façade on the Palazzo Ricasoli: Borghini, Vasari, and Bronzino," in *Report and Studies in the History of Art* (Washington, D.C., 1969), pp. 75–83; Edmund P. Pillsbury, "Vincenzo Borghini as a Draftsman," *Yale University Art Gallery Bulletin* 34, no. 2 (1973): 6–11; Edmund P. Pillsbury, "Vasari and his Time," *Master Drawings* 11 (1973): pl. 33; Anna Maria Testaverde Matteini, "Una fonte iconografica francese di Don Vincenzo Borghini per gli apparati effimeri del 1565," *Quaderni di Teatro* [*Il teatro dei Medici*] 2, no. 7 (1980): 135–44; Anna Maria Testaverde Matteini, "Feste Medicee: la visita, le nozze e il trionfo," in *La città effimera,* ed. Fagiolo, pp. 68–100; Cristina Acidini, "Invenzioni borghiniane per gli apparati nell'età di Cosimo I," in *La nascita della Toscana, Dal Convegno di studi per il IV centenario della morte di Cosimo I de' Medici* (Florence, 1980), pp. 159–67; R. A. Scorza, "Vincenzo Borghini and *invenzione*: The Florentine *apparato* of 1565," *Journal of the Warburg and Courtauld Institutes* 44 (1981): 57–75; and R. A. Scorza, "A New Drawing for the Florentine 'Apparato' of 1565: Borghini, Butteri and the 'Tuscan Poets,'" *Burlington Magazine* 127 (1985): 887–90.

64. Mellini, *Descrizione dell'entrata,* p. 6.

65. Bottari and Ticozzi, *Raccolta di lettere,* doc. LVI, 1:175, and doc. LVII, 1:205.

66. For the traditional parade route and its relation to the Roman *castrum,* see Fagiolo, "L'effimero di stato," pp. 9–21; and Testaverde Matteini, "Feste Medicee," pp. 69–100.

67. See Cochrane, *Florence in the Forgotten Centuries,* pp. 90–91.

68. For one of many contemporary examples where the Romanesque baptistery was said to have been the Temple of Mars see Frey, *Der literarische Nachlass,* doc. DI, 2:186. As Frey points out in a note, the tradition goes back to Dante (*Inferno* 13.147) and Giovanni Villani (*Cronica,* ed. F. G. Dragomanni, 4 vols. [Florence, 1844–45], 1:42).

69. See Vasari, *Le vite,* ed. Milanesi, 8:538, where Vasari speaks of the necessity of hiding the "bruttezza dell'armadure e de' legnami" of the Arch of Maritime Empire.

70. Hale, *Florence and the Medici,* pp. 133–36. But cf. Litchfield, *Emergence of a Bureaucracy,* who insists that the new bureaucrats were mostly from the same old patrician families that formed the elite of the republican regime.

71. Bottari and Ticozzi, *Raccolta di lettere,* doc. LVI, 1:157, 175. Borghini also designed the wine-spouting fountains to flatter Giovanna, since he was aware that "la nazione todesca reputa gran cosa, e molto magnifica far fontane che gettino vino."

72. Ibid., doc. LXVIII, 1:235.

73. Ibid., doc. LVI, 1:134.

74. *Le vite,* ed. Milanesi, 8:521.

75. Ibid., p. 530.

76. Bottari and Ticozzi, *Raccolta di lettere,* doc. LVI, 1:144.

77. Ibid.

78. C. C. Bayley, *War and Society in Renaissance Florence: the "De Militia" of Leonardo Bruni* (Toronto, 1961).

79. *Le vite,* ed. Milanesi, 8:531.

80. Ibid., pp. 541, 544. The Arch of Austria represented the imperial line in eight effigies running from Rudolph of Hapsburg to the reigning emperor, Maximilian II. Giovanna's brother, Maximilian II, and her father, Ferdinand I, assumed the positions of honor above the two central arches flanked by Charles V and Maximilian I (fig. 70: 6–9). Effigies of the father (Philip the Fair of Burgundy) and the son (Philip II of Spain) of Charles V appeared on the back of the structure (fig. 70: 18–19).

The Theater of the Medici (and Borghini does call it a theater; see, for example, Frey, *Der literarische Nachlass,* doc. DV, 2:198) featured Cosimo I above the triumphal arch of the entryway. He was flanked by statues of his father, Giovanni delle Bande Nere, and his predecessor, Alessandro, the first duke of Florence (fig. 71:2, 4, 6). At the exit from the theater were the other Medici with ducal titles, Lorenzo and Giuliano, dukes of Urbino and Nemours, flanking Francesco I (fig. 71:23, 26, 29). In between were effigies of Giovanni di Bicci and the most important male members of the two Medici lines descending from Giovanni di Bicci's two sons, Cosimo il Vecchio and Lorenzo, the former branch having become extinct with Duke Alessandro, the latter culminating in Cosimo I. Also included were the three Medici popes, Queen Catherine de' Medici and her children, and the five sons of Cosimo I (fig. 71:9–43). A series of coats of arms emblematized Medici marriage ties to some of the major families of Austria, Spain, France, and Italy.

81. Bottari and Ticozzi, *Raccolta di lettere,* doc. LVI, 1:168: "Il concetto [of the Canto de' Carnesecchi] è concatenato con quello di sopra dal Canto a' Tornaquinci, e tanto unito e simile che quasi ha da avere quel medesimo andare di concetti e di parole come si disse allora."

82. Vasari, *Le vite,* ed. Milanesi, 8:552.

83. Ibid., p. 555.

84. In chronological order after SS. Peter and Paul: St. Romualdo, St. Giovanni Gualberto, St. Francis, St. Filippo Benizi, St. Giovanni Tolomei, and Blessed Giovanni Colombini, the founders respectively of the Camaldolese, Vallombrosan, Franciscan, Servite, Olivetan, and Gesuati orders at Florence, Camaldoli, Vallombrosa, La Verna, Arezzo, Monte Oliveto, and Siena.

85. Vasari, *Le vite,* ed. Milanesi, 8:552.

86. Ibid., p. 531.

87. Ibid., p. 530.

88. Mellini, *Descrizione dell'entrata,* 4v.

89. Vasari, *Le vite,* ed. Milanesi, 8:534.

90. For which see Mario Fabbri, Elvira Garbero Zorzi, and Anna Maria Petrioli Tofani, *Il luogo teatrale a Firenze* (Milan, 1975), pp. 55–70, esp. cat. no. 1.39.

91. Leon Battista Alberti, *L'architettura [De re aedificatoria],* ed. Giovanni Orlandi and Paolo Portoghesi (Milan, 1966), 1:339: "Ac veluti in urbe forum plateae, ita in aedibus atrium sala et generis eiusdem habebuntur: loco non reiecto non abdito nec angusto, sed prompta sint ut caetera in eas membra expeditissime confluant (the atrium, the hall, and other such spaces in a house should be made in the same way as the forum and grand streets in a city: that is, not marginally positioned, hidden and narrow, but visibly placed so as to be reached in the most direct way from the other parts of the

building)." Alberti explains (p. 65) that "a city is like a great house, and a house in turn is like a little city." It is clear from the decoration of the courtyards in Filarete's palace design for the prince in the imaginary town of Sforzinda that this writer also conceived of them as microcosms of the whole city and state: *Filarete's Treatise on Architecture, being the Treatise by Antonio di Piero Averlino, Known as Filarete*, 2 vols., trans. John R. Spencer (New Haven and London, 1965), 1:115–19.

Borghini is more explicit. The program of the cortile for the Palazzo Vecchio should correspond with that of the Arch of Security (which, he says, shows "quelle cose che in un ben governato stato si reputano per parte di felicità") in order to demonstrate "che quello [the cortile] sia la sede e domicilio d'ogni grazia, virtù e contentezza." See Bottari and Ticozzi, *Raccolta di lettere*, doc. LVI, 1:183, 185; and Pillsbury, "An Unknown Project for the Palazzo Vecchio Courtyard."

92. In Austria, Vienna, Patavia, Stain, Klosterneuburg, Graz, Linz, Ebersdorf, and Neustadt; in Bohemia, Prague; in the Tyrol, Sterzing, Innsbruck, and Hall; in Germany, Freiburg am Breisgau; in Hungary, Possonia or Passau; and in the Swiss Confederation, Constance.

93. The deeds of Cosimo I were founding Cosmopoli at Porto Ferraio on Elba, building the Uffizi, conquering Siena and pacifying Tuscany, erecting the Column of Victory in the Piazza Trinita, remodeling the Palazzo Pitti, completing the library of S. Lorenzo, draining the swamps of Pisa, abdicating in favor of Francesco, fortifying Tuscany, founding the Order of St. Stephen, establishing a militia and addressing his troops, returning standards and artillery to Florence captured under the republic, building the aqueduct and erecting the Neptune Fountain in the Piazza della Signoria, and cutting and straightening the Arno. In the lunette above the entrance door two ovals showed the ascendant zodiacal signs of Capricorn and Aries that not only alluded to the founder (Augustus) and the founding (in March) of Florence but were also the birth signs of Cosimo and Francesco.

With regard to the representation of the establishment of the militia, Vasari states that Cosimo was "addressing many soldiers according to the ancient custom." Thus it is clear that at least this oval was based on the classical compositional formula of an *adlocutio*.

For the medals on which these scenes were based see G. Johnson, "Cosimo I de' Medici e la sua 'storia metallica' nelle medaglie di Pietro Paolo Galeotti," *Medaglia* 6, no. 12 (1976): 14–46. For marble reliefs (illustrated) also based on these medals see *Palazzo Vecchio: committenza e collezionismo medicei* [Firenze e la Toscana dei Medici nell'Europa del Cinquecento, Consiglio d'Europa] (Florence, 1980), pp. 338–44.

94. For the history of the fountain: Günter Passavant, *Verrocchio* (London, 1969), cat. no. 6, pp. 174–76; and Allegri and Cecchi, *Palazzo Vecchio*, pp. 227–29.

95. Vasari, *Le vite*, ed. Milanesi, 4:451 (Life of Cronaca); see also Edmund P. Pillsbury, "Vasari's Staircase in the Palazzo Vecchio," in *Collaboration in Italian Renaissance Art*, ed. Wendy Stedman Sheard and John T. Paoletti (New Haven and London, 1978), pp. 125–41.

96. For the Sala Grande see Alfredo Lensi, *Palazzo Vecchio* (Milan and Rome, 1929); Alessandro del Vita, *Lo Zibaldone di Giorgio Vasari* (Rome, 1938); Wilde, "The Hall of the Great Council," pp. 65–81; Gunther Thiem, "Vasaris Entwürfe für die Gemälde in der Sala Grande des Palazzo Vecchio zu Florenz," *Zeitschrift für Kunstgeschichte* 23 (1960): 97–135; Gunther Thiem, "Neuentdeckte Zeichnungen Vasaris und Naldinis für die Sala Grande des Palazzo Vecchio in Florenz," *Zeitschrift für Kunstgeschichte* 31 (1968): 143–50; Gunther Thiem, "Neue Funde zu Vasaris Dekorationen im Palazzo Vecchio," *Il Vasari storiografo e artista* [Atti del congresso internazionale nel IV centenario della morte] (Florence, 1976), pp. 267–73; Paola Barocchi, *Vasari pittore* (Milan, 1964),

pp. 53–62, 138–39; Paola Barocchi, "Complementi al Vasari pittore," *Atti e Memorie dell'Accademia Toscana di Scienze e Lettere, La Colombaria* 28 (1963–64): 253–309; Paola Barocchi, *Mostra di disegni del Vasari e della sua cerchia* [Gabinetto Disegni e Stampe degli Uffizi, 17] (Florence, 1964); Piero Bargellini, *Scoperta di Palazzo Vecchio* (Florence, 1966); Nicolai Rubinstein, "Vasari's Painting of *The Foundation of Florence* in the Palazzo Vecchio," *Essays in the History of Architecture Presented to Rudolf Wittkower*, 2 vols. (London, 1967), 1:64–73; Matthias Winner, "Eine Skizze Giorgio Vasaris," *Festschrift Ulrich Middledorf* (Berlin, 1968), pp. 290–93; Catherine Monbeig-Goguel, "Giorgio Vasari et son temps," *Revue de l'art* 14 (1971): 105–11; Catherine Monbeig-Goguel, *Inventaire général des dessins italiens: Vasari et son temps* (Paris, 1972), 1:164–66; Pillsbury, "Vasari and his Time," 171–75; Edmund P. Pillsbury, "Drawing by Jacopo Zucchi," *Master Drawings* 12 (1974): 3–33; Edmund P. Pillsbury, "The Sala Grande Drawings by Vasari and his Workshop: Some Documents and New Attributions," *Master Drawings* 14 (1976): 127–46; Richard Harparth, "Eine Studie Vasaris zur 'Glorie Cosimos I,'" *Kunstmuseets Årsskrift* 58 (1975): 58–65; Jean Rouchette, "Niveaux de langages et niveaux de communication dans l'œuvre peint de Vasari au Palais-Vieux," *Il Vasari storiografo e artista* [Atti del congresso internazionale nel IV centenario della morte] (Florence, 1976), pp. 815–55; Giulio Lensi Orlandi, *Il Palazzo Vecchio di Firenze* (Florence, 1977); Roland Zentai, "Deux esquisses aux peintures murales de la Grande Salle du Palazzo Vecchio à Florence," *Bulletin du Musée hongrois des Beaux-Arts* 51 (1978): 95–106; Cristina Acidini Luchinat, "Due episodi della conquista cosimiana di Siena," *Paragone* 345 (1978): 3–26; Heikamp, "Ammannati's Fountain for the *Sala Grande*," pp. 117–73; Detlef Heikamp, "Scultura e politica. Le statue della Sala Grande di Palazzo Vecchio," in *Le arti del principato mediceo* (Florence, 1980), pp. 201–54; Mercedes Carrara, "Vasari e il suo messaggio politico nel Salone dei Cinquecento," *Antichità Viva* 18 (1979): 3–9; Allegri and Cecchi, *Palazzo Vecchio*, pp. 32–39, 223–85, 368–76; Henk Th. van Veen, "Antonio Giacomini: un commissario repubblicano nel Salone dei Cinquecento," *Prospettiva* 25 (1981): 50–56; Henk Th. van Veen, "Cosimo I e il suo messaggio militare nel Salone de' Cinquecento," *Prospettiva* 27 (1981): 86–90; Henk Th. van Veen, "Ulteriori considerazioni su alcuni personaggi negli affreschi del Salone dei Cinquecento," *Prospettiva* 31 (1982): 82–85; Henk Th. van Veen,"Art and Propaganda in Late Renaissance and Baroque Florence: The Defeat of Radagasius, King of the Goths," *Journal of the Warburg and Courtauld Institutes* 47 (1984): 106–18; and Malcolm Campbell, "Observations on the Salone dei Cinquecento in the Time of Duke Cosimo I de' Medici, 1540–1574," in *Firenze e la Toscana dei Medici nell'Europa del '500: Relazioni artistiche; il linguaggio architettonico* (Florence, 1983), 3:819–30.

97. Or as Vasari stated it, the cities and regions of Tuscany were "divisato secondo l'ordine de' giudici di Ruota": Vasari, *Le vite*, ed. Milanesi, 8:200.

98. In the northeast corner of the vault were the cities and regions north and northeast of Florence: Fiesole (with the river Mugnone), Mugello (with Scarperia and the river Sieve), Romagna (with Castrocaro and the river Savio), and Casentino (with Poppi, Pratovecchio, and Bibbiena; the rivers Arno and Archiano; and Mt. Falterona); in the northwest corner cities to the west and northwest: San Miniato nel Valdarno (with the river Elsa? [Vasari says Pesa]), Prato (with the river Bisenzio), Pistoia (with the river Ombrone and the Alps), and Pescia (with the rivers Nievole and Pescia); in the southeast corner cities to the southeast: San Giovanni in Valdarno, Borgo Sansepolcro and Anghiari (with the rivers Tiber and Sovara, and the Apennines), Arezzo (with the river Castro), Cortona and Montepulciano (with the river Chiana); in the southwest corner cities and regions to the south and southwest: Chianti (with Castellina, Radda, and Brolio, and the rivers Pesa and Elsa), Certaldo, Colle di Val d'Elsa and San Gimignano (with the river Elsa), and Volterra (with the river Cecina). The dates

inscribed on the frame of each of the sixteen panels record when the towns or regions were thought to have been acquired by the republic. As far as one can tell there was no consistent order, by either date or location, within each group of four.

99. Siena, of course, lies almost due south of Florence but just slightly to the east.

100. Vasari [Cini], *Descrizione dell'apparato* in *Le vite*, ed. Milanesi, 8:527, reports that the canvases represented "the principal squares of the most noble cities of Tuscany" and lists (p. 621) nine of the ten towns, omitting only Volterra. If they were placed according to their compass directions from Florence, we can deduce that the two most important cities, Pisa and Siena, must have been placed in the center of the west and east walls respectively so as to correspond with the scenes of the Pisan and Sienese war on the west and east sides of the ceiling above; Pisa would have been flanked from left to right by the cities to the southwest, northwest, and north of Florence (Volterra, Pistoia, Prato, and Fiesole) and Siena (from left to right) by the cities to the southeast (Borgo Sansepolcro, Arezzo, Montepulciano, and Cortona). See fig. 93: *32, 44, 34, 33, 42, and 43.*

101. The Hippocrene spring of Mount Parnassus was commonly used as a metaphor for the river Arbia near Siena; see Heikamp, "Ammannati's Fountain for the *Sala Grande*," pp. 127, 172, and doc. LXV. The corner paintings at the north above the dais represented the fortification of Tuscany and the draining of the swamps of Pisa (land empire); those at the opposite end, the founding of Cosmopoli on Elba and the French surrendering the keys of Livorno to the Florentines (sea empire).

102. The five dukes were Lorenzo, the duke of Urbino; Giuliano, the duke of Nemours; Alessandro, the first duke of Florence; Cosimo I, the second duke of Florence; and Francesco, the third duke of Florence. The ducal crowns surrounded a chandelier in the shape of a royal crown honoring Catherine de' Medici placed in the center of the hall.

103. Vasari gives the dimensions as 90 × 38 × 33 *braccia* or about 53 × 22 × 19 meters: Frey, *Der literarische Nachlass*, doc. CCCXCVII, 1:725. Mellini, *Descrizione dell'entrata*, p. 123, in characteristic inflation, gives 100 × 40 × 36 *braccia*.

104. This count includes Ammannati's fountain but not the later paintings on slate in the four corners of the hall or the six sculptures of the labors of Hercules by Vincenzo de' Rossi. The water deities do not include the two representations of Neptune (he is included with the gods). Besides Neptune, the gods include Bacchus (thrice), Hercules, Mars (thrice), Mercury, Pan, Vertumnus, and one figure Vasari identifies only as a satyr. The goddesses include two women identified by Vasari simply as nymphs, Bellona, Ceres (twice), Diana or Fiesole (twice), Flora or Florence (six times), Juno, Minerva, Nemesis, Pomona, an allegory of the Via Flaminia, and five winged victories (four in stucco above the dais statue niches with popes Leo X and Clement VII, and one in the painting depicting the triumphal return from Pisa in the ceiling). The personifications of mountain chains include the Alps, the Apennines (twice), and a figure Vasari calls an "Atlante" personifying the hills of Fiesole. The zodiacal signs are Aries and Capricorn (9 times).

The light emanating from the clouds at the top of *Building the Third Circuit of Walls* (fig. 97) and in the background of the *Apotheosis of Cosimo I* (fig. 94) suggests either a pagan or a Christian radiance, just as the six flying children signifying bishoprics in the allegories of Fiesole, Pistoia, Volterra, Borgo Sansepolcro, Arezzo, and Montepulciano (fig. 93: *13, 16, 21, 23, 24, 25*) can be read as either classical putti or Christian angels.

105. Aries in the sky above the *Foundation of Florence* (fig. 96) was the sign of March, the month of Mars, the first protector of Florence, as well as the month of the Annunciation, the day of the city's founding. Thus Aries invoked both the pagan or Christian

and temporal or spiritual destiny of Florence. The divine radiance above the bishop's mass consecrating the third circuit of walls (fig. 97) suggested the continued divine favor in Florentine affairs.

Although not represented visually in the scene of the *Florentines and Romans Commanded by Stilicho Defeat the Ostrogoths Commanded by Radagasius* (figs. 93: 4; 98), divine intervention played a part in the Florentine victory over Radagasius, according to Borghini in his letter of 4 November 1564 to Cosimo (Frey, *Der literarische Nachlass*, doc. CDLXVIII, 2:116–17): "Che essendo assediata et stretta Fiorenza da Radagasio, re de' Gotti, et stando e cittadini di malissima voglia, apparve in visione Sancto Ambrosio a uno et lo confortò a stare di buono animo et dir' a sua cittadini, ch'il giorno seguente sarebbono liberati: Il che riferendo lui presono grandissimo comforto; et cosi segui, ch'il giorno seguente sopragiunto Stilicone con l'esercito, roppe Radagasio!" Borghini goes on to say that the battle took place on "il dí di Sancta Reparata," even though, as Frey notes (p. 120 n. 3), the battle took place on 23 August 405 and not as Borghini believed on 8 October.

106. E.g., Vasari writes (*Le vite*, ed. Milanesi, 8:201–2) that in the allegory of Cortona and Montepulciano Bacchus shows "l'abbondanza ed eccellenza del vino che produce quel paese" or (pp. 202–3) that Vertumnus and Pomona denoted that San Giovanni Valdarno "è coltivatissimo ed abbondantissimo di frutti." Similarly the ducal secretary, Tanai de' Medici, wrote that the river Arno on Ammannati's fountain "fa fertile la città" (Gaye, *Carteggio inedito di artisti*, 3:423–24).

107. In the allegory of Certaldo, the birthplace of Boccaccio, e.g., Minerva represents eloquence, "essendo quel luogo patria del padre dell'eloquenza toscana" (Vasari, *Le vite*, ed. Milanesi, 8:204); "la fonte di Parnaso" on Ammannati's fountain alludes to the fact that "Fiorenza habbia molto proprio la poesia" (Tanai de' Medici in Gaye, *Carteggio inedito di artisti*, 3:423–24).

108. Bellona, e.g., is "ardita e risoluta" and so represents the bold and determined people of Romagna (Vasari, *Le vite*, ed. Milanesi, 8:205). And the arrows in the hand and the chain of the Order of the Golden Fleece around the neck of Flora on Ammannati's fountain surely refer to the military might of Florence.

109. Nemesis flying above the republican council convoked to discuss the Pisan war in the Sala Grande (fig. 104), for example, denotes the "vendetta contra i Pisani, i quali, ribellandosi, furono cagione che i Fiorentini di nuovo deliberassino contra di loro la guerra con tanto sdegno" (ibid., p. 212).

110. Neptune is represented in the scene with Pope Eugenius IV (fig. 101) in order to signify that he had "condotto sano e salvo" the pope from Rome to Livorno (ibid., p. 211) and the figure of Fama or Gloria or Victoria accompanies the victors into Florence in the *Triumphal Entry into Florence after the Conquest of Pisa* (fig. 108).

111. The intermezzi of the play represented in the hall on 26 December, a week after the nuptials, served to express the goal of such service. They dramatized the story of Cupid and Psyche from the *Golden Ass* of Apuleius. Psyche's achievement of immortality was surely intended in part as an allegory for the progress of the soul toward salvation through penance and love. This Christian version in classical guise conformed to the significance of the allegorical statues of Good Works and Grace above the portal of the cathedral.

With regard to the divine favor of Florence to which Cosimo I was heir we should also note that Borghini believed that the Medici church of San Lorenzo had been built originally by St. Ambrose, whose intervention had aided in the defeat of Radagasius (figs. 93: 4; 98): Frey, *Der literarische Nachlass*, doc. CDLXVIII, 2:116–17.

112. Borghini's triumphalist thinking is evident in his 5 April 1565 letter to Cosimo (Bottari and Ticozzi, *Raccolta di lettere*, doc. LVI, 1:148–49). When describing "quelli

mezzo." It is likely that the marble reliefs attributed to Domenico Poggini and based on medals commemorating the deeds of Cosimo I, now in the deposits of the Palazzo Pitti, were for this balustrade. The iconography would have been most appropriate. See *Palazzo Vecchio: committenza e collezionismo medicei,* pp. 338–44, which—without mentioning the Sala Grande—suggests that the reliefs "facevano probabilmente parte di una balaustrata."

130. The following statement by Baccio Bandinelli to Cosimo I in a letter of 12 October 1554 suggests that, like the effigies on the Theater of the Medici, those of Cosimo il Vecchio and dukes Giuliano and Lorenzo were originally planned for the dais: "Il secondo lavoro è l'Audienza di Palazzo, dove Ella mi ha fatto fare più illustri della vostra Santa casa, e di già ci ho fatto Papa Clemente, la statua di V. E., e del Sig. vostro padre [Giovanni delle Bande Nere], e del Duca Alessandro. Mancaci Papa Leone, il vecchio Cosimo, il Duca Giuliano, il Duca Lorenzo; che più nicchie e figure non ci vanno": Bottari and Ticozzi, *Raccolta di lettere,* doc. IV, 6:28; Allegri and Cecchi, *Palazzo Vecchio,* p. 36. The presence of Cosimo il Vecchio, of course, would have suggested even more strongly that Cosimo I was a "new Cosimo" and therefore another *pater patriae.*

Specifically in the context of planning the decoration for the Sala Grande, Vasari also compares Cosimo I to Cosimo il Vecchio noting, of course, that Cosimo I is many times greater: "Sonmi forse disteso troppo; et tutto mosso dalla afettione che Le porto, conoscendo, che sel gran Cosimo Vecchio non avessi veghiato per le memorie che si vede di suo, la fama di lui non sarebbe si chiara come quella di V. E.: Che per far quel ch'ella fa [i.e., the Sala Grande, 'una tanta onorata, terribile et magnifica impresa'] acechera ogni gran lume di glorie passate con le Vostre presenti": Frey, *Der literarische Nachlass,* doc. CCCLXXXIX, 1:696.

131. Vasari says (*Le vite,* ed. Milanesi, 6:172) that Leo's gesture of blessing signified his establishing "la pace in Italia," a model for Cosimo who on the Arch of Prudence was also shown to establish peace in Italy.

132. See ibid., pp. 170–75; Allegri and Cecchi, *Palazzo Vecchio,* pp. 36, 39.

133. Vasari, *Le vite,* ed. Milanesi, 8:57. For the play: [Domenico Mellini,] *Descrizione dell'apparato della comedia et intermedii d'essa recitata in Firenze il giorno di S. Stefano l'anno 1565 nella gran sala del palazzo di sua eccellenza illust. nelle reali nozze dell'illustriss. & eccell. s. il s. don Francesco Medici principe de Fiorenza & di Siena & della regina Giovanna d'Austria figlia della felice memoria di Ferdinando imp. sua consorte* (Florence, 1566); *La cofanaria, commedia di Francesco d'Ambra, con gl'intermedii di Giovambatista Cini. Recitata nelle nozze del illustrissiomo s. principe don Francesco de' Medici, & della sereniss. regina Giovanna d'Austria* (Florence, 1566). Cf. Fabbri, Garbero Zorzi, and Petrioli Tofani, *Il luogo teatrale a Firenze,* pp. 93–98; Andrea Gareffi, "La 'Cofanaria' di Francesco d'Ambra," *Quaderni di Teatro* 2, no. 7 (1980): 145–56; Ludovico Zorzi, Giuliano Innamorati, and Siro Ferrone, *Il teatro del cinquecento, I luoghi, i testi e gli attori* (Florence, 1982), pp. 27–28.

134. Heikamp, "Ammannati's Fountain for the *Sala Grande,*" pp. 120–30. As Heikamp notes (p. 126), Giovanni Guerra's drawing in the Albertina after the fountain (his fig. 26) certainly seems to interpret the oval band as a Medicean ring. Not only does Prudence have the form of Apollo but, according to Heikamp (p. 127), "the Pythic Apollo is, in fact, the god of navigation, Delphinios, to whom the dolphin was dedicated as a holy animal." With regard to Flora, Heikamp (p. 130) points to "the chain stretching across her chest in the guise of a quiver strap . . . [and] her arrows and her short garment [which all] speak for Diana."

135. See Irving Lavin, "On the Sources and Meaning of the Renaissance Portrait Bust," *Art Quarterly* 33 (1970): 207–26, especially figs. 3 and 4.

136. The bearded face bears a close resemblance to the marble image of Cosimo carved by Baccio Bandinelli about 1540, now in the Bargello; also note that the angels in the frieze above the niche hold a ducal crown over the Medici *palle*.

137. Frey, *Der literarische Nachlass*, doc. cccxcvii, 1:724. Simon Pepper and Nicholas Adams, *Firearms and Fortifications, Military Architecture and Siege Warfare in Sixteenth-Century Siena* (Chicago and London, 1986), pp. 117–57, document the repeated exchange of letters and messengers between Cosimo and his field commanders to arrive at a consensus for most strategic decisions.

138. Frey, *Der literarische Nachlass*, doc. cdi, 1:735.

139. Vasari, *Le vite,* ed. Milanesi, 7:212: "Ho ritratta la sala del Consiglio, nella quale i cittadini di quelli tempi deliberarono e dettono principio alla guerra di Pisa, dove ho rappresentato . . . la signoria a sedere con gli abiti loro. . . . Particolarmente ho ritratto in bigoncia Antonio Giacomini che ora; sopra in aria fingo una Nemesi con una spada di fuoco, denotando vendetta contra i Pisani, i quali, ribellandosi, furono cagione che i Fiorentini di nuove deliberassino contra di loro la guerra con tanto sdegno."

140. For the entire episode, see Francesco Guicciardini, *Storia d'Italia* 6.14–15, ed. Silvana Seidel Menchi (Turin, 1971), pp. 617–27.

141. If the date of 1505 now inscribed in the vault to the right of *Florence Declares War Against Pisa* (appendix 2:15.26) is correct, then the connection between Giacomini and the disastrous campaign following the battle of Torre di San Vincenzo would be even stronger, since this campaign occurred in 1505. The date, however, is suspect and probably the result of a misunderstanding in the recent restoration of the ceiling. On an old Alinari photograph (Alinari 16970) the date is clearly mcccxciiii, and 1494 is the year that Florence declared war against Pisa.

In three recent articles Henk Th. van Veen argues that Cosimo had three representations of Antonio Giacomini painted in the Sala Grande as an example of a "sostenitore di una milizia nazionale," and, therefore, an important forerunner of Cosimo's own development of a "national militia." This is part of a larger argument advanced by van Veen that the Pisan war was not meant as a contrast to the Sienese war but as a record for his subjects of "la virtù militare dei vecchi repubblicani, affinché questi la emulassero: affinché cioè anche essi, come i Fiorentini di un tempo, 'in rebus militaris' si mettessero al servizio del bene publico." See van Veen, "Antonio Giacomini: un commissario repubblicano," pp. 50–56; "Cosimo I e il suo messaggio militare," pp. 86–90; "Ulteriori considerazioni su alcuni personaggi," pp. 82–85.

These arguments are unconvincing on the grounds that, although Vasari tells us that Antonio Giacomini is represented in *Florence Declares War Against Pisa,* van Veen's other two identifications are highly problematic. None of the three supposed likenesses very closely resembles the others or the labeled comparative portrait he illustrates ("Ulteriori considerazioni su alcuni personaggi," fig. 1). Furthermore, one of the supposed portraits, as van Veen admits, not only appears in a scene from which Giacomini is historically excluded on chronological grounds but is also shown with the coat of arms of Paolo Vitelli on his chest. While Cosimo would surely have appreciated, to use the words of van Veen, the "perseveranza" and "virtù" ("Cosimo I e il suo messaggio militare," p. 88) of the Florentine republicans during the Pisan campaign, the contrast between the two campaigns is such a fundamental part of the style and structure of the decoration that Giacomini could only have been understood as the opposite of someone to emulate, especially given the characterization of Giacomini by Guicciardini, the known source of the scenes of the Pisan war. Finally, van Veen's argument that Cosimo was influenced by the treatises of Jacopo Nardi and Jacopo Pitti— who tried to rehabilitate the reputation of Giacomini by making of him a patriotic citizen-soldier anticipating the "national militia" of Cosimo—is not convincing. Since

neither treatise was published until long after the ceiling was painted (Nardi's, written in 1548, was published in 1597 and Pitti's in 1570), surely the influence runs the other way: i.e., the writers of the treatises tried to rehabilitate Giacomini in terms of an image they judged would appeal to Cosimo.

142. Cosimo's claim to divinity was reinforced by the display within the apotheosis of the emblems of the two military orders dedicated to the defense of the Church, the chain of the Order of the Golden Fleece and the cross of the Order of St. Stephen.

143. Cosimo's claim to mediate between heaven and earth was enhanced by the two scenes closest to the *Apotheosis*—*Florentines Named Defenders of the Church by Pope Clement IV* and *Pope Eugenius IV Seeks Refuge in Florence* (figs. 93:6–7; 100–101)—which suggested that Cosimo had inherited a pro-papal policy from the previous republican and Medicean regimes.

Originally these two scenes were to have been "Charles IV Gives Privileges to Florence" and "Charles V Gives Order to Florence by a Ducal Government with Forty-Eight Councillors"; see Rubinstein, "Vasari's Painting of *The Foundation of Florence*," figs. 2–3; Thiem, "Vasaris Entwürfe für di Gemälde in der Sala Grande," pp. 132–35 and fig. 1. Their replacement by the present scenes not only strengthened Cosimo's claims to piety and service to the Church—a calculated policy in 1565 to persuade the pope to grant the grand ducal title—but also eliminated any hint of Florentine dependence on outside authority for legitimacy.

144. Vasari, *Le vite,* ed. Milanesi, 8:529: "Ora, nel basamento di tutte queste sei grandissime e bellissime tele [on the Arch of Florence] si vedeva dipinto una graziosa schiera di fanciulletti, che ciascuno nella sua professione, alla soprapposta tela accomodata, esercitandosi, pareva, oltre all'ornamento, che molto accuratamente mostrassero con quali principi alla perfezione de' sopra dipinti uomini si pervenisse; sì come giudiziosamente e con singolare arte furono le medesime tele scompartite ancora ed ornate da altissime e tonde colonne e da pilastri e da diverse troferie, tutte alle materie, a cui vicine erano, accomodate." Ibid., p. 534: "Una quantità poi, e tutti vezzosi e tutti lieti e tutti in accomodato luogo posti, di putti e d'Amorini se vedevano [on the Arch of Hymen] sparsi e per le basi, e per i pilastri, e per i festoni, e per gli altri ornamenti, che infiniti v'erano, che con una certa letizia pareva che tutti o spargessero fiori e ghirlande, o soavemente cantassero"; and so forth: ibid., pp. 538 [Arch of Maritime Empire], 543 [Arch of Austria], 549 [Theater of the Medici], 552 [Arch of Religion], 560 [Arch of Happiness], and 563 [Arch of Prudence].

There were also forty-four coats of arms that could be considered as trophies; see Ginori Conti, *L'apparato per le nozze,* pp. 116–18, app. 3; Ginori Conti counts only forty-two (p. 64).

145. Bottari and Ticozzi, *Raccolta di lettere,* doc. LVI, 146–47.

146. Curzio Mazzi, "Le gioie della corte medicea nel 1566," *Rivista delle biblioteche e degli archivi* 18 (1907): 133–41, 170–74; 19 (1908): 131–35; 20 (1909): 56–62, 102–11, 136–41; 20 (1910): 34–38; but especially 18 (1907): 134–38. This ducal crown along with the ducal scepter is held by an angel in the *Apotheosis of Cosimo I* (fig. 95). It was apparently melted down and the gems reused for the later grand ducal crown, for which see C. W. Fock, "The Medici Crown: Work of the Delft Goldsmith Jaques Bylivelt," *Oud Holland* 85 (1970): 197–209.

147. Nagler, *Theatre Festivals of the Medici,* pp. 13–35; Anna Maria Petrioli, *Mostra di disegni vasariani, Carri trionfali e costumi per la genealogia degli dei (1565)* [Gabinetto Disegni e Stampe degli Uffizi, 22] (Florence, 1966); Gaeta Bertelà and Petrioli Tofani, *Feste e apparati medicei da Cosimo I a Cosimo II,* pp. 15–24.

148. Bottari and Ticozzi, *Raccolta di lettere,* doc. LVI, 1:168–69: (5 April 1565, Borghini to Cosimo) "Gli antichi Greci e Romani nelle nozze usavano far due schiere o

compagnie, or ragunate che noi vogliam chiamarle, di tutti i parenti e amici stretti, così dello sposo, come della sposa; et una ne davano allo sposo, che aveva a ricever la sposa, l'altra compagnia era con la sposa, e l'avea a consegnare a'primi, benchè per lo più, e per una certa loro usanza, se la lasciavan rapire come per forza; ma con lo sposo erano tutti i giovani così del suo sangue come dell'altro, e con la sposa le fanciulle sole."

For Florentine marriage customs see Christiane Klapisch-Zuber, *Women, Family, and Ritual in Renaissance Italy* (Chicago and London, 1985), pp. 178–260; Ellen Callmann, "The Growing Threat to Marital Bliss as Seen in Fifteenth-Century Florentine Paintings," *Studies in Iconography* 5 (1979): 73–92; Witthoft, "Marriage Rituals and Marriage Chests in Quattrocento Florence"; and Baskins, "*Lunga pittura:* Narrative Conventions in Tuscan Cassone Painting."

149. Vasari, *Le vite*, ed. Milanesi, 8:529.

150. Ibid., p. 538.

151. Ibid., p. 567.

152. Richard C. Trexler, "Ritual in Florence: Adolescence and Salvation in the Renaissance," *The Pursuit of Holiness in Late Medieval and Renaissance Religion*, ed. C. Trinkaus and H. Oberman (Leiden, 1974), pp. 200–64.

153. See Wilde, "The Hall of the Great Council," pp. 65–81.

154. Allegri and Cecchi, *Palazzo Vecchio*, pp. 4–5, citing G. B. Adriani, *Istorie de' suoi tempi* (Florence, 1583), p. 73.

155. He might also have added that Cosimo had to move because he had no impressive palace of his own. He had been obliged to rent the Palazzo Medici from Margherita of Austria who had inherited it from her deceased husband, Duke Alessandro de' Medici.

156. Campbell, "Observations on the Salone dei Cinquecento," pp. 819–30, also makes the connection to Sansovino's Loggetta.

157. Patricia Fortini Brown, *Venetian Narrative Painting in the Age of Carpaccio* (New Haven and London, 1988), pp. 37–42, 261–65.

158. Barbara Hochstetler Meyer, "Leonardo's *Battle of Anghiari:* Proposals for Some Sources and a Reflection," *Art Bulletin* 66 (1984): 367–82, is one of the more recent contributions to a vast literature, the most important of which she cites concerning both Leonardo's *Battle of Anghiari* and Michelangelo's *Battle of Cascina.*

159. Some further borrowings: Vasari's *Battle at Marciano in the Val di Chiana* (fig. 93: 39) owes much to Leonardo's *Battle of Anghiari*; The *Foundation of Florence* (fig. 96), including its inscription (appendix 2: 15.2), was inspired by the same scene represented on the Capitoline theater built for investing Roman citizenship on Giuliano de' Medici in 1513 (see Rubinstein, "Vasari's Painting of *The Foundation of Florence*," p. 66), as well as by Roman reliefs showing prisoners kneeling before an imperial commander (e.g., the sarcophagus in the sculpture court of the Vatican Cortile del Belvedere); Vasari's *Florentines Named Defenders of the Church by Pope Clement IV* (fig. 100) is derived in part from the *liberalitas* relief on the Arch of Constantine; the same source combined with Michelangelo's so-called *Giuliano de' Medici* in the Medici Chapel underlie the figure of Cosimo in the *Apotheosis of Cosimo I* (fig. 94); Baccio Bandinelli's marble statue of *Alessandro de' Medici* (fig. 118) on the dais was based on Donatello's *St. George*; etc.

160. The deities are Diana, Pan, Bacchus (three times), Vertumnus, Pomona, Ceres, Minerva, and two nymphs.

161. Vasari, *Le vite*, ed. Milanesi, 7:73–74: "l'illustrissima Signora Duchessa . . . la quale certamente come Giunone, dea dell'aria, delle ricchezze, e de'regni, e de'matrimoni . . . ha con la sua Iride mandato sopra lor [i.e., servidori, sudditi, miseri] lo splendore dell'arco celeste consolandoli. . . . Quanto poi ella sia dea de' matrimoni . . .

certo Sua Eccellenza è Giunone istessa. . . . E quale simile è lei, che abbi sopra i parti la fecundità e le felice generazione? . . . Si vede . . . col mostrare nelle virtuose azioni sue esser serena, coniugale, fecunda, ricca." See also Campbell, "Observations on the Salone dei Cinquecento," pp. 819–30.

162. In his "Ragionamento quinto, Sala di Giove" (*Le vite,* ed. Milanesi, 7:62–71), Vasari makes it clear repeatedly that the scenes concerning Jupiter allude to Cosimo I. In the "Ragionamento sesto" (p. 71) he says so explicitly: "essendosi trattato di Giove, in figura del duca signor nostro."

163. Wilde, "The Hall of the Great Council," pp. 116–17.

164. Frey, *Der literarische Nachlass,* doc. cccxcvii, 1:722. Vasari also conceived his system of new stairs leading to the Sala Grande in direct competition with those of Bramante in the Vatican. On 15 January 1561 he wrote to Cosimo that he had designed "not stairs but a miracle in that place, and that it will seem to you like going up and down the stairs that go to the Sala Regia in St. Peter's in Rome": ibid., doc. cccxxx, 1:593.

165. Vasari [Cini], *Descrizione dell'apparato* in *Le vite,* ed. Milanesi, 8:572.

166. Bottari and Ticozzi, *Raccolta di lettere,* doc. lvi, 1:125–28, 138, 140, 155–56, 167–68, 180, 184, 186, 201.

167. Ibid., doc. lviii, 1:207.

168. Frey, *Der literarische Nachlass,* doc. dv, 2:195; also ibid., doc. dvii, 2:201.

169. Ibid., doc. cccxcvii, 1:722.

170. The full description of the initial conceit is in ibid., pp. 723–24. The quotations in the next two paragraphs and notes 171 to 174 are from this source unless indicated otherwise. For the tangled history of the changes and additions to scenes of the early history of Florence along central axis of the ceiling see Rubinstein, "Vasari's Painting of *The Foundation of Florence,*" pp. 64–73; and Thiem, "Vasaris Entwürfe für die Gemälde in der Sala Grande," pp. 97–135.

171. One scene (fig. 93:2) would represent "the first building of Florence with the sign of the Romans, another the restoration or amplification of the city [fig. 93: *location of 3*], and that in the middle [fig. 93: *location of 1*] . . . the happiness of Florence in a celestial glory."

172. The quarters and their vicariates were to be in two roundels at the two ends of the ceiling (fig. 93:8–9) flanked by sixteen square panels with "the sixteen standards of the four quarters with their insignias" (fig. 93: *location of 10–25*).

173. "On one wall [fig. 93:32–34] all the war of Pisa, which lasted thirteen years, and on the other [fig. 93:42–44] that of Siena, which lasted thirteen months," including "the taking of fortresses, the victory in the Val di Chiana, and the siege of Porto Ercole"; on the side of the ceiling directly above the war of Pisa were to be "three large paintings" (fig. 93:26, 29, 35), one showing "its beginning, that is, the deliberations concerning the campaign, another the manner of its execution, and in the middle the triumph"; on the side of the ceiling directly above the war of Siena were also to be three large panels (fig. 93:36, 39, 45) "responding to those of Pisa," "in one a scene of the decision made with advice how to undertake this campaign, where," Vasari writes to Cosimo, "there would be Your person accompanied by some virtues, in another Your constancy against difficulties, and in the middle a triumph, where the virtue and the perseverance of Your Excellency won out, so that together one would see the beginning with prudence, the carrying out with strength, and the ending with happiness."

174. "The twenty-one guilds of the city with their insignias or banners . . . with virtues or genii taken from antiquity and from medals, the little spirits instructing the guilds and holding their symbols" (fig. 93:4–7, 27–28, 30–31, 37–38, 40–41). In the

final scheme the principal part of the *concetto*—the contrast between the war of Pisa and the war of Siena—was modified only to the extent that the duration of the two wars was changed from thirteen years versus thirteen months to fourteen years versus fourteen months.

175. It is significant that in his *Ragionamenti* Vasari described the *concetto* of the final scheme almost exactly as he had described the initial one. Vasari, *Le vite,* ed. Milanesi, 8:199–200: "Per rendere questo palco bello, vago e copioso, come Vostra Eccellenza può avvertire, l'ho divisato in tre invenzioni. Ed in prima consideri i quadri dalle bande, che sono vicini alle mura che corrispondono, e sono accomodati alle storie, alle quali essi son sopra [i.e., the war of Pisa and the war of Siena], e l'ho fatto sì per la veduta, come per la continuazione dell'occhio, massime che il signor duca giudicò che così tornasse meglio. Nella fila poi de' quadri di mezzo, che sono separati e non continuano la storia con quelli da lato, ci ho figurato storie della città, come più particolarmente, venendo alla dichiarazione, credo ne resterà capace. Restano poi le due teste, l'una posta verso S. Piero Scheraggio sopra il lavoro che fa M. Bartolommeo Ammannato, e l'altra qua verso il Sale sopra l'audienza fatta dal cavaliere Bandinelli, dove sono due gran tondi, ciascuno de' quali è messo in mezzo da otto quadri minori. Ed essendo divisa questa città di Firenze in quartieri, sono posti due quartieri di essa per tondo. Ne' quadri poi, che gli mettono in mezzo, sono le città e i luoghi più principali dello stato vecchio di Firenze, non ci mescolando cosa alcuna dello stato nuovo di Siena; e tutto si è divisato secondo l'ordine de' guidici di Ruota."

176. The battles assigned to two of the large octagonal scenes (fig. 93:29, 39) followed the initial plan to show "the manner of executing" the Pisan and Sienese wars.

177. They prefigured his victory at Montemurlo, his annexation of Siena, his foundation of the Order of St. Stephen, his self-interested pro-papal diplomatic policy, and his establishment of a naval base at Livorno.

178. For the preparatory drawings in the Louvre, the Accademia in Venice, and the Kunstbibliothek in Berlin, see Pillsbury, "The Sala Grande Drawings," pp. 132–33 pls. 7 and 8a.

179. For Cosimo Bartoli, see Frey, *Der literarische Nachlass,* notes to doc. CXXVII, 1:266; and Judith Bryce, *Cosimo Bartoli (1503–1572): The Career of a Florentine Polymath* (Geneva, 1983). On his programs for the Sala degli Elementi and Sala di Leone X in the Palazzo Vecchio see Frey, *Der literarische Nachlass,* doc. CCXX, 1:410–13, with references to other inventions; and Bryce, *Cosimo Bartoli,* pp. 55–71.

180. Frey, *Der literarische Nachlass,* doc. DCLXII, 2:426–27.

181. Ibid., doc. DXV, 2:211.

182. Ibid., note to doc. CDLXXIV, 2:132–33.

183. In the letter of 5 April 1565 to Cosimo (Bottari and Ticozzi, *Raccolta di lettere,* doc. LVI, 1:200–201) Borghini had recommended Caccini for finances and supplies: "Se l'E. V. potesse per tre o quattro mesi accomodare questa impresa di Giovanni Caccini, secondo me, non potrebbe dare in persona più a proposito, più sollecita e più atta a questo, e potrebbene stare sicura che al debito tempo le cose sarebbono fatte bene, e non sarebbe da darsene briga o pensiero."

From a letter of 10 June 1565 (Frey, *Der literarische Nachlass,* doc. XDVII, 2:171) it is clear that the trio had been established: "Et bisogna, messer Giorgio mio, che voi aiutate messer Giovanni Caccini in questo principio del allogare et fermare i pregi. . . . Ricordatevi, che S. E. I. in camera Sua, quando finimo di leggere la mia intemerata [i.e., the program for the entry], lasciò à me la cura della inventione, a voi de disegni et de modi." See also ibid., "Le Ricordanze di Giorgio Vasari" (1565), 2:878: "Ricordo, come lo illustrissimo duca sotto di 20 di Gennaio ordino, che si dovessi far l'apparato

per le nozze di Don Francesco, principe di Fiorenza et Siena: Che ebbi di tutti disegni et architetture et altre cose, che si apartenevano, l'ordine, il carico di condurle con reverendo Don Vincentio Borghini, spedalingho degli Innocenti, che se l'inventione delle storie. . . ."

Borghini's role as programmer and Vasari's as designer for the Sala Grande are proven by a letter of Vasari to Cosimo on 20 January 1563 (ibid., doc. CCCLXXXIX, 1:696): "Et gia siamo insiemi, lo spedalingo [Borghini] et io, all'inventione del palco; et fra non molto tempo penso che V. E. I. la vedera disegnata." Also ibid., doc. CCCXCII, 1:712; doc. CCCXCVII, 1:722–23; doc. CDXIV, 2:2; doc. CDXV, 2:4; doc. CDLXVIII, 2:116; doc. CDLXIX, 2:123; doc. CDLXX, 2:124–25; doc. CDLXXII, 2:126; doc. CDLXXIV, 2:131–32; doc. CDLXXXIII, 2:144; Lorenzoni, *Carteggio artistico inedito*, 1:55–56; and Gaye, *Carteggio degli artisti*, 1:386.

184. For these three drawings (Archivio di Stato di Firenze [hereafter ASF], Mediceo del Principato, Carteggio universale, filza 497a, fol. 1597; Uffizi, Gabinetto Disegni e Stampe, 7979A; ASF, Carte Strozziane, 1st s., 133, fol. 141), see Frey, *Der literarische Nachlass*, doc. CCCXCVII, 1:728; Rubinstein, "Vasari's Painting of *The Foundation of Florence*," pp. 64–66, figs. 1 and 2; Thiem, "Vasaris Entwürfe für die Gemälde in der Sala Grande," pp. 97–135, fig. 1; and Barocchi, *Mostra di Disegni del Vasari*, cat. nos. 28–29, pp. 31–37. As Barocchi points out, one of the drawings (ASF, Carte Strozziane, 133, fol. 141), appears to have corrections and annotations in Borghini's hand.

185. Bottari and Ticozzi, *Raccolta di lettere*, doc. LVI, 1:127.

186. Rolf Quednau, *Die Sala di Costantino im Vatikanischen Palast: Zur Dekoration der beiden Medici-Päpste Leo X. und Clemens VII* (Hildesheim and New York, 1979), pp. 330–45.

187. Examples include the Sala del Mappamondo in the Palazzo Pubblico in Siena; the Sala di Costantino and the pre-Vasarian Sala Regia in the Vatican; and the Sala dei Cento Giorni and the Sala dei Fasti Farnese in Rome.

188. This aspect of the program likely influenced the integrated programs for the ceilings of the Sala dello Scrutinio and the Sala del Maggior Consiglio in the Doge's Palace in Venice after the 1577 fire. The decision in the first place to use elaborate painted ceilings in these two rooms was perhaps also motivated by a desire to surpass Florence.

189. Ginori Conti, *L'apparato per le nozze*, pp. 124–25.

190. Borghini's list breaks down as follows (the dates are those given by Borghini and are not in every case accurate):

Hapsburg entries: Charles V into Bologna (1529), Palermo (1535), Messina (1535), Rome (1535), Siena (1535), Florence (1535), Lucca (1535), Poitiers (1539), and Milan (1541); and Philip II into Geneva, Milan, Mantua, and Brussels (all 1548). Hapsburg marriages: Charles V (1526), Maximilian II [to Maria, daughter of Charles V] (1549), Philip II [to Mary Tudor] (1554) and [to Elisabeth of Valois] (1560), Eleonora [daughter of Philip I to Francis I] (1529), and Elizabeth [daughter of Ferdinand I to Sigismund II, King of Poland] (1542). Hapsburg coronations: Maximilian I (1486), Charles V (1520), Ferdinand I [as King of Bohemia] (1527).

Medici entries: Pope Leo X into Florence (1515), Pope Clement VII into Marseilles (1533), and Cosimo I into Siena and Rome (both 1560). Medici marriage: Cosimo I (1539). Medici coronation: Pope Leo X (1512). Medici festival: Roman citizenship conferred on Giuliano, duke of Nemours, on the Capitoline in Rome (1514).

Farnese entries: Paul III into Perugia (1535) and Rome (1538) and Vittoria Farnese into

Venice (1549). Farnese marriage: Ottavio to Margherita of Austria, widow of Alessandro de' Medici (1538).

Valois entries: Henry II into Lyons (1548). Valois coronations: Henry II (1547), Francis II (1559).

The remainder include the marriages of Duke Francesco Sforza of Milan (1534) and Count Ludovico Londrone (1536), "feste della reina Maria in Bins (1549)," "feste in Milano pel Cardinale del Marchese di Pescara et altri (1559)," and "Monte di Feronia in Ferrara (1561)."

191. Bottari and Ticozzi, *Raccolta di lettere*, doc. LVI, 1:142–43. Borghini singles out in particular the conceit of the six statues with their accompanying paintings on the Arch of Florence representing "sei proprietà, o chiamiamle come noi vogliamo, virtù o prerogative che pare essere state proprie della città nostra" as being "cosa assai nuova, e, se io non m'inganno, ha ragionevole invenzione" (ibid., pp. 143–44). Further along in the letter he again notes that "questo disegno [for the Arch of Florence] mi pare assai ragionevolmente nuovo, ed anche buon concetto" (ibid., p. 149). As an alternative, he offers Cosimo "gli stati principali e terre di Toscana sotto l'impero di VV. EE., come Siena, Pisa, Arezzo, Pistoia, Volterra, e ciascuna di queste ornata con le sue proprietà" but tends to reject this idea precisely because it had been done before "nelle nozze di V. E. I., ancorchè in altro modo," as well as "nell'entrata del Re cattolico in Milano l'anno 1548" (ibid., p. 149).

192. Ibid., pp. 190–91.

193. Ibid., p. 184. In a similar vein Borghini had noted earlier (ibid., p. 155) with regard to the Arch of Hymen that "saranvi Armi, Imprese e Motti accomodati a questo concetto, che lo potran fare copioso e bello." Toward the end of the letter (pp. 202–3) he returns to a consideration of the "motti e imprese" noting that they "danno grazia ed ornamento, ed è quasi come mettere armi o insegna del principe che fa o per chi si fa la festa, ma con più grazia e con una certa gentilezza ingegnosa"; with regard to "i rovesci delle medaglie" he writes that "perchè talvolta sotto una statua, sotto un'arme, sotto una storia dove non è gran capacità di luogo, una simil cosa vi fiorisce e arricchisce maravigliosamente un vano che rimane."

On the writers consulted for the programs see ibid., pp. 146 (Plato, Aristotle, Cato), 154 (Catullus), 155 (Plutarch, Plato), 164 (Virgil's *Aeneid*), 165 (Virgil's *Aeneid*), 164 (Ariosto, Dante), 167 (Virgil's *Aeneid*), and 176 (Aristotle, Virgil's *Aeneid*); ibid., doc. LXII, 1:218–19 (Catullus); and Vasari, *Le vite,* ed. Milanesi, 8:216 (Villani, Guicciardini).

194. Bottari and Ticozzi, *Raccolta di lettere*, doc. LVI, 1:180–81.

195. Ibid., p. 145.

196. Ibid., p. 150.

197. Ibid., doc. LXIII, 1:220–21.

198. Frey, *Der literarische Nachlass,* doc. DIII, 2:191–92; ibid., doc. DV, 2:197.

199. Ibid., doc. DVII, 2:201.

200. Ibid., doc. DIII, 2:191.

201. Ibid., doc. XDVII, 2:170.

202. Bottari and Ticozzi, *Raccolta di lettere*, doc. LVI, 1:136.

203. Cochrane, *Historians and Historiography in the Italian Renaissance,* pp. 171–77, 295–305, 366–77 et passim.

204. Bottari and Ticozzi, *Raccolta di lettere*, doc. LVI, 1:130; see also pp. 140–41, 170–71.

205. Ibid., doc. LXVIII, 1:234–37. For a closely related version of this letter see Lorenzoni, *Carteggio artistico inedito,* doc. XXI, pp. 42–43.

206. Vasari, *Le vite*, ed. Milanesi, 8:560.

207. Ibid., p. 538.

208. E.g., the Arch of Florence, the Arch of Maritime Empire, and the Column of Victory in the first half had as much to do with Cosimo and his regime as with the reception and welcome of the bride. The Arch of Happiness related as much to the third part of the conceit, the benefits of Cosimo's regime, as to the first, public festivity. As a German motif made to make Giovanna feel at home, the two wine-spouting fountains were as much a part of the second part of the conceit, the welcome of Giovanna, as the first, public festivity. And so forth.

Even in Borghini's own attempts to describe the overall structure to Mellini, there was considerable fuzziness and confusion. See Lorenzoni, *Carteggio artistico inedito*, doc. XXI, pp. 42–43; Bottari and Ticozzi, *Raccolta di lettere*, doc. LXVIII, 1:234–37, and doc. LXIX, 1:237–38.

209. Bottari and Ticozzi, *Raccolta di lettere*, doc. LVI, 1:158. Borghini's sketches in BNCFlor 2.10.100 have been published by Ginori Conti, *L'apparato per le nozze*, figs. 1–19; Pillsbury, "Drawings by Vasari and Vincenzo Borghini," pp. 281–83; Pillsbury, "The Temporary Façade on the Palazzo Ricasoli," pp. 75–83; Pillsbury, "Vincenzo Borghini as a Draftsman," pp. 6–11; Fagiolo, ed., *La città effimera*, figs. 10, 106–9; Testaverde Matteini, "Una fonte iconografica," pp. 135–44; Scorza, "Vincenzo Borghini and *invenzione*," pp. 57–75; and Scorza, "A New Drawing for the Florentine 'Apparato,'" pp. 887–90.

210. Bottari and Ticozzi, *Raccolta di lettere*, doc. LVI, 1:140.

211. Ibid., p. 127. See also Ginori Conti, *L'apparato per le nozze*, doc. III, p. 90.

212. Frey, *Der literarische Nachlass*, doc. XDVII, 2:171; and Bottari and Ticozzi, *Raccolta di lettere*, doc. LVIII, 1:208.

213. See Frey, *Der literarische Nachlass*, doc. ID, 2:183; doc. DXVI, 2:212–13; doc. LX, 3:111; Bottari and Ticozzi, *Raccolta di lettere*, doc. LIX, 1:211; doc. LXI, 1:214–15; doc. LXV, 1:226; doc. LXVI, 1:231; doc. LXX, 1:239; and Ginori Conti, *L'apparato per le nozze*, app. 2, p. 113.

214. Bottari and Ticozzi, *Raccolta di lettere*, doc. LVI, 1:126; doc. LXVI, 1:229; doc. LXVIII, 1:235; Frey, *Der literarische Nachlass*, doc. DV, 2:196; doc. LX, 3:109; doc. DXVI, 3:212; Lorenzoni, *Carteggio artistico inedito*, doc. XXI, pp. 42–43.

The thick, bound manuscript of Borghini's working notes for the entry (BNCFlor 2.10.100) consists almost entirely of lists: Hapsburg and Medici coats of arms, genealogies, and devices; deeds of Hapsburg emperors; shields of Florence and Florentine guilds; founders of religious orders; poets, men of arms, scholars, artists; signs, symbols, deities, virtues, and medal reverses of classical antiquity; state ceremonies, and ceremonial protocol and costume; crown types; iconographical schemes of arches; inscriptions; expenses; payments; work crews; etc.

215. Frey, *Der literarische Nachlass*, doc. XDVII, 2:171. In his *Selva di notizie* (quoted in Paola Barocchi, ed., *Scritti d'Arte del Cinquecento: Pittura e Scultura* [Turin, 1978], 3:663) Borghini calls this mental concentration "una fatica tutta mentale, la quale è nell'intelletto che s'affatica discorrendo, immaginando, conferendo e commettendo insieme più cose, e di tutto formando il suo concetto o idea o resoluzione o invenzione che la vogliàn chiamare. Questa è eccellentissima e soperiore a ogni altra fatica, e da questa s'acquista nome d'eccellenzia, e da questa vien la fama e la reputazione tutta, e questa è comune a poeti, istorici, filosofi etc., pittori, scultori et architetti."

216. Frey, *Der literarische Nachlass*, doc. DXVI, 2:212.

217. Ibid., doc. CDLXVIII, 2:117; doc. CDLXIX, 2:123; and Lorenzoni, *Carteggio artistico inedito*, pp. 39–40.

218. Lorenzoni, *Carteggio artistico inedito*, doc. X, pp. 16–19; doc. XVI, pp. 33–37.

Borghini followed only a few of Cini's recommendations but probably found them most useful to stimulate thought. For Cini see M. Feo's biography in the *Dizionario Biografico degli Italiani* (Rome, 1981), 25:608–12.

219. Frey, *Der literarische Nachlass*, doc. DXII, 2:206; doc. DXVI, 2:213; doc. DXVII, 2:215; doc. LX, 3:109; Bottari and Ticozzi, *Raccolta di lettere*, doc. LXIII, 1:219–21; Lorenzoni, *Carteggio artistico inedito*, doc. XIX, pp. 40–41; and doc. XXVIII, p. 49.

220. Lorenzoni, *Carteggio artistico inedito*, doc. XXII, pp. 43–44. Already in June 1565 Cosimo had expressed his opinion that inscriptions should be brief, incisive, and elegant; Frey, *Der literarische Nachlass*, doc. D, 2:185.

221. Bottari and Ticozzi, *Raccolta di lettere*, doc. LVI, 1:128.

222. Ibid., p. 185; Frey, *Der literarische Nachlass*, doc. DIII, 2:191–93; doc. DV, 2:194–99; and doc. DXII, 2:206–7.

223. Vasari, *Le vite*, ed. Milanesi, 8:208, 212, 222.

224. Bottari and Ticozzi, *Raccolta di lettere*, doc. LXII, 1:216–17.

225. Ibid., doc. LVI, 1:139–40.

226. Ginori Conti, *L'apparato per le nozze*, doc. I, p. 79.

227. Bottari and Ticozzi, *Raccolta di lettere*, doc. LXVII, 1:233; and doc. LXIX, 1:237.

228. Ibid., doc. LXVI, 1:229; doc. LXIX, 1:237; and doc. LXX, 1:239.

229. Lorenzoni, *Carteggio artistico inedito*, doc. XXII, p. 44; and doc. XXVII, p. 49.

230. For the dates of the composition and printing of Mellini's description, see Ginori Conti, *L'apparato per le nozze*, pp. 62–63 n. 86.

231. Vasari [Cini], *Descrizione dell'apparato* in *Le vite*, ed. Milanesi, 8:517–617. In a letter to Borghini Cini writes that his "Descrizionetta" was destined for the imperial court: see Lorenzoni, *Carteggio artistico inedito*, doc. XXIV, pp. 45, 154–63.

232. "Ragionamento unico," in *Le vite*, ed. Milanesi, 8:199–223.

233. Bottari and Ticozzi, *Raccolta di lettere*, doc. LXVII, 1:234.

234. "Since I have spoken of them [fifteenth-century Florentine artists] in the previous books, I will pass by without saying more about them, thus avoiding the tedium that might come upon my readers by repetition." "And to the end that all may be the better understood, and in order to show more clearly and distinctly in what manner the work was constructed, it is necessary that some measure of pardon should be granted to us by those who are not of our arts, if for the sake of those who delight in them we proceed, more minutely than might appear proper to the others, to describe the nature of the sites and the forms of the arches." "Such, as a whole, was the interior of the theater [of the Medici] described above; but although it may appear to have been described minutely enough, it is none the less true that an infinity of other ornaments, pictures, devices, and a thousand most bizarre and most beautiful fantasies that were placed throughout the Doric cornices and many spaces according to opportunity, making a very rich and gracious effect, have been omitted as not being essential, in order not to weary the perhaps already tired reader." See Vasari, *Le vite*, ed. Milanesi, 8:521, 529, 539, 549. Vasari's "Ragionamento unico" also contains several similar statements concerning the tedium of over abundant, difficult to view material; ibid., pp. 206, 208, 212.

235. Ibid., p. 568.

236. Bottari and Ticozzi, *Raccolta di lettere*, doc. LVI, 1:200. Caccini's record of the expenses for the entry and the Sala Grande is in Frey, *Der literarische Nachlass*, app. 5, 3:229–51.

237. Bottari and Ticozzi, *Raccolta di lettere*, doc. LVI, 1:188. For the collaboration between Borghini, Vasari, and Caccini in the acquisition of the wood for the entry, see Lorenzoni, *Carteggio artistico inedito*, pp. 15–16, doc. IX and n. 2. The fullest discussion

of the necessary supplies, a "Discorso per i legnami," was published by Ginori Conti, *L'apparato per le nozze*, app. 5, no. 8, pp. 148–49.

238. Bottari and Ticozzi, *Raccolta di lettere*, doc. LVI, 1:189–90. See Ginori Conti, *L'apparato per le nozze*, app. 4, pp. 119–23, for the many additional tasks with which Caccini was charged: making arrangements for the ceremony of greeting Giovanna by all the notables at the Porto al Prato; overseeing the completion of the fountains on the Arch of Maritime Empire and the Arch of Happiness; checking on the progress of the statues for all the arches and seeing that they were waterproofed; checking on the progress of the paintings for a number of arches and reallocating assignments in the case of those painters who were falling behind; making an inventory of what statues and paintings had been completed and what remained to be done; checking on the progress of the masons and carpenters and seeing if they needed anything; checking on the men and supplies in the workshops set up in S. Maria Novella, S. Michele Vis-domini, Compagnia de' Tessitori, Spedale di S. Noferi, and S. Maria Soprarno; arrang-ing for the erection of gutters above some of the arches attached to buildings to protect them from water; and so on.

239. Lorenzoni, *Carteggio artistico inedito*, doc. XI, p. 19; doc. XII, pp. 23–24; and doc. XIII, pp. 25–26.

240. Ginori Conti, *L'apparato per le nozze*, doc. I, p. 83.

241. Lorenzoni, *Carteggio artistico inedito*, doc. XI, p. 20. Also quoted in Ginori Conti, *L'apparato per le nozze*, p. 83 n. 12.

242. Frey, *Der literarische Nachlass*, doc. DII, 2:188.

243. Ginori Conti, *L'apparato per le nozze*, doc. II, p. 85.

244. Ibid., pp. 73–74, gives the total sum as about 23,333 *fiorini*.

245. Ibid., p. 75. When Borghini wrote to Cosimo on 5 April 1565 (Bottari and Ticozzi, *Raccolta di lettere*, doc. LVI, 1:130–31) that "almeno qualche parte di questi archi dependano o si facciano in nome della città or de' magistrati, che così si può so-disfare facilmente all'obbligo nostro e alla modestia de' nostri signori," he probably meant that the city and magistrates would bear part of the expenses. In any case, it is certain that his own Ospedale degli Innocenti paid for the Arch of the Virgin Mary on the cathedral; see ibid., doc. LXVI, 1:230–31.

246. Ibid., doc. LVI, 1:204.

247. Ibid., p. 192. Borghini also recommends holding back a final payment as an in-centive to get the work done on time (ibid., pp. 201–2).

248. Lorenzoni, *Carteggio artistico inedito*, doc. XI, pp. 22–23; and doc. XIII, pp. 24–25.

249. Frey, *Der literarische Nachlass*, doc. XDVII, 2:171; and Ginori Conti, *L'apparato per le nozze*, doc. II, p. 88.

250. Ginori Conti, *L'apparato per le nozze*, doc. II, p. 87. See also ibid., doc. I, p. 84, and doc. VI, p. 101.

251. Frey, *Der literarische Nachlass*, app. 4, 3:227–28. For a very similar statement see ibid., p. 224.

252. Ginori Conti, *L'apparato per le nozze*, doc. II, p. 86; doc. VI, p. 102; and Frey, *Der literarische Nachlass*, app. 4, 3:224.

253. Frey, *Der literarische Nachlass*, app. 4, 3:224; and Ginori Conti, *L'apparato per le nozze*, doc. I, p. 84.

254. Domenico Mellini in Vasari, *Le vite*, ed. Milanesi, 8:620. The only recent biog-raphy of Vasari is of limited usefulness: T. S. R. Boase, *Giorgio Vasari: The Man and the Book* [Bollingen Series 35, vol. 20] (Princeton, 1979).

255. Bottari and Ticozzi, *Raccolta di lettere*, doc. LVI, 1:185, 193.

256. Ginori Conti, *L'apparato per le nozze,* app. 5, nos. 5 and 6, pp. 142–47.

257. Bottari and Ticozzi, *Raccolta di lettere,* doc. LVI, 1:193–200.

258. See appendix 2:*1–14* for the painters, sculptors, carpenters, and masons who worked on each monument for the entry. These attributions are derived from Domenico Mellini (in Vasari, *Le vite,* ed. Milanesi, 8:617–22), Borghini's working notes (BNCFlor 2.10.100; and Ginori Conti, *L'apparato per le nozze,* app. 5, nos. 2–7, pp. 125–48), and records of payments to artists and artisans kept by Borghini and Caccini (Frey, *Der literarische Nachlass,* app. 4 and 5, 3:220–51). There are many discrepancies among these sources, but in making decisions on contradictory evidence we treat the payments as the most authoritative.

259. For the documentation on the cortile and the Sala Grande see Allegri and Cecchi, *Palazzo Vecchio,* pp. 30–39, 223–82; Frey, *Der literarische Nachlass,* app. 5, 3:229–51; and Pillsbury, "The Sala Grande Drawings." Since the stage in the Sala Grande was always referred to in the documentation as the *prospettiva,* no distinction can generally be made between the actual stage, the proscenium arch, and the stage flats. Unless stated to be for the cortile, all work listed below is for the Sala Grande. For a full description of the art work and inscriptions in the Sala Grande see appendix 2:*15.*

Architects: Giuliano di Baccio d'Agnolo (dais), Vasari (new ceiling, new stairway and entrance into Sala Grande, upper part of dais), and Michelangelo (consultant on new ceiling).

Painters: Giorgio Vasari (overall design of both Sala Grande and cortile, much execution of Sala Grande), Giovanni Stradano (assisted with design and execution of ceiling and walls), Battista Naldini (assisted with design and execution of ceiling and walls, *vedute* [panoramas] of Pisa, Livorno, and Torre di San Vincenzo for backgrounds of wall battle scenes, two temporary paintings on side walls over dais [*Cosimo I Drains the Pisan Swamps, Cosimo I Fortifies Tuscany*]), Jacopo Zucchi (assisted with design and execution of ceiling and walls, two temporary paintings on side walls at end opposite dais [*Cosimo I Builds Cosmopoli on Elba, French Return the Keys to Livorno*]), Santi di Tito (assisted with execution of ceiling), Michele di Ridolfo Tosini (assisted with execution of ceiling), Federico Zuccaro (stage curtain representing a hunt), Stefano Veltroni da Monte San Savino (gilding in ceiling, grotesques in ceiling and cortile), Tommaso di Battista del Verrocchio (grotesques in ceiling), Prospero Fontana (stage flats, assisted with execution of ceiling), Marco Marchetti da Faenza (grotesques in cortile, possibly in ceiling), Orazio Porta da Monte San Savino (*vedute* of cities for backgrounds, grotesques in ceiling and cortile), Francesco Morandi da Poppi (grotesques in cortile), Lorenzo Sabbatini (temporary paintings of the founders of the ten cities for side walls), Roberto di Filippino (coat of arms for cortile), Alessandro Fei del Barbiere (*vedute* of Pisa, Livorno, Cortona, San Giovanni Valdarno, Figline, Borgo Sansepolcro, Anghiari, San Gimignano, Certaldo, Colle, Cascina, Vicopisano, San Miniato al Tedescho for backgrounds in ceiling, temporary paintings of cities for walls [*Siena, Pisa, Montepulciano, Cortona*]), Giovanni Lombardi da Venezia (temporary paintings of cities for walls [*Borgo Sansepolcro, Prato*], frescoed cities in cortile), Bastiano Veronese (temporary paintings of cities for walls [*Fiesole, Pistoia*], cities in cortile), Turino da Piemonte (temporary paintings for walls [*Arezzo*], cities in cortile), Cesare Baglioni (frescoed cities in cortile), and Domenico Beceri (assisted Vasari).

Sculptors and stonecutters: Bartolomeo Ammannati (Rain Fountain) assisted by three *intagliatore* (Domenico di Benedetto Lorenzi [also did some stone articulation for dais], Amadio di Vincenzo Baccegli, Dante di Nese) and seven *scalpellini* (Michele di Tommaso, Raffaello di Raffaello, Nicolò di Michelangolo, Michele di Filetto,

Giovanni di Michele de Filetti, Michele di Gerardo Mecini, Andrea di Jacopo detto Boccaletto), Baccio Bandinelli (marble statues of *Giovanni delle Bande Nere, Duke Alessandro, Duke Cosimo I* [head unfinished], *Pope Leo X* [unfinished], and *Pope Clement VII* for the dais), Vincenzo de' Rossi (marble statue of *Charles V*, completed *Duke of Cosimo I* and *Pope Leo X* for the dais), Francesco di Gerardo Mecini (stone articulation for dais and walls), Leonardo Ricciarelli da Volterra (stucco work in cortile and on dais?), Giovanni Boscoli da Montepulciano (stucco work on dais?), Francesco di Lorenzo da Corbignano (stone articulation for walls), Domenico d'Antonio (gesso preparation of ceiling for painters, stone articulation for walls), Romualdo d'Antonio (stone articulation for walls), Andrea di Vincenzo da Settignano (stone articulation for walls), Battista di Francesco Ferrucci del Tadda da Fiesole (stone articulation for walls, stucco work in cortile), Battista Lorenzi (marble doors), Carlo di Ceseri (ten *termini* of papier-mâché to hold lamps above theater seats), Francesco Moschini (two small clay river gods for the stage), Lorenzo Pinacci (two large putti in front of stage), Giambologna (clay *Flora or Florence Victorious over Pisa*), Michelangelo (marble *Victory*), Santi Buglioni and Lorenzo Marignolli (five terracotta putti, nine heads of Capricorn in papier-mâché, twenty-five heads of lions in papier-mâché, and various stucco work for cortile, as well as gesso and papier-mâché putti to hold lamps on stage), Pietro Paolo Minzocchi da Forlì (stucco work in cortile), Andrea di Giovanni di Betto (capitals for columns in cortile), and Francesco Ferrucci detto il Tadda assisted by Raffaello di Domenico di Polo and Andrea di Domenico (basin for the fountain in cortile with Andrea Verrocchio's *Cupid with a Dolphin*).

Masons: Bernardo d'Antonio di Monna Mattea (raised walls for new ceiling, stone articulation for walls), Santi Maiani (*tramezzo* in Sala Grande [for dais?], wall preparation and scaffolds for the painters in cortile).

Carpenters: Battista di Bartolomeo Botticelli (new ceiling, stage, theater seats), Dionigi di Matteo Nigretti (assisted with new ceiling).

Glassmaker: Giovanni da Venezia (glass globes for lamps in Sala Grande in front of stage).

Gold beater: Taddeo di Francesco.

Twelve painters, six sculptors, one mason, and one carpenter who worked in the Sala Grande or cortile of the Palazzo Vecchio also worked on the entry decoration.

260. Frey, *Der literarische Nachlass*, doc. D, 2:185; doc. DII, 2:187; doc. DVI, 2:199; and doc. DXVII, 2:215. See also del Vita, *Lo Zibaldone*, p. 35 n. c.

261. Frey, *Der literarische Nachlass*, doc. DXIV, 2:209–10.

262. Ibid., doc. XXX, 3:52.

263. Ibid., doc. XDVII, 2:171.

264. Vasari, *Le vite*, ed. Milanesi, 1:168–69.

265. Vasari was particularly proud of the variety he was able to give to the human figure in the ceiling of the Sala Grande, having exploited every posture humanly possible. See Frey, *Der literarische Nachlass*, doc. CDLXXIV, 2:131 (27 November 1565, Vasari to Don Giusti): "son infastidito in 39 storie, tutte piene di figure: che vi giuro, che non si puo fare attitudine varie a nessuna figura, perche è messo in questo tutto quel che puo far un uomo."

266. Bottari and Ticozzi, *Raccolta di lettere*, 1:181–83.

267. Frey, *Der literarische Nachlass*, doc. DVI, 2:199. Vasari also spoke elsewhere of the intense effort that went into designing the Sala Grande (Vasari, *Le vite*, ed. Milanesi, 7:702): "Ma chi vede quest'opera può agevolmente immaginarsi quante fatiche e quante vigile abbia sopportato in fare, con quanto studio ho potuto maggiore,

circa quaranta storie grandi, et alcune di loro in quadri di braccia dieci per ogni verso, con figure grandissime, e in tutte le maniere."

268. Vasari, *Le vite*, ed. Milanesi, 1:169, 174.

269. Frey, *Der literarische Nachlass*, doc. DVIII, 2:202. Borghini himself in his 5 April 1565 letter to Cosimo made the distinction between conception and execution (Bottari and Ticozzi, *Raccolta di lettere*, doc. LVI, 1:210): "Quanto al disegno, non guardate al mio, che forse è sproporzionato, ma guardate alla invenzione."

270. Pillsbury, "The Sala Grande Drawings," p. 135.

271. Barocchi, *Vasari pittore*, pp. 57–61.

272. Vasari, *Le vite*, ed. Milanesi, 7:702.

273. Frey, *Der literarische Nachlass*, app. 4, 3:228.

274. See Lucia Ragghianti Collobi, *Il Libro de' disegni del Vasari* (Florence, 1974) with further bibliography.

275. See Karl Frey, ed., *Giorgio Vasari: Le Vite de' più eccellenti pittori, scultori e architetti* (Munich, 1911), p. 104; Ugo Scoti-Bertinelli, *Giorgio Vasari scrittore* (Florence, 1903), pp. 83–86; and most recently Robert Williams, "Vincenzo Borghini and Vasari's 'Lives,'" (Ph.D. diss., Princeton University, 1988), pp. 153–59.

276. Guicciardini, *Storia d'Italia* 4.10, ed. Seidel Menchi, 1:408–14.

277. Frey, *Der literarische Nachlass*, doc. LXVIII, 3:139.

278. See Phyllis Pray Bober and Ruth Rubinstein, *Renaissance Artists & Antique Sculpture, A Handbook of Sources* (London, 1986), pp. 158–62; and James S. Ackerman, *The Architecture of Michelangelo* (Harmondsworth, 1970), p. 167.

279. Vasari's image of an equestrian Mars on the Temple of Mars derived from the bronze statue believed to be Mars on the Ponte Vecchio that was lost in the flood of 1333. The statue is recorded visually in the copy of Giovanni Villani's *Cronica* in the Vatican Library, Chigi LVIII, 296, fol. 70.

280. E.g., the second-century Roman sarcophagus of a *General Crowned by Victory Receiving Barbarians* known to have been in the Vatican Belvedere by the early sixteenth century as it still is today: Bober and Rubinstein, *Renaissance Artists*, pp. 194–95, fig. 160.

281. Vitelli himself may have been intended to recall Uccello's Niccolò da Tolentino in the London panel of the *Battle of San Romano* (in the Palazzo Medici in Vasari's day), as if to equate Vitelli with another Florentine commander of the republic who failed to exploit a hard-won advantage. For Uccello's battle panels: Randolph Starn and Loren Partridge, "Representing War in the Renaissance: The Shield of Paolo Uccello," *Representations* 5 (1984): 32–65.

282. Vasari, *Le vite*, ed. Milanesi, 1:168.

283. For the Accademia del Disegno, see above all Zygmunt Waźbinski, *L'Accademia medicea del disegno a Firenze nel cinquecento, Idea e istituzione* [Accademia Toscana di Scienze e Lettre "La Colombaria," Studi, 84] (Florence, 1987) with an exhaustive bibliography.

284. Vasari, *Le vite*, ed. Milanesi, 8:206, 219.

285. Ibid., 7:701–2.

EPILOGUE

1. For Vasari's theory of history see his "Proemio di tutta l'opera," "Introduzione," "Proemio delle vite," "Proemio alla parte seconda," and "Proemio alla parte terza," in *Le vite de' più eccellenti pittori, scultori ed architettori*, ed. Gaetano Milanesi, 9 vols. (Florence, 1878–85), 1:91–244, 2:93–107, and 4:7–15.

INDEX

Italic page references indicate illustrations; section numbers in Appendixes 1 and 2 are also italicized and are listed in parentheses following the relevant page number.

Accademia del Disegno, 209–11

Adriani, Giambattista, 186, 198, 300 (*15.45*)

Agnolo, Filippo di Giuliano di Baccio d', 291

Agnolo, Giuliano di Baccio d', 364 n.259

Agnolo di Tura, 24

Alberti, Leon Battista, 95, 268 (*1.7*), 346 n.91; as architect, 90; *Momus o del principe*, 132; *On Painting*, 89, 91, 92–93, 95–96, 100–101, 119, 124, 127

Alfonso of Aragon, 159

Alighieri, Dante, 268–69 (*1.7,15*), 360 n.193; *Divine Comedy*, 11–12, 14, 19–20, 25, 30, 40–41, 158, 262; *De vulgari eloquentia*, 38

Allori, Alessandro, 200–201, 204, 271, 277

Ammannati, Bartolomeo, 202; Column of Victory, 279; Neptune Fountain, 180–81, 205, *225*, 279 (*5*), 293 (*13*), Rain Fountain, 156, 175–76, 181, 254–55, 302 (*15.60–62*), 341 n.16, 353 n.134, 356–57 nn.161–62, 364 n.259

Andrea di Domenico, 365 n.259

Andrea di Giovanni di Betto, 365 n.259

Andrea di Jacopo detto Boccaletto, 365 n.259

Andrea di Vincenzo da Settignano, 365 n.259

Angiolieri, Cecco, 27–28

Antiquity: invoked for legitimacy, 16, 86, 169, 175, 181, 184, 208–9; representations of evil in, 25; triumphs in, 153, 157–59, 166, *213–16*; tyrants in, 39, 129; use of in Camera

Picta, 96, 115, 127–31; use of in Sala Grande, 176–77, 182, 184, 194, 208; victory in, 164

Apuleius, 166

Aquinas, Saint Thomas. *See* Thomas Aquinas, Saint

Ariosto, 360 n.193

Aristotle, 360 n.193; *Ethics*, 41, 44; on government, 20, 40, 126; on middle class, 24; on politics, 12–13, 39, 58; on representation, 13

Arnheim, Rudolf, 123

Arnolfo di Cambio, 295 (*15.3*)

Arrivabene, Giovanni Pietro, 90

Astrology, 53, 113, 173, 186

Baccegli, Amadio di Vincenzo, 364 n.259

Baglioni, Cesare, 364 n.259

Bandinelli, Baccio, 156, 205, *252–53*, 302–3 (*15.53–57,69*), 304, 352–53 nn.129–30, 365 n.259

Barbara, Saint, 116–17

Barocchi, Paola, 206

Barthes, Roland, 100

Bartoli, Cosimo, 191

Bartolomeo, Francesco di, 271

Bartolus of Sassoferrato, 20, 22–23

Baxandall, Michael, 100

Beceri, Domenico, 289, 364 n.259

Bellini, Jacopo, 108

Benjamin, Walter, 26

Bernardino, Saint, 46–47, 51–52

Bernardo d'Antonio di Monna Mattea, 291, 293, 301 (*15.47*), 365 n.259
Bernardo di San Giorgio, 293
Biondo, Flavio, 159
Boccaccio, Giovanni, 27, 47, 269 (*1.15*), 297 (*15.19*)
Bologna, Giovanni. *See* Giambologna
Bonichi, Bindo, 22, 34, 37, 318 n.87
Bonvesin de la Riva, 20, 22, 23, 55
Borges, Jorge Luis, 127
Borghini, Vincenzo, 169–70, 172, 177, 183, 185–86, 189–90, 192–207, 209, *227–29*, 300 (*15.45*), 340 n.14, 350 n.112, 361 nn.214–15, 363 n.245
Boscoli, Maso, 204, 289, 290
Boscoli da Montepulciano, Giovanni, 365 n.259
Botlan, Ibn, 53
Botticelli, Battista di Bartolomeo, 301 (*15.47*), 365 n.259
Bronzino, Agnolo, 198, 201, 202, 204, 277
Bruni, Leonardo, 178, 268 (*1.7*)
Buglioni, Santi, 365 n.259
Burckhardt, Jacob, 3, 7, 83, 88, 157, 259
Burke, Peter, 55
Butteri, Cresci, 271
Butteri, Giovanni Maria, 271

Caccini, Giovanni, 192, 200–203, 205, *253*, 302 (*15.58–59*), 304, 362–63 nn.237–38
Calvi, Lazzaro, 161
Cambiaso, Luca, 161
Camera Picta, Mantua, plate 5, 83–133, *136–48*, 325 n.6; as audience hall, 85, 94, 151, 152; ceiling, 114–31; decoration of, 92, 94–96, 98, 101, 115, 133; situation of, 84–85. *See also* Mantegna, Andrea
Camillo d'Ottaviano, 271
Casali, Fra Giovanni Vicenzo, 271
Castiglione, Baldassare (elder), 99
Castiglione, Baldassare (younger), 120
Castles. *See* Palaces
Cato, 360 n.193
Catullus, 272 (*3.1*), 360 n.193
Center, as organizing principle: and Caccini, 200; in Camera Picta, 123, 126; and Cosimo I, 179, 184, 190; of Florentine power, 169, 175, 178; in procession, 175; in Sala dei Nove, 19, 28; in Sala Grande, 184, 193; of the state, 1–2; urbanistic, 17, 32; and Vasari, 210; and victor, 164. *See also* Perspective
Centi, Jacopo da Pistoia, 290

Ceseri, Carlo di, 365 n.259
Charlemagne, 2, 177–78
Charles V, 151–53, 157, 159, 162, 172, 181, 302 (*15.58*). *See also* Procession
Christian I of Denmark, 97, 104, 330 n.48
Chrysolorus, Manuel, 100
Cicero, 35–36, 39, 42–43, 100, 166, 262
Cini, Giovanni Battista, 188–89, 198–99
Cioli, Valerio, 293–94
Citizens: republican, 21, 23, 36; subjects and, 22; tyrants and, 24
Classicism, 159; Camera Picta, 126–31; conception of programs, 194; humanism, 130, 193. *See also* Antiquity
Colombini, Simone, 290
Compagni, Dino, 12
Copia, 166–67, 189–90
Corradi, 87
Court, 5; culture of, 90, 99, 105, 107, 109, 119–20, 131, 258; entertainment at, 120; as gendered space, 123, 259; legitimacy of, 88; of Tyranny, 27–28, 42, 48, 50; of women, 51; women at, 121–23. *See also* Mantua
Crocini, Antonio, 290

Dante. *See* Alighieri, Dante
Dante di Nese, 364 n.259
Danti, Vincenzo, 204, 290
Delumeau, Jean, 21
Descherini, Daccio, 285
Diplomacy, 83, 88, 92, 99, 105, 133
Disegno, 179, 192, 205–9. *See also* Accademia del Disegno
Disorder: in description (*copia*), 167; and order in government, 22, 36, 46, 188, 208; in Sala dei Nove, 19; in triumphs, 163, 197
Domenico d'Antonio, 365 n.259
Domenico di Zanobi, 285
Donato di Neri, 24
Douglas, Mary, 27, 93–94
Dürer, Albrecht, 161

Education: artist's, 206; classical, 128; humanist, 139
Elias, Norbert, 93
Entry of Giovanna of Austria, 168–74, 178–80, 185–86, *217–26*, 231, 267–94 (*1–14*); artists working on, 203–5, 267–94 (*1–14*); Arch of Austria, 172, 186, 196, 204, 221, 279–81 (*6*), 346 n.80; Arch of Austria and Tuscany, 171–73, 196, *218*, 271–72 (*2*);

Arch of Florence, 170, 173–74, 178–79, 181–82, 185, 196–97, 209, *218*, 267–71 (*1*), 351n.117, 352nn.120–21, 355n.144, 360n.191; Arch of Happiness, 196, *224*, 352n.124; Arch of Hymen, 171, 174, 178, 186, 202, 204, *219*, 272–77 (*3*), 352n.122; Arch of Maritime Empire, 169, 185, 196, 202, 204, *219*, 277–78 (*4*), 352n.122; Arch of Prudence, 155, 178–80, 182, 196–97, *225*, 291–93 (*12*), 352n.126; Arch of Religion, 173–74, 179, 185, 196, 204, *223*, 285–89 (*8*), 346n.84, 352n.123; Arch of Security, 174, 178, 180, 186, 204, *226*, 293–94 (*14*); Arch of the Virgin Mary, 174, *224*, 289–90 (*9*); Column of Victory, 169, 172, 186, *220*, *227*, 279 (*5*), 352n.122; courtyard, 156, 174–75, *231–32*, 346–47nn.91–94; Equestrian Monument, 178–79, 196, 204, *224*, 290 (*10*); Neptune Fountain, 180, 205, *225*, 293 (*13*); Theater of the Medici, 172–73, 176, 179–80, 203, 205, *222*, 281–85 (*7*), 346n.80. *See also* Procession; Programming; Vasari, Giorgio

Entry ritual: history of, 153; medieval French, 151–52; Renaissance examples, 359n.190. *See also* Procession

Erasmus, 166–67, 190

Evil: in antiquity, 25; and government, 11, 25; represented in Sala dei Nove, 19–20, 25–27, 34, 42, 58; and wealth, 22

Fancelli, Luca, 89–90
Fei del Barbiere, Alessandro, 364n.259
Feldges-Henning, Uta, 48, 53
Feliciano, Felice, 111–13
Ferrucci del Tadda da Fiesole, Battista di Francesco, 365n.259
Ferrucci detto il Tadda, Francesco, 279, 365n.259
Fiera, Battista, 131
Filarete, Francesco, 85, 89–90
Florence: and antique style, 89, 155; and conquest of Siena, 58, 155–56, 184; myth of, 173, 177–78, 351n.113; princely regime, 86, 176; republican, 12, 24, 156, 169, 177, 183–84, 186–87, 195, 208; and tyranny, 24; and war with Pisa, 183–84. *See also* Medici family; Urbanism
Fontana, Prospero, 364n.259
Formalist pragmatics, 5
Foucault, Michel, 4, 93
Francesco della Cammilla, 204, 272, 290
Francesco del Tadda, 279

Francesco di Gratia Dio, 281
Francesco di Lorenzo da Corbignano, 365n.259
Francia, Pier, 289
Frederick II, Emperor, 55, 158
Frederick III, Emperor, 97, 104, 109, 330n.48

Gellius, Aulus, 129
George of Trebizond, 101
Ghiberti, Lorenzo, 46, 52
Giacomini, Antonio, 183–84, 354nn.139,141
Giambologna, 156, 161, 180, 290, 293, *255*, 302 (*15.64*), 365n.259
Giotto, 47–48, 52, 74, 269 (*1.13*)
Giovanna of Austria. *See* Medici, Giovanna of Austria
Giovanni da Venezia, 365n.259
Giovanni dell'Opera, 204, 278, 289–90
Giovanni di Giovanni Francesco da Settignano (il Rossino), 293
Giovanni di Michele di Filetti, 365n.259
Giovanni di Piero di Valdimarina, 277
Girolamo da Cremona, 117, *146*
Gobbo, Bartolomeo, 293
Gobbo, Vittorio, 289, 293
Goffman, Erving, 93
Gonzaga, Barbara, 95
Gonzaga, Barbara of Brandenburg, 83–84, 87, 92, 94, 98–99, 116–17, 121
Gonzaga, Federico, 83–84, 97–98, 102–3, 126, 152, 153
Gonzaga, Francesco, 97, 104
Gonzaga, Cardinal Francesco, 96, 98, 102–4, 109, 112
Gonzaga, Gianfrancesco, 87, 89, 95, 101
Gonzaga, Ludovichino, 95, 97
Gonzaga, Ludovico, 83–85, 87–90, 94, 97–99, 102–3, 105, 107, 109–10, 113, 126, 130–31, 133, 151
Gonzaga, Luigi, 87
Gonzaga, Paola, 95
Gonzaga, Rodolfo, 95
Gonzaga, Cardinal Sigismondo, 97, 104
Gonzaga family: rise to power, 87; dynastic portrait, 95, 97. *See also* Mantua
Grazzini, Antonfrancesco, 157, 160–61
Great halls, medieval, 2
Greenstein, Jack M., 49, 53
Gregory the Great, Pope, 25
Guarino, Battista, 132
Guarino da Verona, 101

Guicciardini, Francesco, 183, 207, 268 (*1.7*), 360 n.193
Guidoriccio da Fogliano, 18

Hall of Nineteen Divans, Constantinople, 2
Halls of state: ancient, 1–2, 305–6 nn.1–2; Byzantine, 2, 306 n.4; Carolingian, 307 n.5; as civic centers, 32; communal, 3–4, 310 n.19; German, 2; medieval, 2–3; papal, 2–3, 306 n.4, 308 n.9, 341 n.19. *See also* Camera Picta, Mantua; Sala dei Nove, Siena; Sala del Maggior Consiglio, Venice; Sala Grande, Florence
Heikamp, Detlef, 181
Herodotus, 129
Historical record: in Camera Picta, 97, 103–5; as documentation, 32, 58, 102, 197; in Siena, 24, 32–33, 56; as subject of painting, 56–57, 193
Hobbes, Thomas, 22, 31, 32
Horace, 291 (*11.3*)
Hugh of St. Victor, 38, 53
Humanist: art criticism, 100–101, 111; early, 39–40; education, 130; history, 178, 193; programs, 115; scholarship, 159

Iconography, 3, 5, 14, 29, 160, 259; of Camera Picta, 95, 114–15, 117; of Entry of Giovanna of Austria, 166, 178; of Sala dei Nove, 14, 20, 25, 50–53, 90, 322 n.142; of Sala Grande, 185
Ideology: bodies as site of, 93, 105; construction of in painting, 4–5, 20, 33, 59, 120, 195, 211, 258–59; republican, 13, 22, 31, 45, 49, 52, 55, 59
Individualism: of Mantegna's work, 91; in nineteenth century, 21
Inscriptions: antique, 159–60, 169; in Camera Picta, 114; and literacy, 30–31, 33, 39, 316 n.67; and relation of image and text, 29, 37, 41, 45–46, 50; in Sala Grande, 185; in triumphal procession, 186. *See also under* Sala dei Nove
Isidore of Seville, 41, 262

Josephus, 129
Julius II, Pope, 6

Kantorowicz, Ernst, 93

Lancia, Pompilio, 281, 289
Landscape: in Camera Picta, 104; and govern-

ment, 15, 35, 48; as historical record, 56; in Sala dei Nove, 19, 25, 46–47, 49, 53; in Sala Grande, 210; and time, 52–53
Lastricati, Zanobi, 271
Latini, Brunetto, 22, 35, 36, 40–45, 63, 268 (*1.7*)
Laura, Giacomo, *150*
Legitimacy: republican, 3–4, 12, 21, 38, 43, 45; of Gonzaga rule, 87; of Renaissance courts, 88. *See also* Antiquity
Le Goff, Jacques, 28–29
Lenzi, Domenico, 55, *78, 80*
Leonardo da Vinci, 154, 187, 257
Leo III, Pope, 2
Ligozzi, Jacopo and Francesco, 301 (*15.49,52*)
Limbourg brothers, 52–53
Literacy, 30–33, 38, 45
Livy, 111, 159, 293 (*14.2*)
Lomazzo, Giovanpaolo, 161, 163–65
Lombardi da Venezia, Giovanni, 364 n.259
Lorenzetti, Ambrogio: as citizen, 24, 28, 33–34, 38, 55, 57; commissions, 6, 13–14, 37; and contemporary theory, 25–26, 45, 49; and illustrator of *Tacuinum Sanitatis*, 54–55, *80*. Works: Allegory of Redemption, 34; *Annunciation* (1344), 34, 56; Bad Government (plate 1), 18, 19, *64, 66–68*; Common Good, as book cover, 56; frescoes for the hospital of Siena, 34; Good City (plate 3), 19, 53–54, 56–57, *65, 73–74*; Good Country (plate 4), 19, 51–55, 57, *75–76, 78–79*, 257; Good Government (plate 2), 49, *65, 69–72*, 193; Madonna and Child (1319), 34; *Presentation in the Temple*, 34; Roman histories, 34; *Virgin in Majesty*, 34, 51. *See also* Sala dei Nove
Lorenzi, Antonio di Gino, 281
Lorenzi, Battista, 204, 277, 365 n.259
Lorenzi, Domenico di Benedetto, 364 n.259
Lorenzi, Stoldo di Gino, 281, 290–91, 294
Lorenzo del Berna, 272, 277, 290
Lottini, Baccio, 271
Lucian, 115–17, 121–22
Lucretius, 278 (*4.8*)

Macchietti da Faenza, Marco, 364 n.259
Macchietti del Crocifisso, Girolamo, 289
Machiavelli, Niccolò, 11, 91, 268 (*1.7*)
Macrobius, 43
Maiani, Santi, 365 n.259
Mantegna, Andrea: and Alberti, 93, 101; and antiquity, 111–12, 116, 126–27, 131; bronze

bust of, 106, *142;* children, 108–9; coat of arms, 112, *142;* courtier, 99, 105, 107–8, 113, 133; in literature, 111, 130–33; marriage, 108; patronage, 6, 104, 108, 110; perspective, 124–26; status, 105–9, 112–14, 257, 333 n.90; training, 108. Works: ceiling (plate 6), 118–31, *136, 143–45, 147–48;* Court, 92, 94–98, 101, *137–38;* Dedicatory Plaque, 105, *139, 142;* horse and groom, 104, *139,* 257, 259; Meeting, 101, 104, 106, *139–41;* self-portrait in grotesques, 106–7, 113, *142; Triumph of Caesar,* 159, 161

Manto, 86

Mantua: court of, 85, 87–89, 91, 94, 98–99, 101, 116, 118, 133; entry of Charles V into, 151–54, 157; map of, *82;* myth of, 86–87, 105, 131, 154; politics of, 88–89, 131. *See also* Gonzaga family; Urbanism

Manzuoli di San Friano, Tommaso, 289–90

Marco da Faenza, 289, 301 *(15.47)*

Marignolli, Lorenzo, 365 n.259

Marliani, Bartolomeo, 159–60

Marsiglio of Padua, 20, 22

Martial, 2

Martini, Simone, 18

Marzio, Galeotto, 111

Mauss, Marcel, 93

Mecholi, Fruosino, 294

Mecini, Francesco di Gerardo, 365 n.259

Mecini, Michele di Gerardo, 365 n.259

Medici, Alessandro de', 152, 172, 173, 176, *252,* 282 *(7.6),* 302 *(15.56)*

Medici, Cosimo I de', 152, 154–57, 162, 168–74, 176, 187–92, *252,* 281 *(7.2),* 302 *(15.53),* 347 n.93, 351 n.117, 352 nn.120–24, 355 nn.142–43; as artist, 191, 211; as Augustus, 154–55, 169, 173, 178–84, 193, 339 n.11; as victor, 178–84

Medici, Cosimo il Vecchio de', 173, 282 *(7.9–10)*

Medici, Francesco de', 6, 152, 155–56, 189, 196, 205, 283 *(7.29),* 302 *(15.59),* 351 n.116

Medici, Giovanna of Austria, 6, 152, 154–57, 164, 168, 174–76, 185, 196

Medici, Giovanni delle Bande Nere, 176, *252,* 267 *(1.3),* 282 *(7.6),* 302 *(15.54)*

Medici, Lorenzo de', the Magnificent, 157, 179, 282 *(7.12–13)*

Medici family: and the church, 155, 166, 173–74, 176–77, 181–82, 184, 187, 356 n.143; dynastic ambitions, 155, 172–73, 176, 186,

196, 353 n.130; genealogy and marriage ties, 172, 281–85 *(7)*

Meeting halls. *See* Halls of state

Mellini, Domenico, 195, 199, 210–11

Michelangelo, 109, 156, 180, 187–88, *255,* 257, 269 *(1.13),* 302 *(15.63),* 364–65 n.259

Michele di Filetto, 364 n.259

Michele di Ridolfo Tosini, 202, 278, 289, 364 n.259

Michele di Tommaso, 364 n.259

Middle class: and Sala dei Nove, 28–29; and tyranny, 24

Milan, 54, 158; and Mantua, 88–89, 113, 133, 154, 326–27 nn.20–22; and tyranny, 23. *See also* Diplomacy; Sforza *(family members, by name)*

Minga, Andrea del, 289

Minzocchi da Forli, Pietro Paolo, 365 n.259

Mirabello, 289

Monti, Giovanni, 294

Morandini da Poppi, Francesco, 289

Moschini, Francesco, 204, 290, 293–94, 365 n.259

Music: at court, 130; popular, 160–61; in triumphs, 165

Mussato, Albertino, 20, 22

Naldini, Battista, 204, 206–7, 289, 294, 300 *(15.45),* 364 n.259

Nanni di Stocco, 281, 289, 291

Narrative, 100–101; Albertian, 92, 100–101; in Camera Picta, 104; historical, 1, 257–59; in Sala dei Nove, 46, 52, 56

Naturalism: in Castello Sforzesco, 85; of Lorenzetti, 25, 47–48, 259; of Mantegna, 91, 97

Nicolas V, Pope, 3

Nicolò di Michelangolo, 364 n.259

Nigretti, Luigi (or Dionigi) di Matteo, 294, 365 n.259

Opera, Giovanni dell'. *See* Giovanni dell'Opera

Pächt, Otto, 53, 99

Palaces: ancient, 1–2; Byzantine, 2; Castel Nuovo, Naples, 159; Castello San Giorgio, Mantua, 83, 88, 90, *135,* 151–52; Castello Sforzesco, Milan, 85; Palazzo Medici, Florence, 156, 356 n.155; Palazzo Pitti, Florence,

Palaces (*continued*)
157; Palazzo Pubblico, Siena, 6, 17–18, 48, 56, *61*, 193; Palazzo Schifanoia, Ferrara, 85; Palazzo Vecchio, 6, 156, 174, 178, 186, 230–32, 347 nn.91–93; Papal Palace, Avignon, 3; Papal Palace, San Giovanni in Laterano, 2; Papal Palace, Vatican, 3
Palatine Hill, 1–2
Palatium, 1–2
Palazzo Vecchio. *See under* Palaces
Pali, Giovanni di Matteo, 289
Pannonius, Janus, 111
Panofsky, Erwin, 14, 47–48, 93
Panvinio, Onofrio, 159–60
Particini, Antonio, 278, 281, 289
Particini, Francesco di Giovanni Battista, 281
Passignano, Domenico, 301 (*15.50,51*)
Pastoral Eye, 56
Patronage, 107, 258; Gonzaga, 88–89; and learning, 113; Medici, 195, 201
Peace of Lodi, 89
Peri, Raffaello, 285
Perino del Vaga, 161, 269 (*1.13*)
Perspective: Albertian, 1, 124, 336 n.120; in Camera Picta, 124–26; in Sala dei Nove, 48–49
Petrarch, 100, 158–59, 165, 167, 269 (*1.15*)
Peyraut, Guillaume, 41
Philo, 129
Piero di Cosimo, 161, 165
Pillsbury, Edmund, 206
Pinacci da Carrara, Lorenzo di Antonio, 294, 365 n.259
Pisanello, 89, 100–101
Platina, Bartolomeo, 89–90, 126
Plato, 126, 360 n.193
Pliny the Elder, 2, 115, 129
Plutarch, 165, 360 n.193
Poggini, Domenico, 281, 289–90, 353 n.129
Politics: and art, 3, 38, 86, 91–93, 101, 119, 211, 258; Aristotelian, 13; and the body, 93; and halls of state, 1–4, 13, 58, 126, 162, 257–59; and morality, 22, 24
Porta da Monte San Savino, Orazio, 364 n.259
Portelli, Carlo, 272, 289
Power: abuse of, 23; and authority, 4, 12, 153–54; centralization of, 1; and images, 5, 24, 47, 175, 259; of learning, 30–32, 40, 131, 209; of perspective, 126; in processions, 178; sites of, 4; and status at court, 119; among tyrants and citizens, 21. *See also* Center, as organizing principle

Prince: artist as, 211, 258; body of, 2, 5, 32, 47, 92–93, 96; entry of, 153; ideal, 91–92, 130, 170; as patron, 3, 89, 327 n.24; representations of, 193; rule of, 12, 40, 86, 191; of Siena, 20; of tyranny, 25–26; as viewer, 116, 123, 126, 131, 181. *See also* Gonzaga, Ludovico; Medici, Cosimo I de'; Sforza, Galeazzo Maria; Tyrant
Procession: art of, 151; of Charles V, 151–54, 157; through claims of regime, 169–71; of Giovanna of Austria, 6, 152, 155–56, 168–75, 185–86, 191, 196, 213–26, 267–94 (*1–14*); organization of Sala Grande as, 175–77, 179; and seeing, 20; sexual coding of, 186; across space and time, 171, 173, 184, 195; spiritual, 173; triumphal, 157–61, 163–64, 166; typology of, 162–63. *See also* Entry of Giovanna of Austria; Entry ritual; Triumphalism; Triumphs
Programming: of Camera Picta, 86, 104, 109, 115, 133; Mantegna and, 130–33; of procession of Giovanna of Austria, 267–94 (*1–14*), 359–60 nn.190–93, 361 nn.208,214,218, 362 n.234; of Sala Grande, 176–78, 183, 187, 189–203, 294 (*15*), 357–58 nn.170–78, 358–59 nn.183–84; of Sala dei Nove, 36, 45, 48, 261–66; triumphalist, 165–66, 168. *See also* Borghini, Vincenzo; Vasari, Giorgio
Provenzani, Sapìa dei, 11–12
Prudentius, 25, 116

Quintilian, 166

Raffaello di Domenico di Polo, 365 n.259
Raffaello di Raffaello, 364 n.259
Raphael, 154
Realism: in Lorenzetti, 49; in Mantegna, 91, 101, 104; medieval, 48
Regime: as center of representation, 258–59; of the Nine, 14, 58; princely, 86, 99, 126, 169–70, 177, 180, 188, 194, 196, 211–12; republican, 11, 47, 55, 169, 177, 187, 194; tyrannical, 22
Renaissance, 96–97, 257; and writing, 31
Representation: and anxiety, 21, 24–25; and the body, 91–93, 163–64; conditions of, 93, 132–33; role of in constructing ideology, 6, 13, 20, 25, 50, 58–59, 90, 98, 257–59; as truth, 5, 36–37, 57

Republicanism, 12, 31–32; Hobbes on, 22, 31; and legitimacy, 3, 21; medieval, 12; principles of, 11–14, 31–32, 35, 47, 51; as response to tyranny, 21, 22; in Sala Grande, 183, 186–88, 191–93, 208; in Sala dei Nove, 20, 22, 45, 47; and writing, 31–32, 38, 40, 45, 59. *See also* Ideology

Ricciarelli da Volterra, Leonardo, 365 n.259

Roberto di Filippino, 290, 364 n.259

Romano, Giulio, 154, 161

Romualdo d'Antonio, 365 n.259

Rossi, Vincenzo de', 180, 202, 285, 289–90, 302–3 (15.53,55,65–66), 365 n.259

Rosso Fiorentino, 161, 269 (1.13)

Rubino, 95

Ruler. *See* Prince

Ruspoli, Larione, 285

Sabbatini, Lorenzo, 204, 293, 364 n.295

Sala dei Nove, Siena, 11–59, 61–62, 64–76, 78–79, 90; in building context, 15, 18; inscriptions, 19, 30, 32–35, 37–39, 43, 45, 50, 62, 261–66; plan, 17–19, 28, 38, 61; program, 14, 45, 48, 56–59; and representation of evil, 19–20, 22, 42. *See also* Lorenzetti, Ambrogio; Narrative; Programming

Sala del Maggior Consiglio, Venice, 156, 186–87, 193, 359 n.188

Sala Grande, Florence, plate 7, 6–7, 152; artists working in, 180–81, 188, 194, 198–99, 200–205, 210; commissioning of, 156; decoration of, 155, 164, 168, 174–78, 180–84, 186–89, 348–50 nn.98,100–110, 351 n.113, 352–53 nn.129–30, 355 n.143, 356–57 nn.159–62, 357–58 nn.170–78; financing of, 200–203; plan, 152, 155–56, 175, 232; and processional route, 176, 178, 182, 195; program, 184, 190, 207–12, 232–34, 294–304 (15); and St. Stephen's Day play, 176, 181, 188–89, 256, 350 n.111; sexual coding of, 187–88; site of victory, 180, 210, 257. Works: *Apotheosis of Cosimo I*, 184, 190, 193, 236–37, 294–95 (15.1), 354–55 nn.136,141,142; *Battle at Scannagallo*, 183, 190, 250, 300 (15.43); *Battle of Stampace*, 183, 190, 207–8, 245, 299 (15.33); *Building the Third Circuit of Walls*, 178, 182, 191, 193, 239, 295 (15.3); *Conquest of the Fortress near the Porta Camollia* (plate 8), 183, 190, 209, 249, 300 (15.42); *Cosimo I Plans the War of Siena*, 182–84, 191, 248, 299–300 (15.36); *Flor-*

ence Declares War against Pisa, 183, 190, 244, 298 (15.26), 354 nn.139,141; *Florentine Defeat of the Pisans at Torre di San Vincenzo*, 183, 246, 299 (15.34); *Florentines and Romans Defeat the Ostrogoths*, 182, 240, 259 (15.4), 350 n.105; *Florentines Named Defenders of the Church*, 182, 241, 296 (15.6); *Foundation of Florence*, 177–78, 182, 190, 208, 238, 295 (15.2), 351 n.113; *Pope Eugenius IV Seeks Refuge in Florence*, 182, 241, 296 (15.7); *Portraits of the Chief Mason, Carpenter, Gilder, and Grotesque Painter*, 251, 301 (15.47); *Triumphal Entry into Florence after the Conquest of Pisa*, 247, 299 (15.35); *Triumphal Entry into Florence after the Conquest of Siena*, 190, 210, 251, 300 (15.45); *Union between Florence and Fiesole*, 182, 190, 240, 296 (15.5). *See also* Ammannati: Rain Fountain; Borghini, Vincenzo; Programming; Vasari, Giorgio

Salviati, Francesco, 161, 208, 269 (1.13)

Sansovino, Francesco, 122–23

Sansovino, Jacopo, 186

Santi di Tito, 272, 291, 293, 364 n.259

Scherano, Alessandro, 293

Schivenoglia, Andrea da, 98–99, 102–3

Sciorini, Lorenzo, 277

Segni, Fabio, 198

Seneca, 42–43

Sforza, Bianca Maria, 102–3

Sforza, Francesco, 88, 102–3, 330 n.48

Sforza, Galeazzo Maria, 83, 85, 97, 99, 105, 113, 133

Siena, 5, 10, 15–18; conquest of, 11, 58, 155–56, 183, 191; Council of Nine, 13, 15–18, 23–25, 28, 30, 33, 43, 47–48, 51, 56–59; government of, 11, 16–17, 20, 36, 43, 264–66 (B1–B3); personified, 27; relations with Church, 12, 15, 28–29, 38, 54; and tyranny, 20–21, 24, 262–64 (A1–A3); urbanism in, 15–17

Sigismund, Emperor, 87

Signorini, Rodolfo, 102–4, 106, 115, 122

Skinner, Quentin, 39, 44

Spoils: Giovanna of Austria as, 185; republic as, 185–89; role of, 164–65, 200

Squarcione, Francesco, 108, 333 n.84

Status of the artist: as victor, 154, 197, 205; in signature, 29, 38, 105–6, 109, 113–14, 210, 332 n.79; in society, 112, 209–10. See also *Disegno*; Mantegna, Andrea; Vasari, Giorgio

Stock, Brian, 30–31

Stradano, Giovanni, 204, 206, 281, 300 (15.45), 364 n.259

Structuralism, 42, 62, 162, 168, 207
Suetonius, 128–29
Susini, Giovanni, 271
Sustris, Lambert, 285

Tacitus, 129
Tacuinum Sanitatis, 53–55
Taddeo di Francesco, 365 n.259
Theater: court as, 88, 94, 113–14, 116, 132; politics as, 189, 194–95, 212, 350 n.11; of power, 1–2; and processions, 153, 166, 174; and representation, 132; St. Stephen's Day, 176, 181, 188–89, *256,* 350 n.111; triumph as, 151, 160, 163–66, 178
Theocritus, 272–73 (*3.2,3*)
Thomas Aquinas, Saint, 39–40, 44–45
Titian, 161
Tolomei, Pia dei, 11, 14
Torelli, Lelio, 197
Tosini. See Michele di Ridolfo Tosini
Trexler, Richard, 186
Triumphalism: in antiquity, 151, 154, 159; in Renaissance, 157, 161–62, 168, 177, 178, 189, 200, 203, 212
Triumphs: as carnival, *150,* 159–61; classical, 157–60, 165–66, *213–16;* in literature, 158–59, 167; Renaissance, 159–61, 163–64, 166, 193, 359 n.190; in representation, 160–62, 164. *See also* Entry ritual; Procession
Turino da Piemonte, 364 n.259
Tyranny: Bartolus of Sassoferato on, 22–23; Bindo Bonichi on, 23–24, 34; of capital, 27; in decoration of Sala dei Nove, 19–20, 22, 37, 47, 50; and middle class, 24; and morality, 22, 34; in republican ideology, 21–23, 37; in Trecento Italy, 20; and vice, 25, 38, 42
Tyrant: in antiquity, 39, 129; Carraresi of Padua, 20; Cosimo I as, 180; as Other, 24, 27; Pandolfo Petrucci, 20; personification of, 19–21, 24–27, 35, *67;* Scaligieri of Verona, 20, 87; Galeazzo Maria Sforza, 133; Visconti of Milan, 20

Urbanism: Florentine, 155, 169, 176, 340 n.14; Mantuan, 88–89, 90; Sienese, 15–17
Urbini, Carlo, 161

Vannola da Scesi, Ignazio, 291
Varchi, Benedetto, 177
Vasari, Giorgio: *disegno,* 205–11; as im-presario, 151, 189, 198, 203–12; *Lives,* 33, 106, 109, 113, 154, 165, 170–74, 180, 188, 193, 205, 207, 210–11, 257–58; status, 154, 191, 210, 258, 300–301 (*15.45–46*); work-shop, 206–7, 211, 304. Works: Arch of Security, *226,* 293–94 (*14*); *corridoio,* 156–57, 205; grand staircase in Palazzo Vecchio, 156, 175, 232, 357 n.164; Sala Grande, 156, 190, 198–99, *236–51,* 304, 364–65 nn.259,265,267. *See also* Entry of Giovanna of Austria; Programming; Sala Grande
Veen, Henk Th. van, 354 n.141
Velleius Paterculus, 129
Veltroni da Monte San Savino, Stefano, 301 (*15.47*), 364 n.259
Veronese, Bastiano, 364 n.259
Verrochio, Andrea del, 175, 269 (*1.13*), 365 n.259
Verrochio, Tommaso di Battista del, 364 n.259
Vettori, Piero, 198
Victor: and celebration, 158, 162–64; Charles V as, 152–53; Cosimo I as, 180, 188; obligations of, 164, 203; persona of, 164, 178–80; representation of, 164; and violence, 11
Villani, Giovanni, 41, 55, 177, 268 (*1.7*), 360 n.193
Virgil, 86–87, 166, 268 (*1.9*), 278 (*4.8,12*), 282 (*7.4*), 294 (*14.5,6*), 360 n.193
Vision: allegorized, 56; in Camera Picta, 118–19, 122, 126; and control, 126; educative work of, 47; Latini on, 35; and procession, 20, 163, 165, 175; in Sala dei Nove, 37, 49; and speech, 115
Vitelli, Paolo, 207–8, 299 (*15.33*)
Vittorino da Feltre, 88–89, 95, 101, 104, 131, 330 n.50

Walter of Brienne, 24
Wealth: and evil, 22; incompatibility with art, 130; knowledge as, 42; and learning, 30, 131
White, John, 49
Writing: authority of, 30–32, 36, 166; as capital, 30, 42; Latin vs. vernacular, 33, 37–39, 43; of letters, 101–3; and reading, 38–39; role in government, 45, 59; in Siena, 38, 40

Zuccaro, Federico, 181, 205, 293, 364 n.259
Zucchi, Jacopo, 204, 206, 294, 300 (*15.45*), 364 n.259

Designer: Janet Wood
Compositor: G&S Typesetters, Inc.
Text: 10/13 Palatino
Display: Palatino
Printer: Malloy Lithographing, Inc.
Binder: John H. Dekker & Sons